To Rob.
Happy Christmas 2008
from
Margaret

MICHAEL FREEMAN **Mastering**
Digital Photography

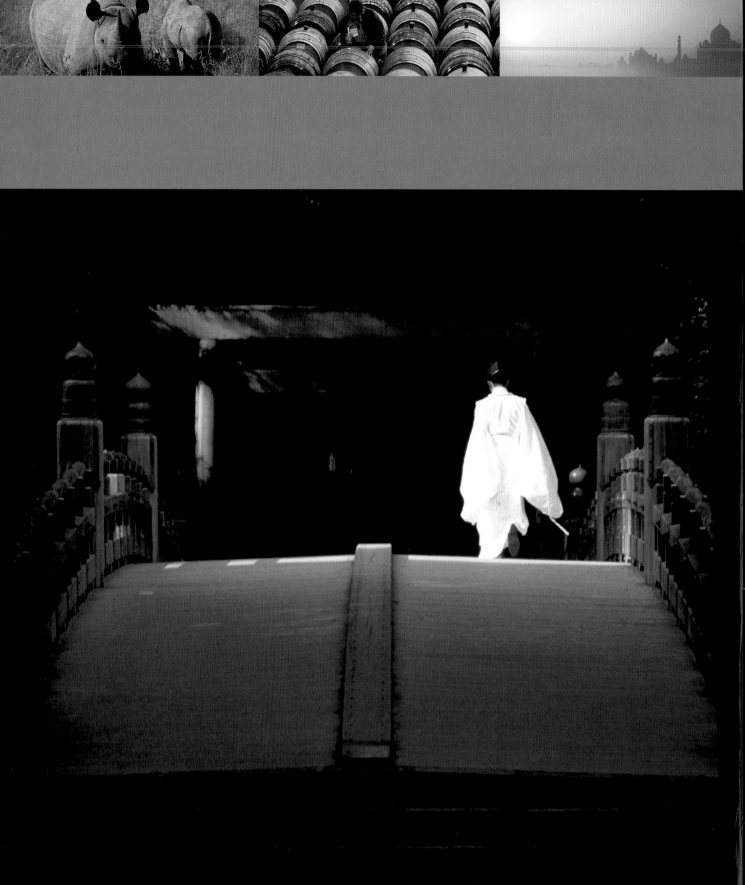

MICHAEL FREEMAN **Mastering**
Digital Photography

ILEX

Contents

Mastering Digital Photography

First published in the UK in 2008 by

ILEX
The Old Candlemakers
West Street
Lewes
East Sussex BN7 2NZ

www.ilex-press.com

Copyright © 2008 The Ilex Press Limited

Publisher: Alastair Campbell
Creative Director: Peter Bridgewater
Managing Editor: Chris Gatcum
Senior Editor: Adam Juniper
Art Director: Julie Weir
Designer: Ginny Zeal
Design Assistant: Emily Harbison
With thanks to: Joanna Clinch, Jane Waterhouse,
Tony Seddon, Hugh Schermuly

British Library Cataloguing-in-Publication Data:

A catalogue record for this book is available from the British Library.

ISBN 13: 978-1-905814-42-8

This book is made up of elements previously published in
The Digital SLR Handbook and the *Michael Freeman Digital
Photography Expert Series* (including *Black and White,
Close-up, Color, Light and Lighting, Landscape and Nature,*
and *Photographing People*).

Interactive digital resources can be found at Vincent Bockaert's
www.123di.com (not a part of Ilex Press).

For more information on *Mastering Digital Photography*, go to:

www.web-linked.com/fatpuk

Printed and bound in China

8 The Facts of Light
10 Brightness
12 Meter and exposure
14 Metering models
16 Histogram
18 Case studies: histograms
20 White balance
22 Exposure basics
24 Case study: Low contrast
26 Case study: High contrast

28 Natural Light
30 Bright sun, clear sky
32 The sun's angle
34 Skylight
36 Morning and afternoon
38 Sidelighting
40 Low sun
42 Frontal lighting
44 Into the sun
46 Silhouette
48 Edge lighting
50 Sunrise and sunset
52 Twilight
54 Moonlight
56 Cloud cover
58 The variety of clouds
60 Bright cloudy skies
62 Rain and storms
64 Digital effects
66 Brightening up
68 Haze
70 Mist, fog, and dust
72 Mountain light
74 Tropical light

76 Available Light
78 Daylight indoors
80 Incandescent light
82 Fluorescent light
84 Vapor discharge light

86 Mixed lighting
88 City lights
90 Lighting displays

92 Photographic Lighting
94 On-camera flash
96 Making more of flash
98 Studio flash
100 Studio flash equipment
102 Incandescent
104 Incandescent fine tuning
106 Attachments and supports
108 Controlling flare
110 Diffusion
112 Varying the diffusion
114 Diffusing materials
116 Reflection
118 Concentration
120 Modeling form
122 Revealing transparency

124 People Posed
126 Capturing expression
128 Planning
130 Setting the scene
132 The contextual portrait
134 Familiar surroundings
136 Activity and props
138 Lens focal length
140 Torso
142 Full-length
144 Face
146 Detail
148 Twos and threes
150 Groups
152 Natural light
154 On-camera flash
156 Basic portrait lighting
158 Softening the light
160 Portrait studio
162 Make-up for photography

164 Digital retouching
166 Retouching brushwork
168 Digital manipulation
170 Changing the background
172 Lighting for effect
174 Children

176 Daily Life
178 The natural approach
180 Street photography
182 Wide-angle techniques
184 Medium telephoto
186 Long lenses
188 Work as the subject
190 Skin tones and white balance
192 The moment
194 Anticipation
196 Framing the figure
198 An eye for the unusual
200 Intimate moments
202 City scenes
204 Small-town life
206 Following one subject
208 Parties and gathering
210 Weddings and anniversaries
212 Rites of passage
214 Parades
216 Behind the scenes
218 Sports events
220 Peak moment
222 Blur for effect
224 Picture essay

226 Natural Landscapes
228 A long tradition
230 Organizing the scene
232 Figures for scale
234 Overlooks
236 Framing the view
238 Other frame shapes
240 Panoramas

242 Stitching and mosaics
244 Interactive landscapes
246 Natural frames
248 A point of focus
250 The horizon
252 Managing bright skies
254 Golden light
256 Case study: a summer's morning
258 Sunrise, sunset
260 Twilight
262 The dramatic
264 The unusual
266 The critical view
268 Minimal views
270 Skyscapes
272 Weather
274 The color of light
276 Aerials
278 Preparing for a flight

280 Wildlife and Habitats
282 Animals in the landscape
284 Animal behavior
286 Stalking
288 Blinds
290 Wildlife from vehicles
292 Birds
294 Underwater
296 Woodland
298 Grassland
300 Coastlines
302 Wetlands
304 Mountains
306 Snow and ice
308 Deserts
310 Volcanoes and geysers
312 Caves

314 Landscapes of Man
316 Cityscapes
318 City views

320 Street furniture, street art
322 Buildings grand and modest
324 Converging verticals
326 Digital solutions
328 Architectural details
330 Gardens
332 Case study: Japanese gardens

334 Another World
336 Degrees of magnification
338 The optics of close-up
340 SLR techniques
342 True macro
344 Depth of field strategies
346 Making shallow focus work
348 Composite focus
350 Case study: closing in
352 Reflections and shadows
354 Flash
356 Photographing with a scanner
358 Micro
360 The microscope
362 Special techniques
364 Fiber optics

366 The Art of Still Life
368 Composing a still life
370 Minimalism
372 Props, styling, and sets
374 Shadowless white
376 Case study: clipping paths
378 Drop-out black
380 Settings and textures
382 Digital backgrounds
384 Tools of the trade
386 Light tents
388 Glass
390 Jewelry
392 Food
394 Liquids
396 Built to order

398 Copyshots
400 Lighting flat artwork
402 Coins and stamps
404 Case study: out of the studio

406 Nature in Detail
408 Color and pattern
410 Flowers and fungi
412 Life in miniature
414 Special flash setups
416 Indoor sets
418 Wet sets
420 Shells
422 Minerals
424 Gemstones

426 The Language of Color
428 Color theory, color practice
430 Color models
434 Saturation
436 The color of light
438 The color of objects
440 Red
442 Yellow
444 Blue
446 Green
448 Violet
450 Orange
452 Black
454 Color
456 Case study: chromatic grays

458 Working Digitally
460 Color management
462 Color space
464 Calibrating monitors
466 Camera profiles
468 A question of accuracy
470 Memory colors
472 Black point, white point
474 The subjective component
476 Printer profiling

478 Real Life, Real Colors
480 Optical color effects
486 Harmony
490 Red and green
492 Orange and blue
494 Yellow and violet
496 Multicolor combinations
500 Color accent
502 Discord
504 Muted colors
506 Case study: unreal color

508 The Language of Mono
510 Different concerns
512 Case study: visualizing in mono
514 The essential graphic qualities
516 Case study: the problem of skies
518 Basic color conversion
520 The traditional filter set
522 Using channels
524 Individual channels
526 Practical channel mixing
528 Using an adjustment layer
530 Case study: appropriate proportions
532 Case study: mixing to extremes
534 Hue adjustment
536 Layer masks
538 Case study: drama in the red channel
540 Case study: yellow's compromise
542 Case study: blue's atmospheric depth
544 Case study: luminous green foliage
546 Flesh tines: dark and light
548 Fine-tuning dark skin
550 Fine-tuning light skin

552 Digital Black and White
554 The zone system
556 Case study: placing a tone
558 Adjusting tonal distribution
560 A different approach to tones
562 Gradient mapping
564 Dodging and burning

566 High dynamic range images
568 Noise control
570 Copying in black and white
572 Scanning negatives
574 Scanning positives
576 Mood and atmosphere
578 Case study: defining the mood
580 Toner effects
582 Analyzing traditional tones
584 Mimicking film response
586 Duotones
588 Manipulating duotone curves
590 Stylized black and white
592 Posterization
594 Adding age
596 Hand-coloring

598 The Print
600 Desktop printers
602 Contact sheets
604 Printer calibration
606 Ink and paper
608 Mounting and display

610 Appendix: Digital Camera Basics
612 Your digital camera
614 The sensor
618 Resolution
620 File format
622 Lenses
626 Exposure
628 Kitbag
630 Power
632 Glossary
636 Index

Introduction

Digital cameras have taken photography in new directions, many of them exciting, some of them less certain. One of the most obvious is the instant feedback and near-immediate availability of the images, which in theory allows you to chart and improve your creative and technical progress. Another is that digital cameras have extended the occasions in which anyone can take photographs—they work well in low light and many are small enough to carry around all the time. And the ability to process, print, and display by yourself gives you control over everything.

Many things in photography, however, have not changed, and these are all in the area of the subject matter. The content of the photography, you could say. An art director friend of mine has an expression to describe pictures which haven't quite made it: "a photograph in search of a subject." I think I see more of this now than ever before, an enthusiasm for playing with the camera and messing around with the digital images that is not always matched by the confidence to go out and shoot interesting scenes in the first place. Too many flowers, details of brickwork, and less-than-special landscapes, basically. This book, on the other hand, is mainly about shooting.

As I'm a firm believer that photography is more about using the eye rather than the inner workings of the camera, I've put the technical and mechanical information as an appendix rather than kick off with it, as most books do. Not that I've stinted on this important technological groundwork, far from it, but learning about sensors and optics is preparation for photography, no more than that. So, what really is photography? Is it the equipment, now more enticing and shinily presented than ever? Is it secret knowledge of the perfect and exact way of photographing each particular subject? Is it image-editing software?

As a professional photographer working in the editorial and mainly documentary field, I naturally have my own firm opinions about this, and that really is why I write books when I'm not out shooting. One thing I am not going to do is to be fair and even-handed, and acknowledge that photography is just as much about tweaking and manipulating digital images on the computer as it is about shooting. It is absolutely not, as far as I'm concerned. Photography is first and above all about capture, about the moments surrounding the pressing of the shutter release.

At its most fulfilling, photography is about connecting to the real world in front of the camera and making from it an image unique to you and your particular vision. It's easy enough to stick to a formulaic way of choosing viewpoints, framing subjects, setting the exposure, and so on, but if you use a camera for pleasure rather than as an adjunct to business, that's a tame and bland approach. What I've done here in all these many pages is to present the whole world of photography as a rich set of opportunities for creating images that are personal to you, memorable, and satisfying. And speaking personally, I don't ask much more from one of my photographs than that.

The Facts of **Light**

Digital capture brings an unprecedented exactness to measuring light. The more advanced cameras, for instance, will display a histogram of any image—basically a graph of how the various tones in an image, from dark to light, are distributed. Once the image has been transferred from the camera to the computer, this and other kinds of analysis can be made. These are not academic exercises, but are practical means of capturing and displaying the fullest visual information—making the best of light and color.

The process of digital photography begins at the level of each miniature photo cell on the sensor array in the camera. Light falling on it is recorded as an electrical charge, in proportion to the light's intensity. The pattern of millions of these units ultimately becomes the image. To make sure that this reads well, the camera and lens have to control the quantity of light, its color balance, and (in the case of flash) its synchronization. Quantity means, in practice, exposure, as the sensor needs a certain amount of light in order to make a legible image. There is some leeway in this, because the sensitivity can be adjusted to dim lighting conditions, albeit with some loss of quality. Gone are the days of choosing types of film—the entire range is now effectively embedded in one sensor array.

This is one variable in dealing with the amount of light. The other two are the shutter and the aperture, which each regulate the amount of light. They have other functions as well, and in many picture situations you can choose which has the higher priority—a higher shutter speed to freeze movement or a smaller aperture to give better depth of field. Unless you decide to override the controls, most cameras now adjust shutter and aperture automatically, so you can usually assume that the exposure will be acceptable.

Light also has color, more so than the human eye normally recognizes. We accommodate so well to the color of light—whether white from a midday sun, blue in the shade, orange by incandescent lamps or greenish under fluorescent tubes—that it all tends to looks normal. The camera is more faithful to the original source, and compromises less, which, in the days of film, caused some unpleasant surprises in the form of strong and unwanted color casts to photographs. Digital capture takes care of this in two ways: by showing the result immediately, and by being able to make adjustments within the camera.

Modern digital cameras take care of most of these technical matters, which is all to the good because it is in the quality of light that the really important decisions lie. This means appreciating what kind of lighting works most effectively for different subjects and scenes; how to make the best use of the lighting conditions that you are faced with when you cannot change them; and being sensitive to the varieties of mood that different types of lighting can create.

Brightness

If there is an average source of light in photography it is normal daylight; the scale of shutter speeds and aperture settings, as well as the camera's basic sensitivity, are geared to this.

Most digital cameras' high-quality setting is ISO 100 or 200, and a normal exposure in the middle of a clear day would be about f16 at 1/125 or 1/250 second. Compared with this daylight standard, most artificial light sources are weak. Certainly, non-photographic light, such as domestic lamps and street lighting, causes some problems for photography. Even photographic lighting causes more difficulties because the light levels that they offer are too low rather than giving too much output. At close distances, such as in still life photography, this problem is rarely severe, but large-scale sets usually need expensive amounts of equipment to throw an adequate amount of light on them.

Light intensity depends on three things: the output of the source; how it is modified; and its distance from the subject. The sun is our main source of light, but there are a number of other, artificial light sources that can be used for photography, albeit with varying degrees of success. Some, like domestic tungsten lamps, exist simply because they are an easy method of producing light, even if this bears little resemblance to daylight. Others, like fluorescent lamps, are designed to imitate the effect of daylight on a small scale. Still others, such as electronic flash, are intended only to meet the specific needs of photography.

There are three main light sources other than daylight: incandescent light; fluorescent and vapor lamps; and electronic flash. Incandescent light works by means of intense heat. In a tungsten lamp, the most common type of incandescent light, a tungsten filament is heated electrically, and

Sunlight
As well as being the most common light source in photography, sunlight is also the brightest in normal circumstances. Shooting directly into the sun creates images with a range of brightness too great for any film or sensor to record fully.

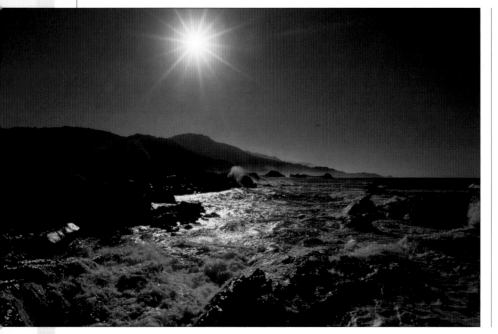

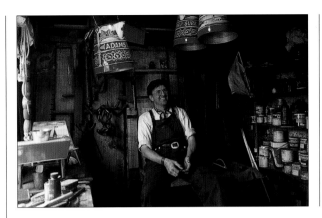

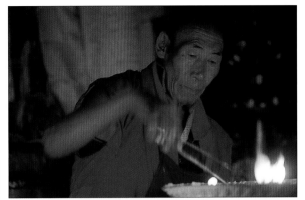

glows. Fluorescent and vapor lamps produce light by exciting the molecules of a gas, again with an electric current. An electronic flash unit uses the principle of an electronic discharge, but this occurs as a single, very short pulse in a sealed gas-filled tube.

The sun is so far away that its light is just as intense in one part of a scene as in any other. That is, the difference in distance between the horizon and foreground in a landscape shot is infinitesimal compared with the distance between the sun and the earth. All artificial light, however, weakens with distance, and the fall-off in illumination is a major consideration with photographic lighting and available lighting at night.

Daylight and tungsten lamps are continuous and, at least from the point of view of exposing a photograph, steady. Fluorescent lamps, on the other hand, pulsate, producing rapid fluctuations in their light output. Flash tubes are built on the principle of a pulse: one single, continuous, concentrated discharge that will expose a photograph just as well as a lower level of continuous light. Synchronizing the flash pulse to the time that the camera shutter is open is critical for regulating the exposure of a photograph.

Domestic tungsten

After daylight, the most common lighting condition is that found in buildings. The intensity of the light depends on the size of the room and the position of the windows and lamps, but even during the day, light levels are likely to be in the order of 7 stops lower than outdoors.

Flame

The weakest light source normally encountered in photography is probably a candle. Although the flame is always bright enough to record an image, the illumination from the flame needs long exposures.

Inverse square law

Light falls off with the square of distance — twice as far from a light source means four times less illumination. The most noticeable thing about this comparison chart of the main light source used in photography is that the sun's light does not seem to change with distance. This is because the distance between the earth and the sun is so much greater than any local differences.

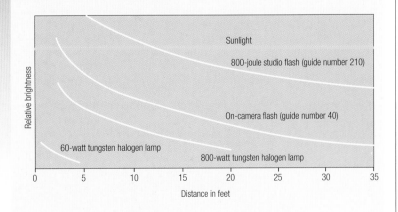

Sunlight

800-joule studio flash (guide number 210)

On-camera flash (guide number 40)

60-watt tungsten halogen lamp

800-watt tungsten halogen lamp

Relative brightness

Distance in feet

Meter and exposure

The ideal exposure is usually one in which you can see all the important detail, and which has a good range of tones and saturated colors. Delivering this is the meter's job, but it needs your judgment also.

Exposure is the amount of light that reaches the sensor. Too much light and the photograph will be pale and washed-out; too little and the image will be dark and murky. Getting the exposure right depends on the sensitivity of the sensor, which in most cameras you can adjust. The built-in meter has the job of measuring the light and working out the exposure, which it will happily do automatically. When the scene is lit strangely, or when you deliberately want an unusual effect, you may need to override the automatic settings. Personally, I like to use a manual meter setting in many situations—it demands more attention to the lighting conditions, but I do that anyway.

Cameras control the exposure with the shutter and the lens aperture. As well as varying the way that movement looks in a picture, the shutter delivers a dose of light—short or long according to its setting. The aperture, which is a multi-bladed diaphragm set in the lens barrel, cuts down the light when it is closed down. These two mechanisms are linked to the metering system, which measures the light entering the camera from the scene, and sets the exposure accordingly.

Cameras offer different ways of setting the exposure. Depending on the model, you can choose the aperture and the camera sets the shutter speed (this is known as aperture priority); you can choose the shutter speed and the camera sets the aperture (shutter priority); or you can let the camera choose both according to pre-set rules (program metering). Alternatively, you can do it all yourself and see the over- or underexposure displayed in the viewfinder (manual).

Setting shutter and aperture yourself

Manual exposure gives you direct access to the aperture and shutter settings. As with film cameras, digital cameras link these according to what is called reciprocity. One level more of one, matched with one level less of the other, gives the same exposure. Aperture and shutter adjustments are arranged in steps. Each full step doubles the exposure in one direction and halves it in the other. The simplicity of this is that you can operate the shutter and aperture in tandem; if you need to use a faster shutter speed without changing the exposure, all that you need to do is open up the aperture by the same number of steps. Say you are shooting at 1/60 second and ƒ5.6 and want a faster speed to deal with a quickly-moving subject. Turn the shutter speed dial two steps to 1/250 second, and the aperture two steps to ƒ2.8 – the exposure will stay exactly the same. Advanced automatic cameras are stepless, but still usually show the familiar series of shutter speeds and f-stops in the display.

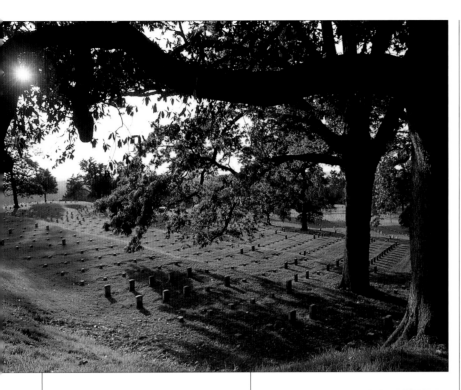

f-stops

The size of the lens aperture is measured in f-stops. The reason for using this special notation is that the same numbers can be given to all kinds of lenses. Each f-number refers to the same amount of light passing through to the sensor, whatever the lens. For example, f4 on a 35mm lens is actually a smaller aperture than it is on a 200mm telephoto because of the different optics, but the exposure would be exactly the same. The sequence of f-stops looks somewhat strange because the numbers represent the ratio of the aperture to the focal length, but each stop passes half the light of the one above.

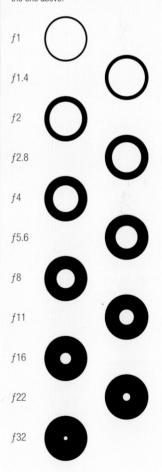

f1

f1.4

f2

f2.8

f4

f5.6

f8

f11

f16

f22

f32

Bracketing

Bracketing means making additional exposures lighter and darker than the metered reading. Normally, a bracket of three would be: +f1/2 stop; normal; -f1/2 stop. A bracket of five would be: +1 stop; +f1/2 stop; normal; -f1/2 stop; -1 stop. This is useful when the exposure conditions are uncertain and when you don't have enough time to check which exposure is right on the LCD screen. Many cameras will do this automatically.

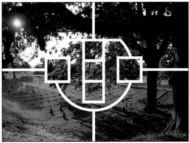

◢ Matrix metering

Matrix, also known as multi-pattern or evaluative metering, works by segmenting the image area, reading each segment separately, and then comparing the pattern with a "library" of known situations. The overall exposure is adjusted accordingly. Depending on the sophistication of the manufacturer's database of lighting situations, this method is potentially the best at dealing with non-standard scenes, as here, with a sun just shining through the leaves in the upper left.

Metering models

Most built-in meters read the image in such a way as to weight the exposure towards likely kinds of composition, and many cameras offer a choice.

The meter measures the light falling on the sensor in order to gauge the best exposure, but is also designed to favor certain areas of the frame. The reason for this is that in compositions that vary in brightness across the scene—and these are in the majority—the exposure that suits one part will not be right for another. In other words, it depends very much on your choice of subject. Most camera meters now attempt an analysis of the image in order to second-guess the composition.

Matrix metering, which is also known as multi-pattern or evaluative metering, is something that has been refined over the years, and is now the most sophisticated of metering methods. In this, the frame is divided into a number of segments, and the value of the lighting in each segment is read separately. The resulting pattern within the frame is then compared with a number of types of photograph that have been programed into the system's memory. If the meter matches your image to one of these known types, the exposure should be near-perfect. Some manufacturers use algorithms of simulated images for comparison; others use a library of real photographs (30,000 in the case of Nikon).

However, you need to be cautious when the view is unusually lit. Matrix metering is based on types of image. The top camera manufacturers pride themselves on researching most possible permutations, but the shot you want to take may not fit the pattern, or it may fit the pattern wrongly. In a minority of cases, matrix metering gets it wrong by assuming that you want a certain kind of picture when in fact you want something else.

The other two metering models, which are not available on all cameras, are center-weighted and spot. Both of these are designed to be used with the photographer's considered judgment, and so, while unrefined in comparison with matrix metering, are more predictable. Center-weighted measurements are taken from an area in the middle of the frame, which may be marked in the viewfinder. The one shown here, for example, from a Nikon SLR, is an 8mm-diameter circle that feathers off towards the edges and is included in the 12mm-diameter circle shown in the viewfinder. Spot metering is more precise. In both cases you should measure the important area in the scene

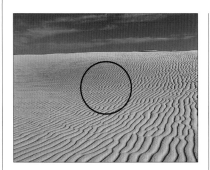

Know your center-weighted area

Choose a scene which, through the viewfinder, is divided sharply between two contrasting tones. In this example, the central circle engraved on the focusing screen of a Nikon D300 measures 12mm. The greatest weight is given to an 8mm circle inside this. To find the exact limits of the weighting, move the camera around while watching the exposure reading, to see how it interacts with the edge in the scene. Once you are completely familiar with the metering bias, with any scene you can aim off to take readings from different areas, or take substitute readings of a completely different view.

▲ Other options

In addition to the matrix metering shown on the previous pages, simpler alternatives that involve less in-camera calculation are center-weighted with a bias away from a presumed sky (above), center-circle (below right) and spot (above right). Spot metering is intended to be used by first aiming the center spot to the area you want to measure, then recomposing.

and then either use the exposure lock to recompose the image without changing the settings, or use manual exposure. Fortunately, you can see the result immediately on the LCD screen and compensate if it proves necessary.

In studio situations and for maximum understanding of light measurement, a handheld meter is unbeatable, although it is the case that the instant feedback from digital cameras' LCD screens has made it redundant for most photographers. A handheld meter allows you to take another light measurement, known as an incident reading. By fitting a translucent dome, you can measure the light, irrespective of the subject, and so can ignore the question of whether the subject is darker or lighter than average.

Histogram

Because the images are stored digitally, they can be measured absolutely precisely. Some cameras have an on-board histogram display, which shows you instantly what your exposure is like.

One of the great advantages of shooting digitally is that it offers you instant feedback: you are able to check the image that you have just taken. This has catalyzed a fundamental change in the way that many photographers shoot, particularly in situations where there is some doubt about the results. Exposure accuracy is one of the main beneficiaries of instant feedback, and by reviewing the shot you can do away with bracketing, even in such uncertain situations as back lighting and silhouettes.

However, the habit of immediate checking can sometimes breed a kind of complacency, and it is tempting sometimes to review the shot too briefly. The LCD screen on the camera has two drawbacks when it comes to assessing exposure. One is the angle at which you view it; if you are several degrees off perpendicular, the image can appear darker or lighter than it really is. The other is ambient light; overly dark conditions or bright sunlight can affect your judgment.

Some cameras have the option of displaying a histogram of each image, and this offers a precise and unbiased reading. A histogram can appear either as a graph or as a bar chart, and shows the distribution of tones in an image, from black at the far left through grays in the middle to white at the right. At first glance this may seem unnecessarily technical and geek-like, but, once you have become accustomed to reading a histogram, you can interpret it at a glance, often much faster than analyzing the image itself.

Good basic exposure

This is complicated by the many possible kinds of image, but in an average scene with a full range of tones from shadows to highlights, the histogram of an accurate exposure has two characteristics that soon become familiar:

☐ The curve fills most of the horizontal spread, from close to the left to close to the right.

☐ The curve peaks approximately close to the center. In other words, the deep shadows are dark without being completely void of detail; the highlights are almost but not completely white; and the midtones (the bulk of the peak) are in the middle where they should be.

Photoshop histograms

If your camera does not have a histogram view on the menu, you can find one later in an image-editing program such as Photoshop. In this case, one solution to an uncertain exposure situation is to bracket, and then check later on the computer.

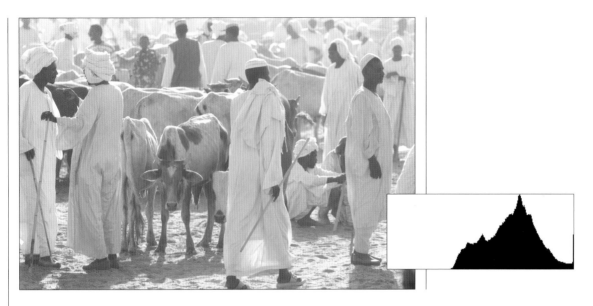

Overexposure

When too much light reaches the sensor, there are no dark shadows and too many washed-out highlights. The histogram shows that the entire curve is shifted right, squashed against the bright end, with a gap at the left.

Underexposure

When insufficient light reaches the sensor, the shadows are dense while the highlights are muddy. The histogram is unmistakable—the entire curve is shifted left, crammed up against the end, with a gap at the right.

Highlight check

Some cameras offer another precautionary check against overexposure, by flashing or coloring the bright highlights. Usually, these should be small and few.

Case studies: **histograms**

Learn to read histograms, and life (or at least exposure) will become much easier and more accurate. In particular, learn to read which parts of the histogram relate to which parts of the image. Study the varied examples shown here and you will get a feel for this kind of representation. A histogram is, in a way, a map of the image.

Cow
This Indian mural has mainly pale colors on a near-white background that takes up most of the space. Most of the tones are where you would expect, at far right. The thin line at far left is the small dark hooves and horns.

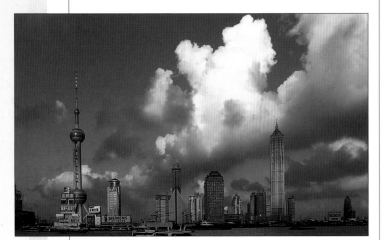

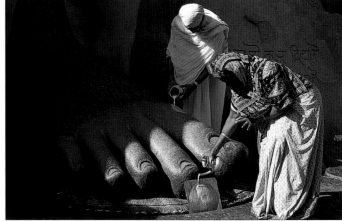

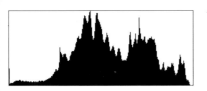

Skyline
This city view with billowing clouds divides into three main tonal group in the histogram: the largest group is the blue sky and darker buildings, to the right is the pale gray parts of the clouds, and the small area at far right is the white cloud.

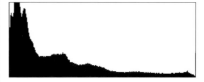

Statue
More than a third of the image is in deep shadow—the tones at far left crowding the edge, showing loss of detail— while the toes and two people carry a range of tones stretching in steps to the right. The small line at far right is the highlights on the white cloth.

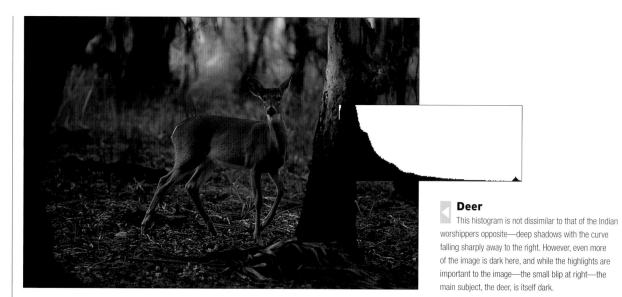

Deer
This histogram is not dissimilar to that of the Indian worshippers opposite—deep shadows with the curve falling sharply away to the right. However, even more of the image is dark here, and while the highlights are important to the image—the small blip at right—the main subject, the deer, is itself dark.

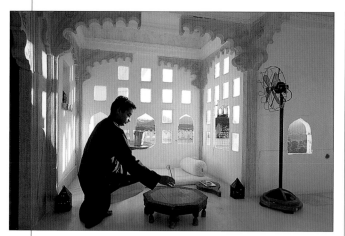

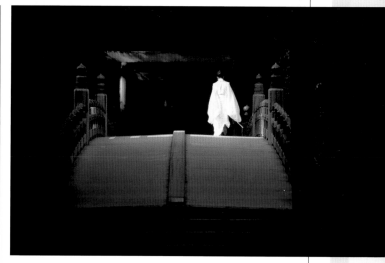

Cocktails
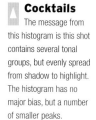 The message from this histogram is this shot contains several tonal groups, but evenly spread from shadow to highlight. The histogram has no major bias, but a number of smaller peaks.

Priest
Three components of the histogram reflect the three obvious tonal groups in the picture: dark surrounding shadow gives the sharp peak to the left, the dark bridge is the "plateau" to the right, while the white-robed Japanese priest is represented by the tiny group of spikes at the far right.

White balance

White balance is digital photography's answer to the different, sometimes unpredictable colors of light. It is a wonderfully convenient solution to getting the overall color of the image as you would like it to be.

Looking at the spectrum and color temperature, it's clear that the color of light can vary significantly. Even if our eyes and brain interpret the view so that it looks "normal," more often than not the light falling on objects is somewhat colored: it may be bluish in shade under a clear sky; reddish at sunrise and sunset; tinted by colored surfaces such as a painted wall, and so on. The white-balance controls on the camera's menu take care of this.

The options and controls vary from camera to camera, but the principle is the same. The bright highlights in a scene are the brightest reflections of the light source. Place a white card in sunlight and you will have an accurate reflection of the sun's color. If the sun is high, it will be more or less white. White is as much a state of mind as a physical reality—we perceive it as neutral. Setting the highlights in a scene to neutral white will make the image look "normal," which is to say "correct."

This is what a digital camera can easily do by processing the information collected by the sensor. Think of the white card under different lighting. In open shade under a blue sky it will reflect blue quite strongly, but if the camera is instructed to deal with the image as "open shade," it will compensate so that the card appears white. And of course, all the other colors in the scene will follow.

Testing white balance

The ever-useful gray card is a simple means of checking color balance objectively; this version is from Kodak. Photograph it under different conditions of daylight using at least two of the relevant white-balance settings, including automatic. Then check the RGB values in an image-editing program. They should be equal to each other. The reverse, white, side can be used for white-balance presets.

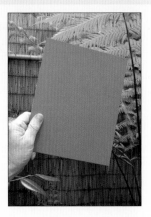

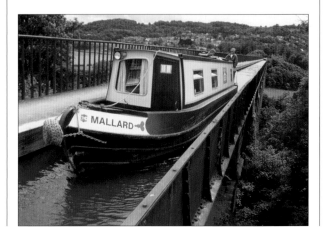

White balance choices

Digital cameras at their simplest offer a choice of a few typical lighting situations, such as sunlight, cloudy, shade, flash, tungsten and fluorescent. These are grouped under "White balance" on the menu accessible via the LCD screen. Choose the appropriate one and the results will usually be quite acceptable. Typical color temperature corrections are:

| Direct sunlight 5200K | Flash 5400K | Cloudy 6000K | Shade 7000K | Tungsten 3200K | Fluorescent (not strictly on the color temperature scale, but usually greenish) |

Fine-tuning the WB

Some cameras offer flexible alternatives in addition to the set choices. One of the most useful is the Auto setting, in which the camera analyzes the scene and makes a "neutral" interpretation—that is, with the least color cast overall. This works well in many, even most, situations, although not with a scene that has a strong overall color that you actually want to keep. Another choice is the ability to increase or decrease the color correction manually in increments. More customization is possible using a Preset option, in which you focus on a white surface under the lighting you are about to use, and the camera neutralizes it, remembering the setting for future use.

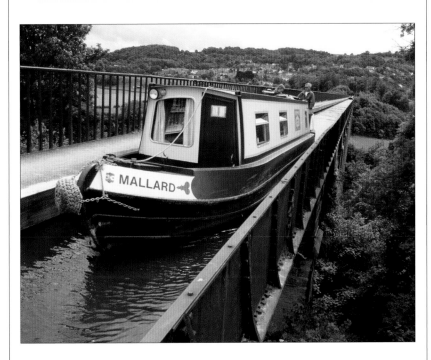

◁ Cloud cover

Overcast skies raise the color temperature a notch, by between about 200K and 1000K. Check the color temperature of the camera's overcast setting in the manual for an accurate idea.

▷ Exercise in correction

The blue of the sky is caused by scattering of the short wavelengths, and is known as skylight. In shade, the eye expects skylight to be neutral—that is, white. Occasionally it is, but usually it's blue to some degree. Don't expect to be able to judge this by eye alone. Shoot a shade situation under an intense blue sky, as in this snow scene, first with the camera's white balance set to sunlight (top), then set to shade (middle), and then to Auto (bottom). The sunlight setting will show you exactly how blue the shade really is—and it may come as a surprise. The other two settings will make a reasonable correction.

Exposure basics

In most situations, the camera's automatic exposure system will deliver excellent results, but the key to getting the exposure exactly as you want it every time is judging in advance how the image should look.

In practice, exposure is a matter of camera settings and meter readings, but the key to being able to make the right exposures easily and consistently is first to understand the criteria; you should first know what an acceptable image is. Ultimately, this depends on personal judgment, and although most people would agree more or less on whether an image appears too dark or too light, there remains a margin of individual taste. It is for this reason that there is no precisely set standard for correct exposure. The idea of correct exposure is a valuable one, but only if you allow it to be expressed a little loosely.

Under normal circumstances, the best exposure is the one that allows the most information to be recorded. The aim is to produce a photograph that resembles the way the original scene looked to the eye. In a typical view, this means that all the tones are present, from shadow to highlight. The highlights are bright, but still show a hint of texture, and the shadows are dark, but not so dark that they hide their detail. The parts of the scene that looked average in tone—neither bright nor dark—would also look average in the image.

However, there are many views that should appear light or dark, and not average. A white-painted building should look bright and white, not muddy and gray. Equally, a black London taxi cab should look black, not gray. Moreover, there may be a big difference in tone between the subject and its background. In this case, you'll want just the subject exposed correctly, and this may not be easy to achieve if the subject is small in the frame.

It's because of these different potential picture conditions that all serious digital cameras offer the choice of metering systems (center-weighted; spot; and matrix or multi-pattern). The key to using these is to appreciate that the camera's meter can measure an area and set the exposure accordingly to record the maximum detail, but it does not know how you want the image to look. If you can identify potentially difficult, non-average picture situations, you can compensate. Importantly, exercising control over the exposure means not using the matrix metering, as you cannot be certain how sophisticated it is in any given situation. In such situations, use the center-weighted or spot systems.

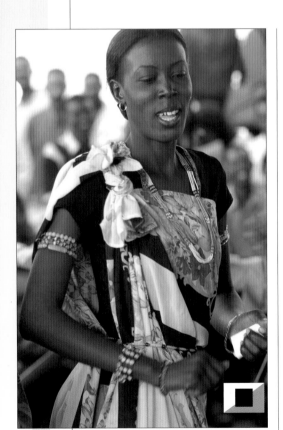

Important tones dark
The key tone in this shot of a Sudanese singer is the woman's dark skin.

Lighting situations

In a simplified form, most scenes in front of the camera fit one of these 12 stylized conditions. High-contrast conditions are the main source of exposure difficulties. Each of these situations is dealt with in detail on the following pages.

Average tonal range

Important tones average

Important tones dark

Important tones light

Low contrast

Average

Dark

Light

High contrast

Large bright subject, dark background

Large edge-lit subject, dark background

Large dark subject, light background

Small bright subject, dark background

Brightly side lit subject, dark background

Small dark subject, light background

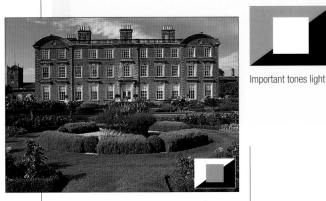

▲ **Important tones average**
The principal subject in this image is the brick façade of this country house.

▼ **Important tones light**
The sky makes this shot, and it is essential to hold the whites of the clouds.

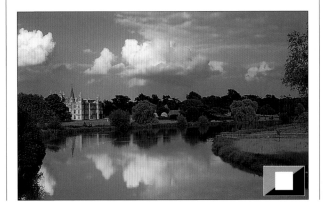

Exposure methods that you can control

For hands-on metering, use the center-weighted or spot measurements in any of the following ways:-
- ☐ Direct reading, no compensation. This is ideal for average lighting conditions and when you want an averagely exposed result.
- ☐ Direct reading with compensation. With experience, this can work remarkably well. The principle is to take the reading, then judge how much darker or lighter than average you want the result.
- ☐ Aiming off, to exclude unwanted areas from the metering area.
- ☐ Substitute readings. Aim the camera at a different view that, in your judgment, is the same brightness as the part of the picture you want to measure. This is useful when the subject is too small for the camera's through-the-lens (TTL) metering area.
- ☐ High/low readings. Aim off to read the bright part of a scene and then the dark part. Average the two readings.
- ☐ Spot readings. If your camera does not have a spot-metering system, use the longest focal length on the zoom, or fit a telephoto lens and use the camera like a spot meter. Good for reading small areas.

Case study: **low contrast**

These examples are all flatter than average, either because of the lighting or the subject, or both. Because contrast is low, you can choose how light or dark the image should look.

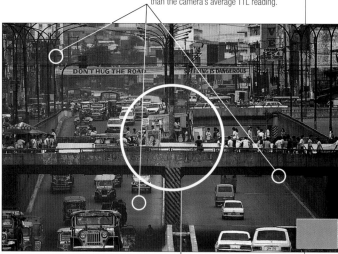

A random selection of spot readings shows consistency to within 1/3 of a stop. There is no reason for taking any measurement other than the camera's average TTL reading.

▷ Low contrast, average subject

This is about as close as you can expect to come to an even tone in normal shooting conditions. The contrast is low to the point of drabness. There are no particularly bright or dark areas to worry about, and no reasons to want any other than an average reproduction. Any kind of meter reading will deliver the same result.

Even at a glance, it is obvious that the central metering area is completely typical of the entire scene. Reproduced as an average exposure, it will look like this, and the only possible variation is whether to suggest a bright cloudy day (add 1/2 a stop) or an approaching storm (reduce 1/2 a stop). Typically, average scenes like this offer the least latitude in exposure.

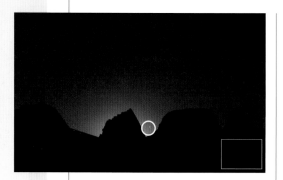

▲ Low contrast, dark subject

Because this is a night-time view, with the subject (pyramids) silhouetted against a rising moon, it should remain dark to be realistic. The brightest area is the glow around the moon, and this has been kept low in tone to avoid the image being mistaken for a daytime shot. Exactly how dark to make it is a matter of judgment, and several versions would be acceptable. In this case, I went for 3 *f*-stops darker than average, which keeps a sense of the silhouettes only just being revealed.

▷ Low-to-medium contrast, average subject

Apart from the skyline, the contrast in this scene is also below average, and the center-weighted area gives a typical reading, as would matrix metering. No adjustments are necessary.

The moderately bright sky just above the horizon is the only anomaly in this otherwise low-contrast scene.

The camera's center-weighted reading is accurate for the entire scene, as long as the metering circle does not include the sky.

Low-to-medium contrast, bright subject

In this backlit shot of spring daffodils, the sun shining through bright yellow petals makes it necessary to keep the overall tone light. If it had been given an average exposure, the result would simply be muddy. Exposure compensation was +2/3 f-stop.

Within the area of this inscribed headstone, any reading will give the same result. The three circles represent different aiming points for the camera's TTL metering circle.

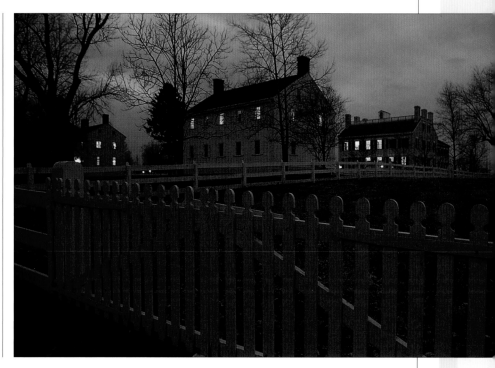

Low contrast, bright subject

Again, contrast is low, but an average TTL reading, if followed, would make this image gray rather than white. Compensate by increasing the exposure by about 1/2 to 2 stops. More exposure than this will cause the texture of the stone to disappear.

Low-to-medium contrast, medium-dark subject

Despite the locally bright windows, the gathering dusk over this Shaker village lowers the overall contrast. To preserve the feeling of twilight, the best exposure is about one f-stop below average.

Case study: **high contrast**

Contrasty scenes bring the risk of losing detail because their brightness range is likely to be beyond the dynamic range of the camera's sensor. The critical judgment is what tones to preserve.

Although a center-weighted reading would be overly influenced by the sky and shadow, aiming the camera slightly off will give a usable reading of the essential parts of the scene. This will still need compensation to avoid underexposure.

The dark blue sky should not influence the exposure measurement.

As a dense black shadow, this area of the picture plays no part in the exposure calculations, and does not need to be measured.

The key tones are these rim-lit highlights outlining the figures. Not only are they too small even for a spot meter reading, but the movement leaves insufficient time. A substitute or incident reading would be the only reasonable alternative.

This brightest face of the building is the key tone. Any exposure calculation must hold this tone as a just-readable white. Too much exposure would give it a washed-out appearance.

The metering circle in this case is useless.

▲ High contrast, subject partially lit

Any direct TTL reading here, center-weighted or spot, has no value. Take a substitute reading of another sunlit area and bracket. In this example, many other photographs had been taken in full sunlight before, when the basic setting was familiar: 1/250 second at f5.6 with ISO 64 film. As the highlights are more important for outlining the shapes of the figures than for showing their own detail, the exposure given was deliberately 1 stop over—1/125 second at f5.6.

▲ High contrast, subject bright and dominant

Here, the first step is to identify the subject—that is, from the point of view of exposure. Exclude the deeply shadowed frame and sky from the reading by aiming off so as to meter only the pale buildings. The indicated reading would give a fairly dense exposure. For a more average, if slightly less richly colored, version compensate by increasing the exposure by ½ to 1 stop.

▶ High contrast, subject bright and small

A reading of the darker part of the gold sign would be accurate, but only possible with a spot meter, a spot reading alternative in the camera's TTL system or by changing to a long telephoto. Otherwise, make a substitute reading of another surface that is in the same sunlight and of average reflectance and then bracket.

The key tone naturally is within the small area of the subject. A spot meter reading would be ideal; allowance would then be made to avoid underexposure.

The area occupied by the subject is too small for the metering circle, even if the camera is aimed off in order to make the reading.

The brightest part of the scene needs to be held. Too much exposure would wash it out.

Given that the metering circle covers both dark and light areas about equally, a center-weighted reading would, in this case, probably be accurate (although bracketing would be advisable). On the whole, an incident reading would be safer.

The contrast range between subject and background is 8 stops.

The contrast range between these two extremes is 6 stops.

The easiest practical method here is to read the background and then open up the aperture by 2 to 2½ stops so that it is held just below the point of being washed out.

▲ High contrast, subject dark and dominant

This high-contrast scene allows considerable latitude for interpretation. Nevertheless, the objective ideal would be an exposure that leaves some tone in the foggy sky, and shows the barest hint of detail in the silhouetted bell. One method is to aim the camera so that the metering area takes in the light sky and dark bell in equal proportions. This is essentially a quick method of approximating a high/low reading. Again, where there is uncertainty, it would be sensible to bracket.

Ideally, this large shadow area should be sufficiently well-exposed to show some detail—about 1 or 1½ stops above the threshold of dense shadow.

A snap judgment from the center-weighted reading would be to reduce the indicated exposure by around 1½ stops.

▲ High contrast, subject partly in shadow

Here the bright areas have priority, but the shadow area also needs to be held. Matrix metering would probably work. Spot readings of the brightest and darkest parts would be ideal, but in such a situation there is no time. Or you could take a center-weighted or spot reading of the bright areas and reduce by about 1½ stops, bracketing for safety.

▶ High contrast, subject dark and small

There is no point attempting any kind of reading of the boat, or of a substitute dark area. The most easily available reading is of the bright sunlit water. Take this reading and compensate by adding about 2 or 2½ stops. Less exposure will give you more texture and color to the water, but may absorb some of the outline of the boat. More exposure will tend to introduce flare and a grayness to the boat's silhouette.

Natural **Light**

The sole source of natural light is the sun. Even the moon is simply a reflector of sunlight, as is the sky. Yet the variety of lighting effects is tremendous; there are so many ways of modifying sunlight that the range of lighting conditions is infinite.

The direction of sunlight is the first variable. The sun moves across the sky, reaching different heights according to the time of day, the season, and the latitude. Add to this the camera angle—facing towards or away from the sun, or with the light shining from one side. The result is an enormous variety of possible angles between sun, camera, and subject.

Before it falls on any scene, the sunlight first has to pass through the atmosphere. It is slightly softened, the more so if it passes through a greater depth of atmosphere, as it does when the sun is low. It is also scattered selectively, so that the sky appears blue, and the sunlight can be any color between white and red. In addition to this, weather conditions filter and reflect the light even more strongly. Clouds can take an infinite variety of forms, while haze, fog, mist, dust, rain, snow and pollution have their own distinctive filtering effects. Finally, the surroundings themselves alter the illumination by the way they block off some of the light and reflect other parts of it. The net result of all this is that three things happen to sunlight: it is diffused; absorbed selectively (which changes the color); and reflected from surfaces.

One way to think of natural light is in terms of a giant outdoor studio. The sun becomes a single lamp, and the other conditions have their equivalents in diffusing screens, filters, and reflectors. Although you can do little or nothing about where these all are, you can at least move the camera around. Perhaps even more importantly, the better your understanding of how they work and how they change, the more easily you will be able to predict the best lighting conditions for the image that you want to obtain. Choice of viewpoint, timing, and, above all, anticipation are the fundamental skills in using natural light.

Bright sun, clear sky

The most basic, least complicated form of natural light is the sun in a clear sky. Without clouds or other weather effects, the lighting conditions are predictable during most of the day.

The sun's arc through the sky varies with the season and the latitude, but it is consistent. As the sun rises in the sky, the light levels increase. They rise quickly in the morning and fall quickly in the late afternoon, but during the middle of the day they change very little. Once the sun is at about 40 degrees above the horizon, it is almost at its brightest. How long it spends above this height depends on the season and the latitude. In the tropics, this can be as much as seven hours; in a mid-latitude summer, eight hours; and in a mid-latitude winter, no time at all. On a winter's day in the northern USA or Europe, light levels change steadily but slowly from sunrise to sunset. In the summer, the levels change more quickly at either end of the day, but very little for the hours around noon.

The thickness of the atmosphere affects the light's intensity—at higher altitudes, the light levels are higher. The atmosphere also scatters different wavelengths selectively. White light from the sun is scattered, but it is the shortest wavelengths that are scattered the most, and these are at the blue end of the spectrum. So, looking away from the sun, you can see this

▽ **Airport sunset**
The atmosphere scatters sunlight, most strongly when the sun is low. As the shortest wavelengths scatter the most easily, and these are at the blue end of the spectrum, what remains when we look at a low sun is red or orange. The soft shadows on these airport buildings are lit by the bluish light that has been scattered.

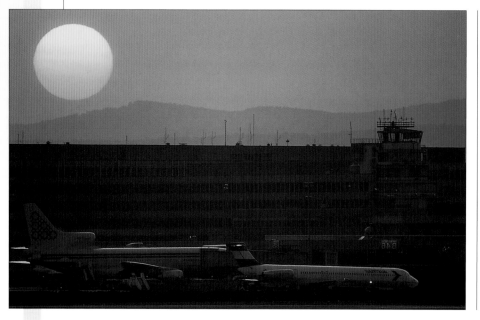

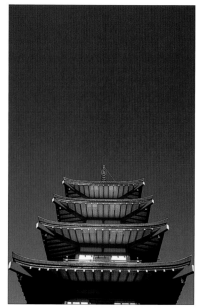

scattering in the form of a clear blue sky. Looking directly at the sun, its color depends on how much blue has been scattered and lost; when the sun is high, very little is lost, but close to sunrise and sunset, when the light has to pass obliquely through a much greater thickness of atmosphere, the light is shifted towards red. The atmosphere close to the ground has the greatest effect on sunrise and sunset, and as these vary locally quite a lot, the colors can differ from place to place and from day to day, between yellow and red.

The sky as a studio

In many ways, the sun in a clear sky works for photography like an over-sized studio, with the sun as a single light source like a naked lamp, and the surrounding blue sky as a colored reflector. Objects, whether buildings, people, or landscapes, are lit directly by the sun and indirectly by its bluish reflection from the skylight.

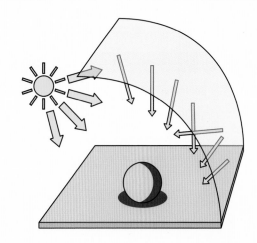

The effect of the blue sky, which is also known as skylight, is so much weaker than direct sunlight that it is felt only in the shade. It acts as a reflector, and tints shadows. In addition to this on a clear day are the surroundings, which act as colored reflectors, and also the shadows: green grass; the walls of buildings, and so on.

San Xavier

Clarity and sharpness, with details picked out in light and shadow, are typical of clear weather, as in this view of San Xavier mission near Tucson, Arizona. The sky is often darker than the subject—quite the opposite from scenes under cloudy skies.

Churieto temple

In the middle hours of the day, when the sun is high, the contrast between blue sky and subject dominates most scenes, as here where sunlight strikes, and reflects off, the roofs of a Japanese temple.

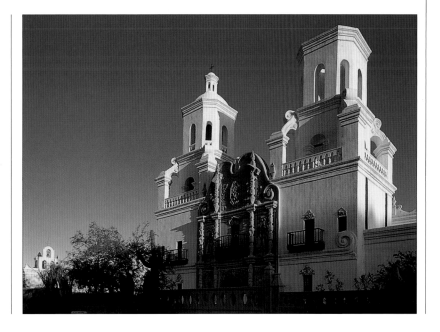

The sun's angle

As the day unfolds, the changing direction of sunlight reveals different aspects of the scene. Some are more appealing than others.

All the possible variations of lighting direction cover a sphere surrounding the subject. In a studio, any of them can be used, but sunlight operates only over a hemisphere (apart from unusual reflections), as shown below. There are, in fact, two directions to consider at the same time: the sun's angle to the camera, and its angle to the subject. Together, they make too many permutations to classify sensibly, and we will concentrate here on the direction that has the main influence on the quality of illumination: the angle to the camera.

Quality of illumination is primarily responsible for atmosphere and the overall image qualities. The angle of the sun to the subject is mainly important for those subjects that "face" in a particular direction, and in revealing plastic qualities such as shape, form, and texture. The lighting sphere is included here to make a deliberate comparison with studio lighting.

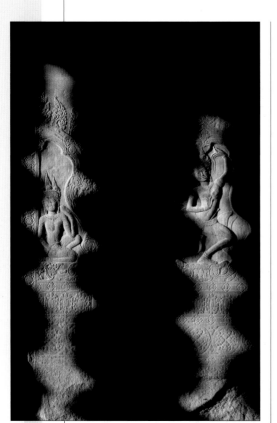

◢ A matter of timing
The precise angle of sunlight becomes important when, for example, it casts shadows for a short time only on a particular subject. In this case, the gaps between stone window balusters fall on carvings on the wall opposite at the temple of Angkor Wat, Cambodia.

Lighting directions

The direction of light, which outdoors can be from anywhere above the horizon, can be grouped into zones. This "lighting sphere" is segmented to show the main directions, which are dealt with in greater detail on the following pages.

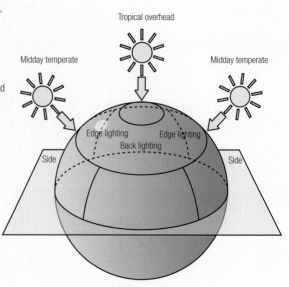

Tropical overhead

Midday temperate

Midday temperate

Edge lighting Edge lighting

Back lighting

Side Side

Naturally, the directions shown are related to the time of day and season. By far the majority of outdoor photographs are taken with a camera angle that is close to horizontal—at least within 10 or 20 degrees. For these, the lighting-sphere diagram holds true. The exceptions are extreme verticals, either up or down. Upward vertical shots, in any case, tend to produce disorientation, and this usually overwhelms other image qualities, such as lighting direction. Nevertheless, back lighting is a common condition of shots like this. Downward verticals, particularly over a distance, such as from high buildings and aircraft, are usually of a flat surface: the ground. Lighting considerations for this kind of picture are usually similar to those needed for revealing texture.

▼ The sun across the sky

A single, isolated feature—in this case, a sea arch off the coast of Mallorca, Spain—reveals its different aspects during the course of one day under a bright sun. Reflections on the surface of the clear water add to the complexity of the changing image.

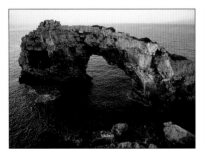
aSunrise

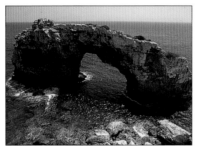
Noon

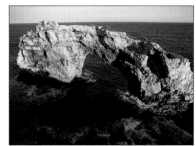
Late afternoon

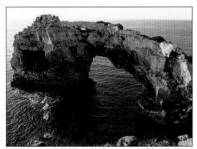
Early morning

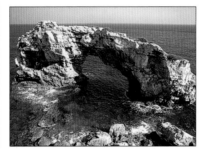
Early afternoon

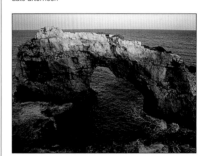
Sunset

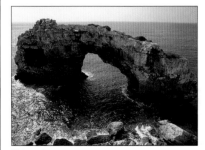
Mid-morning

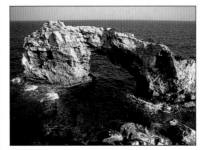
Mid-afternoon

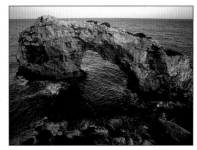
Dusk

Skylight

Indirect lighting from the sky—that is, when the sun is shaded by an obstruction—is soft and potentially attractive, but its color varies widely.

Traditionally, artists' studios were built with large north-facing windows because the gentle illumination was consistent. Known as "north light" or skylight, this light may appear to the eye to be consistent, but in reality it has very unreliable color properties. This meant that it was generally avoided during the days of color film, but fortunately digital cameras can easily neutralize the color. Skylight is blue because of the scattering of short wavelengths in the atmosphere. The blueness varies with the weather conditions and the altitude (it is more blue in the thinner air of mountains). Its effect is weakened by clouds and by any bright object, such as a white building, that reflects sunlight. Although skylight is what remains on a sunny day when the direct sunlight is blocked, it behaves, from the point of view of taking pictures, as a light source in itself.

Skylight is most important when you are photographing entirely in shade. What happens in this situation is that, because there is only one kind of illumination visible and it is consistent, the eye expects it to be neutral in color; in other words, white. Occasionally it is, but more often it is not, and

The range of blue sky

The color temperature of skylight covers approximately the range shown here. In the first panel, the atmospheric conditions are clear and dry; the intensity of the blue depends on altitude, season, position of the sun and which part of the sky you look at (normally the higher, the more intense). In the second panel, the blue is diluted by increasing amounts of haze. Broken cloud in the third panel reduces the overall color temperature; this varies with how bright the clouds are and how much of the sky they cover. Finally, the surroundings may obscure some or most of the skylight, and if they are pale in color and sunlit themselves, they can virtually take over as the light source.

Clear sky 12,000–7000K

Haze about 6000K

Variable cloud about 5700K

Pale surroundings about 5400K

that is when the white balance of a digital camera comes into its own. The "shade" setting can vary according to the manufacturer, but is typically around 8000K. Some camera menus allow this to be raised or lowered. Remember that the eye is a poor judge of color temperature in shade, but check to see how blue the sky looks, as this makes up most of the illumination, added to by local reflecting surfaces (such as walls, sand, or water).

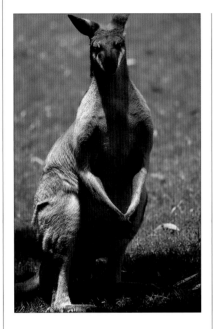
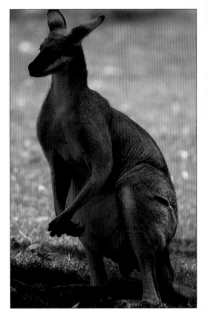

Sun and shade

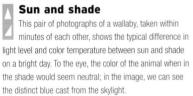
This pair of photographs of a wallaby, taken within minutes of each other, shows the typical difference in light level and color temperature between sun and shade on a bright day. To the eye, the color of the animal when in the shade would seem neutral; in the image, we can see the distinct blue cast from the skylight.

High-altitude blue

In mountains and in clear weather, there is less atmosphere, less haze, and more ultraviolet. When the sun is low in the early morning and during the late afternoon, shadow areas easily dominate a scene, as in this Andean village, and reflected blue from the sky takes over.

Morning and afternoon

A lower sun makes life more interesting for photography. There is more variety than with midday sun, because the sunlight interacts more with buildings, people and objects, and you can choose different camera angles to it.

For striking, immediately attractive lighting, the morning and the afternoon are some of the best times of day for shooting. Instead of everything being bathed in the same light from above, there is more local interest as the sunlight strikes the sides of objects and casts less predictable shadows. The lower angle of the sun is more flattering to most subjects than that around midday. In addition, while the sun—when it is well clear of the horizon, but not really high—may lack the potential drama that it has around dawn and dusk, it still gives attractive and more reliable lighting. The color is nearer a neutral white and, if you find a long run of orange- and red-hued images exaggerated, it is more straightforward. If a true color rendering is important, shoot when the sun is at least an hour or two away from the horizon.

▶ Shooting down

An overhead camera position can be a good option in this light. In this case, the contrast is usually much less because of the ground, or whatever surface the subject is resting on, but the texture remains strong. In addition, the long shadows make for interesting graphic compositions.

Make full use of the sun's lower angle by choosing its angle to the camera: behind, in front or to one side. The visual effects are quite different, and are more accentuated when the sun is closer to the horizon. When shooting silhouettes in mid-morning and mid-afternoon you need tallish subjects for best effect. The most characteristic lighting effect at these times is side lighting, which can be both dramatic and useful, and we explore this more fully on the following pages.

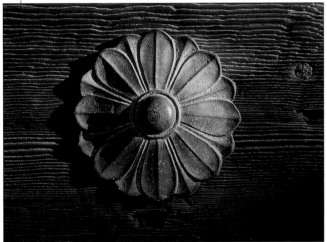

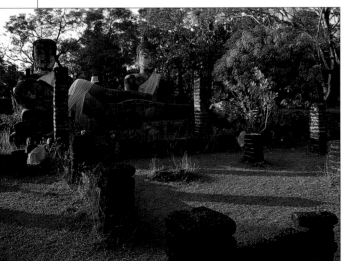

Wall details
Cross-lighting reveals texture at its strongest. Just as some vertical surfaces receive this at midday, others are at their best early and late in the day, as with this bronze fitting on a wooden wall. Here, the window of opportunity was only a few minutes long before the shadows covered everything.

Using shadows
The shapes cast by shadows when the sun is fairly low can be put to good graphic use. In this morning shot of an old French abbey with a garden of lavender, the foreground shadow makes a solid base for the composition; the middle-ground shadows of trees suggest the unseen forest at right; and the shadow cast by the conical roof continues the lines of the hill beyond.

Horizontal light and shade
The visual play between highlights and shadows is an important component of photographs taken at these times of day. Shooting at right angles to the sun makes the most of this effect and adds a linear, horizontal component to the image.

Side lighting

Of all the types of direct sunlight, side lighting is probably the most useful when it is important to bring out modeling and texture in the subject, and this is all down to the way that the shadows fall.

Shadows are the feature of side lighting that stands out the most, and it is these shadows that show the relief of surfaces and objects. As the two diagrams below show, shadows appear longest to the camera and most distinct under side lighting. The other condition under which the sunlight is at right angles to the camera's view is when the sun is overhead, but, in this case, the ground limits the extent of the shadows, and also tends to act as a reflector to fill them in.

The shadows from side lighting have three effects. The first is that the shadow edge traces the shape of the front of the subject, and so has a modeling effect. You can see this in the photograph of the two women on the opposite page. The second effect is on surface texture. Shadows are longest under side lighting, and so the small ridges, wrinkles, and other fine details of a surface show up in the strongest relief, as in the photograph of the paper lantern opposite.

Light and shade

Side lighting produces the most distinct shadows. This sequence shows what happens as the direction of sunlight moves from front to back. The shadows are smallest from the camera's viewpoint in frontal lighting, while in back lighting, the shadows dominate to the extent that there are few sunlit parts to give local contrast. The maximum light/dark contrast is when the sun is at right angles to the camera.

High contrast

High contrast is typical of many side-lit scenes. The lighting is at right angles to the view, and thus the shadows are too. As the diagrams show, a surface needs to be angled only slightly away from the sun, or be shaded by quite a narrow obstruction, to give a high light/dark contrast.

The third effect of side lighting is on contrast. If the sky is clear, and there is nothing nearby to reflect the light, such as buildings, the contrast between light and shade will be high. Moreover, as the diagrams opposite show, it needs very little to change a lit background into a shaded one, and a dark setting will help a side-lit subject to stand out very clearly. The photograph of the two women illustrates both of these points.

Getting the exposure right

Light measurement and exposure depend on the shape of the subject and on the proportions of highlight and shadow. If a major part of it faces the sunlight, then expose for this. This situation is where matrix metering comes into its own, but you will need to check the result carefully on the LCD display. Alternatively, measure just the lit areas (in spot or center-weighted mode if your camera has these), using exposure lock to hold that setting when you re-frame the shot. If, on the other hand, what you can see of the subject is virtually flat and facing the camera, an average reading will produce successful results.

Light and texture

The angle of this Japanese lantern's paper surface changes gradually from left to right, and this affects the amount and distribution of shadow. The strongest impression of textural detail is when the sunlight grazes the surface at a very acute angle. Broadly speaking, there are three areas of texture detail in the shot of the lantern, with light readings as follows: left = f16; center = f11; right = f4. The area of maximum texture detail is in the center.

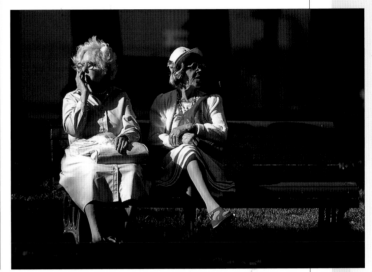

Sharp outline

One of the most effective uses of side lighting to outline a subject depends almost entirely on the camera viewpoint. In this shot taken in a Montreal park, the sun is at right angles to the view, and the background is in shadow.

Raking light

In this shot of a yogurt dish, photographed from directly above, side lighting establishes the texture—an essential quality in food photography, where any tactile sensation helps to stimulate taste. A white card on the side of the dish opposite the late afternoon sunlight opened up the otherwise strong shadows.

Low sun

In clear weather, the times of the day when the sun is close to the horizon can produce some spectacular lighting on landscapes. To take advantage of this, be prepared to shoot quickly and move the camera as the light changes.

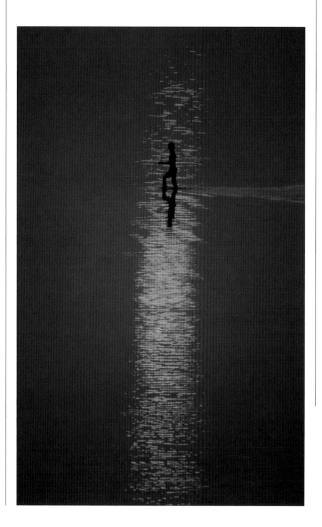

The most concentrated periods for working with the changing angle of the sun are at the beginning and end of the day, generally within an hour either side of the sun crossing the horizon. Every quality of the light changes: direction; diffusion; color; intensity. It is usually unpredictable because of atmospheric effects and clouds, which reflect the light. In high latitudes, the sun stays close to the horizon throughout the day in winter, making cold, clear days perfect for photography.

All the remaining directions of sunlight are those of a relatively low sun. Low in this case means no more than about 30 degrees above the horizon, and in most of the examples shown here, no more than about 20 degrees. In a mid-latitude summer, this is before 6 o'clock in the morning and after 6 o'clock in the evening. The special value of a low sun is that it offers a choice of four major varieties of lighting quality at once—frontal, side, back, and rim. All four types of lighting can be found at the same time, with the same position of sun.

In addition, there is also the old cliché of using the setting (or rising) sun itself as the main subject of an image. The sun on the horizon seems an irresistible subject for many people, as evidenced by the number of "sunset viewpoints" at tourist spots around the world. Watching the sun go down is a time-honored pastime (watching it rise demands more discipline), but turning this into a good photograph means finding a graphically interesting setting, not a featureless horizon. A long telephoto lens comes into its own in such cases.

The sun's reflection
The red column of light here is effective for two reasons: it neatly encloses the silhouette of the boy wading through the shallows; and the heavy haze makes it contrast less with the surrounding water.

Warm tones

Normally an undistinguished gray, the sandstone into which this Khmer bas-relief has been carved acquires a rich golden glow in the early morning sunlight.

Cholla cactus

These three shots of a clump of jumping cholla cactus were all shot within minutes of each other as the sun was setting over Saguaro National Monument near Tucson, Arizona. The lighting effect is quite different in each, according to the viewpoint, between back lighting, frontal lighting, and side lighting. This illustrates one of the valuable qualities of a low sun—the variety that it offers to the camera.

Frontal lighting

Light that is full on the subject casts no obvious shadows, but brings out all the differences in color and tone at their strongest, as well as intense reflections.

Frontal lighting is when the sun is directly behind the camera. If you use it well, this can be very powerful and colorful, but the difference between creating a successful and an unremarkable image is more delicate and less predictable than with the other varieties of low sunlight. Being frontal, the sun in this position throws shadows away from the camera, and if the viewpoint is exactly along the lighting axis, they will be invisible—like using on-camera flash but covering the entire scene. As shadows are responsible for modeling and texture, and help with perspective, the character of frontally sunlit shots tends to be flat and two-dimensional. This is almost a prescription for a dull effect, but what can make the difference is the color and tone of the subject, and the intensity of the sunlight.

When the lighting is intense and is behind the camera, the most immediate quality of the picture is the strength of the colors. With real frontal lighting, this effect is even stronger, with the addition that the color temperature is lower, and the light more yellow-orange. This means that the contrast of both color and tone is high. If these are already inherently powerful in the subject, as in the picture of the Japanese woman shown on this page, the combined effect is very strong. Reflections jump out in these conditions, sometimes too strongly, but look for the effect on any surface that has shiny or iridescent qualities.

Richness of color
The contrast between the black silk and gold embroidery is already strong. Frontal lighting enhances this by illuminating the glossy embroidery as strongly as possible.

Mirrored contrast
Shooting straight into a highly reflecting surface, such as this mosaic of mirrors, will give extremely high contrast, so that any matt surfaces appear almost as silhouettes, as in this decorative detail.

Your shadow

When the sun is almost on the horizon, and provided that it remains bright, shadows begin to appear and can soon cover everything. This means that your own shadow will appear, which is usually unwanted. One solution is to alter the shape of the shadow you cast, so that it appears natural and indistinguishable (for example, withdraw your arms, duck your head, or cover over tripod legs). The other is to move so that the lighting in the picture is not exactly frontal. In the case of the shot of the cemetery here, slightly off-axis lighting produced graphically strong shadows that edged the lit shapes and could be used in the design of the image.

Flat graphics
The lack of shadows when the sun is directly on the camera axis can work well with strongly colored or contrasting subjects if you treat the composition as two-dimensional, ignoring perspective and depth.

Bright reflections
Shiny surfaces such as the gilding on this northern Thai temple, which faces east towards the sunrise, leap out of the picture for the short period of time that they catch the light.

Shadow shapes
Narrow but hard shadows from a setting sun almost behind the camera play an important part in a view of a Shaker cemetery near Albany, New York. It was necessary to position the camera carefully to prevent its shadow from appearing in the photograph.

Into the sun

Back-lit photographs are intrinsically dramatic and exciting, although as with any other distinctive technique, their strength and appeal also lie in being applied sparingly.

Shooting into the sun gives a photographer some of the best opportunities to create atmospheric and abstract images. The hallmark of direct shots is the silhouette, in various forms; this can be powerful if you take care to show a clear shape and expose appropriately. Off-axis shots, with the sun only just out of frame, can give a more interesting and unusual range of images, which draw very much on the texture of surfaces to produce their effects.

There are four types of lighting conditions that can be classified as back lighting. One is a direct shot into the sun and another a direct shot into a *reflection* of the sun. The other two types are off-axis shots; one normal, usually with the horizon visible; and the other, which is

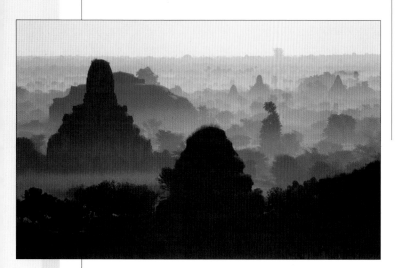

Receding planes

A light morning mist combined with back lighting creates a strong aerial perspective in this view of ancient pagodas in Burma, by progressively softening the silhouettes with distance.

Types of back lighting

There are four basic kinds of effect when shooting towards the sun, depending on the height of the sun and the camera position. Shooting directly into the sun produces a hard silhouette against a concentrated area of brightness. A higher angle into a reflective surface, such as water, also gives a silhouette, but the bright background will be larger. When the sun is higher and out of frame, some shadow detail can be retained. With rim lighting, the background is dark enough to show the brightly lit edge of the subject.

Directly into the sun

Into the sun's reflection

Slightly off-axis

Rim lighting

a slightly special condition, with a dark background that throws up the lit edges of the subject in sharp contrast.

When you take a direct shot into the sun, the contrast will almost certainly be extremely high. Even accepting that any subjects in the foreground or middle distance will be very dark, you will usually have to lose legibility at both ends of the brightness scale. The photograph of the beached fishing boat below is fairly typical of a wide-angle shot that includes both the sun and a main subject. Here you can see what is being lost in the distant light tones and in the foreground shadows. The brightness of the sun causes a loss of richness in the color; the boat lacks full detail. Note, however, that these are technical points and are not necessarily damaging to the overall effect of the picture; in fact, the atmosphere generated by the use of back lighting in this image is very successful.

There is one ameliorating condition: the light clouds on the horizon, which have helped to weaken the intensity of the sun. In addition, two actions were taken to reduce the top-to-bottom contrast. One was simply to wait until the sun was low enough on the horizon before taking the photograph. The other was to use a strong neutral graduated filter, sliding it up in its mount in front of the lens until the soft edge of the dark tone was aligned with the horizon.

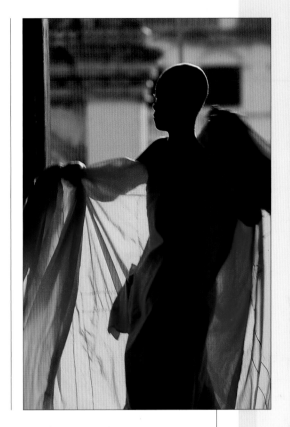

◢ Intense color

Back lighting through anything translucent brings out richness of color—as in the case of this monk's saffron robe —as long as you can avoid overexposure.

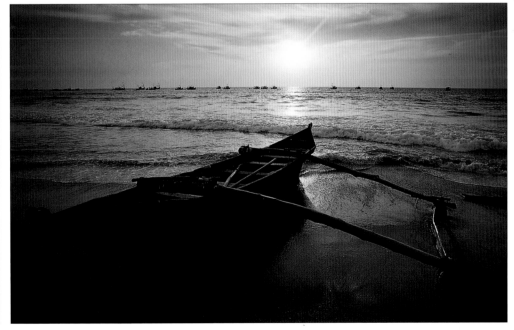

◀ Filtering the sky

This shot of a boat into the setting sun had such high contrast that it needed a neutral grad filter to darken the sky.

Silhouette

Silhouettes are a special case when shooting into the sun and, provided that your subject has an obvious profile and hides the sun, you have the makings of an arresting image.

Sun as background

The silhouette of the caddis fly in the main picture below was shot with a macro lens at 1/2 x magnification, and at full aperture—ƒ2.8. At a smaller aperture of ƒ16, the diaphragm blades' shape deforms the sun into a polygon and makes it appear smaller, spoiling the silhouette.

The high contrast from back lighting is exactly what you want if you wish to create a silhouette image. To work well, this kind of photograph depends on the shape of the subject and on the co-ordination of two principal tones: black, and the light background. One of the key conditions is that the outline of the subject is strong, clear, and recognizable, which is not always easy to arrange, as the subject also needs to be positioned between you and the sun.

Exposure in this circumstance can be tricky, for a number of different reasons. Silhouettes taken directly into the sun normally hide the image of the sun itself, as the shot opposite of the dockside crane demonstrates. In a clear sky, the brightness around the sun is highly localized, so that severe underexposure, particularly with a wide-angle lens, will make the sky quite dark towards the edges of the frame. This will lose any silhouette outline away from the center. If the silhouette is small in the frame, and you use a telephoto or macro lens, you can outline an object against the sun's disk itself, as with the image of the caddis fly shown on this page. In either case, a range of exposures will work, and it is worth experimenting with bracketing.

The other type of silhouette is where the image is taken against the sun's reflection, usually in water. One advantage with this is that, unless the water is perfectly calm and flat, it will have a slight diffusing effect on the sunlight. Instead of there being a concentrated patch of brightness, the background will appear to be larger and more even. If you use a telephoto lens, as I did for the photograph of the moose on the opposite page, this background can fill the frame, while the outline of the silhouette appears clean, sharp and obvious. A further advantage with this situation is that the necessary higher camera viewpoint gives a view that is angled slightly down, and it is often easy, as was the case with this example, to isolate the image of the silhouette completely. This is usually more legible than having the silhouette merge with an equally dark ground-level base.

Silhouette exposure

Make all the practical light readings that you can for a silhouette shot, and then bracket the exposure widely, shooting several frames. The normal criteria for judging exposure do not apply here. In a high-contrast silhouette shot there is no midtone area that needs legible exposure. The subject is the silhouette, and so the clarity of the outline is the standard. The absence of a midtone gives you a certain freedom of choice in the exposure, which is why you should bracket very widely, over several f-stops. You will probably find that more than one exposure looks acceptable. The upper limit on exposure is usually when the density of the silhouette weakens noticeably into gray and when the edges of the outline begin to lose definition due to flare. The lower limit is when the background becomes dim, obscuring the silhouette's outline. However, you might find that overexposure in some situations creates an attractive, ethereal effect.

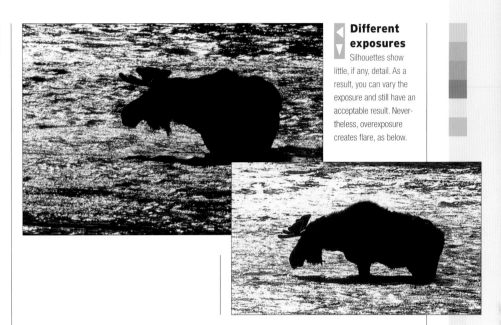

Different exposures

Silhouettes show little, if any, detail. As a result, you can vary the exposure and still have an acceptable result. Nevertheless, overexposure creates flare, as below.

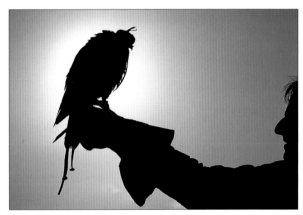

A clean silhouette

For a simple dark-on-light, two-tone silhouette of a hawk on the gloved hand of a falconer, I used a medium telephoto and a viewpoint that concealed the sun's disk behind the bird.

Wide-angle silhouette

The treatment of this dockside silhouette is basically the same as that for the falcon, with the key difference that the lens is wide-angle. This takes in more of the much darker surrounding sky.

The sun's reflection

Any surface texture tends to diffuse the reflection and spread the bright area, as in the photograph of the moose above. The angle of reflection is critical. Either move higher or lower, or wait for the sun's position to change.

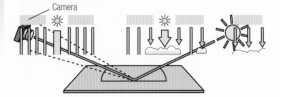

Camera

Edge lighting

Highly atmospheric and striking effects are possible to achieve when the light strikes your subject from behind but slightly to one side.

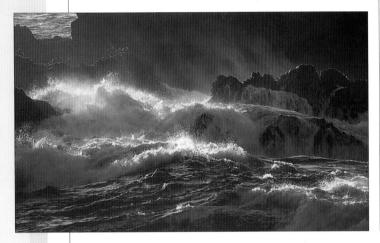

Overall back-lighting flare
Lens flare creates the warm glow that suffuses this telephoto view (taken with a 400mm lens) of waves breaking at Point Lobos, near Carmel, California. Whether you see this as a problem of weakened contrast or as a pictorial addition is largely a matter of taste.

Tip

If you are shooting into the light with the sun only just out of frame, hold your hand or a piece of card as far forward as you can reach, just out of frame. Better still, if the camera is on a tripod, stand in front and make sure that the shadow you cast just covers the lens surface.

Off-axis back lighting can give considerable atmosphere to a photograph, with a glow softening the high contrast. This glow is in fact a mild flare, and so needs to be kept under control. Flare is by no means always something to avoid, but you should be certain that the effect you get is really what you want rather than a lowering of image quality. The two hallmarks of flare are a line of bright polygons across the frame and an overall haze that weakens contrast and color. The first of these is caused by light striking the aperture diaphragm inside the lens. Flare also happens if your subject is surrounded by white—a close-up in the snow, for example, or a typical still-life "product shot" set against a white surface.

You can make a quick check for flare before shooting by lowering one hand in front of the lens; see if the picture in the viewfinder becomes crisper and slightly darker just before your hand comes into view. In fact, your hand, or a piece of card, will make an effective mask for flare, but in any case you should fit a lens shade. In most situations, photographs look better when the lens is shaded, but you can also make flare work to your advantage. With a telephoto lens, the overall flaring tends to spread light, and sometimes color, all across the image. The flare from an orange setting sun can look very attractive. If there are any pinpoint lights or reflections in the view, flare can sometimes give them a halo—you can even exaggerate this effect by smearing a very light film of grease on the lens (in practice, on a filter in front of the lens). Occasionally, the overlapping string of bright polygons and other streaks of light can add to the feeling of the sun's intensity. As always, experiment for yourself.

The special condition of off-axis lighting is rim lighting, in which the light reflects off the very edges of the subject, creating a bright rim, as in the picture of the men in uniform here. In order to work visually, however, it needs a dark or fairly dark background to show up the subject's bright edges.

◀ Translucent fish

These dried fish are lit at their edges by the sun, which also shines through them to silhouette their bones. The camera was placed so they appeared against a background in shadow.

▼ Rim lighting

At a very low angle, almost into the picture frame, the sun creates a rim-lighting effect. How brightly the edges appear depends strongly on the texture of the subject— here, cloth uniforms.

Reducing the risk of flare

☐ Use a lens shade. Fit either a customized shade made by the camera manufacturer for your particular lens or an independent make. The most efficient lens shade is one that masks right down to the edges of the picture frame, and so is rectangular and adjustable, like a bellows shade. Many telephoto lenses have built-in shades that slide forward.

☐ Keep the lens clean. A film of grease or dust makes flare much worse. Check the lens and wipe it.

☐ Remove any filter. Filters, however good, add another layer of glass that increases the risk of flare. Try removing any that might be fitted.

☐ Use a properly coated lens. High-quality multi-coated lenses give less flare than cheaper ones. Use the best optics you can.

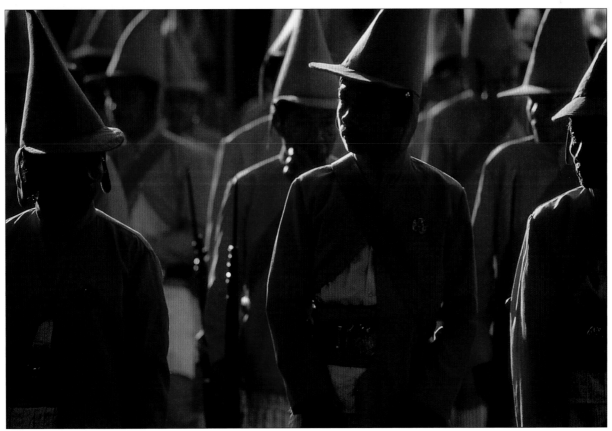

Sunrise and sunset

During the time in which the sun rises or sets—usually no more than an hour—the light can change dramatically, revealing different picture opportunities for different lens focal lengths.

Variety and unexpected effects are the keynotes here. Whether you shoot at sunrise or sunset will probably depend on the location. You can expect the greatest variety when you shoot into the sun, and few scenic locations offer a 180-degree choice of direction. Apart from the actual direction of shooting, which is obviously vital in making the photographs, the differences in lighting quality between sunrise and sunset are indistinguishable to anyone else looking at the images. During shooting, however, the times feel quite different. Fewer people are familiar with sunrise, which is a good reason in itself for shooting then—and in most locations you'll find few people around at that time.

▽ Silhouettes

Shooting into the sun as it rises or sets creates obvious opportunities for silhouettes. These are easiest with a wide-angle lens, which makes the image of the sun small, and so easy to hide behind a feature such as this Shanghai tower.

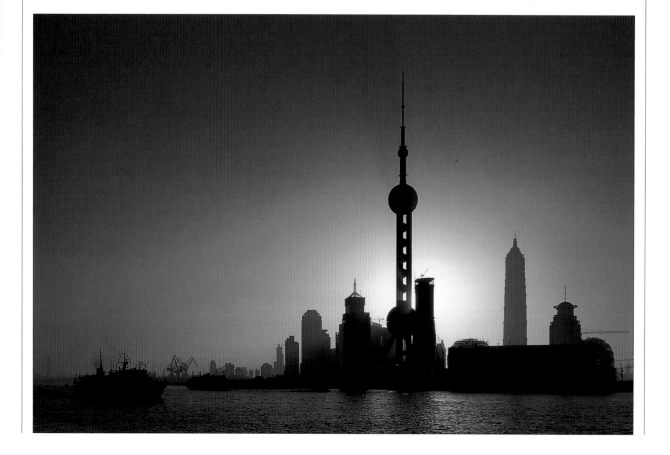

For dawn photography, you need to be in position at first light. That means that you should make a recce the day before as you'll have to travel there in the dark. The shooting experience is rather different from that at sunset—as the light increases, the possibilities of the view reveal themselves slowly. However, because the eye is already well adapted to the darkness, you'll find that the light levels appear much higher than they really are. If there is any movement in the scene that needs a reasonable shutter speed, you may have to wait longer than you expect in order to be able to shoot.

White balance caution

If you are in the habit of shooting with the white balance set to Auto, this will over-compensate for the warmer colors from a low sun, and can produce a disappointing lack of richness to the image. The daylight setting, which is balanced for 5400–5500K, will give a truer rendering of the color.

Warm, rich color

Exceptionally clear air keeps the sun bright even when it is on the horizon and at its reddest, as in this shot of Monument Valley, Utah/Arizona. The strongest colors appear with the sun behind you and the camera. You can avoid the problem of showing your own shadow by positioning yourself so that it falls in the distance, as here, and not on foreground features.

Watch the white balance

Make sure that the camera's white balance is set so that it does *not* compensate for the warm tones of a low sun, or the image will look strangely *un*sunset-like. This happened with an Auto setting (above), in contrast to a straightforward daylight setting (right).

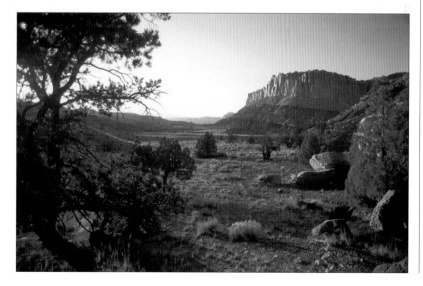

Twilight

With the sun below the horizon, it is the afterglow that lights the scene, often with a surprising delicacy not found under any other conditions.

Like normal daytime skylight, twilight is a reflected light source, but is rather more complex in its effects. It is the light that appears a little before sunrise ("first light") and that remains for a short time once the sun has set. In a clear sky, the intensity shades smoothly upwards from the horizon, where it's brightest, and outwards from the direction of the sun. (The studio equivalent is a light placed on the floor, aimed up towards a white wall, and used as back lighting.) The sky, in fact, acts partly as a diffuser and partly as a reflector. The actual light levels vary considerably from a just-discernible glow to actual sunset or sunrise.

These conditions allow a fairly wide choice of exposure. If you are shooting directly towards the twilight, you can try a short exposure in order to make a silhouette of the horizon and subject. In this kind of back-lit shot (the photograph above right is a good example), the shading of the sky from bright to dark gives some choice of exposure, particularly if you use a wide-angle lens. Less exposure intensifies the color and concentrates the view close to the horizon. More exposure dilutes the color in the lower part of the sky, but shows more of the higher, bluer parts. In other words, increasing the exposure extends the area of the subject within the frame. A range of exposures is acceptable, depending on what kind of effect you are trying to achieve from the photograph.

Not only does the brightness shade upwards from the horizon, but the color does also. The exact colors depend on local atmospheric conditions, and different light-scattering effects are combined in a twilight sky. At a distance from the brightest area—opposite and above—the color temperature is high, as it would be during the day. Close to the horizon in the direction of the light, however, the scattering creates the warmer colors at the lower end of the color temperature range: yellow, orange and red. These merge in a graded scale of color.

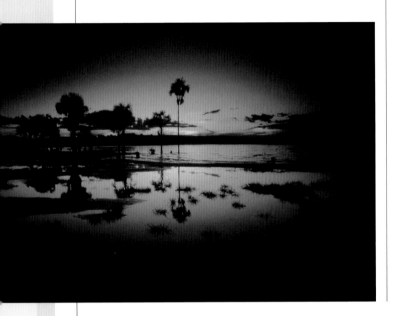

Reflections at dusk
Shooting from almost at water-level enhances the delicate tonal gradation before night falls over the Guiana Highlands of Venezuela. What makes this view attractive is that almost all the color has been drained from the scene.

Lens focal length

Experiment with both wide-angle and telephoto lenses, or both ends of the zoom range. Wide-angle views take in more of the height of the sky and capture a wide range of color. Telephoto shots, with a narrower angle of view, can only take in a small part of this; perhaps only a single color.

Smooth reflected light

The gradual shading of light and color can be very valuable when shooting a subject with a highly reflective surface. At the right angle, twilight produces a broad reflection without distinct edges, and this can make simple and attractive illumination for reflected objects, such as a car. Experiment with the height and camera angle to get the maximum reflection of the sky.

◀ Blue intensity

When the sky is not red or orange at sunset or sunrise, an overall blue cast is typical, as in this winter scene.

▲ Shading of the sky

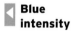
A clear sky at dusk or dawn acts like a smooth reflective surface for the sun as it lies below the horizon. The light shades smoothly upwards from the horizon, and this effect is most obvious with a wide-angle lens, which takes in a greater span of sky. For example, while a 180mm telephoto lens gives a limited angle of view of only 11 degrees, a 20mm wide-angle gives an angle of view of 84 degrees.

Clouds at twilight

Added to the basic lighting condition, clouds are fairly unpredictable in their effect. If continuous, they usually destroy any sense of twilight, but if broken, they reflect light dramatically: high orange and red clouds create the classic "postcard" sunset. One of the things that becomes clear after a number of occasions is that clouds at this time of day often produce surprises. The upward angle of the sunlight from below the horizon is acute to the layers of clouds, so that small movements have obvious effects. On some occasions, the color of clouds after sunset simply fades; on others, it can suddenly spring to life again for a few moments—a good argument for not packing up as soon as the sun has set.

Moonlight

The moon simply reflects sunlight, but very weakly. Capturing a scene by moonlight means allowing for the way we perceive it, as dark, colorless and mysterious.

Photographing by moonlight needs long exposures, even at a high-sensitivity setting, as the intensity is in the region of 19 stops less than daylight. Such shots are generally worth attempting only around the time of a full moon, with clear skies.

A bright full moon is about 400,000 times less bright than the sun. Start with a setting of about one minute at f2.8 at ISO 200, and check the result in the LCD display.

Such long exposures make it tempting to switch to a higher sensitivity, but this increases the noise in the image and, as you will need to use a tripod in any case, it may be better just to make a longer exposure at the standard setting. Two other factors come into play. One is that we see moonlight as dim, and to reproduce that impression you should keep the exposure at least an f-stop or two less than normal. The other is that our night vision lacks color sensitivity, whereas the camera's sensor will pick up color as normal. Consider desaturating the image, or increasing the blue, for final display.

To photograph the moon itself you will need a telephoto lens of at least 400mm equivalent to make a reasonable-sized image. The brightness depends on atmospheric conditions and on the phase. A bright, full moon needs an exposure at ISO 200 of about 1/250 second at around f8, but check on the LCD screen. Other phases of the moon and hazier conditions need longer exposures. Apart from the need to avoid camera shake, keep the exposure short because the rotation of the earth causes the moon's image to move across the frame. You will usually need to reframe each shot.

Shutter speed

For the moon to be a reasonable size in the frame, a powerful telephoto is needed, and as the maximum aperture of the lens is likely to be small, bracketing usually has to be done by altering the shutter speed. The limit to the slowest shutter speed is the movement of the moon's image in its orbit around the earth. The moon's image moves at a rate of its own diameter every two minutes. For a 400mm-equivalent lens, an exposure of one second or longer will cause blurring.

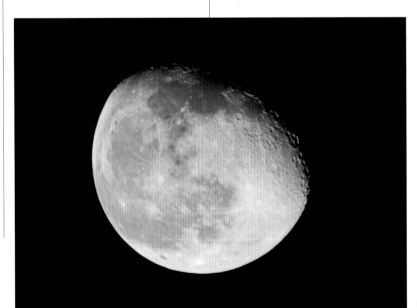

The moon itself
Photographed with a 600mm lens on a Nikon D300 (an efl of 900mm), the gibbous moon almost fills the frame, with good detail. I made three exposures at the full aperture of f4, at 1/80, 1/100, and 1/125 second. This is the second. Even at these shutter speeds, camera shake is likely at this magnification.

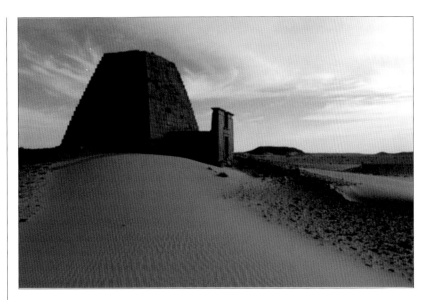

By moonlight

The uncertainties of shooting by moonlight on film have all disappeared with digital. An adequate exposure is guaranteed by being able to check the results on the LCD screen, and shutter speeds rarely need to be so long that stars turn from points into streaks. Instead, the greater problem is preventing the image from looking like a daytime shot. Here, illuminated by a full moon in a clear sky, this Meroitic pyramid in the Sudan was first shot with Automatic exposure, which gave 10 seconds at $f2.8$ at ISO 1600. The only small clue that this is not daylight is that there are a few stars. For the more succesful version, I gave a shorter manual exposure (6 seconds at $f2.8$ and at ISO 1000), and asked a friend to trigger a small flash unit inside the entrance.

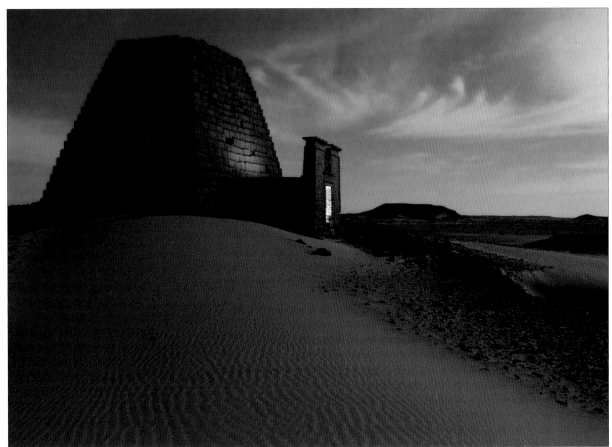

Cloud cover

Clouds are the most visible component of weather and in outdoor photography they are by far the most important controlling factors in daylight, creating an enormous variety of effects.

Clouds diffuse daylight, softening scenes and reducing shadows. To make a comparison with a studio, they act as variable diffusers and as reflectors at the same time. Depending on their thickness, texture, extent, height, how they are arranged in layers, and their movement at different speeds, the permutations of cloudy conditions are infinite. The simplest situation is when the cloud cover is continuous. Overcast skies just diffuse the light, and if they are sufficiently dense that there is no patch of brightness to show the position of the sun, the light is as soft and shadowless as it ever can be.

Medium-to-heavy overcast skies have a reputation for bringing dullness to a scene, and to an extent this is true. Light comes more or less evenly from the entire sky, so the only shadows are those caused by objects being close to each other; this lack of shadow reduces modeling, perspective, and texture. Objects appear to have less substantial form, and large-scale views appear flat. There is virtually no modulation of light, and the even illumination in all directions makes conditions less interesting, with none of the lighting surprises that occur when shooting in changing weather.

The value of shadowless, overcast lighting is in its efficiency rather than in its evocative qualities. It helps to clarify images. Much depends on what you see as the purpose of the shot. If the photograph has to remain faithful to the physical, plastic qualities of the subject, then this even lighting may be valuable. Clarity in the image takes precedence over more expressive qualities.

▲ Pastel greens

Soft, shadowless light and a delicacy of color characterize landscapes under the diffuse light of continuous cloud.

Image clarity

Overcast skies are good for certain subjects, particularly those with intricate shapes. The chief characteristic of this kind of lighting is that it is clear and uncomplicated. Hence it is good for giving distinct, legible images of complex subjects. Reflective surfaces also make for more legible images under diffuse lighting: the reflection of a broad, even light source will cover all or most of any shiny surface. By contrast, in clear weather, the sun appears as a small, bright, specular reflection.

Clouds and color temperature

Clouds affect color temperature by changing the relative strengths of sunlight and skylight. On a clear day (1), even though the sky is blue, the sun is so much stronger that it overwhelms the higher color temperature from the rest of the sky; only the shade, typically 3 or 4 stops darker, is bluish. When scattered clouds cross in front of the sun (2), they reduce its strength, leaving the blue skylight relatively more important. When the entire sky is cloudy (3), the color temperatures of the two light sources, sun and skylight, are thoroughly mixed; as a result, the color temperature of the diffuse light reaching the ground is raised slightly overall.

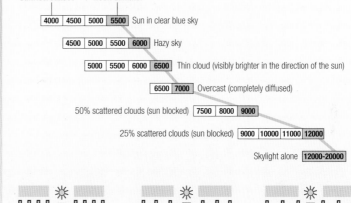

Sunrise/sunset Noon summer

| 4000 | 4500 | 5000 | 5500 | Sun in clear blue sky |

| 4500 | 5000 | 5500 | 6000 | Hazy sky |

| 5000 | 5500 | 6000 | 6500 | Thin cloud (visibly brighter in the direction of the sun) |

| 6500 | 7000 | Overcast (completely diffused) |

50% scattered clouds (sun blocked) | 7500 | 8000 | 9000 |

25% scattered clouds (sun blocked) | 9000 | 10000 | 11000 | 12000 |

Skylight alone | 12000-20000 |

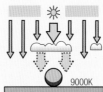

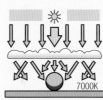

5500K 9000K 7000K

1. Clear day 2. Scattered clouds 3. Overcast sky

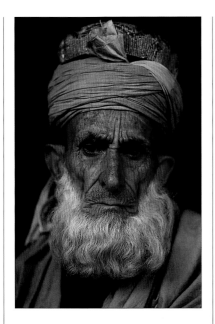

Portrait lighting

One of cloudy light's better qualities is that it does away with harsh shadows, making it useful for portraits.

A tinge of blue

The effect on color temperature is most obvious when clouds pass across the sun, as in these two images of a peacock. Use the camera's Cloudy white balance setting, which will compensate.

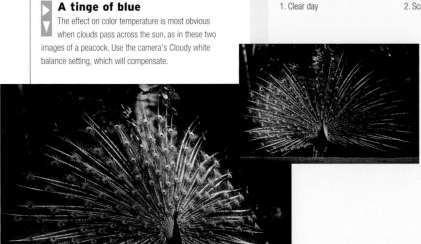

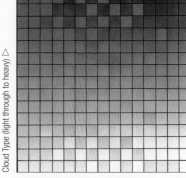

Cloud Type (light through to heavy) △

Cloud Cover (none through to heavy) ▷

This chart plots brightness of clouds (which depends on how thick they are) against the degree of cloud cover.

The variety of clouds

Clouds of different kinds, layers and thicknesses create a complex, endlessly changing arena of light.

Lighting conditions are more complicated and less easy to anticipate when clouds are broken, so that there is a mixture with blue sky. In fact, the complexity extends to situations where there is more than one layer of broken cloud, each different in type. The diagram on page 57 gives an impression of the range of possibilities, though of course it is simplified. The intensity, quality, and color of light can vary. On a windy day, these conditions change rapidly, not only from cloud to direct sun, but from one type of weather to another. Watch what happens when a cold front passes over. Between scattered and partial cloud cover, the most noticeable effect is the fluctuation of the light; at the left and right of the scale, conditions are most consistent.

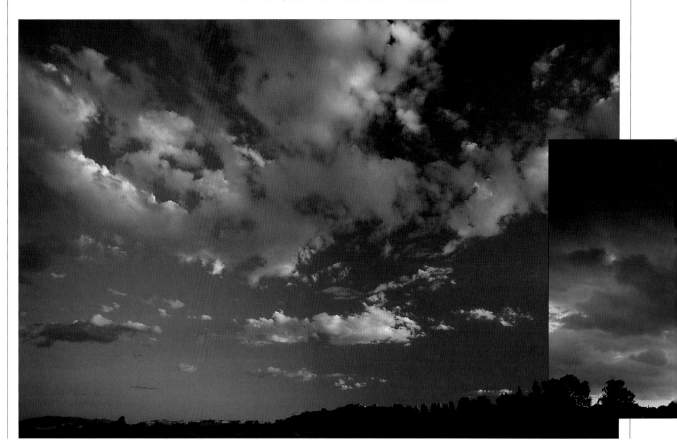

If you are trying to take a particular shot that you have fixed in your mind, scattered cloud on a windy day can be frustrating, to say the least. The light changes up and down, delaying the shooting. However, the sheer variability of broken cloud can produce some of the most interesting, and even dramatic, lighting. To take advantage of it, however, you need to react quite quickly. Familiarity with the different light levels in any one situation will help; if you have already measured the difference between cloud and sunlight, you can change from the one setting to the other without having to use the meter again. Under heavy cloud with a few gaps, this may be particularly useful, as the sunlight is likely to move in patches across the landscape and be difficult to measure quickly.

Distinct clouds

Some idea of the visual complexity of distinctly shaped clouds is given by the chart below, which plots the brightness of individual clouds—mainly a matter of how thick they are—against the degree of cloud cover. The less cloud cover, the more the blue of the sky has an effect.

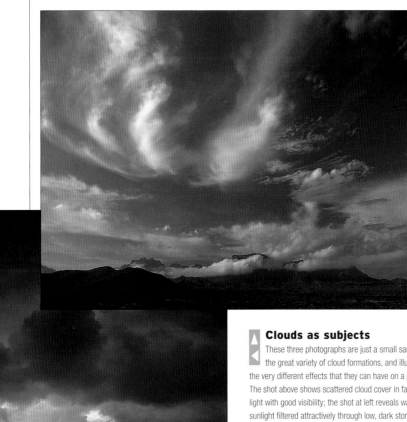

► Clouds as subjects
◄ These three photographs are just a small sample of the great variety of cloud formations, and illustrate the very different effects that they can have on a picture. The shot above shows scattered cloud cover in fading light with good visibility; the shot at left reveals watery sunlight filtered attractively through low, dark storm clouds; and the photograph far left illustrates puffy rain-shower cumulus in a bright sky.

▲ Light and shade
Clouds passing over a landscape create a kind of chiaroscuro (light and shade) effect. This tonal overlay is seen to its best advantage at a distance and from a high viewpoint, as in this aerial view of a southern Philippine port.

Bright cloudy skies

Unless the sky is a rich, deep blue, the contrast between it and the ground is likely to be very high, to the point where it appears washed out.

In landscapes and other views that include the horizon, 100% cloud cover alters the tonal relationship between sky and land. Without cloud, the difference in brightness between the two is usually fairly small; quite often, the subjects are lighter in tone. This is not the situation when cloud extends all over the scene. Then the cloud cover is the light source and, if you include it in the view, you will have a contrast problem. In other words, if the scene includes the horizon, you will inevitably lose detail either in the sky or in the ground. If the subjects or the ground are properly exposed, the sky will be white, without any visible texture to the clouds.

Many photographers simply avoid including the horizon and sky in a shot under these conditions, but you may occasionally find that you have no choice. One answer during shooting is to use a neutral density graduated filter over the lens, aligning the soft edge of the filter's darkened area with the horizon line, so that the sky is made darker.

There is also a purely digital answer, which works best if you use a tripod and can keep the framing perfectly steady. Make two exposures, one good for the subjects on the ground, the other good for the sky (dark enough to show cloud texture). Later, in an image-editing program, the ground from one and sky from the other can be combined to get the best of both worlds.

Neutral graduated filters

Although skies can be darkened later during image editing, a grad filter at the time of shooting preserves more sky detail. Neutral density grads are available in different strengths—here ND0.3 darkens by 1 f-stop and ND0.6 by 2 f-stops. Two grads can also be used to reinforce each other or, with one inverted, to focus attention on the horizon.

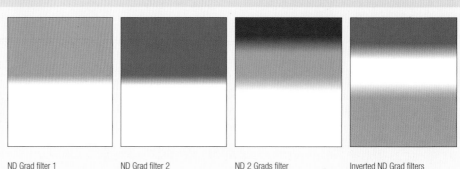

ND Grad filter 1 ND Grad filter 2 ND 2 Grads filter Inverted ND Grad filters

Combining two exposures

In this Icelandic landscape, a normal exposure for the valley leaves the clouds overexposed. Making a second, darker exposure with the camera on a tripod, so that the images are in perfect register, makes it easy to combine the valley tones from one with the deeper sky tones from the other. In Photoshop, the "valley-normal" shot is placed in a layer over the darker version, and with a large-diameter eraser brush the over-bright sky area in the upper layer is gently removed.

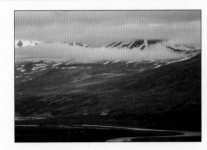

Normal exposure

Exposure for clouds

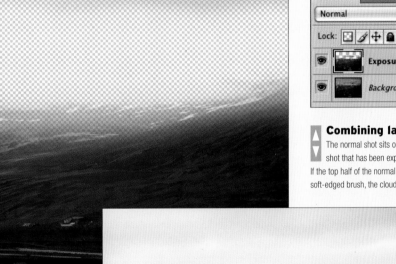

Combining layers
The normal shot sits on the top layer, above the shot that has been exposed for the cloud cover. If the top half of the normal layer is erased with a soft-edged brush, the cloud layer shows through.

Curves
To make the most of the color tones in the image, a slight adjustment is made using the Curves command.

Rain and storms

Wet and stormy weather tends to discourage photographers from going out, but it offers a range of interesting conditions, from glistening surfaces to flashes of lightning.

Rain may be uncomfortable, and digital cameras, with all their circuitry, certainly need good protection from rainwater, but in terms of lighting rain makes a relief from standard sunlight. Light levels are typically low because of the thickness of most rain clouds, but the gentle, shadowless and enveloping light is good for capturing the purity of natural colors in landscapes. Greens in particular come out well on wet days, so this can be the ideal time for garden and woodland scenes.

Photographing rain itself is not easy, because of the poor light and the speed at which raindrops fall. Often, rain looks like mist in many photographs, or, if heavy, as lines. To capture actual raindrops, the best conditions are back lighting against a dark background, which is uncommon in rainy weather. The best sense of raininess often comes from the subjects—such as drops on leaves and car windscreens—rather than from the light itself. The levels are usually very low: rain and cloud together easily reduce the light by 4 or 5 stops.

Lightning can add considerably to the power of a landscape. The problem is predicting it—the exact moment and also the direction. There is no way of synchronizing lightning flashes with the shutter, and the only certain technique is to leave the shutter open in anticipation of a strike. Fortunately, the electrical conditions that produce one lightning flash usually produce a number, often more or less in the same place. At the height of a storm, you should not have to wait more than 10 or 20 seconds for the next flash, and it is more likely to be in the direction of the last few flashes than in any other. Nevertheless, lightning in daylight is difficult to shoot without overexposure. If there is still light in the sky, estimate the average interval between flashes, and set the camera to allow a time exposure longer than that.

Ordinarily, the exposure depends on the intensity of the individual flash, whether it is reflected from surrounding clouds and how far away it is. You can estimate the last, at least through a group of flashes: count the number of seconds between seeing the flash and hearing the accompanying thunder. The difference is the speed of sound; a gap of five seconds means that the lightning is 1 mile/1.6km away. Check your first exposure on the LCD screen, and adjust the aperture as necessary.

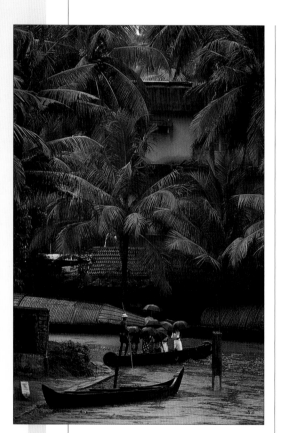

Monsoon haze
In this shot of a typical south Indian day during the monsoon, the rain is heavy yet appears like a dull haze. However, the people sheltering beneath umbrellas underline the reality of a rainstorm.

▶ Impression

Sometimes the most effective image of a storm relies on minimal detail, as in this view of swirling mist and driving rain on a mountain in Central America.

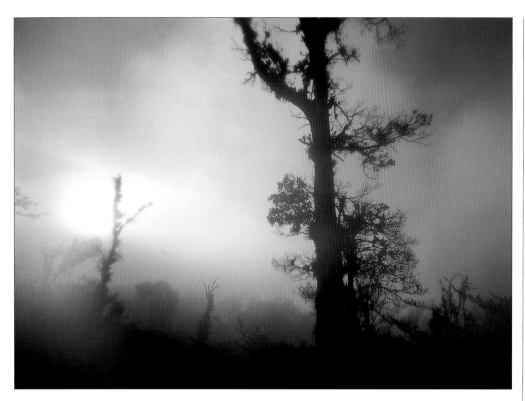

◀ Capturing lightning

Distant lightning over Rangoon was shot at dusk with a 30-second exposure—long enough to catch a few cloud-to-cloud strikes and one cloud-to-ground strike. The aperture was f2.8 and the sensitivity ISO 100.

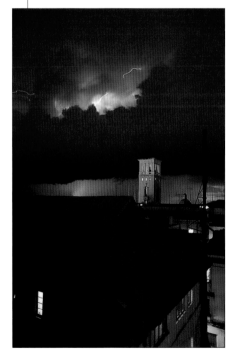

◀ Rain effects

To establish "raininess", some visual clues can help if you include them deliberately. In this shot, the reflections of car headlights in the wet surface of a Toronto freeway make the point effectively.

Digital effects

Many of the conditions of natural light and atmosphere can be worked on very effectively on the computer; they can be modified and even, at times, created from scratch.

There are no limits to the amount of adjustment and alteration that can be made digitally to images, but here I will confine myself to those that have an effect on natural light. The most obvious of these digital techniques are those applied to the sky. On this page, for example, I can use the Hue/Saturation adjustment and the Curves tool to create the perceptual effect of turning fine weather into a threatening storm. Unlike traditional grad filters, this can be target only on the sky.

Close to the ground, atmospheric haze, mist and even fog can be poured into a scene, though to be effective the technique calls for a hands-on alteration to detail. These atmospheric conditions are readily imitated by placing a pale gray layer over the image at some degree of opacity, but the skill comes in thickening this with distance from the camera. The usual method is first to create a depth map, tailored to the particular image. These are just some of the possibilities, and if you are inventive—and can spare the time and effort—there are endless ways of tweaking the light. In addition, on the following pages we look at the more complex issue of actually introducing light into the scene.

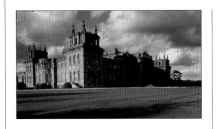

The gathering storm
Dark skies, indicators of a looming storm, can dramatize a landscape, particularly if combined with sunlight. However, if the sky is blue, this will simply look unrealistic. The trick is to desaturate the sky, turning the clear blue areas into what appear to be thick alto-stratus cloud. Then apply darkening and stronger contrast to taste. In this example, the sky was first selected with an auto selection tool (complete edge accuracy is not so important here, as the main alteration will just be desaturation). The blue sky was selected with the dropper, in order to leave subtle cloud colors relatively unaffected, and then desaturated, darkening slightly. Then, the entire sky was lowered in contrast, using Curves for realism.

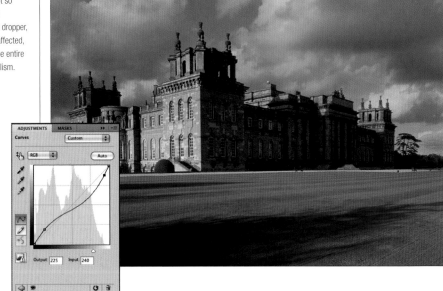

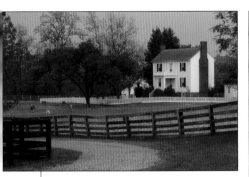

Digital atmosphere

Adding fog or mist to an image digitally is a hands-on
procedure, as it requires objects at different distances
from the camera to be isolated and masked. This is
impossible to automate.

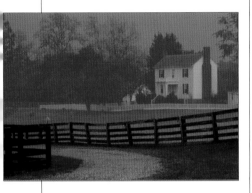

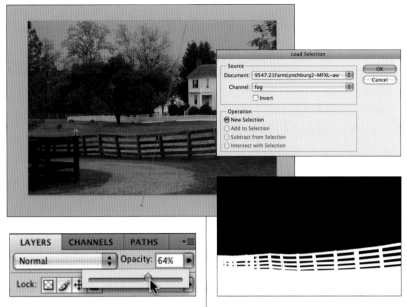

Step 2

A gray color, representing the fog, was selected and
the Gradient tool used to drawn it onto a new layer
by clicking and dragging. The strength of the effect is then
adjusted using the Opacity slider.

Step 3

To make the effect realistic, the foreground and
middle-ground fences had to be protected from this
overall effect. To achieve that, the selection created earlier
is loaded, and turned into a mask. The strength of the fog
can still be adjusted using the Opacity slider, but it won't
affect the masked foreground or fence.

Step 1

With this shot of a countryside scene near
Lynchburg, Virginia, the basic means of applying fog
was straightforward. Before adding the fog the fence was
selected (selected area shown in color, unselected in red)
and that selection saved under the name 'fog' before
being temporarily disabled.

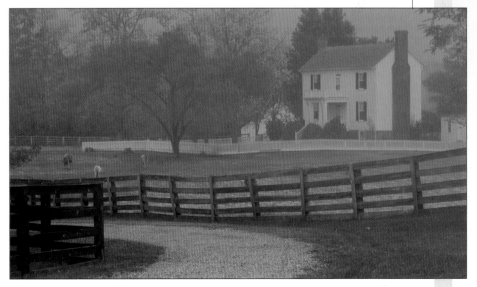

Brightening up

One of the special challenges in altering the appearance of light digitally is to create the effect of bright, sharp sunshine, but there is software available that will help.

One of the fundamental questions in image editing is how far you should go—that is, how far you should move away from the original as it was shot. We will keep returning to this theme throughout this book because there are no clear rules. In principle, anything and everything can be changed; in practice, it depends on what you personally feel is acceptable and on how much effort it is worth to you.

With daylight photography, the major hurdle is bringing sunshine into the picture. If you have ever waited for a break in the clouds to brighten up the scene, you will know that there is a demand for this—and to an extent this can be done digitally. The problem, as you can check by comparing two versions of the same view, overcast and sunny, is that direct sunlight affects everything and in many ways, down to tiny shadows and the glow reaching into shadows from sunlit surfaces.

I try to avoid discussing specific software programs, but in this case there is, to date, one specialist application that makes a passable job of adding sunshine to dull or hazy scenes: the appropriately named Sunshine filter in the nik Color Efex suite. It uses a series of complex light-casting algorithms at different contrasts as the starting point, with slider controls that allow you to adjust saturation, warming, intensity (brightness), and spill-over of all these into adjacent areas. That done, if you want clearly defined shadows then you will need to add them by hand—but it may be sufficient to create only a few large ones. Once the viewer has been given enough visual clues to believe that there is sunlight, detailed omissions tend to be ignored.

Another piece of light-bringing effects software is a flare filter, of which there are a number of makes,

▽ Dull and overcast
The original scene, on a very English cloudy day. While this lighting works for some things it does no favors to a landscape like this that includes sky and water.

Light levels under cloud

Although clouds reduce brightness when they block the sun, the amount depends very much on the type of cloud. If the clouds are indistinct and spread across the sky, the light loss is on a simple scale from a light haze (as little as 1/2 a stop less than clear sunlight) through thin high stratus to dark gray, low clouds (up to 4 or 5 stops darker, and more in exceptionally bad weather). With distinct clouds, however, such as scattered fair-weather cumulus, the light levels can fluctuate rapidly, particularly on a windy day. Light, white clouds usually cause a simple fluctuation of about 2 stops as they pass in front of the sun from bright to shade in one step. Dark clouds with ragged edges, or two layers of moving clouds, cause more problems, as the light changes gradually and often unpredictably. In the first case, two light measurements are all that is necessary—one in sunlight, the other as a cloud passes—and once this is done, you can simply change the aperture from one to the other, without taking any more readings. In the case of more complex moving clouds, constant measurement is essential, unless you wait for clear breaks and use only these.

Light loss with evenly spread cloud cover							
	Clear sun	Light haze	Heavy haze	Thin high cloud	Cloudy bright	Moderately overcast	Heavily overcast
f-stops	0	-1/2	-1	-1½	-2	-3	at least -4

including some supplied within Photoshop. These need to be applied with caution and only occasionally, due to general over-use. Even though optically accurate, they can, through over-familiarity, easily look like what they are—computer-generated effects. At the right time and place, however, a touch of flare can help tip the balance in convincing the eye that there is sunlight where none existed.

Sunshine
This filter in the nik Color Efex Pro suite uses a complex mix of procedures to simulate the effects of sunshine—except shadows, which need a human eye to interpret. In this case, the absence of relief in the foreground means that there would have been no prominent shadows in real sunlight.

Haze

Haze softens sunlight, weakens colors, and brings an extra sense of depth and perspective to a scene. Depending on what you want from a photograph, you might want to reduce haze or exploit its special qualities.

Haze is the scattering of light by particles in the atmosphere. Fine dust and pollution produce it, as does high humidity. Haze varies considerably, not only in density, but in the wavelengths that are affected. The finest particles scatter the short wavelengths more than most, and produce bluish ultraviolet views over a distance. The haze from humidity, on the other hand, has a neutral color effect, and looks white over a distance.

There are two main visible effects of haze. One is on the view itself; the other is on the quality of light. The effect on a landscape is to make it appear paler at a distance; this is progressive, so that contrast, color, and definition gradually drain away from the foreground to the horizon. This effect is strongest when the sun is in front of the camera (but not necessarily low), and is what contributes most to aerial perspective—the impression of depth due to the atmosphere. To make this work strongly, however, you would need to shoot in such a way that there are at least

▽ **Depth and atmosphere**
Haze adds a luminous, slightly mysterious quality to an image and brings a greater sense of depth and distance. In this photograph of a stone-capped burial tomb in coastal Wales, far from spoiling the shot, haze enhances the atmosphere of this ancient landscape.

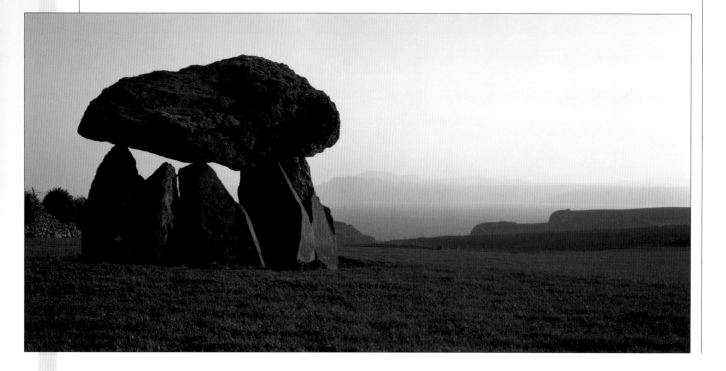

a few obvious planes of distance in the scene; simply photographing a long view, with no foreground or middle ground, will create a pale image.

The effect of haze on lighting is to soften the hard edges of sunlight. The extra scattering reduces contrast and helps to fill shadows. The effect can be an attractive balance between sunlight and diffusion, particularly when the sun is a little in front of the camera, as in the photograph on the opposite page. The amount of haze varies, as does its effects. Strong haze has much the same visible effect as light, continuous cloud.

Ways of reducing haze

Haze can be unwelcome if it hides detail, color, and crispness. The following are ways of reducing it:-

Ultraviolet filter This works on the short wavelengths only, so the effect is unlikely to be total. With black and white film, an orange or red filter has a stronger haze-cutting effect.

Polarizing filter This works most strongly at right angles to the sun (in side lighting) and gives an overall improvement.

Frontal or side lighting Either of these is preferable to back lighting, which exaggerates haziness.

Avoid distant views The closer you shoot, the less atmosphere, and so the less haze. For this reason, a wide-angle lens may be an improvement over a telephoto.

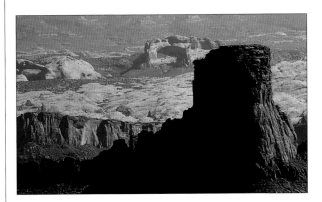

Unfiltered

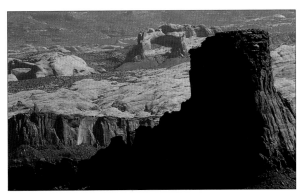

Ultraviolet filter

Ultraviolet

In a distant view with a telephoto lens, as in this sequence shot in Canyonlands National Park, Utah, the ultraviolet effects are likely to be pronounced. You can make a substantial improvement in picture quality by using filters. In the unfiltered version (above) the haze appears as pale blue, and both contrast and color saturation have been weakened. Adding an ultraviolet filter (above right) improves the color contrast. Using a polarizing filter (right) has an even stronger effect.

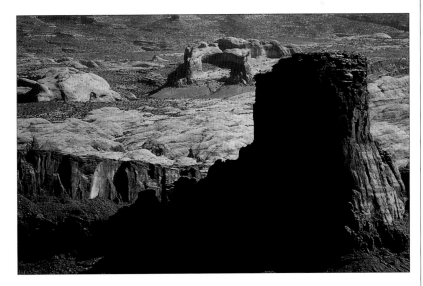

Polarizing filter

Mist, fog, and dust

Thicker than haze, mist, fog, and dust tend to shroud scenes to hide all distant detail, but these conditions can also offer strange, evocative scenes.

Mist, fog, and dust can be so dense as to make even nearby objects difficult to see. The droplets or particles are so large that there is no selective scattering of wavelengths, just an overall diffusion. (Dust has its own color, and tinges the view yellow, light brown, or whatever.) Do not view these as problem conditions: they clear eventually—and when fog dissipates it often does so very quickly—and meanwhile can make interesting graphic images.

In dense fog, or when the sun is fairly high, there is little if any sense of direction to foggy light. If you choose the distance at which you shoot carefully and close to the limits of legibility, the color and tonal effect of the resulting pictures will be extremely delicate. Against the light, depending on the density, these conditions produce some form of silhouetting. Close to the camera, the subjects are likely to stand out quite clearly, with good contrast. At a distance, the silhouettes and setting will be in shades of gray. As the conditions shift, thicken or clear, the nature of the images will change quite significantly. Dust in particular is a very active condition: it needs wind or movement to remain in the atmosphere. Back lighting gives the best impression of its swirling and rising, but then there are obvious dangers in using your equipment in such conditions.

Fog offers a wide range of opportunities. A valuable project on a foggy day is to restrict your shooting to one location, while trying to create as varied a selection of images as possible. As well as looking for different subjects and viewpoints and using lenses of different focal lengths, wait until the fog begins to clear to take advantage of the following shifting effects:

☐ Delicate colors in directionless lighting.

☐ Depth of view with subjects at different distances from the camera, fading progressively towards the distance.

☐ Strong silhouettes against the light.

☐ Pale silhouettes.

☐ Clearing, shifting fog; a wide-angle lens is often best for showing different thicknesses of fog in one image.

☐ A view from a high point of a sea of fog with clear air above, ideally with the tops of trees or buildings standing out.

△ Shapes in the fog
In this early morning shot, fog over the River Ganges obscures the background and turns a large, not particularly attractive water tower into a soft, looming shape—a delicate counterpoint to the bather in the foreground.

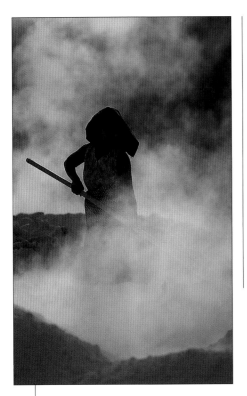

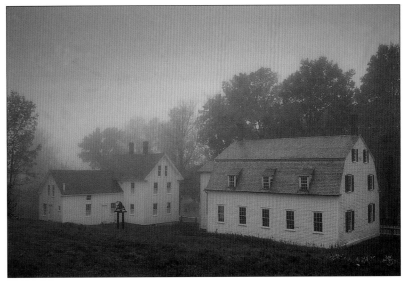

Swirling dust

Although very damaging to cameras, dust can add considerable atmosphere to a picture. Here, swirling clouds of dust churned up by the earth-mover give the figure a looming presence. Backlighting from a setting sun makes the most of the subject.

Receding pastels

Morning mist gives an overall softness to this shot of a Shaker village in Maine, USA, lending an attractive delicacy to the tones and colors.

Ground mist

Another early morning condition is mist hugging the ground in a low layer. It rarely lasts long after sunrise, but when it happens it adds an ethereal quality to landscapes, giving the sense that taller features, such as buildings and trees, are floating.

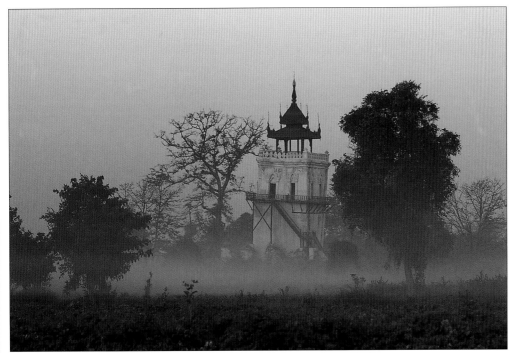

Mountain light

Mountains have a special effect on photography: the clearer, thinner air makes lighting starker and brighter, and the weather can change in an instant.

The sheer height of mountains helps to create some of their special conditions of light; their relief produces the others, through the frequently rapid changes that occur in localized weather. One of the most memorable weather conditions for photography is the clear, crisp air in sunlight that gives high visibility to long views and fine detail. This, however, is only one of a variety of types of lighting found in mountains.

The air is thinner at altitude, and is therefore clearer, provided that the weather is fine. Since the air is thinner, there are fewer particles to scatter light into the shadow areas, which consequently can be very deep. Local contrast, as a result, is often very high. The skylight in shade is a more intense blue than at sea-level. This intensity is more than usually difficult to

Clarity
At an altitude of 16,400 feet (5000 meters), there is 50% of the oxygen that exists at sea-level. For photography, this means an unusual sharpness and clarity. In sunny conditions, as on this Tibetan plateau, there is high contrast with deep shadows. If your camera offers tone or contrast compensation, you may need to make adjustments to lower it.

estimate and without correction can be stronger than you expect. The thin air is also a less effective screen against ultraviolet rays, and there is a higher component of these short wavelengths. This produces an unusually large difference between what you can see and what the camera's sensor will record. Unless you want to make use of the blue cast to emphasize distance, use strong ultraviolet filtration. Remember also that, in reacting to the ultraviolet wavelengths, the sensor receives more exposure, and the distant parts of the scene will look paler than they do to the eye.

So much for the thinner atmosphere. The interesting part of mountain light comes from the changeable weather, and this is controlled strongly by the relief of ridges and valleys. In particular, clouds become an ever changing part of the local lighting which you'll need to keep a constant eye on.

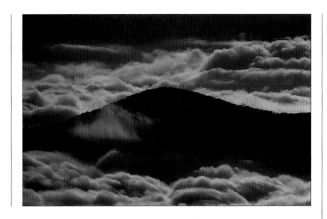

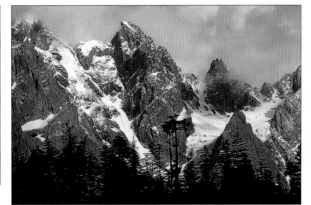

Islands in cloud

Among the more spectacular opportunities that high mountains offer is the chance to look down on the lower cloud levels. This is more typical of early mornings, as in this detail of the Sierra Nevada in Colombia.

Variable weather

Mountains guarantee unpredictable weather. Shifting clouds and light give a constantly changing scene, as in this sequence of shots of the Hindu Kush; the light changed rapidly within just a few minutes.

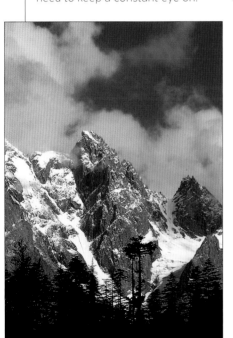

Tropical light

A high sun for much of the day and very rapid sunrises and sunsets make shooting in the tropics a different experience, with short periods of attractive lighting.

Heat and sun
People living in the tropics usually shelter from the sun, and this can be used as a visual symbol. This worker in Manila is heavily masked, despite the heat.

For most of the year in the tropics, the sun is almost directly overhead in the middle of the day, and its effect on the distribution of light and shade is unfamiliar to many photographers. If you live in the middle latitudes—New York, say, the Midwest, or Europe—your idea of a high sun is probably around 60 degrees above the horizon. For a few hours a day in the tropics, however, there is no sense of front, back or side to the sunlight. Shadows lie directly underneath objects. Roofs and awnings cast deep shadows, but under many subjects, such as people or cars, the shadows are very small. Anything flat, like most landscapes, appears without any shadows at all.

It would be easy to brand this overhead light as unattractive, and by conventional standards it probably is for many subjects. However, it would be too dogmatic to dismiss it as being generally unsuitable. It can play a part in conveying the atmosphere of the tropics. Look for scenes that convey the impression of heat, images with stark contrast, and patterns of light and shade that are distinctive to the tropics—for instance, long, downward-pointing shadows on a bleached wall; a face completely shaded by the brim of a hat, and so on. In other words, look for images that say "tropical" through the quality of lighting as much as through the subject matter.

Portraits and landscapes are the two subjects that suffer most under the harsh lighting of the tropical sun. A face directly under the sun will have prominent, deep shadows under the eyebrows, nose, and chin; moreover, the eyes, which carry so much of the expression in the face, will be fairly well hidden by shadows. The lighting problem for landscapes is almost the opposite: a lack of shadow. There is, as a result, less sense of shape and

texture to the landscape, and consequently a weaker perspective. To avoid this, you should shoot earlier or later in the day; alternatively, an immediate answer for a portrait is to shoot in open shade, but be careful to set the white balance accordingly.

The sun rises and sets more or less vertically, which at least makes it easy to predict its position for aligning subjects with sunrise and sunset. However, rising and setting like this, the sun appears to move quickly and dusk and dawn are short. If you are used to the amount of time that is normally available in a temperate climate for preparing a shot or changing position, you may be caught out when you first photograph in a more tropical climate.

▶ Flat light
In flat subjects, like this beach landscape off Borneo, there is nothing to cast a shadow under the vertical lighting, and the contrast range is remarkably low.

▼ Overhead light
With the sun very high for much of the day, shadows tend to pool under subjects, and high contrast is common, as in this shot of an egret. The typical distribution of light and shade is highlights above, shadows beneath.

Available **Light**

Among the variety of light sources used in photography, the artificial lighting found in houses, offices, city streets, and public spaces is often considered to be the poor relation. Daylight is the natural source of light. Photographic lighting (discussed in the next section of this book) is purpose-built and so designed for camera and lens settings that are close to ideal. What remains, generally known as available, ambient, or existing lighting, can be problematic, but may also be interesting.

Available light used to be at best a challenge, with a great deal of built-in uncertainty. Available light levels are lower than ideal for use with film, so one of the issues was whether to sacrifice detail by opting for a faster and so grainier emulsion, or accept some movement blur by staying with a fine-grained emulsion and using a tripod for steadiness. Another issue was color balance, involving first a choice of daylight or tungsten film, and second a choice of filter (assuming that you had already invested in a set sufficiently comprehensive). This was on top of having a method of judging the color of the lighting: namely a color meter, experience, or guesswork.

Digital photography does away with all of this at a stroke, and available light becomes a pleasure—or at least an arena of lighting situations that is almost as easy on the camera as it is on the eye. This has some very important practical effects, on time and cost. There is almost no need for advance planning and calculation. You can decide in an instant what the color balance is likely to be (note the emphasis on the imprecise "likely"), then choose the appropriate white balance and check the result. If it is not quite right, you can go back to the menu and adjust it. It should take no more than a minute to reach a passable color balance in even the most difficult conditions.

And then there is the issue of cost, which affects the number of different shots that photographers attempt. Available light is often patchy, with the light sources themselves frequently in shot, and this encourages bracketing and different filter combinations just to be safe. Or rather, it used to encourage this, but now the immediate view on the LCD screen shows you what adjustments to make. No longer do you need filters, or backup rolls of tungsten and high-speed film, or a second camera body for them. A single digital camera has it all, and this surely takes the pain out of available-light photography.

Daylight indoors

Photographing interiors by the light through a window is easy enough, provided that you pay careful attention to the window itself, which can give exceptionally good modeling.

The most valuable quality of daylight indoors is its naturalness. Although there are some technical difficulties with light level, contrast, and the uncertainty of the color balance, the quality of light from a window is often both attractive and useful. In fact, the most commonly used form of still-life lighting is based on this effect: boxed-in area lights are designed to imitate the directional but diffuse natural lighting from a window.

The typical source of indoor natural light is a window set conventionally in a wall. Which way it faces and the view outside it control the amount and color of the daylight entering the room. Look carefully at the view out of the window to determine whether or not there is likely to be a major rise or fall in color temperature. The walls of any neighbouring buildings may have a much greater effect than the sky.

If there is no direct sunlight (or if this is diffused by net curtains, for instance), then the window is the source of light. This has an important effect

Unexpected effects

When the sun is low enough to shine through a window and across a room, the light will pick out objects—though not for long, as the sun's position moves relatively quickly at these times. Here, in a Catholic church, it shone directly onto the ladder used each evening by the bell-ringer.

Frank Lloyd Wright

To avoid window highlights blowing out, choose the camera position carefully. In this room designed by American architect Frank Lloyd Wright, the viewpoint ensures that most of the sky is hidden —further back would cause too much flare, further forward would lose the shape of the awning.

on the intensity, as the light, instead of being constant at any distance, falls off rapidly. This means that, if you are taking a portrait by diffused window light, how close your subject stands to the window will make a significant difference to the exposure. If you are photographing the room as a complete interior, the level across the picture may be so great that you need some remedy to reduce the contrast.

Light from a window is a distinctive mixture of being highly directional and broad, so the shadow is even, simple, and soft-edged. This combination of qualities makes diffuse window light almost unequaled for giving good modeling, and can be particularly successful for portraits and full-figure shots. This modeling effect is strongest when the window is to one side of the camera's view; the density of the shadow, and thus the contrast, will depend very much on what happens on the other side of the room: whether there are other windows; how big the room is; and whether it is decorated brightly or not. If the shadow side of the picture is dark and you want to preserve some detail, you can add reflectors.

The value of reflection

Bright sunlight falling on a patch of floor in front of this young novice nun illuminates the shadowed area of her face and pink robes—an effect that not only makes the details visible, but is beautiful in its own right.

Incandescent light

The orange cast of domestic tungsten lamps, which is much more obvious to the camera than to the eye, needs white balance adjustment, although not always to the maximum.

Tungsten lamps are the standard, traditional form of lighting for domestic interiors, and this is where you are most likely to find them. Outdoors, and in large interiors used by the public, they have mainly been replaced by fluorescent and vapor lighting. A tungsten lamp is incandescent—that is, it shines by burning—and its brightness depends on the degree to which the filament is heated. As this in turn depends on the wattage, you can get an idea of the brightness, and the color, from the rating of the lamp. The color range, which is between orange and yellow, depends on the color temperature.

Color temperature is perhaps the first thing to think about when shooting by available light in houses. If you enter a shuttered, tungsten-lit room straight from daylight, you can immediately notice how orange it looks. Usually, however, we see tungsten light at night, and it does not take the eye long to adapt and to see it as almost white. However, photograph a tungsten-lit interior uncorrected—that is to say, with a "daylight" white balance setting—and you may be surprised at the orange cast, which will not be what you remembered. The color temperature values for the usual ratings of domestic lamp are lower—that is, redder—than the 3200K rating for

A familiar light source
Tungsten lamps are one of the oldest forms of artifical lighting, the direct successor to candles, and although largely superseded in public and office spaces, are still the preferred type of domestic lighting.

Lights in shot
A typical lighting situation with tungsten, flames and other incandescent lighting is when the light sources appear in shot, as in this picture of the Amarvilas Hotel in Agra. Experiment with different exposures to get the right visual balance.

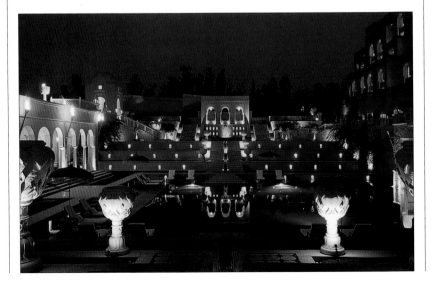

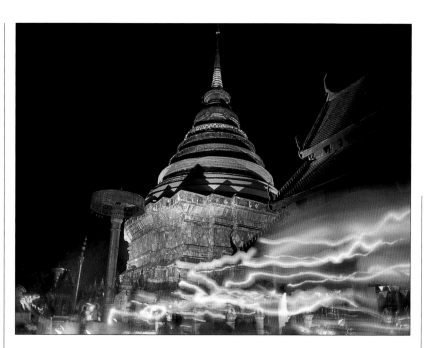

Streaked time exposure

A procession of worshippers carrying paper lanterns passed in front of this northern Thai temple, leaving a strange flow of orange light across the foreground in this two-second exposure. The camera was mounted on a tripod.

standard "incandescent" white balance correction, and so will still appear rather warm even with this setting, although normally this is quite acceptable. As with so many things in photography, the complete answer is not a purely technical one. The ultimate criterion is what looks right, not what measures perfectly. This color temperature, as we will see later in the section on photographic lighting, is normal for photographic tungsten and tungsten-halogen lamps.

In the examples shown right, the subject was a Javanese classical dance, and the lighting was tungsten floodlights with a color temperature of about 2900K. One shot is shown with a "daylight" white balance, the other with "incandescent." How you judge the results of this and your own shooting will depend on your taste. In this example, my own feeling is that either version is acceptable. The color difference is immediately obvious when compared side by side, but if you cover up the corrected version, the other does not appear to be quite so red. In fact, sometimes the orange cast of uncorrected tungsten light can be attractive, as it gives connotations of warmth and comfort. This may be worth bearing in mind. As an interesting aside, traditionally butchers' shops and meat markets have used tungsten lighting, for the simple reason that it makes the meat look a little redder. By contrast, imagine how unappetizing it would look by green or blue light.

Acceptable warmth

This pair of photos was taken under the same tungsten lighting in Java. The right shot was taken with the white balance set to 5400K daylight, the top set to 3200K (incandescent). What this shows is that the warm tones of under-corrected tungsten are visually acceptable, and the value of correcting the color temperature is a matter of personal taste.

Fluorescent light

One of the most common types of indoor lighting, fluorescent lamps look white but photograph green, and call for white balance correction.

Fluorescent lamps have a discontinuous spectrum and produce, usually, a greenish color cast. They work by means of an electric discharge passed through vapor sealed in a glass tube, with a fluorescent coating on the inside of the glass. These fluorescers glow at different wavelengths, and have the effect of spreading

Variety of lamps

Fluorescent lamps are available in several different shades of white. These have a visual effect, obviously, but have an even stronger difference in photographs. The most common are "Daylight," "Warm White" and "Cool White," but in practice it is difficult to tell which you are dealing with in a new situation. Make an immediate test at any setting and check the results on the LCD screen.

Mixing sources

The real problems arise if you mix fluorescent with other sources of light. Adding flash will emphasize the color difference, unless you filter the flash green and use the fluorescent white balance correction.

▽ Fluorescent emissions

Covering the full range of the visible spectrum, from violet to red, these bar charts show the different emissions from different types of fluorescent lamp. The visual effect is approximately the total of what you see here.

△ Fine-tuning adjustment

A Tokyo beauty parlor lit entirely by fluorescent lamps. The lights visible in shot are sufficiently overexposed to lose their apparent color.

▷ Typical green

This barrel-ageing room in a Napa Valley winery is, like many industrial interiors, lit by overhead fluorescent striplights. The difference in color cast is obvious between a frame shot with the camera's white balance set to daylight (left) and a second set to fluorescent (right).

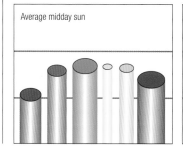

Average midday sun

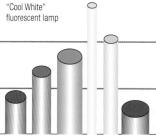

"Cool White" fluorescent lamp

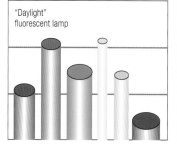

"Daylight" fluorescent lamp

the spectrum of the lamp's light. Visually this works very well and the eye registers the light as white, if a little cold. However, in photography, this colors the scene unattractively.

If these deficiencies were consistent, it would be a simple matter of using one standard white balance correction. However, fluorescent lamps vary in the visual effect that the manufacturer tries to produce. Some are only slightly green when photographed; others are very green. All digital cameras have at least one white balance correction setting, but some feature a choice, with, for instance, separate settings for "Daylight," "Warm White," and "Cool White" lamps. It is difficult to tell just by looking how much of a green cast will appear. It is usually best to test it by shooting with the basic white balance setting and then adjusting from there.

A large part of the problem, aesthetically, is that an overall bias towards green is considered unattractive by most people, except in special and occasional circumstances. A shift to orange is generally tolerated but the same is not true of green. Whereas orange is a color of illumination that is within our visual experience (e.g. firelight, rich sunsets) and has, on the whole, pleasant associations of warmth, green is not a natural color of light. Although this is a fairly good reason for wanting to make corrections, you should, as a first step, think about whether you can make some use of the green cast, or indeed whether the color will make any important detrimental difference to the image.

Acceptable color cast

One reason why it may not be important to make a color correction is sheer familiarity. Fluorescent lighting is used so much in large interiors, such as supermarkets and offices, and so many uncorrected and under-corrected photographs are published, that we are all accustomed to seeing the greenish color cast. It can usefully add a cold, industrial atmosphere to a scene, or add interest to an otherwise flat shot.

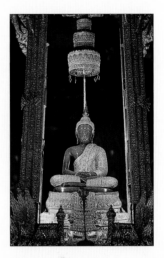

When green is acceptable

Vertical strip-lights cast the usual greenish light in this shot of Bangkok's Emerald Buddha. Filtration would have made the green statue appear duller.

Vapor discharge light

Digital capture comes to the rescue in what have traditionally been some of the nastiest lighting situations in photography—the greens, blues, and yellows from vapor lamps that often look deceptively white.

Vapor discharge lighting is definitely on the increase, particularly in public spaces, department stores and shops, and is gradually taking over from fluorescent and tungsten lighting. Being more powerful than either of these two, vapor lamps are good for lighting large spaces brightly, both outside and inside. What they are not good for, unfortunately, is photography. The problem is that, for the most part, they look white to the eye—which is why they are popular—but in photographs they usually cast a strongly colored light over the scene. Worse still, they are not consistent or predictable.

The three principal types of lamp are sodium, which looks yellow in photographs; mercury, which looks like a cold white and photographs between green and blue-green; and multi-vapor, which also looks cold white but may, if you're lucky, appear reasonably well balanced in a photograph. Sodium lamps are typically used for street-lighting and for floodlighting buildings; multi-vapor lamps are used in sports stadiums where television cameras need good color balance; and mercury lamps are used in lots of different situations. Sodium is easy to spot—it looks yellow and, when just switched on, glows orange for a few minutes. The other two easily fool the eye, although when mercury lamps are switched on, they glow greenish before they reach full strength (note that if you switch them off to check how the scene looks without them, it may take several minutes to restart them).

⬆ Colour contrast
The visual mixture of green vapor lighting in this glass lobby and cool dusk daylight produces a delicate effect that it would be a pity to lose, even though the green could be shifted to neutral in image editing.

⬇ Sodium yellow
The yellow cast from sodium vapor lamps is intensified by reflections in these stainless-steel wine vats. Neutralizing the cast is possible in-camera, but here the yellow added to the severe, industrial scene.

The reason for the problem is that the emissions of vapor discharge lamps peak strongly in very narrow bands of the spectrum, and are completely lacking in many wavelengths. Unlike fluorescent tubes, they don't have the benefit of a coating of fluorescers to spread the output over other parts of the spectrum. With film this made for a truly difficult situation, but digital cameras score in two ways: the normal response of the sensor to vapor lamps is less extreme than with color film, and the white-balance menu allows you to reach a neutral color balance—or something close to it at least.

A variety of colour

In this shot of an East Malaysian oil refinery, the blue-green lights are mercury vapor, and the yellowish are sodium. However, from this distance it is not worth using color correction, as the lights are only a small element in the composition.

Intense green

The vapor lighting on this old church is basically uncorrectable in-camera because of its extremely restricted spectrum. One solution is during image editing to alter the hue to something more visually acceptable, while reducing saturation. The difficulty is that the range of hues is so narrow that a normally colorful result is impossible.

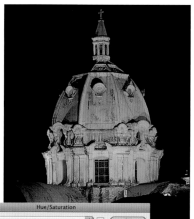

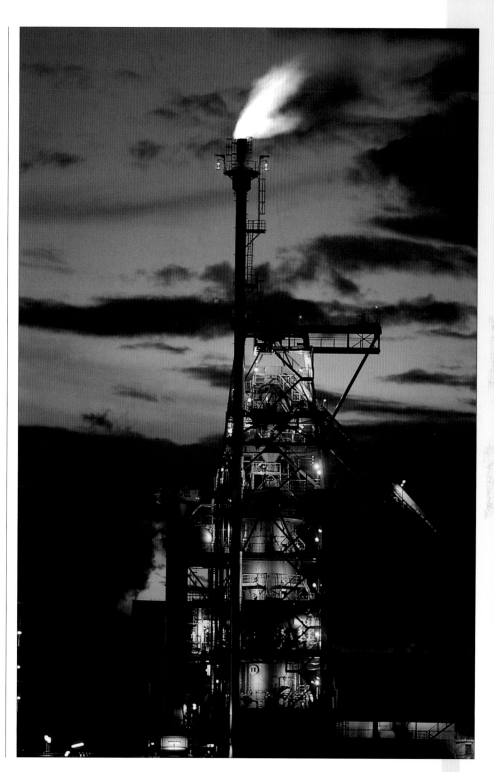

Mixed lighting

When interiors combine different kinds of lighting, you can expect a clash of colors, but for shooting you will have to choose one white balance setting that makes the best of the situation.

One trend in lighting interiors, particularly large spaces, is to mix light sources from incandescent, fluorescent, and vapor discharge lights. Again, the issue to address in photography is the gap between what the eye sees and what the sensor records. Mixed lighting works because our eyes accommodate to color changes so easily, but the camera's response will nearly always show up the differences within the same scene.

Depending on how the lamps are situated, they may combine to give a blend of color, or they may cast separate pools of differently colored light.

Once again, digital cameras come to the rescue in a way that was impossible with film photography. Not only is the color response of the sensor less extreme than that of film, but you have the advantage of instant feedback from the LCD display. Before anything else, I shoot a test frame with the widest angle focal length lens I have, simply to examine the relative difference in color across the scene. The white balance setting for this test is not critical, but for an accurate measurement I normally set it to "daylight." On the basis of this I can decide whether to switch off certain lights, and then find the least offensive white balance setting.

However, before heading towards correction, you might want to pause and consider whether or not the mix of lighting colors is a bad idea after all.

The positive side of mixed lighting is that the color combinations can be intrinsically attractive and contribute to the image. Then again, the unattractive associations of green light may be exactly what you need if you intend to convey a particular kind of atmosphere. Institutional settings, such as the emergency reception area of a hospital, a seedy bus terminal, or subway, are likely to look more effective if the fluorescent lighting is left uncorrected.

The warmth of candles
Traditonal English afternoon tea is still served in an old hotel in Darjeeling, India, with candles lit. Shooting through to the room beyond gives the shot context, but also includes the daylight through the far window. Although inacandescent lighting dominates most of the image, the white balance was set for little correction, partly to keep the daylight looking normal, partly to retain the expected warmth of the candlelight.

▲ A complex mix

This Tokyo department store has a bewildering mixture of lights, from tungsten to fluorescent to vapor discharge. The net effect, however, with the camera's white balance set to Auto, is a surprisingly normal blend, as one cast cancels out the other.

▶ Color harmony

A straight mix of daylight and tungsten might seem to be a color-balancing challenge that could only be solved selectively during image editing. However, the basic attraction of the shot is precisely the harmonious contrast between orange and blue, and it was important to set the white balance midway between the two sources to capture this effect.

City lights

Downtown street lighting and display lighting continues to get brighter and more colorful around the world, and is perfect material for digital shooting.

The light sources available outside at night are the same types as those that we have just looked at, but in different proportions. Vapor lamps are used much more extensively outdoors than indoors, because of their higher output; this is particularly true of street lighting and floodlighting. Tungsten as street lighting is increasingly less common, but can be seen in shop and other windows, and as car lights. Overall, entertainment and shopping districts in cities are getting brighter and more interesting.

Although the light sources are the same as those used to illuminate interiors, their effect is very different. The scale of the usual type of outdoor shot is greater, and the surroundings do not give the same degree of

Keeping it bright
A Shanghai street packed with seafood restaurants has a lighting level to match the buzz of night-time business. Shots like these always repay bracketed exposures—the brighter frames are usually most successful.

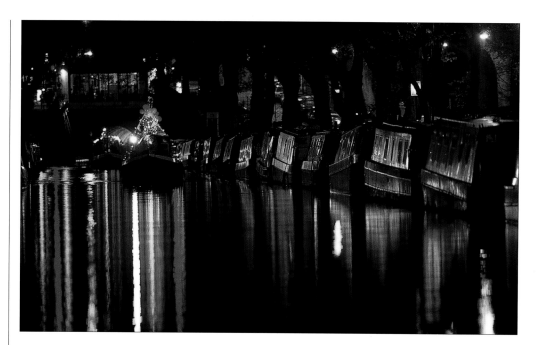

Light reflections

To get the most out of the fairly low lighting on a canal in London, I shot with a long telephoto at an acute angle to the moored canal boats (to catch reflections in their side panels) and from very low, for maximum reflections in the water. Without these two kinds of reflection, the shot would have been hardly readable—as it is, the effect is atmospheric and slightly mysterious.

reflection as do interior walls and ceilings. As a result, there is much more pooling of light: in a typical scene there are many lights, and they are localized. Only very rarely are there enough lights in a concentrated area to give the impression of overall illumination. This happens, for instance, in the busiest part of a downtown night-club district; at some open-air night-markets; and, as you might expect, in sports stadiums. A general solution to this is to shoot at dusk, when there is just a little residual daylight.

In most night-time city views, however, there is either one well-lit area, such as a floodlit building, or a pattern of small lights. In many ways, this type of light causes fewer difficulties than an interior, and there are fewer occasions when you might need to decide on the principal light source and correct the color. The impression of a color cast occurs when most of the picture area is affected; when there are other lights in the image, color balance becomes a much less important consideration.

The localization of the light sources makes measurement difficult. Use it as a guide rather than as a completely accurate recommendation, and bracket exposures around the figures given. For many night-time scenes, the accuracy of the exposure is not, in fact, very critical. Overexposure often does little harm, as it opens up the shadow areas in a scene. The best answer is to experiment, which is of course what digital cameras allow.

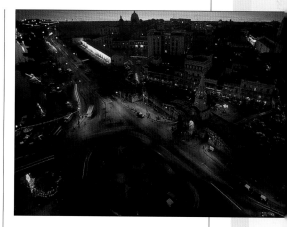

City at dusk

Twilight just after sunset is an important element in this elevated view of a Caribbean city. Its muted, but general illumination helps to give definition to buildings and streets, in what would otherwise be a picture composed solely of dots and streaks of light.

Lighting displays

Outdoor lights as subjects rather than illumination need more careful exposure to preserve colors and shapes, while fireworks are a special case that calls for anticipation.

Although these are fluorescent lights, the colors of the displays overwhelm the greenish color cast typical of fluorescent lighting, and the white balance rarely needs to be accurate. Most displays are high up—well above street level—and the easiest technique is usually to stand back, across the street or further, and use a telephoto lens. For one exposure, use the fluorescent white balance setting, just to be able to see what difference it makes. Apart from this, take a series of different exposures, starting with the meter reading and increasing the exposure from that. If you are using a tripod, there will be no need to increase the sensitivity, and in any case you will need to keep the shutter speed at 1/30 second or slower to compensate for the tendency of fluorescent lamps to pulsate.

Which exposure looks best is usually a matter of taste, and the range of what is acceptable is quite wide. When comparing the results later, you should notice that short exposures give more intense colors, reproduce the tubes as thin lines, and show nothing or very little of the surroundings. Longer exposures give a thicker appearance to the display, which appears paler in color also. If you use a tripod and so have perfectly matched frames, it might be interesting to take two different exposures and combine them in a single image in Photoshop, keeping the color saturation of the darker frame.

Firework displays, like lightning, make their own exposure. Light intensity apart, there is little point in trying to use a fast shutter speed: the effect of a bursting firework is created by the streaking of the lights, even to the eye. A short exposure simply shows less of the display. Conversely, provided that the sky is really black, leaving the shutter open will not cause overexposure, but instead add more displays to the image. Two things to be careful of are the clouds of smoke from the fireworks that sometimes drift across the view, and the lights of buildings if you include the setting in the shot. Both of these set limits to the overexposure.

For the best effect of the bursts, exposure times are usually between half a second and four seconds, but you can judge this for yourself by watching the initial displays and timing them from the moment the rockets reach their bursting height. There is no need to switch to a higher sensitivity: f4-f5.6 is a

Display cycles
Some neon displays cycle through changes as striplights switch on and off in sequence. Try different moments in the cycle, and also vary the exposure. Neither of the exposures above is right or wrong—simply a different effect. Color is stronger with shorter exposures, but a luminous glow needs longer.

reasonable aperture with ISO 100-200. In any case, the exposure is not critical: try making a variety of exposures to determine this for yourself.

For a view of a firework display that includes the setting, as in the photograph below, lock the camera firmly on the tripod, and make sure that the framing and focal length are right for the height of the displays. Check this and the location of the fireworks by watching a few through the viewfinder before shooting. For a close view of a single burst, try using a medium telephoto lens with the tripod head partially loosened (enough so that you can move the camera, but still sufficiently tight to hold it when you stop). Pan upwards to follow the rocket as it ascends and, as soon as it bursts, stop and open the shutter.

▶ Colored neon
The green-cast issues of shooting by fluorescent lighting are irrelevant with strongly colored displays such as this. The greenish cast remains, and you would still probably want to set the white balance accordingly, but this is largely overwhelmed by the coloring.

▶ Fireworks
To take a wide-angle photograph of fireworks in a setting, use the start of the display to judge the height and position of the bursts, and frame the shot accordingly. With the camera locked on a tripod, vary the exposure times to include single and multiple bursts. This shot was taken in New York at the centenary celebrations of the Statue of Liberty. The lens's focal length was 35mm equivalent (slightly wider than standard), and the aperture ƒ2.8 with a sensitivity of ISO 100.

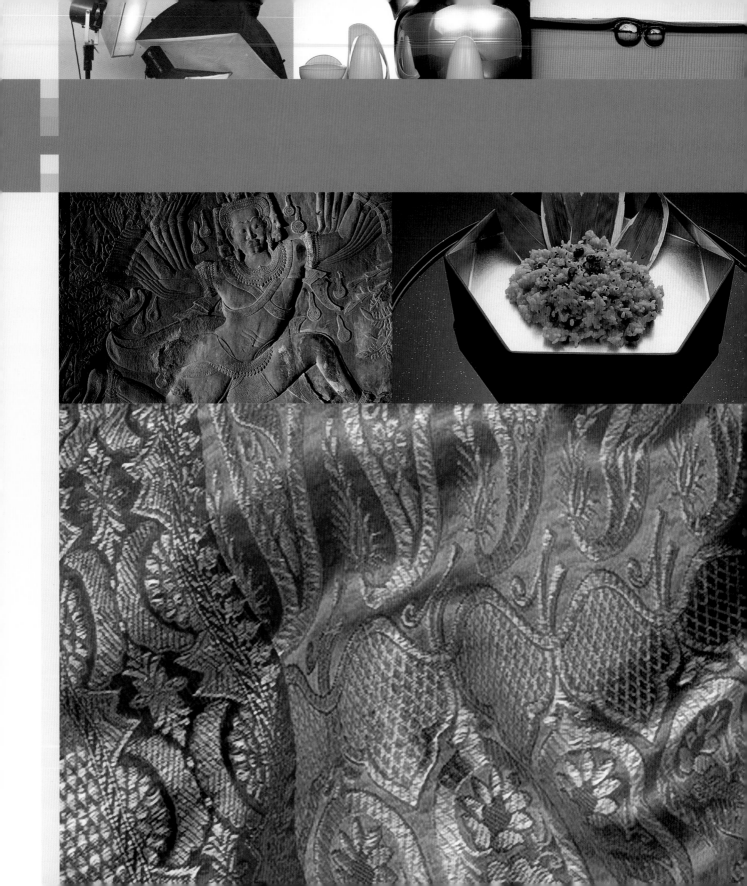

Photographic **Lighting**

What sets photographic lighting apart from other light sources is that it is designed specifically to work with cameras and certain popular kinds of subject. On-camera flash is a standard does-everything light, but has serious limitations when it comes to creating a carefully arranged, imaginative set-up. In professional photography, particularly in studios, lighting is a specialized, important, and costly concern. This has always been the case, but as pro-lighting manufacturers improve their equipment, the range increases and can cope with more and more specific lighting situations.

If you were planning to cover the full range of lit studio and location photography, you would eventually find a use for all the sources of photographic lighting covered here—and their even greater number of attachments. However, for cost, if nothing else, most photographers commit themselves to one type of lighting, at least to begin with.

While most of this applies to digital photography as much as to traditional film photography, digital capture is creating some major changes, albeit quietly and even a little subversively. Much of the effort that has gone into pro-lighting in the past has been to cope with the limitations of film. This applied especially to high-powered studio flash, where the systems developed in the 1960s and 1970s were designed for exact color fidelity and motion-stopping output. Digital, however, is much more flexible than film in its response to color, as well as being, in most cameras, more sensitive (the standard high-quality ISO setting is higher than the traditional ISO 50 of fine-grained emulsions). A standard digital camera simply does not need the precision and power of expensive studio lighting. This may be heresy to the purists, but is good news to photographers with smaller budgets. You can use almost any source of illumination, and the digital sensor, with the help of a good white balance menu, will generally cope with it. For example, if you have a light box for viewing transparencies and are wondering whether to mothball it as you shift to digital photography, try using it as an area light, or for backgrounds. Never mind about color balance—the camera will take care of that.

What I want to stress throughout this section is the importance of controlling the quality of lighting. This may seem obvious, but if you are used only to portable flash, the sheer quantity of materials, time, and effort that goes into full lighting control may be a surprise. In still-life shooting, studio portraits, room sets, and other controlled situations, convenience and simplicity are low priorities. Precise lighting takes time to plan and construct. The top priority is creating as full as possible a range of directions, diffusion, concentration, and all the other qualities of lighting. This takes a lot of effort, and will introduce you to a special class of lighting problem. For instance, diffusing a lamp in a way that suits one object in a group may cause an unwanted spill of light onto another. The main light and background light may (and often do) conflict, and separating the effect of each on the other may call for some ingenuity in managing and placing the equipment.

On-camera flash

Whether built into the camera body or attached via a hotshoe connection, basic flash units were designed as a convenience for getting the shot in the absence of any other useful light.

In the range of photographic lighting, on-camera flash is principally a convenience, and it is important to appreciate its limitations. Most on-camera flash units are built-in (some pop up on demand), but some are detachable and fit on the camera's accessory shoe. All these units are designed for compactness and ease of use; with these as priorities, quality and variety of lighting take second place. While this kind of flash has its uses on location, it does not have quite as many advantages as its manufacturers would like you to believe. Nevertheless, the sophisticated metering and exposure control in a digital camera makes it possible to mix flash with existing lighting for some dynamic effects.

Guide number

The guide number is a practical measurement of output, and varies with the ISO sensitivity. It is the product of the aperture (in f-stops) and flash-to-subject distance, in feet, meters, or both. A typical manufacturer rating, for example, might be "Guide Number 17/56 at ISO 200," meaning meters/feet. Divide the guide number by the aperture you are using to find the maximum distance at which you can use it. In this example, if you were using an aperture of $f4$, it would be 14 feet (4 m). When using a unit off-camera, remember that the shadows will be larger and the contrast very high unless you use a reflector or a second flash unit opposite. Off-camera flash is easiest to use with the assistance of someone else to hold he flash unit.

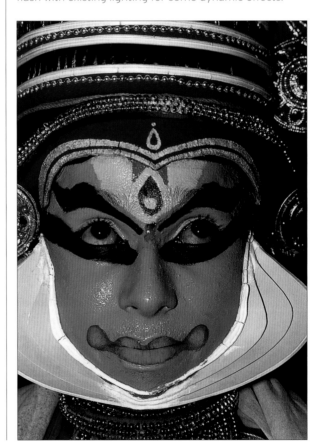

Intense color

The great value of portable flash is that it makes it possible to take at least some kind of photograph in situations where there is insufficient light. Direct, on-camera flash pictures usually work best when the subject has strong tones or colors, as here.

Flash units work by means of a capacitor charged by battery. When triggered, the capacitor releases its full charge instantaneously through the flash tube, ionizing the gas inside. Intensity of the light output depends on the size of the capacitor and on the square of the voltage at which the unit operates, and is normally quoted as a guide number.

The limitations of full flash illumination are those of frontal lighting. In other words, the light is almost shadowless and it falls off in proportion to the distance from the camera. A typical purely flash-lit photograph tends to feature flat illumination on the main subject and a dark background. The result is clear, sharp, and with good color separation, but is generally lacking in ambience. Typical good uses of full-on flash are close-ups of colorful subjects, as these can benefit from the crisp precision and strong colors afforded by flash illumination.

Problem checklist

☐ Exposure is only good for one distance, because the light fall-off is along the line of view. Thus backgrounds are typically dark, and off-center foreground obstructions typically overexposed.
☐ There are often intense reflections in shiny surfaces facing the camera (spectacles, windows, etc.). Lack of a modeling lamp prevents preview.
☐ Red reflections from the retina of the subject are likely, particularly with a longer focal length lens (this makes light more axial). The solution supplied by some cameras is a pre-flash to make the person's iris contract, but this adds a delay.
☐ Flat, shadowless light that gives a poor sense of volume.

▼ Automatic fill
Allowing the camera to decide on the balance between ambient light and flash gives an efficient, if slightly unnatural, effect—as in this shot of a man steering his boat along a canal.

▲ Crisp, sharp and clean
While the small head of a portable flash unit prevents subtlety in lighting, it has the advantage of bringing out texture and color very vividly, particularly when, as in this picture of a fighting cock, the flash is used from a slight distance off-camera, using a sync cable. The background as usual disappears to black, which in this case helps the bird's head stand out strongly.

Making more of flash

By adding to the ambient light rather than totally replacing it, on-camera flash can achieve interesting effects, and even subtlety. Experimentation is easier than ever with digital cameras.

While on-camera flash works well enough as a no-frills light that at least enables you to capture a recognizable image, it totally changes the view of any scene, usually dropping the background right out of sight. There are ways of working around this, however, including diffusing the light and using it in combination with a longer exposure. A slight amount of diffusion is possible by fitting a translucent attachment to the flash head, but there are physical limits to this as the diffuser attachment has to sit above the lens. More usual in interiors with low, domestic-style ceilings is to use bounce flash, swiveling the head upwards so that the light spreads by reflection (only with white or pale ceilings).

Adding to the ambient light, however, is one of the best uses of on-camera flash, and there are two variations of it. One is shadow fill. This is especially useful when you are shooting towards the light and detail in objects facing the camera tends to be lost in shadow. All digital cameras have a setting for this, in which a smaller dose of flash is added to the longer exposure so as to give a balanced combination. The second variation is streaking with rear-curtain synchronization. In this, the exposure and flash output are similarly balanced, but the flash is timed at the end of the exposure. If there is movement, either in the subject or because you move the camera, there will be trails of light terminating in a sharply frozen image.

Manual balance
When there is time to consider a shot and make adjustments, it's usually better to select the amount of fill flash yourself in Manual mode rather than accept the standard Auto calculation. In this scene of fire prayers in a Japanese Buddhist monastery, the soaring flames were the key subject, and flash was needed only to make the monk visible. Auto would have drowned the scene in flash.

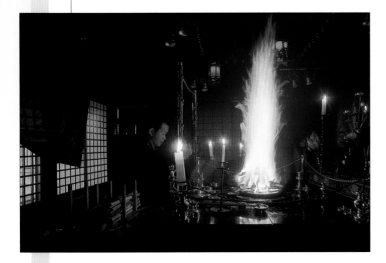

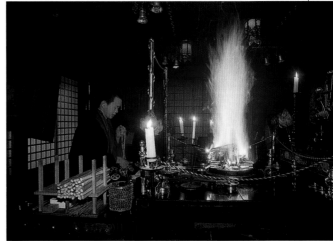

Bounce flash

This technique works only with flash units that have swiveling heads, and relies on having a white or pale-colored surface close to the camera. One of the most readily available is the ceiling of a room, and most such units are designed to tilt upwards and make use of this. The effect is to diffuse the light and to alter its direction. The light intensity is, expectedly, very much reduced.

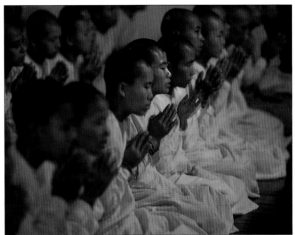

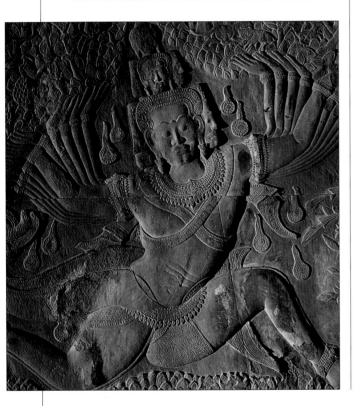

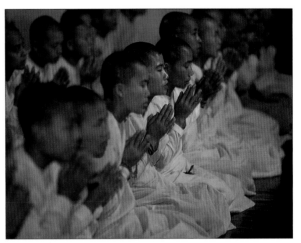

▲ Off-camera for texture

To light this sandstone bas-relief at Angkor Wat effectively, the angle had to be acute—just grazing the surface so as to throw the delicate carving into relief. A portable flash unit was connected to the camera (an SLR) by a 6-foot (2-m) sync cable.

◀▶ Judging the effect

A sequence of three frames of nuns in a convent, with varying degrees of fill flash—from none (top) to full (bottom). In a situation like this, the chosen balance is entirely up to personal taste. The trade-off is between the natural effect of existing light and the sharp, bright colors of flash.

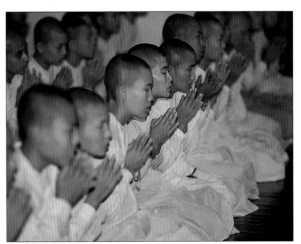

Studio flash

Mains-powered flash units offer the
ultimate lighting control: a full range of
light fittings and no problems with
moving subjects.

The real limitation of on-camera flash is that its
full-frontal direction and harsh quality are rarely
flattering—probably the last thing you would choose if
you had control. The limitations of tungsten lighting are
that it does not combine with daylight easily and that the
great heat output limits the fittings you can attach. For
the extra effort of planning and setting up lights, you can
achieve a much wider range of effects with powerful,

▲ Basic still-life set-up

Lighting set-ups are endless in their possibilities, and
much of the pleasure of studio photography comes from
experimentation and devising your own, elegant solutions.
This is a simple starter for objects of handheld size: one
light fitted with a window-like bank suspended overhead,
and a curved sheet of white flexible material (such as
Formica) to give a horizonless background shading from
bright to dark.

▶ Light fittings

Because the only heat
generated is from the
low-wattage modeling
lamp, flash heads can
take a variety of fittings.
These banks (above right)
enclose the heads and
give a diffuse but
directional effect, in
addition to standard bowl
reflectors (far right) and
umbrellas (right).
Umbrellas are particularly
useful for portraits.

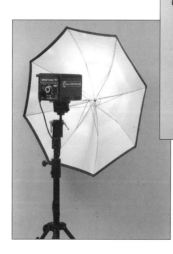

separately triggered flash heads. There are two kinds: high-output portable flash powered by rechargeable batteries; and mains-powered flash, which is normally used in studios. Both can be used with a variety of fittings, and it is these—the diffusers, reflectors, and spots —that control the quality of the light.

Lighting in a controlled environment is the essence of studio shooting, and digital cameras take this to another level of ease and convenience. Many models, and particularly prosumer ones, allow the camera to be operated directly from a computer. Once the camera is locked on the tripod and the lights are in position, you can simply sit down with a laptop and shoot from the comfort of your keyboard and mouse.

Sync workarounds

By no means all digital cameras include a co-axial flash sync terminal —in fact, fewer do now than in the days of film. Fortunately there are workarounds, although you should check whether these will work with your camera. The most convenient is to use the camera's built-in flash to operate a slave trigger. The better studio flash units have a slave built in, as here on an Elinchrom, to obviate the need for messy cables. If your camera allows it, set the built-in flash to its minimum setting. If not, vary the shutter speed, turn the room lights off, open the shutter and use open flash, triggering the unit by hand or with a small handheld flash trigger.

Flash meter

A flash meter is essential equipment with these large units, and the most consistent measurements in a studio set-up are from incident light readings, made with a milky dome over the sensor, pointed at the camera. This measures the light, not the subject. For close-ups, a flexible miniature attachment is useful.

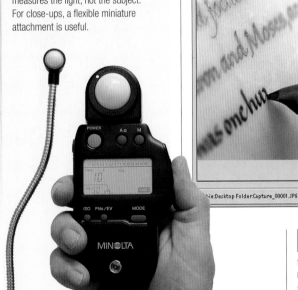

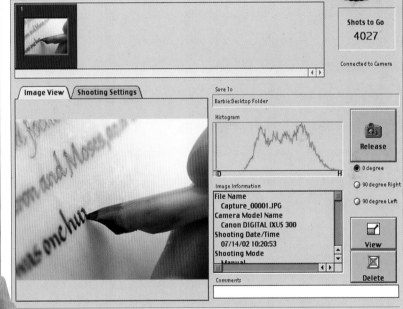

▲ Shooting from the computer

Many digital cameras allow remote capture through their software and a connection to the computer (usually USB or, better and faster, Firewire). The advantage is in the larger display, which allows better analysis of the image, and the histogram is the key tool; all camera functions are usually controllable.

Studio flash equipment

Being able to draw continuous power at a significant level makes it possible to deliver light that can be diffused, reflected or redirected in all kinds of ways, and still reach the subject at a level that allows good depth of field.

A mains flash unit works in the following way. As the power supply is in the form of an alternating current in a relatively low voltage, the first part of the circuitry is a transformer and associated rectifier (or more than one in the case of larger units). The transformer steps up the voltage and the rectifier converts the alternating current to a direct current (in other words, it converts AC to DC). This uni-directional high-voltage source then supplies the capacitor that stores the charge. On command, the high-voltage output in the capacitor is discharged through the flash tube.

Given the light output possible from just a single flash tube—and the fact that it is practically instantaneous—it is not surprising that mains-powered flash is the lighting equipment of choice in studios. Output is measured in watt-seconds, or joules, and typical units are between 200 and 1000 joules. To make use of the extremely high output of the mains flash capacitors, the flash tubes are much larger than in on-camera units. Instead of a short straight tube, the most common design for medium-power units is circular. High-output units may use spiral tubes. One result of the need for high output and larger tube size is that the peak flash duration is longer than that of an on-camera flash—sometimes as slow as a few hundredths of a second.

Lampheads

These heads require power from a separate generator unit. This means buying into a particular Flash system, but there are advantages in terms of long-term reliability and fine control.

Elinchrom A300N Bowens Esprit head

Monoblocs
Monobloc flash units contain the power supply and controls within the body of the flash itself. This makes them particularly useful when you need flexible, easily-portable lighting equipment.

Bowens Monobloc range

Monobloc controls

Esprit 3 head kit

Food on location #1

When choosing studio flash units, consider the value of being able to take them on location. If this is likely, they need to be compact and relatively light, as in the case of this monobloc unit fitted with a collapsible softbox. Being able to suspend a main light overhead is useful, but needs extra supports—here a goalpost arrangement of aluminum stands and pole.

Food on location #2

The great value of portable flash is that it makes it possible to take at least some kind of photograph in situations where there is insufficient light. Direct, on-camera flash pictures usually work best when the subject has strong tones or colors, as here.

Power packs

With a separate power pack and lamphead system, it's possible to channel more power into a single head, or control the spread across several.

Balcar power pack

As with other photographic equipment, such as cameras, there are many competing systems, and these are often not compatible. This is particularly the case with mains flash, in which the power units, connectors, and flash-heads cannot normally be interchanged. Before buying anything, make all the comparisons you can, and anticipate your future needs. You might, for instance, eventually need several identical lamps, or a set of specialized lights —one for still-life main illumination, and others for backgrounds, and so on. Also, if you expect to shoot on location as well as at home or in the studio, the weight and transportability of the equipment will be important.

Elinchrom Ranger power pack

Incandescent

Photographic tungsten lamps and the newer high-performance flicker-free fluorescent lamps have the advantage over flash that you can work by eye, although they are not as effective at stopping movement.

▲ **Fill light for rooms**
Almost all room interiors shot towards a window need some kind of fill lighting, simply to bring the contrast level into line. Windows are often an important part of the view, as in this shot of a Los Angeles 1930s house, and for shadowless fill, lights aimed behind the camera onto walls and ceiling are usually the most efficient.

Tungsten lighting is incandescent, created by burning a tungsten filament at a controlled rate in a sealed transparent envelope (glass in the case of traditional lamps; a quartz-like material in the case of more efficient tungsten-halogen lamps). When designed specifically for photography, the light output is high and the color temperature is controlled, at 3200K (312 mireds), in nearly every design. Some lamps are available with a blue coating to the glass, giving a color temperature that approximates that of daylight. These are intended more for use in mixed lighting conditions, such as combined with daylight, than for straightforward studio use.

The more efficient version of tungsten lighting is the tungsten-halogen lamp. This uses the same coiled tungsten filament, but it burns at a much higher temperature in halogen gas. As a result, these lamps maintain virtually the same light output and color temperature throughout their life; they also last longer than traditional lamps and are smaller for their equivalent wattage. Available wattages range from 200 to 10,000, although the most powerful are intended for cinematography; the highest normal wattage for still photographic lights is 2000. The light output is the same as that from a new tungsten lamp of traditional design of the same wattage.

A newer development, particularly relevant to digital photography, in which the camera's white balance settings can take care of color differences, is high-performance fluorescent. The lamps used are flicker-free, almost as bright as tungsten, color-balanced for 5400K or 3200K, as well as being cooler and less expensive to run (though more expensive to buy in the first place).

Tungsten vs flash

Tungsten: pros
- ☐ Photographs the way it looks.
- ☐ Good for large, static subjects—just increase the exposure time.
- ☐ Mechanically simple, little to go wrong.
- ☐ Easy to use.
- ☐ Can use to show streaked movement.
- ☐ Some units very small and portable.

Tungsten: cons
- ☐ Not bright enough to freeze fast movement.
- ☐ Hot, so can't accept some diffusing fittings, and dangerous for some subjects.
- ☐ Needs blue filters to mix with daylight.

High-performance fluorescent: pros
- ☐ Photographs the way it looks.
- ☐ Good for large, static subjects—just increase the exposure time.
- ☐ Mechanically simple, little to go wrong.
- ☐ Easy to use.
- ☐ Can use to show streaked movement.
- ☐ Inexpensive running costs.
- ☐ Cool—none of the heat problems of tungsten.

High-performance fluorescent: cons
- ☐ Not bright enough to freeze fast movement.
- ☐ Bulky.
- ☐ High unit cost.

Flash: pros
- ☐ Stops any fast action.
- ☐ Cool, quick to use.
- ☐ Daylight-balanced, mixes easily.

Flash: cons
- ☐ No preview with small units, others need modeling lamps used in relative darkness.
- ☐ Fixed upper limit to exposure, beyond which needs multiple flash.
- ☐ Technically complex.

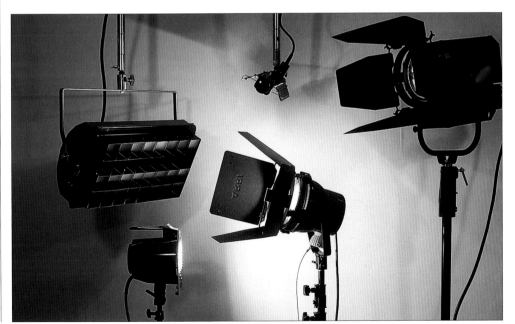

◄ Types of incandescent light
Clockwise from top left: Ballancroft 2500-watt northlight fitted with honeycomb or "egg-crate;" Lee-Lowell 800-watt Totalite with barn doors; Rank-Strand 1000-watt Polaris manual spotlight; 800-watt Arrilite; Hedler 2000-watt videolux.

Incandescent fine tuning

As with studio flash, incandescent lighting can be modified with various attachments, although these must always be heat-proof and adequately ventilated.

Every type of incandescent light housing incorporates some kind of reflector behind the lamp. This is partly to make use of all the light radiated (and so increase the light falling on the subject), and partly to control the beam. The deeper and more concave the reflector, the more concentrated the beam. As it is more difficult to spread a beam that is already tight when it leaves the housing than it is to concentrate a broad beam, most general-purpose housing has reflectors that give a spread of between about 45 and 90 degrees. Light that gives tighter concentration is intended for more specialized use.

Many housings allow some change to the beam pattern by moving the lamp in and out of the reflector, or by moving reflector doors. Barn doors fitted to some housings have a slightly different effect: they cut the edges of the beam rather than concentrate it. The beam patterns from most housings show a fall-off from the center outwards; even with a well-designed reflector, there is still an intense concentration of light in the lamp's filament. One method of reducing this fall-off in the design of the housing is to cover the lamp from direct view with a bar or a spiller cap. If the reflector dish is large as well, the result is a degree of diffusion. Even softer, but less intense light is possible if the inside of the dish is finished in white rather than bright metal.

Used alone in the studio, tungsten lamps simply need 3200K "incandescent" white balance. However, tungsten lighting is frequently used on location, in interiors, and this is often in combination with existing lighting, like daylight and fluorescent light. As a result, lighting filters are typically used for converting the color temperature or for correcting the color to that of fluorescent lamps. You could use mixed lighting and post-production methods, but it is best to get it right at the shoot.

The most common filters are blue, to match daylight. Full blue is -131 mireds; half-blue -68 mireds; and quarter-blue -49 mireds. These filters are available as heat-resistant gels (actually plastic film), glass and dichroic. Dichroic filters are partial mirrors, reflecting red back to the lamp and passing blue; they are not always consistent, and ideally should be checked before use with a color-temperature meter.

Lamp position

Moving the position of the lamp in its reflector changes the spread of the beam. When it is as far back as possible, the beam is relatively narrow; moved forward, the lamp is not as enclosed, and so spreads more.

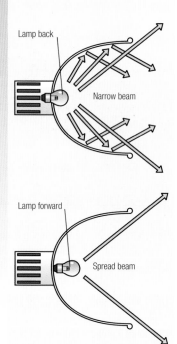

Lamp back

Narrow beam

Lamp forward

Spread beam

Reflector angle

Some tungsten lights in which the lamp position is fixed allow a lens-precise control of the beam spread with hinged reflector panels. These are the basic configurations, but the hinges can be moved speperately.

Closed

Open

Filters

It is often more convenient to filter each lamp rather than to use a lens filter on the camera. Fittings vary, but usually avoid enclosing the lamp to prevent over-heating. A universal fitting is an outrig frame, which attaches in front of the light. It is essential to use purpose-made non-flammable filter material with lamps.

Filters

This range of filters, intended for use over light sources, is designed for raising and lowering color temperature, and for reducing levels from certain sources.

1/8 CTO converts 5500K to 4900K for very slight warming. Mired shift +20; 92% transmission.

1/4 CTO converts 5500K to 4500K, or 4000K to 3200K for slight correction or when daylight is warm. Mired shift +42; 81% transmission.

1/2 CTO converts 5500K daylight to 3800K, or 4500K to 3200K for partial correction or when daylight is fairly warm. Mired shift +81; 73% transmission.

85N3 combines the effects of the 85 and N3 filters. Mired shift +131; 33% transmission.

85N6 combines the effects of the 85 and N6 filters. Mired shift +131; 17% transmission.

N3, a neutral filter, reduces light level by 1 stop. 50% transmission.

N6, a neutral filter, reduces light level by 2 stops. 25% transmission.

85 used over windows or flash heads to convert 5500K to 3200K, the standard window correction when using tungstem-balanced white balance settings and photographic tungsten lamps. Mired shift +131; 58% transmission.

1/8 blue boosts 3200K to 3300K. Use as for 1/2 blue left. Mired shift −12; 81% transmission.

Full blue is a standard correction filter from tungsten (3200K) to daylight (5500K). It is commonly used over photographic tungsten lamps with daylight-balanced WB. Mired shift −131; 36% transmission.

1/2 blue for partial conversion from 3200K to 4100K to compensate for voltage reduction or to boost domestic tungsten when used with photographic tungsten lamps. Mired shift −68; 52% transmission.

1/3 blue for partial conversion from 3200K to 3800K. Use as for 1/2 blue left. Mired shift −49; 64% transmission.

1/4 blue boosts 3200 K to 3500K. Use as for 1/2 blue left. Mired shift −30; 74% transmission.

Attachments and supports

Being able to position lights in exactly the right point in space is as important to effective lighting design as more obvious properties such as beam control and diffusion, particularly with regard to overhead positions. No matter how powerful or effective the lamp or flash unit, its usefulness should always be considered in proportion to how easily and securely it can be fixed or supported.

A few large, sophisticated lights are self-supporting—they are supplied with their own means of positioning—but most need additional help. The first, essential function of any such fixture is to hold a light, and whatever fittings it needs to control the quality, in the right position. It is pointless having a good lighting system and then needing to make compromises in the photograph just because you cannot obtain the lighting direction that you would like. Certain lighting angles are difficult, particularly with large diffuser fittings, but if this is what the photograph needs, you should try to find a practical way of providing support.

Apart from being able to aim the light in the right direction and from the right height, there are several other factors that you should consider before buying any supports. The first is that it should be safe and secure. The heavier and larger a light, the more important this factor is. The lamps themselves usually cause few problems and, if they sit on an appropriate size of conventional stand, they cause none at all.

Most lamps that are used in still photography are fitted either with a spigot or a socket; in either case these are $\frac{5}{8}$ inch (16mm) in diameter. The same is true of most stands. The spigots fit into the sockets, and double-ended separate spigots are available to convert sockets if necessary. Some very heavy tungsten lights, not normally used in still photography, have $1\frac{1}{8}$ inch (29mm) spigots, and some lighting systems use, inconveniently, individual proprietary methods of attachment.

Over-balancing problems are likely to occur when the stand or fixture used is too small or lightweight for the lamp; when a heavy fitting is attached to the lamp and shifts the center of gravity; and when lighting is suspended, tilted or cantilevered out at an angle overhead. Test fixtures by shaking them gently and by applying pressure in different directions. For the sake of safety, wires, pins, clamps and so on can be attached to the lamp, tying it in to a secure fixture (usually on the wall or on the ceiling), in case of the support failing in some way.

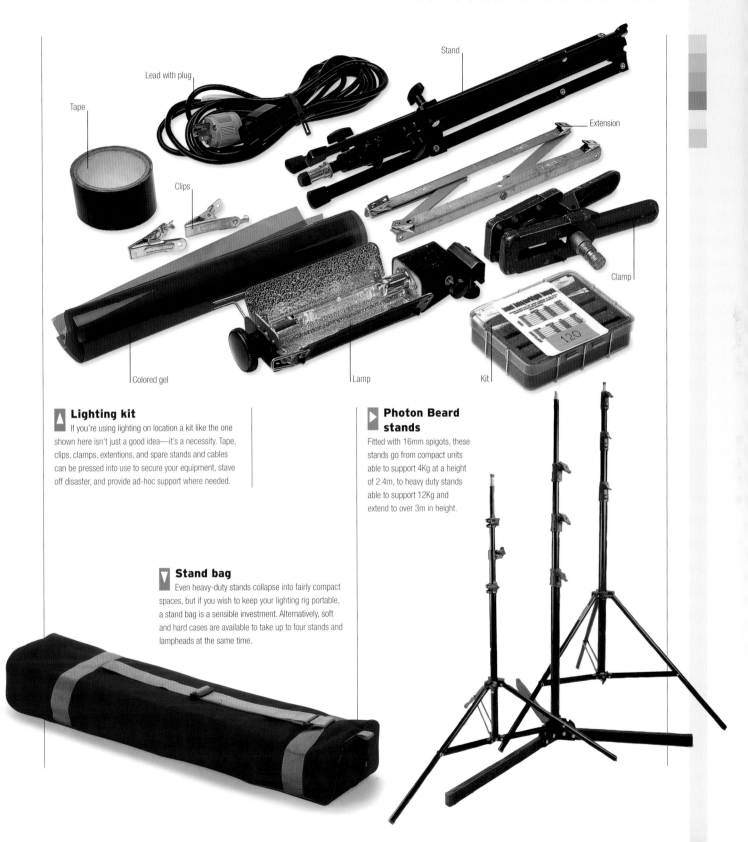

Tape

Lead with plug

Stand

Extension

Clips

Clamp

Colored gel

Lamp

Kit

120

Lighting kit

If you're using lighting on location a kit like the one shown here isn't just a good idea—it's a necessity. Tape, clips, clamps, extentions, and spare stands and cables can be pressed into use to secure your equipment, stave off disaster, and provide ad-hoc support where needed.

Photon Beard stands

Fitted with 16mm spigots, these stands go from compact units able to support 4Kg at a height of 2.4m, to heavy duty stands able to support 12Kg and extend to over 3m in height.

Stand bag

Even heavy-duty stands collapse into fairly compact spaces, but if you wish to keep your lighting rig portable, a stand bag is a sensible investment. Alternatively, soft and hard cases are available to take up to four stands and lampheads at the same time.

Controlling flare

Protecting the camera lens from any light that is not contributing to the image is a critical part of a studio set-up, and greatly improves image quality.

In studio lighting it is normal to use a variety of lamps and fittings, and some are often only just out of view in an image. These are likely conditions for causing flare, particularly if you make late adjustments to the lighting and forget to check the effect carefully through the viewfinder. Flare often occurs at the edges and corners of the photograph, and you may not be fully aware of it until the image is enlarged.

Flare control principally involves shielding the lens from light. We can be a little more precise about this. Any light that reaches the lens and does not come from the picture area can cause flare, so the ideal solution is to mask down the view in front of the lens right to the edges of the image. The most sophisticated professional lens shades do just this; either by extending and retracting, or by having adjustable sides that can be moved in and out, they leave only the picture area exposed to view.

There are three places for shading the lens from flare. One, just mentioned, is on the lens itself, or just in front of it. Another is between the camera and the lights, using larger masks, or "flags", as they are known, made of black card or similar materials on stands. The third is on each lamp. Some lamps are available with barn doors—hinged flaps that cut off the main beam at the sides. Others can be fitted with a simple flag on an adjustable arm.

▼ Lens shades

The three most common types of lens shade are (left to right): the screw-on or bayonet mounted shade made for a specific focal length; the adjustable bellows shade, which adapts to a variety of focal lengths; a simple black flag clamped in front of the lens.

Standard lens shield

Bellows lens shield

Black flag shield

The most important flare control is to cut off the spill from a direct beam. A straightforward technique is to look at the lens from in front, and then to move whatever mask you are using until its shadow falls across the lens and just covers it. Any further control depends on the lighting; if there are strong reflections from walls or other bright surfaces, it is wise to go one step further. To do this, move the masks until they just appear through the viewfinder, and then move them back out of sight a fraction.

Finally, a special case of controlling flare in still-life photography is when you are shooting onto a bright surface, particularly when you are using a broad overhead light. The bright surface that surrounds the picture area will produce a kind of flare that is not immediately obvious, but that degrades the image nevertheless. The solution to this problem is to mask down the surface itself with black paper or card.

Light shades

The alternative to shading the lens is to shade the light sources. Although this is usually impractical on location, in a studio or small interior it is generally straightforward.

Background flare

Even a white background can degrade the image. Having set up the camera, mask down to the edges of the frame with black paper or cloth. Do this while looking through the camera viewfinder. The position of these black masks depends on the focal length of the lens (and so its angle of view).

Diffusion

Softening the output of a lamp is the most basic procedure in lighting. It cuts hard shadows and makes the illumination more even.

You can diffuse a light by shining it through a translucent material; the important effect of this is to increase the area of the light source. Think of the naked lamp, whether flash or tungsten, as the raw source of light, small and intense. Unless there is a lens and a beam-focusing mechanism, the pattern of light will be intense in the middle, falling off rapidly towards the edges. The beam may also be uneven in shape, depending on the construction of the lamp and the built-in reflector. Check this for yourself by aiming the light directly at a white wall from fairly close, and then stand well back and look at the spread of the beam.

Placing a sheet of translucent material in front of the lamp makes this sheet—the diffuser—the source of light for all practical purposes. Try this out for yourself with a lamp on a stand, aimed horizontally. From in front, the light is intense and small; this is why the shadows that it casts are deep and hard-edged. Now take a rectangle of translucent acrylic of the type similar to that used for light boxes. Hold it in front of the lamp; if it is very close, or very large, you will see a bright center graduating outwards to darker edges: this is exactly the same as when the lamp was aimed at a white wall. Move the sheet away from the lamp and towards you until it looks fairly evenly illuminated. This is efficient diffusion, and the source of light is now the acrylic sheet.

The area of the light is larger, and so the shadows it casts have soft edges and are less intense overall. One side-effect is that the intensity of the light is reduced, and this is more or less in proportion to the degree of diffusion. The greater the thickness of the diffusing material, the more light it absorbs. If the diffusion is increased by moving the light further away, natural fall-off will reduce the intensity.

◢ Modeling effect
Although the lighting in this shot is highly directional, diffusing it weakens the shadow density, softens the shadow edges, while at the same time reducing the highlights. On subjects with strong relief and pronounced detailing, as this marble putto in Washington's Library of Congress, it gives a better sense of form.

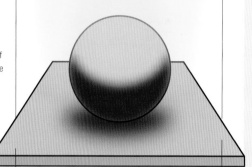

▼ Diffusion & shadow 3

As a close view shows, the shadow density varies considerably, from very weak close to the edge, to quite strong directly underneath. In fact, only a small central circle underneath the sphere is completely hidden from the diffused light.

▲ Diffusion & shadow 1

The essential difference between naked and diffused light is in the way each treats shadows. The shadow edge from an undiffused lamp is hard, because the source is tiny, almost a point. In addition, the density of the shadow is deep and uniform, not only on the underside of the object, but the cast shadow underneath on the surface.

▲ Diffusion & shadow 2

Placing a diffuser between the light and the object in effect makes the light source larger. Essentially, the diffusing surface becomes the light. Being larger, some of the illumination from it weakens the shadow edge and the shadow density.

◀ Extreme diffusion

The lighting for this arrangement of spices needed to be almost shadowless for clarity, while still retaining some highlights to distinguish individual seeds. The set-up was a large diffuser from a short distance, so that the area of the light was larger than the area of the subject. Additional shadow fill came from silvered reflectors on each side.

Varying the diffusion

The amount of diffusion depends on the translucency of the material, on its distance from the light, and on the size of the diffuser relative to the subject.

Three factors control the degree of diffusion, which means that there are three ways in which you can increase it or decrease it. The first is the thickness of the diffusing material (two separated sheets have the same effect as one single, thicker sheet). For any given distance between the light and the diffuser, the optimum thickness of the diffuser occurs when it absorbs any fall-off from the center of the beam. In other words, the diffuser needs to be sufficiently thick to give the effect of a thoroughly even coverage, from corner to corner. If the diffuser is thinner, the light will appear brighter in the center and darker towards the corners—the area of the light will be, as a result, a little smaller. However, if the diffusing sheet already projects an even light, increasing its thickness will only lower the intensity—it will not create any more diffusion.

The second factor is the distance between the light and the diffuser. The greater this is, the wider the spread of the beam, and the less noticeable the fall-off from center to edge. This also increases the area of the diffused light, although as long as the illumination is even across the sheet, moving it further from the light does nothing to help.

Turning now from the light source to the subject, the amount of diffusion in the light it receives depends on the third factor: size. The larger the area of light appears from the position of the subject, the greater its diffusing effect. Imagine yourself as the subject underneath a typical area light. If the rectangular area light is small or far away, it occupies only a small part of the "sky," and the shadows that it casts will be fairly hard-edged and deep. If it is replaced with a larger rectangle, or is brought closer, it fills more of your view. The light reaches you from a greater angle, and this weakens the shadows and softens their edges.

The important measurement is the relative apparent size, a combination of the size of subject, size of area light, and the distance between them. One way of combining these elements in one measurement is to take the angle of view from the subject to the light, making allowance for the size of the subject. As a general guide, as long as the light appears the same size as the subject or larger, it is diffuse.

A light tent
The extreme of diffusion occurs when the light surrounds the object from all visible sides (the qualification of "visible" is important; light from opposite the camera contributes nothing). To achieve this, the diffusing sheet must be shaped to wrap around the subject.

Larger diffused light

A large area light (relative to the size of the subject) gives good diffusion, measured as the angle of view from beneath the subject.

Larger subject

The same light as above with a larger subject has less diffusing effect (a more acute angle of view). Also, the working space is reduced, in this case impractically.

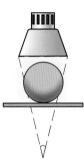

Smaller diffused light

A small area light from closer gives the same angle of view as above, and so the same diffusion. There may be practical problems, however, in sufficient working space between light and subject, and lens flare may be an issue.

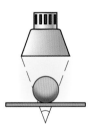

Smaller subject

The same light with a smaller subject has a greater diffusing effect. As these four variations show, it's the relative size of light and subject that is the critical factor.

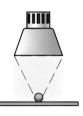

Variations on diffusion

Standard diffusion, 1, can be modified by: 2, using a thicker diffuser, which gives a more even area of light; 3 , moving the light farther away, for a similar effect; 4, using a larger sheet of diffusing material, which increases the area of the light source; and 5, moving the diffuser closer to the subject, to make the light source relatively larger.

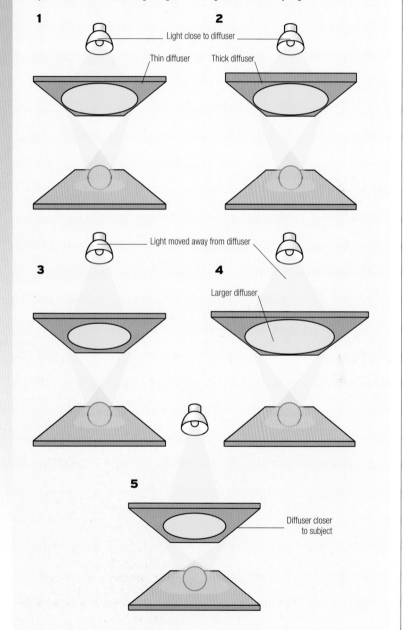

Diffusing materials

Any translucent material can be turned into a diffuser, and its thickness, composition and texture will add subtle qualities to the final effect.

Diffusing materials have various qualities that are not always immediately noticeable. One is texture, apparent in fabrics, netting, and corrugated plastic. To some extent, this texture actually helps the diffusing effect by scrambling the light that passes through it, making the diffuser more efficient. However, if any part of the subject or setting is highly reflective—a polished surface, smooth metal, or a liquid perhaps—there is always a possibility that the diffused light will itself appear as a reflection. If so, any texture in the diffusing screen will be visible, and this may spoil the image. Another quality is the shape of the diffuser. This also becomes important when its reflection can be seen, even with non-reflective subjects. It may not matter if you use the diffused light to cover only a part of the scene. The fall-off from a diffused light is soft and gradual, but if you need it to occur precisely, following a line, the diffuser must have an appropriate shape. The simplest and least obtrusive shapes are rectangular and are the staple lighting for still-life work. Portraiture rarely needs this kind of precision and umbrellas are more usual.

Allied closely to the shape of the diffuser is control over the amount of spill from the sides. The space between the diffuser and the lamp allows direct light to escape, and this will reflect off any bright surroundings, including the walls and ceiling of the room and equipment used close to the set. One basic method of limiting the spill is to shade the lamp with barn doors or flags, angled so as to limit the beam of light as much as possible to the diffuser. A more efficient method is to seal the gaps entirely, effectively enclosing the light into a softbox (also known as an area light or window light) are very popular for still-life photography. There are several possible designs, all box-like. Ideally, the interior of the fitting helps to control the beam so that the front

Testing for neutral color

Although it is normally safe to assume that the basic light source, if purpose-built for photography, is color-balanced, there is usually no guarantee that the diffusing material will not add a cast. In practice, most of the materials are neutral: if a material looks white to the eye, it will probably transmit the light without altering any of the wavelengths. Nevertheless, you should test the materials that you finally choose. Use one of the fixed white balance settings, such as flash, not Auto, for this test.

If the diffusing screen makes any difference at all, it will be very small. To check in detail, use a neutral gray card. Take one shot with no diffusion, and then however many others are necessary to test the different screens that you have. Finally, adjust the white balance using the compensation controls (if available on your camera) or by using the Preset white balance.

translucent panel is evenly lit: most such fittings are shaped to act as reflectors and have reflective surfaces either in bright metal or white.

Enclosing a light like this is only safe if the heat output is low, and this is a good time to consider the relative merits of flash and tungsten for diffusion. Tungsten lamps, particularly the highly efficient tungsten-halogen variety, generate a great deal of heat, and the majority of diffusing materials, if not actually inflammable, can warp and discolor if placed close. Fittings that enclose the light create a build-up of heat, and cannot safely be used with tungsten lamps unless they have a built-in electric fan or ventilation. For choice of diffusion, flash has major advantages over tungsten.

Clean texture
Highly reflective subjects, such as these drops of mercury, will reveal any texture in the diffusing material.

Diffusing materials

Opal tough frost: Like light tough frost but less dense.

Light tough frost: Lower density form of tough frost.

Tough frost: Medium diffuser, spreading the beam but keeping the center.

Tough white diffusion: Heat resistant, with similar properties to tracing paper.

Tough rolux: Dense dffuser which gives soft almost shadowless light, useful for adding several lights into a single light area source.

Roscoscrim: Perforated material for reducing transmission by 25 per cent through windows.

Light tough rolux: Like tough rolux, but less dense.

Tough silk: Slight diffusion, maintaining directional qualities of the light.

Tough spun: Slight diffusing, softening edges but maintaining the shape of the bearm. Light tough spun and Quarter tough spun also shown.

Corrugated diffusing plastic sheet.

Opalescent perspex.

Grid cloth: Reinforced diffusing material which can be sewn.

Light grid cloth: Lower density form of grid cloth.

Soft frost: Moderately dense, like tough frost, but giving more diffusion.

Hilite: Moderate diffusion with high transmission and no color temperature shift.

Reflection

Aiming a studio light away from the subject and towards a large bright surface is an easy, convenient way of diffusing the light, but in a small studio you need to be careful that this does not happen inadvertently.

Bouncing light off a bright surface is mainly an alternative to diffusion. Its effects are very similar, both in principle (it increases the area of the light) and in the way it softens shadows and lowers contrast. Although it is difficult to control bounced light as precisely as diffusion can be controlled, which means that bounced light is not as useful for still-life shooting, reflective lighting can be very easy and convenient. Suitable surfaces are commonly available, and photographic lamps can often be used naked, without any fittings at all. What reflection can do particularly well is to produce extremely diffuse lighting; so soft as to be almost shadowless. The value of this is when you simply want to increase the level in order to use a smaller aperture or shutter speed, without the appearance of introducing another light.

In the basic arrangement for lighting by reflection, the light is aimed directly away from the subject towards a white surface. There are several potential problems for controlling the light in such a set-up. The silhouette of the lamp and stand appears in view; the beam is not even and does not have precise limits; and changing the direction of the lighting would involve moving both the light and the reflecting surface separately (which obviously is not possible if you are using a wall as a reflecting surface).

On the positive side, lighting by reflection can be a space-saver, because, by bouncing, the light path is effectively being folded in half.

To maintain full control over reflections, as in very precise still-life shooting, some professional photographers paint their studio walls and ceiling either black, for no unwanted reflections at all, or a neutral mid-gray. The smaller the studio space is, the more this matters. In a large studio, the space beyond the set may be sufficient to kill any stray reflections.

Window reflection
One use of reflected lighting is to boost the light level in an interior when daylight is visible through a window. Here, a 1000-watt halogen lamp, filtered with a full blue gel was sited behind the camera, pointing up and back, to give a shadowless increase in lighting.

Corner

Rear wall

Ceiling

Ceiling in front

Side wall

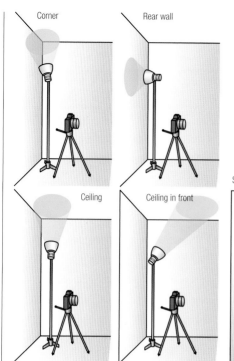

◀ Positioning a fill light
▼ There are several variations possible on basic bounce-lighting techniques. Experiment with the ones illustrated here. Moving the light closer to the wall, corner or ceiling increases the brightness, even though it means moving the light away from the subject, but it also concentrates the reflection.

▲ Frontal reflectors
▲ In still-life and close-object photography, a main difffused light above is one of the standard techniques, used here for a highly reflective gold bar. This leaves the forward-facing surfaces at risk of underexposure, easily solved by small reflectors placed just out of frame under the camera.

Reflector materials

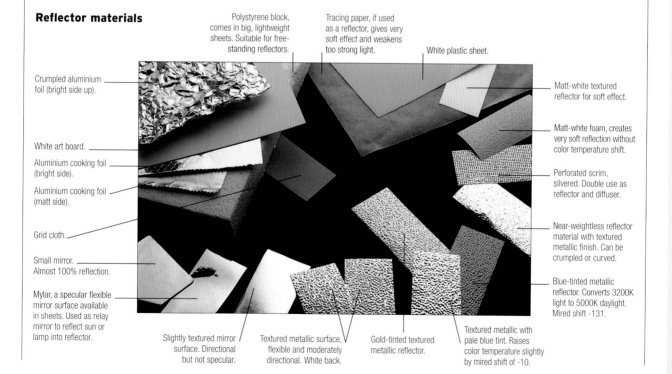

Crumpled aluminium foil (bright side up).

White art board.

Aluminium cooking foil (bright side).

Aluminium cooking foil (matt side).

Grid cloth.

Small mirror. Almost 100% reflection.

Mylar, a specular flexible mirror surface available in sheets. Used as relay mirror to reflect sun or lamp into reflector.

Polystyrene block, comes in big, lightweight sheets. Suitable for free-standing reflectors.

Tracing paper, if used as a reflector, gives very soft effect and weakens too strong light.

White plastic sheet.

Matt-white textured reflector for soft effect.

Matt-white foam, creates very soft reflection without color temperature shift.

Perforated scrim, silvered. Double use as reflector and diffuser.

Near-weightless reflector material with textured metallic finish. Can be crumpled or curved.

Blue-tinted metallic reflector. Converts 3200K light to 5000K daylight. Mired shift -131.

Slightly textured mirror surface. Directional but not specular.

Textured metallic surface, flexible and moderately directional. White back.

Gold-tinted textured metallic reflector.

Textured metallic with pale blue tint. Raises color temperature slightly by mired shift of -10.

Concentration

In contrast to diffusion and reflection, concentrating light is a precision technique to limit its spread and confine it to an exact area, often for dramatic, high-contrast effects.

Although diffusion increases the area of a light source, concentration is not its complete opposite. A diffuser spreads the illumination, but then so can a naked lamp if unshielded and used without a reflector fitting behind. Concentration is concerned with the area of light that falls on the subject—its size, shape, and the sharpness of its edges.

Light can be concentrated at various points in the beam: by shaping the reflector behind the lamp; by using a focusing lens; by flagging the light at the sides; and by masking it close to the subject (including placing a black card with an aperture cut into it in front of the light). The most efficient method by far is to use a lens, and this is how focusing spots and luminaires work. The lens makes it possible to produce a sharp-edged circle of light on the subject, and its size (and even its shape) can be varied. Although focusing spot fittings are available for flash units, they are mechanically simpler for tungsten lighting, as the focus can be judged by sight. The modeling lamp in a flash unit is usually in a slightly different position and has a different shape from the flash tube, and therefore focusing the modeling lamp will not always have exactly the same effect on the flash.

This is extreme concentration, which is not needed very often in most studio photography (although it is very useful for rim-lighting effects, such as highlighting hair in a beauty or portrait shot). The basic kind of light concentration is created by shaping the

▼ Strong concentration
Snoots and lenses give tight beams. This Bowens Esprit universal spot attachment focuses the light from the flash unit. Using a lens attachment on a lamp makes it easier to judge the final effect.

Universal spot attachment

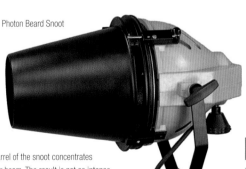

Pro-Spot

Photon Beard Snoot

▲ Snoot
The tapering barrel of the snoot concentrates the light into a tighter beam. The result is not as intense as the beam from a lens attachment.

▶ Snoot grid
The honeycomb grid adds a further level of control over the quality and intensity of the concentrated light.

reflector of the lighting unit itself. This has a different kind of focusing effect. Except in those lamps (usually tungsten) that contain a control for moving the relative positions of the lamp and reflector to alter the beam, all the standard reflector fittings are designed to give what is considered to be a normal beam: in the region of 60 to 90 degrees. This is quite concentrated, but additional reflector fittings narrow the beam still further. The most effective reflector design is parabolic.

Apart from using reflection to concentrate the beam, other methods work subtractively—by cutting off light at the edges, leaving just the central part—with the result that the beam loses some intensity. Fittings on the light include a snoot, or cone, and various types of mask such as flags and barn doors. Other masks, such as black card, can be used closer to the subject; the closer they are placed, the better defined are the edges of the illumination.

High concentration
For the strongest spot-lighting effect, concentrated lights like those at the bottom of the opposite page generally need to be positioned at some distance from the subject. To isolate the desk and typewriter from the surroundings, a 400-joule flash fitted with a snoot was suspended from a boom close to the ceiling.

Focusing spot
A lensed spot used at a raking angle from the right and slightly behind gives a clear and controllable shadow of a bunch of keys, cast on a textured paper surface. These shadows, and others cast by objects strategically placed between the light and the keys, have the effect of adding interest to a very basic shot.

Modeling form

Use a variety of side lighting, modulated by diffusion to soften the shadows, to convey the maximum impression of the roundness and depth of objects.

One of the most basic challenges in all two-dimensional arts, including painting and photography, is to convey the three-dimensional solidity and volume of a real object. This depends very heavily on a kind of illusion, because form is essentially the representation of volume and substance. By comparison, shape is fairly straightforward because it is a more purely graphic quality, and comes across easily even in a silhouette limited to two tones. As a plastic quality, however, form needs a lighting technique that stresses roundness and depth—full realism, in effect. Lighting for form inevitably results in representational photography.

In principle, then, the techniques for showing form involve using the modulation of light and shade. This means that the lighting should be directional, throwing distinct shadows, and from an angle that gives a reasonable balance between the light and the shade. Strongly frontal or back lighting does not work particularly well. In the first, the shadows cover only a small visible part of the object, while in the second, the lit areas appear very small. Any version of side lighting, however, gives a modulation that is more equally divided.

There are two things involved in using light and shade in this way. One is the darkening of the surface from one side of the object to the other; this alone gives an impression of bulk and volume. The second is the shadow edge itself. Its shape and position as seen from the camera give more detailed information about the relief. Both of these qualities can be altered in three ways: by the direction of the lighting; the strength of the contrast; and the degree of diffusion. In addition, much depends on the object itself, and the best way to appreciate this is to take a simple, rounded object, such as a pot, and with one light only take a series of images with slight variations, as shown in the sequence opposite.

High-contrast modeling
One technique, suitable with fine detail, as in this close-up of the curved side of a wooden Shaker box with swallow-tail grooves, is to use a hard raking light—in this instance, bright sunlight unmodulated by any reflector opposite. The effect can be graphic and powerful.

Light slightly to front

Moderate diffusion, no reflector

Full diffusion, no reflector

Full diffusion, with reflector

Light slightly behind

Moderate diffusion, no reflector

Full diffusion, no reflector

Full diffusion, with reflector

▲ Simple volume

Small changes to the lighting make delicate but appreciable differences to the way the form of an object is recorded. A pre-Columbian pot was used for this project; in the three pictures above left the lighting is slightly frontal, and in the three pictures above right the lighting is slightly behind.

▶ Soft modulation

The highly reflective surface of this white cowrie shell, and the deep shadows inside, call for a more delicate means of modeling—a heavily diffused overhead light plus frontal reflectors. The gentle curves of the shell are revealed without the distraction of hard highlights.

Varying the Light

Three basic variations that will affect the modeling. Lighting controls modeling, which is essentially the treatment of form and relief. The three lighting variables are the angle, diffusion, and shadow fill, as these diagrams illustrate.

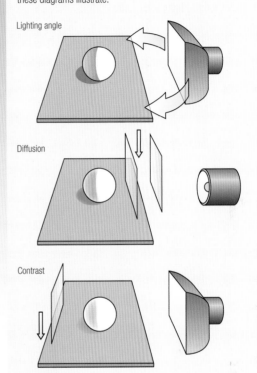

Lighting angle

Diffusion

Contrast

Revealing transparency

Of all the possible physical qualities of an object, transparency needs the greatest care, depending heavily on various forms of back lighting. Translucency is a muted, more opaque quality.

A transparent object essentially refracts its background. As a result, it is the lighting of the background that needs major attention, and the most common method of photographing something transparent is to make the light the background. Effectively, this involves some kind of back lighting in most situations. Although this is hardly a rule, there is rarely any other way of showing the transparent qualities of an object while also keeping the image simple and legible. If the transparent object has to feature strongly in a photograph, then it needs some variety of lighting to show through it. The most obvious and cleanest technique is trans-illumination. For this, the light source should be

◀ Blackening the edges

Plain back lighting gives a clean rendition and brings out the delicate color of the liquid, but the edges of the glass need to be defined, otherwise they would simply merge with the background. The standard solution is to place pieces of black card out of frame.

broad and fairly even—a light box placed beneath the subject is ideal.

Objects that are completely transparent, such as clear glass bottles and jars, pose an additional problem: that of making a clear, legible picture. The edges of an object define its shape, but in a transparent material there is always a danger that these edges become lost to view. To get the maximum definition of outline in, say, a bottle or glass, mask down the area of the back light as much as possible. The masking must be behind the transparent object. There are two methods for this: to use black cards or flags; or simply to move the light source further back.

Highlight gradation

To emphasize the faceted base and sculptural modeling of this crystal lion, black card was used at the edges, although the light was not completely diffused, but graded by placing it close to the diffusing background sheet.

Back-lit color

A perfect and uncomplicated subject for back lighting—cricket lollipops. The colors come out beautifully, while the silhouettes of the crickets encased within are perfectly readable. Imperfections in the candy give texture.

Exposure calculation

Calculating the exposure for back lighting needs care, but is not particularly difficult. With a broad back-lighting source, treat the background as a highlight. This gives you two fairly simple methods of measuring the exposure. One is to take a direct meter reading, either with the TTL meter in the camera or a handheld meter pointed directly towards the object with its reflected light fitting. The reading you get will then be between 2 and 2½ stops brighter than average, so simply add that amount of exposure to the camera setting. The second method is to use a handheld meter with its reflected-light dome, with the sensor pointing directly towards the back light. This will give an exposure setting that will be within ½ stop of a good exposure.

People **Posed**

When we think of a portrait, this is what we normally have in mind—the sitter, positioned and lit, looking out through the camera's lens to the viewer. It is a kind of statement in which the person being photographed is saying, "This is who I am, and this is what I look like." It is deliberate and considered, and stands in a long line of tradition from the earliest portrait painting. And yes, in fact, photographers are the heirs to classical portrait painters whenever they undertake this kind of image.

Underlying such portraits is an arrangement between the sitter and the photographer. As we will see, there are other, more fluid and less formal ways of arriving at the same end, but in the case of a planned and posed likeness, the two of you are in some sort of agreement to make it work. The subject, by agreeing to be photographed, is complicit in all of this, though not necessarily compliant. There may of course be a commercial side to the arrangement, in which you are being paid for your skill in making what the sitter will consider to be a "good" photograph.

In this context, "likeness" is an apposite term. Almost without exception, a key aim of portraiture is that the end result should look "like" the person portrayed. The complication arises when it comes to who will decide this. The sitter's aims are always positive; they want to look at their best. There are different ways of detailing this, according to their self-perception. It may mean physical attractiveness, or social status, or power, for example. There is usually an element of idealization. Indeed, there may be an ulterior purpose. For a

company's annual report, a board director will want to appear serious, solid and capable. An actor may want to look suitable for the next role that he or she is after. A politician will try to project an image that will appeal to the key bloc of voters—whoever they are at the time.

The photographer may have different ideas. Even if you agree with your subject in the desired effect, you may, by being more objective, think of a different way of achieving this. The sitter is unlikely to know many of the techniques described in this book, and for this reason you, not they, will need to take control of the session—in the nicest way, of course. And you may, as often happens in newspaper and magazine photography, want to present another aspect of your subject. This does not necessarily mean an adversarial approach, showing them in a deliberately unsympathetic light (although this has happened, particularly with photographers who have large egos to feed). It may be simply that you want to make an editorial point—showing the person in relation to something that makes them newsworthy. In addition to all of this, most photographers enjoy exercising their visual imagination; we like to make images that are interesting, original and satisfying to look at.

In any case, this kind of portrait is pre-arranged, whether a few minutes or a few days in advance. And it is you, the photographer, who will have to make the arrangements and be sure that they are geared towards a successful final image. You are the director, and your skills at dealing with people will be called upon. In the following pages we look at ideas and techniques to help.

Capturing expression

Whether animated, relaxed, or enigmatic, this is what brings a portrait alive for the camera, and the photographer's two tasks are to encourage it and capture it.

If you asked one hundred photographers "which single element is the most important in a portrait?" you would probably get the answer "the eyes" one hundred times. Expression, however, is more than just the eyes; it is the interplay of all the features of the face filtered through the angle at which you view it. From an early age all human beings learn to read the facial expressions of others and good photographers develop the ability not only to read expression, but to encourage particular expressions in others.

Some photographers know what expression they want from their subject and work hard to encourage it, while others prefer to watch and capture a naturally occurring expression. Both methods are perfectly valid and both rely on the photographer establishing a rapport with the subject (*see box*). Time spent getting the trust of your subject will be repaid with interest when you start shooting.

Even without a camera in your hands you can study other photographers' pictures as well as people's faces and work out which elements combine to give easily read expressions. Mastering the subtlety of expression is a life's work, but employing what we all know from childhood about the messages a face can give you delivers a big advantage.

Sikh girl
A young Sikh girl in an annual procession in Amritsar, capital of the Punjab and home to the Golden Temple. Her pale green eyes were the most striking feature, added to the rich blue turban, clear complexion and a calm, direct gaze straight to the camera. No embarrassment, no self-consciousness; an on-the-spot portrait I was glad not to have missed.

Rapport

Establishing a rapport with your subject begins from the instant that you first have contact. If the person is a friend or relative then use your existing relationship as this. The majority of portraits are made between strangers, so it is up to the photographer to establish a relationship that inspires trust. The combination of an easy, confident manner with some simple uncontentious topics of conversation is the easiest way. There are photographers who specialize in confrontation and others who use flirtation, but the use of an approach that deviates from the amiable will always be a big risk. The importance of the interaction between the photographer and subject cannot be overstated. You need to be able to communicate with each other by talking, making gestures or even through eye contact in order to increase the probability of a good expression.

Eye contact is not at all easy to maintain when you are constantly looking through a camera, so it is important to keep the communication between you and your subject alive through conversation and gesture. It is equally important to use eye contact whenever you aren't looking through the lens just as you would if you were having a normal conversation. One of the uses of a tripod is that, once the shot is framed, you can talk directly to the sitter without having to look through the viewfinder.

Macaque and owner

During a pause in shooting a magazine assignment about monkeys trained to collect coconuts on the east coast of the Malay peninsula, one of the young macaques climbed up to sit next to the plantation owner. The glance exchanged between the two was momentary, but hard to read as anything other than a close affection, even though the monkey was a co-worker rather than a pet.

Catcher

The expression that makes the shot in this picture of a baseball game in a Toronto park is the sheer frustration of the catcher as the player takes off for a home run.

Pathan man

I was photographing a series of portraits of Pathan tribesmen after prayers in Pakistan's Northwest Frontier Province. I asked each man to look straight at the camera for a simply posed image. Pathan men possess a certain warrior vanity, this one in particular. He raised and turned his head slightly; I was impressed by the haughty expression and made the most of it.

Planning

A portrait session is one kind of live performance, and as with any staged event, the behind-the-scenes preparations can go a long way to guaranteeing its success.

A phrase used in all sorts of fields is "precise and proper planning prevents poor performance." Portrait photographers more than most need to adopt this mantra. Another, familiar to photojournalists, is "who, when, where, what, and why." If you ask yourself these questions before you set out to shoot the pictures, you will have your planning to all intents sorted out.

Who? You will probably know the name, age, and gender of your subject—and whether there is more than one person—and this will give you some ideas about what techniques you might use.

When? The time of day and the time of year will give you important clues about how much light there will be and which direction it will be coming from, and indeed whether you can rely on natural lighting. It might point you towards a particular event—the answer to "when?" could be at a family event or after a soccer match.

Where? The location will dictate the lights you may want, or need, to use. It will also usually dictate the possible backgrounds, and these will have a strong influence on the type of picture that you take.

What? This might indicate an event or an activity. It might suggest a formally lit portrait or a relaxed, candid photograph.

Cornucopia

This cover shot for a book on Asian cuisine required a tropical beach shot with a cornucopia of Asian food. Fill-in light was tungsten with a blue gel, powered via extension leads from the hotel mains. Flies were inevitable, but by shooting at 1/15 second they disappeared from the image.

The importance of lists

It's always a good idea to make lists when you are shooting unfamiliar jobs. Here are a few samples:
Equipment list: Everything you need to do the job, which bag it's packed in and a check that you have all the necessary batteries, fully charged.
Timetable: List every important stage in the event, an approximate start time and probable duration.
Shot list: The various images that you need to shoot, ranging from those that are essential to those that are merely desirable.
People: Who's who, their phone numbers and addresses.

As you become more experienced you will work out your own way of doing things and you will learn to rely on your own lists. Good planning means leaving as little to chance as possible, and having your plans on paper is always a good idea.

Why? The reason why you are taking the shot. Is it for a framed picture on somebody's wall, or is it for use in a magazine? The end use of the picture often directs the way you shoot it.

Five simple questions that all add up to the big one. How? This question decrees what sort of equipment you need to pack, and whether you can call on your experience of doing something similar before. It may be that you need to search for examples of the ways in which other photographers have tackled a similar subject, or should do some reconnaissance at the location. If there is a degree of uncertainty in your mind, make some test shots before attempting the session for real.

Once you have answered all of the questions, you are well underway with your planning. You need to consider what could possibly go wrong—for example, bad weather, late arrivals, equipment failure—and make contingency plans. Well made and flexible plans allow photographers to concentrate on what they do best— making strong images.

Flying club
The subject was a pilot at a club that had several of these old air force trainers. I also wanted to show as much as possible of the aircraft, so with a day's notice it was possible to arrange for most of them to be lined up to give this view from the control tower.

The office
This portrait session with Hong Kong entrepreneur David Tang was set up at short notice and there was little time available for planning. The circular window and eclectic decoration were obvious features, and the viewpoint was chosen with these in mind. The sitter was then placed, not behind his desk as normal, but in front.

Setting the scene

The place where you choose to photograph your subject can be much more than a blank backdrop; it can be an active, even an interactive, part of the shot.

We opened this chapter of the book with a discussion about expression which, when it is strong and definite, usually dominates a portrait; it immediately draws attention. But a portrait does not have to be restricted to depicting the face alone, or even the person alone. There are times when it makes sense to bring the location into the photograph, and even to let it play a leading role.

With the single exception of the "pure" studio portrait, in which the canvas is a blank backdrop for the sitter, all photographs of people take place in some definable setting. If these settings are interesting because of what they are or how they look, why not consider stepping back and making something of them?

Inevitably, this means reducing the size of the person in the frame, either by shooting from further away or by making a wide-angle composition. In the examples here the setting, once chosen, immediately began to take over the shot, both in preparation and in the picture area. This is no bad thing as a way of ringing the changes; portrait photography, as much as any other kind, benefits from variety and originality, and this is just one of a number of ways of achieving this.

Elevating the importance of the location requires more attention to be paid to setting it up. It may need to be dusted, cleaned, tidied, pared down or even built up. Factor in extra time, effort, and the cost of making sure that the setting is up to scratch for the final shoot.

Chipmunk pilot

The subject of this portrait owned and flew a Chipmunk trainer, and was one of the main characters in a story for *Air and Space Magazine* about this old RAF aircraft. There were three other people, all pilots also, to be photographed for the same article, so each shot had to look different, while at the same time including aircraft. An in-flight cockpit shot was a natural, but needed to be arranged, and planned for interesting weather. The forecasts were watched for several days, and the shoot finally set for an afternoon with a mixture of sun and rain. The pilot flew from the rear seat, I sat in the front and used a 20mm wide-angle lens so as to include as much of the setting as possible.

An architect and his work

An assignment to photograph the new British Library included a portrait of the architect, Sir Colin St John Wilson. It made sense to photograph him in context, and I explored three different types of shot, all taken within a few feet of each other. In one (left) I looked for part of the interior with strong graphic possibilities, keeping the figure relatively small. In a second approach (above), I used a wide-angle lens with the architect prominent in the foreground and a broad view of the interior in the background. In the third shot (below), I focused solely on the architect, using the plain white of the staircase as an abstract setting.

Location checklist

- ☐ Does it need tidying? Look for scraps on the floor, anything obviously disordered, drawers left open, doors ajar, and so on.
- ☐ Do surfaces need to be cleaned? Look for films of dust (particularly noticeable at a shallow angle to the camera), marks on windows, crumbs and fluff on the carpet.
- ☐ Are there unnecessarily distracting objects in view? Look for strong clashing colors, images (posters, photographs, paintings) and words (posters, book covers, signs). Do they add or detract?
- ☐ Are there any shiny or mirrored surfaces in view that will reflect you, the camera, the equipment, the lights, or anything else that is unwanted?
- ☐ Does the setting need props and dressing—in other words, to be treated almost as a film set? If so, what needs to be added, where can it be found, how long will this take, and how much will it cost to hire or buy? This may be making too big a thing of the photo session, but equally it may make all the difference.
- ☐ What additional lighting will it need? Can you manage without? Are there sufficient accessible power points?

The contextual portrait

Pitched between documentary reportage and studio portrait, this supremely editorial approach links the subject to his or her life, work, or activities.

One highly effective way of making a portrait, although it takes some preparation, is to set the person in the context of what they do—whether work, an interest, some characteristic location, or unique activity. This approach, heavily used by magazines, attempts to cram more information than usual into the image by telling a mini-story. The reason it is used so often

Chef

With an outgoing personality, this French chef at a famous restaurant in the Dordogne felt happiest in her restaurant. The photograph was taken a couple of minutes before the lunchtime sitting. The added lighting was a single incandescent lamp, diffused with an umbrella and filtered half-blue to fit between the color balance of the daylight and the interior tungsten lights.

editorially is because this kind of picture usually accompanies an interview or an article which is focused on some aspect of the person's life. In this sense it is a form of photo journalism.

The key is to decide on what the appropriate context is—the location and the props. It may all exist already, or it may be necessary to bring together a number of objects. In either case, be prepared to spend some time organizing the shot. There are no rules about lens focal length, but there is often an argument in favour of a wider angle simply in order to gather together a number of things in the frame. If the props are small, a wide-angle lens will emphasize them if they are arranged in the foreground.

Natural designs

A working portrait of a textile designer who produced knitted designs inspired by natural, found objects, such as shells. A wide-angle lens (20mm efl) made it possible to include a large amount of the detail of her work, including sketches, yarn, and the shells. In order to combine all of these with the subject I used a mirror to reduce her size in the image.

Painter's technique

This painter was the opposite in personality to the French chef, somewhat retiring, but relaxed when working. To emphasize one of the trademarks of his style—a meticulous attention to detail—the photograph was shot with a wide-angle lens close to a glass of wild flowers being painted. Natural daylight in the painter's studio was sufficient.

Improve your portrait

1 Lens: Use a telephoto for more flattering proportions, particularly if you close in on the face or head-and-shoulders. If you have only a wide-angle lens, step back and frame the subject in a setting.

2 Depth: For close shots, set the aperture wide—no smaller than two f-stops down from the maximum—to isolate the person from the background. Focus on the eyes.

3 Light: Diffuse the main light and place it slightly in front of the subject, overhead and slightly to one side. With a photographic light, an umbrella is the easiest diffuser to use, but sift daylight from a window also works well. Use a reflector (white card or aluminum baking foil) on the side of the face opposite the light.

4 Pose: There are no hard and fast rules, but when people lean forward slightly towards the camera, they usually look more interesting and alert. One fail-safe pose is to sit the person down with a surface to lean on, like a table, then shoot from a slight angle to the body with the head turned towards the camera.

5 Rapport: People generally photograph best when they are relaxed. Ways of encouraging this are to keep the conversation going, and to look as if you know what you are doing. If the expression starts to freeze, ask them to look away for a moment, and then back at the camera.

6 Frames: Shoot a lot. It costs nothing, and more than anything else helps to relax a nervous sitter, who won't feel the need so much to hold an expression.

Familiar surroundings

Photographing people on their own home ground helps them to relax and be themselves, and so eases the occasion, but you need to observe the protocol of a guest.

From the moment that you arrive, you have two potentially conflicting tasks—to take good photographs and to be a welcome visitor. With these in mind, one of the most useful tactics is to take an interest in your subject's home. Everybody responds to some form of flattery and this will help to relax your subject and get a conversation going. You might talk about a particular painting or the color of the carpets—it doesn't matter as long as you are engaged in conversation and your role as a photographer is taking second place to your role as a guest, while you both settle in.

Ideally, you will be given a choice of rooms to shoot in and most people will have a preference about where they are photographed. The chosen location must add to the atmosphere of the image and not dominate it. As a photographer there will nearly always be a legitimate technical reason why you might not choose a particular room, so don't be afraid to mention your objections on those purely technical grounds when you want to shoot in the sitting room rather than their favored study. Sometimes it's easier to shoot a selection in more than one room as well as the garden.

The room's lighting may affect your decision. Very few homes will have a great deal of ambient light unless you sit your subject by a window, and you will often need to supplement it with flash or other photographic lighting. Make sure that you have enough of the right kinds of cables to power any light you want to use, and that you ask before removing one of your host's power connectors.

10 things to remember

- ☐ Make sure that the surroundings complement the subject. The aim is to show the person at home.
- ☐ Make sure that you have enough space for any lighting or reflectors.
- ☐ Ask your subject to have a quick look around to make sure that they are happy with how tidy (or untidy) the area you are shooting in is.
- ☐ Avoid sitting people in their favorite chair unless you are sure that they will not slouch and that their clothing will not look unflattering.
- ☐ Watch out for ornaments, lamps, and plants appearing to sprout from someone's head and shoulders. Homes tend to be far more cluttered than is ideal for photography.
- ☐ Never forget that you are in somebody's home, so be careful with your equipment and ask permission before shifting the ornaments or furniture around.
- ☐ Keep your subject away from walls, where shadows will limit your lighting options.
- ☐ Unless there is compelling reason, avoid shooting from below or above. Use the same level as your subject.
- ☐ Check in the LCD screen for unwanted reflections in glass, metal, or other highly reflective surfaces.
- ☐ When you leave, do so as a guest.

A naturalist at home

The renowned entomologist Dr Miriam Rothschild, who felt uncomfortable about a formal portrait (we had already done a number of working portraits with her at the microscope and with her study specimens). I persuaded her, still wearing her snow boots, to sit on the sofa with her dogs, and the attentions of these pets helped her to relax.

The perfume house

The proprietor of one of the most famous French perfume houses, a family business, also happened to have an exceptional talent for blending perfume—in the jargon of the business, he was a "nose." The obvious place to make his portrait was where he was most comfortable and happiest, in the laboratory, where he was delighted to explain and demonstrate the arcane techniques of the parfumier.

Art restorer

A German painter who specializes in the restoration, and sometimes complete copies of damaged or lost works of art. The studio, in a south Bavarian village, was worth a shot in itself, and the painter was at his most relaxed explaining his procedures. A large canvas, bare except for a sketched outline, made an obvious backdrop.

Activity and props

Keep your subject busy doing something useful and relevant, and they will soon forget the camera's presence, allowing you to sit back, observe, and shoot them at will.

Even if you are not particularly concerned with showing your subject firmly in context, as on the previous pages, there is often value in encouraging subjects to occupy themselves in some simple way. This is particularly useful if you don't yet have a clear idea of how to arrange the shot and the person feels awkward or self-conscious. On arrival, before shooting, look around to see if any obvious activity presents itself to you, and in conversation look for topics that will give you some clue about the person's interests.

This technique usually resolves itself into your subject holding something or demonstrating how something is done, and neither of these needs to be complicated. Try not to make a meal of any of this. Have camera, and lens (and lights, if any) all set and ready to go. Shoot quickly and, as in all the examples here, you should have the shot in a few frames.

One of the standard variants is the interview shot, a staple of magazine and newspaper feature pages; it may often be necessary in professional

Interview
The subject is a calligrapher and graphic designer, and the interview was set up to take advantage of the lighting. The shot was chosen for the interesting position of the hand.

Cub
This woman took care of orphaned animals in South Africa. Young animals are among the easiest and most attractive props to work with, demanding close attention from the subject.

photography if the subject has time enough only for one session with the writer and photographer. The advantage for shooting is that it circumvents any problems of expression or self-consciousness, but the pose and camera position are still extremely important. The person who is being interviewed will usually be sitting; you should look for a position to one side of the interviewer, sufficiently off-axis so that it doesn't appear that the eye-line is just missing the camera. Shoot from the same height as the subject, and make sure that there are no out-of-focus foreground distractions, such as armrests or knees.

Waving hands, open mouths

The interview shot, aka "talking head," is, as has already been described, a fall-back activity option, but there are pitfalls to this type of shot. Ideally, you need an animated expression—it should look as if the person is in the middle of making an interesting point. An open mouth in an expressionless face, however, is likely to look vacant. Some open-mouth positions look more convincing than others, so be prepared to shoot a large number of images from which you can then select the most successful one. Expressive hand gestures usually help the shot (try asking the person to explain something), but make sure that the shutter speed is fast enough to freeze the movement, and watch out for hands obscuring the face.

Internet
A grandmother in the north of England prepares for a video link on her new computer. The moment of applying lipstick was by far the most interesting action of the session.

City farm
At an inner-city farm which was established to introduce urban children to rural activities, this girl was hugging a lamb protectively as a pet—a natural and instant pose.

Lens focal length

Match the zoom setting not only to the type of framing you have in mind, but also to facial proportions. The most flattering perspective is usually from a telephoto lens.

All lenses will have the effect of distorting the human face and figure if you use them incorrectly. Some forms of distortion can be very flattering, and others can be used to give strength and emphasis to your work. Learning to use the right lens in order to create the right look is one of the key lessons to be learned in portraiture.

There are two ways that you can choose which lens to use for a specific task, and in portraiture one of them is far more desirable than the other. Sometimes the situation dictates that you have to shoot from a given distance and you can say, "there's my subject and here I am, let's see which focal length on my zoom works best." More often than not, you can say, "my experience tells me that this particular focal length will give me the effect that I'm looking for," so you select the right lens for the job and move yourself to get the right composition.

Either option is valid, but the second is usually a better way to approach shooting people whenever possible. Being too close to your subject will usually make them uncomfortable, so the minimum amount of space that you need to give them is often a matter for personal judgment. Getting closer

A simple exercise

All you need is a zoom or a range of lenses (the more you use the better but at least one wide angle, one normal, and one medium telephoto), a willing volunteer who is prepared to sit very still, a notepad and pencil, some paper, tape, and 10 minutes of your time.

Start with a standard focal length—around 50mm efl. Sit your model on a stool and stand back far enough so that their face fills the frame. Focus, check the framing once more, and, finally, shoot a picture. Now get your model to look 45 degrees left and take another picture. Put a small piece of tape on the ground so you can find this position again.

Repeat this process with each lens (or focal length if a zoom). If your model is still awake, try shooting with each of the other focal lengths from the other pieces of tape on the ground.

By comparing the pictures side by side you can see for yourself the effect that each of your lenses has on a person's face. You will find some of the pictures more pleasing than others, and some will be amusing. Not every subject's face will react in the same way when confronted with the same lens from the same distance, but you now have an idea of what works with your equipment.

than two meters to start with is rarely a good idea, and this is one of two reasons why 85mm efl or 100mm efl lenses are generally considered to be "good portrait lenses." The other important reason is that by flattening the perspective, all the facial features are shown close to their true size. A wider angle lens used from closer to fill the frame will exaggerate the apparent size of the nose and front part of the face.

In general, telephoto lenses tend to be more flattering, while wide-angle lenses can be used to add dynamic elements to the composition. These effects can often be magnified if you are shooting down towards your subject or if they are looking out of camera. Try the simple exercise opposite to see the effects for yourself—and to see how it works with your own equipment.

As much as possible, give yourself the option to shoot with different lenses, once you have achieved the look that you want before you start the session. Sometimes you will surprise yourself by shooting a better picture with the "wrong" lens, but most of the time you will simply add to your knowledge for next time.

Breathing room

Giving the subject space in which to feel comfortable will produce more expressive results. Moving backward, shooting from a slightly higher angle, and allowing the lens to do the work is, at times, the best option to take.

Expand perspective

As a technician extracts a pearl from an oyster, the aim of the shot was to show the basic action while drawing attention to the pearl. A wide-angle lens, 20mm efl, exaggerated its size relative to the man.

Compress perspective

Two contrasting lens solutions on the same assignment. Here, an employee of a Japanese distributor examines a large pearl for blemishes. A telephoto lens, 180mm efl and stopped down for maximum depth of field, compresses perspective to bring together pearl, magnifying glass, and eye into close relationship.

Torso

The "default" framing for a portrait, a head-and-shoulders view, is a standard solution that focuses on the key elements.

Over the years this has become the "classic" portrait composition. The blend of facial expression and body position that is made possible when you shoot the whole torso, head, and shoulders has become part of the culture, from magazines to television. Because this style of portraiture has become so heavily used across the world, much has been written about the various subtleties of pose and expression. Every detail has its own conventions and nuances, and here are a few elements to consider.

New ideas

Once you have started to master this familiar style, try a few variations on the theme:

☐ Try bringing your model's hands into the composition—leaning on the elbows with hands to chin, or perhaps running a hand through the hair.

☐ Typically you would fill an upright frame with your model so experiment with using a horizontal or square frame, and with having a looser composition that brings an interesting background into greater prominence.

☐ Introduce one or two relevant props, such as a book or an item of sports equipment. You can use anything you like as long as it adds to the message you want to give about your subject.

☐ Use different lenses to alter the feel of the picture. Longer telephoto lenses will compress the perspective, which you might find more appealing.

☐ Shoot from a higher or lower angle to give a surprisingly different mood.

Framing to suit props

For this portrait of a pilot, I wanted the minimum background that would communicate his aircraft. The cockpit and roundel made a neat composition, but this meant cutting the figure at the knees—normally an uncomfortable framing. The problem was solved by having him hold his headset and chart in a natural-looking position.

☐ The angle of the subject's shoulders in relation to the camera is extremely important. If the shoulders are too square to the camera then the photograph may look static and formal, and too much like an identity photo. Conversely if the shoulders are at a strong angle to the camera, the atmosphere of the portrait becomes unsettling.

☐ The tilt of the subject's head can make a huge difference. Upright and straight into the camera presents a look of honesty and solidity. If the head is slightly tilted to one side, it can look coy. Tilted the other way it can look slightly quizzical.

☐ The height of the camera in relation to the subject. Safe and sensible is a few degrees above the subject's eye-line.

☐ The position of the subject's eyes also affects the image to a considerable degree. Notice the difference between the eyes looking straight ahead and looking out of the corner.

☐ In this moderately tight composition, your subject's clothing and hair will be highly visible, and play a part. Clothing is easy to change quickly.

☐ The background needs to be something relatively unobtrusive unless it has a constructive role to play in the photograph.

☐ The direction of the light is critical, and this requires some thought. A good starting point is to arrange the picture so that the main light is facing your subject's chest.

This list stresses the conventional, and is a good starting point even if you want to break out and try things differently. Rules in photography fall into two groups, and the classic portrait is a curious mixture of both types— technical ones that you break at your peril and creative ones that you will want to bend more and more as your work improves.

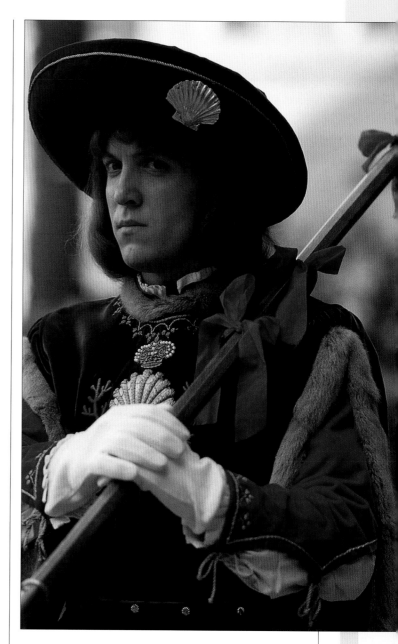

Historical pageant
A participant in the annual Palio in the Tuscan city of Siena. The position of his hands, elbow, and the hat determined both the framing and the camera positio— an example of how the fine-tuning of a composition often depends on the details of the subject.

Full-length

Although it shows less of the subject's expression, pulling back to show the entire figure makes more of the pose and stance.

Sidelighting
Full-length lighting from the side, such as from a large window on one side of the room, makes a dramatic difference to images of standing figures. As long as the figure is facing into the light, as here at this reception in Manila, the absence of shadow-fill is rarely a problem.

The full-length portrait allows you to show your subject in an entirely different way from the more classical, tighter compositions. By pulling back you lose the detail of expression but you gain greater freedom to explore stance, posing, and body language.

One of the biggest difficulties that aspiring photographers encounter when trying to shoot full-length is attempting to fill the frame. The term full-length doesn't always mean standing up. It can equally be applied to lying down, sitting or kneeling, so if you feel the need to fill the frame start gently with a seated composition. In the section on expression we talked about facial features, angle of head, and eye contact as important factors and these principles can be carried over to full-length portraits.

The arrangement of your model's limbs, the angle of their shoulders and their position in the frame all assume the same level of importance that facial expression has in closer compositions. In almost the same way that we all learn to read facial expressions as children, we all have a basic knowledge of body language and as photographers we can use that shared vocabulary to our advantage.

Legs can be straight or crossed, hands can go into pockets or behind the back, and arms can be stretched out or folded. Whatever you decide to do

Full-figure poses

Be prepared to suggest a pose if the person feels awkward. One typical problem for some people is what to do with their hands. Illustrated here are some suggestions.

with your subject's limbs, body language experts will tell you that everything has a meaning.

When your subject is standing up, experiment with the transfer of their weight from one leg to the other and then equally between both legs. You can also try asking your model to lean against something—walls, door frames, and posts all make good supports and your model can lean with their shoulder, back, or hands. The list of possible poses and variations on those poses is almost endless. It is worth going through magazines and books to get an idea of what works. Some poses suit men more than women, the young more than the old, so it's a good idea to make notes and even keep a scrapbook so that you have some ready references when you are planning a portrait.

The other big challenge presented by full-length portraits is the relationship between your subject and the background. When the composition is tight it is relatively easy to make the background incidental, but when you have the whole person featured it becomes more difficult. Foregrounds can also come into play, so be aware of the impact that anything between you and your subject might have on the feel of the picture.

In all types of portraiture it takes time to establish your own style. With fewer conventions about this kind of portrait you are likely to feel a lot less certain when you start to experiment, but most photographers quickly learn to enjoy the freedom presented by full-length portraits.

Period piece
One common reason for full-length framing is to show the clothing, whether for a fashion shot or, as here, to show a period costume. To complement the dress, the location chosen was London's Café Royal with its *fin de siècle* decor.

Face

Cropping in on just the face can produce the most intimate of all kinds of portrait, but demands the most care in technical matters of lens, lighting, and depth of field.

Some photographers regard this kind of portrait as a technical challenge but the majority see it as the most intimate and revealing study in the whole sphere of portraiture. Framing a portrait so tightly that you show your subject's face on its own would seem to be easy. There is virtually no background to worry about, no body language to interpret, and your model's clothes won't dominate the photograph. The flip side of all of this is that there is very little room for error with composition, focusing, lighting, or expression. Indeed, facial expression usually dominates this kind of image.

There are many ways in which you can compose a portrait that concentrates on the face. The most obvious one is to include the entire head in a vertical frame, but this is often the least interesting solution. Using a horizontal frame and cropping the top of your subject's head can make a far more interesting portrait and it also increases the viewer's concentration on the eyes. The position of the eyes in the frame, the direction in which the eyes are looking, and the light around the eyes are all vital to the success of the photograph.

No matter which lens you decide to shoot such a tight image with, you will be working with a relatively short depth of field. Using a 135mm efl lens your depth of field will be less than 2.5cm (1 inch) with an aperture of f4 when shooting this close. Even if you can work with an aperture of f11 you still only have less than 8cm (3 inches), which can easily mean that you have eyes in sharp focus and ears out of focus.

Digital cameras with smaller chips will give you greater depth of field but it remains important to keep your point of focus on one or both of your subject's eyes. It's a matter of personal taste if, because of a shallow depth of field, you have to focus on one eye and the other remains un-sharp. One school of thought is that it should always be

Eye contact
Direct eye contact with the camera dominates this shot, holding the viewer's attention. By shooting in shade on a sunny day (and making the appropriate white balance adjustment), I made sure that the eyes picked up strong highlights from the sunlit area behind the camera.

Check sharpness

The key parts of a portrait need to be sharp, and this means at the very least the eyes. If there is a danger of shallow depth of field, focus on these. Also ensure that there is no motion blur, either because your subject moves (blinking eyelids in particular) or because of camera shake if you are handholding. A full-frame view in the LCD display is too small to check for this, especially if you are shooting large, high-resolution images. Use the zoom-in controls to full magnification in order to check that all is well on the first shot before continuing.

the nearest eye, while another says that if one eye is better lit than the other you should focus on that eye.

The way that your portraits are lit makes a huge difference to their success. The closer you crop into the face, the more importance the subtlety of that light assumes—and that includes any catch-lights in the eyes. Later sections of this book will expand on the ways that you can light a portrait, but whether you use ambient light or flash this kind of picture will show off your abilities to master light.

Reflected light

Also shot with a medium telephoto for a compressed perspective, this outdoor portrait makes use of a white wall and floor to bounce strong sunlight on to the subject.

Studio shot

A studio-lit portrait in which different poses were tried. Chin on hand is a classic pose, and works strongly here because all else—background and clothing—is reduced to black.

Detail

Occasionally, a close-up detail of one part of the face or body can be both striking and revealing—an alternative and potentially eye-catching approach.

Brass-bound legs
A woman of the Padaung tribe in eastern Burma, wearing the traditional ornament of brass rings encircling the legs. Unusual and decorative, they merited a photograph to themselves.

"In photography, the smallest thing can be a great subject," wrote one of the world's greatest photographers, Henri Cartier-Bresson. "The little human detail can become a leitmotif." He was writing about a principle, but one method of homing in on this is to shoot close detail. It's useful for two reasons. First, it increases the variety of images in your shooting by shifting things to a different scale, and second, it enables you to make a different point by focusing the viewer's attention on an element that might otherwise pass unnoticed.

In portraits of people, close-up means individual parts of the body, and once you start looking with this kind of detail in mind, you'll find that there is a rich variety. There is, of course, an element of intimacy in this, because such close-focused images take the viewer closer than they would normally ever be to a stranger. This brings with it the slight risk of appearing uncomfortably close, but set against this is the opportunity to surprise the viewer, and on occasion even to add sensual overtones.

The lens of choice is a medium telephoto lens with close-focusing ability, or the equivalent setting on a zoom lens. A specifically designed macro lens is ideal, but most lenses nowadays are capable of focusing close enough in order to fill the frame with, say, an eye or a pair of lips.

Depth of field becomes an issue at such short distances, and while occasionally you can make a shot work with shallow depth—selective focus, in other words—soft areas in a close-up image usually look like faults. Basically, stop down to a small aperture and check the front-to-back sharpness by enlarging the view on the LCD screen.

 Black Watch

A geometrically exact composition deliberately matches the precise turn-out of a guard of the Black Watch regiment. A low camera viewpoint was chosen so that the belt, forearm, and lower fringe of the sporran were all aligned with the edges of the frame.

Rose picker

Wearing red protective clothing, a young Bulgarian girl rests during the annual rose harvest, holding a single flower in one hand. This close, almost abstract shot stood out for its very simplicity.

Hands

These are the hands of an old woman in Indonesia. Set against her tie-dyed dress, with a stack of ivory bracelets for contrast, it was an irresistable shot.

Twos and threes

Photographing more than one person at a time introduces different dynamics of direction and rapport, and calls for a compositional plan.

By shooting people together you instantly suggest that there is some form of relationship or bond between them. They could be mother and daughter, two boxers about to do battle in the ring, or a trio of war veterans who have been reunited for the first time in years. If you can imagine any kind of relationship then at least one photographer somewhere in the world will have been asked to shoot it, probably in the last week. Any way that you arrange your subjects will have a message, from sisters holding hands to our two boxers standing back to back. As a photographer you need to know what the social dynamic of your group is and be prepared to arrange them in a way that reflects their relationship and makes a good picture.

It is almost inevitable that you will find that your rapport with one is better than with the other, so you need to have a strategy for dealing with that. You can't keep eye contact with two or three people at a time so you have to direct your remarks clearly if they are to an individual, or more generally if they are aimed at everyone. Remembering names is important.

With two or three people you can either have them side by side or one in front of the other. If you decide to have one closer to the camera, then you have to have a legitimate reason for choosing to shoot that way because it is quite likely that you will be asked to explain why. Good reasons come in many forms, and a simple answer like "it makes the composition of the photograph stronger" is often enough if you give your reason in a confident and authoritative manner. Differences in height can be overcome by seating one or two people or by shooting from a higher angle. The most important thing is to have as much information as possible about the people before you shoot so that you can make some plans about how you are going to group them. Here are a few things to think about.

More often than not you will have your subjects looking into camera. It is worth experimenting with having them look at each other, or at the same point in the distance above and behind the camera, or even have one looking into camera and another looking at something else. Digital gives you the option of shooting more at no extra cost and learning from your experiments. This feature is never more useful than it is in small group portraits.

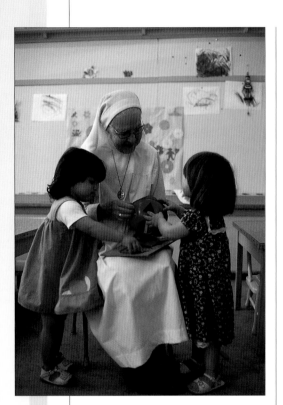

Triangular composition
Three-figure shots usually contain a natural potential for a triangular structure. Here, in this shot taken in a crèche in Montreal, it has been deliberately strengthened by the viewpoint, which shows two triangular relationships —between the heads and the outline of the three figures.

Before you start

☐ What clothes are they going to wear? In general it is a good idea to have a theme and that might be based on a style of clothing or on a color scheme.

☐ Where are you going to shoot? The location will often dictate how you arrange your group and whether you will have easy access to chairs or cushions.

☐ How is the photograph going to be lit? If it's going to be available light, will you have enough depth of field if you want to stand one person behind the other? If you are using flash, can you get the light evenly distributed across two or three people?

Side-by-side

This strong compositional arrangement combines key similarities across the subjects—costume, general stance, and posture—with powerful vertical elements (the oars). What's interesting is how this highlights differences in individual attitude and expression.

Sitting and standing

One solution to the question of how to arrange two people while keeping the design interesting is to vary the height. In this portrait of two elders of a Shaker community, circumstances dictated the composition, as one of the ladies had difficulty standing. A Shaker rocking chair made an ideal prop.

Groups

Put several or many people together and you have a very different situation in which you have to play the part of stage manager and deal with group interaction.

Most of us have been in a classic sports team or school class photo line-up with two rows, one seated and the other standing. This is another photographic convention that is worth paying attention to, if only to get ideas about how to break away from it. The best lesson you can take from the two lines style of picture is that having some chairs or benches placed in advance will give you a starting point.

Some hints and tips

☐ Tell your group that the session will go more smoothly, quickly, and get better results with their co-operation.

☐ Get the whole group to look in the same direction by giving them a point to look at. The maker's name of your camera is a good one.

☐ Make the session as light-hearted as you can without resorting to telling long and rambling stories.

☐ Informal groups often look good when shot from about thirty degrees above their eye-line, so consider bringing a step-ladder.

☐ Everybody blinks. The larger the group, the more certain it is that somebody will have their eyes closed as the shutter opens. Tell your group this and use it as a reason to take a large number of pictures.

☐ The "noise" associated with digital cameras at high ISO settings will show up really badly in large group photographs, so try to shoot at your camera's best quality settings.

☐ It is always tempting to shoot large groups with wide-angle lenses. Be aware that the distortion associated with even the best quality lenses will do strange things in the corner of the frame, so try to get a bit further back than you would think necessary.

☐ Try to end with a few "fun" frames so that the session ends on a high note.

Picture the scene; you have arrived and got your camera ready to go. If you are using lights, they are unpacked and tested. So far everything is going to plan. Eight burly men arrive and they all know each other—while you might only have met one or two of them before—and they want to have a laugh and a joke with each other. It's absolutely vital that you establish control of the situation and you need to use some subtle psychology to help. Having some of the set-up already in place will say to them that you probably know what you are doing, and the most obvious signal is to have your camera on a tripod pointing the right way and looking ready for action. Even if you don't need to use a tripod, it's a way of stating that you mean business. You need to establish if there is a leader or captain in the group, or any other hierarchy and then quickly get them into the positions that you had planned. You are in control, this situation doesn't really allow room for discussion and democratic decision-making. Politely tell them what you want and where you want them. In other words, you need to combine the skills of an orchestral conductor with those of a traffic cop.

The more that you break away from the conventional line up, the more certain you have to be in your own mind about what you want and the more clearly you have to be able to ask for it. Hesitation and uncertainty will mean that you start to lose control, and once you lose control it's very hard to re-establish it. Large groups need the photographer to work quickly and methodically.

Planning the quality and output of light is a vital step in preparing your group photo. The lighting should be as even as possible, so avoid direct sunshine and its accompanying shadows. If you are lighting the group yourself, make sure that you test the whole area where the people will be. There should be less than half an f-stop variation across the whole scene.

Maintaining the shape

What began as a small group portrait in Colombia, expanded as friends from the street joined in. The only way to keep cohesion was to step back and arrange the new group both as a compact, triangular shape and vertically—some standing, others sitting, others squatting.

Regatta crew

An impromptu group portrait as the winning crew of the Livorno regatta in Tuscany returned to their mooring. With no time to lose, the shot was simply composed, making the most of the strong colors by filling the frame. The diagonals of the oars held the composition together.

Natural light

Portraits outdoors have the advantage of spontaneity, but only certain conditions are flattering for portraiture; in others you will need to adapt and improvise.

Many non-photographers assume that bright sunshine is the photographer's friend, and that dull days are the enemy. For landscapes and architecture that might be generally true, but when we are photographing people there is an optimum quality of light that can be very elusive. One of the greatest skills that a portrait photographer can acquire is the ability to look at the natural light and know how to work with it, adapt it, and get the best from it.

Direct, midday sunshine is extremely difficult to work with. The shadows are hard and from above and the image contrast is high. There is almost no circumstance where you would choose to shoot a portrait in these conditions. On days like this most photographers would be looking for "open shade"—not found in the hard shadow of a building but rather under trees or in areas of shade near areas of natural reflection. Here, shadows are tempered by light reflecting off surfaces such as sand or water.

These conditions are not necessarily easy to find, so photographers have developed techniques over the years to help simulate these conditions. Some go to the trouble of erecting their own tents made out of special light diffusion material, whilst others make use of large translucent umbrellas to create their open shade. These are commercial products, but it is pretty simple to develop your own system for producing the right quality of light. The real trick with getting the light to do what you want is to make sure that the principal light-source is hitting your model from a flattering angle. You can introduce your own reflectors to bounce light back at your subject. These are also available commercially and most of them fold away into smaller bags when not in use. Big six feet by four

▽ Bright sunlight
Not normally the lighting of choice for a portrait, direct sun worked well in this shot of a young Beijing boy wearing his father's military cap because of the strong colors and simple compositional elements. Being almost frontal, the sunlight cast no awkward shadows.

feet (180cm x 120cm) white, gold, or silver reflectors can be a good investment if you intend to do a lot of natural light portraiture. Holding them in place represents a challenge if you work alone— especially if there is any wind—so consider all of these options as you are planning the shoot.

Occasionally you get the kind of misty, watery sunshine that watercolor painters adore and this produces a wonderful quality of light for portrait photography. You cannot plan to get this kind of light in advance, but wherever you are shooting there will be certain times of the year where the chances of getting good light are improved. Alternatively the light just after dawn and just before sunset can produce an excellent quality of light for shooting people.

Sometimes the light is just plain horrible. It's on these days that your skill as a natural light photographer is called into action and you need to use all sorts of tricks to make the light seem a lot better than it really is. Other sections of this book cover the use of your camera's own flash and location studio kits, so all that needs to be said at this point is that on really bad days you need to introduce your own light to supplement what's there already. Alternatively you can consider shooting your portraits with the intention of working on them in the computer; this is also covered later in the book.

Check histogram and highlights

Invaluable though the LCD screen is for displaying the image just shot, don't rely on it totally for exposure accuracy. The surrounding light conditions will affect your judgment, as will the inevitable viewing-angle problems (look at the screen from several degrees off-axis and the image will appear lighter or darker than it really is). If your camera can display the histogram and highlights, use these options—they give you an objective analysis of the exposure. The histogram should show you, as here, that the skin tones are located somewhere in the middle; exactly where depends on the intrinsic darkness or lightness of the skin. For more on skin tones, see pages 68–69. "Highlights" in this context means pixels that are out of range and blown out.

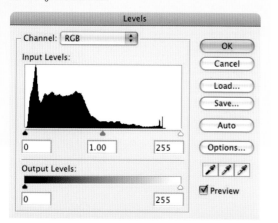

Backlight
Bright afternoon sunlight bouncing back up from the stone-flagged street provided enough shadow fill to make this backlit portrait of an Italian trainer and his horse readable. Highlights around edges are typical of this atmospheric kind of lighting.

Reflection
An extremely bright, clear day with a high sun offered only harsh sunlight or deep shade. One solution was to position the girl in the shade of a tree with sunlight in front and behind, and to use large sheets of white paper to reflect light on the face.

On-camera flash

Use the camera's built-in flash to supplement the existing lighting subtly rather than to overpower it. Full-on flash is rarely flattering, but understanding its limitations will help you to get the best out of it.

The quality of the flash units now supplied for digital cameras is such that you will probably end up with a correctly exposed image, but the nature of the light makes it unlikely that you will end up with a worthwhile portrait.

On-camera flash falls into one of two categories: units that have only the ability to point directly forward and those that can be used to bounce the light off a reflective surface away from the camera. The second category will usually be a hot-shoe type flash unit with a bounce and/or swivel head, whereas the first will usually be built into the camera. Some of the built-in strobes have a maximum effective range of only about two to three meters.

The best use for on-camera flash, when shooting people, is to provide a supplementary or "fill-in" light rather than using it as the main light source. This is useful in various conditions, including the following. It can help remove deep shadows when shooting in strong, directional sunlight; most cameras nowadays have a facility automatically to reduce the flash to achieve this effect. A variation on this is that you can correctly illuminate the foreground when you are shooting against the light, avoiding your subject becoming essentially a silhouette. Another technique is to use flash to freeze your subject when the rest of the image is rendered blurred by a slow shutter speed. And flash can simply add some light and life to your subject in a situation where the picture would otherwise have been flat and dull.

Under most conditions the effect that you are looking for when you use supplementary flash is a subtle one, adding just enough light to lift the image rather than completely dominate it. All of this is a question of balance, between the ambient lighting and that from the flash, so be prepared to vary the mix between the two. Once again, digital's facility to check as you shoot takes the uncertainty out of this.

Fill lighting

Typical of traditional Indian shops, this family business, the oldest perfume business in Delhi, opens directly on to the street, posing an obvious contrast problem. The action at the shop entrance was key, and the exposure was set for this, but at the same time it was important to hold some shadow detail on the boxes inside. A small flash output, set manually and calculated by trial and error, provided shadow fill. The camera's LCD screen review is invaluable for this kind of lighting uncertainty.

Fill flash

Contrast control is what fill flash accomplishes best. The classic case is where you have a bright background and a dimly lit subject in the foreground. You add enough flash to bring the foreground subject up to the same exposure as the background, "filling-in" the shadows. Otherwise to expose the foreground correctly would have left a badly overexposed background. Subtle use of flash is the key.

If you watch professionals such as wedding photographers you will quickly realize that they use flash most of the time. They often set the flash at between one and two f-stops under the correct exposure so that areas of shadow get proportionally more flash than areas of highlight, but not enough to burn the highlights out. Most modern cameras have an automated version of this function, but learning to do it yourself means that you will have far more control when you use fill flash for this purpose.

Rear-curtain flash

To capture something of the bright night-time energy of Tokyo's downtown Shibuya district, I used a combination of slow shutter speed and rear-curtain flash for this portrait of a sculptor. Panning the camera in a jerky movement captures the contrast between blur and sharpness.

On-camera flash

In some situations, direct on-camera flash will be your only recourse. Such lighting works best when there are strong shapes and bright colors to work with.

Basic portrait lighting

When you are using photographic lighting, among the many permutations there is a basic set that is guaranteed to deliver satisfactory results—a useful starting point.

Professional photographers often need to set up portrait sessions well in advance, particularly so if the photograph is to be taken indoors with lighting. This makes things rather less fun and simple than an on-the-spot casual shot, but it does make it possible to be inventive and to guarantee a particular type of image. Lighting is a key element in portraiture, and if you are building it from scratch, rather than relying on existing light, you'll find that softer rather than harder lighting suits most faces.

The basic configuration of the human face dictates some standard principles of lighting. One of the most simple and reliable lighting set-ups features one main light, diffused (such as with an umbrella) and a little above the face to one side and in front; a weaker second light or silvered reflector fills in shadows; a spotlight from a distance behind can highlight hair or the side of the face. The main light is responsible for the basic modeling, the fill-in light reduces contrast and lightens shadows, and the "effects" light, normally well behind the subject but positioned or shaded so that it does not cause lens flare, is used to pick out highlights in the hair or to brighten the outline of the head and shoulders. To further lighten the under-chin shadow, which is often the deepest, the sitter can be asked to hold a simple reflector in the form of a card on which is pasted crumpled aluminium foil.

There are, of course, as many ways of lighting a face as there are portrait photographers, and it is worth experimenting with different styles. All the suggested positions of the lights or reflectors can be changed as necessary.

A simple set

A typical lighting set-up for head-and-shoulders portraiture uses an umbrella as the main light, with fill-in from a second light bounced off a large white board known as a "flat." Polystyrene/styrofoam board is often used for this. An effects light, high and behind the subject, is fitted with a "snoot" to concentrate the beam on a small area. Finally, a background light is here placed on the floor, pointed diagonally upwards on to a wide seamless roll of background paper for a graded effect.

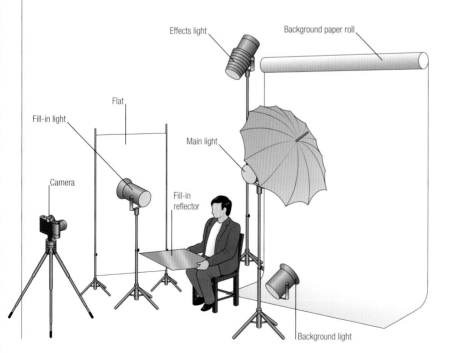

Effects light · Background paper roll · Flat · Fill-in light · Main light · Camera · Fill-in reflector · Background light

Hair
The hair looks best when at least partly backlit, giving it life and sparkle.

Forehead
Unless shadowed by the hair, the slope of the forehead can reflect strong lighting and appear over-exposed. Diffused lighting reduces this problem.

Eyes
The sockets often need extensive fill-in in order to prevent them looking like deep pits.

Ears
If the model has unusually large ears, only altering the pose will help. A three-quarter view will be better than straight on.

Cheekbones
These are an important feature in photographic portraits. Strong, high cheekbones are particularly photogenic.

Nose
There are no particular problems with lighting the nose, although it may be necessary to prevent it looking too prominent. Hard cross-lighting will cast a shadow and accentuate the nose unpleasantly. Lighting which makes it less obvious will be more effective.

Mouth
The mouth does not generally cause lighting problems. But be careful with red lipstick, which will look very dark on black and white film and may also be more prominent than intended in color.

Chin
Because the chin can cast a hard shadow with the overhead lighting which is best for other features, a crumpled foil reflector placed beneath it is generally an effective source of fill-in.

▲ Full-face framing
Full-face framing offers only a few varieties of pose. Most typically, these involve the use of one or both hands. The lighting used here was overhead/frontal, with shadow fill for the lower planes of the face and the eye-sockets from a crumpled aluminium foil reflector underneath and just out of frame.

How the face reacts to light

The shape of the human face determines to a great extent the way lighting is used in portraiture. The approach will depend on the result intended—a soft beauty shot or a vigorous portrait, for example—but some principles must always be observed. Lighting can additionally be used to strengthen the best features of a face, and play down those that are unattractive. Such decisions must be taken in relation to the circumstances—the lighting being built up and modified as you go along.

Softening the light

Faces usually look at their most attractive under soft lighting, and the techniques for spreading the light from a lamp are essential to master.

Portraits call upon softened light more than any other type of photograph, for the single reason that the human face, with its structure of planes, recessions and protrusions, by convention looks more attractive when the transitions between highlight and shadow are smooth and gentle. You might occasionally want to emphasize lines and wrinkles, or create a high-contrast drama, but the general run of portrait photography overwhelmingly aims for the attractive.

Technically, soft light is achieved by increasing the area of the light source relative to the subject. A point of light casts hard shadows on a large subject; a light the size of a window gives almost no shadow to something the size of an apple held close to it. The diagrams illustrate why. So, the standard method of softening a light is to shine it through a much larger sheet of translucent material, as in a so-called soft-box, and then position this close to the subject.

An alternative is reflection, bouncing the light off a surface, and this is the principle behind the ubiquitous portrait attachment, the umbrella. There are endless variants of these two systems: you can hang sheets of plastic or tracing paper between the light and the person, or use differently shaped soft-boxes, or line the umbrella with silver or gold material, or bounce the lights off free-standing white-painted boards known as flats. Studio photographers often tinker with lighting combinations in order to arrive at a special style.

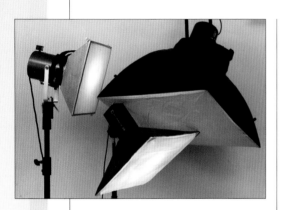

Soft-boxes
Soft-boxes, which attach directly to the light source, provide an effective and popular method of diffusion. The amount of softening can be decreased or increased by moving the screen nearer to or further from the source.

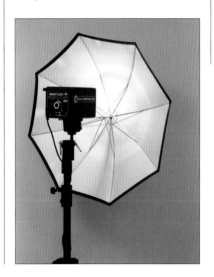

Umbrella
The standard equipment of nearly any portrait photographer, the umbrella can be used to reflect light from the source onto the subject for a softer effect, or turned around and used as a diffuser.

Spotlighting

Concentrating the light is in many ways the opposite of diffusion and reflection, focusing on one small area with great intensity and high contrast. While they are rarely employed as a main light, spots are valuable when used from behind the subject slightly off-axis, illuminating the outline and edges of the hair. Spots can either be lensed or in the form of snoots (a long black-painted barrel, often tapered).

Using umbrellas

Part of the reason for the ubiquity of the umbrella in portrait studios is its versatility. By changing the position and angle of the umbrella, the distance between it and the source and the reflective material, it is possible to create a wide range of lighting types, from highly softened to a more concentrated reflection.

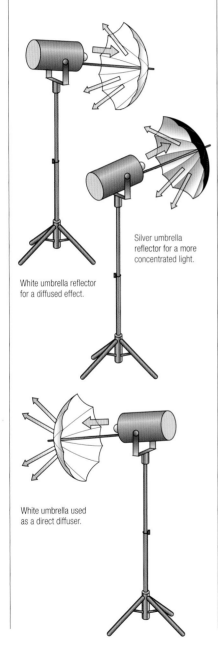

White umbrella reflector for a diffused effect.

Silver umbrella reflector for a more concentrated light.

White umbrella used as a direct diffuser.

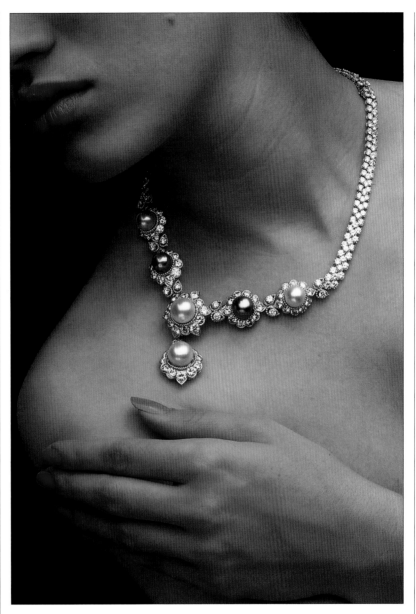

Diffused lighting

The diffusion from a rectangular area light provided just the right balance between being directional and casting gentle shadows on the model's neck, shoulder and hand, and at the same time bathed the pearls in soft highlights.

Portrait studio

Bear in mind that a studio is simply a space in which you can control the lighting, and does not have to be a costly, state-of-the-art environment. Save money by building and painting your own fittings and backdrops.

While a professionally equipped studio can be a daunting investment, it is by no means the only type. Naturally, professional photographers who shoot portraits of this highly controlled type, and do it constantly for a living, can justify the expense and upkeep. It may also be necessary for them to demonstrate their status in the industry. Clients have varied needs, and a quick change of idea or layout for a fashion shoot, for example, may require extra lighting, a different background or more space. It helps to be able to accommodate new requests within the existing studio facilities, and this makes for an inevitable redundancy, which costs more.

But if you don't need to impress, and if you are prepared to go through a little more specific planning and preparation, all kinds of interiors can be turned into studios. The fundamental requirement is space—between the camera and subject, between subject and background, and between lights and subject. What dimensions you actually need, rather than would simply like, depend on your preferred style of shooting and lighting, as follows.

Calculating space and distance

Add together the figures from both charts to arrive at the minimum length for a studio space.

A	Head-and-shoulders	Torso	Full length	Group
50mm efl	1 m	1.5 m	3 m	4 m
100mm efl	2 m	3 m	6 m	8 m
150mm efl	3 m	4.5 m	9 m	12 m
200mm efl	4 m	6 m	12 m	16 m

B

Shadow-free background: about 1.5 meters behind
Background separately lit: about 2 meters behind
Backlighting for subject: about 2.5 meters behind
Backdrop illuminated from behind: about 3 meters behind

Three things determine the length of the studio space: the lens focal length, the framing of the subject, and the separation between the subject and the background. A longer focal length gives more attractive facial proportions, but needs more distance. The further you are from the sitter, the less easy it is to maintain a rapport, and a natural compromise is a focal length between two and three times standard. In other words, an efl of 100mm or 150mm. Head-and-shoulders framing is the most common, and this would typically need a throw of about two meters from camera to subject. As you'll need a background, more often than not in the form of a seamless paper roll or the painted wall, it's an advantage to have some distance behind the subject so that it can be lit separately and so that the person's shadow from the main light does not fall on the background. Ideally, allow at least a couple of meters.

The portrait studio
Tight organization is needed to create an effective space and leave enough room for different set-ups. Office space (bottom left) might not be a necessity, but an area for dressing and make-up (center left) should be considered a basic requirement.

Make-up for photography

The vast armory of cosmetics allows you to enhance some features, suppress other, while at the same time helping to create a specific aura. In addition, make-up for photography has its own rules and needs.

For beauty shots, make-up is an integral part of the photography. It and the lighting go hand in hand; one complements the other. In general, make-up for the camera is usually more pronounced—that is, more definite—than the styles applied for normal, everyday occasions. However, exactly how strong the make-up is depends very much on the style of lighting. A well-diffused light needs stronger make-up than does a spotlight.

The aim, as with most general make-up, is to enhance the best—or at least most striking—features of a face while suppressing the less attractive ones. High cheekbones tend to be valued in beauty shots and can be made even more striking by applying highlights above and shadows below. Or close-set eyes can be made to seem further apart by extending the eye shadow outwards. In a professional shoot, the make-up is planned with the lighting in mind. So if a high frontal light is being used from just above the camera, then the top of the cheekbones, ridge of the nose and forehead will automatically be given highlights. At the least, they will need make-up to make them less shiny (unless a wet look is the idea).

Each individual face benefits from certain specific make-up techniques, and most models know which effects suit them best.

Sequence of applying make-up
Eye make-up begins (1) after the basic skin make-up has been applied with some highlighting to the inner areas close to the nose. To widen the appearance of the eyes, shadow is brushed on first at the outer corners (2), followed by the upper lids (3) and under the eyes with a finer brush (4), in both cases with stronger application towards the outside, for the same reason. After this, a highlight is applied on the upper lids right up to the eyebrows to give a more open appearance (5). Mascara follows, first at the corners (6), then the lower lashes (7), and finally the upper (8).

Make-up and lighting

The more diffuse, the stronger the make-up should be. Conversely, a bright spotlight, giving hard-edged and deep shadows, calls for more restrained, even bland, make-up (but a spotlight would be a rather dramatic, unusual choice for beauty lighting). Axial lighting from a ringflash around the lens is completely frontal, so flat and shadowless, and needs the strongest make-up of all.

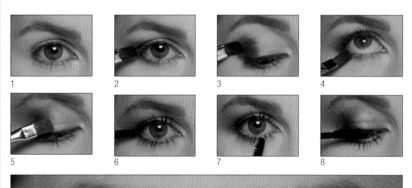

1 2 3 4

5 6 7 8

Professional models, by the nature of their job, rarely have "problem" faces, but if you are choosing a female face for a beauty shot, look for the following: fine bone structure, a balanced facial outline with small chin, unblemished complexion, unobtrusive, straight nose, and eyes set relatively well apart. Skin blemishes can be concealed with strong foundation make-up and well-diffused lighting. Always apply make-up under the exact lighting that you will use for shooting. Then the highlights and shadows can be matched to the illumination.

1

2

3

4

Skin

Basic make-up begins with a moisturizer, then foundation (1), which gives a basic surface for everything that follows, adds an overall color and smooths the skin texture; this is applied with a sponge pad. Highlight is then applied with a brush (2), blending well, and this helps to give a basic shaping, lightening those areas where shadows fall naturally, including under the eyes, below the lower lip and under the base of the nose.

After this, powdering (3) helps to set the foundation and remove shiny highlights (which the camera would emphasize). Shading with another brush (4) refines the shaping of the face, here at the sides and under the cheekbones, but very subtly. Finally (left), lipstick is applied—but with a brush for complete accuracy of line.

Lighting for beauty

Strong shadows generally work against a beauty treatment, and the general principle is an enhanced version of basic lighting already shown. The position of the light is very important:
☐ Overhead for naturalness.
☐ Frontal to reduce shadows (particularly under the eyebrows, nostrils, and lower lip).
☐ Symmetrical, in line with the camera, for a balanced effect across the face.
Shadow fill comes from two white panels on either side and a reflector, either white or covered with crumpled foil, held by the model to light up the underside of the chin and nose. Beauty lighting is nearly always in conjunction with specific make-up, and the only way to ensure the perfect combination is to apply the make-up under that lighting. For convenience, move the reflector panels away while applying make-up, and make the final adjustments to these once the model is made-up and dressed.

Set up 1 Set up 2

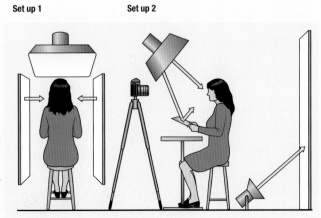

Digital retouching

This is post-production make-up, capable of effects both subtle and obvious, with the advantage that you can work precisely on the final result— on the image, not the face.

Retouching the photograph is a standard procedure in any kind of portraiture that aims for an idealized result—as is the case with fashion and beauty, for example. For the majority of photographs of people this is less so, if at all, simply because it alters the reality of the shot. However, there may be special cases when you do want to make some changes to the complexion, eye color, hair, and so on. There is an issue of integrity here, as well as the risk that by perfecting things to an extreme you may end up with doll-like features.

At the time of shooting, briefly consider the retouching possibilities, as it may be more effective to eliminate a blemish, for example, by digital procedures later rather than by adjusting the lighting or applying make-up. With this in mind, once you have transferred the image to an image-editing program such as Photoshop, step one is to assess it and decide exactly and in advance what should be altered and to what extent. Image editing is open-ended, so you do have to set your own limits, not only on the grounds of realism but also in terms of how much time to spend retouching. Make an overall assessment of the entire face, then zoom in and scroll through everything at 100% magnification.

There are two methods of retouching, and both involve the use of a soft (that is, feathered) brush to avoid defined edges to the retouched areas. Follow the checklist here. One is direct, one-step brushwork, which would be useful for, say, removing a spot, freckle or pimple. The aim here is to substitute the surrounding color and texture of skin to the blemish, and this makes the cloning tool (rubber stamp) the normal procedure of choice. We will look at this in hands-on detail on the following pages.

Beauty retouching checklist

Complexion	**Chin**
texture (smoothness)	dimpling
color	under-chin shadow
shininess	
blemishes	**Hair**
wrinkles and lines	tidiness

Complexion
texture (smoothness)
color
shininess
blemishes
wrinkles and lines

Eyes
brightness
catch-lights
color
eyelash definition
mascara clumping

eyebrow definition
eyeliner
eye shadow

Mouth
lipstick color
lip gloss
teeth whiteness
teeth regularity

Nose
shadow irregularity
nostril hairs

Chin
dimpling
under-chin shadow

Hair
tidiness
extent (hair loss)
facial hair
color
highlights

The second method divides the retouching into two steps—selection and alteration—and is more suitable for color changes to large skin areas and for effects that are measurable. In a masking layer (Quick Mask in Photoshop), brush over the area that you want to change, then convert this to a selection and apply changes using Curves, Levels or the HSB sliders.

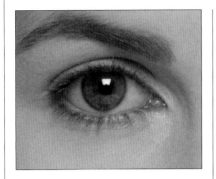

Small lines

The image-editing operation here is to remove the fine lines under the eyes that are still evident after make-up and photography.

Mask painting

For procedural effects, the first step is to brush in the areas over which they will be applied, in a masking layer which will then be saved as a selection.

Blending in

Normal skin texture is now re-applied to the filtered area with a clone brush, taking its samples from the area just above the cheekbone, which has few blemishes. The retouched area is blended into the original first by darkening the layer using Curves, then by reducing the opacity to 67%.

Duplicate layers

For the finest blending control, two duplicate layers are made, one for the operation and another as back-up. This allows an extra level of control by varying layer opacity, with the original maintained as the background layer.

Median filter

A median filter with a wide radius replaces the lines with the most typical pixel color from within that radius. Now, the effect is too smooth to be realistic.

Final

Finally the lines have been all but eliminated, while maintaining a realistic texture. The opacity blending of retouched and original layer is a matter of personal judgment.

Retouching brushwork

Because digital imaging tools are so closely modeled on real painters' brushes, effective retouching depends very much on dexterity, making practice essential.

In the old days of portrait photography, retouching was a great skill. A good retoucher, and there were specialists at this, was effectively a painter in the traditional sense, applying dyes and pigments to prints with a range of camel-hair brushes, sponges, swabs, and sometimes an airbrush powered by compressed air. It's no coincidence that these artists' tools are reproduced digitally in image-editing programs. The great advantage of digital retouching over the brush-and-paint variety is simply that you can undo mis-strokes and mistakes. This does not lessen the skill needed, but it does make the apprenticeship much easier. Nor do you have to concern yourself with the reaction between the paint or dye and the surface of the print—in digital retouching there are no textures or blobs.

Portraits are the most demanding of subjects in photography to retouch, partly because human skin is very subtly shaded, and partly because as observers we are highly attuned to the nuances of facial appearance—most people will quickly notice a blemish on someone's face, even if it is just a pimple or a shaving nick. Retouching is usually about removing these things and perfecting skin texture. Above all, it must be undetectable in the final image.

Brush sizes

A typical face contains a very large range of textural detail, from open skin areas (low contrast, absence of detail) to very precise features such as eyelashes. Vary the brush size according to the level of detail, as shown here. Actual pixel width depends on the size of the image—these are the recommended settings for a high-resolution 50-megabyte RGB picture.

Wrinkles
Tightly packed wrinkles demand a low brush size and a steady hand.

Eyelashes
Use as small a brush as possible in areas of intricate detail.

Skin details
For bigger areas that need retouching, use a medium-sized brush with a softer edge.

Larger skin areas
Open skin areas, with less texture and color detail, can be retouched using broader strokes.

Two-pass retouching

Using a close-up of the same face as on the previous pages, the exercise here is to remove a small mole, only just visible by its elevation. The easy technique is to tackle first the mole highlights with a clone brush set to "darken", and then the mole shadows with the same brush set to "lighten".

Because imaging tools are designed to imitate real brushes, pens, pencils, airbrushes and so on, it's easy to forget that there are in fact no physical constraints. The more familiar you become with an image-editing program, the more likely you are to develop your own individual techniques. Nevertheless, fluid, natural brushwork is the basic skill to develop, and the more practice you put in, the more naturalistic your retouching will look. Begin with simple exercises on a blank screen, concentrating on different types of stroke, from short to long and from thin to broad, including applications of single dots of varying size. If you use a stylus with graphics tablet (*see below*), practice increasing and decreasing the flow by means of pressure. Move on from this to practical exercises in skin retouching, using copies of any face close-ups that you have in your files.

Graphics tablet for full control

Mouse, trackpad and trackball are the usual computer solutions for moving the cursor around the screen, but to get the full benefit of the retouching tools available in an image-editing program, the device of choice is a cordless stylus and graphics tablet. The area of the tablet represents the screen area and the tip of the stylus moves the cursor. Pressing down on the stylus activates the tool selected. You can configure the set-up so that increasing pressure on the tip makes the tool behave in an even more brush-like fashion, such as increasing the flow of "paint" or broadening the area of the brushstroke. This is an essential computer accessory for anyone who intends to work seriously on computer images.

Graphics tablet
The conventional mouse simply doesn't have the finesse required for professional retouching. A graphics tablet offers more prccise control over brush dynamics.

Cloning variations

Brush size: match the size approximately to what you are trying to correct or replace.

Feathering and fading: keep soft for complexion, tighter for details such as eyes and eyelashes.

Percentage: 100% cloning gives immediate full replacement and is standard. However, if the effect looks too striking, consider more than one application of a reduced percentage. The disadvantage is that this softens definition.

Color: if you do not want to alter the tone, then restrict the cloning tool to one quality, such as hue or color or saturation.

Two-pass technique: one way to deal with pronounced texture such as deep pores or raised spots is to clone from a selected smooth area first as "lighten" to reduce the shadowed sides, then as "darken" to reduce the highlights. Doing this in two passes increases your control.

Alignment: in aligned cloning, the distance and direction between source and target stay the same, which gives a natural-looking replacement from the source area. However, if you have only small patches of clear skin as your sources, it may be better to switch to non-aligned, in which the source remains the same. This runs the risk of creating an identifiable pattern.

Digital manipulation

Moving beyond retouching to outright manipulation is not to everyone's taste, but here anything is possible, the only barrier being your judgment and the sitter's willingness.

Post-production improvements are not limited to cosmetic effects of texture and color. This being digital, much more can be done, and the full scale of alterations possible is such that every digital photographer needs to make a conscious decision about how far to go. As we hope we've demonstrated already, digital photography doesn't end with the shooting, and at the very least images need to be prepared and edited, even if only for color, tone, sharpness and so on. Image-editing, in other words, doesn't have inherent limits.

By shifting not just the colors and tones of pixels, but large groups of image pixels themselves, you can later shape, and if you apply this to portraits you have the opportunity to alter people's appearance and expressions. Heighten the cheekbones, widen the eyes, slim the hips? It's all possible, and perhaps not surprisingly this is becoming something like standard practice in public relations and in celebrity photography. There is,

Making use of asymmetry

Starting point
The original image, full-face, softly lit and unretouched.

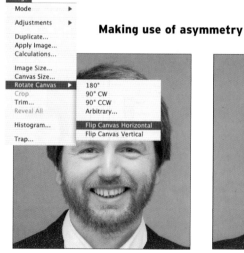

Duplicate and flip
While faces are in principle bilaterally symmetrical (mirrored left and right), individually there is always some difference. As a first step to re-combining the two halves, a duplicate layer is flipped horizontally.

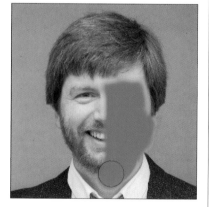

Selecting one side
Concentrating on the key elements for recognition (eye, nose, mouth), one side is selected by mask painting. The soft edges of the selection are located mainly in open areas of skin, which will facilitate blending.

arguably, little difference between botox injections to "improve" the face, and the same effect created less expensively with a distortion tool in Photoshop. Both are artificial tricks.

Distortion is the principal technique, and there are several tools and procedures, some needing more technical expertise than others. The type of software known as a distortion brushing engine allows intuitive freehand work and is easy to start with, although mastering its subtleties takes practice. As a general rule, a large brush size relative to the image and a low percentage of strength will give more natural, smooth results. And remember how little it takes to change a facial expression—whether of muscles in real life or pixel-pushing on the computer.

In this example I've used displacement maps because they allow control and repeatability. A displacement map is a guide that tells the software how much to move which pixels—mid-gray not at all, black the most (in Photoshop, 128 pixels in any direction). Expression is complicated and subtle, and nearly always needs experiment. For all the effort of setting up displacement maps, they allow this, and it is always worth trying different percentages of movement and judging the effect by how much it appears to alter the expression—and by extension the mood of the person.

Changing the eye-line

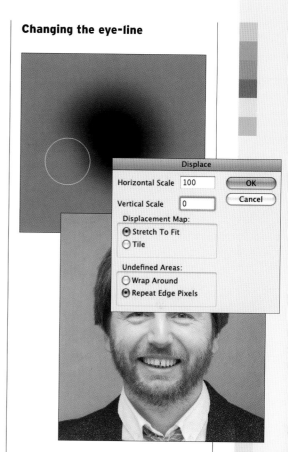

Moderate horizontal shift
A large diffuse circular area over the center of the face is retouched to leave the left outline of the face relatively undisturbed while the rest is shifted left (positive horizontal displacement).

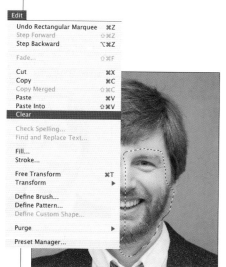

Knock out the selection
The selected area in the upper flipped layer is deleted, leaving a soft-edged hole which reveals the original image underneath—and so a combination of two identical halves.

Combining the opposite half
By knocking out half of a duplicate of the original image, and overlaying this on the mirrored image, the opposite halves are combined—a second, strikingly different symmetry.

Indirect gaze
The progressive shift of pixels to the right has the effect of making the pupils appear to be directed slightly to the right of the viewer, reinforced by the general rightward warping of the face.

Changing the background

Digitally separating people from their surroundings demands careful technique, particularly for the outline of the hair, but once done allows the background to be adjusted, even changed completely.

This is a major procedure, but is performed routinely at a professional level in advertising photography. The obvious advantage is that you can save time and money by shooting in one accessible location, and then digitally substitute a more exotic or hard-to-guarantee background. Less heroic procedures involve cleaning up the existing background or removing parts of it. If you do undertake this procedure, be prepared to spend time and skill on making the results believable.

The key to all of this is making an accurately outlined selection, and the human figure is one of the most challenging subjects for the procedure, mainly because of the hair. There are several techniques for making a selection in an image-editing program like Photoshop, each with advantages and disadvantages. In cases where the characteristics of the outline vary from one area to another, you may find it best to combine two or more of these techniques. They include paths (good for clean outlines, but no use for

Overlay for interaction
The work of this scientist researching immunology was on the scale of electron microscopy, and to combine both in one image, the micro image was copied

into one layer and blended so that it appeared as a projection—a kind of virtual screen to which the subject could point. Using black as a convenient background, the layer containing the original electron

microscope image of nerve fibres was inverted and blended in Lighten mode. As electron microscopes image in monochrome, the initially colorless layer was given slight hue adjustment.

fuzzy detail), freehand lasso tool, mask painting and smart selection tools, such as Photoshop's Magic Wand. Smart selection is any kind of semi-automated process in which you click on an area (of the figure or the background) and the software then searches for other similar pixels. How similar depends on a range setting that you give it. This is particularly useful in situations where there is an obvious contrast between figure and ground, and even more so when the background tone and color are fairly even.

In Photoshop you can convert a selection into a mask, and vice versa, at any time. A masking layer, in which the mask is usually given a strong color (you decide), allows you to paint the selection by hand. This is useful for creating a selection from scratch, or for retouching one made in the standard way.

The hair is almost always the arduous part to outline, unless it is very smoothly shaped and has no loose ends. Using any of the above conventional selection techniques, you have three basic choices. One is to make the selection outline around the hair fuzzy, by feathering it. This is a quick-and-dirty procedure that will work only if the figure is small in the frame and there is little detail visible. Another is to re-sculpt the hair to eliminate the fine strands, but it runs the risk of looking artificial. The third is simply to zoom in to 100% or even 200% magnification and work your way slowly along the outline—a painstaking and lengthy procedure.

▲ Center of the galaxy

The subject of the portrait was a Nobel Prize winner specializing in the study of the galactic center. This image was taken in HCN radiation of the black hole in the central cavity. It was presented simply as a backdrop, re-scaling a cut-out image of the professor and adding a drop shadow for realism.

▷ Cleaning up

Two Tokyo designers with one of their products, furniture based on transparent elastic membrane. The nature of the chairs made an all-white background an obvious choice, but the location was far from ideal—the designers' own atelier. However, knowing that the black-clad figures and the chairs could be outlined digitally later made it feasible to go ahead and shoot anyway.

Lighting for effect

Most photographs of people set out to give either a flattering or an accurate representation of what they look like and what they are doing. Sometimes, however, there is a need for a dramatic, unusual, or graphically striking treatment.

It's one of the cruel ironies of photographing people that you can spend years learning to light them in a flattering way, but the one time your lighting is actually noticed is when you do something a bit unusual. Anyone who has held a torch under their chin to frighten a child on Halloween knows just how easy it is to use light to achieve a desired effect. As photographers we can use five attributes of lights to make our pictures that little bit different.

Quantity. There is no limit to how many or how few lights you use, nor is there any limit to the degree by which you deliberately over or underexpose the photograph.

Quality. Lights can be hard or soft and once the conventions of portraiture are replaced by the creative possibilities of lighting for effect, you can experiment with both extremes of the light quality scale.

Direction. We mentioned above the idea of the horror style of lighting. Effect lighting allows you to explore every possible way of pointing your lights to make an interesting image. Uplighting is always unusual.

Color. Some of the most effective lighting techniques involve using colored gels over your lights. A mixture of strange colored and uncolored lights in a single frame can give your work a lot of impact, although there should be a solid reason for it to avoid looking like no more than a gimmick.

Type. The most common lighting for adding atmosphere and mood to still photographs is flash, but a mixture of flash and ambient light gives you all sorts of creative possibilities.

With these five methods of giving your lighting dramatic effect there is no limit to what you can achieve. You can use one or all of them at the same time, but the notion that "less is more" should never be far from your thoughts. It can be very effective to combine a more conventional style of lighting to all or part of your subject's face while using one or more of these effects on the background and the rest of their body.

When you want drama in your work, one of the most important things to avoid is light bouncing around where you don't want it. Many of the best studios are either so large that there are no near surfaces off which light

Gem sleuth
This New York gem collector and dealer specialized in tracking down rare specimens, and while he was happy to be the subject of an article, he did not want a completely recognizable portrait. The solution was a silhouette with an added focusing spot directed on to his eyes. The position, with hands holding a glass and a stone, created a shadow on the lower part of his face.

can accidentally bounce, or they are painted entirely matte black for the same reason. If you don't have a studio, it's well worth exploring the idea of getting some black "subtractors." They are used in exactly the same way as their more conventional cousins—white, gold, and silver reflectors—except that they provide a surface that deliberately absorbs light. You can buy black panels, make them out of painted styrofoam, or simply use big sheets of black cloth to do the job (velvet absorbs the most).

◀ Architect

Kengo Kuma, a well-known Japanese architect, had just completed a building which featured slatted illuminated panels on the sidewalk outside. Printed with Japanese characters, these were illuminated mainly from the ground, an unusual and striking direction when used for portraits.

Children

Children have an entirely different reaction to the camera than do adults; realize this and you are well on the way to taking great photographs of them.

Children are reputed to have a shorter attention span than adults, although experience photographing them says that this isn't completely true. Children simply show their boredom more openly, so as photographers we need to develop strategies for lengthening their attention span. Keeping a child's interest for long enough to shoot good photographs is a skill in itself. Some studio photographers who specialize in child portraiture invest in an array of attention-getting props, such as glove puppets and soft toys. Sometimes, it's best to rely on somebody or something to keep the child busy and occupied, to allow you more time to set up and get the shot.

Spontaneous play
In an Italian piazza, this boy was entranced by the hordes of pigeons fed by tourists, and stepped away from his father to walk among them, oblivious to anything else. An ordinary moment but special for this child, as his expression shows.

In the digital age children usually know that you have an LCD on the back of the camera and they will try to see what you've taken after every single frame. Managing to keep them on your side by showing them pictures while avoiding their desire to see every frame as it happens is a tricky balance, so it's important to set down some rules about when and how many images they can see. It's only when you talk to the individual child that you can judge this balance and an amount of negotiation is often required.

School break

Break at a Chinese village school. The photographer captured the bustle by using a tripod and slow shutter speed (a half-second), shooting when two of the children, more interested in her than in their classmates, paused to look.

Rhino

At a privately run game reserve in South Africa, the owners arrange school trips to familiarize city children with animals such as this rhino whose mother had been killed by poachers.

Children's day

In this Japanese children's festival, they are dressed up in traditional costume and are then taken to a shrine.

Daily Life

Photography is constantly challenging many of the old assumptions about what a portrait is, or could be. Digital photography is taking this even further. Ultimately, this is because the continuing improvements in the technology of cameras, lenses, film—and now sensors and digital processing—make it easier to create images. But what is fascinating is the wide-ranging effects that this has had on the way we see images. In other words, simply because we can now photograph people successfully in all kinds of situations, a freer, looser style of portraiture has become accepted.

People are not by nature static subjects, and so the ideal camera is one that responds quickly and flexibly. In the earliest days of portrait photography, there was never enough light and the recording medium, daguerreotypes and glass plates in particular, were pitifully insensitive. The result was constant compromise—arranging sitters in poses that they could hold for a minute or more (sometimes even headrests were employed out of sight) or firing pyrotechnic banks of lighting.

Since that time there has been a history of improvement, but never quite reaching the point at which photographers could simply relax and shoot. There was always some workaround needed for a problem of lighting, shutter speed, depth of field, or color accuracy. And in fact, some of the formality of the traditional posed portrait was in response to this. Being still and under the photographer's instruction guaranteed a sharp, well-focused image.

Modern cameras, and in particular digital ones, have broken down many of the restrictions in photographing people. Small, light, and fast, the early 35mm cameras made candid, unplanned photography possible, and now digital cameras have extended the situations in which you can shoot. This is because they respond so flexibly and show you the results instantly. Flesh tones, lighting, and shutter speed are no longer a problem.

As we will demonstrate, digital cameras score through their ability to process the image in any number of ways. Even though the sensor array is inherently less sensitive than average film, this is misleading. The signal can be enhanced, meaning that if you set it to high sensitivity you can do things that were almost impossible before. Ultra-high-speed color film had quite nasty image qualities, including muddy shadow tones and a fat grain size that all but ruined the picture. The worst that a high-sensitivity digital image suffers from is noise—a random pattern of wrong pixels which becomes obvious only in enlargement—and this can be repaired digitally.

So now you can photograph people under almost any circumstances, day or night, outdoors and indoors, without having to stop and adjust the situation or lighting. Given this, what defines a portrait? Clearly it no longer has to take place in a studio or be formally arranged. It can have movement, action, and interaction. You can shoot so that it appears candid. Indeed, by giving up the role of director-photographer and becoming an observer, following your subject, you are in effect shooting candidly. Portraits have never been so easy and varied.

The natural approach

You can often capture an unselfconscious spontaneity by ignoring preparation, control, and considered lighting, instead encouraging your subject to do whatever comes naturally.

Pictures like this appear to have no technique at all, and I say that without a hint of criticism. It is indeed the very idea—to be artless, spontaneous, and natural, a moment caught among many, with no obvious interference on the part of the photographer. There are no frills, no lights, no posing—at least on the face of it.

But of course there is technique, every bit as much as in the posed portraits in the first section of the book. The difference is that the techniques are different, having been shifted from those of production, organization, timing, and reaction. They are downplayed in the image, and the result is that everything looks casual and uncomplicated: the person just happened to be there with that expression and that gesture, and the camera just caught it.

And that may very well have been the case. Or, the photographer may have loosely set the scene in motion, then stepped back and retired, as it were, from view, observing a more-or-less natural situation. The key to all of this is having sufficient confidence in your own ability to compose and focus quickly, and this is something you can actively practice and improve (no need to worry about wasting film; just check and delete).

Begin by making a quick assessment of the general setting in terms of the lighting and the background. Are they consistent and suitable? If not, consider changing the location, particularly if your subject is going to move around. Check that the camera settings are right for this: sensitivity, white balance, shutter speed, and aperture.

▽ Instant reaction
At a small engineering workshop in Athens, I waited until the welders had finished. They looked up, one with a huge grin. That was the moment to shoot, with no delay.

Trappist monk
The style of this portrait is as plain and direct as the circumstances in which the Trappist order of monks live in the Belgian monastery of Orval, famous for its beer. Father Lode, in charge of brewing, stands calmly in the cloisters of the thousand-year-old building.

Harvest
In the Valley of Roses, near the town of Kazanluk, Bulgaria, ninth-grade teenagers from nearby schools harvest the world's most expensive roses. These are the Damascene roses that set the standard for the perfume industry's rose oil. One of the girls pauses briefly from her work to talk to a friend.

Assessing the setting: checklist

- ☐ **Lighting**: is it consistent, or a mixture (eg sunlight and shade)?
- ☐ **Color balance**: make sure that the white balance setting is appropriate.
- ☐ **Light level**: is it sufficient to allow a reasonable shutter speed (say 1/100 sec) at the widest aperture (say, f-2.8)? If not, set the ISO sensitivity to allow these.
- ☐ **Background**: is it uncluttered or will it be out of focus when the subject is sharp? Are there any over-bright areas against which the subject will be silhouetted?
- ☐ **Focal length**: anticipate which you will need.

Street photography

Take your subject out on to the street to interact with the neighborhood, in the portrait version of a classic reportage way of shooting.

In reportage photography, the street is the arena for a wide range of human activity, and street photography, as it is generally known, is one of the standard working procedures. Equipped with the minimum of tools—a shoulder bag, camera, and a lens or two (or a single zoom)—the idea is to explore on foot, photographing life on the pavement, in open-air cafés, markets, parks, and so on. Nothing is pre-planned; you rely solely on your powers of observation and anticipation, and on luck, to find interesting images from ordinary situations. This is urban life, but there is a consistency to it around the world, even if the people themselves may be different.

The emphasis is on three things—being unobtrusive, spotting potential pictures in advance, and shooting quickly—and while these are techniques designed originally for candid shooting, you can also use them for a kind of freestyle portraiture. For a change, even with a planned portrait, have your subject simply walk around, shop, take a coffee, whatever comes naturally.

Nice market
A shopper at the morning market in Nice strikes a pose as he jokes with one of the stall-holders off-camera. The camera viewpoint was an elevated walkway, and I was looking for just such moments of conversation and interaction with a medium telephoto lens.

Cuzco
Three Peruvian children step up to the edge of a road as they prepare to cross. Seeing them approach, I had several seconds to prepare as they climbed the few steps.

The idea of being unobtrusive rather than drawing attention to yourself is so that the people in shot will not be looking towards the camera or otherwise reacting to you, the photographer. This is a simple enough aim to achieve: don't festoon yourself with obtrusive equipment; dress down, don't stand in the middle of the road, and keep moving around. Anticipating a good shot is down to staying alert and constantly checking potential views, bearing in mind focal length (*see box*). Above all, because there is often a constant flow of people and traffic, the opportunity for a clear shot may only last for a second or so.

You must be prepared to react instantly—which of course is where the camera's automated settings come in: autofocus, auto exposure, matrix/multi-pattern metering, and automatic white balance.

Tip

If you really don't want to look like a photographer but still need to carry a reasonable amount of equipment, buy a cheap small bag with a strap for the cameras and lenses. The cheaper and more ordinary it is, the less noticeable you will be.

▷ **Morning coffee**
In the town of Aix-en-Provence tables from the surrounding cafés fill one of the old squares. The aim was an overall view, and so I was using a wide-angle lens (20mm efl). The moment was made by the animated gesture of the man as his friend leans back and looks at the sky.

Focal length and distance

Familiarize yourself with the combination of focal length and distance that will give you the basic kinds of framing, from full-length to close-up head shots. This will speed up focal length selection so that you can simply raise the camera and shoot.

	20mm efl	35mm	50mm	100mm	150mm	200mm	400mm
Standing/ horizontal format	1.5 m	3 m	4 m	8 m	12 m	16 m	32 m
Standing/ vertical format	1 m	2 m	3 m	6 m	9 m	12 m	24 m
Two people/ vertical format	1.5 m	3 m	4 m	8 m	12 m	16 m	32 m
Head and shoulders/ vertical format	NR	NR	1 m	2 m	3 m	4 m	8 m
Head shot/ vertical format	NR	NR	0.75 m	1.5 m	2 m	3 m	6 m

[NR - not recommended]

Wide-angle techniques

Provided that you take care to avoid the characteristic distortion, a wide-angle lens has two valuable functions: it places the person firmly in their surroundings, and it draws the viewer into the scene.

Whether you use fixed lenses or zooms, the focal length you choose for any particular shot makes a substantial difference, not only to the character of the image but also to how you prepare for it. At its simplest, changing to wide-angle, or standard, or telephoto is a framing convenience: from whatever distance you happen to be standing, changing the focal length either expands the view or drops in on it. Zooms have a clear advantage here: they allow you to react much more quickly than by stepping back or forward.

But there's more to it than this, particularly in a situation in which there are people moving around. With a wide-angle lens you will be taking in much of the immediate surroundings, as these examples illustrate. This goes hand in hand with the camera position, as in order to partly fill the frame with a figure, you will typically be shooting from a few or several feet away. This naturally makes you fairly obvious to passers-by, and one problem is having someone who is not your subject in frame and staring at the camera. The way to avoid this is to raise the camera only immediately before you shoot, then lower it.

Alternatively, if you have the camera to your eye and the image framed, you could simply wait it out, or even briefly lower the camera, glance to one side so as to divert their attention, then shoot.

The value of wide-angle for photographing people in an interesting setting is precisely related to this close shooting. This kind of image has an involving character that projects the viewer into the scene. The photographer is clearly in the middle of things, a style sometimes known as "subjective camera," that conveys a sense of being there and of activity.

Aiming off

One difficulty, although only an occasional one, is that people can also see you easily—and that may make it impossible to get a second natural-looking shot. Quite frequently, you will get only one opportunity, and if you fluff it there's nothing for it but to move on. A wide-angle lens, however, can help in this. If you compose the view so that the person you want to photograph

Deep focus
A scientist near Grasse in the South of France, conducting a "headspace" experiment with a rose, analyzing the scent it gives off. A 20mm efl lens was completely stopped down to ƒ22 for maximum depth of field and full use was made of this to get the rose as close as possible to the camera, while keeping the image of the man sharp.

is off-centered, it will appear as if you are aiming the camera to one side. On occasions, you can continue shooting as much as you like within a few feet of the person.

Shooting without viewing

If you are using a wide-angle lens, then critical framing may not be necessary. With practice, you should have a fairly good idea of what the lens will take in without actually looking through the viewfinder. If so, you can shoot on auto-focus without appearing to use the camera—hold it rather lower than usual, and look away as you squeeze the shutter release. The composition may be a little sloppy, but that may matter less than getting the photograph.

Near-far composition

"Near-far composition" is a term that was coined by the great landscape photographer Ansel Adams to describe photographs which exploit the strong perspective of a wide-angle lens: close objects loom much larger than distant ones.

Designating focal length

Over many years of familiarity with 35mm film, the standard in photography, we have all become accustomed to using the lens focal length as a shorthand description of the general image qualities of wide-angle, extreme wide-angle, telephoto, and so on. Therefore, 35mm means "slightly wider view than standard," 20mm means "extremely wide coverage with distortion." However, these numbers apply strictly only to a 35mm format, measuring 24mm x 36mm. Because most digital camera sensors are smaller than this, the equivalent focal lengths are shorter. It has become customary in photographic parlance to continue using the old 35mm figures, while appending "equivalent" or "efl" (equivalent focal length). This is the system that is used here.

Morning market
Although not as extreme a use of near-far composition as the rose picture opposite, this scene taken in a French market is composed and the aperture adjusted so that vegetable produce fills most of the frame while maintaining depth of field. The framing of the shopper and the vegetables connects one with the other.

Aiming off
An old man reads a guide to the great medieval Cathedral at Chartres, standing close to a font. I liked the sense of empty space and silence. The way to handle this, it seemed to me, was to place the man almost at one edge of the frame to let the stone space dominate.

Medium telephoto

Longer focal lengths make for objective "across-the-street" compositions in which your subject can go about without the distraction of a camera constantly hovering nearby.

Whereas shooting wide-angle draws you closer to people and delivers busy, engaged images, longer focal lengths separate you from your subject, both physically in distance and in the sense of involvement. As with wide-angle focal lengths, telephotos are important less for the fact that they save you the effort of moving closer to your subject than for the distinct graphic style that they bring to an image. When you are photographing people, these longer lenses also have the added advantage of keeping you, the photographer, out of the way. This makes it relatively easy to shoot without being noticed.

50mm efl has always been considered standard as a focal length, and anything noticeably longer than this —basically from 80mm upwards—is classed as telephoto. The longer the focal length, the more pronounced the characteristics described here. Because of the narrow angle of view, less of the surroundings are in the picture, and if your subject is some way in front of the background, another factor will come into play—shallow focus. The longer the focal length, the shallower the depth of field, meaning that when you focus on one person in a crowd, those nearer and further away will be out of focus. Stopping down to a smaller aperture improves the front-to-back sharpness, but rarely completely, and needs either a slow shutter speed or high sensitivity. There is nothing at all wrong with this, and selective focus (as it is also known) is valuable in that it allows you to separate a person visually from the surroundings.

Ultimately, a telephoto is a good method of focusing attention on your subject and removing the distraction of busy surroundings. In many ways this is opposite in character to the wide-angle style on

◀ **A reasonable distance**

A 180mm efl lens allows this kind of framing from about 10 meters, which is far enough to shoot without drawing attention to yourself. This shot was taken from a footbridge.

the previous pages, and a major factor in choosing the focal length will be your preference for one or the other style of image. All telephoto portraits, as you can see here, tend to look more detached and less involved.

Shutter speed and camera shake

Long focal lengths magnify, and this applies to vibration as much as to the image. A common mistake is switching to a longer focal length without paying attention to the shutter speed that is set. As a rule of thumb, the slowest shutter speed at which you can safely shoot handheld is the reciprocal of the focal length. So, while 1/50 sec is no problem with a standard (50mm efl) lens, use at least 1/200 sec for a 200mm efl lens.

Defining "standard"

Wide-angle and telephoto have easily recognizable characteristics in photographs, but they exist on either side of a notional "standard" focal length. The logic behind this is that the image appears to have the same perspective and relationship between objects as it would to the naked eye. In fact, if you keep both eyes open, one to the viewfinder, the view and size of objects should be about the same (this is one way of finding the standard setting with a zoom lens). For the technically minded, this standard focal length is the same measurement as the diagonal of the sensor array.

Selective focus

Except in special circumstances when there is a good reason for trying to hold everything in the frame sharp, the usual focusing technique with a telephoto is to keep the aperture well open—perhaps a couple of f-stops less than full so as to keep the entire figure within the depth of field—and ensure the face is always sharply focused. In vertical framing, if the camera has a choice of focusing areas, it's useful to select the upper one, as shown above right.

◢ Priority to the eyes
Shooting at dusk with a 150mm efl lens, there was little light, needing a full aperture of ƒ2.8, and so very shallow depth of field. At a distance of less than two meters, the only sensible point to focus on was one of the boy's eyes, using the camera's upper focusing area.

▶ Compressing into one plane
A dressing scene for a television production of a historical costume drama. The moment was a natural, but was particularly successful with a telephoto lens, which kept the three figures in close relationship to one another.

Long lenses

The ultimate in objectivity, a long lens puts a distance between you and your subject, both literally and figuratively. It allows you to stand back and make detached, compressed-perspective images.

There is no clear division between medium and long telephoto lenses, but if you move along the scale of increasing focal length, there comes a point at which the effects are clearly extreme, akin to picking up a pair of binoculars. My own definition of a long lens is one which gives an image that reveals more than the a camera lens because it involves perception—and we can quickly change from taking in a very wide field of view to paying attention to a narrowly defined scene. Long lenses go further, and as a result often deliver surprises. 300mm efl is at about the cusp of distinctly long telephotos.

All the characteristics, and difficulties, of telephoto lenses are exaggerated with these focal lengths. Used for people, particularly in street photography, they allow you remarkably close shots while staying well back (and often completely unnoticed). From eight meters with a 400mm lens and a 24mm x 16mm sensor, you will have a frame-filling head shot. At full

▶ **Filling the frame**
The subject was pockets of village life in the center of Athens, and a 400mm efl lens was used here to compress the perspective and fill the frame with this old street (a shorter focal length would have included sky and other buildings). The shot was a matter of waiting for the right passer-by—an old woman taking her cats for a walk.

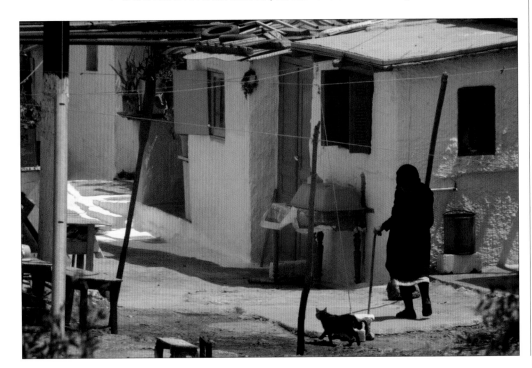

aperture, which is how these long lenses are normally used, the background will usually be completely blurred.

Small sensors boost the effect

At this stage in digital photography, most cameras' sensor arrays are smaller than the 24mm x 36mm format of 35mm film, while most SLR lenses were designed with 35mm in mind. Because the digital sensor uses a smaller area of the focused image, the effect is a greater magnification, so a 300mm lens used with a 16mm x 24mm sensor, for example, will behave as if it were 450mm.

Why telephoto?

The term telephoto is common currency for lenses that give the kind of image shown here and on the previous two pages: magnified, with compressed perspective and shallow depth of field. But in fact it refers to the most common design of long focal length lenses. In a simple, non-telephoto design, a 400mm lens would actually measure 400mm from its optical center to the back of the camera, where the sensor sits. Using multiple lenses, the telephoto design "folds" the path of light to make the lens smaller and more convenient.

Zoom ratios and magnification

Because a colon (:) is used by manufacturers to designate both the zoom and magnifying capabilities of lenses, there's scope for confusion. A 1:2 zoom can double its focal length, but this could be from 35mm to 70mm efl, or from 100mm to 200mm efl. Magnification, on the other hand, always has the standard focal length as its reference point—50mm efl. A 400mm efl lens gives a magnification of 1:8, or 8x.

Finding a good camera position is critical, because you need clear space between you and your subject. In public areas, unless you shoot from an elevated viewpoint, you are very likely to have a flow of passers-by interrupting the view. If you are able to shoot with both eyes open (a useful technique), so much the better, because you'll then have a little advance notice of an obstructed view, but do still be prepared for a proportion of wasted shots. One of the best ways of shooting is from somewhere that you can sit quietly for a while without drawing attention to yourself.

◣ Isolating the figure
In the rays of the setting sun, a Surinamese girl fishes in the river from a canoe. The shot was taken from a boat about a 100 meters away, using a 400mm efl lens. Compression helps the shot by making the deeply shadowed forest appear large, so that the attention is drawn to the girl.

◢ Sikh guards
The typically shallow depth of field with a long lens used wide open can be used, as here at a parade in the northern Indian city of Amritsar, to convert foreground and background into a color wash, which frames the figures.

Work as the subject

The procedures of individual work can add a new dimension to portraiture. By focusing on the physical aspects you can make the image informative and explanatory.

Not all work is visually compelling, hence the inherently boring nature of pictures of business meetings and people sitting at computer workstations— an increasing phenomenon. However, work that is in some way physical, and even more so if it contains an element of craft, has the possibility of becoming itself the subject of the photograph—rather than being simply a setting for the person. The result will still be a portrait, but with the flavor of reportage. Instead of the person pausing to be photographed, he or she remains involved in the work they are doing.

This kind of image is, however, far from being spontaneous, even though the final image will, or should, look natural. To photograph a sequence of work effectively, you need to know in advance the logic behind it. This is partly to ensure that everything in the shot is accurate; it is all too easy to set something up, introduce props, or interfere in other ways that will make a good composition, only to discover later (and too late) that things are not normally done that way and that the set-up is a nonsense to anyone familiar with the procedure. Some people can be over-compliant in allowing a photographer to re-arrange their workplace. Rule one is to observe without suggesting, by watching quietly and then asking the person to take you

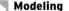
Scribe
Using a traditional quill pen made from a goose feather, and hand-prepared parchment, a modern-day scribe works on a specially commissioned version of the New Testament. Hands and face, with an expression of complete concentration, reveal the essence of this painstaking work.

Modeling
In the model-building department of a theatrical costumiers a model maker molds a head for an exhibition at which period costumes will be displayed. The head itself is striking enough to catch the attention, but the reference photographs and camera viewpoint make sure that the process is explained instantly.

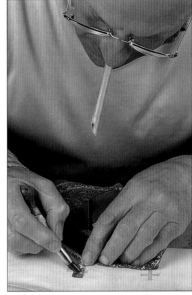

Rose petals
During the annual rose harvest, sackloads of petals are dumped on the warehouse floor of a perfume distillery each morning and are then scooped into buckets ready for distillation. Checking the location the day before allowed me to plan the shot in advance. I photographed from a catwalk for a strong, overhead view that fills the frame with color.

Gold leaf
Working in the same scriptorium as the scribe on the opposite page, the chief designer of the project applies wafer-thin gold leaf to part of the parchment that will become an illuminated title page. Another view of detailed concentration.

through the process. The other reason for taking time to prepare is so that you can find a clear, coherent view, and while you should rightly be cautious of moving a vital piece of equipment out of the way, there is no point spoiling the image by not shifting furniture that serves no useful purpose. Ask first.

Once you have understood the work procedure, you can then if necessary ask for pauses, which may well be necessary if you are using a slow shutter speed. If you close in on a pair of hands, for instance, the ideal depth of field may call for a small aperture and so a slow shutter speed. An alternative is to set a high ISO sensitivity and accept some random noise in the image.

Skin tones and white balance

Keep the color of skin on target, even under the varying conditions of sunlight, shade, cloud, and low sun, by using the camera's white balance options and the histogram.

The range of color and shades of human skin is both strikingly broad and at the same time subtly differentiated, however much we may tend to think that our own family color is normal. First, though, a word about memory color.

This is an important concept in understanding what color is and how great a part our perception plays in defining it. As explained more fully in another chapter in this book, entitled *The Language of Color* (see page 426), color exists only because the human eye recognizes it and interprets it. We discriminate certain colors better than others, meaning that they are more important to us and we are generally more familiar with them. For this reason they are known as memory colors; we see and know immediately whether or not they look as we think they should look.

And why shouldn't they? The usual causes are color shift and wrong exposure, too much or too little. Neutrals are prominent memory colors—the various shades of gray, in other words—followed closely by skin. The eye makes an immediate, intuitive appraisal of a portrait in terms of color accuracy without analyzing the details. It looks right or wrong: too red, or tinged with green, or bluish. Note that this applies only to images, never to the

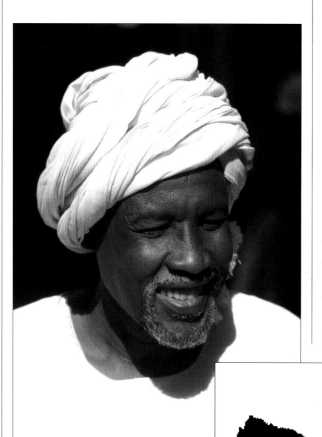

Dark skin exposure

Automatic exposure tends to lighten dark skins. After you take the shot, check the image immediately for its brightness, ideally by looking at the exposure histogram.

real thing. Even if you see a face under colored light, your eyes will accommodate.

This is highly subjective. There is no measurement that will tell you what you don't already see, so it's perfectly reasonable to judge the result on the LCD display by eye.

If you have time, shoot a test frame and judge the color balance. Then adjust the white balance as necessary and according to the choices that your camera offers. If there's no time for this, choose Auto or one of the other basic settings and plan to do any fine-tuning later in an image-editing program. Exposure matters in this case because of its effect on color saturation. Underexposure will exaggerate the color of lighter skins, while overexposure on darker skin will introduce highlight colors that you had not actually anticipated. Look at the histogram to see where the tones fall.

Close in for a test reading

This is suitable only if you have the time and opportunity. Use a longer focal length and frame the shot right in on the skin tones, excluding the background and clothing. Alternatively, use the center-weighted or spot

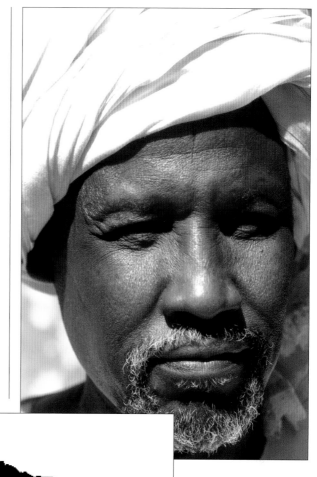

Dark skin exposure
To fix the problem in camera, reduce exposure by between 0.5 and 1.5 f-stops. Otherwise, use Levels in Photoshop to bring the shadows back in and take the highlights under control.

metering if your camera has that choice. The result will be an average tone, which you will then have to judge in relation to the type of skin—it will be too dark for a black skin, but too light, for example, for a pale Scandinavian skin.

A case for center-weighting

With a head shot, center-weighted metering may be more accurate than multi-pattern/matrix metering, provided that you fill the central metered area with skin tone.

The moment

Through expression, action, and gesture, people present a constantly changing subject to the camera. Choosing and capturing the appropriate instant calls for judgment and fast reaction.

In unposed photography—candid photography, reportage or whatever you care to call it—the people in front of the camera present a fluid situation. They move, they act and they interact with one another, all without interference from the photographer. Inevitably, in any given scene that you frame, certain moments will simply make a better-looking image than others. They may be more interesting, more unusual, more dynamic, more graphic, or have any number of other qualities that you value highly. They make the difference between a so-so image and a compelling one that will stand the test of time.

Reaction shot
At a traditional broom factory in northern Thailand, I was arranging a set of these distinctive implements when this girl walked quickly behind me carrying some more (and probably hoping not to be part of the shot). There was no time to change settings, and hardly enough time for a single exposure as I swung round and panned the shot. It worked, but only just, at 1/100 second.

The great French reportage photographer Henri Cartier-Bresson coined the phrase "the decisive moment" to describe this key quality in a photograph. In his 1952 book of the same name, he defined it as "the simultaneous recognition, in a fraction of a second, of the significance of an event as well as the precise organization of forms which gives that event its proper expression."

Such is the regard in which Cartier-Bresson is held, it has become a widely accepted ideal in the photography of people. It's also fair to mention that every so often some writer on photography tries to argue that it is an outmoded concept, but the reality is that professional photographers pay attention to the idea, even if they express it differently. Other photographers have challenged it with the idea of ordinary "in-between" moments, but not with any lasting success.

Indeed, one main issue is, who decides? There are two parts to photographing the moment: deciding what it should be, and capturing it. The two do not necessarily occur in that order, because while you may shoot carefully until you know that you have it, you can also shoot more freely and choose the key frame later in editing.

Gesture

Bathers at a hot spring in Tuscany on a Sunday afternoon. The chiaroscuro effect of the light and the color of the water combined made for a potential shot, but it called for something more from the bathers. I waited without anything particular in mind, until the woman reached out at the same time as the man turned to steady her.

Pattern and movement

Vietnamese girls dressed in the traditional *ao dai* at a statue-unveiling ceremony in Ho Chi Minh City, with a telephoto lens. There were a number of opportunities while the girls were waiting similar to the smaller picture (left), but at one point two of them decided to shield their faces from the hot sun, creating quite a different —and strongly graphic— image. It was all the more interesting for not having any faces in shot.

Anticipation

The most important aid to knowing when to press the shutter release is being able to predict what will happen in front of you—meaning how your subject is likely to react.

As you saw on the previous pages, capturing the moment depends on two skills meshing perfectly. One is being able to react to it in time and accurately, the other is recognizing it as the moment. You can help both of these along if, in any given situation, you have a good idea of what is going on. If so, you stand a chance of being able to predict what will happen. This might be as simple as realizing that in a few seconds someone will turn around, or reach out for something, or start walking. In other words, anticipating the next move.

At root, this is not much more than a combination of observation and common sense, but to make it effective you need to sustain a high level of alertness, looking around your subject and guessing the often several options. One of the most basic situations in candid photography is a person walking and approaching. Which way will they go? Are they likely to turn at that corner, or enter that shop, or cross the road?

The second part is applying your prediction to the image, meaning that you also have to judge how the action or movement that you expect to happen will look—its visual effect. In the case of a person walking towards you or across in front of you, where would look best? Silhouetted against a bright patch of wall, or framed in a doorway, or perhaps entering an area of sunlight? These are all highly specific decisions that depend entirely on the situation. They will influence whether or not you shoot, when you shoot, and what focal length or camera settings you will need. The examples here are equally specific, but the principles stay the same.

▽ Sugar cane sellers
A simple matter of watching what was happening. Although I first saw the single boy holding sugar-cane for sale by the side of the road, I quickly realized that he had a junior partner, and they would soon meet up—with the possibility of some interaction.

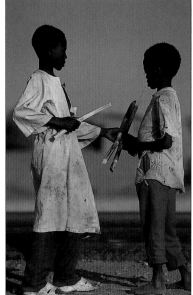

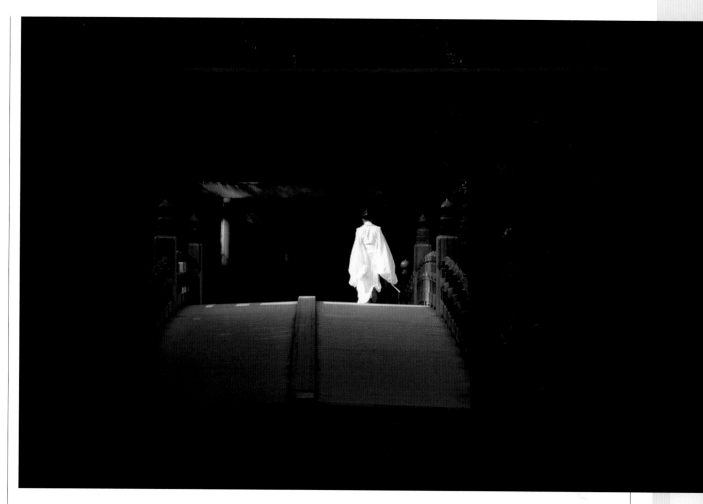

◢ Passer-by #1

This wooden bridge in the forest at the Imperial Shrine at Isé, Japan, was no shot at all on its own, but I had spotted the patch of sunlight and realized that a figure crossing might make a good image at the moment of walking into the light. A few people crossed before the figure that I really hoped would appear—a Shinto priest in white robes. I spent part of the waiting time checking the exposure in anticipation.

▶ Passer-by #2

In contrast to the image above, this shot would work without a passer-by, but not as well. In particular, a figure gives scale to this unusually massive door to the mosque at an ancient Indian city. It was predictable that people would pass frequently—I had simply to decide on the position (against the shadow at right would be clear and leave all of the door visible) and which person (I opted for traditionally clad).

Framing the figure

The choice of how much and which part of the frame a person should occupy depends largely on their relationship with the frame and with their surroundings.

In terms of where to position your subject in the picture frame, tight compositions generally take care of themselves, especially when you match the format to the shape. Closely cropped shots of a single figure tend to favor a vertical frame, whether the 2:3 proportions inherited from 35mm film and now used mainly in high-end digital cameras, or the "fatter" 3:4 format in most others.

Things get more interesting when you pull back so that your subject no longer fills most of the frame. Not only does the figure have to fit into the surroundings in a visual sense, it also has to have a considered position within the rectangular picture frame, by no means always in the middle. Design decisions enter the equation, and the smaller the figure within the frame, the more these matter.

The bull's-eye approach of placing the subject plumb in the center is absolutely safe—and not very interesting. In fact, symmetry and centeredness can be curiously unsatisfying, maybe because they are so predictable and static. Consider a face in profile in a horizontal picture frame. There will inevitably be empty space on one or both sides. Now, as the head in profile faces either left or right, so does the eye-line—an imaginary line following the direction of the gaze—and this creates a vector within the image. In design terms, it feels more satisfying if the head is off-centered so that any free space lies in front of it.

This is a standard solution, but not to be followed slavishly. If there is a sense of direction created by the way the person is standing, sitting, or facing, try framing so that they face from one edge into the frame. If there is movement, the case for doing this is even stronger.

Off center
In these shots, one in the Carrara marble quarries overlooking the coast in Tuscany, the other looking out on to a south Indian temple town, the figure has been placed at the edge of the frame, looking inwards, to direct the viewer's attention to the scene in front of them.

Letting the graphics decide

The treatment has been determined by the diagonal pole of the large flag and the circular shape of the hat. The geometry of these two shapes directed the composition.

Standing stones

The subject, a scientist, suggested these standing stones in Wiltshire as a setting. Choosing a wide-angle treatment to include the landscape, the natural place for the figure was against one of the stones, continuing the circle's line.

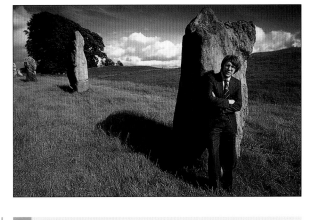

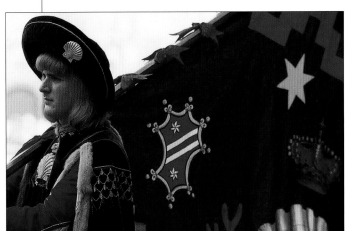

The proud hotelier

The successful owner of the IceHotel in northern Sweden, photographed for a magazine feature. The hotel is built of ice and has been a hit with tourists. The entrepreneur needed no encouragement to be expansive and simply had to be placed in front of his invention—and slightly to one side.

Orientations

These diagrams illustrate how the most common tight portrait framings shape up. The less closely they match the camera's format, the more choice you have in where to place them—in the center, slightly to one side, more to one side, and so on.

Vertical format

single figure full-length two figures full-length head and shoulders full face

Horizontal format

reclining figure seated figure, knees raised head in profile

Beyond this, look at working your subject into the design dynamics of the setting. If there is a strong diagonal, for instance, consider how the person might relate to that. If there is a natural frame within the picture, such as an archway, perhaps your subject would fit comfortably into that. Above all, try not to get fixated on just one or two ways of composing a picture.

An eye for the unusual

Even allowing for the inevitable differences in customs, traditions, and societies, certain people in certain situations stand out. They deserve to be treated with an informed and affectionate eye.

The element of surprise plays a constant part in photography, probably more so than in other visual arts. Fundamentally this is because almost all photography is a record of actual life rather than invention, and in order not to be repetitive photographers look for something new in what they shoot or in how they shoot. The unexpected, the fresh, and the unusual have become underlying expectations.

This applies to people and portraits every bit as much as to other camera subjects, although as you might imagine there are some limits and protocols to be observed. Unusual can cover a wide range of interpretation, not all of it pleasant or tasteful. Just as with general differences between cultures, it's a matter of judgment as to what constitutes unusual appearance or behavior. And here at least we're playing safe and focusing on the very obviously odd, while at the same time looking at the humorous rather than the unpleasant side of life (although culinarily challenged readers may disagree in the case of the Khmer girl photographed here).

Much of this is down to personal judgment, and you can be sure that whenever you search out and photograph the peculiar, there will always be a number of people who do not appreciate it as much as you. Still, for some of us the odd moments in life are a treat, and if you have at least a slight sense of the ridiculous, keep your eyes open. If a situation strikes you as quirky, then shoot it. That said, it is precisely the unusual nature of situations, such as those shown here, that makes them rare. In general, they have to be sought out and to some extent organized. These examples were all researched beforehand, and the portraits were posed for their strongest effect.

◀ A brisk dip

Scandinavians acknowledge the invigorating effects of a sauna followed by cold water, but here in Lapland they take it even further. An impromptu swimming pool has been carved out of the thick ice covering a river. This seemed the moment to shoot—when there was no turning back.

▼ A chilly breakfast

Close to the cold bath at left, a hotel has been constructed from ice. After a cozy night spent sleeping on a block of ice (admittedly in a sleeping bag), guests can have breakfast served in their rooms, where the temperature is a balmy 5° Celsius.

◀ Rat-catcher

The Irula, a tribal group near Madras in southern India, have become specialists at catching the rats that live beneath the rice fields and consume a third of the country's rice crop. Under a sponsored programme they are paid for the catch, some of which is sold to local snake farms.

◀ Arac snack

A culinary specialty of one small town in Cambodia is deep-fried tarantula, sold at the side of the road to passing motorists. Reminiscent of soft-shell crab without the fishy flavor, it remains a local delicacy with poor export potential. One of the stall-holders was only too happy to bite into one of these arachnids for a photograph.

Intimate moments

Discreet observation with the camera will, every so often, give you the chance to capture the candid occasions when people are absorbed in their own thoughts or in each other.

The line between a posed portrait and a candid shot is, perhaps surprisingly, a fine one. Put another way, what actually is a candid photograph? We normally use the term to refer, often vaguely, to images of people taken when they are unaware, and it carries overtones of a hidden, surreptitious camera. This can indeed be the case, but by no means necessarily.

The question is highly relevant when it comes to images of people so completely caught up in their own world that they are oblivious to the photographer's presence. They may be in a reflective mood, engaged in private thoughts, or quite commonly they may be two people deep in conversation. There's a special value to photographs of this type of moment, because such images usually have more character, are more intense in feeling, and are more charged. The viewer has the sense of being privy to a kind of intimacy, and is more likely to be drawn into the picture than when the expressions are blank or uninvolved.

These moments are also more difficult to shoot, partly because they are less common, and partly because they require the subjects to be completely unconcerned

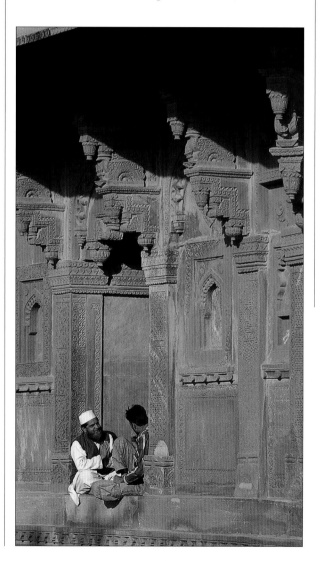

Fatehpur Sikri
Seated on the sill of a window in the abandoned sixteenth-century Indian city of Fatehpur Sikri, two men were deep in conversation. The red sandstone monuments, though architecturally magnificent, are normally lifeless apart from strolling tourists, and natural human activity like this made a welcome change.

Taj Mahal
An Indian couple in an alcove of the Taj Mahal (hence the bare feet, as all visitors must remove their shoes), more interested in each other than in the monument. As in the picture opposite, natural moments are less common at such heavily-visited sites than tourism, so all the more valuable for photography.

about the presence of a camera. So, even if you have set up the occasion and the surroundings for a portrait, you'll still need to give your subject the opportunity, the space, and the time to relax and forget about you. This is a good case for stepping back and being, if not actually out of sight, at least out of your subject's field of view. This kind of image is usually best taken with a telephoto lens from some distance away. If you are close, the camera will be a distraction, particularly if you are continually raising it to your eye every time you think the person's expression is about to become interesting.

Reflection
Sunlight glints off the hair of a girl lost momentarily in her own thoughts.

A private joke
Two men in an Athens street, one of them just returning from shopping, share a private moment of amusement.

City scenes

These are the great energetic concentrations of human life—open season for the camera and offering the strange combination of connectedness and anonymity.

There is no shortage of potential portraits in a city, and whether this is where you live or an unfamiliar one abroad, it will contain a wealth of opportunity. This extends beyond people as subjects for the camera to settings and backdrops; there is no shortage of locations for posed portraits, particularly among downtown public spaces.

Cities naturally have a specific character, most obviously in the prominent buildings and public spaces (the immediate mental image of Rome, say, or Paris, or Sydney, tends to focus on the central, somewhat clichéd views of the Spanish Steps, Eiffel Tower, Opera House), but

◀ **Rush hour**
London Bridge as commuters stream across from the railway station headed for the financial district. Planning and viewpoint are the keys to shots like this.

▶ **Park bench**
Parks in the center of cities offer another take on urban life. Two residents of Athens relax in the afternoon.

Location checklist

☐ Downtown shopping areas, pedestrian precincts.
☐ Downtown entertainment district.
☐ Business district.
☐ Parks and recreation areas.
☐ Bridges.
☐ Stations, especially at rush-hour.
☐ Sidewalk cafés.
☐ Traditional areas: "village in the city."
☐ Markets (wet markets, produce, farmers' markets, antique and flea markets at weekends).
☐ Squares and plazas.
☐ Events, processions, parades.

also in the style of daily life. If you want to reflect the character of a city through its people, spend time observing the street life and note the differences in dress, behavior, and custom.

The key to city shooting is research—of location and time (*see boxes*). Use a guide book and street map to check locations, and work out when the action is in each. Despite local and national differences, city life worldwide tends to converge. Specific activities such as business, shopping, and entertainment cluster into certain parts of town. Rush-hours are common to all, though the timing differs (early in the morning for Tokyo, late for Madrid), and certain spots are predictably crowded: London Bridge, Grand Central Station, and Hong Kong's Star Ferry, for example.

There is an anonymity in all this "to-ing" and "fro-ing," and you can take advantage of this in shooting—photographers do not stand out in busy city centers as they would elsewhere. Using a camera is seen as a completely unremarkable activity.

Dance class

A strange but oddly charming sight for foreigners is the dancing class held early in the morning on Shanghai's Bund, or waterfront, with its elegant Art Deco backdrop of buildings. Idiosyncrasies like this help to give character to city photography, and in this particular case the opportunity to combine people and cityscape in one shot.

Work, rest, play

- ☐ **Work**: morning and evening rush-hours, lunch-hour, workplaces.
- ☐ **Rest**: Cafés, restaurants.
- ☐ **Play**: Bars, entertainment districts, family amusement parks.

Small-town life

Less dynamic and less crowded than cities, provincial small towns are a setting for people who generally have a stronger sense of community.

Compared to cities, small towns have a stability and regularity that translates into a slower pace of life, fewer complete strangers, and a better connectedness among people. Older towns also tend to retain something of their original character, at least in the centers.

Here anonymity does not work as well as in cities, and as a photographer you don't naturally recede into the street life. Equally, it is generally easier to make connections with people, to introduce yourself and have conversations. The places where people gather are fewer than in large urban centers, but easier to reach, and there is usually just one hub.

Traditionally, most towns evolved as places where transport routes crossed and as trading centers for the surrounding countryside. Many still function as market towns, and it's worth checking the dates for markets—often weekly. It's also because towns serve a particular area that they often develop a specific character. The local economy tends to dominate, and you can see aspects of this reflected in the way people live—mining towns, seaside resorts, small ports with a fishing fleet, spa towns, mountain ski resorts, and so on. If you look at what makes a town special, you can use this to add a distinctive character to pictures of its inhabitants.

▲ Village green

Cricket, a quintessential part of English village life, is at its most picturesque played on a small green. A telephoto lens made it possible to include three players in the same frame.

▶ Sunday morning

The end of the service at an attractive church in a small Ontario town—one of the few occasions in the week when more than a few people gather together in public spaces.

Peruvian café

In a mountain town in the Andes, one of the regular clientele of a café plays an old harp, as much for his own amusement as for the entertainment of other people.

The publican

The owner of 't Brugs Beertje, a Belgian bar, pours one of the four hundred brands that he proudly stocks.

Following one subject

Instead of settling for a single image in one chosen situation, consider following your subject during a round of activities —with the intention of displaying a grouping of several images.

In most portraits, the photographer is looking for a single "best" shot, and many of the techniques and strategies that we've looked at so far have been directed at finding this. Yet another approach is to build a composite picture of a person by photographing them in a variety of situations and activities. Clearly, this kind of extended portrait works best with real-life photography rather than strictly posed settings, because much of the success depends on showing your subject interact with events— in other words, building a story.

This is mainstream reportage photography, and may have as much to do with the person's activity as with their appearance. We will return to this area on page 224 when we look at picture essays, but for the time being we want to see how a series of portraits can work when they are displayed together, side by side.

The keywords are variety and coherence. These two slightly contrasting qualities have to work together, and in principle the variety should be visual while the element that ties the images together is the storyline. Just having several individual portraits of one person, however varied they are in scale,

Preparation

The bird, a Peregrine falcon, is kept hooded until it is ready to fly. The falconer adjusts the thongs attached to the bird's legs, as his dog, a pointer, sniffs his gloved hand, bloodied from an earlier kill. The role of the pointer is to find the grouse, keep them pinned down until the falcon is up, and then dash forward to put them up into the air.

lighting, expression, or whatever, is unlikely to tell us anything new. What is needed is a sequence and relationship with what the subject is doing. One natural storytelling device is a day in the subject's life, another is a project they are undertaking. The examples here are from editorial magazine assignments on subjects more wide-ranging than the people themselves, but they still show a more rounded view of the people than a single portrait image would.

The kill

As the prey breaks cover, the falcon swoops and strikes in mid-air. By the time the falconer arrives at the scene, it has already started to eat.

Patrolling for grouse

Launched and ready to swoop, the falcon scans the ground for signs of grouse, as the dog attempts to flush them from the heather.

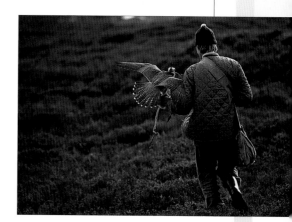

The return

On some occasions, the falcon has to be tempted back with a bait of meat that the falconer swings around on a line. It's important to keep the bird hungry while out on the moors, or it may simply fly off and perch on a crag for a day or two. Finally recovered, man and bird walk slowly home.

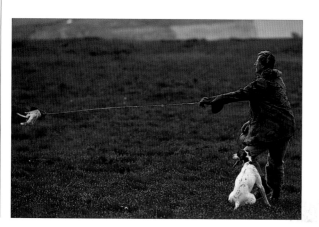

Parties and gatherings

Whether you are the "official" photographer or just another guest with a camera, parties present a rich vein of opportunity for shooting people.

Knowing what you want to achieve before you set out is one of the most important steps in creating a good set of images. Nevertheless, every party and gathering has a life of its own, so as photographers we need to be flexible when we turn up with a camera. Planning for the unexpected might seem like a real contradiction, but it's the best way to handle this particular type of photography. Make sure that you know what the location is like so that you have some idea how you are going to handle the light. If the existing lighting is reasonably even and relatively bright (for an interior), consider racking up the ISO sensitivity and shooting without flash. Alternatively, use fill-in, rear-curtain sync, flash.

There are essentially two ways to approach parties and gatherings. You can decide to shoot as a "fly on the wall" and be an observer, or you can shoot pictures with the full co-operation of the other guests. The type of the occasion might dictate which approach you use because some more formal gatherings have their own protocols. Children's parties will inevitably be a lot less formal and give you more scope for a good combination of posed and candid shots. The important thing to remember is that a photographer should always take their lead from the host of the party.

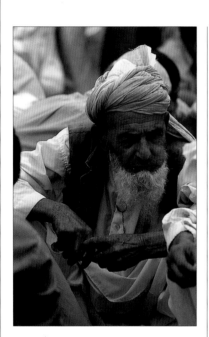

Pathan feast
The slaughter of a water buffalo is the occasion for a feast at a Momand Pathan village in Pakistan's Northwest Frontier province, to which old friends and relatives have been invited—a chance to catch up on events, and for the photographer to catch a variety of expressions.

Relaxed moments
Parties are occasions for people to relax, chat, and joke, at which time they normally pay no attention whatsoever to someone with a camera, particularly if you shoot from a slight distance. There are endless opportunities for photography with a medium telephoto.

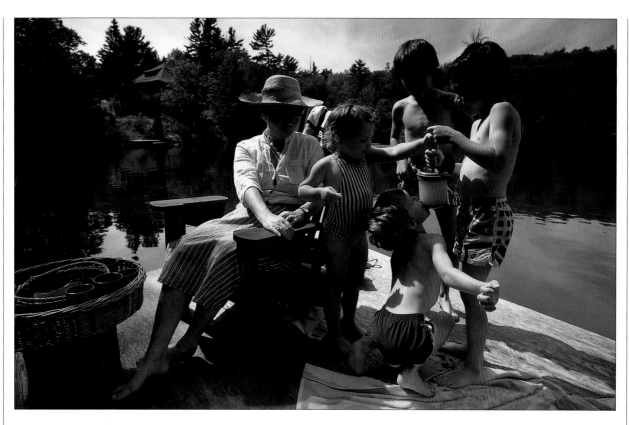

Seven tips for shooting parties

☐ If it's a large gathering and you are taking candid photographs, try using a telephoto lens and shooting from a vantage point slightly above the crowd to pick out individuals.

☐ If you decide to set up some lights, make sure that any power leads or sync leads that you use cannot be tripped over or have drinks spilled on them. Run them under carpets and tape them down securely.

☐ If you are shooting whilst circulating, try to keep your equipment down to an easily-managed level. There is nothing worse than bumping into people with cameras all of the time.

☐ If people are eating or drinking, try not to shoot when they have their mouth open or have a glass to their lips unless you know them very well and know that they wouldn't mind.

☐ If the party has a guest of honor, make sure that they feature in more than one picture and that they are photographed with the host.

☐ If you don't know everybody there, ask one of the organizers to point out some of the key people.

☐ If you are there as a guest rather than as a photographer, remember to enjoy yourself!

Summer cottage

At a lakeside weekend retreat near Ottawa, the children entertain themselves with licking a honeycomb while their grandmother looks on.

Mad Hatter's tea party

This was a party with an *Alice in Wonderland* theme, organized by the local municipal authority, with organizers dressed for the part. A wide-angle lens used close into the crowd gives a sense of being in the thick of things—typical of what is sometimes called "subjective camera."

Weddings and anniversaries

There is a big difference between being a wedding photographer and being a photographer at a wedding. Shooting weddings is a professional skill that takes years to master, but taking your camera to a friend's wedding is a different matter.

A lot of people with a camera at a wedding find themselves standing next to the official photographer snapping the group photos that they carefully arrange. This is a tempting idea, but it's not much fun for those of you who like a creative challenge. Professional wedding photographers often act as the master of ceremonies and have their own schedule to fulfill, but there is another type of photograph that you can take, a far less formal and more intimate kind of picture. These will remind everyone of the special day just as warmly as the formal and posed ones. A photographer who is free from the need to organize everyone can move around and shoot relaxed, candid images in those unguarded moments while the guests and the wedding party socialize.

Different countries have very different rituals that are observed leading up to the wedding, so even before the big day there are some great wedding images that can be captured. Many cultures have occasions similar to the American bridal shower where the bride's close female family and friends will gather to give the bride gifts and enjoy some time without the men. Other cultures have parties for the groom and his friends where the last days of

Wedding photos
At this Muslim wedding, the official photographer becomes part of the shot as he records the bride on the evening at which only women attend. A mix of existing lighting and fill-in flash provided the illumination, using the Auto white balance.

Posing

Take advantage of the distraction afforded by the demands of the official photographer to catch subjects off-guard.

bachelorhood are enjoyed. These are just two examples from all sorts of pre-wedding events that can make memorable and valuable pictures.

On the day itself, the last-minute preparations and the time spent waiting can be interesting, although these moments should only be shot with the permission of the families. As the day progresses you can build up a narrative of the proceedings that tell the story as well as any video.

Anniversaries

Most people hope for only one wedding and many anniversaries. Celebrating a wedding anniversary is always a happy occasion and can make great photographs. The nature of the celebration is different around the world, but the scope for memorable photographs isn't. Hiring an official photographer for an anniversary celebration isn't as common as it is for the wedding itself, so a friend or family member is often called into action to capture the day. Everything about anniversaries is less formal, so an informal set of pictures will be in keeping with the occasion.

Referring to the best photographs of the wedding itself is often a great starting point when planning what to shoot. Re-creating group photos five, ten, or twenty years on can be a good idea as long as most of the people in the original picture can be there. Shooting a husband-and-wife portrait to give to guests at the anniversary party can also be a good gesture.

Share the shooting

Photographs shot digitally are easy to share on the camera's LCD screen. Many cameras have the facility to be connected to a television monitor, and if there is a break in the day it might be worth sharing the pictures on a decent sized screen too.

Bride, Calcutta
Dress figures prominently in most weddings. The bride at a Hindu ceremony wore a spectacular and colorful sari, as well as traditional make-up. The richness of color responded well to direct flash, not normally the lighting of choice for portraits.

Successful wedding shots

Hundreds of photos will be taken at a wedding, but many will be dull variations on a few obvious themes. Take a different approach:
☐ **Background detail:** By keeping the focus on the bride and groom or the formal parts of the day, you can miss interesting family moments taking place in the background. Watch out for them.
☐ **Waiting:** There is a lot of dead time during any wedding. Use it to catch the less important participants in informal shots.
☐ **Plan:** Have some idea of the shots you want to take and when you want to take them, but keep this flexible.
☐ **People:** Knowing the people involved helps you to capture their mood or character during the different stages of the day.

As with any formal occasion, use your discretion and commonsense while you shoot. Take advantage of photographic opportunities, but keep the feelings of the family in mind and avoid being intrusive.

Rites of passage

As well as weddings, other milestones in life are celebrated, or mourned, according to the culture and religion. Most are good situations to photograph, and the results will make a record that is appreciated by the people involved.

Weddings are perhaps the most popular of family special occasions for photography, but there are a number of other events in life that call for celebration or, when less happy, solemnizing. In most cases the camera has a role to play, because not only are these rich opportunities for taking photographs, but the people you photograph will welcome pictures for themselves. Births, coming of age, even funerals are rites to be observed and marked—and photography does this well.

Ceremonies such as these have a social importance, and so tend to be more numerous and fuller in traditional societies. As a rule, the more rural and less industrialized the culture, the more varied they tend to be. If you travel, keep your antennae tuned for them, because at these occasions you are likely to find interesting and concentrated collections of faces and activity. Ask around and you may be surprised that, even as a stranger, you will usually be welcomed.

Getting permission is, of course, the first essential, and not just from the individuals involved. The ceremony may be held elsewhere than at their home, particularly if there is a religious aspect to it, as is often the case. For similar reasons, there may also be other people officiating, such as a priest or a monk, and you should make sure that they have no objections either. Ask also about restrictions; in a place of worship such as a church there are likely to be areas which you cannot enter, and it's as well to know about these beforehand. Also in tune with not disturbing the events, ask before you use flash. Better still, given the ability of digital cameras to adjust sensitivity and work well at moderately low interior light levels, consider using a high ISO setting and shoot as much as possible by available light.

As with any organized occasion, arrive early if you can and find out the sequence of events and a rough description of what will happen. This applies even more if you are in a foreign culture, as there are likely to be unfamiliar aspects to the ceremony. If there is a local professional photographer, he or she will know what is about to happen at any given point. If there is a video cameraman, the likelihood is there will be a 3200K tungsten light in use some of the time—a good reason for leaving your white balance setting on Auto.

Shan ordination
A major ceremony in the life of Shan males in northeastern Burma and northwestern Thailand is *shin pyu*, the ordination into the Buddhist monkhood. In reference to the Buddha's original princely life, which he rejected, ordinants like this young boy dress before the ceremony in an ornate costume and wear make-up.

Vietnamese funeral

Funerals are almost always difficult occasions for photography because of the grief involved. It is absolutely essential to arrange permission first, and it may be more appropriate to do this through a friend of the family or someone officiating rather than directly.

Grief and respect

It can be difficult to achieve a balance between capturing the emotions and atmosphere of the rites, without disturbing the understandably tender feelings of the mourners. On the other hand, many people welcome the record and respect that photographs can offer.

Monks

In a continuation of the *shin pyu* ceremony opposite, the young boys' heads are shaved, after which they exchange their fancy costumes for the red robes of a monk.

Preparation

Most of the boys will spend just a few weeks during the rainy season —the Buddhist Lent— studying in a monastery before returning to normal, family life.

Parades

Parades, fairs, and other public showcase events offer some of the richest and most colorful possibilities for photography. Finding the right viewpoint for the right moment is essential, and the key to this is planning.

There is never any shortage of material for photography in organized events such as these, and the only serious concern is usually working your way around the crowds. Most events are highly structured, and you can usually expect to find viewpoints and work out the timing in advance, although you can expect some restrictions.

If you have enough time in the days before the event, get a schedule from the organizers or the local newspaper. Then look around the site or the route to find the best vantage points. If the event is very popular and likely to be covered by the media, the very best positions are likely to be reserved, but even then doing your own groundwork can turn up a free viewpoint. Also, there is no harm in asking if you can enter the area or seating set aside for the press—even if you have no professional claims to a press pass, there is always a chance if the occasion is relaxed.

Somewhere high, like a balcony or the roof of a building, is often a good, safe bet, allowing you a variety of images with different lenses. Even a slightly elevated position is useful for shooting over the heads of crowds—if you are checking before the day, anticipate where other people will be. The disadvantage is likely to be that, on the day, everywhere may be so crowded that you can't move. All of this, of course, depends on how big and busy the event is. If you know that you will have to stay in one fixed position, take more rather than less equipment—a tripod, for instance, is useful with long lenses (just loosen the head when you use it so that you can pan around the scene). On the other hand, if you are going to be on the move, take only what will fit easily into one bag. Take more memory cards than you think you will need—these occasions encourage heavy shooting—and if possible carry two camera bodies so that there is no risk of losing a shot at a key moment.

Most events, in fact, turn around one or two key moments, such as the high point of a procession. Always try and make sure that you get these, but don't ignore all the other possibilities that may occur. These include the asides, the unpredictable events, behind-the-scenes preparations, and the faces and reactions of spectators.

Tip

The best view of a parade is often head-on with a telephoto lens. A bend in the road or a traffic island are likely to be good positions, unless restricted.

▲ Carnival #1
A medium telephoto lens fills the frame with the color and energy of Kingston's annual carnival in Jamaica. Dancers and bands move in sections separated by gaps, giving the opportunity to shoot from in front.

◀ Carnival #2

A brightly costumed and helmeted dancer at the Jamaican carnival gets ready to move off, just before the beginning of the parade. As well as the obvious scenes during a procession, there are many opportunities for detailed portraits, for which a medium or even long telephoto lens is useful.

▲ Military order

The regularly ordered line of these Thai soldiers, photographed obliquely with a long telephoto (400mm efl), provides the setting for a rhythm that begins when the eye scans the image, moving from faces to the lines of the uniform and back again.

Tip

Some professional photographers who are used to covering special events carry a short, lightweight step-ladder to guarantee a clear view over crowds.

Behind the scenes

With easier access, fewer restrictions, and the chance to see things that may be hidden from the normal audience, rehearsals and preparations offer great opportunities—sometimes better than the event itself.

While it's normally assumed that a procession, parade, festival, or performance is bound to be the focus of interest for everyone, it may not necessarily deliver the best photographs. This entirely depends on the interests of the photographer, but the sheer weight of organization that goes into many events can also make the imagery predictable—and shared by all photographers present. Going behind the scenes can give you the opportunity to be more original and see things from the more workmanlike point of view of the participants. Also potentially interesting is the reaction of spectators watching an event. If the occasion is sufficiently riveting, their expressions may make a better subject for the camera than the object of their attention.

Vietnamese opera

This was a traveling opera troupe that had set up stage in a provincial town in southern Vietnam. The conditions were far from comfortable, with make-up and costume taking place in the cramped space underneath the stage itself. The lighting was minimal—a few lamps and candles—but the scene was strong on atmosphere.

Corpus Christi

This strange, almost unintelligible scene was a rehearsal for an event that was already a little peculiar—Corpus Christi day in a small Venezuelan town, where the action revolved around masked and red-clad, so-called Devil Dancers. The main event also delivered many good images, but this individual rehearsal of one dancer and a drummer in an oddly painted room was my favorite.

Coach rehearsal

The streets of London on a wet early morning in November presented a very different aspect on the day before the Lord Mayor's Show. Before commuters and traffic filled the streets, the coach, wrapped in plastic, was driven around the exact route for familiarization. As it stopped on a pedestrian crossing, the only spectators, slightly bemused, were a group of office cleaning ladies.

Sports events

When you think of sports you think of action, the World Cup, the World Series, or the Super Bowl, but many of the best sporting images ignore the action altogether and feature portraits of fans, hot-dog vendors, and souvenir sellers.

The sad fact about trying to shoot professional sport these days is that, unless you are an accredited member of the press, it is very difficult to get access to the venues with your camera. All of the governing bodies and the top clubs now try to manage their image, and that includes trying to prevent unauthorized photographs from being taken of their valuable stars. Lower league and amateur sports, on the other hand, present an almost endless supply of photographic opportunities which you can use either to enjoy your photography or as practice for when you become good enough to move up to the professional ranks.

Depending on your interests, the world of sport offers you nearly every type of people "centered" photograph that you could imagine. Whichever sport you choose, photographing it has its own challenges and conventions, but there are some basic principles that you can follow with all of them. The atmosphere at even the smallest sporting event is worth capturing. Freezing parents on the touchline at a children's soccer match and anxious little-league coaches behind the nets at a softball game are perfect subjects for candid, long-lens pictures. Early morning golfers as they set out on their round and mud-covered mountain bikers fresh from the race make great portraits. It pays to be familiar with the rules and etiquette of the sport

Mid-air
Even the most basic amateur sports can offer some worthy photo opportunities. In this shot by Martin Gisborne, quick thinking captures the action in mid-air.

Speed
This rider in the Tour de France would have passed the camera at about 35mph. With a shutter speed of 1/2500 second the photgrapher froze him in the moment.

concerned before you start shooting, so that you know what's going on and so that you don't go anywhere you shouldn't.

Planning your sports shoot usually starts with finding out when and where the event is taking place. It is good manners to contact the organizers to make sure that they are happy for you to be there with a camera and to find out what restrictions, if any, they place on photography at their events. The equipment that you choose to take with you will dictate how close to any action you can get and it's worth noting that a large number of sports don't allow the use of flash photography because it can be distracting to the competitors. For most sports you really need a fast and long telephoto lens to get close to the action. It's normally a good idea to get as close to what's happening as you can and if you have zoom lenses you can frame your shots without having to move around too much.

Getting great sports photos requires more practice than almost any other style of photography. Time spent at the local stadium will never be wasted because learning to anticipate what is going to happen next is a key skill for sports photographers. Starting out with amateur or school sports is wonderful training because it is often harder to predict the next move in the lower leagues than it is in the professional ranks.

Using blur for effect

Sometimes a moderate shutter speed will capture certain fast moving parts of a photo with some blur, retaining sharpness in the more static areas. In the top shot, the San Jose Sharks' Jonathon Cheechoo was photographed with a shutter speed of 1/180 of a second. At that speed his head is steady (he's taking a shot) but the hands and the stick are moving rapidly. A similar principle applies in the shot below. The goalkeeper remains sharp, but the puck and sticks are blurred by rapid movement.

Peak moment

Every sport has its classic photographs. From the crunching tackle in football to the follow-through in golf there are iconic moments that can be relied on to provide memorable images.

One of the downsides of most digital cameras is that they have what we call "shutter lag"—that is, a slight delay between pressing the button and the picture actually being taken. It's important to practice shooting action with your camera so that you get to know what fraction of a second that delay is and learn to anticipate by the right amount.

A good knowledge of the sport that you are trying to capture is always useful. Equally useful is a knowledge of how that sport is usually shown on the sports pages of your favorite newspaper or magazine. Many sports have concentrated bursts of energy which only give you one frame to "get the shot," whilst others will have prolonged passages of action allowing you to have several attempts. Here are a few examples of each:

High jumper. The jumper is at the top of the arc for a fraction of a second and this is the point at which those classic pictures are taken. You can pre-focus on the bar and compose your picture in anticipation because you know that is where the action will be. Each jumper will have only a limited number of attempts.

Baseball pitcher. You know that he is going to pitch from the mound and you know where his front foot will fall so you can pre-focus and get your composition sorted. Each pitcher will be doing it many times in a single game, so you have more than one go at getting it right.

Swimmer. Only on the diving board is the swimmer still. Otherwise they are moving through the water at speed. You can compose and focus as you follow their progress, or pre-focus on a given point on each length of the pool. Whichever way you shoot the swimmer, there will be more than one chance. Head-on from the end of the lane can produce striking images, particularly when the swimmer surfaces, as in the butterfly stroke.

Soccer player. It's almost impossible to pre-focus on action when there is a ball involved in the game. The direction of play switches very quickly and players will cross in between you and the action, blocking your shot. The game lasts for a long time though, and you will get many opportunities to get a good shot. Concentrate on following the ball, working the zoom control (if you have a zoom lens) to maintain the framing of players around it.

◢ Take the shot

Golf is one of the easier sports to photograph. There are plenty of peak moments—the driving shot, the triumphant putt, the blast out of the bunker—but the movement of the players is more static and easier to predict. Lucky too, as you will often need to shoot from long-range in the spectator's area.

Where you position yourself usually dictates the shot that you are likely to get. Head-on to the action is often more dramatic, but makes focusing even more critical. It's a good idea to watch where professional photographers situate themselves for each sport so that you get a good idea of the angles that work most effectively.

The lenses that you choose will have a dramatic effect on what you shoot as well. Getting tighter crops from a set position, foreshortening, and shallow depths of field are the three main reasons most sports photographers shoot the majority of the time with telephoto and super-telephoto lenses. Capturing action pictures is all about practice, planning, and anticipation.

A cautionary tale

Sometimes there are rules about when you can and cannot press the shutter, illustrated by the actions of one top golfing caddie who threw an amateur photographer's equipment into a lake when he shot at the wrong point in his player's swing, causing the player to badly miss-hit the ball. In sports where silence is required, the sound of even the quietest camera or the sight of a single flash can be upsetting to the players. If your camera has a flash built in, make sure that you have the flash disabled if you are in any doubt about whether flash photography is permitted.

Skiing
The best moments are those where the skier is moving at speed or, as here, up in the air with the powder spraying out behind. The difficulty is in getting close enough to the action without becoming part of it. The photographer took this from a safe vantage point using a long lens with a fast shutter speed. The reflective snow and bright sun helped, giving plenty of light to work with.

Boules
The French game of boules played in a Provençal town park. In this sport, the moment is this: with the steel ball in mid-air and the player still in the throwing pose. It took a few tries before the position of the ball's image in the frame could be predicted and the right camera viewpoint chosen. The shutter speed needed to be moderately high at 1/250 second.

Blur for effect

The impression of movement rather than its strict factual details may sometimes make for a more effective picture, but be prepared for unpredictability, surprises, and constant checking.

There is another, opposite treatment for people in motion that is occasionally useful. Emphasis here is on "occasional," because individual portraits demand a certain recognizability, and that pre-supposes reasonable sharpness. Nevertheless, as long as there is a purpose to it, the techniques are fairly straightforward and revolve around long exposures to create streaking. What was once an unavoidable by-product of slow shutter speeds needed for dim lighting with slow film, seen as a fault, is now used deliberately to convey the sensation of time and movement, and also for graphic effect. Digital photography makes it possible to apply motion blur, as it is also called, with something approaching precision.

Instead of the minimum shutter speed being the baseline (*see the previous pages*), the idea here is to work with speeds slower than that which records the movement of a person as a noticeable blur. As in freezing the action, the actual speeds depend on how much movement you can see within the frame, but to work well visually the blurring must be obvious. The small range of shutter speeds that almost give sharpness are of no use—the result will appear to be just a mistake. This is where the checking and feedback capabilities of a digital camera really come into their own. On automatic exposure, simply start with any speed slower than about 1/8 sec and examine the result on the LCD screen at magnification. The speed that works best is a matter of personal judgment; adjust the ISO sensitivity as necessary.

If you keep the camera steady, for instance by using a tripod, the

▼ **Bullfight**
The motion-stopping speed at a bullfight with a medium telephoto lens turned out to be 1/250 second for most of the time, but to introduce a significant blur, a speed of 1/2 second was used here. The intention was to convey the flow of action rather than its bloodier details.

streaking effect will come from people moving, and it is the combination of this and the sharp rendering of the surroundings that helps to make this kind of shot work.

Another possibility is to have your main subject keep still while surrounded by other people moving—again, a contrast of sharp and streaked. If you move the camera during a time exposure, everything will be streaked, normally a fault, but if you do this with a definite smooth movement, the impressionistic effect may be successful.

Finishing with flash

Slow synchronized flash can make a useful contribution to motion blur by superimposing a sharply rendered image on to the streaking. Experiment with the balance of time exposure and flash by adjusting the + or – compensation settings. With a focal plane shutter, as in an SLR, you may have the choice of front-curtain sync, in which the flash is triggered at the beginning of the exposure, and rear-curtain sync, in which the flash fires just before the end. Experiment with both syncs to see which effect appears the more satisfactory.

Panning

One special variant of motion blur is when you track a person moving across your field of view from one side to the other, and use a shutter speed that is just fast enough to keep the subject sharp. The result is a streaked background, which not only gives the impression of speed and direction but also helps to separate the person from the surroundings in a way similar to selective focus using a telephoto.

◀ Monk on a bicycle
This shot of a monk being taken to a house ceremony in Cambodia was taken from a passing vehicle through the open window. By keeping the shutter quite slow at 1/30 second, the background was given a speed-streak blur, while the figures remain sharp.

▲ Architect
This portrait of a well-known Japanese architect was set up in a new subway station he had designed, with him leaning against one of his benches. To focus attention on him, he kept still while the shutter speed was set to one second (with the camera on a tripod).

▲ Shopping frenzy
The subject was this main branch of Marks & Spencer, one of the world's busiest stores. To emphasize this, the shutter speed was set at two seconds for a mixture of blur as some people examined merchandise while others walked by.

Picture essay

This famous tradition of feature photojournalism, established by the earliest picture magazines, aims to present a personal, extended view of a subject in the form of a set of images that tell a story.

One of the great editorial inventions, which is usually attributed to *Life* magazine but in actual fact dates to the 1930s, is the picture essay. The art director of the magazine *Weekly Illustrated*, Stefan Lorant, was the person who was primarily responsible for laying out combinations of photographs in such a way that they made a single graphic entity—such as a main shot that was supported by a strip of smaller images in a sequence.

At the time, this represented an entirely new way of presenting photography. It introduced a narrative element—a storyline—and created a justification for using several different pictures of the same subject or on the same theme. Used in conjunction with portraits, it became a powerful tool of magazine publishing.

Most important for photography is that the format of a picture essay induces a fresh way of thinking about a shoot, one in which the photographer is encouraged to see the totality of the session—which may be very extended, over a much longer period than one day. This in turn means planning for a series of pictures and being able to imagine, during shooting, how they might enhance each other, what juxtapositions of which images will work best, and how they can be ordered. In still-image form this is much the same procedure as in documentary film-making and video.

Although the picture essay was first designed for illustrated magazines (and is still used in this way), it works perfectly well in other media that are more useful and available to individual photographers. These include a sequence of prints in an album, groups of images laid out digitally and printed on a single sheet of paper, groups of images on a web page, and on-screen slide shows.

Very few picture essays can stand alone without captions or an introductory text. This is not a weakness, and should not be confused with the common art gallery practice of hanging prints with minimal captions or none at all. A picture essay is a form of reportage, telling a story, and that story needs to be made clear.

Elements of a picture essay

☐ Theme.
☐ Narrative flow.
☐ Captions.
☐ Large vs small.
☐ Juxtapositions.
☐ Visual variety.

▲▶▼ A working life on the canals

Britain's canal system, once the transport infrastructure that enabled the Industrial Revolution, has survived only because of its leisure potential, as thousands of narrowboat (as the traditional craft are called) owners use it for leisurely holidays. One of very few people who actually earn a traditional living from their boat is Ivor Batchelor, delivering fuel up and down the canals (with the help of a mobile phone and a good sense of humor).

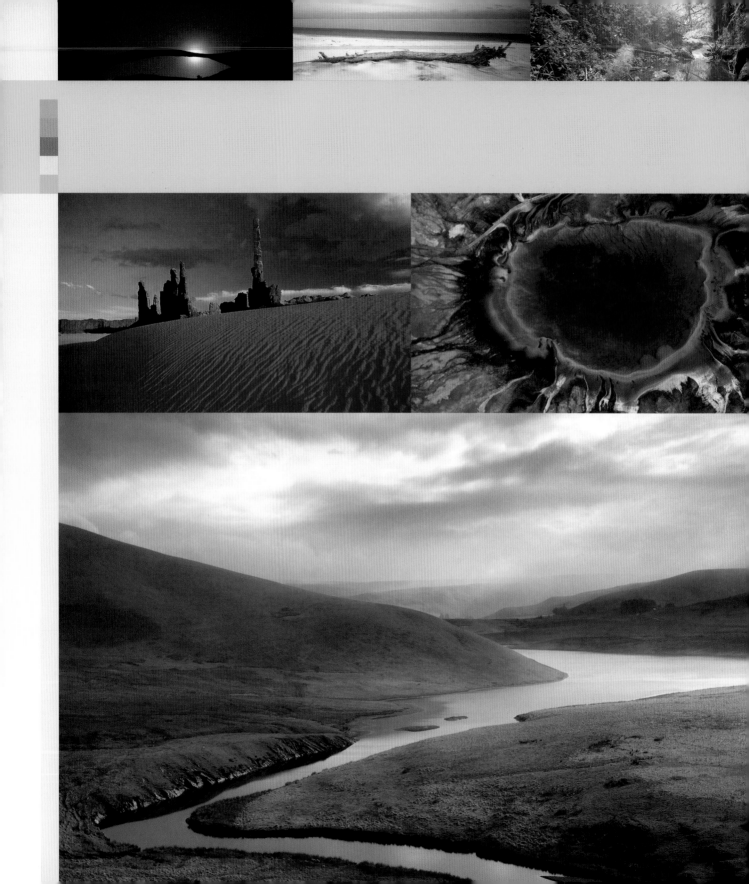

Natural **Landscapes**

Landscape implies image. By themselves, mountains, lakes, valleys, and forests are physical features, but combined and organized into a particular stretch of country, they become a landscape—something we can look at and appreciate visually. And what we can see, if it impresses us, we can make into pictures.

To make a good landscape photograph, it's important to appreciate the complexity of the place itself. Most landscapes create a wide variety of impressions, from the quality of the lighting and the sense of space to the details of rocks and plants. The aim is to distill one image from the total of sensory inputs. Anyone can appreciate a fine landscape, but turning this into a single still image takes skill. Ansel Adams, one of the greatest American landscape photographers, called this "the supreme test of the photographer—and often the supreme disappointment." Adams identified the essential problem, writing that, "Almost without exception, the farther an object lies from the camera, the more difficult it is to control and organize."

And landscapes are mainly far from the camera, and can't be moved around. Instead, the experienced landscape photographer begins by understanding what is appealing about a particular place. This is likely to be a combination of things—the wind, the sounds, the smell of the sea from a cliff-top, the scudding clouds. Not all of these aspects are visual, but it is only through the visual that a photograph can communicate the experience. To capture the rustling of leaves in a wood on a blustery day, the photographer has to find a view and a framing that shows the branches and the sky. Viewpoint, composition, and waiting for the right weather and light are the practical controls that you have.

There are many approaches that you can take to landscape photography, although most of these fall into three basic types. The first is representational—a realistic, straightforward treatment. The second is impressionistic, in which obvious detail is suppressed in favor of a more atmospheric and evocative image. The third explores abstract, graphic possibilities, also at the expense of recording all the details. Many landscape photographs combine these approaches. The first, representational, group is by far the largest, because showing what things are like is what the camera does best. The impressionistic and abstract approaches take more effort and run the risk of being seen as more mannered. Yet even within representational photography there are many styles, from formal to minimal.

It's important to remember that photography follows a long history of landscape painting, during which many ideas, perhaps all possible ideas, were at some point tried out. The ethos of much photography is that of breaking new ground, and this has become almost expected. And yet there is much pleasure to be had from hiking an area of natural beauty and simply capturing it in the way that we experience it individually. There is not necessarily any need to strive to be different. Landscape photography is as much about expressing a personal, simple enjoyment of the outdoors as it is about aiming to create fine art. For many people, it is more so.

A long tradition

"I like definite form in what my eyes are to rest upon; and if landscapes were sold, like the sheets of characters of my boyhood, one penny plain and twopence colored, I should go the length of twopence every day of my life."
Robert Louis Stevenson

Digital landscape photography follows in a tradition that began in the fifteenth century—the idea of treating the land and its views as a subject for art. Until then, landscapes had been depicted only as the background for people and events, and the notion that a scenic view could be celebrated in its own right proved to be revolutionary for painting. The landscape gradually assumed more importance in painting, although it was still often just a scene in which things happened. It was only in the nineteenth century that landscape was finally elevated to its own distinct genre, celebrated by great painters like Caspar David Friedrich, J.M.W. Turner, and John Constable.

Photography followed, with its own special dynamics. Chief among these was the urge to show what places looked like, particularly exotic places. This was landscape photography as discovery; recording amazing sights. This happened all over the world, but because the evolution of photography coincided with the opening of the American West, wilderness landscape

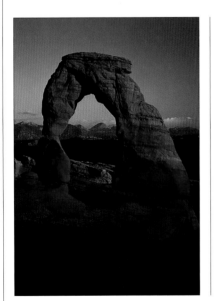

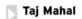

Arch
Landscapes can reveal the natural beauty of the environment, as in this shot of Delicate Arch in the Arches National Park, Utah.

Taj Mahal
There are so many well-worn "beauty spots" in the world that it's important to look for a new angle, such as viewing the Taj Mahal from the opposite bank of the Yamuna river.

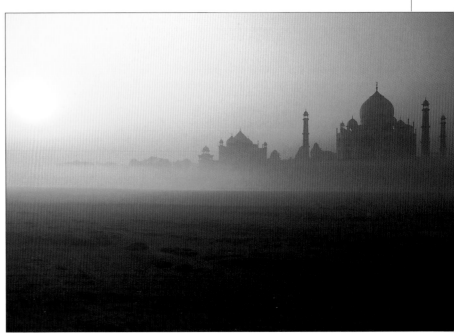

photography was really an American phenomenon. When the first of these photographers, including Carleton Watkins, William Henry Jackson, and Timothy O'Sullivan, ventured West, they were explorers in two senses. They were trailbreaking and discovering new sights, but they were also working out the imaging possibilities of the camera, which was then still a new invention.

This was the other special dynamic that photography brought to landscape—the curiosity about what the camera could do. From Alfred Stieglitz and Edward Weston onward, many photographers have found that the purest way of working is to explore through the camera, and to be guided by the surprises that it delivers. This was landscape photography as a creative act—using the landscape as raw material from which to construct images in the photographer's own unique style.

Although landscape painting may seem far removed from digital photography—even further than from traditional film photography—its long history still has a lot to teach us. Not least among the lessons is that there can be a philosophy of landscape; an underlying intention behind the picture. This easily gets overlooked in the sheer simplicity and speed of making a photograph, and in the many things you can do to the image with software.

Ultimately, though, the great pleasure and excitement of digital landscape photography is the freedom that it gives you to explore and capture the beauty of nature—and, above all, the colors of nature. Digital imaging has introduced photographers to a new way of thinking about color because it makes available a toolbox for adjusting every minute and subtle aspect of color. You can choose your palette according to your style: perhaps delicate and undersaturated; perhaps close to monochrome; perhaps vibrant and full of contrast. This may be far removed from landscape painting in time, but it is closer in terms of artistic freedom.

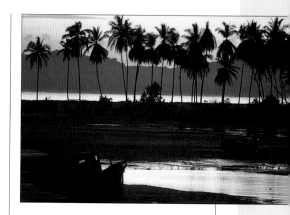

Rivermouth
Time of day is essential in getting the perfect landscape; here, the dusk light sets off this Malaysian scene beautifully.

Toronto
Urban environments and manmade vistas can be just as impressive as nature, as this dusk shot of downtown Toronto, Canada, reveals.

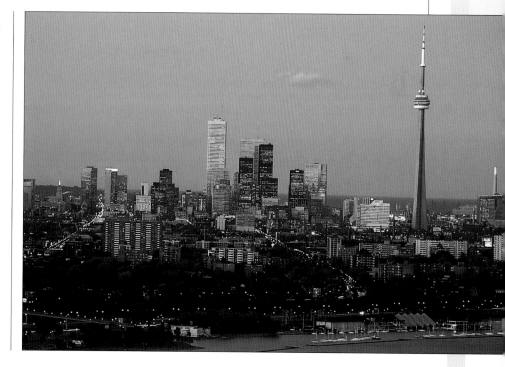

Organizing the scene

Composition in photography is the way in which you order the different elements visually in the frame, and has a special importance when it comes to landscapes.

Landscape is nature, and often—all too often—chaotic. This is at the heart of the problem for photographers—how to bring some sense of visual order to the scene in front. Edward Weston, one of the great American photographers in the formal tradition, at first believed that landscapes were a lost cause for the camera, calling them in general "too crude and lacking in arrangement." Later, significantly, he went on to master them, but Weston put his finger precisely on the issue. He, like most photographers, wanted to make graphically strong images of his own choosing, but landscapes are what they are, and they can't be physically re-arranged in the way that a still-life can.

The view, however, can be altered, simply by moving around it. Finding a good camera position may sound such an obvious thing to do that it's hardly worth mentioning. In practice, however, many people simply shoot what they see from where they first see it. This is by no means always the lazy option—photography is often about catching the immediate on film, and there may just not be enough time to move around before shooting.

▽ Minimalist

The combination of snow and thick cloud on a winter's day in Massachusetts produced scenes that were inverted in tone and almost abstract. Even so, I felt that the beach needed something tangible to hold the composition together, and walked until I found this long piece of driftwood. The camera viewpoint is high enough to locate the tree trunk entirely against the snow. Being slightly off-center with the roots at the right, it draws the eye across the frame from right to left.

Nevertheless, when there is time, use it to make sure that you have the best viewpoint for the shot. Sometimes this may be no more than a matter of improving slightly on your first position; at other times, you may find that a radical change gives you a picture you had not imagined existed. To an extent, and with experience, you can anticipate the view from different positions, but it is always better to walk around and try out the possibilities. Fortunately, landscapes tend to be less transitory than many other camera subjects, except when the weather is changeable.

When you are making this kind of reconnaissance, try out, or at least keep in mind, your different focal lengths. Viewpoint and lens are inextricably linked, and with unusual viewpoints—from above and below—wide-angle and telephoto lenses give completely different types of image, even more so than from ground-level. The view with a wide-angle lens changes much more than with any other kind as you move around the terrain—provided that you are close to the foreground.

Graphic vs. disorganized landscapes

The type of terrain has a decisive effect on composition. Without doubt arid, coastal, and mountain landscapes that feature bare rock and strong shapes have an advantage in the graphic department. Lush vegetation can, from many angles, simply look untidy, blurring the lines and shapes. Graphic is not the only ideal, but it certainly makes for stronger, more immediately striking, compositions.

Finding the foreground
In this sequence, overlooking Bear Wallow canyon near Sedona, Arizona, the late afternoon light was right for the escarpment beyond. With a wide-angle lens, the missing component was a foreground that would relate compositionally with the cliffs. I climbed around an area of rock about a hundred yards in both directions, with these results. The most satisfying composition was the one shown right, when I crouched low so that the branch would fill the right part of the sky.

Figures for scale

With or without people? You may not always have the choice, but including—or introducing—figures into the scene creates a different type of image, with the potential for added dramatic effect.

Several of the techniques that we have looked at already, particularly those that exploit the special characteristics of wide-angle and telephoto lenses, have a secondary effect in that they help to establish the scale and proportions of a landscape. If you crouch down to include a clump of flowers in a view that extends to distant mountains, you are immediately making the scale and perspective clear to the viewer. Equally, focusing in on a distant tree with a telephoto provides a recognizable key. There is, of course, no rule stating that photographs have to be easily understandable, and later, we look at styles of shooting that deliberately take the context out of a landscape. Nevertheless, making a scene intelligible is a common approach, and scale is one of its basic qualities.

There are other reasons for including figures. One is simply that it humanizes a landscape. The figure has a relationship with the scene, and in a way stands in for the viewer, who can identify with the person and have some impression of what it feels like to be a part of that landscape. Figures were an essential component in Classical and Romantic landscape paintings for this reason; when they were depicted in the foreground looking away toward the distance, they were, in effect, inviting the viewer to stand by them and admire the scene. Yet another reason to include a figure in an image is that certain features in a manmade landscape, such as a winding road, look as if they ought to be in use. A passing cyclist, or even a car, often makes a shot look more satisfying than emptiness.

How large the person, or people, should be relative to the landscape is another question to consider. Imagine a scene in which someone is walking along a path toward you, their image getting larger. At a certain point, the figure takes over the image, becomes so dominant that the picture is no longer landscape-plus-figure, but figure-with-background. On occasions like this, it's a good idea to keep shooting and decide later which proportion of person to landscape works best for you. As a general rule, the smaller the figure, the more impressive the setting appears to be by comparison. If the figure is so small in the frame that it takes the viewer a moment or two to discover it, this can add an element of interest and surprise to the image.

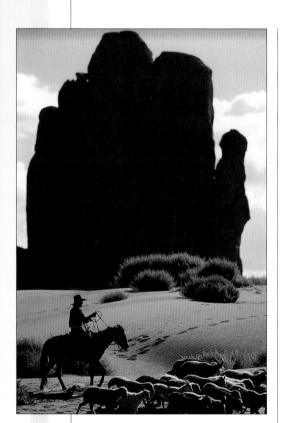

Monument Valley
This area of mesas and buttes on the borders of Utah and Arizona is a paradise for desert landscape photographers. This unplanned opportunity of a local farmer herding his sheep was too good to miss, and offered a different take on a landscape normally photographed without people. It also made the cover of a state guidebook.

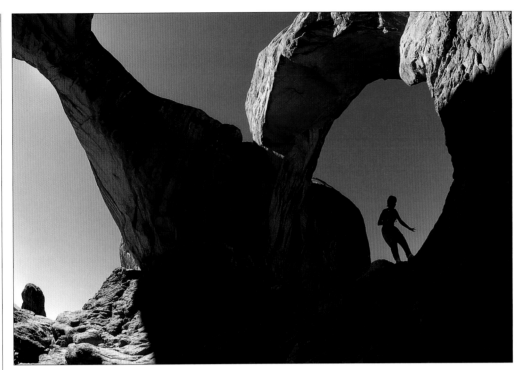

Arches
Arches National Park is known for its exotic arch and window landforms, carved out of sandstone by wind and water. In the version shown left, the presence of a figure gives context and scale, while the image is more graphic.

Cyclist
The shape of this gently winding road in New Brunswick, Canada, seen through a telephoto lens and glistening in the late afternoon sun, had the makings of a photograph, but not alone. I waited until a lone cyclist came pedaling by, giving not only a sense of scale, but a purpose to the shot.

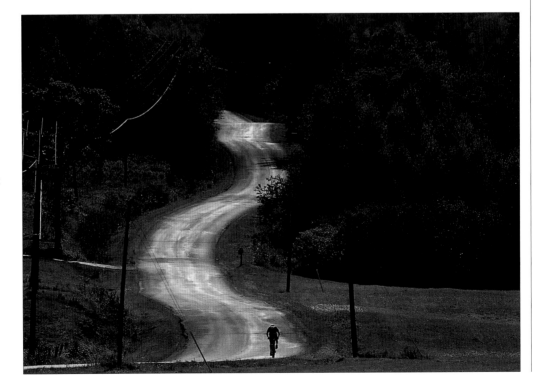

Overlooks

It is a part of human nature to want to climb up to survey the view—any view—and for the camera this offers the opportunity for a larger variety of images than just an overall establishing shot.

High viewpoints have a particular value for photography. They often give a sweeping overview of the landscape—an all-encompassing shot that sets the scene—but also give the opportunity to pick out details. Different treatments can be made with wide-angle and telephoto lenses, and overlooks are places to experiment with this.

Overlooks define themselves. They are locations, usually quite small, that offer a wide view over the surrounding country. Built in to this definition is that it is a worthwhile view, and of course the range and impressiveness of the view varies enormously. But it seems that most of us have a natural urge to look out over things, and good overlooks are usually signposted, marked on maps and recommended in guides. This was less of a problem in the early days of photography when fewer photographers— indeed, fewer people—scoured the countryside looking for grand views.

This is all right as long as you don't mind repeating images that other people have shot. One added limitation of overlooks is that, because of topography in hilly terrain and vegetation, particularly trees, there may be

▷ **Paradise Valley**
As the road climbs up to the snowline on the slopes of Washington's Mount Rainier, it switchbacks through the pine forests. For the most part, the trees obscure the view, but at each outer bend there are possibilities, more or less good. Driving up slowly, I finally found one break that gave the basic conditions for an overlook view—foreground trees but to one side; a middle ground slope falling away; and a clear view to two ranges of mountains. The whole scene tied together as a continuous landscape.

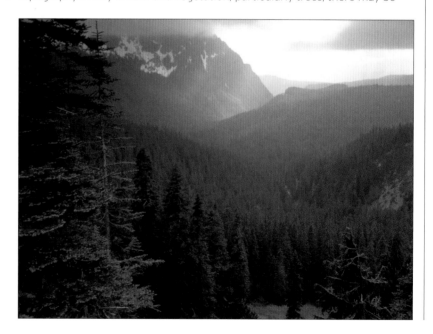

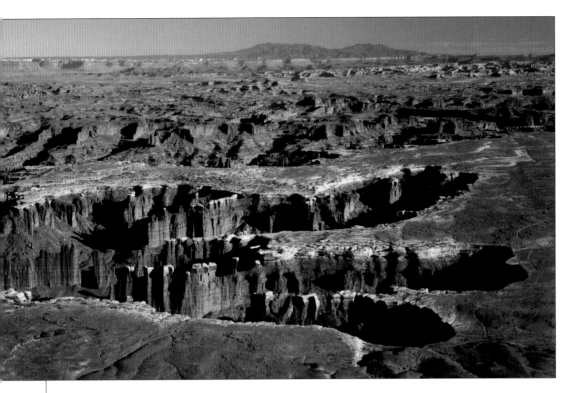

Variety of image
One ever-likely possibility from an overlook is that there may be quite different images depending on the focal length of the lens and the cropping. Here is a simple example from a viewpoint in Canyonlands National Park in Utah. In addition to the obvious main shot taken with a wide-angle lens (left), there are also details to explore with a telephoto, such as the characteristic caprocks (below), where a harder band of pale sandstone has resisted weathering more than the red.

little choice in the camera position, and so little opportunity to vary the composition. To a certain extent you can play with different focal lengths, and so also with the position of the horizon, or whether to include it at all. Here is what Ansel Adams wrote about one of his most famous photographs, Clearing Winter Storm, shot in 1940 in Yosemite: "At this location one cannot move more than a hundred feet or so to the left without reaching the edge of the almost perpendicular cliffs above the Merced river. Moving the same distance to the right would interpose a screen of trees or require an impractical position on the road. Moving forward would invite disaster on a very steep slope falling to the east. Moving the camera backward would bring the esplanade and the protective wall into the field of view. Hence the camera position was determined..." This is entirely typical of shooting from overlooks.

What can make the difference, and allow you to make an individual image, is the light and the sky. Changeable weather can make a stunning difference. With storm clouds in particular, there can never be two exactly similar images. There may be a strong temptation to shoot close to sunrise and sunset in clear weather, but this may not result in an original image.

Framing the view

The frame that you see through the viewfinder is not the only format for a photograph, and many landscapes benefit from having an appropriate shape of frame.

One of the less-than-obvious benefits that digital cameras have brought to photography is that they have released it from the tyranny of the fixed frame. Not all photographers have yet realized the full implications of this development, but the ability to choose the shape of the final image—on screen or in print—is a worthwhile creative freedom. And landscapes, more than many other subjects, need this extra thought, particularly the many views that suffer from uninteresting skies and foregrounds. Being able to crop out certain parts of a scene is an extension of the natural process of composing the image.

And yet digital cameras themselves have a picture format as fixed as any film frame, so why should there be anything different? The answer is in the way that digital photography is now open-ended. Unless you go straight from memory card to printer, you have the intermediate steps of opening and optimizing the images on the computer, where cropping tools are common. And because you can do this, there's every reason to consider exactly how each image should be cropped. Paradoxically, this takes photography back to the days when black and white ruled, and it was normal to treat enlargement and printing in the darkroom as a follow-on creative stage. It was color slides and fast, efficient, photo-finishing labs and shops that removed printing from the hands of most photographers.

▲ **Low horizon, big sky**
From this viewpoint In Big Bend National Park, Texas, there was little of interest in the foreground. There would have been little incentive to shoot were it not for a sky full of different clouds.

The family of frame shapes

One of the following picture formats will best suit a particular subject. The decision of which to use is personal. Within these basic shapes are opportunities for precision cropping.

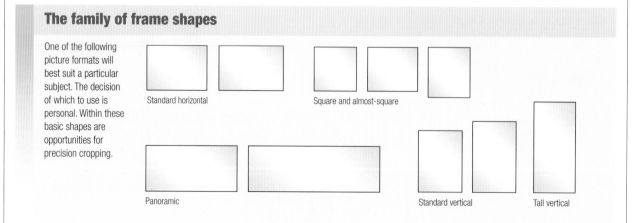

Standard horizontal

Square and almost-square

Panoramic

Standard vertical Tall vertical

Now you can treat each image as its own special case. Most digital sensors—and so the viewfinder and LCD frame—are in proportions of about 4:3, with a relatively small number of digital SLRs offering the 3:2 proportions of 35mm film. Of course, almost any view can be made to work visually in one of these standard frames. In fact, a large part of photography has to do with fitting a scene into the space that the viewfinder allows you. Nevertheless, you should not feel restricted to the format of your camera. You have the option of cropping the picture area later, and this means two things. One is that you can improve the composition of a shot when you come to image editing. The other is that you can anticipate at the time of shooting how you will later crop it.

Fine-tuning the crop should be a normal part of image editing—for instance, taking a little off to remove a twig intruding into the frame. However, the first decision is the basic format, and the choices are shown in the box opposite. Most photographs are shot as horizontals because cameras are made to be used that way (though there is something of the chicken-and-egg in this, as cameras are designed for the way most people take pictures). Also, a horizontal frame is easier to look at because of our binocular vision. In many landscapes, the scene is laid out horizontally, and so suits this shape well. Unless you have a high viewpoint and strong relief, it's likely that this horizontality will be very strong. This is where panoramic formats come into their own, and we look at these in more detail on the following pages.

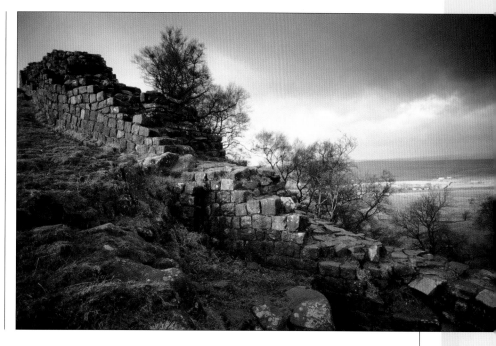

Filling the frame
Hadrian's Wall was built by the Romans across northern Britain. Here, where it courses down a steep slope, it was possible to make it occupy the full horizontal frame as a diagonal, using the storm clouds at upper right to balance the composition.

Cropping to horizontal
This shot is of high moors and wetlands in central Wales. Seen from a slight elevation, the horizontality of everything in view, from the marshy river to the series of low hills beyond, made for a very spare composition. Strong cropping top and bottom emphasized this.

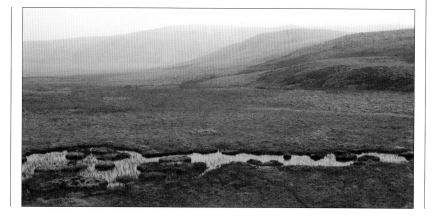

Other frame shapes

Vertical and square picture formats have their role in landscape photography as well as horizontal formats, and digital cropping can improve the final image.

The camera can always be turned on its side for a vertical view. A vertical frame is often worth the slight extra effort to think about and shoot, if only to bring some variety to your pictures. In landscapes, this tends to work best with a telephoto lens and from some elevation, as in the example shown left. Under the right circumstances, the compressing effect that a long lens has on perspective helps to make a compelling image simply because it shows us what we don't normally see in a landscape—features stacked one above the other.

Wide-angle views are much less amenable to the vertical treatment, mainly because of what happens above the horizon line—or rather, what doesn't happen, for surprisingly few skies are interesting enough to fill the larger part of a picture frame. A distinctly wide-angle lens takes in at least an 80-degree angle of view, so this is always an issue, unless the foreground is really worth concentrating on. By the same token, if you can make this work, the image will have the value of being less than common.

Another way of using a vertical frame is when your main focus of interest is relatively small. A vertically framed photograph is slightly less easy to view, and the eye naturally tends to fall to the lower half of the picture—often the most comfortable place to position a subject. Vertical framing obviously also works for tall, thin subjects, such as a lone pine tree. Occasionally, it's worth considering an extreme vertical cropping for subjects like these—the effect is unexpected and so has a certain surprise value.

A square format, very much a hangover from the more old-fashioned medium-format cameras, seems at first glance to fall between the two stools of horizontal and vertical. Nevertheless, it has its own particular character, albeit a fairly rigid and formal one. This makes it suitable for subjects that have an element of symmetry to them, and also to graphically simple, minimal scenes. These can be refreshing occasionally, but can be dull if used in succession. Patterns and textures, however, often work very well in a square frame, simply because it doesn't have a bias one way or another. And, naturally, a square format also suits any subject that fits neatly into it, such as a broad single tree in full leaf.

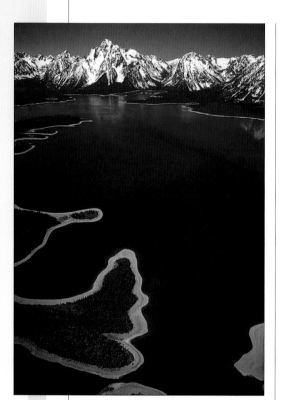

Vertical aerial
To work vertically, overall landscape views generally need foreground interest to sustain the composition. In this aerial of Jackson Lake and the Grand Tetons, Wyoming, shot with a 20mm efl lens, the shoreline made an obvious counterpoint to the mountains beyond. I began shooting horizontal frames, but as the aircraft approached the lake, the visual separation between the shore and the mountains increased, and I switched to vertical framing.

▶ Giant fern

A square frame, giving no bias in either direction, perfectly suits this shot of a giant tree fern on the slopes of a mountain. The essence of the image is the evenness of texture and color, which fill the picture frame.

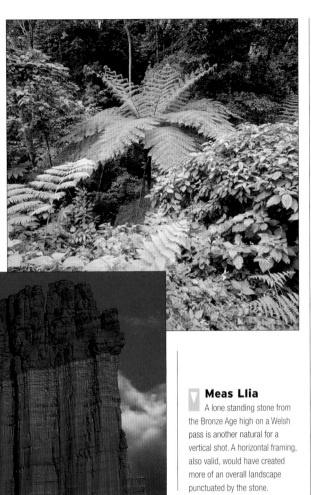

Cropping or extending

The natural way to alter the frame shape is to use the Crop tool in an image-editing program, and this is intuitive. An alternative is to enter new dimensions for the canvas size. But you could also consider extending the frame by taking an additional shot or two that overlaps with the first. These can be assembled easily.

▽ Extreme verticality

A huge Douglas fir growing in a narrow sandstone canyon is one of the spectacles of Bryce Canyon National Park, Utah. The viewpoint is limited to just this, and the extreme verticality of the image makes this strong vertical cropping a natural.

▽ Meas Llia

A lone standing stone from the Bronze Age high on a Welsh pass is another natural for a vertical shot. A horizontal framing, also valid, would have created more of an overall landscape punctuated by the stone.

△ SLR ratio

The proportions of this sandstone tower coincide closely with the 2:3 ratio of a digital SLR, making it an easy fit that emphasizes the color contrast between the rich red of the rock at sunset and the surrounding margin of blue.

Panoramas

Although the shape of this format is extreme, a panoramic frame has a special place in photography—and above all in landscape imagery, with which it has a close affinity.

There are no precise definitions of a panorama, but it is normally accepted to be at least twice as long as it is high—proportions of 1:2, 1:3 or even more. The dynamics of this kind of picture frame are quite different from those of the standard rectangles in digital photography (3:4 and 2:3), and work as well as they do in landscapes because they fit neatly into the way in which human vision works.

We see by scanning, not by taking in a scene in a single, frozen instant, meaning that the eyes build up a composite impression of a view by moving rapidly across it, lingering over details one at a time. The easiest movement for the eyes is from side to side, which is why we tend to "see" and remember open scenes, such as those from an overlook, as panoramas. Expansive landscapes are exactly the type of subject that comes closest to these conditions. In fact, the majority of landscapes, as we experience them, are essentially horizontal, frequently dominated by the horizon and by the linear

▼ Pleasure in detail
To work for the viewer, a panorama needs to be reproduced large and seen from close. The effect is of immersion within the scene. At this scale of reproduction (ideally even larger than below), the eye can explore the details of a landscape, which does not, therefore, need to contain obvious and dominant features. Here, the play of light after an evening storm picks out the fine details of fields and hillsides.

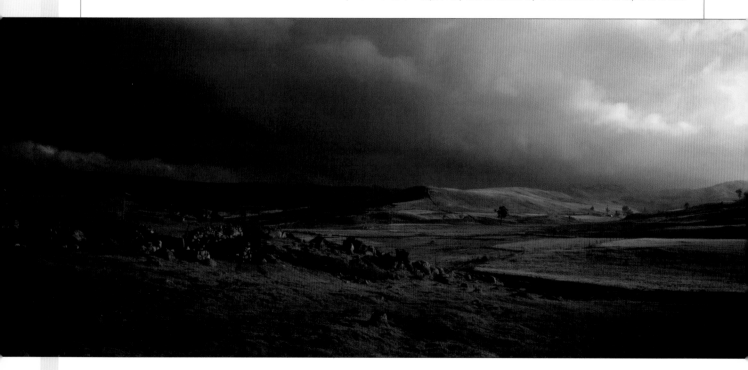

appearance of features that recede into the distance, such as ranges of hills and mountains. By contrast, we tend to ignore the upper part of the sky in a view.

To work optimally, a panoramic image needs to be reproduced large and viewed from close—in other words, approaching something of the scale of a real scene. This gives added importance to the way in which you display and present the image, ideally as a large print or on a large screen (the desirability of so-called "cinema" monitor displays and letterbox formats is further evidence of how attractive this format is to most people).

One of the features of a "longish" panorama, say 1:4 proportions, is that if you view it at a sensible distance, so that the height seems adequate, it is not possible to see the entire image at once. Parts of it remain peripheral, and this replicates the way we look at an actual landscape. It adds an element of realism to the picture, and, in theory at least, slows down the viewing process, prolonging the interest of exploring the image.

Digital photography is arguably the best means ever of reproducing a panoramic landscape. In the days of film there were just two alternatives. One was to crop the image down from the top and bottom of the negative or slide, with the obvious disadvantage of losing resolution if a small frame had to be greatly enlarged. The other was to use a special panoramic camera, of which several designs are still made, each using a wide strip of film; these are a costly additional piece of equipment. With a digital camera, however, it is possible to build up a larger, longer image by shooting several overlapping frames from one side to another. Indeed, now that stiching software is widely available, this is not just possible but easy. Many camera manufacturers include this capability on the software package that accompanies the camera; this attests to the popularity of stitched panoramas, which we examine on the following pages.

Moving the eye horizontally

It can help to strengthen the composition of a panoramic frame if you use features in the landscape that give a direction across the image from one side to the other. In this late afternoon view from close to the summit of a volcano in the Andes, the slope of the terrain, partly defined by the clouds, is from the left foreground to the distance on the right. The plume of gases from a fumarole on the left sweep down the hillside in a blur (because of the long exposure in fading light), adding to the sense of direction.

Stitching and mosaics

Now an integral part of digital photography, software to join adjacent frames is at its most useful in creating images featuring broad panoramic sweeps of a wide landscape.

Panoramas have a time-honored role in landscape imagery, and they have truly come of age with digital photography. In a striking example of how technology can have a positive creative effect, the invention of stitching software has made it extremely easy to shoot overlapping frames and join them together into one seamless image. The software is available from a number of sources—even included with the camera in some instances—and its success has been due as much to simplicity in use as to engineering. The software varies in its user-friendliness. The better-designed ones require no special skill, and it is only by being fast and practical that stitching is useful as a part of landscape photography.

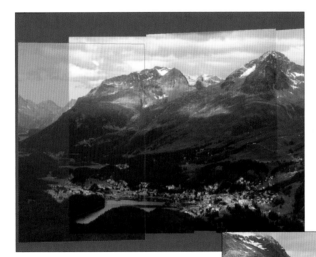

Stitcher

Using the Stitcher 3.5 software from RealViz, this sequence was shot and compiled with minimum preparation. Using a 160mm efl lens without a tripod, the sequence was shot rapidly from a mountain overlook in the Swiss Alps, from right to left, overlapping by approximately 40 percent from frame to frame. The long telephoto lens offered no distortion problems, and the only disadvantage to not using a tripod was a slight loss top and bottom because of the unevenness in the sequence.

What to look for in stitching software

1 Drag-and-drop loading and placement of images.
2 Largely automated.
3 The ability to stitch hand-held sequences.
4 The ability to predict lens focal length and distortion.
5 The facility to handle the file format that you usually shoot.
6 Manual "force" stitching override.
7 Planar output as well as cylindrical and other interactive formats.

The basic use for photographers is to assemble a panorama. While stitching software is also designed to produce cylindrical and even spherical images, for a normal, flat photograph you simply need planar output. The stitcher works by matching identical features in adjacent frames, so the more information it has, the better. A good rule to follow is to allow 50 percent overlap. The easy way of doing this is to pan and shoot from one side to the other, using an obvious detail close to the leading edge of one frame as a reference point, then centering this in the next frame (see box). Strictly speaking, the camera should be rotated around the nodal point of the lens, but in practice it doesn't have to be so accurate, unless you are shooting with very close to something with a very wide-angle lens. The second step in the process is equalization, in which the software computes the blending of tones and colors. To do this accurately, the exposures should all be the same; hence manual, not automatic.

A second use is to build up a larger image from smaller sections. There are two reasons why you might want to do this. One is to make a higher-resolution image than your camera is capable of in one shot—simply switch to a longer focal length and cover the same area with a pattern of frames, then stitch. The second is when you can't step back far enough to cover the view. Again, take two or more shots (or as many as you like) and stitch on the computer.

These are essentially realistic solutions, but there are other approaches. One is to make a multifaceted portrait of a location by shooting from a number of camera viewpoints, then combining the different images in a mosaic. There's no question here of a seamless image, but you can take more of a Cubist approach. The digital component in this treatment is really the ease of cutting, pasting, and joining.

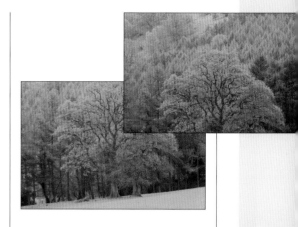

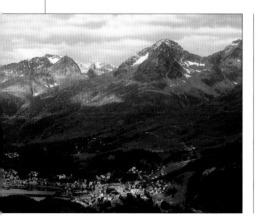

Shooting a panoramic sequence

Choose a convenient viewpoint and shoot the entire sequence from there. Make a dry run first to see how many frames you need to complete the panorama, allowing for a large overlap. Work from left to right, or right to left, in one sweep, and use details at the far edge of each frame as a focus for the center of the next frame. For accurate blending, which applies especially to the sky, switch to manual exposure and find a setting that will cover the widest range of tones. In a cylindrical or very wide panorama, the sun is likely to be in shot somewhere. One solution to avoid flare is to stand so that it is shaded by a natural feature, such as a tree.

Achieving higher resolution

It was not possible to get far enough back along a country lane to include all of this tree with a 270mm efl. The solution, with the added benefit of higher resolution, was to build up the image from two partial shots, taken with the 270mm efl lens, using stitcher software to create a composite.

Interactive landscapes

Panoramas encourage the eyes to wander, exploring the scene and finding their own views within, but to make the most of this involvement, the images need to be presented large.

The first reaction to an interesting landscape is to try to take it in as a whole. It will be most immediately absorbed as a wide vista, stretching to the horizon. The eyes sweep across the scene, taking in the sense of scale, the mass of detail, and the relationship between the foreground and the background. These are the appealing qualities of a panoramic view—it is expansive yet full of hidden interest. The stretched frame forces the eye to flick from side to side, just like viewing a real landscape.

To convey this impression in an image takes care. Human perception views the scene quite differently from a photograph taken from the same viewpoint. With the real landscape, our eyes build up a composite impression by scanning, lingering over details one at a time. To allow this to happen with a photograph, it must be reproduced at a scale so that at a normal viewing distance it cannot be taken in without moving the eyes. Panoramic frames such as these give the eye a chance to roam around the picture. Provided that you view it close enough, you discover different things within the picture, even if this takes only a few seconds. This draws people into a panorama, and helps to make it more interactive than a normal image, in the same way that wide-screen movies, like those shot in Panavision, have something of a "wrap-around" feeling. In composing a panorama, don't feel compelled to integrate everything. The frame can act like a storyboard, with things going on in different parts. It even works to have the frame "divided" into panel-like areas. Where possible, include plenty of detail or events in the frame, so that the eye has every opportunity to explore.

Andean landscape
Panoramic formats are easier than any other for landscape composition and framing because they seem so natural to the eye. The main concentration of interest here is the pale-colored stream fed by geothermal springs. The expanse of vegetation right and left, instead of being redundant, helps to enhance the setting.

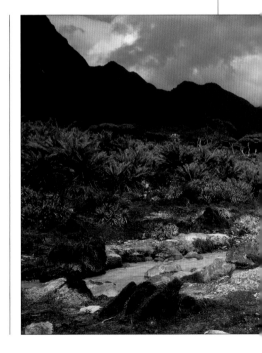

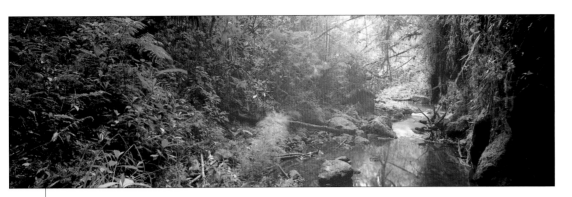

Rain forest
This enclosed view of rain forest deliberately excludes any horizon or open space. By extending the view left into a mass of vegetation, the panoramic frame gives an entirely accurate sense of forest stretching on endlessly.

Sunset
This minimal panorama was shot late in the evening in uncharacteristically clear weather in the Scottish Hebrides. With the sun just touching the low hills at the end of the loch, everything of interest was compressed into a narrow horizontal band. No other format would have done adequate justice to this scene.

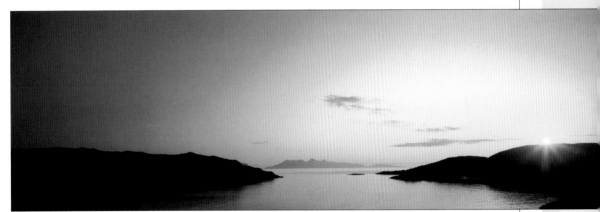

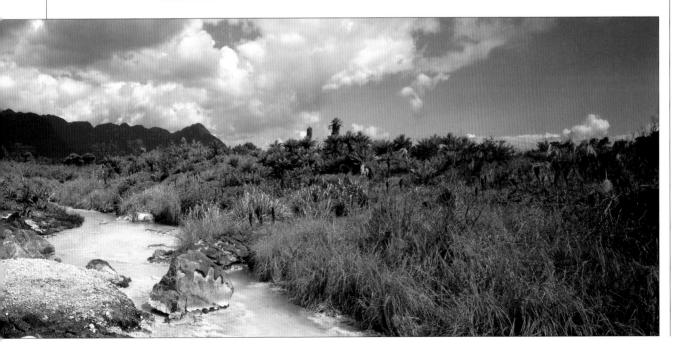

Natural frames

Although hovering on the edge of a cliché, the use of overhanging branches and natural windows as devices to organize a scene can be effective if used sparingly.

Occasionally you can find—or make—a kind of frame within the scene that you are photographing. It might be something as obvious as an archway or the overhanging branch of a tree, or it might be more inventive—an arrangement that exists only because of the way you position the camera. Like any other strong technique, it succeeds when used occasionally, not most of the time, and also when you exercise some originality. If the device is repeated too often or if it is too obvious, it becomes a cliché.

When it does work, it gives a graphic completeness to a picture. This is partly because the frame is natural—in the sense that it is part of the scene itself, and not just an arbitrary rectangle like the camera's viewfinder. There is a kind of formality in this kind of composition, because the natural frame contains the view. This is exactly the opposite kind of picture design to that in which you allow the elements in the scene to spread out and flow beyond the edges of the frame. The emphasis here is on concentrating the view and directing the attention inward. There is another reason why it tends to integrate an image—the frame is a distinct foreground. Combined with the scene beyond, this gives a sense of depth, and helps to pull viewers into the picture, giving them the impression that they are looking through from one scene to another.

Natural frames include branches of trees (this tends to be most effective when you include part of the trunk and the lower curve toward roots), rock arches, cave

▼ Window onto a beach
By a happy coincidence, this natural window, formed by an old piece of driftwood, not only faced out toward the sea on a Washington beach, but also corresponded in shape with a rocky island just offshore. The combination of lens focal length (wide) and camera position was important in creating a tight frame.

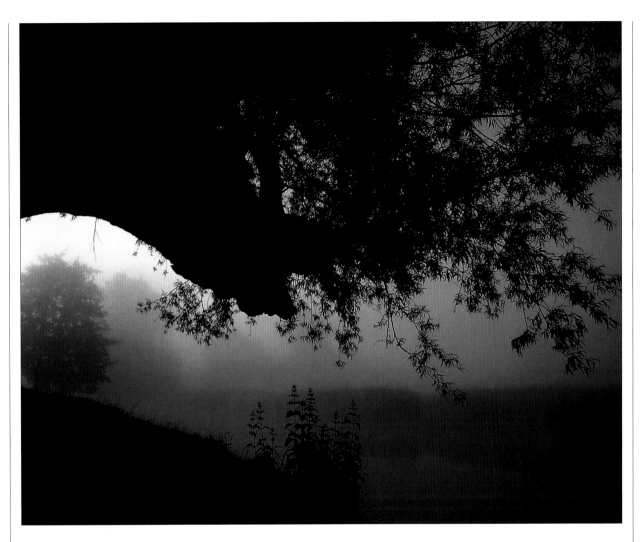

openings, gaps in fences and gates, and more. Pay attention to the light, color, and detail on this natural frame. The cleanest graphic appearance is often when the frame is in shadow and the scene beyond brightly lit, but an interesting texture, such as the bark of a tree trunk or weathering on an old gate, will usually add to the image. Also experiment with the size of the frame that you've found in relation to the picture frame in the viewfinder. If you leave too much space between the outer frame edge and the inner natural one, the full framing effect will be less. If there is only a narrow gap between them, this in itself can make an interesting shape. Silhouetted frames, such as those that you can find when looking outside from a darkened interior, are graphically the strongest of all.

Overhanging branch

Morning mist along the banks of the Stour River in eastern England gave all kinds of silhouette possibilities with the oaks, willows, and other riverside trees. The curve of this thick, overhanging branch was begging to be used as a frame. As in the picture opposite, the choice of lens focal length and distance determined the framing—in this case, of a misty tree in the distance.

A point of focus

One classic approach to landscape photography is to emphasize one particular subject within the scene, making it the key to the composition.

At the heart of landscape photography is the appreciation of how the image differs from the experience of actually being present. The image frame fixes the view and our response to it. Instead of the eye roaming around a real scene, concentrating for a moment on a detail, then moving elsewhere so as to build up a composite impression, a photograph is channeled into a tighter way of seeing. And the eye naturally looks for reference points—for objects in the landscape that give some sense to it.

Ansel Adams, who wrote extensively about his own exacting methods of landscape photography (which is why I make no excuse for quoting him a number of times), was of the opinion that "in landscape work, we must strip the image of inessentials." In other words, decide what the picture is about, concentrate on one or two elements, and compose the image to make these prominent. There are other ways of designing a landscape photograph, as we'll see in some following pages, but it's no bad idea to begin with a single, dominant subject.

The essence of a subject

The subject here is a forest waterfall. This was attractive enough in long shot, but not particularly distinctive. This was a feature that would benefit from a less obvious treatment. Using a longer lens made it possible to fill the frame with falling water, but keeping the focus on the leaves in the foreground. A long exposure turned the water into a streaked blur, but it is still very much the subject of the shot.

With a single subject there are all kinds of choices. You can move the frame around and make it larger by moving closer or by switching to a telephoto. As the pictures here show, each different choice gives a new sense to the subject. If it fills the frame, the visual impact can be immediately striking; if it is small and isolated, the subject is set firmly in its surroundings. First decide which approach would work best for the scene in front of you. Filling the frame lets you show more detail in a subject, and also cuts out irrelevant or distracting surroundings. On the other hand, the setting may be very important to the subject—it may be unusual, or put the subject in context, or simply help make an interesting design.

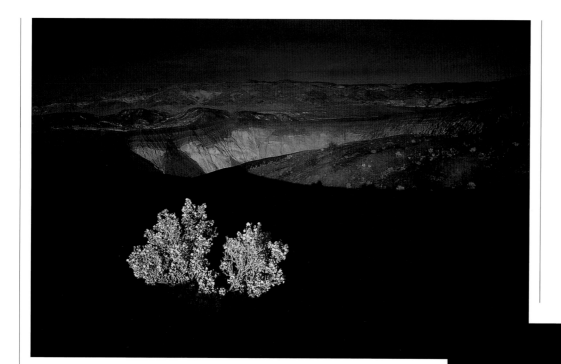

Supposing that you choose to show the background, you can then usually place the subject anywhere in the frame. Each position would make the whole photograph work in a different way. Take the example of a tree that has grown in an exposed, windswept position, such as on top of a coastal cliff, leaning slightly and with most of the branches extending away from the wind. This is an obvious example of a feature that contains implied movement, a sense of direction. If you place the subject close to the edge of the frame, you will have added motion, either inward or outward depending on which side of the frame you choose. Position a small figure near one corner, and the background takes on a new and interesting role. Don't necessarily do the obvious: aiming the camera like a gun to place the subject in the bull's-eye center is often the dullest idea of all. In fact, the closer in you are, the less room there is to move the subject around in the frame. Consider moving in toward or farther away from the subject, or to change the focal length. This is easiest to do with a zoom lens. When you are really close, it becomes a matter of simply fitting the subject into the frame. Generally speaking, if you fill the frame and leave very little room for the background, the image will have a stronger, more immediate impact; this does not necessarily mean that it will be better, however.

Lighting determines the focus
Late afternoon at Ubehebe crater in Death Valley. The black volcanic soil makes a strong contrast with almost anything, and, as the sun just grazes the rim of the crater, it throws a lone silver bush into sharp relief. This is very much an opportunistic point of focus, and it was a simple matter to find the lens and position that would set this against a more distant sunlit patch—the far rim. This completed, I looked for a counter-image, shooting the silhouette of the bush from below. This was also quite interesting, though less informative and less striking.

The horizon

Landscapes, more than any other class of subject, present you with the possibility of having a horizon line in the frame—and the compositional choice of where to place it.

In landscapes and in many other long shots, the horizon line insists on making its own division of the picture, and the more the contrast between sky and land, the stronger it cuts through the photograph. The horizon also tends to overwhelm the composition when it is flat (and so lines up with the top and bottom edges of the frame), and when the view is bare and simple.

Depending on the actual view, you can choose where you place the horizon line at any height in the frame, from close to the top to right at the bottom. The two most conventional positions are roughly a third of the way down from the top or a third of the way up from the bottom, and much depends on whether the landscape or the sky is more interesting. Usually, intuition will guide you best, and the specifics of the view tend to suggest the most natural position. If in doubt, shoot different versions and select later. The extreme positions—at the top or bottom—can be more exciting, but need some justification. If the horizon is very low in the frame, it gives the sky overwhelming prominence. This is a good choice if there are interesting clouds, or when you want to create the impression of wide open spaces.

If the horizon is very close to the top of the frame, this type of placement might in theory seem to take attention away from the sky, but it often has the opposite effect. Because it is such a deliberately unusual way of handling the horizon, it can actually concentrate the viewer's attention on the very narrow band of sky. This is good way of making an effective feature of storm clouds, for example.

Horizon at the base

Every scene containing a prominent horizon line needs to be considered on its own merits. For this water-level view of limestone islands in Thailand's Phangnga Bay, shot from a boat, there was nothing of interest below the horizon other than a few reflections, but plenty of interest above. This made an otherwise extreme placement, at the bottom of the frame, the natural choice.

In all cases, make sure that you keep the horizon level; an angled horizon line is hard to ignore and spoils a picture. Some digital cameras have the menu option of displaying a grid—the equivalent of fitting a special grid focusing screen into a traditional SLR—and this is an excellent way of keeping the horizon level. In any case, the horizon can be straightened later by rotating the image slightly in an image-editing program.

A final choice that you have is to break the horizon line by changing your viewpoint so that part of the foreground comes more strongly into view. In a landscape, for instance, lowering the camera position may make a rock or plant appear higher in the frame. This reduces the graphic effect of the horizontal break.

Progress

Rotate Canvas

Cancel

Mono Lake

There are no rights and wrongs in locating the horizon, as long as there is some logic to it. In this view of Mono Lake in California, taken on a perfectly still evening, the reflection of the sky in the water, and the minimal simplicity of the scene, made both these versions acceptable: the more conventional off-centered placement, and the one in the center, which exploited the mirror-like appearance of the scene.

Aligning the horizon line

If the horizon is at an angle in the image, use one of the rotation tools in an image-editing program to realign it. Switch on the grid to assist; you can specify how dense or open this should be in the program's references.

Managing bright skies

Including both ground and sky in one shot sometimes brings technical problems of contrast and brightness, which you can solve both at the time of shooting and later, digitally.

While there is no compulsion to frame the view so as to include the horizon, most landscape images tend to follow this composition. Indeed, for any overall view, you would have to work quite hard to avoid it. Including the horizon creates a division between sky and land, which brings with it the question of brightness. This is largely a technical issue, and depends very much on the weather. If the sky is much lighter than the ground, a straightforward shot will fail to record both adequately. The most extreme conditions are "cloudy bright," with unbroken but not particularly heavy cloud.

There is a matter of creative judgement involved in dealing with this. Most photographers would see the high-contrast split between sky and ground as a problem, but it is also possible to use the large area of white in the upper part of the picture as a strong element in the composition. It can even suggest more depth to a landscape, which is why traditional black and white landscape photographers (Ansel Adams, for example) often used a blue filter to increase haze and decrease visibility.

Nevertheless, there are ways of overcoming the difference between the sky and ground exposure, more so with digital than ever before. One straightforward method is to reduce the sky exposure by using a neutral grad filter—this is still one of the most useful accessories in the outdoor photographer's kit. It works

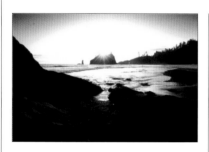

Exposed for foreground
Shooting into the sunset, when the exposure is good for the foreground rocks, the sky is blown out—a large area at 255 on the histogram.

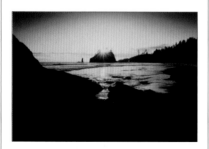

Exposed for the sky
Reducing the exposure brings the sky back into range, particularly around the sun's flare halo, but the foreground is now far too dark.

Low-contrast correction
A standard reverse S-curve lowers the contrast, but still fails to preserve details at the shadow and highlight ends of the scale.

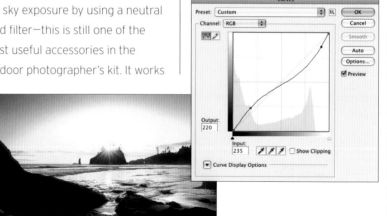

only with standard to wide-angle lenses, not telephoto, and is best when there is a clean horizon break. If a tree, rock, or other feature rises above the horizon, this too will be darkened. The most useful strengths are one f-stop (ND 0.3) and two f-stops (ND 0.6). There are also digital grad filters, such as the comprehensive set from NikMultimedia in its Color Efex suite, but these simply add a visual impression and do not help to restore any of the original sky detail lost in overexposure.

There is a certain amount of tone compensation that you might be able to apply, depending on your camera's menu, and lowering the contrast will help overall. However, this will also lower the contrast of the landscape, which you may not want at all. In order to capture everything, you need to combine two different exposures during the image-editing stage. Overlay one image exposed for the ground in perfect register with a second exposed for the sky (and so much darker overall), and erase the sky in the upper layer.

One way to achieve the two exposures is to shoot with the camera firmly on a tripod, but if you shoot in RAW format, you can work with a single, handheld image. The RAW format will give you an exposure leeway of at least two f-stops, and can create two differently exposed images using the camera manufacturer's editing software, or a RAW plug-in with Photoshop, for example.

Flare

Flare is a by-product of a bright sky that can work against the photograph. Cheap lenses and zooms with many elements are prone to flare, and the manufacturing solution is to apply extremely thin coatings to the lens surfaces. Basically, the better the lens, the less the flare. With bright skies, flare appears insidiously as an overall degradation and desaturation. Digitally, you can work on flare when image editing by setting the black point on the darkest part of the image, and by turning up the saturation in the HSB controls. Needless to say, it's better to avoid this by minimizing the flare when shooting, by shading the lens.

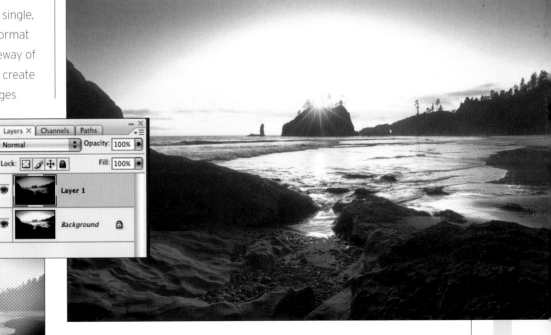

Layer composition
By superimposing the dark exposure frame over the light version, in register, the sky from the upper layer can be erased. Note that the left foreground rocks have been protected by a selection mask while the large eraser brush is applied.

Ruby Beach
The final version is a composite of two halves, upper and lower, each well exposed within their tonal ranges. If you use TIFF or JPEG, shoot two frames to do this. In RAW, you may achieve a similar pair from one shot, opened on the computer with different exposure settings.

Golden light

The most reliable time to search for idealized, romantic landscapes is when the sun is within an hour of rising or setting—this is the "sweet" light for outdoor photography.

Trying to evoke the special and the beautiful in photography is part of a long line of tradition that strives for a kind of perfection—capturing scenes that are idealized and evocative. The light, above all else, is the engine for creating this kind of image, and even though the subject and composition is extremely important, what normally motivates photographers is first and foremost the special lighting. They then go looking for a good view to make the best use of it.

This is the Hudson River School of painting brought up to date—gorgeous skies and the warm glow of sunlight raking across the land to alternate with deepening shadows. This school of American painters were following the tradition of European Romantic landscape painting, which was concerned less with subject than with luminosity and sensuality. Their preferred time of day was typically the end of the afternoon, with long shadows and warm, soft sunlight. Similarly, when photography followed in this tradition, after the invention of Kodachrome with its famously saturated colors, this more often than not became the lighting of choice for sensual and evocative scenes. Photographers such as Ernst Haas and Jay Maisel made regular use of these rich and theatrical colors. Digital photography can make even fuller use of this light because you can choose exactly what color balance to use, as well as altering contrast and saturation. Although there is a temptation with this new-found color freedom to go for extremes and exaggerate the effect, a more muted and restrained approach is usually more successful.

One modern master of the dramatic landscape photograph, Galen Rowell, called the brief time when daylight is at its most colorful the "magic hour." The sunlight becomes warmer (that is, more orange), while

Bryce Canyon
The tops of rock formations of Utah's Bryce Canyon are lit as the western slope falls into shadow well before sunset, but the rock reflects the opposite canyon wall.

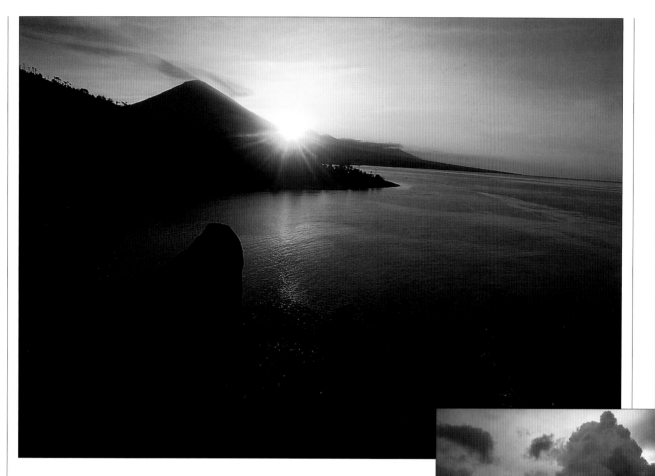

the shadow and sky tones become bluer and cooler. It evokes a predictable admiration from most people, the major exception being sophisticated viewers of photographs treated to a surfeit of such luxurious lighting. As to why this lighting has such a universal appeal, the reasons are complex, cultural, and tied up with the idealism that is at the heart of Romanticism.

As we'll see in the following pages, there are practical, as well as expressive, reasons why the golden light of early morning and late afternoon is so often used by landscape photographers. It allows completely different kinds of image, from the deep color saturation with the sun behind the camera, to crisp silhouettes when shooting into the sun.

Eastern Bali

Two features help this late view up the eastern coast of the Indonesian island of Bali. One is the marked silhouette of the island's largest volcano, Gunung Agung; the other is the plume of smoke rising from its summit, which diffuses the sunlight into a soft glow.

Clearing tropical storm

At the end of the hot season, storms frequently build up in the tropics during the late afternoon due to convection—the land heats up and rising air builds up into thunderheads. The complex layering of clouds, as in this view over the Gulf of Thailand, is unpredictable but always worth looking out for.

Case study: **a summer's morning**

The golden light depends partly on time of day, but also on the weather. This is Dedham Vale in eastern England (coincidentally Constable country) in June. This valley of the Stour River often has morning mist in the summer, which gives a softness to the light as it gradually burns away. The sun rises early, at 4:30 a.m., which gave me a good hour of delicate, warm light, sufficient to fully explore the scene.

Meadow, Dedham Vale
Morning dew among the water meadows catches the sunrise to give a sparkling halo around the flower heads.

Dawn mist on river
The banks of the Stour River. The branches of a fallen tree obscure the sun's disk for this into-the-light shot.

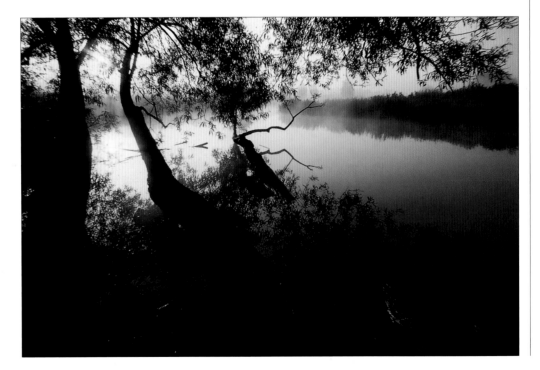

Duck on river

A duck and her chick paddling away from the camera give a charming point of focus, from both a visual and photographic perspective, to this tranquil early-morning image. They also provide a much-needed touch of movement to an otherwise virtually lifeless scene.

Caddis fly

A caddis fly warming up on a leaf blade. The shot is enhanced by the dew, which catches the morning sunlight and adds definition. The fly feeds on plant juices and nectar, so will often pause on a stem like this for quite some time.

Trees in morning mist

The mist slowly rises up the valley slopes, dividing the trees and hedgerows into separate planes.

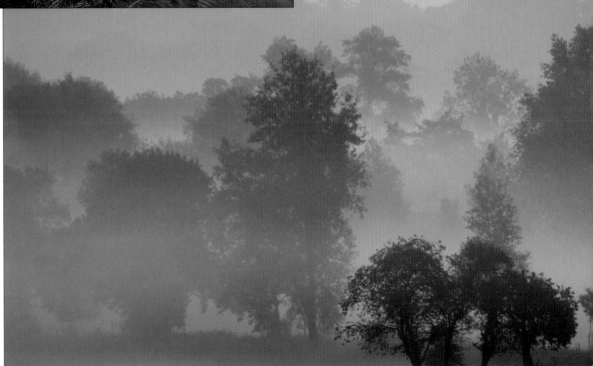

Sunrise, sunset

Often a postcard cliché and a magnet for snapshots, the setting and rising sun can still, with enough care and imagination applied to it, make for a strong image.

The hour or two around sunrise and sunset are special times for photography. Provided that the sky is not overcast, the light will usually be interesting, varied, and very picturesque. There's something of a risk of cliché attached to these moments, as they have been photographed so many times and are often used commercially in sugary ways, but this is precisely because so many people find them attractive. They obviously strike some chord in us. The more you photograph sunrises and sunsets, the more discriminating you become, and you quickly tire of seeing simply the red disk of the sun hovering near the horizon. To work best, the sun usually has to make some contribution to the design of the image.

For photography, these short moments also offer a tremendous variety of lighting effect. Every quality changes from minute to minute, and there is usually the pleasure of unpredictability. With the sun so low, you can often choose from frontal lighting, side-lighting, and back-lighting. A wide-angle lens will capture the full sweep of the sky, while a telephoto can concentrate on the detailed effects of color, silhouettes, and reflections.

Although the timing is important for the particular location, there is no intrinsic difference between sunrise and sunset. In a photograph, if you were not familiar with the place, you would find it impossible to tell the difference. In the summer at least, sunset is usually a more convenient time to shoot—but there are likely to be more people around as well, which you might not necessarily want in a view. Sunrise rewards early risers with (normally) peaceful and empty scenery.

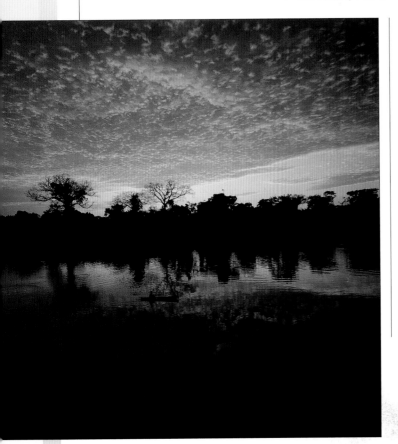

Amazon sunrise
Here the sun rises over the Estreito de Breves, a set of narrow channels in the lower river. Timing was important to catch the right combination of sun and clouds—and the lone canoeist. The dense and unusual cloud pattern makes the shot.

Clouds can either kill or make a sunrise and sunset view, and you can rarely be certain exactly what will happen. Overcast is usually a wash-out, but mixed clouds offer the possibility of the sun breaking through over different parts of the landscape. In any case, unless you have a pressing engagement for cocktails, stay on for dusk after the sun has set. The most frustrating thing is to pack up after you think you have captured the best of a sunset and then, on the way home, suddenly see the sky light up for a resonant twilight that you miss shooting. If you are shooting at sunrise, try to set up the camera at least half an hour earlier than the actual time of sunrise.

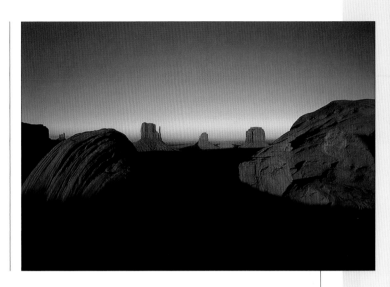

▲ Mitten Buttes

A view of Monument Valley famous for its symmetry. The clear desert air kept the intensity of sunlight until the very last minute of setting, with the rich red increasing all the time.

◀ Into the sun

Photographs of the sun's disk close to the horizon with a telephoto lens (here 500mm efl), risk being clichéd through their overwhelming popularity. Nevertheless, this does not invalidate them, provided that something of interest is happening in the sky apart from the sun—in this instance, the veiling of a band of clouds.

Twilight

After the sun has set, and a little before it rises in the morning, the sky can go through some remarkable changes, creating a delicate, sometimes magical, effect.

Twilight is the brief period when the sun lights the sky from below the horizon. How long it lasts, and what happens to the colors, depends on the season and the latitude. Summer twilight in Northern Europe and the northern part of North America can last for a few hours (in the far north, all night in high summer); in the tropics it lasts less than an hour.

On an overcast day, there is no special light to speak of—it simply fades to black—but in a mainly clear sky, the colors shade from the horizon upwards. Like sunrises and sunsets, the effects are often unpredictable, but the sky colors can occasionally be intense. A classic twilight in clear weather goes from orange on the horizon, through yellow, to deep blue. Occasionally, there is even a trace of green between the yellow and the blue. The reflection of the sky in water can give a useful balance to the composition of the picture.

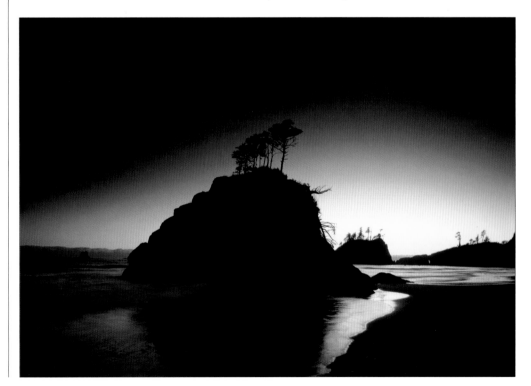

A strong silhouette

Twilight is almost always pure backlighting, with no detail visible in the shadows. This makes it important to have clearly distinguishable shapes that give coherence to an image. Two small islands weathered down from rock stacks on the Olympic National Park coast of Washington contrast with reflections in the sea.

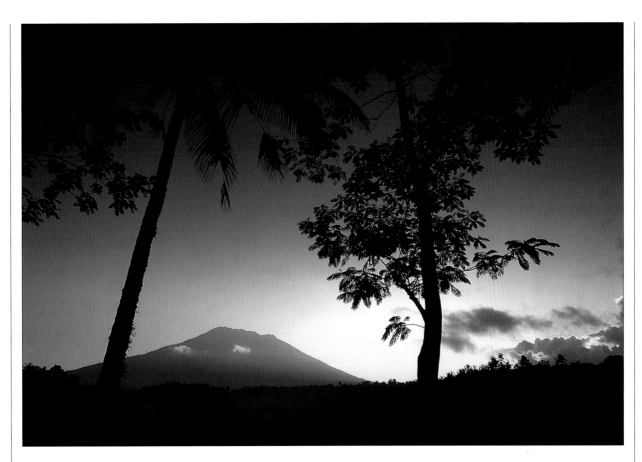

High clouds sometimes light up briefly during twilight, and this effect can happen very suddenly. After sunset, even if the sky looks as if it is just fading with little color, try and wait for a little longer. The few occasions when a brief flash of red or orange hits high wisps of cloud are worth the many times when nothing more happens.

To get the full range of this smooth gradation of color and light, use a wide-angle lens, which takes in more of the sky. For detailed silhouettes of objects on the horizon, use a telephoto lens. In either case, bracket the exposure: more light records more of the lit sky but with weaker colors, while a shorter exposure shows a narrower band of bright sky in more intense hues. If you are hand-holding the camera, select a higher sensitivity, with the risk of noise. A tripod allows you to work with the camera's lowest ISO setting. Details and close-ups in twilight benefit from the softness of the light, but as one side of the sky is brighter than the other, there is a directional quality to the light that is missing, for instance, on an overcast day.

Gunung Agung

This is the sacred volcano of Gunung Agung on Bali, shortly before sunrise. I spent the day looking for different views of this mountain, and this was the first. The difficulty with dawn shots in an unfamiliar place is that you have to guess how the light will develop. The color of the lighting and clouds around the volcano were the reason for the shot, although the viewpoint could have been much better. The moment lasted for only several minutes, and I made what use I could of foreground trees to help the composition.

The dramatic

Less predictable than most are those landscape images that, through wild weather and light, convey the powerful, elemental side of nature.

Conventional landscapes tend toward the gentle and placid, but with some effort and luck it's also possible to inject excitement and surprise into an image. Although as a subject landscape is not normally associated with energy and raw power, drama can be found, and it depends heavily on the lighting conditions.

The key to this is to take advantage of looming weather conditions, and storms in particular. Drama in landscape was a development of the Romantic style of painting, and with it came the concept of the Sublime—pictures that were intended to inspire awe in the face of powerful, elemental nature. One of its greatest exponents was the English painter J.M.W. Turner, one of the most original of all landscape artists, who developed an approach that was almost abstract in its use of swirling color

▽ **Breakthrough**
The shifting patterns of storm clouds and their effect on sunlight are always unpredictable in detail, but they are often reliable conditions for spectacle. This shot shows an afternoon build-up over the Gulf of Thailand.

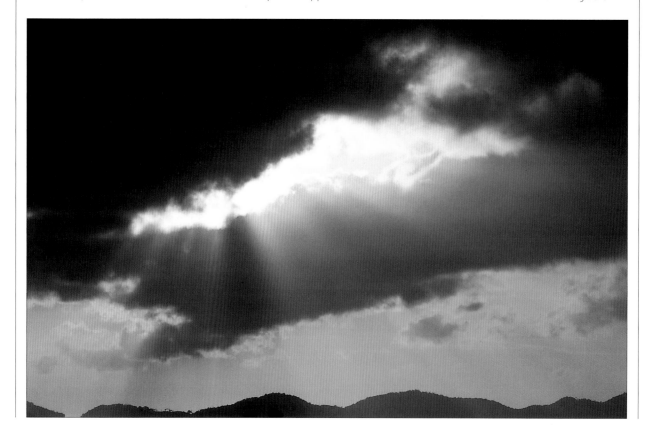

and light to convey the power and beauty of nature, as in one of his most celebrated pictures, *Snow Storm: Steam-Boat off a Harbour's Mouth, 1842*. Much of his work, and certainly this painting, was considered to be controversial, but Turner expressed the view very clearly that he wasn't trying to make attractive pictures. About this one, he explained that he had experienced that storm and that it had been "a terrifying experience," adding, "Nobody has any business to like that picture!"

To recreate this in photography requires searching out what Galen Rowell called "the dynamic landscape," pursuing the extremes of place and weather. Rowell's specialty was mountains, which have more than their share of both. If you are actively looking for what most people would consider bad weather, then the least predictable element is light, which Ansel Adams believed to be "the protagonist of the drama." High winds and lashing rain or sleet can completely transform a scene, particularly if you can show their effect—trees bending, waves being whipped up. Yet simply having a storm may not be enough to make a good image—it is the breaks within it that are likely to produce the most exciting conditions. This means, above all, staying flexible and ready to respond quickly to changing circumstances. Inevitably, the more time you spend in wild conditions, the more likely you are to come across the special juxtapositions of weather.

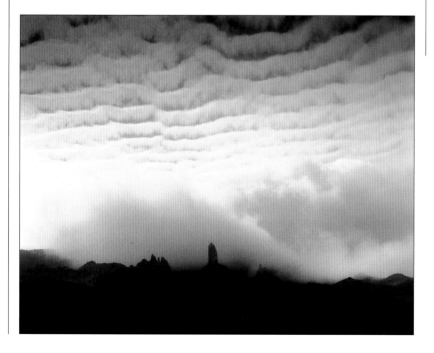

Rainbows

Rainbows are among the most unpredictable elements of weather. To see the full arc, you need a combination of sunlight, rain, ideally dark clouds behind to show off the colors at their strongest, and a low sun. Rainbows are projected with the sun behind you, the observer, so they are at their largest and fullest when the sun is almost on the horizon. Because of all these associations, they are traditionally an element of the dramatic, sublime landscape.

The Storr

The potential for drama in a landscape is at its strongest with a combination of two elements: striking landforms and a powerful skyscape. Shattered walls of volcanic rock and ancient landslips have created a spectacular, brooding landscape at Quiraing on the Isle of Skye, Scotland (the name means "pillared stronghold" in Gaelic). Here, one of the giant pillars, The Storr, emerges from rolling morning mist below a herringbone pattern of clouds. Printing in black and white enhanced the dark mood of the scene.

The unusual

More than anything else, photography is concerned with producing fresh images—views of the unexpected and different ways of looking at our surroundings—and this applies as much to landscapes as to any other subject.

The exotic and unexpected can be found in terrain and landforms that are inherently striking and unusual, and also in the treatment that you apply to a landscape. Typically, strange landforms are found more often in wilderness areas than in the landscapes softened by grasses and trees and tamed by humankind. Mountains, deserts, seacoasts, snow, and ice are all good places to look for extremes. Searching for exotic locations can be arduous and time-consuming, but the results can be extremely rewarding. Much of the world is already familiar, either through personal travel or through television, magazines, and so on, but there are still some surprisingly accessible places that are quite unknown to the majority of people. In North America, there are many spectacular scenes within easy reach of good highways—such as Arches National Park, or Death Valley, for example. The well-populated parts of Europe have, by definition, few really unknown landscapes, but Iceland and northern Scandinavia are just two examples of areas that are rich in potentially exciting views. Every part of the world has pockets of the unusual, and popular travel guides and television travelogs have by no means exhausted them all.

Arch
The shape and proportions of this long span of rock in Utah's Arches National Park are arresting enough under conventional lighting conditions. However, by finding a camera position on the edge of the arch's shadow, with the sun just visible, and by underexposing, I gave the image an added element of abstraction.

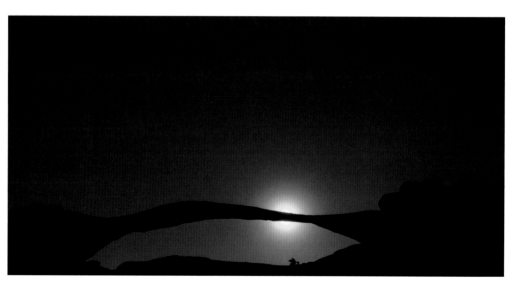

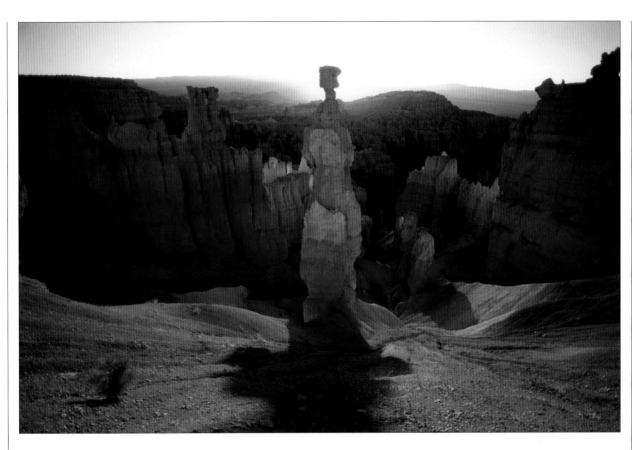

Aiming for the unusual

Creating the unusual with your own style and approach to photography enables you to work with more familiar and easily available scenes, but there is a considerable challenge in attempting to find a fresh image of a well-known view. One worthwhile approach is to reduce a landscape to basic graphic elements, creating a view that is more abstract than naturalistic. Essentially, this relies on your being able to find graphic possibilities to begin with, but there are a number of helpful techniques.

1 Wait for the light. Silhouettes at dusk, dawn, or against a low sun can reduce rocks, trees, and other objects to simple shapes.

2 Ultra wide-angle and long telephoto lenses introduce unfamiliar perspectives.

3 Alter the tone compensation for higher or lower contrast to help emphasize shape and pattern.

4 Experiment with the white balance and/or hue adjustment.

5 Deliberately over or underexpose, particularly in high-contrast lighting conditions, such as shots directly into the sun. You can exploit the graphic possibilities of silhouettes and experiment with any reflections off shiny surfaces.

6 At the image-manipulation stage, you can push any of the above features to extremes. There are also many effects filters to consider, but beware of using those that will merely look like gimmicks.

Thor's Hammer

One strange rock formation is the hoodoo—tall, isolated pinnacles of soft rock formed by differential erosion. They are a remarkable feature of Bryce Canyon in Utah. One of the most striking is this giant, called Thor's Hammer for its prominent caprock. I researched the view the previous afternoon, and found the spot where the rising sun would be exactly behind the "hammer." Naturally bright reflections from sunlit cliffs behind the camera give the warm glow.

The critical view

Landscape photography is not always about celebration, and can be used to make statements about how we use, and abuse, the environment.

There is a certain amount of nostalgia in natural landscapes, because the wilderness areas of the world are in retreat, and need our protection. Untrammeled views toward a horizon with no hint of humankind are becoming something of a rarity these days, and transmission towers, or wind farms are increasingly likely to decorate those horizons. Wilderness photography is a very American phenomenon, and because of its still-spectacular natural landscapes, it also has the most garish examples of what might be called visual pollution—strips, billboards, trailer parks, and roadside trash.

The response of most photographers whose sights are set on wild nature is to drive on by and ignore the casual wrecking of the landscape. But in fact, it's a perfectly valid subject for landscape photography because it calls for comment. The most obvious comment is straight condemnation, an exposé of man's bad habits, most easily achieved by juxtaposing as strongly as possible the good (natural beauty) and bad (vandalism). The techniques for doing this are exactly those for bringing together different scales and different features in a wild landscape. Wide-angle and telephoto treatments can both do this.

Salton City
Abandoned automobiles are an unavoidable feature of the open roads of the American West, and occasionally contribute a strange kind of beauty to empty landscapes—although this is a matter of opinion and cultural familiarity.

But there are other, less strident, treatments possible. For instance, the abandoned automobile by a desert highway can certainly be seen as just something dumped inconsiderately. But from another point of view, it has its own, dare I say it, nostalgia—part of America's road culture with memories of Route 66. And abandoned mine workings from the nineteenth century? Most people would see these now as historical sites that are worth preserving (and many of them are in fact protected), even picturesque. But in principle they are no different from modern scarring such as strip-mining and burnt, clear-cut forest. Today's despoiling can sometimes become part of yesterday's historical romance.

Damaged landscapes exist, and if you believe that photography should be as open and as truthful as possible, that's a good argument for photographing them, whether with a cool, objective eye, or a committed, conservationist one. The photographer Robert Adams, among others, has explored this largely ignored area of imagery.

The American photography critic and curator John Szarkowski makes the argument that with so much photographic exploration of natural beauty already done, from Edward Weston and Ansel Adams to David Muench and Jim Brandenburg, there's less incentive for younger photographers to follow the same road. He wrote, "...one must begin with respectful attention to what remains alive, even if scarred and harshly used, and trusting that attention will grow into affection, and affection into a measure of competence, so that we might in time learn again to live not merely on the earth but with it."

△ Failed hope
Abandoned enterprises, from mines to farms, bring a sense of nostalgia and historical context to wilderness areas. Here, a derelict farm slowly decays in New Mexico.

▽ Power lines
One widely recognized form of modern visual pollution is the power line. In this image, however, the graceful curves of the cables intersect with a misty view of English countryside.

Minimal views

Photographs of very little have their own special visual language in which the frame is cleared of all detail and conventional subject matter, and replaced with a subtle exploration of tone and color.

If you eschew the idea that a photograph must have a principal subject dominating the frame, with foreground, middle ground, and background all in ordered array, there are possibilities of a different kind of imagery. If you take abstraction (as we just saw on the previous pages) in one particular direction, toward extreme simplification of tones, shapes, and lines, you arrive at minimalism. This kind of image is not for everyone, but its value and justification is in encouraging a different way of looking at landscape.

There are a number of ways of doing creating minimalist images, but all involve in some way looking away from the obvious, at the blank parts of a view, and concentrating on those. The American photographer Frederick Sommer, for example, made a series of images in the 1930s and 1940s of featureless parts of the Arizona desert—not empty graphic dunes, but scrub-covered hillsides, in flat lighting, without horizon.

In one sense, the camera is simply focused on a background to the exclusion of anything else. In fact, it is the distance, the openness, the very lack of feature that is the real subject of this kind of photograph. The principal is "less is more" and the style is minimalist. Photographic historian John Szarkowski called this "nominal subject matter," meaning that the subject itself was of much less importance than the graphics of the image. Another argument is that apparently featureless images encourage the viewer to look more carefully into the detail. Most photographs are full of detail, even if on the level of texture, but in images with strong subjects this tends to be ignored.

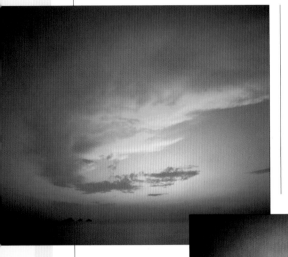

Samui Island
The only solid points of reference in this swirling arrangement of pinks, grays, and blues are a tiny group of distant islands. To make the image even more minimal, the sky area was selectively darkened in image editing to make the tones more even across the frame.

Seascapes offer some of the most minimal possibilities to photograph, provided that you ignore the obvious foregrounds of the coast, and concentrate instead on the play of light and color. When confronted with a view of the sea, this is, in fact, very close to what we see and experience—an immense flatness, lack of feature, vastness, and distance, that challenges our sense of orientation. In real life we may well turn away from it, becoming

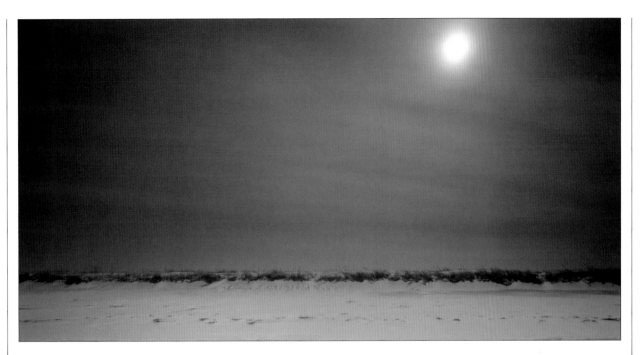

quickly bored without any focus of interest to hold our attention. Nevertheless, just because it is the antithesis of the organized, detailed, traditional landscape does not meant that this is invalid or without meaning. A number of photographers have explored this blankness, including the American Joel Meyerowitz and, more extremely, the Japanese Ikko Warahara and Hiroshi Sugimoto.

Another minimalist avenue to explore in landscape is time, as conveyed by a long time exposure. The blurring of form that happens with anything that moves, such as leaves in the wind, clouds moving across the sky, or, most famously, water, is another way of reducing the image, removing detail, while at the same time allowing a very photographic imprint to record itself on the image. Water, when photographed with a slow exposure, appears differently according to how it flows and how long the exposure is. With a moderately slow exposure (perhaps 1/8 sec or 1/15 sec for a fast-flowing stream over rocks) it takes on a silky appearance, but with very long exposures it turns into a mist; a rocky seacoast can look as if it is covered by a ground-hugging fog.

▲ Winter beach

This bleak scene on a Massachusetts shoreline in winter gains its strange quality from the heavy grayness of the sky, with the weak sun glowing faintly.

▽ Mist and softness

A very long telephoto (600mm efl) used across marshland scene in poor visibility achieves an impressionistic effect, enhanced slightly by the use of a digital grad filter.

Skyscapes

Conventionally treated as a kind of accessory in landscape photographs, clouds and skies are often rich enough in character to qualify as subjects in their own right.

The world above the horizon line is often either ignored in favor of what is happening on the ground, or else drawn in as a counterbalance in the composition. But the sky is a world of its own, full of change and cloudforms that are often spectacularly different from each other. As with terrestrial landscapes, skyscapes also vary greatly in how interesting and photogenic they are. The sky that I can see out of the window right now is pale gray and, even by the most generous standards, fairly boring, but there are moments when you come across true spectacle. And at these times it may well be worth ignoring the landscape in front of you and aiming your camera upward.

The base, of course, is the horizon, and placing it very low in the frame, just having a thin strip at the bottom, has the effect of grounding the skyscape. This puts it in context, and, by making such an extreme contrast in the proportions of land and air, enhances the impression that the sky really dominates an open, boundless space. To be worthwhile, there needs to be some special character to the sky, and it's hard to predict when and how this will happen. Skyscapes are not subjects to plan for, but to react to. Many of the prime conditions that we've already seen in the previous pages as part of some other aspect of landscape photography also feature picturesque skyscapes. Early and late in the day, the appearance of the sky is likely to change fastest, simply because of the changing light, and twilight has a

Polarizing filter

One of the most obvious effects of a polarizing filter is the way in which it darkens a blue sky—often, but not always desirable. The filter quenches polarized light from a particular angle. Outdoors, the most strikingly visible polarized light is that reflected from the minute atmospheric particles in clear sky. This is strongest at right angles to the sun (from the camera viewpoint), and you can control the effect by rotating the filter in its mount.

Sky panorama

Panoramic formats work particularly well with the lower section of sky, because the acute angle of view to the clouds gives a vertical compression. This shot shows evening over the Colombian Andes near Popayan.

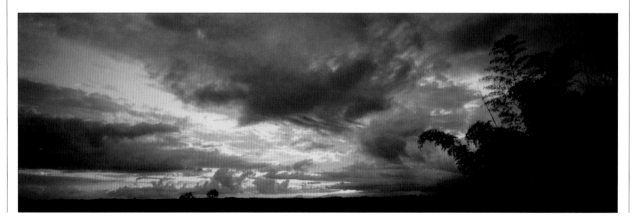

Reversed grad filter

The conventional use of a grad filter in landscape photography is to gently darken the sky so as to help bring it more into line with the darker tones of the land. But if you shoot above the horizon line with a wide-angle lens, the sky will naturally darken with height, and using a grad filter rotated 180 degrees will help to even out the brightness across the frame. Alternatively, you could progressively darken the sky when you reach the image-editing stage.

special value in this case. If the conditions are fairly clear, for a short period before sunrise and after sunset, the land is in complete shadow, while the lighting is purely on whatever clouds are in the sky.

Wide-angle is the focal length of choice for most skyscapes, in order to take in the visual reach that our eyes have when we look up. When there is at least some clear sky in view, a wide-angle lens will also reveal the range of tone. This is almost always noticeably darker as you move up from the horizon, where a greater thickness of dust, haze, and pollution mutes the color and tone. A polarizing filter is worth thinking about for its darkening effect and an associated increase in color saturation, but be careful when using it with an ultra-wide-angle lens. Because the polarization is strongest at right angles to the sun, a wide-angle view will show this as a band of darkness across the frame, which can look odd.

Use a standard focal length or a medium telephoto to pick out individual clouds or groups. Alfred Stieglitz, one of the founders of American photography, found in clouds images that were the "equivalents of my most profound life experience, my basic philosophy of life." He used clouds as an almost abstract subject in conveying a very personal vision.

Halo
Specific events and features of the changing skyscape make subjects in their own right, as revealed in this shot of a spectral halo behind a dense cumulus cloud.

Sea and sky
Unbroken visibility over great distances and a plain, simple horizon line make the sea one of the best locations for unbroken skyscapes.

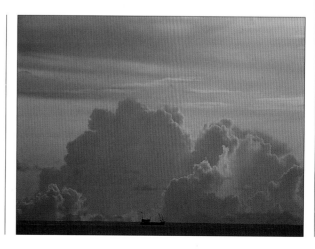

Weather

A bright sun on a clear day may often seem like the perfect prescription for a photographic trip, but more interesting light and skies come from weather and patterns of clouds.

Although the lighting on sunny days is easy, pleasant, and uncomplicated, the variety from less comfortable weather is infinite, from light, summer cumulus clouds to complete overcasts, and from thick morning fog in a valley to a high-altitude haze. Most important is what clouds do to the quality of light. Cloud cover softens shadows, and at the extreme of a really overcast day, they flatten the light completely. If your camera has tone compensation, a higher-than-normal contrast setting will help. This kind of lighting is difficult to make look interesting, and the color temperature will be a little higher than usual. Experiment with the white balance choices in the camera menu to warm up this slight blue cast. Ragged clouds can throw a patchwork of light and shade across a landscape, which can look attractive from an overlook. Billowing white clouds can sometimes act like giant reflectors.

Clouds These can obviously affect the light, but they also change the view itself in a broad landscape shot. If the clouds are well-defined and contrast well with the rest of the sky, then they are likely to make a stronger part of the photograph. At times, they can even be the entire subject of a photograph—possibly with just a thin strip of the landscape at the bottom of the frame.

Rain Unless there is backlighting or sidelighting from the sun, which is unlikely, it is often difficult to catch falling rain in an image. Usually, and at a

▼ Stormlight
Evening sun breaking through very heavy clouds over the marshes at Ipswich, Massachusetts, after a day of driving rain. At moments like these, weather is the shot.

distance, it just looks like mist. To convey something of rain you would need to include some of the obvious effects—ripples in a pond, drops on car roofs, umbrellas, and so on. On the rare occasions when the sun shines through rain, you can expect to see a rainbow. This is an optical effect, so if you move, the rainbow appears to move as well—you can use this to change the background. To capture the full arc of a rainbow, shoot with a wide-angle lens. If the rainbow is weak, remember that you can make it appear richer later by increasing the saturation.

Fog It's often difficult to predict how long fog will last, and it can sometimes clear in minutes. Make the most of it whenever you find it, as the effects can be wonderfully atmospheric. Some of the most picturesque conditions are early in the morning, when the fog is just light enough to show weak sunlight filtering through; shoot toward the sun to capture silhouettes of trees and other features in the foreground.

Lightning The unpredictability of lightning flashes is the main problem, but as long as you shoot at night or in the evening, you can leave the shutter open until one or more flashes make their own exposure on film. A wide-angle lens will increase your chances of getting them in the frame. The exposure is not critical, but as a rule, at ISO 200, for example, use an aperture of about ƒ5.6 for distant lightning (over 10 miles/16km), ƒ8 for between about 2 and 10 miles/3 and 16km. If the flashes are even nearer, ƒ16 may be better, but then you probably shouldn't be out in the open anyway. Flashes usually occur in sequences, so there should be time to check the result on the camera's LCD from the first shot.

▲ **Threatening sky**
Thunderclouds build up in the east in late afternoon over a valley in northern Thailand, providing a contrast to the sunlight falling on an abandoned monastery building and rice fields.

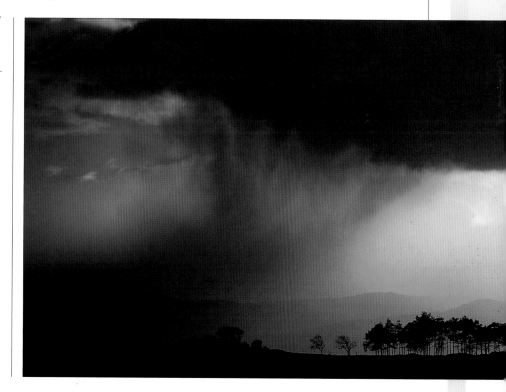

▶ **Falling rain**
Backlit by the evening sun, plumes of rain drift down over the misty hills and inlets of a Scottish island in the Hebrides.

The color of light

Digital cameras have the tools to correct and adjust for all the color varieties of daylight. The skill is in knowing when and how much to use them.

Color temperature scale

12,000K	Open shade under high-altitude sky
10,000K	
9,000K	Open shade under exceptionally clear sky
8,000K	Open shade under normal blue sky
7,000K	
6,000K	Overcast sky
	Electronic flash (typically 5,400K)
5,000K	Midday summer sunlight in mid-latitude
	(CIE standard 4,800K, mean noon sunlight at
	Washington DC 4,200K)
4,000K	Between one and two hours from sunrise or sunset
3,000K	Strongly colored sunrise and sunset
2,000K	A red rising or setting sun

Cool, cloudy light
An overcast spring day in Montana casts a slightly bluish light over a herd of bison ambling past a deserted shack. A dusting of snow picks up this color shift.

The color of light changes during the day, particularly if the sky is clear. When the sun rises and sets, it can be orange or red, but during the middle of the day, when it is high, the light is what we think of as "white," or normal. In the shade, if the sky is clear the light will be quite blue, although our eyes register this much less than does color film. Similarly, at twilight, the light can be blue, depending on the weather.

The scale of colors along which daylight moves is known, for good scientific reasons, as the range of color temperature. The principle of this is that most light sources, including the sun, work by burning—that is, incandescence—and their color depends on their temperature. From warm to very hot, the range of colors goes: red, orange, yellow, white, and finally blue. The exact color, whether of a setting sun or a table lamp, has a temperature, measured in Kelvins (K), which are similar to degrees Celsius but start at absolute zero. So, a candle burning orange has a color temperature of around 2000k, white light from a midday sun is about 5,500K, and open shade under a blue sky is around 8,000K and upward. The only source of confusion is that in normal language we associate blue with cold and red with heat, so that unfortunately warming up a scene involves lowering the color temperature.

The color temperature of daylight changes because of the way that the atmosphere scatters it. When the sun is low on the horizon, its light passes through more atmosphere, and the molecules in the air scatter the shorter, bluer wavelengths more than the others. This makes the light redder. If you look at a clear sky, you see just these scattered blue wavelengths. In a sense, the neutral "white" light is being separated into two main components. In any case, what once was a rather arcane aspect of color film photography is now familiar to most photographers purely because digital cameras offer the controls to normalize color temperature. These controls are found under the "white balance" menu.

Tone compensation

Another control available on some cameras is tone compensation, which allows you to choose the contrast for a particular shot. Where available, the camera menu will typically offer a normal setting; one for high/more contrast; one for low/less contrast; and an automatic setting, in which the camera's processor will judge the contrast range of the imaged scene and optimize it. Doing this manually or automatically is the equivalent of setting the black and white points in image editing, and it is obviously better to do this when capturing the image. If you are shooting RAW format, you can rework the tone compensation without penalty. Only beware of overcorrecting the contrast in scenes where you might actually want the higher or lower contrast effect.

▲ White light
The middle of the day is the human eye's reference point for color; or rather, the lack of it. The color of sunlight falling on these fields in Surrey, England is a little less than 5,000K. Note the slight blue cast to the shadowed sides of the white buildings.

▼ Avoid overcorrection
Optimizing the color to neutral is not always appropriate. Shots taken with the sun close to the horizon, as in this view of Capitol Reef National Park, Utah, are expected to be warm in tone. A "sunlight" white balance setting is usually better than "Auto."

However, simply because it is available, there is no reason to be obsessed with correction. With only a few exceptions, the differences in color are small, and will not ruin the image, which can be adjusted with hardly any damage to the image later, in image editing. Shoot in RAW format and it really doesn't matter which white balance setting you choose, as you can reselect the setting later. Set the white balance when you have time, but don't waste time at it. One occasion when you should pay attention is close to sunrise and sunset. If you normally use an Auto white balance setting, this will correct the orange lighting to white, which is probably not what you really want.

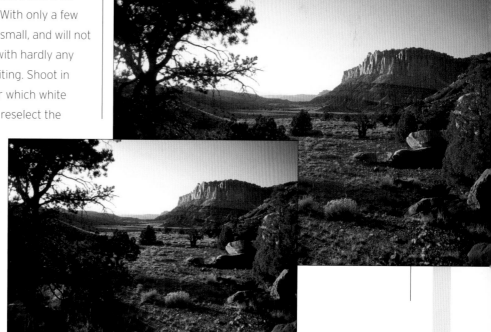

Aerials

An hour's flight over an area of natural beauty, though not cheap, can be a good investment resulting in striking images from an unusual angle.

Aerial photography brings a fresh perspective to landscape. It has its own unique range of subjects and styles of picture, particularly if you shoot vertically downward to create unusual, abstract images. Patterns that are invisible on the ground can be the most striking part of an aerial photograph.

The single most important factor that separates the ordinary from good aerial photographs is the lighting. Direct sunlight is almost always better than an overcast day; the contrast is higher and, being brighter, allows for higher shutter speeds. A high sun in the middle of the day, however, tends to give flat lighting. This is even more apparent if you are

Colors from the air

A combination of algae and mineral deposits around the Grand Prismatic Spring in Yellowstone National Park presents a striking array of colors. This was a candidate for a vertical shot using a medium telephoto lens.

shooting vertically downward rather than obliquely. More reliably attractive is a low sun in the early morning and late afternoon; this casts longer shadows, and gives a stronger and better defined image. One of aerial photography's special problems is haze, because of the thickness of the atmosphere through which you have to shoot. The simplest solution is to fly low—say, at about 1,000 feet (400 meters) above ground level—and use a wide-angle lens. A UV filter will also help to sharpen contrast and cut through any atmospheric haze.

Normal-level flight allows only diagonal shooting at a shallow angle, which works well enough for distant views. For close, graphic shots, however, a steeper shooting angle is usually better, and the most extreme—directly overhead—can sometimes be the most striking of all. There are three ways of doing this with a fixed-wing aircraft. The pilot banks the aircraft, which puts it into a turn, so you may have only a few seconds for shooting. Or the pilot can slip the aircraft sideways toward the subject, reducing the throttle to dampen vibration. The third alternative is to fly in a tight circle over the subject.

As on the ground, different focal lengths give different types of image. Wide angles (28mm efl and less) are particularly good for overall views with less haze effect (see above). The standard focal length of around 50mm efl is obviously useful for most subjects, while a moderate telephoto can be used to pick out smaller subjects like a flock of birds. Keep the aperture wide open and set the highest shutter speed possible (at least 1/250 sec) to avoid camera shake. Aircraft vibration makes manual focusing difficult to judge—autofocus is better—and also limits the length of telephoto lenses.

In-flight precautions:

☐ Avoid vibration by not resting your arm or the camera on the aircraft body, by using a higher shutter speed (preferably 1/50 sec or faster), and by throttling back on the engine when shooting.

☐ Do not lean out of the aircraft—the airflow may tear the camera from your hands, quite apart from the other, more obvious, dangers.

☐ Reduce the effects of haze by using an ultraviolet or polarizing filter, and by flying low with a wide-angle lens rather than high with a standard or long-focus lens.

☐ Although the focus can be set at infinity with a wide-angle or standard lens, take more care with a long-focus lens, particularly as aircraft vibration can make focusing difficult.

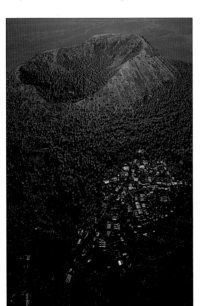

Comoros Islands

This volcanic crater on the coast of an island in the Mozambique Channel was shot from about 1,000 feet (300 meters). The height ensured good contrast and saturation.

Isolation

An empty road, so little used that sand drifting across has almost covered it in one short section, passes an isolated dwelling on the Hopi-Navajo reservation in Arizona.

Preparing for a flight

Save time and money by making all possible preparations before you fly, and allow for the different shooting circumstances between types of aircraft—fixed-wing, helicopters, and balloons.

Flying time is expensive, so time spent planning the flight, briefing the pilot, and preparing the aircraft and cameras always saves money—and gives you more time for shooting in flight; basically, do as much as you can before take-off.

☐ Mark the flight plan on a map, anticipating exact locations as much as possible.

☐ Check with the pilot and airfield personnel what the weather conditions are likely to be. Generally, the best conditions for photography are a fairly low sun, clear air, and minimum cloud. Either early morning or late afternoon may be best, depending on local weather.

☐ Prepare a list of subjects that you are interested in, and show it to the pilot, who can probably make suggestions. Consider wide-angle views of the whole area, and closer shots of special features such as waterfalls or lakes.

☐ Brief the pilot on the type of shots you want, and how you would like him to position the aircraft for them (see box).

☐ Open windows, hatches, or doors as necessary for an unrestricted view. Never shoot through glass or plastic. However clean and unscratched the window, it will reduce sharpness and increase flare. If you cannot avoid doing this, keep the camera as close to the plastic as possible, and use a piece of dark cloth, or your hands, to eliminate reflections. Don't shoot when sunlight strikes the window, as this will cause flare and show up scratches. Adjust your seat and shooting position while still on the ground.

☐ Lay out camera equipment so that it is secure but accessible.

Fixed high-wing
For general aerial photography, a single-engined aircraft like this Cessna is probably the best choice. Flying time is relatively inexpensive, the aircraft is maneuverable, and the view unrestricted. If the wheels are retractable, so much the better, as they give a wider view.

Fixed low-wing
Larger low-winged aircraft are generally more popular among pilots, and they have the advantage of speed (useful if the airfield is distant from where you intend to shoot). The disadvantage is limited visibility. The rear luggage hatch may be the only unrestricted camera position, and this is cramped.

Helicopters
Although helicopters are the most expensive of all aircraft to rent, particularly large models such as the Bell Jet ranger, they have the advantages of relatively high speed to reach the subject without delay, great maneuverability, and a clear view. Light, twin-seater helicopters usually have very good visibility with a bubble dome, and a complete door can often be removed before take-off. All helicopters vibrate strongly when hovering, and slow forward flight gives less camera shake. Avoid including the rotor blades in the frame.

▶ **Banking**
Banking the aircraft makes it possible to take near-vertical shots, such as this of a cinder cone in California's Lassen National Park.

Shooting angles in flight

Level flight
Normal flying allows only diagonal shooting at a shallow angle, which is satisfactory for distant scenic views, but not for close or graphic photographs. The shorter the focal length of the lens, the more restricted the angle, as the wing tips and wheels mark the limits of view.

Banking
A steep shooting angle, even vertical in some instances, is the most generally useful—it gives good possibilities for composition and allows close approach. For this, the aircraft must be banked, and as this puts it into a turn, shooting may be limited to only a few seconds. One technique is to slip the aircraft sideways toward the subject, reducing the throttle to dampen vibration. The alternative is the circular flight pattern. For shots that include the horizon and sky, the aircraft must usually be banked away.

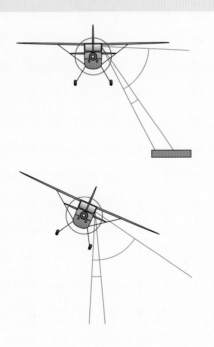

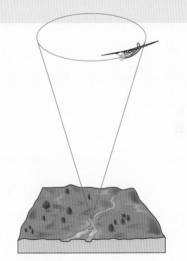

Circling a subject
For a sequence of near-vertical shots of a single subject, a tightly banked circular pattern is best. In practice, however, it is not always easy to center the circle over the subject, and the tendency is to place the aircraft over the subject and out of view. Discuss this with the pilot before takeoff.

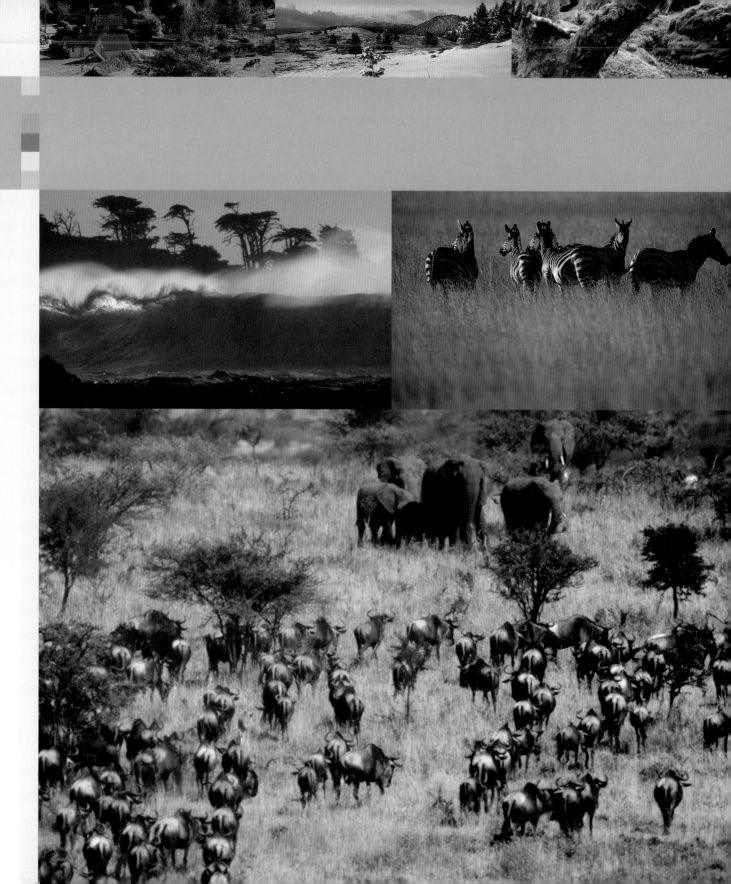

Wildlife and **Habitats**

Wildlife is one of the most challenging and rewarding subjects in the natural outdoors. There may be less of it around than formerly because of environmental pressures, but it is, for the most part, better protected. One of the strongest guarantees for wildlife protection is tourism, upon which an increasing number of places have become dependent financially. In locations as varied as Yellowstone, Florida's Everglades, and Africa's Rift Valley, wild animals have become commercial assets.

Photography is one beneficiary of this development, and digital photography in particular has valuable advantages. A great deal of wildlife camerawork involves long periods of waiting interspersed with brief flurries of fast-reaction shooting, nearly always pushing against the constraints of shutter speed and light. Digital cameras give instant feedback, which allows you to set up more confidently in uncertain situations. Working from a hide, for example, you can test the settings well before an animal appears. Digital cameras are also highly flexible, so that, when stalking, you can switch instantly between sensitivities as you move from sunlight to shade. You can also rework many of the settings later, making any mistakes of exposure, color balance, and so on almost irrelevant. For the most part, the cameras are also very quiet, and, with sensors usually smaller than 35mm film, telephoto lenses have a greater magnifying effect.

Photographing wildlife means immersing yourself in the animal's habitat. Each habitat is like a complex machine of many interlocking parts; an environment with a particular population of creatures and plants that

has evolved in special conditions of geology, landforms, and climate. It makes no sense to consider animals and their habitats separately, particularly when it comes to photography, and in this section we will look at the dozen most distinctive and important kinds of habitat.

By understanding how a habitat works, you can plan to photograph the highlights of the system. For instance, if you were fortunate enough to be in a desert for one of the infrequent showers that heralds a sudden, brief blossoming of flowers, then a combination of shots—of the desert in bloom, a close-up of flowers, veils of rain falling from a rare stormcloud, and the desert in its normally parched state—would tell a larger story than just shooting close-ups.

Modern wildlife photography comes close to research. Gone are the days when the ideal was just to shoot a portrait of an animal. Now the aim of the best wildlife photography is what one behavioral biologist called "a determined effort to portray the actions of nature rather than merely animals or plants." For professionals, this has upped the ante as more and more behavioral scoops are logged. These days, for a wildlife assignment to count as remarkable, a great deal of research, time, and expertise are involved, and still photography is often combined with filming. evertheless, for amateurs the situation has never been better. More wildlife locations are accessible for visitors; foreign travel is less expensive; and digital photography's ability to deliver under less-than-ideal conditions makes capturing successful images more likely.

Animals in the landscape

Not all wildlife shots have to be frame-filling. A distant view of animals can, with skillful composition, make a good scene-setting image that establishes the context.

Getting close to the animals is the key to most wildlife photography, and this is usually a challenge. Fortunately, one class of shot dispenses with this necessity—a longer view that shows an animal, or a group of animals, firmly established in its habitat. Not only can this make a strong image in its own right, it's also a very useful solution to a situation in which there is insufficient cover to approach the animals. Indeed, it sometimes happens that in paying so much attention to getting close for frame-filling shots, the photographer can forget how important it is to set the scene and context in at least one image.

Compositional skills become all the more important in this kind of picture, and are crucial when the viewpoint is less than satisfactory. If you are sufficiently close or have a long enough lens for the subject to fill at least two-thirds of the frame, then there is really little choice in the composition—the picture area will appear full—but if the animal is smaller in the frame,

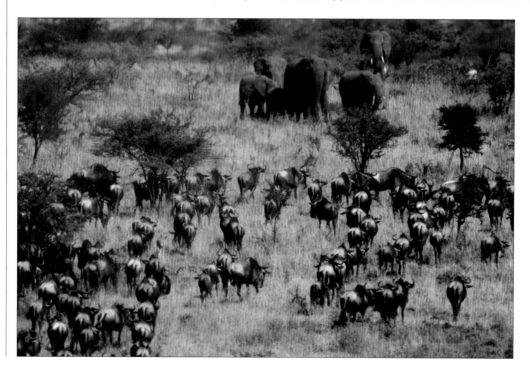

Wildebeest migration

The annual migration of wildebeest in East Africa's Serengeti concentrates large herds in a relatively narrow corridor. In this shot, an advance of the column moving up a slope among acacia trees encounters a small herd of elephants. A 900mm efl lens compressed the scene.

where you place it is important. The most "logical" position—in the middle—is usually the least satisfactory, emphasizing the emptiness of the surroundings and often showing a large area of unsharp foreground. A traditionally balanced position is off-centered, by about one-third from the top or bottom and from either side. This works well if the animal is facing into the frame. As well as producing a sense of balance, this off-centered placement also reduces the impression that the animal appears smaller than you would have liked.

If you are using a telephoto lens, the depth of field is likely to be shallow, and keeping the animal low in the frame helps cut out some of the out-of-focus foreground. This low placement emphasizes the surroundings more, so that the photograph becomes animal-plus-setting rather than just the animal alone. Alternatively, by including a second point of interest nearer the edge of the picture, the composition can suggest relationships, such as those between an animal and its source of food. Basically, placing the main subject eccentrically draws attention to the composition and tends to encourage the viewer to search the image more closely.

At the water's edge

Herons are relatively common, and rather than using a longer lens for a frame-filling view of a bird that is frequently photographed, I preferred to show its feeding activity as it patrolled the rocky margins of a Scottish loch in the late afternoon. As it was facing to the right and moving slowly in that direction, I composed the shot so that it would be facing into the larger part of the frame.

Figure for scale

The small figure of a moose crossing a meadow in Montana in the spring gives action to this landscape and a sense of its vast scale. The size of reproduction of the image is important, because while a slight delay in spotting the animal adds interest to the picture, it must be large enough to be seen by the viewer.

Animal behavior

More interesting than static portraits are behavioral photographs, which call for some research into wildlife activity. Knowing the key moments in behavior also makes it easier to find animals.

Most animals have a limited number of predictable activities. Some of these are tied to a particular location, time of day, or season, and awareness of these can be used to improve your chances of actually finding the animals. The most common activities are: feeding, drinking, fighting for territory, courtship display, nest building, mating, giving birth, feeding young, repelling or fleeing from predators, greeting, and migration.

Actually, the easiest way of finding wildlife subjects is to use an experienced local guide. In certain habitats, and with some species, there may then be no more difficulty than going to a particular site at the right time of day. Really, there is little substitute for good local knowledge. However, on the occasions when you have to rely on yourself, you will need two kinds of information: a general idea of the behavior of the animals you are looking for, and some specific clues about the place you are in. Advance research will give you some indication of what is likely; local information will then help you put this into practice.

For many animals, particularly mammals and birds, the most active times of day are in the early morning and late afternoon. Animals that live in colonies, such as some species of stork, seabirds such as puffins, gulls, and

Bison spring
A female bison just after giving birth in a springtime snowstorm in Montana. Calving time had been anticipated, and was the reason for planning the session.

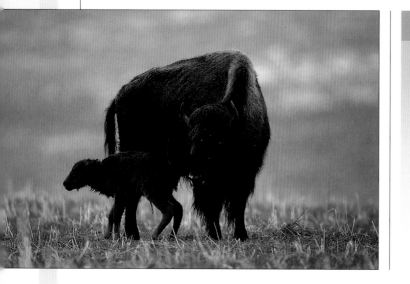

Prime locations based on behavior

Migration
Seasonal events are often very reliable for photography, especially in habitats that have a very pronounced regime. The annual migration of wildebeeste in East Africa's Serengeti is a good example of this.

Feeding
Often, the location of food is more predictable than the animals' rearing ground. In Sri Lanka's Yala sanctuary, for example, painted storks feed in the wetlands in the early morning.

Water holes
Wherever there is a dry season, as in the East African savannah, water becomes very scarce. Water holes then become highly predictable locations in which to see animals.

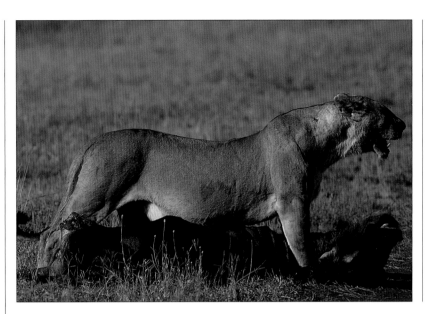

◄ Lioness with carcass
Predators follow predictable patterns of hunting and rest. Having brought down a wildebeest and fed a little, this lioness was dragging the carcass back to the pride. We spotted her easily from a distance as we drove in a four-wheel drive, but she paid no attention whatsoever to us, concentrating entirely on the effort of moving the heavy animal.

▼ Ngorongoro
February is the time for tens of thousands of flamingos to mass at Lake Magadi in Ngorongoro Crater, Tanzania. The seasonal movements of migratory species are predictable and a good starting point for planning a photographic shoot.

terns, and bats, tend to disperse for feeding—leaving and returning at more or less regular intervals. Most species of small mammals are active only during the night, or at dawn and dust, and are therefore rather more difficult to photograph.

Some species migrate to follow sources of food and water, or to seek more congenial weather. This sometimes provides an opportunity to see and photograph spectacular concentrations of wildlife—wildebeeste in the Serengeti, geese on the central flyway of North America, or migrant waders in northwestern Europe, for example. Many animals also gather in colonies in order to breed, and striking gatherings can

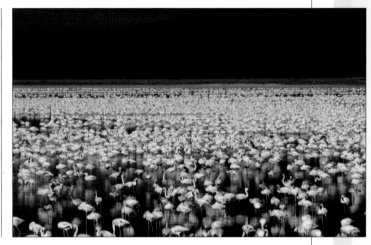

also be seen at these times. Seabirds, seals, and sea lions are good examples of species that are colonial breeders.

Large predators, never so numerous as their prey, are often difficult to find, particularly as stealth and concealment are their own well-developed skills. One useful tip is to watch the behavior of the species they prey on; if these are behaving nervously, a predator may be close at hand. For example, when a hunting leopard is near, deer often call to each other in alarm. Similarly, monkeys will warn of an approaching tiger. Also look for fresh tracks and other signs, such as droppings.

Sources of information

☐ The internet.
☐ Magazine articles and guidebooks.
☐ Local organizations such as conservation departments, national parks headquarters, naturalists' societies, and NGOs.
☐ In the field; park wardens, rangers, and guides, other naturalists with local knowledge.

Stalking

Wildlife photography relies heavily on fieldcraft, which means finding the animal, getting close enough for a clear view and a suitable position to shoot, in most cases unobserved.

How animals perceive

What seems good camouflage to human senses may not necessarily be effective for the animals you are trying to conceal yourself from.

Birds Most birds have better eyesight than humans, particularly in their ability to see detail at a distance. The eyes of a hawk, for example, can take in eight times more than human eyes. Most species also have a very wide field of view—up to 360 degrees in the case of some ducks. On the whole, birds respond more to movement than to any other visual stimulus. Their hearing also tends to be good, although in flight it is almost certainly less effective. On the other hand, few birds have a good sense of smell, apart from flightless species.

Mammals Because most mammals tend to be active at dawn, dusk, or night-time, their eyesight is, on the whole, poor. Mammals that hunt or need to escape from predators at speed, such as cats and deer, are an exception. Their hearing is usually good—large ears are generally a sign of high sensitivity. Their sense of smell can be so well developed that it is difficult for humans to imagine how important a part it plays. It is probably the chief sense for most mammals.

As with candid photography of people, stealth, fast reactions, and being observant are the key skills for approaching animals in the wild. It also helps if you're so familiar with your camera that you can use it immediately without fiddling with the settings. Stalking involves both a knowledge of how to find animals and the ability to approach them unobtrusively. Be aware of the behavior of the species you are stalking. Many animals, for example, are at their most active around dawn and dusk, which means working in low light levels. Weather can affect behavior, and your stalking success. An impending storm makes many animals nervous. In rain, most seek shelter. For your own concealment, the fine weather associated with a high pressure system is often an advantage—the pressure holds down scent. Conversely, moist air makes smells easier to detect.

Moving unobtrusively involves a number of techniques, many of them similar to the ways in which animals themselves hunt or avoid being hunted. The following are the most important:

☐ Dress inconspicuously or, better still, use camouflage. Wear drab clothing and avoid anything that might glint in sunlight. Faces and hands normally appear bright and are easily visible at a distance. If you feel dedicated, apply streaks of dirt to conceal yourself.

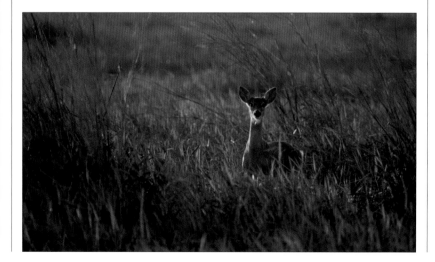

- ☐ Minimize your scent by being well clothed, moving around as little as possible, staying downwind of the animals you are tracking, and avoiding any deodorant or other scent.
- ☐ Walk economically, with as little unnecessary movement of your torso and arms as possible. Roll your feet when you walk, rather than slapping them down, and look where you put them, avoiding leaves or twigs that may crack.
- ☐ If, by mistake, you make a loud noise, freeze instantly and stay motionless for a few minutes.
- ☐ Try never to cross open ground, but instead use natural cover. Stay in the shade rather than sunlight, and never silhouette yourself against a skyline.
- ☐ When making the final approach to an animal in full view, keep low and move only when it is busy with some activity. At the times when it pauses to check its surroundings, keep still. Move directly forward rather than obliquely, so that the animal has difficulty in telling whether you are moving at all. If the animal sees you look down at the ground—avoid eye contact.

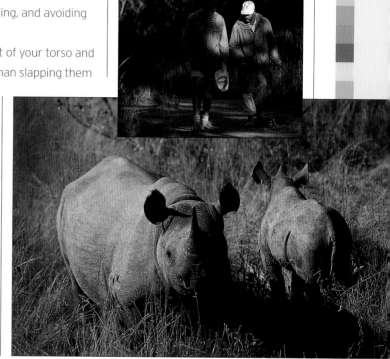

Tracking rhinoceros

With dangerous animals—and a female Black Rhino with a calf certainly qualifies as one of these—it is essential to have professional help; in this case, park rangers in a South African wildlife reserve. It was the tracker accompanying me who decided that we should rapidly climb the tree from which this shot was taken, as the female makes a mock charge.

Stalking wary subjects

Deer, unless tame or used to regular feeding, will only tolerate approach to within a prescribed distance, establishing, like many animals, an invisible perimeter for their feeling of safety. In this case, 50 feet (14 meters) was the closest approach. This white-tailed deer's alertness shows that only a few moments remain before it will take flight.

Using trees as cover

The wooded margins of wetlands are, in many ways, easier photographically than open lakes and reed-beds. Even a little cover, as offered by the acacia trees in this Indian bird sanctuary, makes stalking possible.

Blinds

The alternative to stalking is to use a blind—a concealed location usually sited within the animal's territory that permits close observation and photography over a period of time.

There are many different kinds of blind, depending on the animal, the habitat, and the facilities available. Established wildlife reserves often have permanent blinds that are so well established that the animals accept them as part of the scenery. On the other hand, some wildlife photographers build their own blinds, setting them up temporarily in view of a particular nest or feeding place. At a less elaborate level, it is also usually possible to put together a makeshift blind out of available natural materials.

When choosing a site for the blind, remember that it should have a clear, unobstructed view of a place that is visited regularly by the animal or bird you want to photograph. A nest or lair is one possibility. Others are feeding, drinking, and bathing places. Avoid open spaces such as fields. Look instead for a background of vegetation, such as at the edge of a clearing, and certainly avoid a location where the blind is silhouetted against the sky. Make sure also that the lighting will be right for the subject at the time of day you will be shooting—in other words, avoid having the sun shining directly into the lens and the subject in deep shade. Try and site the blind downwind.

With animals or birds that live permanently in a particular territory, you will need to introduce the blind carefully, in such a way that you do not cause disturbance. Moving the blind right up close on the first day will probably startle the animal so much that its pattern of activity will be disrupted; it may even abandon the site. The normal method of introducing a blind is to set it up at a distance, moving it forward in stages over a period of time. When possible, move the blind at times when the animals or birds are elsewhere—if you are photographing a nest, wait until the bird is away feeding.

Portable blind

This canvas construction, supported on an aluminum tubular frame, is larger than the hides normally used for observing wildlife, to allow sufficient room for equipment. It can be transported easily to almost any location at ground level and can even be moved progressively closer to the subject over a period to avoid disturbance.

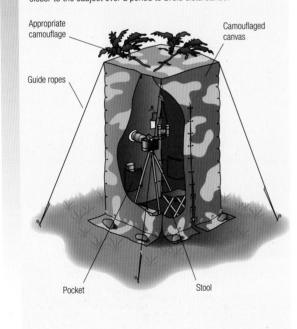

Appropriate camouflage

Camouflaged canvas

Guide ropes

Pocket

Stool

Permanent blind, baited location

With a blind that is permanent, or at least intended to last for a season, it may be possible to encourage some species to visit by regularly putting down food or water. In time, when the animals have become thoroughly accustomed to the blind, it may not even be necessary for observers to remain completely hidden. Baiting, however, can alter animal behavior and should be undertaken with caution.

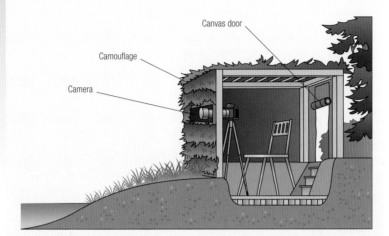

Canvas door

Camouflage

Camera

Using a blind

Even with a well-constructed blind, take the following precautions when using it, so as not to alarm the wildlife:
- ☐ Keep quiet.
- ☐ Don't touch the walls of a canvas blind or allow any visible movement.
- ☐ Move the camera and lens slowly and as little as possible.
- ☐ Use a tripod and cable release to cut down vibrations with long lenses.
- ☐ Don't wear artificial scents.
- ☐ Do not place your eye too close to the viewing hole, as it may be visible from outside.
- ☐ When the blind is not in use, leave the base of a glass bottle poking through the lens opening as a dummy lens.
- ☐ Enter the blind unobtrusively, either at night or when the animals are not present, or by taking a friend with you who leaves after a short while to fool the animals into thinking that the blind is empty once more.

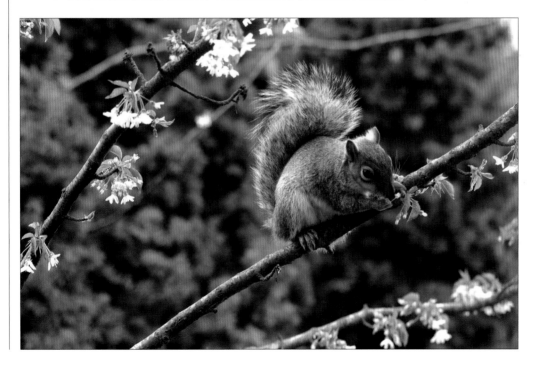

◀ Gray squirrel

This shot was taken from about six feet (two meters away) and the squirrel was entirely unaware of me and the camera even though we were separated only by glass. I took it from an upstairs window, and I was visible even though the room was darker than the outside. Most animals associate threat with conditions that are familiar. Being behind glass, I was simply not recognizable as another creature. When I inadvertently touched the glass with the lens, however, the squirrel made off from the scene at lightning speed.

Wildlife from vehicles

In many wildlife reserves, the standard tour is by vehicle, and provided you don't have to shoot through a window, this is an excellent camera platform.

For most animals, a vehicle, despite its noise, is much less of a threat than a human being on foot. In places with regular traffic, most of the local wildlife becomes accustomed to it. This is particularly noticeable in those wildlife sanctuaries where the only method of touring is by vehicle along established trails—many species will tolerate a remarkably close approach. Although most vehicles are restricted to roads or tracks, and so offer a restricted choice of viewpoints, they have the great advantage of being, in effect, mobile blinds.

Ideally, a vehicle should be pretty rugged, with high clearance, as most wildlife locations have unpaved roads; high, so that it offers clear views over surrounding grass and undergrowth; roomy, so that equipment can be laid out ready for use; and equipped with all-round viewing through windows that can be opened fully. Some safari vehicles have provision for shooting through a roof hatch. The extra elevation and all-round view that

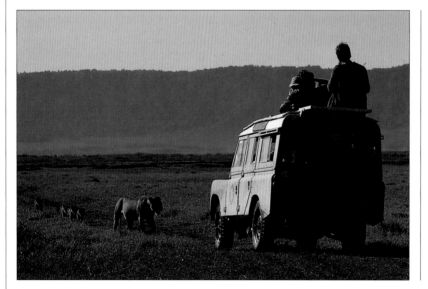

Ngorongoro Crater
Typical safari vehicles have provision for shooting through a roof hatch, as in this Land Rover. The extra elevation and all-round view that this gives makes it much better than a regular side window.

this gives makes it much better than a regular side window. Four-wheel drives are standard and meet all of the requirements for wildlife photography, provided that they are not crowded with other passengers. Some organized safaris, however, use small buses, which offer only second-rate conditions for photographers. If you have no alternative but to ride in one of these, try to sit in the front seat next to the driver, or at least sit next to a window that opens.

A vehicle appears least threatening to wildlife when it is either stationary or moving slowly, but starting, stopping, or obvious changes of engine tone can put animals to flight. When approaching an animal, it is better to roll to a stop with the engine switched off. Also anticipate the best viewpoint as you

approach. Starting up again and reversing to avoid an intervening branch may scare the animal. In very well visited game reserves, however, the animals may be sufficiently familiar with vehicles for these precautions to be unnecessary.

Never leave the vehicle, for outside it you will immediately be identified as a threat. The window ledge is, in any case, a good support for even the heaviest long lens, but use a thick cloth or towel to avoid scratching the lens barrel. When shooting, switch off the engine and move around inside as little as possible, to avoid camera shake. If you can, darken the interior so that you are not, from the animal's point of view, silhouetted against the window behind you.

▶ Hunting dogs

This pack of hunting dogs in Tanzania's Mikumi National Park was photographed from about 65 feet (20 meters) with a 600mm efl telephoto, from the side window of a four-wheel drive. They remained completely unconcerned, and it was as good as if photographing from a blind, with several opportunities for behavioral shots.

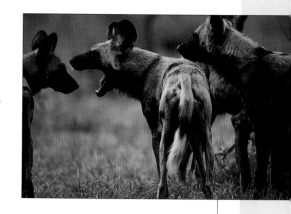

▼ Staying part of the vehicle

With large plains animals, such as this lioness at a water-hole in Ngorongoro Crater, a vehicle is the only safe and practical means of photography. The shot was taken through a roof hatch, like the one shown opposite.

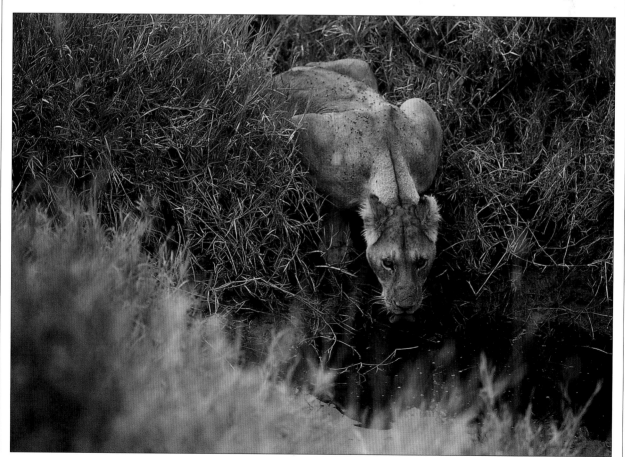

Birds

It is easiest to photograph large birds and colonies of birds, although in most cases a long telephoto lens is essential to capture a worthwhile image.

In flight, birds make wonderful active subjects for the camera, but they are not easy to photograph. There are, certainly, few creative problems, but it takes practice to produce even a technically efficient shot. There are three principal ways of losing a picture: soft focus; wrong exposure; and having the subject too small in the frame. Fortunately, digital cameras can help in overcoming these by efficient autofocus tracking (even predictive tracking with some cameras), the ability to readjust brightness (most effectively when you shoot in RAW format), and digital enlargement.

It's only worth attempting to photograph a bird in flight if you can produce a reasonably large image of it, and freeze the wing beats. Large birds such as herons and storks are easiest, not only because of their size but also because they move relatively slowly. As a rule of thumb, try to make sure that the image of the bird, wing tip to wing tip, fills at least half the picture frame. You can enlarge later with interpolation, but the more you do this, the less sharp the image will be, and it's always preferable to fix this issue at the

Exposure

Because the sky dominates pictures of birds in flight, it also influences meter readings. If it is much brighter than the bird, underexposure is likely. If it is much darker (where you have a white bird against a dark blue sky, for example), expect overexposure. To an extent you can readjust this later if you shoot in RAW format and use the camera manufacturer's editing software or a RAW plug-in, but it's better to get it right the first time. It may be better to switch to manual and do one of two things: take a reading from an average subject on the ground, or even from other similar birds if you are near a nesting colony, or else decide, quickly, how much lighter or darker than average you want the sky to appear and set the exposure to suit. Exposure compensation is likely to vary from two stops lighter for a light, cloudy sky, to one stop darker for a deep blue sky.

▶ In flight
Late afternoon sunlight catches a pair of white pelicans flying against approaching stormclouds over Lake Manyara, Tanzania. Large birds like these fly slowly, and as they were moving across the field of view, there was only a slight change in distance. Continuous automatic focusing dealt with this easily, even with a 600mm efl lens.

time of shooting. Few fixed-lens digital cameras have a sufficient focal length for this kind of shot, but with a digital SLR you can attach a long lens—and the longer the better, 500mm and upward. Fortunately, small sensor size in many SLRs gives an extra degree of magnification.

Unless you want to produce a streaked image for creative effect, use the fastest shutter speed possible—at least 1/250 sec—and adjust the sensitivity accordingly. The most usual camera position to find yourself in is below the bird (although many seabirds can be photographed from cliff-tops, looking down), but generally, the higher you can get, the better. Nesting sites usually offer the most reliable opportunities because the birds' flight paths are regular, and can be checked. A nesting colony is better still.

Nesting colony
Seasonal nesting sites for birds that live in colonies, like these Openbill Storks, offer opportunities for great shots.

High sensitivity
An Indian Roller in rain. For this close-up of a moderate-size bird, I used a 600mm efl telephoto lens.

In focus

Pin-sharp focus is essential, and the difficulty with birds in flight is that there are no reference points in the sky against which to measure the rate of movement toward the camera, compounded by the larger focusing movements needed in a long lens. Autofocus should take care of this, but if it's too slow for the circumstances, you can always fall back on the following three tried-and-tested manual techniques:

Follow focus
Try to keep the bird in focus the whole time by turning the focusing ring at a steady rate toward its closest setting, to match the approach of the bird. In practice, the focus often drifts.

Continuous refocusing
With this method, the bird is focused several times as it approaches, but after each shot the lens is moved out of focus to start afresh. This makes each focusing attempt much more positive than trying to maintain a sharp image the whole time.

Fixed focus
This is a one-shot technique with a high chance of success. The lens is focused ahead of the bird, which is then followed in the viewfinder. Without moving the focusing ring again it is fairly easy to anticipate the precise moment at which the image becomes sharp. Without reference points in the sky, focus first on the bird and then quickly refocus nearer.

Puffin
This single-bird, frame-filling shot of a puffin was taken on a North Sea island colony off the coast of northeastern England. Some species, like this one, are extremely approachable, and their obvious lack of fear of humans is enhanced by the monitored and strictly restricted access to the colony.

Underwater

A range of housings makes it relatively easy to shoot underwater, and digital cameras take care of much of the uncertainty and color problems.

Underwater photography is highly specialized, and the diving techniques involved need to be learned from a qualified instructor. This applies to snorkeling as much as to scuba diving. Remember that the most interesting places for underwater photography, such as coral reefs, can have currents, sharp rocks, and a number of creatures that defend themselves, sometimes very actively, by stinging or biting.

Water absorbs light, and the deeper you go, the darker it gets. Also, water absorbs light selectively, starting with the red wavelengths. Because of this, the deeper the water, the bluer it appears, and even though the camera's white balance menu can accommodate the color cast down to a few feet below the surface, the results lack the saturation and contrast of pictures taken with flash. For scenic shots, showing more than just a detail, natural light has to be used, but they are nearly always more successful with flash added for the foreground. Flash is essential at depths below a few feet, and underwater units are normally mounted on an arm above and to one side of the camera housing. This off-axis position helps to avoid a special problem in all but the clearest water—back-scattering, in which water particles between you and the subject are lit up to look like falling snow.

The higher refractive index of water has an apparent effect on lens behavior, summarized in the box opposite. Basically, lenses behave as if they are a longer focal length. One correction is to use a port in the housing that is domed rather than flat. This cures the problems of size and distance, although the angle of view remains narrower than in air. However, it has a side effect: an ordinary lens will no longer focus on infinity. To restore normal focusing, add a supplementary close-up lens or, for an SLR, a thin extension ring. Dome ports also correct the problems of distortion and poor resolution close to the edges of the picture, and so are always better than the cheaper flat ports. For the best performance, the curve of the dome should match the focal length of the lens.

Housings

There is a fairly wide range of submersible housings for digital cameras, but the basic choice is between those that are adaptable and fit a number of makes, and those that are custom-designed for a specific model. The best housings, which can be used at serious scuba-diving depths, are expensive.

▼ Flash

Flash is virtually essential for close-ups at any reasonable depth, particularly with active, moving subjects. The improvement in color intensity and contrast is marked, as in this image of a Tiger cowrie in Malaysia.

Near the surface

You can shoot without flash within a few feet of the surface, if the water is clear and the sunshine bright. The main precaution is white balance. This pair of images shows the difference between "Daylight" white balance (main) and "auto" (smaller image, right).

Lenses underwater

Being denser than air, water acts as a kind of lens, so that compared with the view on land the image is different in three ways:

1. Objects appear closer, by a quarter of their distance.
2. They appear larger, by a third of their true size.
3. The angle of view of the lens is smaller, by a quarter.

Filter corrections for sunlight

Depth	Filter
5–15ft (1.6-4.6m)	CC20 Red
15–20ft (4.6-6m)	CC30 Red
20–25ft (6-7.6m)	CC40 Red
25–30ft (7.6-9m)	CC50 Red

Light reflected from surface

Sunlight

Light is absorbed passing through water

20 ft (6m) red absorbed
36 ft (10m) orange absorbed
50 ft (19m) yellow absorbed
75 ft (21m) green absorbed
90 ft (27m) blue absorbed

Equipment care

Shooting underwater can be tough on your equipment. Sand, grit, and crystallized salt can cause leaks by becoming lodged in the O-ring groove, if they are allowed to build up after several dives. Take these standard precautions:

☐ Check a new housing by submerging it without a camera. Do this first in a tub or bucket of water and watch for tell-tale bubbles, and then take it to the maximum depth that the manufacturer recommends. Back on the surface, check the interior for drops of water.

☐ Between dives, wipe down the housing, your hands, and hair before changing memory card. If possible, rinse the housing in fresh water before drying it. When returning to the boat or shore after a dive, do not leave a housing out in direct sunlight; being sealed, it will heat up very quickly and this can cause condensation and damage to the lens and components.

☐ At the end of a day's diving, first rinse the equipment in fresh water by immersing it completely for at least 30 minutes to

dissolve all the salt. Then hose it down. After washing, dry the outside thoroughly with a clean cloth, and then open the housing, remove the camera, and pull out the O-ring. Clean the O-rings and their grooves with a cloth soaked in fresh water and with cotton swabs. Wipe them dry with a clean cloth and relubricate, but lightly. Too much O-ring grease prevents a tight fit and may cause a leak. It also attracts grit and sand. Finally, reassemble and protect the port with a cap.

Woodland

Temperate woodlands are rich environments for photography, with a huge variety of plant and animal life, but be prepared for a range of light levels and restricted views.

Woodland offers great opportunities because trees create a number of different habitats, at different heights above the ground, yet all in one place. At the top, where most of the leaves grow to trap sunlight, is a flimsy lattice of thin branches; lower down, the plain, bark-covered trunks provide another food source. Closer to the ground, where less light filters down, bushes and shrubs grow, while on the woodland floor, undergrowth mingles with all the litter that falls down from the higher levels. Because of these different layers, each with its own characteristics, there is less direct competition for food among the animals than there is in a simpler habitat such as grassland.

For all but close-up views, where the surroundings are less obvious, composing woodland photographs generally involves finding clear viewpoints and simplifying the image. The mass of branches, trunks,

▽ **Olympic rain forest**
This shot shows a rare stand of temperate-climate rain forest, in Washington State's Olympic National Park. Shooting mainly in shade, and framing the image so that it was filled with trees and plants, gives the full impression of dense green vegetation.

△ **Weak sunlight**
For overall views of a complex woodland interior, the weaker light from a hazy or low sun is likely to be better than that from a bright midday sun. When photographing into the sun, take care in positioning the sun's disk. By having it cut by a branch, you will still have the image and halo of the sun without excessive flare.

and leaves can make confusing patterns and get in the way of middle-distance shots. If you're stalking an animal such as a deer, tree trunks and undergrowth will help conceal you, but they can also intrude on the picture and careful side-stepping may be necessary for a clear view. In fact, clear views of anything are at a premium in woodland so, to improve your chances, look for clearings, glades, ponds, and the banks of rivers and streams, as well as weather conditions that separate the scene into zones, such as mist and fog. Hilly areas usually offer the most choice of viewpoints.

In relatively open forest, tree trunks receding into the distance make depth of field an issue if you are using a long-focus lens. Even at a small aperture it may be impossible to get everything sharp. A tripod helps for this kind of landscape. In photographing animals, however, shallow depth of field from a wide aperture actually helps by blurring foreground and middle-ground vegetation.

There are so many different small habitats in temperate woodland that it's difficult to predict general lighting conditions, but when the trees are in leaf, the shade deep inside most forests is deep. This is a lighting problem if you are stalking active animals, and calls for a tripod for most other subjects—or a very high sensitivity setting. A tall, well-established beech wood, for example, lets so little light reach the ground that even on a sunny day exposures of around 1/50 sec at ƒ2.8 are likely at ISO 100. When the canopy is thin and sunlight does break through, contrast is likely to be very high in summer. Shafts of sunlight are interesting when they pick out just the right subject—a small clump of bluebells, for instance, or a deer emerging from a thicket—but when it simply dapples the scene it adds to the visual confusion of a habitat that is already quite complex. The range of brightness in these conditions can be as high as 6 ƒ-stops. Small-scale subjects like flowers can be shaded to make the lighting more even, but with overall views it may be better to wait until late afternoon or early next morning when the low angle of the sun picks out the sides of tree trunks. Cloudy-bright weather and hazy sunlight are the easiest working conditions.

Ancient oaks
I took these shots in an old oak forest in a Welsh wildlife reserve. Light levels were low, but a 1-second exposure with the camera on a tripod allowed an aperture of ƒ22 with a 150mm efl lens, and therefore excellent depth of field.

Grassland

Good visibility, open views, and clear lighting are the hallmarks of grasslands, and in some protected areas an abundance of plains animals makes for some of the most exciting wildlife photography possible.

Because of the typically low relief, most subjects in grassland are exposed to the full available light from the sky. While this does not make direct sunlight any more intense, it does increase the level of fill-in reflection from other parts of the sky, and so lowers contrast. On a cloudy day, the lighting is virtually shadowless. In general, plains light is more consistent than elsewhere and, because the horizon is generally flat, lasts longer. However, this can also make it monotonous, particularly when the sun is high and the direction of the light is the same whichever way the camera is pointing. Overcast conditions create very flat lighting, and distant views can appear particularly dull, while at the same time the sky tends to be much brighter than the land (by a difference of up to 5 f-stops). Photographically, early morning and late afternoon are particularly important times and these coincide, fortunately, with the times of greatest wildlife activity.

The savannahs of Africa are archetypal tropical grasslands, justly famous for spectacular concentrations of wildlife, and in particular, large mammals. African safaris have little competition when it comes to reliable, accessible wildlife photography. Finding animals in open grassland is usually easier than in any other habitat, simply because there is less cover, and herds of large grazers are the most visible of all. At the same

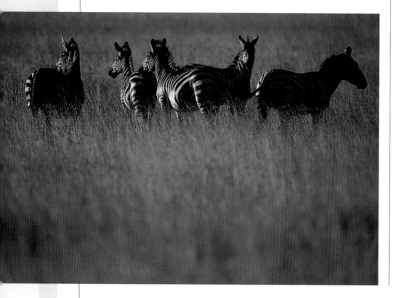

▲ **Horizon line**
One answer to the problem of making an attractive composition with a flat horizon is to frame the image below it. Here, the backlit grass just before sunset is thrown out of focus by a powerful telephoto lens (600 mm) and becomes simply a wash of color.

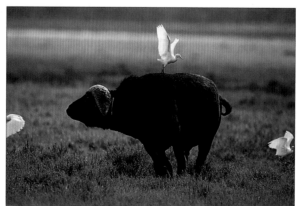

◄ **Cape Buffalo**
A cattle egret tries to land on the back of a huge Cape Buffalo in Africa's Rift Valley. These savannah buffaloes are unpredictable and dangerous and best photographed from a distance.

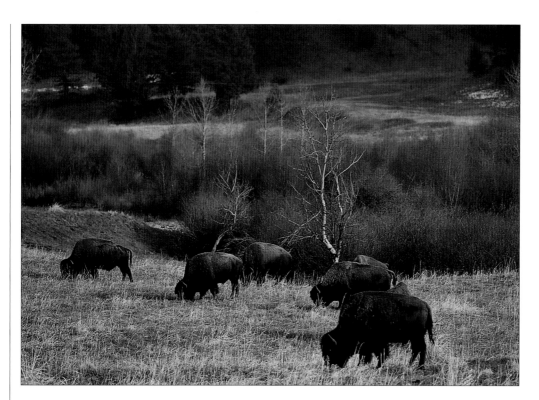

Bison herd
Any elevated point is valuable in grassland—use it to keep the horizon at the top, or to exclude it entirely. This shot captures a downslope view of bison grazing.

time, long grass and clumps of trees can conceal large animals, and predators take advantage of this. For this reason, height is an advantage and a four wheel drive vehicle ideal.

Streams and water holes, which provide both water and cover (in the form of trees and shrubs) are usually good sites for photography, and are often busiest late in the afternoon. Some predators, particularly those that use surprise and pouncing rather than speed in the chase, such as leopards, keep close to such places. The most active times of day for many species are early morning and late afternoon, with the middle of the day reserved for resting or grazing. Nevertheless, good visibility makes it as easy to find animals at midday as at any other time.

Flat grasslands make composition difficult. To capture the sense of spaciousness, try using a wide-angle lens and placing the horizon line low in the frame, especially if there are interesting cloud formations in the sky. From ground level it is not easy to see much more than the foreground and middle distance, and any slight elevation helps. Even using the roof of a vehicle makes a noticeable improvement. A slightly higher viewpoint also makes it possible to photograph animals without always having to include the horizon.

Dik-dik
One of the smallest antelopes (about the size of a hare), the dik-dik lives on the wooded margins of the savannah in East and Southern Africa. Its unusual name comes from the sound it makes through its nose when disturbed or alarmed.

Coastlines

Where the sea meets the land, the contrast between the two environments and the ebb and flow of the tide create an ever-changing range of photographic opportunities.

Coastlines can be flat and muddy; rocky with high cliffs; or feature beaches of sand, coral, or pebbles. The water can be anything from dead calm to violently stormy. Variety and unpredictability, in fact, account for much of the visual appeal of coastal landscapes. Light levels are high, and are enhanced by reflection from the water, and from surf and sand. Be wary of automatic exposure—shots dominated by the sea, especially if it is backlit, are likely to be too dark for the other parts of the scene. Look carefully at the results in the camera's LCD, and above all check the histogram. Make exposure adjustments as necessary, and if your camera has tone compensation, consider reducing the contrast.

Fine spray is common on windy days, particularly off a rocky shore when waves are heavy, and this creates long-distance haze. This is accentuated by high ultraviolet scattering, so ultraviolet filters are important (they also protect the front element of a lens from damaging salt deposits). Water reflections can be useful or awkward, depending on the image you want to

Rock pools

Use basic close-up techniques for photographing the small-scale life in these pools, but take special precautions to avoid reflections from the water. Direct light gives a much clearer image than diffused light, so both sunlight and flash are ideal. In either case, position the camera so that the light comes from one side and is not reflected directly into the lens. Even then, the water may reflect blue sky. A polarizing filter cuts reflections, but also reduces the light reaching the sensor; an alternative is to shade the water above and in front of the camera with something dark, such as a black card-board or even a piece of clothing.

▶ **Monterey**
In this image, back lighting from a late afternoon sun shines through the crest of a wave breaking against a Monterey shore in California.

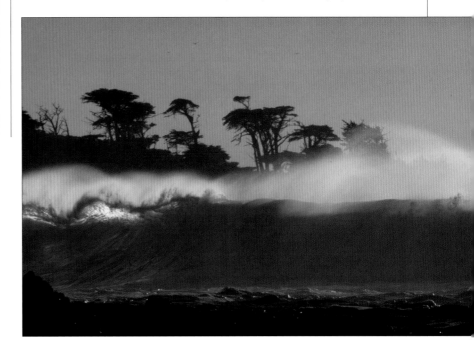

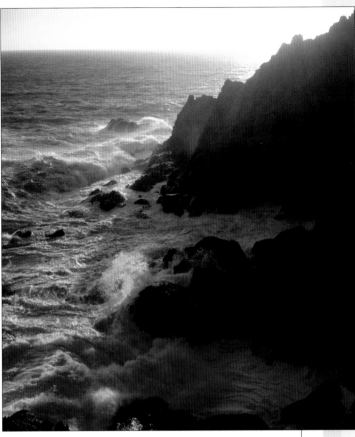

▲ Sea wrack
This image shows boulders at low tide, covered in sea wrack, at Ocean Point near Boothbay Harbor, Maine. By going in close to the wrack, it shows a very different view of the coast than the dramatic waves or perfect sands so common in coastline photography.

▶ Cliffs
Using back lighting with waves and water highlights waves and foam. In this case, the back lighting also creates graphic silhouettes from the cliffs.

capture. Shooting toward the sun can give an attractive high-contrast pattern of bright reflections and dark rocks, while waves are emphasized when backlit. However, when there is clear, unruffled water close to shore, it may be useful to suppress reflections so as to show some underwater details. In this case, use a polarizing filter and experiment with the camera angle and position of the filter to find the clearest view.

There may be bird and seal colonies along rocky coasts. Although localized, where they exist they are generally well known, so ask around. Most seabird and seal colonies are densely packed, which gives you good opportunities for massed shots. As the locations are deliberately chosen by the animals for being inaccessible from the land, a very long focus lens is usually necessary for strong images. Ideal camera positions are high up and directly opposite the cliff or island that supports a colony. However, this inaccessibility has one advantage—the colonies generally feel secure, so that, from a convenient viewpoint, there is normally no need to conceal yourself.

Tropical beaches

Coastlines in the tropics are not always fringed with white sand and coconut palms, but many are, and they offer a distinctive type of scenery. White sand, derived mainly from shells, is very bright and reflective under a high sun. When the beach slopes off gently under clear water, rich sea colors from green to blue are usual. For scenic views, underexposure is often very effective; it darkens the sky, strengthens the color of the water, and can give very graphic images. To capture this, follow the meter reading without compensating, and even try a darker exposure. Graduated filters and polarizing filters can exaggerate this effect.

Wetlands

A flat, watery world offers relatively little in the way of landscapes, but is the habitat par excellence for birds, with a high proportion of larger, easier-to-photograph species.

Being largely flat and open, wetlands share some of the characteristics of grassland. Light levels are high, and there is little in the way of relief or tall forest to hide the attractive light from an early morning or late afternoon sun. However, the repetitiveness of reed-beds and marsh grass, particularly when seen from water-level, can make for dull landscapes. One important visual advantage of wetlands is the water itself, which can at least add a variety of interesting reflections. These are relatively bright habitats, not only because the landscape is flat, but also because the surface of the water reflects light. Consequently, both early and late in the day, when there is plenty of animal activity, there is still usually sufficient light to use a long-focus lens at respectable shutter speeds.

Low direct sunlight is particularly attractive in wetlands as it gives a texture to the reeds, grasses, and water ripples. Sidelighting is also generally good for taking close-up photographs of birds. Reflections in water are more intense under a direct sun, and can give well-defined graphic silhouettes. By comparison, the light on an overcast day or under a high sun is more difficult to work with. The lighting conditions in clumps of trees such as the "hammocks" of the Everglades and in mangrove swamps are essentially those of broad-leaved forests.

The water, boggy soil, and tangled vegetation that deter predators also make quiet approach difficult for photographers. Stalking on foot is worth trying from dykes and raised ground, but this only gives access to the edges of lakes and marshes, and, as there is usually little cover concealment, may be difficult. Stalking by wading is noisy and not very efficient, and is usually best reserved for approaching large nesting colonies where birds live in such large numbers that they do not feel threatened by an intruder. In general, a boat often gives the clearest and closest views. Along deeply indented coastlines, estuaries, and marshy areas, it may be the only practical means of transportation. However, in many ways, a boat is far from ideal as a camera platform. Maneuvering precisely is not easy, and it is much better to have someone else steer rather than try to manage everything on your own. On rivers, it is easier to approach by drifting silently downstream than by sailing

Alligator
Given an even slightly elevated camera position, crocodiles and alligators are reasonably cooperative wetland subjects. This alligator, photographed from a bridge over the Myakka River in Florida, exhibits no fear.

under power upstream. Be prepared to take perched birds by surprise as you round a bend in the river—they will spot you easily at a distance and will eventually flee or dive as you approach. Either hold the camera by hand, or rest it on a soft, padded support. Whenever possible, switch off the engine before shooting, to avoid vibration. In marshes, a flat-bottomed punt is often the best means of transportation as the water is usually shallow enough to use a pole, which is quieter than oars.

For photographing many species, such as ducks and geese, a hide is the only reliable viewpoint. Because most of the wetlands that have spectacular bird populations are also well-known sanctuaries, permanent blinds (hides) administered by conservation organizations are not uncommon. There may, however, be some competition for access to them among bird-watchers, and it is wise to check in advance whether they are available. Visibility, at least for birds, tends to be good in a wetland habitat.

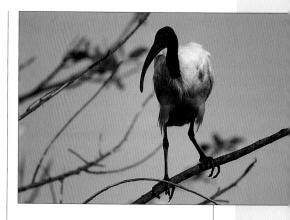

Shooting from a boat
If photographing from a boat, start shooting early, as birds may take flight at any moment.

Florida mangroves
A small flock of flamingos adds a finishing touch to an aerial view of mangrove swamps.

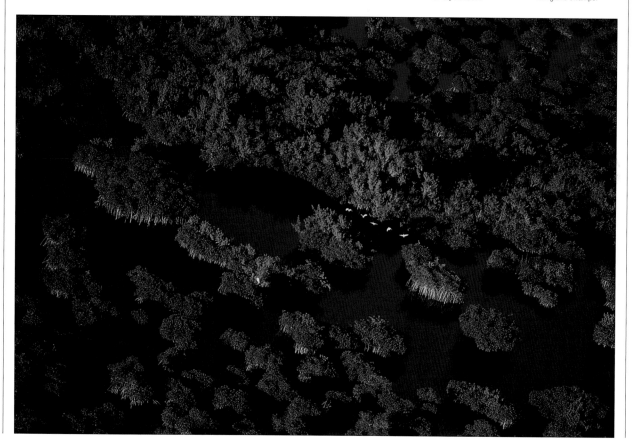

Mountains

For sheer visual spectacle, almost nothing competes with mountain landscapes. The wild terrain, spectacular views, and constantly changing light offer the camera an endless source of dramatic imagery.

Mountain light in clear weather has a special intensity. The sky is a deeper blue, and shadows are stronger, so the contrast in sunlight is often extreme. Because there is less atmosphere, there is much more ultraviolet, and this can give unusual results if you are not prepared for it, as camera sensors are more sensitive than our eyes are to UV rays. Mountain views in sunny weather usually have a blue cast to the distance in photographs, particularly with telephoto lenses. There is not necessarily anything wrong with this—the blue haze gives a good impression of depth—but it does cut down on visibility. To overcome it at the time of shooting, use a strong (that is, yellowish) UV filter and avoid shooting into the sun. During image editing, reduce the saturation of blues.

▼ Thin air
With half the density of atmosphere as at sea level, views at 16,500 feet (5,000 meters) altitude are stunningly clear, even with a telephoto lens, as shown in this shot of the north face of Mount Kailash in western Tibet.

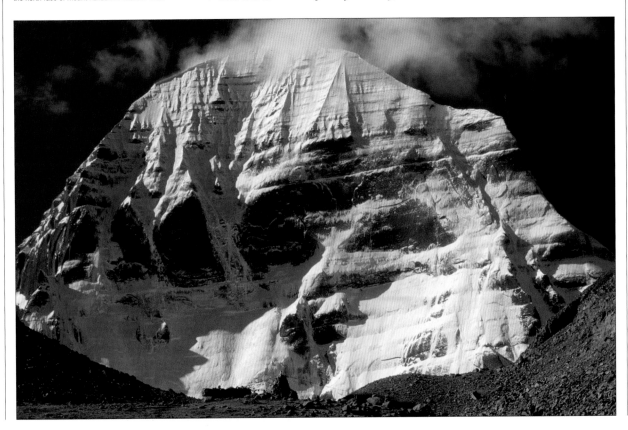

Mountains also have special weather patterns that can change more quickly than in lower altitudes. Be prepared to take advantage of any change as soon as it happens, and don't rely on a slow progression of the light. At high altitudes, watch out for conditions when there are clouds below you—these can sometimes reward you with stunning views of peaks standing like islands in a sea of cloud.

The vertical component in mountain landscapes gives you more freedom when it comes to composition. The best impression of height is either from a distance or from nearby peaks; you can expect to find the most spectacular views first, as you approach a mountain range from a distance, and then when you have climbed up to the upper levels.

Telephoto lenses help to compress the images of foothills and ridges in a way that emphasizes the scale of peaks and ranges in the distance and, unusually for landscape photography, this often works just as well in a vertical format as in a horizontal one.

Camera care

Cameras and lenses need, above all, adequate protection against physical damage. Knocks and scrapes are likely to occur, and everything you carry should be well padded. A knapsack is ideal, particularly one specially dedicated to cameras, while a regular shoulder bag is useful only for hill-walking on moderate slopes. If you carry a camera at the ready on a neck-strap, add a restraining chest-strap to stop it bouncing about as you climb. Make sure that you have sufficient battery power—carry spares and ensure they are charged.

◀ Vertical framing
Mountains and hill country afford good opportunities for framing vertical shots. There are often plenty of foregrounds to choose from, particularly when taking downward-looking shots.

▶ Serow
Large mountain animals tend to be browsers and grazers, such as this serow, photographed in the mountains of Nagano prefecture, Japan. Their sharp eyesight makes them difficult to stalk without being spotted.

Equipment

Mountain travel is usually strenuous and all equipment needs to be chosen with an eye on weight. Clothing should give adequate protection against wind, cold, and rain, and must also be adjustable as weather conditions can change sharply in a single day. Layered clothing that traps air gives the best insulation, with a windproof, waterproof parka on top. For severe conditions, add a down jacket, thermal undergarments, snow leggings, spare socks, down mitts with silk inner gloves, and woolen headgear. Choose boots to suit the terrain—either hill-walking or climbing boots. They should have Vibram soles and be watertight, and climbing boots should be rigid, with thick soles.

Snow and ice

Harsh conditions and bright white landscapes make snow and ice specialized conditions for shooting, but the rewards are spectacular scenics and some interesting wildlife.

Although the physical conditions can be difficult to deal with, snow offers a welcome change in landscape photography from the normal tonal arrangement of land and sky. It reduces overall contrast in a scene by reflecting light back up into the shadows, but in detail views it can provide a white background, creating high-contrast silhouettes of trees, rocks, and dark-coated animals. By coating the land, snow also tends to simplify scenes and make them more graphic.

Some exposure precautions are usually necessary. On automatic, the camera will tend to underexpose images, because it reads the whiteness as a midtone. To preserve the delicate texture of snow, adjust the exposure to be brighter by one or two f-stops, either with the compensation control in auto or by setting it manually. Snow needs to be exposed precisely in order to preserve its luminous quality and texture, meaning almost, but not quite, white (that is, between about 230 and 245 on the 256-level scale). Bracketing exposures is a sensible precaution. Being an efficient reflector, snow also picks up the color of its surroundings, and especially the blue of a clear sky. Shadows in snow on a bright sunny day are inevitably blue, but this is only likely to be a problem if the main focus of interest is in the shadow area. Later, in image-editing, you can reduce the blueness by using Hue Saturation Brightness (HSB) adjustment, selecting just the blues, and reducing their saturation.

Equipment needs special care. There are different levels of severity of coldness. From freezing point at 32ºF (0º C) down to 0ºF (-18ºC), the precautions are principally the commonsense ones of keeping equipment as dry and as warm as possible. Below 0ºF (-18ºC), however, some of the materials alter

Batteries in the cold

Because digital cameras are completely reliant on electronics, they are more susceptible to environmental extremes than are mechanical film cameras. Cold affects batteries, but in two conflicting ways. On the one hand, batteries lose their charge more quickly, but on the other, they work more efficiently because there is less electrical resistance at low temperatures. The net effect is that you can expect to have to replace the camera's battery with a spare frequently, but warming up an apparently discharged battery will often revive it.

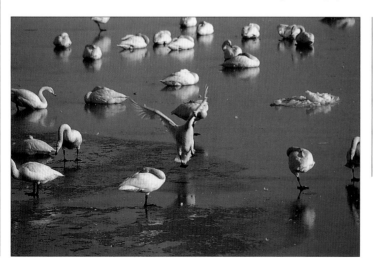

Swans on ice
Swans arrive from Siberia at Abashiri on the northern coast of Hokkaido, Japan's northernmost island, in October. By January, the cold has caught up with them, and the Sea of Okhotsk freezes inshore.

their characteristics—some plastics become brittle, metal can stick painfully to skin, and some lubricants thicken, causing moving parts to slow down or jam up. Severity also depends on the time that you spend out in these conditions. In any low-temperature environment, condensation is potentially serious when cold equipment is brought indoors. It can also be a problem when wind-driven snowflakes melt and then freeze on cameras that have just been taken outdoors, and when warm breath condenses and then refreezes on cold metal and glass.

In extreme conditions, expose the camera to the cold only when shooting. For the rest of the time, keep it insulated in a padded waterproof bag or under as many layers of clothing as possible. A large covering flap on the bag helps to keep out snow, and matching Velcro tabs on the inside of the strap and on the shoulder of your jacket prevents slipping. An oversize front-zippered parka is good protection for a camera on your chest.

When moving into a warm interior, either leave the equipment in a moderately cold room or seal it in a heavy-duty plastic bag containing silica gel and with as much air squeezed out as possible, so that condensation forms on the bag and not on the cameras. Remove film from cameras before bringing them indoors. When moving out into the cold, protect the equipment from snow until it is close to the outdoor temperature; otherwise, the snow will melt and then refreeze in joints. This may be very difficult to remove and can even damage equipment by expanding. Camera tape can be used to seal joints. Never breathe on equipment if you can possibly avoid it. If you can use batteries in a separate pack, do so, and keep it warm under your clothing. Cold batteries will deliver only a fraction of their power, and will need to be replaced and recharged frequently. Another way of keeping equipment warm is to pack it in felt cases with one or more hand-warmers.

▲ Fresh snow

As with sand-dunes, you need to plan your view of fresh snowdrifts a little in advance, particularly if you are using a wide-angle lens from close to capture foreground detail. Footprints usually spoil shots like this when they are visible.

▼ Cranes

Japanese cranes at the crane sanctuary near Tsurui. Like many snow-dwellers, the cranes have partly white plumage. This makes exposure critical, both to keep the whites white without blowing out, and to separate plumage from snow.

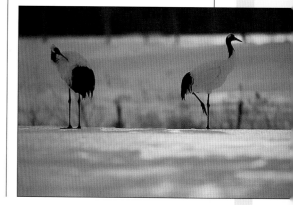

Deserts

Arid regions offer an exotic, minimalist choice of scenery that favors photography with its rock and sand forms, which are often clear of vegetation.

The more arid a desert, the less vegetation there is and so the more stark the scenery. In extreme desert areas, such as Death Valley, the Namib, and parts of the Sahara, the bare topography makes fine material for graphic, simplified images. Not only are these very arid deserts sufficiently unusual to be interesting for their contrast with other habitats, but they also provide the rare opportunity to construct sparse, geometric photographs. With little or no grass, shrubs, or trees, the shapes and textures of rock and sand can become the most important ingredients.

There are three main types of pure desert topography, all influenced to some extent by the wind, which is an important agent only in the absence of vegetation. Desert pavement is a surface of rocks and gravel scoured of fine particles by wind. Dunes occur where the wind is forced to slow down and so drop some of its load of sand; this happens in the lee of rocks and low hills, but dunes, once begun, are self-perpetuating. Rocky uplands usually stand out abruptly from the generally level desert terrain, and are sharply weathered by occasional violent run-offs from storms, the blast of wind-blown sand, and the flaking due to temperature changes.

Desert scrub, composed chiefly of bushes, bunch grass, or cacti, modifies the lunar quality of desert landscapes and is more common than bare sand and rock. Although most of this vegetation makes for less striking images, certain types of cacti such as the saguaro have such strong shapes that they can be used for very graphic compositions.

With so little rainfall, desert light is more predictable than most. As with many landscapes, a low sun gives the most positive modeling for shapes and textures such as the ripples in the sand-dune or the texture of an eroded rock-face. The midday sun, however, also has some value for creating stark views, and for photographs taken completely in shade in rocky uplands, the high reflectivity of sand and rock-faces can give a very attractive light for details of sandstone formations. In the heat of the day, haze may lower contrast in distant views, and heat shimmer just above the surface of the ground can give a partly blurred image, especially noticeable with long-focus lenses. Ultraviolet and polarizing filters help.

Camera care

The downside of a desert's picture opportunities is its harsh conditions, inimical to delicate electronic equipment. As far as possible, keep everything in shade, and avoid enclosed and unventilated spaces such as car interiors. If equipment must remain in the sun, cover everything with a white cloth or other reflective material. Keep cameras packed and sealed when not actually shooting (reflective cases, whether metallic or light-colored, absorb the least amount of heat), and, whenever possible, raise cases off the ground for ventilation.

If wind-blown dust and sand is mild but constant, tape over all joints in equipment, but if wind-blown dust and sand is severe, seal the camera in a plastic bag. If dust storms are likely, consider using a soft underwater housing. Keep the lens-cap on until you need to shoot, and if the lens accepts screw-on filters, attach a UV filter. Remove sand and dust particles frequently with a blower-brush. Stay alert for gritty, scraping sounds when operating moving parts.

◀ Sand-dunes

Desert dunes are highly sculptural, and have different appearances during the day according to the light. A low sun shows up the ripples on one face of a dune in Death Valley, California. You need to plan your approach carefully in order to avoid photographing your own unsightly footprints.

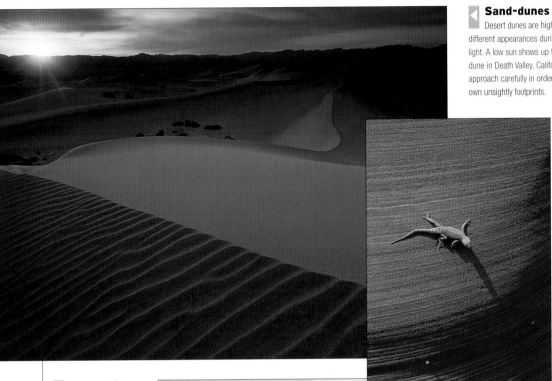

◀ Sandstone walls

Cross-lighting reveals the fine details of texture on the water-eroded red sandstone wall of a slot canyon in Arizona, near Lake Powell, as a small lizard crosses it.

▶ Organ Pipe cacti

Semi-arid landscapes feature specialized vegetation, of which the most well known is the cactus. Organ Pipe National Monument in southern Arizona contains spectacular collections of this relatively rare species.

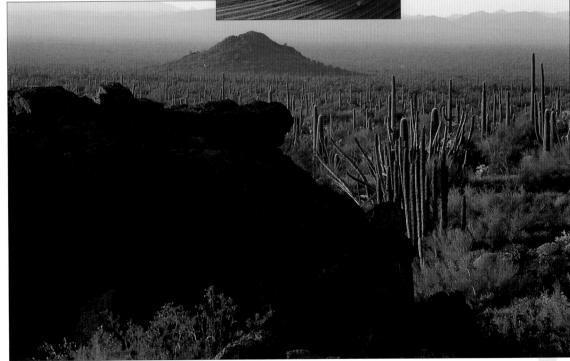

Volcanoes and geysers

The most active of all landscapes are those in areas of volcanic activity. Not always predictable, and sometimes dangerous, these natural features bring a touch of excitement to a normally placid subject.

All the features associated with geothermal activity—volcanoes, geysers, hot springs, fumaroles, and mud pots—are in one sense landscape curiosities, but in another way they are the core of the natural environment, as close as you can get to the workings of the Earth. Just as with active and skittish animals, volcanic activity is unpredictable enough to be an exciting photographic subject.

The most violent volcanic activities are eruptions or lava flows. Volcanoes are complex and individual, but the way in which they behave and look depends mainly on their lava composition. Some lava volcanoes, such as Halemaumau and Kilauea in Hawaii, contain very little silica, and so their eruptions are relatively quiet, with streams of molten lava. Shoot these from a safe viewpoint (the heat is intense, anyway), and dusk will give you a combination of a bright lava glow with just enough daylight to show the surroundings.

Volcanoes with very acidic lava, like Vesuvius, are rich in silica and produce lava that is thick and solidifies quickly. This tends to plug the vent, like a cork in a bottle, and eruptions are often violent and destructive. This kind of volcano conforms to the popular image of a steep cone, whereas many volcanoes are usually flatter and cover much larger areas. Eruptions are obviously dangerous, and unpredictable, so always seek informed local advice before

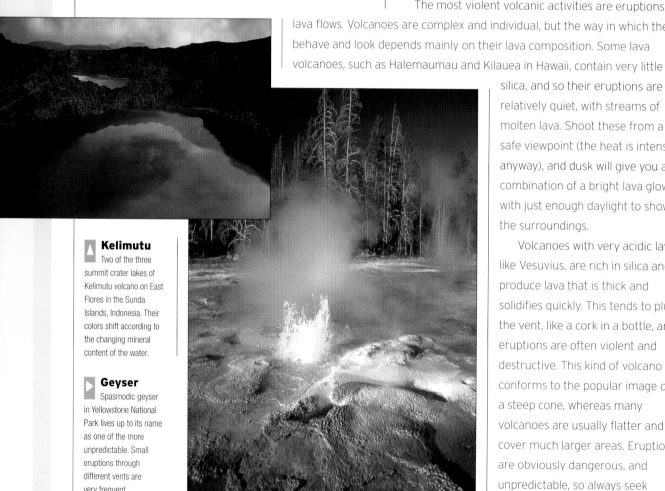

▲ **Kelimutu**
Two of the three summit crater lakes of Kelimutu volcano on East Flores in the Sunda Islands, Indonesia. Their colors shift according to the changing mineral content of the water.

▶ **Geyser**
Spasmodic geyser in Yellowstone National Park lives up to its name as one of the more unpredictable. Small eruptions through different vents are very frequent.

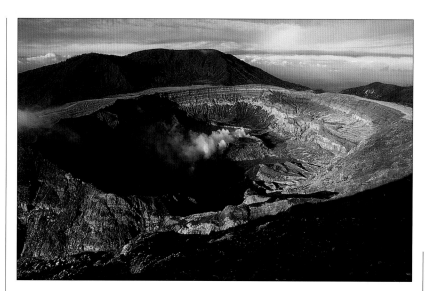

Volcán Poás

Corrosive plumes of steam and gases, including sulfur dioxide, are emitted from fumaroles at the center of Poás volcano in Costa Rica, a collapsed caldera. It took three days before heavy cloud cleared and the crater became visible from the upper rim.

Hot mud

Look for detailed activity in geothermal areas. At Black Dragon's Cauldron in Yellowstone National Park, which emerged in 1948, gases escape through lakes of super-heated mud.

approaching an active volcano. However, even in relatively quiescent stages, volcanoes can be full of interesting activity. For millennia after an eruption, the crater and flanks of a volcano are dotted with fumaroles—vents that emit clouds of corrosive steam.

Hot springs and geysers

Hot springs are upwellings of lukewarm-to-boiling water, heated by molten subterranean rock, rich in dissolved minerals, particularly silica. They are often brightly colored, both from the minerals and from algae that thrive in the heated water, and can be indigo, blue, red, orange, or yellow. Sometimes, the dissolved silica precipitates as a hard deposit, which can form either a surrounding crust or whole terraces.

Geysers are very similar, but spout violent bursts of boiling water at more or less regular intervals. Below ground, a column of water is in contact with hot volcanic rocks, but at this pressure cannot boil. Instead, being very hot, it rises by convection. As it nears the surface, the pressure lessens, the water boils rapidly, and steam then pushes the upper column of water up into the air suddenly. Geysers can spout to any height, and 100 feet (30 meters) is not unusual (the world record is 1,000 feet or 300 meters). In national parks and well-known geyser areas, you can usually find information on times for the main geysers. The behavior of geysers is finely tuned—only the right blend of temperature and pressure distinguishes them from hot springs.

Equipment care

Volcanoes and their surroundings are as extreme a condition as you're likely to find in any landscape. Heat is an obvious problem, but you'll feel it before the equipment suffers. Airborne grit and dirt are more serious, and continuous cleaning is usually necessary. Sulfur dioxide is a major component of volcanic gases, and when combined with steam produces sulfurous acid, which is much more damaging than water. If you are close enough to a fumarole for the sulfur dioxide to make you cough, the camera is too close as well. Consider using a soft plastic housing of the kind sold for underwater photography.

Caves

Underground landscapes are a strange and specialized environment, quite unlike any other, and call for experienced, imaginative use of off-camera flash.

Water, rock-faces, and unremitting darkness are typical characteristics of caving, creating problems that are by no means purely photographic. As with diving, caving is a specialized activity and should not be approached casually. Caves can be dangerous places, and in deep caving photography is necessarily second to all-important safety procedures.

In cave photography, the two main problems are confined spaces and the complete absence of light. SLRs are not ideal. Focusing in the dim light of a flashlight is difficult. A fixed-lens camera with an LCD display is easier to use.

Wide-angle lenses are useful for general views. As most caves are irregularly shaped, distortion, even with an extreme wide-angle lens, is not usually noticeable. One exception is the converging verticals in shots of stalactites or stalagmites aimed upward, but you can correct this later in image editing. Telephotos can isolate details, but a macro capability is essential for small cave life.

Probably the greatest challenge is in keeping the sense of scale. If some light is filtering in, use a tripod

Figures for scale
The lower Gomanton cave in Sabah on the island of Borneo is a major site for the collection of the birds' nests for the eponymous Chinese soup. Only the tiny figure of one of the collectors gives a clue to the immense scale of these limestone caverns.

and a slow exposure. Underground landscapes are unfamiliar and disorienting, so it is often a good idea to include a figure in shot. Apart from these few daylit opportunities, you will have to rely on flash.

There is little point in using on-camera flash for a large cavern. The flash output, even on manual and full power, will be insufficient, and what lighting effect there is will be flat and shadowless. In a large space, with both foreground and background features, the light will fall off sharply away from the camera. A better approach is to have someone carry the flash and use it in one or more distant parts of the cave, facing away from the camera. Mount the camera on a tripod, open the shutter on the "B" setting, and trigger it from different positions. Conceal the flash unit itself from the camera's viewpoint. Try to avoid having the flash-lit areas overlap.

There are three kinds of creatures that live in caves. Troglodytes are the true, permanent inhabitants of darkness. They include cave shrimps, fish, salamanders, and certain fungi. Troglophiles are margin dwellers, including some beetles and spiders, living in the cave only as far from the entrance as there is some light. Trogloxenes are temporary visitors, using the cave as shelter or nesting place—bats, for example.

Cenote
The natural underground lake of the Cenote de Dzitnup on the Yucatán Peninsula, Mexico. A cenote is an underground limestone sinkhole, and they were the principal source of water for the Mayans. With a little research, I knew that the sun at midday would light up the water with a shaft through a hole in the limestone roof.

Cave life
These giant centipedes are troglophile inhabitants of the Gomanton caves, living in semidarkness. As with all cave dwellers, flash is a necessity for taking photographs.

Care of equipment

Water and hard knocks are responsible for most camera damage underground. Secure packing is essential, preferably in padded, waterproof cases. Take extra care when handling all unpacked equipment in the dark. Take cameras and lenses out of their cases only when you are about to use them, as the air is frequently saturated with moisture and condensation is common. Pack desiccant, such as silica gel, in the cases to absorb moisture. Remember that even low-voltage flash units can be dangerous when wet.

Landscapes of **Man**

At different times and in different cultures, the assumptions about what makes a landscape have changed. This goes right back to painting, and has an even greater relevance now to photography, in a world where we alter our environment faster and on a bigger scale than ever before. The natural landscapes that we consideredin the last chapter of this book are rapidly becoming a special case, areas that need to be managed and protected. Indeed, most of those in the West are now national parks or are under some similar kind of official supervision.

A broader definition of landscape photography, however, embraces just about everything else—the parts that humans have carved out for themselves, flattened, built up, and manicured. It was an American writer, Henry David Thoreau (1817-62), who argued the most strongly against man's interference with nature—an inspiration for modern environmentalists—but there is an older, European, view of the land as the place where man lives. This Classic view does not have humankind as the despoiler, but as the inhabitant, with history as a justification for a sort of harmony. The painter John Constable's landscapes of hay-wains, cattle, shepherds, and distant cathedrals, all under towering and impressive skies, celebrate this view. He himself wrote, "...old rotten planks, slimy posts, and brickwork, I love such things..." He stressed the point further, "There is nothing ugly; I never saw an ugly thing in my life: for let the form of an object be what it may—light, shade, and perspective will always make it beautiful."

In photography, the Englishman Peter Henry Emerson showed a similar feeling for the Norfolk Broads in his pictures of rural life in the 1880s. The style is different from Constable, of course, but it also shows a rural world, with plenty of room and time. Some of this has survived the 20th century, although it is becoming more of a relic, worthy of preservation orders. Arguably the true representative of the modern landscape is urban—cities, towns, and suburbs—at least as much as it is rural.

In these built-up areas we have created our own landscapes, and they are open to all kinds of visual interpretation by the camera. There's plenty of beauty, but not of the Thoreauvian, Sierra Club kind. And in any case, beauty may not be the aim of the image. If wilderness photography is about adventure, nostalgia, and preservation, the photography of populated landscapes is about realism, history, and change. One of Edward Weston's most well-known photographs is titled *Quaker State Oil, Arizona*. In 1941 he was touring Arizona by car. Most of his outdoor photography up until then had been firmly focused on nature. Heavy stormclouds were building up above the mesa ahead as the car approached an isolated sign advertising motor oil out in the desert. Weston's initial reaction was that this was a blemish on the landscape. But he immediately changed his mind, shouting at his driver, "No! Back up; the sign is a part of it!" That is what this section of the book is about. The sign—and the road, and the people, and the buildings—they are all a part of it.

Cityscapes

You can treat cities and towns in much the same way as landscapes, not just as a location for photographing people: the city itself becomes the subject.

As subjects, towns and cities are in many ways similar to natural landscapes, with the important addition that they reflect human activity. Therefore, whether or not people appear in the photograph, a shot of an urban landscape inevitably reveals something of the relationship between people and their surroundings. Architectural photography and candid photography of people have their own distinctive approaches. Urban landscape photography takes something from both.

For overall scenic, establishing shots, viewpoint is usually more of a problem than it is with natural landscapes. The most effective shots are often taken at a distance and at some height, but the difficulty lies in finding this kind of camera position. Tall buildings may be the obvious choice, but security considerations these days make many rooftops inaccessible, while the windows of a modern high-rise are likely to be sealed. Otherwise, look for

▼ The distinctive skyline
From an elevated viewpoint, the skyline of a city can often be made to convey some of its distinctive features. Here, aggressively modern towers on former marshes in Pudong form the new view from Shanghai. Skylines are often most striking in silhouette against an early morning or late afternoon sky.

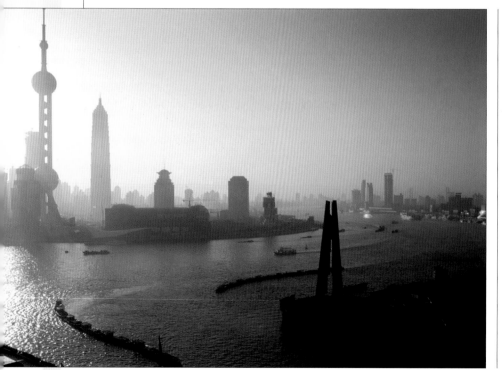

▲ National culture
For a national holiday, a row of giant French flags appeared behind the well-known statue of the national heroine Jeanne d'Arc, looking out over the Place de la Concorde in Paris.

adjacent stretches of open ground or water—a park or the opposite bank of a river, for example.

Overall views are, in any case, just one of the endless possibilities in shooting a city. Several different stylistic approaches are possible, of which the following are examples:

- ☐ A comprehensive view of a city's layout.
- ☐ The grand and famous landmarks.
- ☐ By contrast, the real life of the less-glamorous residential districts and suburbs.
- ☐ The underside of city life; a critical view.
- ☐ Exploiting the graphics of skylines, particularly in industrial areas.
- ☐ Juxtaposing people and landscape to show how one relates to the other.
- ☐ City life: reportage shooting of people.
- ☐ Deliberately excluding people to give a somber, deserted appearance.
- ☐ Details that reflect the character of a city and its inhabitants.
- ☐ Graphic details of signs, shop windows, street art, graffiti, and so on.

I include this list—and it is by no means comprehensive— to stimulate ideas. Above all, a city offers variety and energy for photography; whether you settle on one kind of picture style and approach in order to make a personal statement, or else go for a photographic coverage that deliberately takes in as many aspects as possible, from people to architecture, cities are rich in imagery.

One type of location deserves a separate mention, because it is in one sense a part of the city, yet in another distanced from it—parks and public gardens. Although the majority of these are creations of an earlier age in city planning (in the West they mainly date from 19th-century attempts to introduce green spaces into the city), few of the world's cities are devoid of at least one central park. As with cities in general, there are many different approaches to photographing them, including juxtaposing them against the surrounding city buildings, as works of landscape art in their own right, for details of flowers and trees, and as places for people-watching.

▲ Long-focus
A long-focus lens (400mm efl) compresses perspective, crowding Caracas's buildings, to fill the frame and appear densely packed.

▶ Relevant detail
By careful selection, close-up details can convey an idea of the complete city. Look for details that are characteristic of, and preferably unique to, one place. This old streetcar, clearly named Desire, could only be in one city—New Orleans.

City views

Like scenic overlooks for natural landscapes, city viewpoints are valuable locations if you need an establishing shot that gives an overall impression of the city.

With a few notable exceptions, such as San Francisco and Rome, most towns and cities are built on relatively flat land, and this puts overviews at a premium. Unlike natural landscapes where, in wilderness areas at least, you can explore as much as you like, in a city you don't have unrestricted access. Most buildings are privately owned, and in any case, in these days of heightened security, very few rooftops are accessible.

Also, as construction fills more and more cities with high-rise buildings, the increased density narrows the choices of clear views. Where there are surrounding hills, or else isolated hills within the city, such as in Athens, there are likely to be a number of good viewpoints, but this is the exception. Some of the most effective shots are those taken at a distance and at some height with a telephoto lens. Try the following, while bearing in mind that the most obvious viewpoints will already have been used extensively for photographs, and you may find little new to shoot:

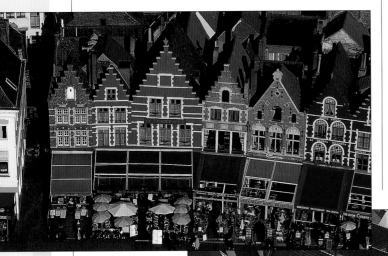

☐ The top of any prominent tall building. Look first for well-known locations publicized in tourist literature and designed as tourist attractions—the viewing platform of Tokyo Tower, for example. High-rise residential blocks sometimes have open access through exterior emergency staircases. Some public buildings may have custom-built viewing galleries or restaurants, but for offices and official buildings you normally need permission in advance.

☐ Any high ground, such as a hillside.

☐ The opposite side of a stretch of open ground or water, such as in a park, or on the opposite bank of a river.

High points

Most cities have some elevated spot from where tourists can look out over the rooftops. In Brugge in Belgium, it is the 290 foot (88-meter-high) medieval belfry tower, built in the 13th to 15th centuries. Viewpoints like this always offer a number of different shots, particularly with a telephoto lens.

Anticipate the lighting conditions that will give the effect you want. As with landscapes, a low sun in the early morning or late afternoon is usually more attractive than a high sun. Midday sunlight usually gives more contrast in a city than in an open landscape, as tall buildings cast large, strong shadows. Sunrise and sunset can be as effective as anywhere else. Cities also usually look good after dark, especially at dusk when there is still enough light to show the shapes of buildings. Nevertheless, the sheer variety and mixture of buildings and spaces means that something will look good in any kind of lighting; it's just that if you are fixed on shooting a particular site, you may have to wait for the best light.

Dusk for the best mix

For a night-time shot, cities are more brightly lit after sunset than before sunrise, and more so in winter than summer, when offices are still full. Different types of light—street lighting, neon displays, and public building spotlights—are switched on at different times. You may have to check the scene the evening before to guarantee the timing for the brightest array of lights.

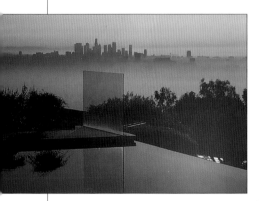

From a distance

Downtown Los Angeles emerges like an island from the all-too-familiar smog, seen from the swimming pool of a house in the Hollywood Hills. What the view loses in detail and clarity, it gains in atmosphere.

Dusk and city lights

Late dusk, when there is just a recognizable tone in the sky, gives a better impression of night than the complete blackness later. It works best when combined with floodlighting, as in this view across Marseilles harbor to the basilica of Notre Dame de la Garde.

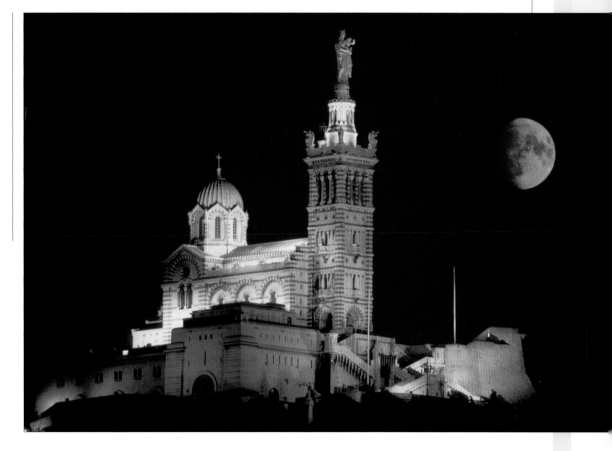

Street furniture, street art

Details and decoration are a subject in themselves, ranging from the things that identify (and even symbolize) a particular city, to the odd and idiosyncratic, such as graffiti.

The fittings and fixtures of a city are for the most part utilitarian, but they have a distinctive visual flavor. They vary in interest, according to their design, age, and how specific they are to a particular city. Some were never designed, but simply evolved. Others are nondescript, but some, such as the Art Nouveau Metro stations of Paris, are worthy of museum display (one did, in fact, feature in a recent exhibition). And always, of course, their interest depends on who is looking at them—foreign visitors to Britain have always seemed to be more taken with the classic red telephone box than the British themselves, who have largely replaced them. The list of street furniture is eclectic and not formalized; guidebooks do not normally identify them, but these are features of a cityscape that are ideal for spotting just when you are walking around.

Even more visually striking are city graphics, which can be in the form of advertising, signage, commissioned and official art, and the unofficial art of graffiti. Advertising changes frequently and follows fashion, and from one point of view—that of someone looking for a long-lasting (if not exactly timeless) view—is an element to be avoided. A stock photographer, for example, hoping to sell one image over and over for at least a few years, has to search for views that do not include billboards and shop displays that will date the image. Yet by the same token, advertisements can add strikingly to a photograph, and some, such as the Marlboro Man on Hollywood's Sunset Boulevard, become iconic—and eventually a part of history.

Together with signage (which includes directions, instructions, and building names), urban graphics also have cultural interest. In India, for

Reflections
The bright new texture of a parked van picked up street colors in downtown San Francisco. A wide-angle lens was used from very close and stopped down for good depth of field.

Juxtaposed
Large murals in urban settings are usually eye-catching, and offer opportunities for striking juxtapositions.

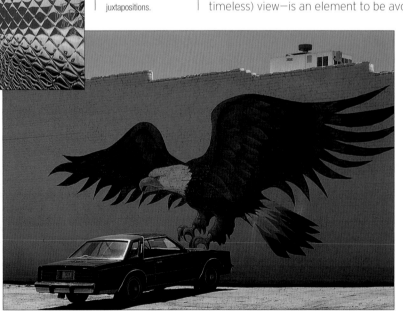

example, most of the country's display advertising is hand-painted, which gives it a pleasing idiosyncrasy. Other languages can be interesting simply for their appearance. Some like, Cambodian and Thai, have a particular cursive beauty, while ideograms, as in Chinese and Japanese, lend themselves easily to graphic design.

Then there is art for art's sake, temporary or permanent. Municipal authorities often have programs promoting art in public places. Gustav Vigeland's sculptures in Oslo's Frognerparken, for example, have been one of that city's famous sights since 1906. Look also for privately funded art in the forecourts of large corporations, and for murals. Large construction sites sometimes decorate the temporary exterior with imaginative designs. The possibilities are endless. And on top of all this officially sanctioned graphic work, there is graffiti, which in some American cities, notably New York, makes a strong statement.

Rope sculptures

Increasingly, municipal spaces are sites for art, mainly sculptures. Their intention, which is of equal benefit to photography, is to bring life and visual surprise to what might otherwise be bleak urban spots.

Pub sign

English pubs of Victorian and Edwardian vintage often carry their names in a variety of decorative means, such as windows. This Docklands pub, in east London, is, of course, called The Ram.

Buildings grand and modest

Architectural photography is part record and part interpretation, with plenty of scope for using your imagination. Digital controls can overcome many of the possible lighting problems.

At its best, architecture is art, and deserves some care and interpretation in photography. If you are taking a picture of a building of any consequence, first take some time to study its design and function. For instance, what was the architect's intention? Was it designed to be imposing, or to make the best use of available space, to make a particular visual statement, or to blend in with the surroundings? Was it designed for a single best view? Does it have one feature that is either remarkable or at least more important than any other? These are the kinds of questions that should guide you toward a particular treatment and viewpoint.

Most architectural photography involves interpretation—appreciating the design and function of a building, and conveying a representative impression.

▽ Southern living
The Cottage (1790s) is a raised cottage style of plantation house, in West Feliciana, Louisiana. This viewpoint made the most sense, with the tree and hanging Spanish moss a key element.

Before setting up the camera and tackling the technical problems, study the building from all viewpoints and decide the following:

☐ What was the architect's intention? Was the building, for example, designed to be imposing, or to make the best use of available space, or to blend in with existing architecture?

☐ Was the building designed for a best view?

☐ Does the building seem more relevant when photographed in isolation or in its setting?

☐ Does the building have one outstanding quality?

From these, you can determine what the photograph should convey, selecting suitable lighting, filtration, lens, and viewpoint. With some buildings, these technical considerations may virtually dictate the shot—if there is a restricted view, for example. In some cases, more than one shot may be necessary. Pay particular attention to details, which can bring a welcome variety of scale, just as in landscape photography.

Usually, there are two aims in architectural photography, which may or may not conflict. One is to show the building and its principal features as clearly as possible. In other words, the photograph is to function as a good documentary record, the type of image that an architectural historian would want. The way of preparing for this is to follow through the checklist above, and learn something about the history of the building, or at least its period. This kind of research is never wasted. The other aim is to make the building look as good as possible—essentially, to beautify it in some way. Given that there is little that you can do to the building itself, other than move away some of the more obvious obstructions, such as trash cans, signs, and inconveniently parked cars (the effort depending on how important the picture is to you), the two means of improving the appearance are viewpoint and lighting. These two options are often linked, with light perhaps only being favorable from one direction. In addition, as photographers we also like to show something of our own individuality and skill, which can add a third layer to the process—that of interpretation. In commercial work, this is an area for potential disagreement with the client or architect, because imaginative treatments sometimes come at the expense of clarity. All of this argues for trying out more than one treatment of a building.

▲ US Supreme Court
Although built only in 1935, the US Supreme Court is firmly in the Greek style, with an intentionally imposing portico of Corinthian columns. This wide-angle view, taken on a summer evening, stresses the grandeur.

▼ Icelandic house
In Reykjavik, corrugated iron is a traditional material for modest dwellings. Its humble origins are partly masked by bright paint. This was highlighted by close cropping.

Converging verticals

Most buildings are straight-sided, and a strong visual convention is that they should appear that way in a picture, even when this conflicts with real perspective.

The way in which lines appear to converge with distance is the perfectly normal effect of perspective. We are not normally aware of this geometric distortion when we look at things in real life, because we are a part of the actual, three-dimensional scene. It does become obvious, however, in an image, which is an object that we look at rather than experience. There is still nothing particularly unusual about this so long as the view is more or less level, and so long as the perspective leads toward the horizon.

However, looking upward is a different matter. Unfortunately for architectural photography, our eyes see convergence as less normal in a photograph taken looking up at a building. Then, the vertical lines lean in toward each other, and the effect tends simply to look wrong. If you do it in an exaggerated and obviously intentional way with a very wide-angled lens, this can work to your advantage, but otherwise you do need to take the trouble to avoid it. If the shot were of people, and the building were just a backdrop in the picture, none of this would matter. If the subject is the building itself, however, the photographer is expected to sort this out.

The obvious problem in shooting is that, in order to take in the whole of a building from close up, which is a standard method of doing it, you would normally need to tilt the camera upward. The laws of optics are fairly simple: the image plane, which in our case is the sensor in the camera, has to be parallel to the façade, meaning vertical. And that

△ Upward shift

A specialized shift lens is available for digital SLRs, which allows the view to be shifted upward. Otherwise, use a wide-angle lens and crop off the lower foreground.

▷ Foreground interest

Following the principle of aiming the camera horizontally, look for shots that make use of foreground detail, such as this gravestone in an English churchyard.

means keeping the camera aimed horizontally. There are a number of ways of doing this:

☐ Look for a higher viewpoint, such as halfway up the building opposite. You keep the camera level and simply find the right focal length of lens. The only problem with this solution is that halfway up is not a normal view of a building, and looks strange if you do this all the time.

☐ Use a wide-angle lens and aim the camera horizontally so that the building's sides stay vertical, but move far enough away to include everything. Later, crop off the lower unwanted foreground, which occupies almost half of the image. This is easy, but reduces the size and resolution of the image.

☐ Use a wide-angle lens in the same way as above, but compose the shot to include some relevant foreground interest, such as a flower bed or ornamental pond. This way, the composition looks like it is intentional.

☐ If the view is unrestricted, move much further back and use a telephoto lens, which will not then need to be tilted very much.

☐ Tilt the camera upward as much as you need to, and correct the distortion during image editing (see the following pages).

☐ The ideal solution is to use a perspective-correction (PC), or shift lens, which is available, for a price, for SLR cameras. It works by covering more of the scene than you can actually see through the viewfinder, projecting an image circle that is much larger than the sensor. By working a rack-and-pinion arrangement on the lens, the front part of it containing the lens elements is shifted upward. This brings the upper part of the image down into frame. Therefore, you can aim the camera horizontally and still include the top.

Using convergence
If by tilting the camera strongly upward you make the convergence obvious and deliberate, this is usually acceptable for what it is—a strong, graphic composition.

Digital solutions

Image editing provides the means to overcome most of the practical difficulties inherent in architectural shooting, from light and color to distortion and obstructions.

Any problems that you are likely to encounter in shooting buildings mainly derive from the scale of the settings. If these were manageably sized objects, you could alter most things to suit the photography. Digital techniques, however, give an outstanding degree of control, beyond what you can do with the in-camera controls. Their most useful role is probably that of correcting perspective distortion—converging verticals—but they can also assist in adjusting color and brightness. For instance, you could use a polarizing filter to darken a blue sky behind a light-toned building for stronger contrast. Another method would be to adjust the blue with the HSB controls during image editing. Even more useful is the ability to remove offending obstructions, from parked cars to scaffolding and overhead cables. This is possible with cloning tools or cutting and pasting. For absolute accuracy, photograph parts of the building that are concealed by stepping to one side or by shooting at a larger scale from the other side of the

Perspective tool

In image editing, the straightforward procedure is to apply the Perspective tool to the image. Perspective tools are one variety of distortion tool, controlled by a bounding box, in which the scale is changed at one end only, and symmetrically, as shown here. Because considerable interpolation is needed, it is safer to drag inward at the bottom rather than outward at the top, to preserve quality. Then crop in. Be prepared to lose a considerable amount of image at the sides. The building shown here is an ante-bellum mansion called Magnolia Hall in Natchez, Mississippi.

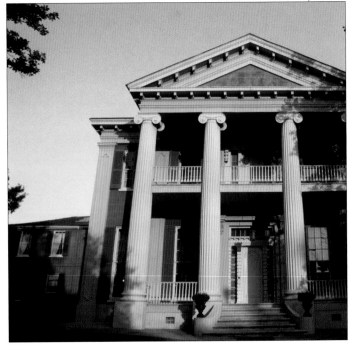

obstruction. You can then scale and distort this patch and paste it over the obstruction.

Perspective correction is straightforward, using either the Perspective tool in an image-editing program, or in a plug-in (there is third-party software available to deal with this). Switch on the grid overlay to align the verticals accurately, and apply. Remember that geometric corrections like this do damage the image, and to minimize these it is better to compress the lower part of the image rather than expand the upper. You will then need to crop. Note that even when this kind of perspective correction has been applied, the proportions may still look a little strange—squatter than it should.

There is no perfect solution to perspective distortion, because it's a perceptual construct to do with the way that we think things should look rather than the way they are. Straightening the vertical sides of a building so that they are vertical in the picture works because it gives a rightness to the image, but it can never be the same as an architectural elevation. The view of the upper stories and of the roof is still from ground level, meaning that most of this structure simply can't be seen. You can stretch and squeeze any part of the image as photographed, but not restore the parts hidden from view.

Having said this, there is an argument for trying to restore the proportions of a façade to those of the original, rather than the proportions that someone experiences looking up at a building. I'm not sure that it's a good argument, because many, perhaps most, buildings were designed to be seen from close up. In any case, there is a digital procedure, shown here, which progressively stretches the upper part (or progressively compresses the lower part if you choose to do it that way). The technique is a graded displacement map, in which a vertical gradient from gray (no displacement) to black (maximum displacement) is applied to the image.

Displacement map for progressive correction

A displacement map is grayscale and can be much smaller than the image to which you apply it. To extend the upper part of a building progressively, make a gradient from gray to black, and apply the displacement vertically upward. Experiment with the amount, as the effect depends on the image size.

Architectural details

While a minimum of one clean overall view of the building is usually the major challenge, the details of construction and decoration may be just as important, and call for different techniques.

In many branches of photography, closing in on details within a subject discloses a different, refreshing range of imagery. In professional shooting, switching to detail becomes second nature—if only to enable us to produce a more varied-looking set of images to show the client. This applies equally to buildings, but it also has a more important role. Architectural detail, whether decorative or structural, is an intrinsic part of the portrait. A professional brief for an architectural assignment will almost always include a list of highly specific features. These might include, for example, the order of the capital in a classical façade, an architrave, the pointing of brickwork, or a finial.

After setting up for an overall shot, with all its attendant issues of lighting, viewpoint, and obstructions, photographing detail is usually a pleasant relief—really, it is a separate exercise. The first step is to identify exactly what details to shoot. There are essentially two kinds: the documentary ones that have architectural importance, and the ones that simply make interesting images irrespective of their significance. For the first group you

▲ Georgetown
This detail captures a cast-iron star and bolt used to strengthen old brickwork in the historic Georgetown district of Washington D.C. Sited between two adjacent terraced properties, the star is also divided by the owners' contrasting color schemes.

▷ Victorian hotel
The façade of an old waterfront hotel in Fremantle, Western Australia, displays its origins as accommodation provided by a large shipping line for its liner passengers as they disembarked at the small port.

need a list, either from the client if this is a professional assignment, or from some published guide. Architecture and architectural history are specialized subjects, and if you are not trained in them yourself, it's best to rely on expert knowledge. Nonessential, but attractive, details justify themselves, and depend very much on what appeals to you—the way a shadow falls across stone, for example, or the texture of wood planking. Just pick these up as they appear.

Access to the details is the first consideration, and a long telephoto is usually the lens of choice. Details at ground level are no problem, and you can normally shoot with any focal length, but for the architectural elements on upper levels you need either to climb up—which may be impossible—or magnify with a long focal length. There will, naturally, be some convergence, but as this is never so extreme as with a wide-angle lens, it normally doesn't matter much. The longer the telephoto (a choice you would have only with an SLR), the less it needs to be angled upward, so the less the convergence. If you can avoid verticals in the detail, so much the better.

◢ Evening shadows

This bas-relief sculpture high on the roof of the Federal Reserve Building in Washington DC appears at its strongest in evening sunlight. The figure faces the sun and for a few minutes stands out strongly against the wall. The location was researched the day before to determine the perfect time.

◢ Convent gate

This shot shows the well-preserved entrance to the Begijnhof convent in the Belgian city of Brugge, in dappled early morning light.

▷ The finger of God

A startling spire to the First Presbyterian Church, built in 1859 in Port Gibson, Mississippi, photographed with a 400mm efl telephoto.

Gardens

Artfully created landscapes on an accessible scale, gardens in all their variety are intended for display, and the key to photographing them is first to understand the how and why of the design.

There are many types of garden, varying according to historical period, culture, and the individuality of the designer, but almost all attempt to introduce some aspect of nature into the manmade world. In some, the view (or several views) are the important feature; in others, the planting. To photograph a garden successfully, it's important, as with architecture, to have some knowledge of what it contains and why it was designed in that particular way.

In the West, one major division is between the formal, geometrically laid-out garden, such as that of Fontainebleau, which symbolizes the taming of wild nature, and the more English design which recreates natural features, often presented from a winding path. In the first case, there are always a few best viewpoints from which the layout can be appreciated, and these are normally the prime camera positions. A more informal design of garden gives a greater opportunity for interpretation in a photograph.

Many Asian gardens follow completely different principles. The Chinese, for example, invented the concept of the borrowed view, in which a part of the landscape beyond the garden's borders was deliberately included, by means of optical illusion, suggestion, and tricks with perspective. The Japanese developed this as *shakkei*. In both cultures, controlling the viewpoint was a necessary feature. In the case of a stroll garden, the visitor was led from view to view, with deliberate surprises at each stopping point. Another noticeable feature of Chinese and Japanese gardens is the importance of rocks, considered as features with their own spirit. In the form of a Zen garden, plant life may be completely absent; instead rocks, sand, and gravel precisely symbolize Buddhist landscapes.

Then there is the planting itself. It very much helps to know what the individual plants are, which are important or rare, which are the best specimens in a garden, and in which month they are at their best. Many gardens are designed so that they have different appearances according to the season. The weather and lighting are as important as they are for any natural landscape, often with special emphasis on the early morning, when many flowers are at their most fresh.

Sculptured English
A small, precise, and highly decorative detail from the Tudor gardens at Hampton Court, near London. Visually, many gardens work on several scales, including close-up.

LANDSCAPES OF MAN **331**

Gardens vary greatly in scale, and this too affects the way in which they can be photographed. Small patio gardens can be highly miniaturized, and the main effort goes into finding a camera position that takes in sufficient of the view, inevitably with a wide-angle lens. At the other end of the scale there are the masterpieces of landscaping that were created in some of the great English country estates, with rivers diverted, hills raised, and forests planted. In the hands of landscape gardeners such as Capability Brown and Humphry Repton, particular viewpoints were essential, and it would be perverse to ignore these with the camera. For example, the first view of Blenheim in Oxfordshire as the visitor enters through the estate through the Woodstock gate was called "the finest view in all of England," and indeed, it is a large landscape intended to be seen from exactly one point on the driveway.

The "finest view"

The first sight of England's Blenheim Palace, designed to be seen from the driveway, is a triumph of eighteenth-century landscaping. The distribution of features is intended to be seen as a long panorama, making a series of three frames and stitcher software the ideal answer.

Japanese

This Japanese garden features colorful flowers among the traditional green ground cover and carefully placed rocks.

Case study: **Japanese gardens**

These photographs were taken for a book on modern Japanese gardens. This was a first; all the previous books had concentrated on traditional Japanese garden design, and no one had looked at contemporary work. This made research and sourcing absolutely key, and we visited each garden with its designer, who explained the principles. The photography stressed the modern elements, some of which were strikingly obvious, others subtle, but it was evident that the designers drew on their knowledge of Japan's long garden tradition, even when they deliberately broke the mold.

Architectural planting
This integrated modern house and garden is striking for its juxtaposition of steel and glass buildings with an architectural planting of bamboo very tightly pruned into these distinctive shapes.

Step garden
Here, imaginative use was made of a small space leading up from a basement to the garden level. Old railroad sleepers were employed to partition off a planting that is changed every season. This shot was taken in spring, and the composition is topped with a cherry tree in full blossom.

Modern tea ceremony

Tea ceremony rooms have long been traditional in Japanese houses that have sufficient space for them. This modern cantilevered version looks out onto a miniature landscape of water, pebbles, and rocks, with the striking juxtaposition of a stainless steel pillar.

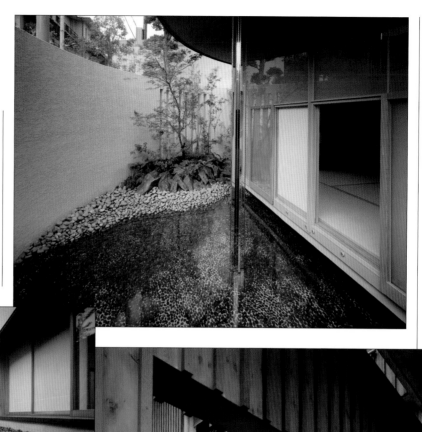

Pebble garden

This shot shows a highly restrained but adaptable small garden of black pebbles, with an old stone horse trough containing a single plant (which is changed seasonally). The area can be flooded to turn it into a pond, in which the pile of larger pebbles in the foreground becomes an island.

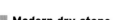

Modern dry stone

One of the influences of Zen on Japanese gardening has been the construction of entire gardens from stones of various sizes to represent miniature landscapes. This modern version uses broken stones and a wooden "gate" deliberately positioned to encourage visitors to stoop and peer through to the space beyond.

Another **World**

What surprises many photographers coming fresh to close-up imagery is that things really do work differently, in optics and perception. Close-up work may sound like photography that simply gets closer than usual, but in fact it calls for some very real adjustments to the ways in which we use a camera, both practical and creative.

First come the practical differences. Camera lenses are designed to work best at the distances that most people use them, but the corollary is that they underperform at close distances. There is no such thing as a perfect lens, and all are plagued to some degree by one or more aberrations. Correcting these involves a certain amount of compromise and, until fairly recently, close-up optics were a specialized area of photography. The manufacturers' solution to the problem of not being able to make lenses perform at short distances was to offer "macro" lenses to those who really wanted them.

SLR cameras, which accept interchangeable lenses, made this practical, and it still applies in the digital world. If you use a digital SLR, a macro lens will guarantee you the best image quality for most of the distances and magnifications that we are dealing with here. A bonus for the owners of digital SLRs that use a sensor smaller than 35mm film is that the imaging makes use only of the center of the lens, which is relatively free of many aberrations, including spherical aberration, which is worse at close distances. The good news for people who use a fixed-lens non-SLR is that most camera manufacturers have finally realized that macro is popular, and have applied sophisticated lens design to the already complex zoom lenses now widely used in digital cameras. In all but the simplest cameras there is a close-focusing option.

Close-up is one field of photography in which some technical knowledge is unavoidable—at least if you intend to explore this different world fully. Digital cameras make this much easier than in the days of film, because you can see what you are doing and judge your success on the spot. Nevertheless, it helps to know what to expect, and for that reason, We have already discussed the technical facts. Much of this is to do with sharpness—choosing which parts of the scene should have it, how to maximize it, and how and why to limit it.

In photography in general, the technical can inspire the creative, and this is even more the case with close-up. Shallow focus is one of the banners hanging over close-up photography, meaning that depth of field is always more limited than at "normal" distances. It is easy to see this as a limitation for making pictures, and there are occasions when overall sharpness is a priority. More often, however, this is simply a fact of imaging in a miniature world, offering a whole new arena for composition and abstraction. In normal vision, we are aware of things out of the direct line of sight and think of them as focused. The camera, however, sees only a soft blur, a characteristic of close-up.

All of this argues for using a camera in close-up interactively and in an experimental way. The closer you delve into this world, the more you will come to rely on the camera and lens to let you know what is happening.

Degrees of magnification

For convenience, the photography of small things is divided into three ranges of magnification, each making particular demands on the lens and on technique.

From normal to macro

Shown opposite is a sequence of three images, closing in progressively on the head of a flower. This illustrates the normal range of macro focusing, from the distance and magnification at which close-up begins, to life-size. Higher magnifications than this call for special techniques and, usually, an SLR camera.

We all have an idea of what we mean by "close," but it's usually an imprecise one. For most people, it means approximately the distance at which you could hold something by hand, or nearer. If you pay special attention to how your eye focuses, you can sense a difference at such close distances (and as we get older, this close-focusing ability is exactly the one that is hit hardest). Camera lenses, too, have to perform a little differently, as we'll see. Because of this there are good reasons for subdividing "close" photography into close-up; photomacrography (macro); and photomicrography.

First, however, there is the language of close imaging. The two standard ways of describing the degree of close-range imaging are "magnification" and "reproduction ratio," and these terms are interchangeable. These are written in different ways, but here I use the most common notations: magnification as in "2X," and reproduction ratio as in "2:1." There's no agreement on the perfect starting point for close-up photography, but most manufacturers and photographers have it in the region of 0.1 magnification (1:10 reproduction ratio) and 0.15 magnification (1:7). Less than this is just normal photography.

Close-up photography runs from, let's say, 0.1X to 1.0X; in other words, from the point at which the image is one-tenth the size of the object to when it is life-size (1:10 to 1:1). In practice, the reproduction ratio of 1:7 is the point at which the minimum significant exposure adjustment (1/3 stop) becomes necessary to compensate for the increasing distance between the lens and the film plane. In the old days, this calculation was important, but now, with auto-exposure and digital previews, the issue of less light reaching the sensor is generally taken care of by the camera. Photomacrography, commonly known as macro, extends from 1.0X to 20X (a 1:1 reproduction ratio to about 20:1), at which point optical conditions demand the use of a microscope. Note: because the word macro is so widely used and understood (and from now on I'll be using it in this book), you'll sometimes see the word macrophotography used ignorantly to mean the same thing. It doesn't; it means the opposite—photography on a large scale, which is so normal that the word isn't worth using. Photomicrography is simply photography using a microscope which is, at a basic level, surprisingly uncomplicated.

Close-up terminology

Reproduction ratio is the relationship between the size of the image and the size of the subject. For instance, if an object 32mm high appears 8mm high on the sensor, the reproduction ratio is 1:4 (i.e. 32mm divided by 8mm). Magnification is another way of expressing the same thing. It is the size of the subject divided by the size of the image. For the same example, the magnification would be 0.25X or, expressed as a fraction, ¼.

Basic close-up

The top image has a magnification of 0.1X, reproduction ratio 1:10. For this moderate close-up, any normal lens will focus without needing any attachments or special capability.

Almost macro

Magnification 0.5X, reproduction ratio 1:2. This level of magnification, with the image half the size of the real subject, is as far as most macro lenses will go without supplementary lenses or extensions.

Life-size

Magnification 1.0X, reproduction ratio 1:1. To reach life-size reproduction, as here, a fixed camera lens will normally need to have a supplementary close-up fitted, while an extension ring can be used with an SLR.

The optics of close-up

Camera lenses, normally designed to work with large-scale subjects, behave differently in several important ways when used at close range.

There most efficient method of magnifying an image is to extend the lens forward, away from the sensor. This, in fact, is the way that most lenses are focused for normal picture-taking. However, the lens elements do not usually have to travel far in order to focus anywhere between about three feet and infinity. For close focusing, they need to move much further.

The reason for this is the relationship between the two conjugates, which are the distances between the lens (to be precise, the principal point inside) and the object on one side and the sensor on the other (*see box*). When the subject is more than about ten times the focal length away, the image conjugate hardly changes. Any closer than this, however, and the image conjugate gets noticeably larger. When the two conjugates are equal, you have 1:1 magnification, with the sensor image the same size as the object.

This causes some problems for manufacturers, because most lenses perform best when subjects are at a distance (a long object conjugate), but

Depth of field

Depth of field is the range of distance from the camera, on either side of whatever the lens is focused on, that appears to be sharp. The emphasis is on "appears," because depth of field is not a completely objective measurement. In front of the focused object, and behind it, there is a transition zone between distinctly sharp and definitely out of focus. In order to be able to put a figure to this range, there first needs to be a measurement of how the human eye distinguishes sharpness. This is the circle of confusion, meaning the largest size of circle that the eye perceives as a point. Even a point has dimension, which is why it makes sense to treat it as a tiny circle. In fact, a small highlight, such as the reflection of the sun in a raindrop, will appear as a distinct circle in an out-of-focus background.

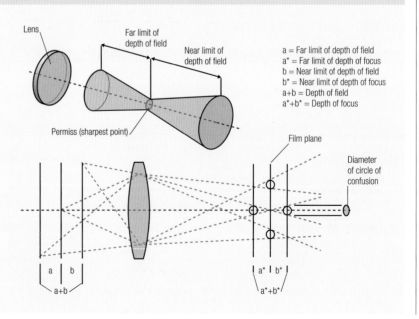

a = Far limit of depth of field
a* = Far limit of depth of focus
b = Near limit of depth of field
b* = Near limit of depth of focus
a+b = Depth of field
a*+b* = Depth of focus

less well when they are close. Apart from the mechanics of moving the glass elements inside the lens barrel, sharpness suffers and aberrations increase. Modern lens design has worked wonders in solving these problems, but not completely at very close distances. On a fixed-lens digital camera, the lens may have a "macro focusing" capability or "close-up mode," meaning that, at the least, the lens will actually focus down to a short distance. The quality of the image at close distances, however, depends on the lens design. Don't assume that just because the manufacturer uses the magic word "macro" the lens performance matches the description. True macro lenses do exist, but, for obvious reasons, they are made for cameras that take interchangeable lenses—in other words, SLRs.

For fixed-lens cameras, there is a simple method for achieving limited magnification—supplementary close-up lenses. These simple meniscus lenses are fitted in front of the camera lens in the same way as a filter and can be used to give reproduction ratios up to about 1:5. Beyond this, image quality suffers. Their advantage is simplicity, and they are available in different strengths, measured in diopters. A +1 diopter lens has a focal length of 1 meter (about 3 feet), and will shift the point of focus from infinity to 1 meter. A +2 diopter lens has a focal length of 0.5 meter, and shifts the point of focus from infinity to 0.5 meter and so on. Supplementary lenses can be combined, and the effect is additive (a +1 diopter and a +2 diopter act as a +3 diopter), although image quality begins to suffer noticeably when more than two are used together. When combining, put the stronger diopter next to the camera lens. Split-diopter lenses cover only half of the mount and can be used to bring a close foreground into focus at the same time as a distant background, without having to stop the aperture down.

Conjugates

A camera lens focuses a point on the subject to an equally sharp point on the sensor, which sits on the image plane. In normal photography, as in the view shown below right of foxgloves photographed from 13 feet (4 metres) with a 105mm efl lens, the object conjugate is much larger than the image conjugate, which changes very little as you focus. But when the subject is quite close, as in the diagram and the tight shot of the flowers below right, the two conjugates become more similar in length.

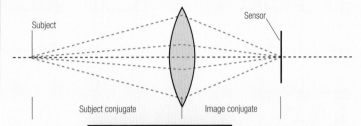

Subject · Sensor · Subject conjugate · Image conjugate

SLR techniques

Interchangeable lenses bring the full range of close-up to SLRs, while digital capture removes at a stroke the traditional difficulties of macro.

Because close-range shooting is a field of photography that is driven by optics, the ability to change lenses and to add extensions and other accessories gives digital SLRs a special advantage when it comes to high magnifications. As we saw, the chief mechanism is extending the lens—or at least some of the lens elements. This makes a macro lens the first choice of equipment if you have an SLR camera and are thinking about trying out close-up photography. A macro lens is one that has been designed from scratch to work best at close range, with an additional ability to focus up to infinity. In practice, there is no trade-off to using one, other than the extra cost of the lens, because its resolution at distance will be visually just as good as a normal non-macro lens.

Extension rings

Close-up magnification can be achieved by increasing the lens to sensor distance. The simplest and sturdiest method is to fit a ring or tube between the lens and the camera body. The focal length is the distance between the lens and the sensor when focused at infinity. Increasing this distance by half gives a reproduction ratio of 1:2. Doubling the distance gives 1:1, and so on (*see table*). Most good extension rings and tubes have linkages that connect the aperture diaphragm to the shutter and TTL meter, allowing the automatic diaphragm, where it exists, to remain in operation. Several can be combined for even greater extensions.

Reference table

Lens extensions, reproduction ratios and magnification

Extension (mm)	50mm lens		100mm lens		200mm lens	
	Reproduction ratio	Magnification	Reproduction ratio	Magnification	Reproduction ratio	Magnification
5	1:10	0.1x	1:20	0.05x	1:40	0.025x
10	1:5	0.2x	1:10	0.1x	1:20	0.05x
15	1:3.3	0.3x	1:7	0.15x	1:13	0.075x
20	1:2.6	0.4x	1:5	0.2x	1:10	0.1x
25	1:2	0.5x	1:4	0.25x	1:8	0.125x
30	1:1.7	0.6x	1:3.3	0.3x	1:7	0.15x
35	1:14	0.7x	1:2.8	0.35x	1:6	0.175x
40	1:12	0.8x	1:2.5	0.4x	1:5	0.2x
45	1:11	0.9x	1:2.2	0.45x	1:4.4	0.225x
50	1:1	1x	1:2	0.5x	1:4	0.25x
55	1.1:1	1.1x	1:1.8	0.55x	1:3.6	0.275x
60	1.2:1	1.2x	1:1.7	0.6x	1:3.3	0.3x
70	1.4:1	1.4x	1:1.4	0.7x	1:2.8	0.35x
80	1.6:1	1.6x	1:1.2	0.8x	1:2.5	0.4x
90	1.8:1	1.8x	1:1.1	0.9x	1:2.2	0.45x
100	2:1	2x	1:1	1x	1:2	0.5x
110	2.2:1	2.2x	1.1:1	1.1x	1:1.8	0.55x
120	2.4:1	2.4x	1.2:1	1.2x	1:1.7	0.6x
130	2.6:1	2.6x	1.3:1	1.3x	1:1.5	0.65x
140	2.8:1	2.8x	1.4:1	1.4x	1:1.4	0.7x
150	3:1	3x	1.5:1	1.5x	1:1.3	0.75x

Some SLR manufacturers offer macro lenses in different focal lengths, from standard to long. The advantage of a longer focal length is that the working distance is greater. You can shoot at the same magnification from further away. In photographing insects and other small creatures, this makes it possible to shoot quietly without disturbing them. When you cannot approach a subject like this to within a few inches, a longer focal length is the only answer. Set against this, if you also intend to use the lens on a bellows extension, the magnification will be less than usual.

Lens elements

Lens elements

Tripod collar

Camera attachment

▲ Telephoto macro lens

Lenses designed specifically for macro work feature a lens construction in which the focusing mechanism suppresses aberrations; here, by moving just the first two groups of elements.

▶ Tilt lens

A highly specialized solution to getting a close foreground and distance sharp is a tilt lens. By tilting lens elements downward, as shown in the illustration, the plane of focus itself is tilted. Normally vertical (perpendicular to the lens axis), it can be aligned with the important parts of a scene. The depth of field remains unchanged.

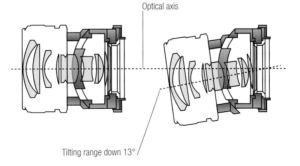

Optical axis

Tilting range down 13°

▲ Depth of field

Taken with a tilt lens, this image retains sharpness not only at the nearby cartographical texts, but also on the far side of the room.

True macro

The range of magnification greater than life-size is the realm of digital SLRs and various extenders, and brings with it the technical issues of sharpness and lens aberrations.

Loss of light

At macro magnifications, the lens elements are further from the sensor, projecting a larger image and reducing the amount of light that reaches the sensor. The f-stop is no longer accurate, necessitating a calculation of the reduction of the effective aperture. Metering and the camera's screen help, but it's good to know what will happen.

The table shows the loss of light at different magnifications:
R = reproduction ratio
M = magnification
E = exposure increase
F = exposure increase in f-stops
X = decrease in flash to subject distance. X is an alternative to F.

R	M	E	F	X
1:10	0.1x	1.2	⅓	1.1
1:5	0.2x	1.4	½	1.2
1:3.3	0.3x	1.7	⅔	1.3
1:2.5	0.4x	2	1	1.4
1:2	0.5x	2.3	1⅓	1.5
1:1.7	0.6x	2.6	1⅓	1.6
1:1.4	0.7x	2.9	1½	1.7
1:1.2	0.8x	3.2	1⅔	1.8
1:1.1	0.9x	3.6	1⅔	1.9
1:1	1x	4	2	2
1.2:1	1.2x	4.8	2⅓	2.2
1.4:1	1.4x	5.8	2⅓	2.5
1.6:1	1.6x	6.8	2⅔	2.7
1.8:1	1.8x	7.8	3	2.8
2:1	2x	9	3⅓	3
2.2:1	2.2x	10.2	3⅓	3.2
2.4:1	2.4x	11.6	3½	3.5
2.6:1	2.6x	13	3½	3.7
2.8:1	2.8x	14.4	3⅔	3.8
3:1	3x	16	4	4

Most so-called "macro" lenses magnify up to life-size—that is, 1X or a reproduction ratio of 1:1—and this is more than enough for most peoples' close-up demands. However, true macro begins around about this magnification, and covers the range up to the point at which a microscope becomes necessary. This is a fairly specialized area, for which the lens needs to be extended considerably, and this inevitably makes it the province of SLRs. This said, digital SLRs are wonderfully equipped to deal with true macro, because the on-board processing of the image can take care of the otherwise tricky problems of contrast, color, and even sharpness. Also, digital SLRs are equipped with ports that allow direct connection to a computer, and at these great magnifications a computer screen is your best window on the scene.

Sharpness is one of the major issues. At macro distances, where the image conjugate is always greater than the subject conjugate, it is affected by a number of phenomena. One of them, more relevant to macro than to normal photography, is diffraction. This is what happens when a hard solid edge (and so opaque) obstructs the path of the light. It causes the light to deviate from its straight path, with a very slight spreading, and this in turn causes unsharpness. This, unavoidably, is what the aperture blades in the diaphragm inside a lens do. The worst part of this for close-up photography is that diffraction increases with smaller apertures, which are needed for good depth of field, and also increases with magnification.

A complication on top of this is that stopping down the aperture of a lens reduces most of the other lens aberrations, including spherical and chromatic abberations, astigmatism, coma, and field curvature.

This is mainly because a smaller area in the center of the lens is being used to form the image. As the graph shows, there is a crossover between the two effects, so that at some point between wide open and fully stopped down there is an optimum f-stop. Exactly which f-stop delivers the best performance depends on the actual lens; how well the various aberrations have been corrected by the kind of glass used and the design; and also on how you, the photographer, judge it. In close-up work, the hazy softening from diffraction is likely to be prominent.

Another aberration that is more obvious in close-up photography is spherical aberration, which is caused by the surface curve of most lenses. Light rays through the outer zones of a lens, where the angles of the glass are greater than at the center, focus closer than the rays passing through the lens axis, as the diagram shows. Stopping down improves this aberration because the smaller aperture allows only the center of the lens to be used. However, it also becomes more noticeable when the object is closer and the distance between the lens and the sensor is greater—which is what happens with increasing magnification.

Optimum aperture

Diffraction is the one lens aberration that increases as the aperture gets smaller, as the graph shows, comparing it with other common lens failings. Unfortunately, this effect is easily noticeable, and therefore merits serious attention.

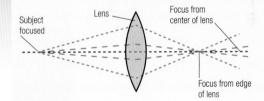

- - - - - Diffraction

- - - Spherical and chromatic aberrations, astigmatism, coma, and field curvature

Spherical aberration

The shape of a typical lens means that the angles at which the light rays are refracted are slightly different near the edges of the glass compared to how they are in the center. The result is that the image from any sharp point tends to be spread slightly, reducing sharpness. Stopping down helps to reduce the problem.

Diffraction
These images show the visible loss of sharpness caused by diffraction at 4X magnification, between an aperture of ƒ11 (left) and ƒ27 (right).

Depth of field strategies

Use not just the aperture, but also imagination to get the most out of the limited depth of field in close-up settings.

The closer the camera is to a subject, the more shallow the depth of field, and this is very characteristic of close-up photography. With some subjects, such as insects, front-to-back sharpness is usually the ideal, which means making the most of what depth of field is possible. Other subjects, particularly those, such as wildflowers, that have complicated backgrounds, may benefit from having little depth of field as this isolates them graphically from their surroundings.

There are three ways of improving depth of field in a close-up shot; two straightforward, and one highly specialized. Perhaps the most obvious is to use a small aperture. Even though some slight image quality is lost at very small apertures, the general effect is a sharper image overall. However, exposures are likely to need to be long to compensate, so camera shake and movement of the subject (leaves in even a slight breeze, for example) could become new problems. Also, simply stopping right down to the minimum aperture is not very good technique, because you may not want everything to be sharp. One of the values of shallow focus is that it helps to isolate subjects visually (see the following pages). If you are trying to maximize depth of field, do it just to the point that you need, and no further.

Just deep enough
Standing a little apart from the surrounding grasses, this Scottish marsh orchid needed a depth of field that just included the leaves and stalk, and no more. In a case like this, experiment with different aperture settings to find the one that renders the subject sharply but the background soft.

Side-on
One way of living without depth of field is to tackle a subject from a position that shows it at its shallowest. At a distance of 760mm, the depth of field with this 200mm macro lens at ƒ11 was only 5mm, but enough for this damsel fly at rest. As the insect seemed undisturbed by the camera (tripod-mounted due to the 1/4 sec shutter speed), it was possible to move around until the camera was exactly side-on to the fly.

The alternative is to change your viewpoint to make the most of whatever differences there are in the shape of the subject. Most things are shorter in one direction than another, and if you photograph a long subject side-on rather than head-on, it presents less depth to the camera. Obviously, this can't work with all objects. If the situation allows, and provided that it will not spoil the image, make sure that the distance between the nearest and farthest parts of the subject are as shallow as possible. Try moving the camera or—if it's amenable to being repositioned—rearranging the subject, for instance, by gently twisting a flower stem.

The specialized solution, at macro magnifications, is to use a bellows with a swiveling front. A good bellows unit will usually have a lens mount that can be tilted slightly, and what this does is to tilt the plane of sharp focus. So, if a leaf slopes diagonally toward the camera, the lens mount can be tilted so that the focus coincides with the leaf. This solution is really a way of managing without great depth of field than by increasing it.

The Scheimpflug principle

This technique is a mainstay in large-format view-camera photography (and at the macro scale, a bellows extension is a very close equivalent of the large studio cameras). The diagram shows how it works. Tilting the lens tilts the plane of focus (which is normally perpendicular). The subject plane and the lens plane will then intersect somewhere, and if the lens is then focused so that the image plane also intersects at this point, then the entire subject plane will be sharply imaged—whatever its angle.

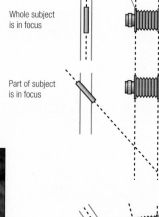

Range of focus Camera

Whole subject is in focus

Part of subject is in focus

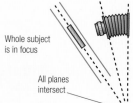

Whole subject is in focus

All planes intersect

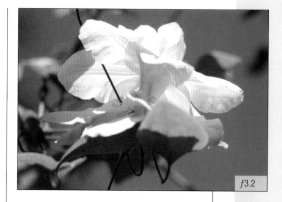

*f*3.2

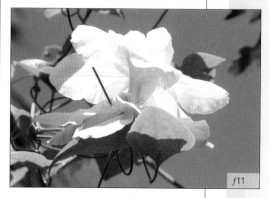

*f*11

*f*36

Depth of field control
Altering shutter speed and aperture gives three different depths of field in this view of a white clematis. The shallow depth of field given by a wide aperture (*f*3.2) isolates the flower but loses sharpness in the petals. At *f*11, there is a balance between having most of the clematis sharp and a blurred, separated background. At the smallest aperture of *f*36, the background is too sharp and distracting.

Making shallow focus work

The interplay of sharp and soft focus is one of the characteristics of close-up imaging—a feature to be explored and enjoyed.

Rather than thinking of the limited depth of field as a problem in close-up photography, treat it as one of the inevitable facts of life. In a normal three-dimensional scene on a small scale, something will always be out of focus. This is the case even when you look at these distances with the naked eye. We're not usually aware of this because the eye–brain combination works in a way that builds up the memory of a scene, and because the eye adjusts its focus very quickly as we scan our eyes over that scene. Look at one close detail and you may be aware of the other parts of the scene being hazy, but glance at one of these and they spring into focus. In a photograph we have the opportunity to appreciate the soft, out-of-focus areas—in fact, it is the only occasion. In this respect, as a photographer you are able to add your interpretation of a scene rather than simply making a factual record.

In photography in general, as well as in close-up, there is a natural tendency to want to get everything sharp and all the detail recorded. However, this is not the only approach to making an interesting image, because unsharpness has its own appealing qualities. It brings an abstraction to photography, allowing the photographer to experiment with pure graphic elements divorced from their sources. Chief among these is color, which by being blurred and softened can be merged and blended, as if spray-painted. These color washes can create an image in themselves, or be made to form a background for the focused detail.

In either case, close-up scales are ideal for this kind of creative experimentation, for two reasons. The first is that blur is very easy to achieve with the optics of close conjugates. A small focusing movement of the lens barrel at a reproduction ratio of 1:4 (0.25X magnification) can make a focused detail completely unintelligible. The other reason is that very small movements for photographer and camera create significant effects for the image.

In playing with the abstract qualities of color and tone, the basic technique is to move the camera forward, backward, or to one side, and watch the effects through the viewfinder or on the LCD screen, while altering the lens aperture to change the depth of field.

▲ Contrast through focus
A small pink geranium in shaded woodland. What was interesting here was the contrast between the pale petals and the dark background, and shallow focus helped to accentuate the difference. The flower stands out not only because of the color contrast but also because of the distinction in sharpness.

Caladium

Caladium leaves after an afternoon tropical downpour in Guyana. The attraction here was the variation in the shades of magenta, accentuated by the back-lighting, so the pale tones blend with dark. The point of focus was less important than filling the frame with an arrangement of color. The sinuous lines of leaf ribs and the out-of-focus stalk in the foreground helped to organize the composition.

Background separation

The berries, just caught by the sun and sparkling with highlights, were the natural point of focus, and the arrangement of twigs and leaves made a natural composition in which they would be on the left. Shallow focus was essential to separate this arrangement from the green background, and careful positioning of the camera ensured that the berries were placed neatly against a darker shaded area behind.

Composite focus

One of the benefits of digital photography, layered images, can be turned into a spectacular solution to extending depth of field as far as you need with even the smallest objects.

Racking the focus backward and forward to find the perfect position, as in the previous pages, suggests a wonderful digital method of improving depth of field. If you could take a sequence of focus positions and combine them, you could in theory have total front-to-back sharpness. It would not actually be better depth of field, which is a purely optical effect, but the appearance would be similar. And indeed, it is a completely practical means of achieving a totally sharp image that would be impossible in any other way. At macro distances, depth of field becomes shallower, and so deep objects are impossible to photograph with front-to-back sharpness at the minimum aperture of a camera lens.

The technique involves taking a series of shots, each focused on a different part of the object. In an image-editing program they are then assembled in layers, and the out-of-focus areas of each layer removed with a soft erasing brush. If the sequence of shots was planned and executed properly, what is left in the composite image is a set of sharp zones that fit together seamlessly. This is not too complicated, but it does take a considerable amount of work. For the sharpest result, you should not stop down completely, because of diffraction effects. Ideally, find the f-stop for

Tibetan rings

These two gold rings were photographed at four different focus points from front to back. Three of the images were then resized to match the first, and the softly focused areas of each were airbrushed away using a soft large brush. Here the image is shown alone for clarity, but in practice the erasing is done with the lower layer showing through.

your lens that gives the optimum sharpness; this is likely to be about 2 or 3 f-stops less than maximum. The depth of field for each shot will then be very shallow, meaning more layers. How many are necessary will depend on the depth of the object and the degree of magnification: 20 separate exposures and layers would not be unusual.

You can shoot the sequence either by adjusting the focus of the lens (set the camera focus to manual for this), or by leaving the focus in one fixed position while moving the camera or the object forward or backward. If you are shooting with a bellows attachment on an SLR, as in the example of the rings here, this is easy—simply use the rack-and-pinion tracking rail at the base. In either case, however, you will need to resize one or more of the layers.

Success is all in the planning, because you cannot afford to have gaps in the sequence, and it is safer to overshoot than risk having a zone that is unsharp. Practice first on a small section, altering the focus very slightly. Take two or three shots and then open them in an image-editing program that allows layers. All should be in perfect register. Examine each layer to see where each sharp zone ends, and brush out the soft areas of the top layer. As you do this, slowly, you will see the sharp zone of the underlying layer appear. This is a purely manual and visual operation; there is no way of automating it, because other image qualities affect the sharpness. For example, a smooth area may be in focus, but show no detail. Do the erasing one stroke at a time, continuing until the brush stroke reveals a softer rather than a sharper result.

◀ **Final rings**
The final composite version, with the image flattened. Only the parts needed are sharp. Not shown here is the slight resizing necessary to compensate for the scale differences caused by refocusing—keep the layers in register.

▲ **Crabmeat**
In this photograph of a Thai crab dish, selective focus was the style. The natural points of focus were the eyes, but it felt necessary to include the sprig of cilantro. Doing this by increasing the depth of field would have spoiled the feeling of selective focus, so the two shots were combined. The camera was on a tripod and unmoved for both shots. The difficulty lies in the slight change of scale caused by focusing the lens, calling for rescaling of one layer by eye.

Case study: **closing in**

To highlight the way in which a simple change of scale alters both subject matter and perception, each of these pairs of images moves from a "normal" view—the first thing you might see when approaching—to a small, but significant, detail within it. This is a special procedure for close-up photographers: scanning the scene not so much for its possibilities to make an image in itself, but rather for completely different images within it.

Context
Going in close to this Chinese Paper Bark tree, even with the same lens, concentrates attention on the strange appearance that gives the tree its name.

History in detail
In the barracks of the famous Scottish regiment, the Black Watch, is the regimental gong. Not obvious from the distance necessary to capture the action is the origin of this bronze piece, captured during the Indian Mutiny. Water drops from a shower add texture to the gong's polished surface.

Water over sculpture

The overall view of the fountains at the base of the Library of Congress in Washington D.C. shows their architectural setting and the range of bronze sculpture. Within this, however, the flowing water promised attractive details, with its movement, highlights, and its glistening effect on the patina of the metal. Different shutter speeds were tried to get the blurring effect of the falling water.

Increasing the focal length

The wide shot, taken with a 20mm efl lens, takes in the entire gilded Tudor ceiling at the palace of Hampton Court, in England, photographed from a balcony. There is clearly a wealth of detail inside this view, but no practical way of getting closer. Switching to a 400mm efl telephoto was the logical way to close in to one of the exquisitely carved details.

Reflections and shadows

In close-up work, use the secondary effects cast by objects to create more interesting and less obvious images.

Another feature specific to close-up is that reflections and shadows are more prominent than at normal scales. The reason is a subtle one, not immediately apparent in everyday life. As the scale becomes smaller, the variation in the size of things becomes greater. Take, for instance, a landscape viewed from an overlook. Even in hilly country, the texture of the scene is quite consistent. The strongest shadows will always occur early and late in the day when the sun is shining, and, even then, the largest shadows are likely to be cast by a promontory such as a rocky crag, or by trees. In other words, the farther back you stand, the less the individual features stand out. A similar thing happens with reflections. The largest surfaces that reflect are bodies of water—lakes or the sea—and even these are only occasionally effective as mirrors, when there is a dead calm.

At close-up distances, all this changes. Shadows loom relatively larger, and reflections, if you choose to include them in the shot, can take over the picture. With imagination, this can provide excellent opportunities to make both the composition and the content of a photograph more intriguing. Both reflections and shadows share a common quality—they are by-products of

Drying chilies
Red-hot chilies drying in the bright New Mexico sun. Intense sunlight in clear air created the ideal conditions for casting strong and definite shadows.

Yak horn
The horn of a yak skull, wedged among prayer stones in Tibet, casts an elegantly curved shadow across incised text from a Buddhist scripture.

▲ Umbrella raindrops

To catch the silhouette of an umbrella in raindrops would have been impractical with a real umbrella. Instead, a small window light was suspended close overhead, and a black paper cut-out taped to its front surface. Rather than water, which evaporates quickly, glycerine was placed on the background (a book) with a dropper.

▼ Shadow of a bird

A Victorian display of a stuffed bird in a glass case reads perfectly well when seen only through its shadow on the wall of an old country house in England—and makes a more interesting image than a straight view of the object itself.

the way that light falls on things. Used in an image, they refer to objects rather than showing them directly, and this obliqueness of vision can be both subtle and graphic. As with all visual references, using them successfully depends on treading a line between the obvious and the obscure. Shadows are at their most interesting when they add some new quality to the object casting them, as in the image here of a Victorian stuffed bird in a glass case. In this instance, the distortions introduced by the glass bring extra visual interest to an otherwise straightforward outline. At the same time, if you decide to concentrate solely on the shadow, the exercise will fail if it is completely unrecognizable, or, worse still, vague. In the photograph shown here of carved Tibetan prayer stones, inscribed with Buddhist texts, one component of the pile of sacred objects was the skull of a yak. Interesting n itself, it made an even more intriguing image through the elegant and unexpected curved shadow that it cast so precisely.

Reflections in water and shiny surfaces, though they work in an optically different way, have similar possibilities in an image. They are less obvious than the real thing, and so bring a touch of the unexpected. Also, as with shadows, they can work as a second visual layer, allowing subjects to be juxtaposed neatly, as in the still life close-up of an umbrella in drops of water.

Flash

Flash can help solve the lighting difficulties of small-scale scenes, but the built-in flash on some cameras may not reach very close subjects.

For several reasons, close-up shooting frequently calls for more light than usual. One is simply that small objects are often shaded by other things, including the camera if it is only a few inches distant. Another is that, as the lens is extended, less of the light passing through it reaches the sensor. Thirdly, when you magnify the image, you also magnify the apparent speed of movement, so that what looks like an almost imperceptible swaying of a blade of grass becomes, through the viewfinder at macro distances, a violent gale. The alternative to raising the ISO sensitivity, which increases noise in the image, is to add flash.

Flash lighting has a special relevance to close-up photography, because at these scales the scene that you are shooting is usually small enough to be lit fully. At normal scales, such as when photographing a group of people in a room, the output from a flash mounted on the camera will usually light the subject but not the background. Shooting close-up, however, is like having a larger light. The normally harsh lighting from the small tube of a portable flash unit is actually improved at close distances with small subjects. The reflector and window of even a small unit is at least as large as most insects, for example, so that at magnifications in the order of 0.5X and 1X, the light will appear to be moderately well diffused.

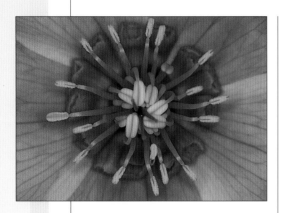

Ringflash

A type of flash unit specifically designed for close-up photography is ringflash, a circular flash tube that surrounds the front of the lens, and creates shadowless illumination.

However, a camera's built-in flash unit may not be in the best position for very close shooting. It points forward, which is perfect for normal shooting distances, but if the subject is only a few inches in front of the lens, it may catch only the lower edge of the beam of light. Automatic exposure will compensate for this either by increasing the aperture or the flash output, but it means that you are losing flash efficiency. Worse still

Calculations

Under normal circumstances, automatic exposure mode will take care of everything, but as a backup, in case you want to shoot in manual mode or are using off-camera flash, the following are the ways of calculating exposure increase and flash position:

1. Exposure increase = $\dfrac{(\text{Lens focal length} + \text{extension})^2}{(\text{Lens focal length})}$

2. Exposure increase = $(1 + \text{magnification})^2$

3. Flash-to-subject distance = $\dfrac{\text{guide number}}{\text{aperture} \times (\text{magnification} + 1)}$

4. Aperture = $\dfrac{\text{guide number}}{\text{flash-to-subject distance} \times (\text{magnification} + 1)}$

with some cameras, the extended lens in macro mode may actually cut off some of the light, leaving a strange semicircular black shadow in the lower part of the image. It's as well to check the flash performance of a new camera at the closest distance that you expect to use it.

Most fixed-lens digital cameras have no provision for synchronization with another flash unit held separately. SLRs, however, do allow this, and in this case it is worth experimenting. The solution to flash cut-off from the lens barrel is to position a detached flash unit to one side, connecting it to the camera's sync terminal with a sync cord (some flash units have these built in). And it's not necessary to spend a lot of money on a sophisticated flash. A small manual unit positioned close to the subject should be quite powerful enough (a guide number of 40 is more than adequate), and you can easily arrive at the best combination of aperture, position, and output by simple trial and error, using the LCD screen to check results. For variety, an off-camera flash position can simulate, at least partly, natural lighting, particularly if the flash is softened. For this effect use either a proprietary diffuser (a small sheet of plastic) or a handkerchief.

Simulating sunlight

In some situations, it is possible to use a portable flash unit to mimic sunlight, either because the natural lighting is not satisfactory, or because a breeze creates a risk of blurring at slow shutter speeds. Because the illumination from a small flash unit falls off rapidly, lighting from the front always looks unnatural. The most effective method is the one shown here, where the flash is used to introduce a certain amount of back-lighting as well as overhead illumination. In the photograph [1], a shaft of midday sunlight isolates the head of a dandelion in a forest clearing. In the right-hand [2] photograph, a flash unit held above and slightly behind the same flower gives a passable imitation. Use a small stand for the flash if it's too awkward to hold yourself while shooting. Alternatively, place the camera in position on a tripod and hold the flash.

[1] Sunlight, 1/60 sec at f11

[2] Flash, f27 with ISO 80 guide number and the flash at 3 feet (1 meter).

Freezing motion

Things appear to move faster in close-up. Freezing the image of bubbles rising in a bottle called for flash, in this case a separate unit fired through a sheet of translucent plastic behind the bottle, and attached by a sync lead to the sync terminal of an SLR.

Photographing with a scanner

With built-in near-shadowless lighting and excellent resolution, even an ordinary desktop scanner can be used to photograph objects to an extraordinarily high quality.

Think of a desktop flatbed scanner, now as common a fixture in offices and homes as a fax machine used to be, as if it were a copy camera. It's fixed, bulky, and points upward, but if you already have one, you will find that it can knock the socks off any digital camera when it comes to certain types of close-up subject. Scanners have some exceptional qualities, not least of which is the resolution. Even a modest design will deliver high resolution by the standards of photography, for the simple reason that scanners are intended for 1:1 reproduction, whereas camera images are always meant to be enlarged.

By analogy with film photography, the scanner is the ultra-large format device, equivalent to a 8 x 10-inch or 11 x 14-inch plate camera—exactly what was once used for the highest quality still lifes and copyshots. If your subject conforms to a few basic specifications, consider scanning it rather than photographing it—the results may well be superior. The requirements are: first, that the object is more or less within the size range of the scanner's bed; second, that it stays still; and third, that it is moderately flat (or can be slightly flattened without damage). A large leaf from the garden is what comes easily to mind, and I chose that for one of the examples shown here. Actually, the flatness is not compulsory, any more than it is for close-up photography in general, but scanners have shallow depth of focus, being intended for documents and images. And, significantly, you cannot choose where to focus—it will be whatever is nearest the glass. Naturally, take care with the glass surface to avoid scratching it.

The quality of the lighting is nonadjustable, but is surprisingly pleasing for three-dimensional objects, being frontal without the harshness associated with on-camera flash. In essence, it is rather more like a ringlight—an enveloping illumination with very gently modulated shadows. As the scan of the white orchids demonstrates, a gentle fading away toward the background produces an unusual and delicate effect. You can control the exposure and color through the scanning software controls. This may mean finding the advanced options and turning them on, depending on the sophistication of the software supplied with the scanner.

A basic scan
Using the standard document setup in which light is reflected from the object, a withered brown leaf is simply laid on the glass and the platen with its bright white under-surface lowered gently onto it. The scanning software—unsophisticated in the case of this Canon scanner—is used at its auto setting. At this high resolution and 48-bit color depth, any color and tonal adjustments can be made later, in image editing.

Against black

A similar document setup to the leaf scan was used for these White Phalaenopsis orchids, the difference being that I wanted a contrasting black background. To get this, I raised the platen and substituted a piece of black cloth, which did not damage the delicate blooms.

Slide scan

Thin, translucent specimens like this green leaf can be treated as if they were slides, if the scanner has a slide-scanning head. In this arrangement, the lights in the head were used to shine through the object for a backlit effect.

Pros and cons of a scanner-as-camera

Pros
- [] High resolution for platen-sized objects (that is, approximately 8 x 10-inch or 11 x 14-inch).
- [] Built-in low-shadow lighting.
- [] Works directly with the computer.
- [] Good range of image adjustment controls.

Cons
- [] Limited depth of field, best with flat subjects.
- [] Scans need some kind of cover.
- [] Non-transportable.
- [] Long exposure.

Micro

Although photomicrography is in general a specialized field, at entry level it is inexpensive and is now fully geared for digital cameras, which offer you instant results.

For the nature and close-up photographer, the huge variety of interest and life-forms that can be found at the microscopic level offer some very exciting possibilities for creative photography. Ideally, in photomicrography it is the microscope alone that should form the image, because it is far better equipped than any part of the camera system to do so, and it is important not to degrade a carefully enlarged image by using an additional camera lens.

Plug in

Using this adaptor (from a range by Brunel Microscopes), a digital camera can be attached to the eyepiece of an ordinary microscope.

A digital SLR is the best choice of camera to use for photomicrography. These models are light enough and compact enough to be supported directly on the eyepiece of the microscope, by using a special adapter tube. Some stereo microscopes even have an additional vertical tube to allow a camera to be attached. These models are known as trinocular microscopes, and they can switch the image into either the viewing or photographic tubes by means of a prism.

Most digital cameras have a fixed lens, which is less than ideal, but there is sufficient demand within the field of microscopy for taking pictures that a number of adapters are available. These are enough to cope with any camera, however basic. The first issue is of physically fixing the camera to the microscope. Some fixed-lens cameras, such as the Nikon Coolpix series, have a screw thread at the front of the lens that can be used to attach the camera directly to the microscope with a coupling ring. If you do not have a camera that allows this, there are two alternatives. One solution, which can be homemade, is a tube attachment that fits like a sleeve over the camera lens at one end, and over the microscope eyepiece at the opposite end. The other solution is to use an adjustable mount that attaches to the underside of the camera via its tripod bush.

The second issue is focusing the image. With a fixed-lens camera, in addition to a mount that enables the camera to "look down" the eyepiece, a secondary relay lens is needed to focus the microscope image, and this is incorporated into the adapter. There are many companies specializing in microscopes and accessory equipment, and probably the best approach is to visit their websites.

Choice of microscope

When it comes to choosing a microscope, what counts first is the application for which you need it. If you are a researcher with a particular field of study, you will already know this, but if you simply want to explore the photographic possibilities with no scientific requirements, you will probably be better off looking for a low-powered monocular instrument.

Typical professional compound microscopes have a range of magnification between 40x and 1,000x. However, magnifications of between 20x and 40x are easier to manage and are better for such recognizable specimens as insect details. You can mount a camera on either a monocular or a binocular microscope, but for maximum convenience (albeit at a price) there are also trinocular microscopes, in which the third lens is dedicated to the camera. Stereo microscopes deliver an upright and unreversed three-dimensional image (unlike the normal inverted and reversed image). This is useful if you have to manipulate the specimen, but it also adds to the expense.

Digital camera settings—checklist

1 Turn the flash off.
2 Set metering to matrix metering if available, not spot.
3 Set white balance to incandescent if the light source is tungsten, or auto.
4 Set macro mode if there is one.
5 Set maximum aperture, by choosing either aperture priority mode or manual.
6 Use the LCD screen to frame and focus.*
7 Zoom lens forward until you see the least vignetting (shading at corners).†
8 Set continuous autofocus.
9 Use a cable release if there is a fitting for one, or the timer.
10 Do not touch the camera or microscope during exposure.

* for fixed-lens non-SLR digitals, or digital SLRs with Live View.
† for fixed-lens non-SLR cameras

▷ Insect

Standard brightfield illumination was used for this photomicrograph of the head of an insect— basically, back-lighting, but there was sufficient density in the insect's exoskeleton to show structural detail.

▽ Pearl section

Measuring 3.2mm at its widest, this thinly sliced section of an unusually shaped natural pearl is here seen under darkfield illumination, explained on the following pages.

The microscope

Microscopes are available at all levels of sophistication, from school classroom models to highly specialized instruments, and all can be used for photography.

Not surprisingly, the best microscope equipment is expensive, and the final choice is often a compromise between optical quality and price. For photomicrography, certain microscope components are particularly important. These are the objective, the eyepiece, condenser, and mechanical stage.

The principal lens in a microscope is called the objective. Its magnifying power is engraved on its mount, and is usually between 5x and 100x. The most important quality in an objective is its ability to resolve detail. The usual measure of this is known as "numerical aperture," or NA, a figure calculated from the angle of a cone of light needed to fill the aperture of the lens. The higher the NA, the better the resolution. In air, the maximum NA is 1.0, but some objectives are designed to be immersed in a film of oil, which allows an NA of up to 1.40. The most common, and least expensive, objectives are known as achromats, and only partly correct the most common optical aberrations. Colored fringes are usual at the edges of the image. The finest quality objective is the apochromat, which is highly corrected.

Brightfield/ no darkfield

This pair of photographs, of a thin section from the middle of a natural pearl, illustrates the difference between the two most basic kinds of microscopy illumination, brightfield (left) and darkfield (right). Note that in this case, with a surrounding featureless area, brightfield lighting is prone to flare— corrected (lower) by close adjustment of the black point and white point.

The secondary lens in a microscope is the eyepiece. It magnifies the primary image and projects it either to the eye or the film in a camera. For photomicrography, a "compensating" eyepiece is needed—this corrects some of the defects in the objective. A matched pair of objective and eyepiece gives the highest quality image. Another important part of the optics is the condenser, a lens situated below the stage, which collects the light from the lamp and converges it on the specimen. There are three types of condenser: Abbé; aplanatic; and achromatic, and the latter is the most corrected for optical aberrations. It is thus best for photomicrography. The final essential component is the mechanical stage, for precise control of the position of the specimen and the composition of the image. These are either manual or the much more precise micrometer drives.

In basic operation, the simplest method of lighting a specimen is brightfield illumination, which, as its name implies, displays the specimen against a brightly lit background. The light is, in fact, passed through the specimen, which is thin enough to be translucent. Standard microscopes have a mirror beneath the subject, and this can be angled to project light upward from a separate lamp. Some advanced models, however, have built-in light sources. The principle of brightfield illumination is to focus an image of the lamp in the plane of the specimen, and in such a way that it falls on the center of the field of view and covers the whole field evenly. The lamp, therefore, is an essential part of the optical system. The standard light source in photomicrography is a tungsten filament lamp, fitted with a condenser lens and diaphragm that can both be adjusted. A tungsten-halogen lamp is the best for color photomicrography, as the glass envelope does not darken and discolor with age. The disadvantage occurs when photographing live, moving organisms that need greater illumination to avoid blurring. An answer is electronic flash, using a pocket flash unit. An auxiliary tungsten lamp must be placed in the same position for viewing and focusing prior to photography, however.

Exposure and color balance

Because microscope optics do not allow the use of an aperture diaphragm, exposure must be controlled by other methods. Altering the shutter speed is one method, but for finer control either the lamp position may be changed or neutral density filters may be used. As an approximate guide, shutter speeds for a typical brightfield arrangement at ISO 200 sensitivity, might run from 1/15 second to 1/250 second.

Microscope lamps are generally balanced at around either 3,200 Kelvins for tungsten light or 5,500K for daylight use, so you can adjust the white balance in-camera. Additonally a 2B filter may be needed over the lens to absorb unwanted ultraviolet radiation.

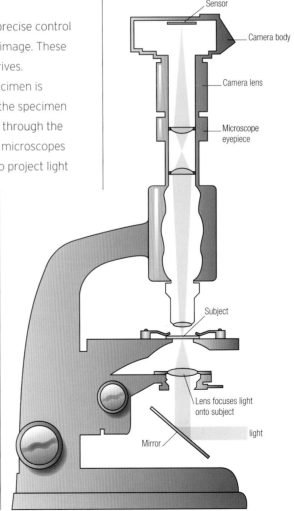

Sensor

Camera body

Camera lens

Microscope eyepiece

Subject

Lens focuses light onto subject

light

Mirror

Special techniques

The delicacy and transparency of many subjects, particularly if they are moving, living ones, calls for an even greater boost to contrast.

Basic brightfield or darkfield lighting, combined with staining, can cope with a wide range of specimens, but by no means all. Live subjects that move need more light, and very shallow, transparent specimens need much more contrast to be clearly visible. For these cases, several advanced techniques have been developed, needing accessory equipment or even dedicated microscopes.

Phase-contrast

A more sophisticated lighting technique that can reveal internal details of completely transparent objects is the phase-contrast method. This uses an effect in which the edges and fine detail in the specimen diffract the light passing through it—the specimen passes a portion of the light directly without modifying it, but scatters the remainder. In a phase-contrast microscope, a special coating behind the objective slows down the direct beam of light by one quarter of a wavelength. When the two beams—one direct, the other scattered—are drawn together again, they are no longer in phase, meaning that the peaks and troughs in the light waves are in slightly different positions. The light reaching the eyepiece is therefore less intense, but the small differences in the structure of the specimen have been enhanced.

Phase-contrast
This tiny decomposing mosquito lava has clearly visible edges thanks to the phase-contrast method. Otherwise it would appear only as slight variations in a clear image.

Interference-contrast

In the phase-contrast system, detail is made visible because two beams of light create interference patterns that correspond with differences in the specimen. Other interference-contrast methods produce a similar result, but the light is split not by the specimen but by the microscope's optical system. The Nomarski system, for example, uses prisms to split the light, one beam of which is directed through the specimen, the other bypassing it. The first is called the "object beam," the second, the "reference beam."

Polarization

Another lighting technique that can produce spectacularly colorful results uses two polarizing filters. Light vibrates at different angles, but a polarizing filter passes only those waves vibrating in one particular direction. If a second polarizing filter is placed in the path of a beam that has already been polarized, it will only let the light pass through if it is oriented at the same angle as the first filter. If it is rotated through 90 degrees, the light is extinguished. Some specimens also polarize light, so that if placed in between the two polarizing filters—called the polarizer and the analyzer—they partly rotate the light, which thus becomes visible again. Many growing crystals have this property, and because of slight variations in thickness, they polarize different colors by different amounts. The resulting interference colors can be very striking.

Electron microscopes

If photomicrography's considerable problems are largely due to the inadequacies of light waves at large magnifications, one answer is to look for shorter wavelengths as a way of forming an image. This should allow greater resolution and higher magnification, provided that the radiation can be guided and controlled in the same way that light can be refracted. This is the principle of the electron microscope, an instrument that can resolve detail down to two billionths of a centimeter, making it capable of over a thousand times greater magnification than the best optical microscope. Although such equipment is only found in specialized laboratories, the electron microscope has extended photography to new limits, and can produce strikingly beautiful images. Using magnets instead of lenses, a beam of electrons is focused on the specimen. This beam knocks other electrons off the surface. These in turn are attracted to a sensor, and output digitally. A further refinement is a means of moving the beam of electrons across the specimen. Each point on the surface of the object can then be resolved separately, permitting great depth of field. The scanning electron microscope can, especially at low magnifications, produce images with such depth of field that the eye finds it difficult to believe the scale.

Polarization

This stunning raindrops effect is in reality a polarized light image of resorcinol, taken at 400x magnification. Under normal lighting, resorcinol is white crystalline compound, used to treat certain skin diseases and in dyes and adhesives.

Interference-contrast

Here a radiolarian skeleton is captured from an optical microscope operating in differential interference contrast (DIC) mode with a 20x plan fluorite objective. Detail can be obtained using the composite focus technique described on page 348.

Fiber optics

Bundles of hair-thin glass fibers can be used to transmit light—and an image—from normally inaccessible corners and crevices.

Pearl extraction

A borescope was the perfect instrument for imaging the surgical extraction of a pearl from the body of an oyster. To preserve the animal, the shell is not opened fully, so that the operation can be photographed only with a miniature lens.

Miniature lenses and fiber optics allow close-up photography from extremely short working distances—only a few millimeters—and from viewpoints that would normally be inaccessible. Endoscopes are the medical version, used as probes inside the body and also for microsurgery. Less expensive, but perfectly usable for photography, are the industrial inspection versions known either as borescopes (rigid probes, as shown here) or flexscopes, which encase the fiber-optic bundle in a tough, flexible sheath.

Fiber optics are widely used in data transmission, but in close-up photography they carry an image in a straightforward analog way. The principle on which fiber optics work is total internal reflection. The refractive index and diameter of the glass fiber are such that light shone from one end does not escape, but is reflected back inside. Each fiber consists of a core of very highly refractive glass and a cladding of slightly less refractive glass. The smaller the diameter and the more tightly bundled the fibers are (many thousands together), the higher the resolution of any image passed along them—much like a camera's sensor array.

The value of these fiber-optic bundles in imaging is that the diameter of the entire bundle is in the order of a few millimeters, so that an extremely small lens can be fitted to one end. The image from this is transmitted undistorted along the bundle to a second lens, which enlarges the image and projects it onto an eyepiece or the sensor of a camera. There is no aperture diaphragm, but depth of field is

Borescope

Essentially a rigid endoscope for industrial inspection, this borescope projects the image from a tiny wide-angle lens back to the eyepiece via a fiber-optic channel. An adapter attaches it to an SLR.

Insertion shaft

Fiber optics to light

Pistol grip

good because of the small size of the imaging lens. As most endoscope photography is conducted in small, restricted spaces, such as the internal organs of the human body, lighting is usually carried alongside the lens system, down a second fiber-optic bundle. Image quality is poorer than that from a normal camera lens, but at least some kind of picture is possible in spaces inaccessible by any other means. It also makes it possible to give the kind of view that a small creature would have.

Depth of field
A by-product of the tiny lenses used in endoscopes is great depth of field, similar to that of a pinhole camera, as demonstrated here close to the tip of a burning cigarette. Image quality, however, is not high.

The view from 5mm
Photographed with the borescope, this minute parasitic crab inside an oyster would have been an otherwise impossible shot. Low light transmission down the fiber-optic cable and back up the channel called for the highest sensitivity setting, which resulted in some loss of quality.

California Glory
Used in the garden, an endoscope is a useful tool for exploration, giving an insect's eye view of plants, as with this interior view of the yellow pistils of a California Glory (*Fremontodendron californicum*).

The Art of **Still Life**

The still life is a genre of image that predates photography by at least three centuries, and yet is one to which the camera brings a distinct and original approach. It is bound up in the idea of things selected and seen closely, with a strong element of the display of the image-maker's skill. Indeed, this inevitable emphasis on creative technique—primarily composition and lighting—held the still life back from consideration as a worthy form of art. In painting, it was long considered as a kind of exercise in which the artist honed skills that would later be employed in subjects of real importance—religious allegories or portraits. Collections of mere objects were simply not considered worthy of art, except in a supporting role for grander scenes.

It took painters like the Spaniard Juan Sánchez Cotán (1561–1637) and the Frenchman Jean Chardin (1699–1769) to elevate still life to respectability, and photography has inherited this—though with qualifications. Chardin, in particular, was highly influential, and widely praised even at the time for his insight into the nature of things and his ability to breathe life into the mundane. Chardin painted one of the most famous of all still life paintings. Called *The Skate*, it features a dead and bloody fish hanging with its face toward the viewer. Diderot, Chardin's contemporary, wrote, "The subject is disgusting, but it is the very flesh of the fish, its skin and its blood; seeing the thing itself would affect you in the same way."

As Chardin demonstrated so convincingly, the choice of subject is not only important, but completely open. Subjects vary enormously—indeed, there's no *a priori* definition of what constitutes the focus of this close attention, as we'll see in some of the examples that follow in this section.

Photography, especially, has allowed a wide range of subject material as it takes much less time than painting or drawing, and so much less is riding on the choice of objects. Even less is at stake with a digital camera, because the completed image is immediately available for assessment. In the days of film, an important set up would be left untouched while the film was processed. With digital capture, the process is complete as soon as it looks right and the image has been checked on the computer. As well as having practical benefits, this gives even more freedom to experiment. Shooting direct to the computer, as is possible with more advanced cameras, is by far the most convenient method.

Because the still life is a tightly controlled form, it inhabits, for the most part, the studio. Here, I'm using the term "studio" in a broad sense as a space in which everything, and in particular lighting, can be manipulated at will. Still life photography is probably the most demanding of all studio work, and its standards, set largely by magazine and poster advertising, are extremely high. Professional studios are typically well equipped and are dedicated to the purpose, but for occasional use the two features that you need are control of the light and a lack of clutter. Given these, you can call any space your studio. Just remember that improvisation certainly does not mean unprofessional. Instead, it lies close to the heart of creativity.

Composing a still life

Follow a plan of action in building up a still life from scratch, so that the composition steadily improves—but stay open to unexpected possibilities.

A still life of your own choosing begins with an empty space waiting to be filled—in much the same way that a blank canvas faces a painter. For photographers who are accustomed to shooting real life and real nature outdoors, this is an unexpected freedom—so much so that it can be a little daunting. There are no guidelines other than your own imagination, and the choice of subject. At least at the start, it may help to ease yourself into the process of arranging the still life by taking a deliberate step-by-step approach, as summarized here. As you gain experience and confidence, this will all start to come naturally.

The first decision, though it may seem too obvious to mention, is to choose the subject—which may be one object or a group. Behind this choice, of course, lies an idea or a theme. You may choose something simply because you like its shape. Fine. In that case, keep in mind that shape is what you want to show, by positioning, camera angle, lighting, and other objects. The theme may be more complex than this, or less obvious, but as you go through the process of arrangement, keep it in sight.

Even when a subject has been selected, the choices of setting, composition, camera angle, and lighting are so open that it may be difficult to know how to proceed. For this reason, many still life photographers follow a sequence, gradually refining down the possibilities until the entire set, arrangement, and lighting have been perfected. There is a very strong element of the constructed image in still life shooting in which there is a path that progresses from the raw ingredients and slowly develops into the final result. The order of doing this varies according to the personality and style of the particular photographer.

Consider the background, because this will need to be in position before you start placing objects. Backgrounds range from the nonexistent—white—to the complex and eye-catching, and over several pages in this section we look at the various alternatives. If you have no immediate idea, look through these examples to see if any stimulate your imagination. At this stage, you may want to put a rough lighting plan into position, and it helps to have an approximate idea of the effect. Again, however, if you have no strong opinion

Like objects
Small archaeological artifacts embedded in blocks of resin were arranged in a backlit still life to emphasize their similarity—but with a few of them deliberately angled for compositional interest.

about this at the start, consider a simple arrangement. You can always change the lights later—and you will almost certainly want to make some refinements once you have completed the composition. Lighting quality, as we'll see, is critical to the success of a still life, to the extent that you could almost think of it as part of the object.

Possibly the most entertaining, and occasionally frustrating, part of still life photography is the detailed arrangement of the parts of the composition. Moving objects slightly in relation to each other, and constantly checking the effect that this has through the viewfinder or on the camera's LCD screen, is a process that can go on forever. Once you have the idea of where, more or less, things should be, pay close attention to the detail—whether the corner of one object interferes with the edge of another, for example; if there is an awkward gap; or if some detail is lost against the background. As you work on this, you will probably find that the parts of the composition gradually seem to interlock, until finally there seems to be no room for improvement—at least, to your original idea.

▶ Avoiding regularity
In unplanned outdoor photography, one of the most eye-catching occasions is the unexpected alignment of objects and lines—order suddenly appearing out of the chaos of everyday scenes. In studio photography, however, there is a reverse problem, of avoiding the obvious in an arrangement of objects. In this shot of jade gems on large blocks composed of rough jade matrix, it is clear that the stones have been arranged and not simply found. Yet the style of the composition is loose, not geometric. Arranging nine virtually identical objects so that they do not lock together into an obvious shape took several minutes of experimentation.

◀ Informal grouping
The purpose of this food shot, taken in an authentic Shaker kitchen in Kentucky, was to show the kind of produce grown on the home farm, in juxtaposition with nineteenth-century utensils. The potatoes in the iron pan key the composition and are off-centered so that the eye can move down along the pan's handle and also up to the crowded baskets of vegetables lit gently by a window at top right. There is deliberately little empty space, yet the arrangement looks comfortable rather than chaotic.

Starting from scratch

Here is one example of a procedure for constructing a still life image:
1 Examine the subject (or subjects) and decide what they need in terms of camera angle, focal length, and lighting, as well as the kind and color of background and props that might help to set them off.
2 Assemble the props to go with the subject.
3 Choose the background or setting.
4 Make a first, casual arrangement, with the main subject prominent.
5 Try different lighting combinations until you find one that best suits the set.
6 Position the camera.
7 Refine the composition.
8 Make final adjustments to the camera angle.
9 Refine the lighting.

Minimalism

Reducing a composition to the bare essentials can sometimes make a more powerful image than the more usual process of building up a still life with props and additions.

The ability to arrange objects in front of the camera in any way you care means that you have complete freedom of composition. It can be interesting to exercise this in the opposite manner to normal, by limiting what you show and concentrating on the "pure" qualities of shape, form, texture, color, and space. This is minimalism. Minimal art emerged in the 1960s and 1970s, and was characterized by its extreme simplicity of content and arrangement, which was often geometrical. It became a mainstay of design, and also enters the world of still life. The reasons for its popularity as a style among studio photographers are not hard to find. First, still life shooting is all about constructing an image, and an almost-inevitable result is that things tend to get discarded from compositions as the photographer exercises an increasingly refined sense of design. One of the tenets of minimalism is to say more with less, and the still life arrangement as translated through the camera viewfinder is an ideal medium for this.

A second, related reason is that photographers, like any artists, generally like to make their own mark on a picture. Yet normal photography makes this harder to achieve than drawing or painting, because it can only deal with what is in front of the camera (digital manipulation aside). Reducing the scene, or at least its components, is one of the few reliable methods of making a dent in the predictably photographic nature of the image. It calls for a rigorous approach to both the selection of objects for the composition, and to the graphic design of the whole image. When you have only a few items in the frame, their placement takes considerably more effort and attention. Minimalist composition presents the viewer with little alternative, and the response is likely to be all the more critical for that. Backgrounds of empty space must be either meticulously clean or convincingly natural.

Least detail
A composition that deliberately looks sideways and a severely restricted palette of colors and tones conveys the essence of the strict simplicity of Shaker life. This nineteenth-century linen shirt was hanging close to a window in a Kentucky meeting house of the utopian religious sect. Absence of decoration was part of the Shaker lifestyle. The obvious framing—the whole shirt, centered—would have been just a record shot, but something more interesting was wanted. Shifting the view to the left loses no essential information (we can already see what a sleeve looks like), but emphasizes the bareness of the setting. The shadow on the left balances the composition.

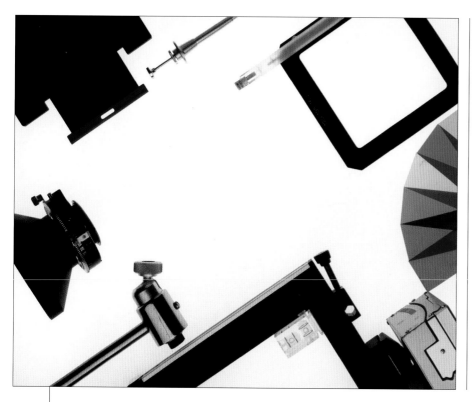

 Symmetry for the formless
Artificial fibers were the subject of this still life. Unwoven, the raw strands had no structure whatever, just small differences in color. The solution here was to construct a pattern, contrasting a semicircle of fibers with a diagonal arrangement. As a final touch, they were photographed by polarized light so that they would glow against the background.

Constructivist
This photograph of various pieces of photographic equipment features a carefully ordered composition based on diagonals. Only parts project into the frame, leaving the center empty, so that no single item holds the attention. The subject, in fact, is the abstract arrangement of the diagonals.

One and many
This image shows titanium limb prosthetics manufactured in large quantities at a factory. The metal sheet perforated with holes was used as a stacking system, and provided the perfect background for a more recognizable view of one of the pieces. The arrangement was simply a matter of positioning the camera for a perfect alignment with the rows, and pulling one prosthetic out. The placement of this and the single hole was off-centered for a harmonious composition.

Props, styling, and sets

In some cases, the context of a still life is as important as the subject. Carefully choosing the props that accompany it can establish the period of the scene and increase the photograph's impact.

Props are the basic material of much still life photography. Indeed, commercially, they are so important that professional stylists are often used in advertising and in better-paid editorial work. The stylist will take the responsibility for suggesting and sourcing props. These usually appear in a supporting role, either establishing or setting off the main subject, but they can also be subjects in their own right. This is particularly the case when the purpose of the shot is to evoke a specific historical period or a situation, as in the photograph to the left. Prop rental companies exist wherever there is a television, film, or photography industry, or where there are theaters for stage production. Most carry a wide range of items that can be rented by the day or week, from the everyday to the unusual. The condition of the stock, being geared mainly to film and television, is sometimes too poor for close-up still photography, which reveals even tiny imperfections.

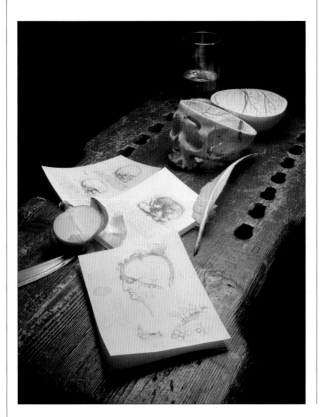

▲ Adding props to a small set
Here, props were needed to illustrate Leonardo da Vinci's work on anatomy. Obviously anatomical drawings were chosen, including one of a skull. The onion was included to represent Leonardo's comparisons between an onion's layers and the membranes covering the brain. The copied drawings were printed on textured paper, and the quill and knife were rented. The glass was handmade to order.

▶ Whaling log
To enhance a straightforward copyshot of a nineteenth-century whaler's log, yet not swamp the book, just three props were added: a sea chest, a pen, and a carved whale's tooth.

Assembling
The raw ingredients for the scene were shells of many different kinds. These were grouped in trays, then placed in position with tweezers.

Final cleaning
After more than an hour of assembly, the sand was brushed down to appear flat, and stray grains removed.

A styled shot
The finished design, worked meticulously in a variety of shells, is lit very diffusely to minimize shadows and emphasize the individual shells.

Preparing the base
For a constructed still life with a beach theme, the first step was to prepare a smooth background of sand. The camera was locked overhead, pointing vertically downward.

Other sources of props are antique dealers and street markets. By offering a deposit on the full value of the item, you can usually find a dealer who is willing to rent, even if it is not normal practice. Many props are inexpensive enough to buy outright, and most still life photographers have a small stock of interesting or useful props. A slab of marble and a butcher's chopping board, for instance, have obvious value to a food photographer, as do glasses, decanters, and tableware for food presentation. With other areas of still life, it's difficult to generalize, and much depends on whether you have a particular style. Even so, most homes have a surprisingly useful range of items, from heirlooms to interior accessories—and that applies to friends' homes also. When you are looking around for anything appropriate, it is important to remember that you can always try different combinations.

Shadowless white

For true absence of background, featureless white is the ultimate. This can be created at the time of shooting by introducing some degree of backlighting.

There are some occasions when only the subject is wanted in the shot, without any hint of background. In order to obtain this, the answer is white: pure and simple. A regular white surface, although it is basic and useful, will not really do the job adequately. However bright and reflective it seems, a surface like paper, card stock, or Formica will always pick up some shadows, and these can sometimes be surprisingly dense, particularly underneath an object with a light overhead.

White without shadows calls for backlighting, and this is a key technique in still life photography. The principle is that the background should be translucent or transparent, with at least one light placed behind, shining onto it in the direction of the camera and subject. It may take some effort to perfect such a setup, because you need to be able to light the background brightly and evenly. This makes the quality of the background material important, as it must be smooth, free from any visible defects, and thick enough to diffuse the light strongly. Milky, translucent Perspex/Plexiglass is the standard, and it should be at least 3mm (1/10 inch) in thickness. For strong diffusion, which spreads the light out more evenly across the surface when it is backlit, the thicker the better—up to, say, 8mm (1/3 inch)—but this will also reduce the amount of light drastically.

Another method of spreading the light evenly is to move the light source further back. This also, of course, reduces the amount of light. Using more than one light is also a solution, and if you use fluorescent striplights, placing two or three

Digital whitening

Even when the background appears completely white when shot, it may need some adjustment later. There are two main digital methods: setting the white point on the background, and selecting the almost-white background before removing any tonal value.

Furoshiki

Here, backlighting using a background table not only serves to isolate the subject, but also displays the color and translucency of a *furoshiki*, or Japanese gift-wrapping cloth.

THE ART OF STILL LIFE

parallel to each other and close will give an even output. This, in fact, is the construction of most lightboxes used for examining slides. If you have one left over from your film photography days, it will make an ideal backlighting setup.

Shooting vertically down solves the problem of supporting the subject, although it makes it more difficult to position the camera (the legs get in the way). Here, a useful accessory is a horizontal arm that attaches to the platform of a tripod. Better still, though expensive, is a background table, which consists of a large sheet of white, translucent Perspex/Plexiglass, bent into an S-shaped curve and held in position on a frame. This allows one or more lights to be placed underneath and behind. The rear upward curve provides a seamless background for an object sitting on the flat central section, while the downward curve falling away in front allows the camera to be lower but still horizontal, if needed. An extra detail is a sandblasted matt top surface to the Perspex/Plexiglass, to reduce reflections.

Near-white as shot
As the histogram shows, the background for this old wooden toy is still about 5% less than absolute white.

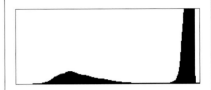

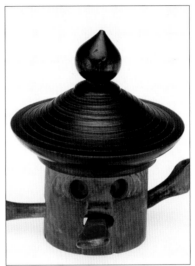

White point
Using the white point dropper, the value of the background is easily set to white. However, in this case, to preserve a minimum printable dot, the white point is first set to a level of 250.

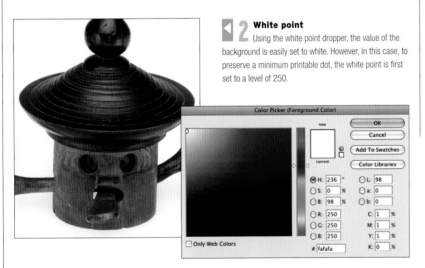

Select and delete
An alternative treatment, which works well with distinct edges to an object, is to use the auto selector (Magic Wand) to choose the background—shown here in mask form for clarity—and then hit the Delete button.

Case study: **clipping paths**

Objects with clean, definite edges lend themselves to cut-outs, and in the commercial world of websites, magazines, and brochures, there is great demand for cut-out images. From the publisher's perspective it makes for a clearer layout. If you know in advance that this is what will happen to the image you can, and should, prepare for the photography appropriately. This means you can ignore the background, because it will simply not appear. However, you will need to consider reflections of colors and other things in the object, particularly if it has reflective surfaces and especially along edges at an acute angle to the camera. Also, make life easy for yourself later by ensuring a clearly visible outline; in most cases, white is best.
In the main example here, a set of Chinese furniture was to be printed in a brochure and also displayed on a website. Of the several methods, a clipping path seemed most appropriate.

Walking Buddha
Even without the ability to set up lighting and reflectors at the time of shooting, a path, converted to a selection so that the background can be deleted, can turn a messy image into a clean and useful one, as in the case of this famous Thai walking Buddha, photographed from two angles in a Bangkok monastery.

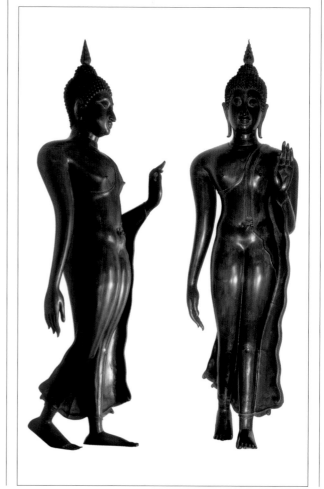

1 Photo setup

The lighting setup uses large sheets of polystyrene to give even illumination across the surfaces of the furniture from the sides, with a white umbrella as additional frontal lighting. The angle of the furniture and the position of the main polystyrene sheet are critical.

5 Check against black

The selection is temporarily filled with black, using the Refine selection window, to see how the edges behave. If the path had been more open, some of the original background would have been included.

6 Clipping path

Finally, the working path is converted into a clipping path that the PostScript interpreter in a page layout program can read. The flatness value determines the margin of error when printed, and the precise value depends on the printer.

2 Cabinet

At a slight angle to the camera to give a conventional and informative view, a cabinet like this presents two flat surfaces. For effective modeling, one must be slightly lighter than the other, and in this arrangement the front gets the most illumination, from the white polystyrene sheet to the left.

Make Selection

Rendering
Feather Radius: 0 pixels
☑ Anti-aliased
OK
Cancel

Operation
◉ New Selection
○ Add to Selection
○ Subtract from Selection

Clipping Path

Path: Path 1
OK
Cancel
Flatness: device pixels

Path 1

4 Make selection

As part of the procedure for checking accuracy, the path, when complete, is converted into a selection using the button on the Paths panel.

3 Drawing path

Working at 200% magnification for accuracy, the Pen tool is used to draw a path around the cabinet, working fractionally inside the edges so that the final clipped image can be used against any color of background.

7 Cabinet

The final clipped image is now ready for delivery and use in any application.

Drop-out black

Deep black is more than just an inverted alternative to featureless white: it provides a rich, strong contrast for light-toned objects.

Black backgrounds give punch to photographs of objects, particularly if these are bright in tone or color. Like white, as we just saw, this is a solution for treating objects in isolation, placed firmly within the frame, with nothing around to distract attention.

Objects emerge from black. In the psychology of perception, light tones advance and dark ones recede, which makes black a perfect background for enhancing the three-dimensional impression of a still life.

Image editing can help, as always, but it's important to take pains over getting the density of the background to its maximum at the time of shooting. There are two ways, used together, of assuring this. The first is to choose the least reflective material, and the second is to illuminate the object so that as little light as possible spills onto the background. Both, of course, have to do with light. The material that absorbs the most light—and one that is readily available—is black velvet. Among the different types and qualities of velvet, good cotton velvet appears blacker than synthetic. If this type of background is one that you think you will make use of more than once, it's well worth buying a couple of yards of it. Keep it unwrinkled by storing it rolled, not folded, and before each shot check the fabric for small pieces of lint and dust. The easiest way to remove this is with a small length of adhesive tape dabbed lightly on the velvet.

As an extra precaution to keep the density of the black deep, try to avoid light spilling onto it. This may be impossible to avoid simply because of the angle of the light and the way the object sits on the velvet, but if the light is from one side, use a barndoor or a piece of black card stock to shade the background just up to the edges of the object. Even more effective when the situation allows is to separate the object from the velvet. One way of doing

▲ ▶ Isolating the subject
The most obvious ways of photographing a lobster would be either in a setting that suggested its habitat, such as rocks or the sea, or one that suggested food, perhaps a marble slab. In this case, however, the intention was to treat the lobster as a still life object, without any associations. For a simple, strongly lit photograph, a single overhead flash, diffused with a square window attachment, was used with a background of black velvet to absorb all light. For additional simplicity the arrangement was symmetrical, and no reflectors were used, so that it emerges seamlessly from the background.

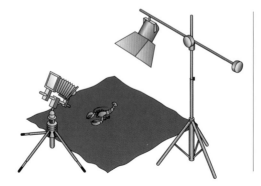

this is to shoot vertically downward while supporting the object on a rod, as in the example of the shell shown here. After all of this, it should be easy to tweak the final image during image editing by using the black point dropper on the background area.

Note that black, like any background, reflects in the edges of many objects. The extent to which it does this depends on how shiny the surface of the object is, and its angle to the camera. This is why edges pick up so much of their surroundings, because the very shallow angle of a curving edge, such as the sides of a bowl, are the most reflective. So, while objects can always be cut out digitally and placed against new backgrounds, realism often suffers. For black to work properly as a background, you need to shoot against black.

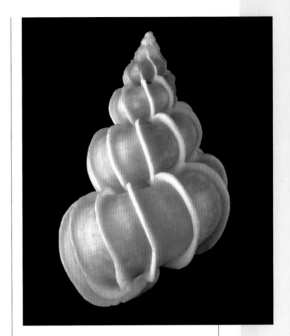

▽ Select and fill
The alternative is to select the background, here with an auto selector, and apply a black fill to this.

▲ Background separation
One way of improving the density of the background, and to avoid specks of dust and lint appearing, is to elevate the object to separate it from the black velvet. By adjusting the light, as shown in the illustration, there will be less spill onto the background.

Settings and textures

Selecting the right background for a still life shot can be as important as choosing other props or even the subject itself.

Where the main subject is a single item or a small group of objects, the background may take up the largest area of the photograph. There are three categories of background: plain, complementary, and setting. Plain backgrounds explain themselves. They are intended to be as unobtrusive as possible, simply providing a color or tone that shows off the subject clearly. Complementary backgrounds can enhance certain features of the subject and become an integral part of the shot, consisting of either matching or contrasting tones, textures, shapes, or colors. Finally, settings are used to put a still life subject in its context, and can give a more natural impression than shots very obviously taken in a studio. Many existing interiors make good settings, but their style and the objects they contain should reflect the nature of the subject itself.

A catalog of backgrounds

The list is endless, but most of the possibilities are either settings, like desks or tables, or fall into one of the following categories:

PLAIN
White For the least texture, use a slightly shiny surface, such as white Formica, or a nonreflecting surface, such as white velvet.
Black For a completely black background, use a high-quality cotton velvet.
Graduated A smooth white curved sheet of Formica, card stock, or paper, lit by an overhead diffused light.
Solid color One method is simply to use colored paper, card stock, or Formica. However, you can avoid the expense by adding color either through filters, or digitally later.
Digitally Either composite a second exposure of just the background with the shot, or else extract the subject in image editing.
Graduated color See Solid color above.
Bicolor Why stop at a single color? Apply the methods in Solid color above using two different colors.

Glass The glass shot is an old standby. Place the object on a flat sheet of glass, itself raised over a background color on the floor (far enough below to be out of focus and so textureless). Arrange the light or lights to illuminate the subject and the background (either together or separately), taking special care to keep the light at a raking angle to prevent reflections in the glass.
Perspex/Plexiglass Opaque colored Perspex/Plexiglass can give a variety of backgrounds. When lit frontally, color saturation is good, and light-toned subjects have subtle reflections. Lighting reflectively (as with the pistol, right), reduces saturation but increases contrast and reflections.
Mylar This thin, flexible material, with a mirrorlike finish, can give unusual distortions of color and shape.

COMPLEMENTARY
Cloth fabrics Cloth offers a very wide range of textures. Try crumpling and folding for even more character.

Textured paper Papers are available in a wide range of not only patterns and colors, but textures also, including embossing. To show off texture, light the paper from the side.
Textured plastic Like textured paper, but more durable, flexes more smoothly, and has a less fibrous texture.
Stone Slate, sandstone, marble and other stones have a tactile quality which can contrast with delicate or elegant objects (such as jewelry) or complement rougher, rustic subjects (a great standby in food photography).
Wood Similar in its possibilities to stone. Varies from smooth to natural. Sources are wooden flooring, bread boards and cutting boards, and driftwood.
Leather Strong natural texture, sometimes with connotations of luxury and the antique.
Water Either as a continuous sheet in a container or as droplets. In either case, it is an addition to another background. Its visual effect depends very much on lighting.
Aggregates Large quantities of sand or gravel and pebbles are easy to spread out.

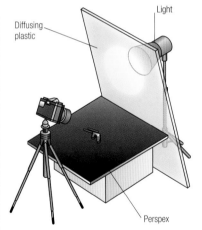

Flexible color

Shooting digitally makes it possible to capture the background separately from the subject and use this second image to apply a wide variety of colors, patterns, or textures. The setup and lighting play an important part, and call for the background to be lit independently, as in this example. In addition to the full image, take a second shot with just the background light, without moving the camera. The two should then be in perfect register. In image editing, combine as layers, and apply any color you like to the background shot, compositing it in any appropriate mode: in this case, Multiply.

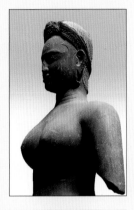

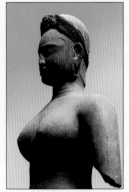

▶ Reflective plastic for precision

Black Perpex/Plexiglass produces a clean effect when used as a background and lit for reflectivity. The tonal range is muted and neutral, and by shooting at an angle that shows the light source in reflection, the shading can be controlled. In this example, the light was placed close to a large sheet of translucent diffusing plastic for a "pooled" effect.

Light

Diffusing plastic

Perspex

◀ Multiples

Large quantities of similar or identical objects can make an unusual but very controllable background. Ball-bearings are one high-tech possibility, another is illustrated here as a setting for rare, orange pearls.

Digital backgrounds

With the ability to outline objects and separate them from their settings, completely new backgrounds can be added, and even generated, digitally.

Replacing one background with another has become one of the signature techniques of digital imaging. It relies primarily on making an efficient, believable selection of the main subject. In still life photography, you might question why this should be necessary, given that all is under control and the real background has to be chosen and put into position in any case. The answer is that some backgrounds involving a certain range of color or type of texture are just simpler to do digitally.

One of the simplest and most effective is a gradient, for which the gradient tool in an image-editing program is tailor-made. The most basic in still life photography goes from a light foreground to a dark background, mimicking the natural distribution of light and shadow on a curved white surface lit by an overhead diffused light. Performed digitally, this is a straightforward linear ramp from almost white at the bottom to nearly black at the top. One method is to create this background first on a plain canvas and then drop in the selected object. Alternatively, load the selection already created around the object, invert it, and apply the gradient. To complete the effect, you will then need to add a drop shadow underneath, either by airbrushing into the inverted selection or by creating a shadow from a copy of the object. To do this, create a new layer underneath the object, load the selection of the object's outline, fill it with a dark tone, and move this shape down so that its lower edge appears below the object. Then deselect and apply a strong amount of blur to this shadow layer, adjusting its brightness or opacity as necessary. There are also third-party filters that will create sophisticated 3D-effect drop shadows instantly.

One of the issues with digital backgrounds is maintaining photographic believability. Artificially created tones and gradients too often look like illustrations rather than real space. One artifact is banding, in which a gradient appears visibly divided into steps. The answer to this is to apply

Textural variety
These five differently generated digital textures illustrate the kind of choice available through image-editing applications such as Photoshop, and through third-party filter suites such as Xaos Tools' Terrazzo and DreamSuite. Incorporating them realistically into an apparently photographic image relies on simple illusion techniques that include drop shadows and three-dimensional shading.

a small amount of noise. This has the added advantage of creating the subliminal effect of grain, which is still strongly associated with the reality of a photographic image. Never mind that grain itself is an artifact of film—the effect works perceptually.

More complex background textures can be created digitally, and there is an almost limitless choice, depending on the effort you are prepared to put in. There are many third-party filter suites that will create textures to order— Auto FX DreamSuite, Alien Skin Eye Candy, furbo filters, and Xaos Tools Paint Alchemy and Terrazzo, to mention just a few. Going a step further, even more convincing textures in depth can be customized with a 3-D modeling program.

Generator

Filters that generate textures digitally employ randomization effects and bump-mapping to appear three-dimensional and not repetitive. The blending mode "bars" were placed on top, after the dish was placed.

Digital vegetation

This precreated moss-like texture, which has a strangely special quality, is one of a set of organic textures available from Xaos Tools in a collection called Fresco.

Digital gradient and noise

A simple gradient can quickly be drawn using most image editing software. It is a simple process of selecting the colors and drawing. Here some noise was also added to give the background some texture, though there are numerous other filters available. You will find many in your imaging software's Filter menu.

Tools of the trade

Working with small objects in a precise manner often calls for an esoteric collection of specialized equipment, drawn from fields as far apart as watch-making and surgery.

Precision is the byword of still life photography, and calls for extraordinary control over everything, from lighting to the condition of the surface and preparation of things to be photographed. Specialists in still life studio work surround themselves with an arcana of bits and pieces, tools, and some of the oddest specializations, including imitation ice and bubbles.

Clamp and pole system, here shown with an arm and spring clip holding mirror.

Antistatic gun to reduce dust pickup on surfaces.

Miniature blowtorch for food photography.

Compressed air for cleaning, and also for attaching to tubes for creating bubbles in liquids.

Assorted small mirrors and metal reflectors, including an inspection mirror with extendable arm and swivel head.

Spirit level for leveling surfaces (essential when photographing liquids in containers).

Bluetac adhesive— re-usable putty for sticking and supporting.

Magnets for supporting and propping up objects.

Brushes for cleaning and moving.

Jeweler's retractable claw for picking up single small objects.

Assorted sharp-nosed tweezers for moving and removing small objects.

Alligator clip.

Molded and carved acrylic imitation ice cubes, for drinks shots.

Tiny glass spheres for imitation water-line bubbles, and glass hemisphere for a surface bubble seen from above, for drinks shots.

Assorted miniature C-clamps for holding mirrors and other things out of frame.

Antistatic liquid for preventing dust pickup.

Plastic tubes to attach to compressed air for bubbles creation, for food photography.

Denatured alcohol for cleaning surfaces without leaving streaks.

Cotton swabs for cleaning and wiping small areas.

Cloth for cleaning and wiping.

Craft knife and snap-blade for trimming and cutting, particularly useful in food photography.

Straight and angled sharp probes for moving small objects on set.

Stand with adjustable arm and spring clamp for holding things just out of frame.

Hand-blower brush for cleaning delicate areas where compressed air would be too strong.

Molded ice

Here the tiny glass spheres and molded and carved acrylic simulate an ice-cold drink perfectly. They have the advantage of not melting under camera lighting, as well as being infinitely positionable.

Light tents

Very shiny objects with curved shapes can reflect their entire surroundings, including the camera and lights. One solution is to enclose them in diffusing material.

With completely rounded reflective surfaces, it is impossible to remove all distracting reflections. However, if a simple reflective surface can be lit effectively with an evenly toned area light source, then the ultimate solution for reflective objects with complex shapes is to surround them with light on all sides. Curved, mirror like surfaces are notoriously difficult, reflecting a wide view of the surrounding studio, and are best handled in this way. The ideal method would be to construct a seamless translucent dome around the subject and shine light into it from outside.

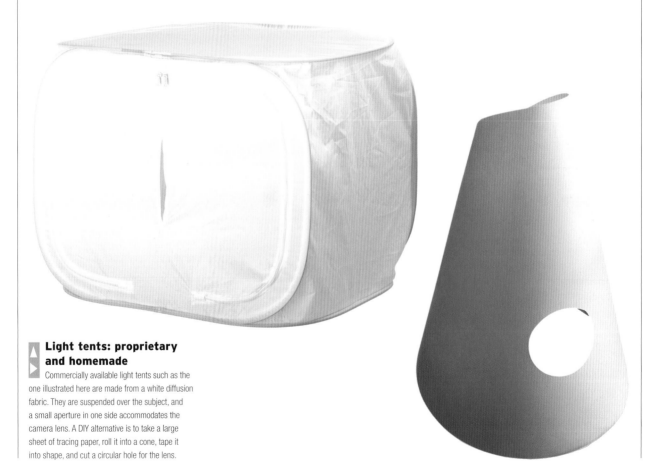

▲ ▶ ▶ Light tents: proprietary and homemade
Commercially available light tents such as the one illustrated here are made from a white diffusion fabric. They are suspended over the subject, and a small aperture in one side accommodates the camera lens. A DIY alternative is to take a large sheet of tracing paper, roll it into a cone, tape it into shape, and cut a circular hole for the lens.

The practical alternative is almost as effective. To give an enveloping light, without shadows or bright highlights, a light tent is the most-favored technique. Basically a translucent cone, which acts as both diffuser and reflector, it can be made of any colorless milky material—paper, tracing paper, or Perspex/Plexiglass. Used in the way shown, it should surround, but not intrude on the picture frame at the base, and enclose the lens at the apex. There are several commercially manufactured models available, but it is also perfectly feasible to construct a makeshift version yourself, from large sheets of tracing paper, thin white paper, or even cotton bedsheets. One of the advantages of building your own light tent is that you can tailor it in size and shape to the subject. Set up the camera, subject, and background first, and then construct the light tent to those specific dimensions. Check the view for any joins or gaps, and remember that it may be easier to remove these with a cloning brush in image editing than to perfect the set up at the time of shooting.

One or more light sources can then be aimed through the aperture of the light tent. Experiment with different lights for effects in which the light shades in tone. Two or three evenly spaced lights will normally create a thoroughly diffuse light, while one light will give strong directional lighting.

One problem with this system is that, even with a perfect light tent, the camera lens itself may show up as a dark patch in the center of the object. This is unavoidable, but it can be concealed by placing a non-reflective object to cover this up (while making sure that the arrangement looks natural and comfortable). Alternatively, this dark patch can be removed with a cloning brush later.

▼ Silver service
▼ Three versions of a highly reflective silver serving spoon, shot against black velvet with a single, moderately diffused light—a large window. In the first shot, no attempt has been made to deal with the reflections in the concave bowl of the spoon. In the second, a light tent has been made from a large sheet of tracing paper folded into a cone, its apex taped around the camera lens. In the third, a commercially available dulling spray has been used instead. This is for comparison only and is not recommended except in extreme situations. It gives the reflective surface a matt finish, but is rarely a good solution: it is sticky and difficult to remove, and in close-up introduces a noticeable texture to a smooth surface. It also completely alters the nature of the object.

Glass

Transparent materials show a fascinating interplay between reflection and distortion, which can be revealed and altered through lighting.

Glass, clear plastics, and even some minerals, like quartz, make exciting subjects in close-up because of what they do to light. Indeed, lighting is completely the key to dealing with transparent materials. Most of them have smooth surfaces that reflect light in the same way as the shiny objects we just looked at, but their most important quality is that they transmit light. How well they do this depends on shape and thickness, but because you can see through them, they can almost disappear into a background if lit in a certain way. This is not what you would normally want in a still life, and the basic lighting technique involves shining light through a glass object.

These objects become interesting in close-up because of the variations in thickness and shape, which affect the refraction, or bending, of light. In appearance, this means some kind of distortion, and on a detail scale this

Cast glass

The precise details of a section of bamboo are faithfully recorded in a block of glass. The artist first made a ceramic cast of the bamboo, then placed it in a furnace with shards of glass. The block took more than a week to cool. The bubbles add textural interest, but the key task was to show the internal structure. Uneven backlighting through a window was the answer, and the proximity of the dark window frame helped define the shadows.

▶ Machined quartz

This finely machined quartz assembly was intended for a space-shuttle experiment and needed extremely careful handling, with no possibility of suspending or clamping part of it. In order to photograph it opened up, two exposures were made, one of each half. These were combined digitally as layers in Screen mode, with one of them inverted. The mixture of smooth and ground surfaces in this exquisitely machined object, and the strong refraction in the quartz, spread the illumination from a single square area light above. The effect is a bright internal glow.

THE ART OF STILL LIFE

is what helps to create a well-defined internal structure—different parts of the glass refract different areas of brightness around it, as happened in the close-up of a block of glass that had been cast in the form of a bamboo section. In this case, if the backlighting had been total and broad, this cast shape would have been almost invisible, but because of differences in the light (natural daylight reflected from a snow scene through a window), it shows up clearly.

Starting with the principle that a large, but not necessarily even, area of light will reveal the structure and shape of glass, probably the best way to discover the effect you prefer is through trial and error. Simply experiment with the camera viewpoint, the angle of the object, and the position of the light. Small changes can make significant differences to the appearance.

Backlighting is certainly the standard technique, particularly in close-up, but there are other possibilities, as the photograph of the glass head illustrates. Placing shaped reflectors behind a piece of glass can be an effective way of redirecting the light. The best reflector will depend on the circumstances, but white card stock, paper, a small mirror, or aluminum foil are all possibilities. It's surprisingly easy to avoid giving the game away with this trick by making use of the natural distortion of glass (even stronger in the case of a bottle or glass filled with liquid). Cut or crumple the reflector to shape, and prop it behind the object, at a slight distance if necessary.

▲ ► Lighting glass by reflection

This glass head was partially painted for a magazine cover. Photographically, there were two problems: lighting the painted areas without flare and capturing the qualities of the glass below. The fairly high camera angle was determined by the design on the head, which was lit by a single diffused light. The top of the forehead was treated with dulling spray to reduce the highlight. For the glass, a second light and crumpled silver foil were used as a completely localized light source behind the head. The thin foil, matte side up, was cut to a shape that would be concealed from the camera position, and a narrow beam of light aimed at it. The reflection illuminated the transparent glass.

Jewelry

Necklaces, bracelets, brooches, and rings are usually designed for first impressions, and so in photography they depend on impact, through lighting and through presentation.

There is tremendous variety in jewelry design, from baroque to modernist to playful, but all pieces have one thing in common—they aim for impact. The more eye-catching they are the better, while a piece that fails to be noticed is generally judged a failure. Strongly wedded to fashion, jewelry is more often than not about making statements, and is intended to draw attention to the wearer. It should, above all, stand out, and this naturally influences the way that jewelry is normally photographed. Subtlety may certainly be needed in the detail of a shot, but the overall effect of the image needs to be as striking as the piece itself.

There is a strong tradition of using expensive materials to make jewelry. Traditionally, this is one of the major uses of precious metals and gemstones, and the way they are used tends to emphasize reflection, refraction, and color. Diamonds, for instance, have a commanding place in jewelry, partly because of their rarity, but also because they sparkle so strongly when cut. We'll deal with gemstones

Enhancing the presentation

Two striking features of this Art Nouveau brooch are the use of unusual pink pearls from conch shells, and the exquisitely worked leaves and petals. Its open structure also required a background. Real leaves were chosen for this, as contrast for the pearls and to continue the theme of vegetation. The background leaves were placed at a slight distance below to avoid shadows, and backlit.

specifically on page 424, and the techniques described there are all applicable to jewelry in general. One piece, however, may make use of a number of different precious materials, and all have particular needs for lighting, as in the 18th century hat clasp containing the famous Dresden Green diamond opposite. Ingenuity and compromise are often called for in lighting jewelry. With each of the pieces shown here, considerable care has been put into lighting that brings out the individual qualities of the item, whether that is the iridescent sheen that is the hallmark of electrolytically treated titanium, or the realistic leaves of an Art Nouveau brooch.

The need for impact also often dictates the way in which a piece of jewelry is presented, including the choice of background. Diamonds, for example, sparkle at their best when seen against a dark background, which makes a material such as black velvet one of the more obvious choices. Indeed, the presentation of the diamond hat clasp shown here was that of the museum in Dresden where it is housed. Another possibility in selecting backgrounds to enhance impact is to use the unlikely—something that contrasts through being rough, or ordinary, such as unworked stone, or cut fruit. And finally, of course, there is also the background against which much jewelry is ultimately intended to be seen—skin.

▲ Thai pendant

This Thai antique gold pendant was set with a ruby. The complex embossed surface seemed best handled with uncomplicated diffuse lighting, and the lid of an old wicker basket was chosen as an appropriately ethnic background. It was dark enough to contrast with the gold.

▼ Titanium brooch

The designer of this titanium brooch made use of one of the metal's lesser-known qualities. The surface color changes when an electric current is passed across it, according to the charge—a kind of painting by electrolysis. A carefully-angled small diffuse light gave the best display of the range of colors.

◢ Diamonds

This spectacular diamond confection encloses one of the world's most famous stones, the Dresden Green. A diffused light at left, together with white reflectors around, were used to model the different facets of the stones and provide basic lighting, while the sparkle and colored refractions were handled by a powerful focusing spotlight aimed from upper right.

Food

By convention, food photography is concerned mainly with making dishes look appetizing, and the emphasis is on lighting, texture, and impression.

Food photography has become one of the most specialized genres of still life. It is in great demand editorially in magazines and books, and commercially in advertising. Just as the function of jewelry, as we just saw, is to be beautiful and eye-catching, food has to look appetizing. How mouthwatering a dish looks is the single most important gauge of success in food photography.

Inherently, not all dishes share the same visual appeal, and this is where the skill and eye of the specialist food photographer are in greatest demand. As a general guide, food that has structure and color usually photographs well, whereas amorphous dishes, like many stews, are difficult, however tasty they may be to eat. In commercial food photography, tinned and packaged foods are among the most challenging, and the job is often that of making a silk purse out of a sow's ear.

In common with all lifestyle subjects, the imagery of food follows fashions. These tend to change slowly, but if you compare a typical cookbook or magazine article from a decade ago with a modern version, the differences in presentation and lighting are noticeable. Nevertheless, the range is familiar: people are conservative in what they like to eat, and food photography tends to be conservative in style so that dishes are presented in a familiar and largely idealized way.

Then there is the matter of authenticity. There are a limited number of ways of presenting dishes so that they remain true to the recipe. For this reason, accuracy is important, and, in professional food photography, expert knowledge is provided by home economists or food stylists. Without this service, research the dish you are planning to photograph, using several authoritative sources, and buy the best ingredients available.

◢ Modern Japanese
The inherent simplicity of many Japanese dishes, such as sashimi (raw fish), lends itself to an emphasis on presentation. In this instance, a specially designed table containing a cast glass light, together with a modern ceramic dish, were the highlights, to which the chef added the seasonal touch of young maple leaves. The combination of built-in tungsten light from the table and blue twilight through the windows created a perfect color contrast, unimprovable by photographic lighting.

Tricks of the trade

In order to make food look right in a photograph, it is often necessary to use a number of tricks that go beyond normal cooking. This may be because a dish suffers from the photographic process: frozen foods can melt, and fresh vegetables tend to wilt under studio lighting. Typically, many dishes are undercooked for photography so that they retain structure, while occasionally substitutes are used, such as glycerine instead of water so that the drops do not evaporate. With stews and curries, it may be necessary to raise the solid contents by placing a small upturned bowl inside, hidden from view.

Caviar

Beluga caviar at its most luxurious, served traditionally with blinis and vodka. The authentic tableware was an important part of the photograph, and was provided by a specialist retailer, The Caviar House, in London. It clearly made sense in this case to approach a knowledgeable supplier and rely on it for authenticity.

Direct to computer

Studio food photography is perfect for direct capture via the computer, which allows the details of each image to be checked and approved on the spot. Cooked dishes, such as this Thai stuffed crab, have a limited life, which makes it convenient to verify the shot before things wilt and congeal. The various control panels allow all the camera settings to be adjusted via mouse and keyboard.

Liquids

Whether drinkable or not, liquids in close-up are all about refraction, color, and movement, with lighting as the key.

Clear liquids, such as beer, wine, and olive oil, make interesting and attractive close-up subjects, but call for the same care in lighting as transparent materials. Generally, the same techniques apply, with diffused backlighting always a standard option.

Nevertheless, it is not a good idea to fall into a fixed pattern when shooting these subjects. Even though a broad backlight will nearly always give a successful, predictable result, it can easily become formulaic and even boring. The best way to keep ideas fresh is to experiment each time, and with liquids in containers (glass, flasks, or bottles) there are countless subtle effects from refraction and distortion.

In any case, if the liquid is part of a larger set, with other objects or dishes to be lit in ways that suit them, backlighting may not be an option. In this situation, one useful method of illuminating a liquid is to position a reflector, such as a small mirror, a sheet of silver foil, or a piece of white card stock, behind the glass or bottle. Angle it to catch the light and reflect this through the liquid to the camera. If the reflector is approximately the same shape as the glass or bottle, its outline will not be noticeable when refracted by the liquid.

More than transparency, the special quality of a liquid is that it can move. Its appearance as it flows, trickles, or forms drops or bubbles, brings it to life. In close-up, this almost always calls for a high shutter speed or flash. While there are interesting slow-motion effects possible in nature, such as the misty appearance of a waterfall photographed with a slow shutter speed, in a still life setting they tend to look confusing. Bubbles, splashes, and ripples all need to be caught as if frozen. Flash is ideal, but only if it can be positioned wherever it looks best, and that, as you can see here, often means behind. Not all cameras allow synchronization with a separate flash unit, and in this case the solution may be to use

Substitute ice and bubbles

Two components that are often desirable in a still life drink shot are ice cubes or bubbles. In both cases, the real thing is difficult to control and does not last. A solution sometimes employed in professional food photography is a handmade substitute. Ice cubes are available customized in acrylic, and bubbles in hand-blown glass. Because real bubbles burst and are difficult to position precisely, glass substitutes are a controllable alternative. Spherical bubbles are used for side-on shots of the surface of a liquid. Half-bubbles are used for shots looking down

sunlight (modified with a diffuser if necessary) and a high shutter speed.

You may have to devise some way of creating motion, and this usually calls for close coordination. Pouring a liquid from a bottle into a glass is one of the classic problems, and you can expect many attempts before getting this right. The neck of the bottle needs to be in the correct position in the frame, and at the right distance for sharp focus. More tricky than this, it needs to be poured at the right speed and caught at the right moment. Too slow and it will look like a weak dribble, too fast and it will splash over. Too soon and the glass will look empty; too late and it will appear over-full. Fortunately, shooting digitally lets you know when you have the shot, but you still need to be patient. Don't be surprised if a photograph that relies on split-second timing takes anything up to, or even beyond, 20 attempts; there is an element of chance involved, after all.

Manufactured bubbles

Creating bubbles in a liquid, sometimes needed in food photography either to imitate boiling without actually using a cooker, or to imitate an effervescent drink like champagne, demands some ingenuity. One method is to attach a flexible pipe to either a can of compressed air or an air compressor (this is easier than blowing with your mouth). The size of the bubbles can be altered by fitting a sponge or other diffuser to the other end of the pipe. To encourage bubbles to remain on the surface, a few drops of dishwashing liquid can be added.

Decanter

Because the fruit pieces, rather than the liquid, are the interesting features in this shot, the lighting was selected to highlight their shape. Most of the light comes from the side, with just enough reflection to reveal the shape of the decanter.

Belgian beer

The aim here was to create a natural impression of a half-drunk glass of beer, deliberately avoiding the pristine perfection of a just-poured glass. One light was used from top left, with a small piece of silver foil placed behind the glass to reflect it up through the liquid.

Turbulence

Boiling can create beautiful patterns in close-up, normally best revealed through backlighting. In this case, the effect occurred naturally at room temperature, as the subject was liquid nitrogen. This was being used to super-cool a piece of scientific equipment in a glass dish suspended over a diffused flash.

Built to order

Custom-built models are an essential part of professional still life work, particularly where photography is used to illustrate ideas and concepts that lack obvious visual elements.

Models are used in a number of ways in photography. Often they are made to a scale that allows the photographer to juxtapose them with another object that will appear life-size. The modeling technique itself can become an important part of the shot, as with the bricks and the mouse on these pages. Most difficult of all is the use of models as perfect substitutes for the real thing, which for any number of reasons may not be accessible. At a certain point in the planning, it may make more sense to do digital compositing instead, but models retain a certain innate appeal.

Although scale-model construction can be a highly specialized skill, doing it solely for still photography is easier and less exacting than usual. In most cases, the model is only intended to be viewed from one position, and provided that the camera angle is worked out beforehand, only the camera-facing side need be built, rather like street frontages on movie lots. Another time-saving advantage is that models for photography hardly ever need to be permanent, so solid construction is not necessary.

Imitating a full perspective scene

To create this fictional moonscape, fine-textured material and false perspective were employed. With a board measuring four by three feet as a base, the shooting angle was chosen, and the camera locked down in position. The area covered by the lens was drawn on the base, as was the compressed distance scale, from infinity at the other side of the base to about ten feet (3m) nearest the camera. The landscape was then modeled in high alumina cement from a sculptors' suppliers. This is ideal because it can be given different textures by spraying or mixing with water. The view was constantly checked through the camera to make sure that the illusion of perspective remained accurate. Black velvet was hung for the background, and the Earth and stars were added later digitally. The lens was stopped right down to its minimum, $f22$, for maximum depth of field, and a small flash gun was used to give hard shadows.

Simple materials

Simple, inexpensive materials can be just as effective as custom-made kits and parts. To illustrate a magazine article on the subject of hoarding, white beans were used to symbolize a mouse hoarding a pile of food. The basic shape of the mouse was made in modeling clay, and the beans were placed one by one to cover the surface. The whole model took about an hour to make.

Forcing perspective

To make an ordinary brick seem the size of a large building, a wide-angle lens was used from a very short distance and angled upward to give a deliberate convergence of verticals. However, if it had been set up against a real landscape, the depth of field would have been insufficient to keep the whole scene sharp. Instead, a twilight setting was used, and a false horizon cut out of black card stock with the recognizable outlines of a church and house to make it obvious. This was laid on a thick sheet of translucent Perspex/Plexiglass and backlit. A small portable flash unit was used to light the brick at a grazing angle to emphasize texture. This helped the illusion of a large scale, because the small flash tube cast very detailed, hard shadows. In addition, being aimed from such an acute angle, the lighting did not include the horizon or "sky." For a realistic evening sky, two sheets of transparent colored acetate were taped under the Perspex/Plexiglass—blue for the upper sky and plum-colored for the area close to the horizon. By shaping them so that they fell away in the middle of the picture area, the transition was smooth and natural. To help the illusion further, one last refinement was to add the moon digitally from another photograph.

Building symbols

The complex theme for this shot was international finance in the construction industry. To convert this non-visual idea into a simple image, model bricks were built into a wall in the shape of pound sterling and dollar signs. Construction time was ten hours.

Copyshots

Photographing flat images such as paintings and illustrations demands precision and technique, the three most important considerations being alignment, fidelity, and lighting.

Copying can be used to record documents or illustrations, or as part of other photographic techniques such as photomontage. There is absolutely nothing creative in this, but there is considerable technique, and when it's necessary it saves a great deal of time and frustration if you follow a few simple procedures, as follows.

▲ Daguerreotype
Originals with reflective surfaces need special care. This daguerreotype had a silvery, mirrorlike finish that is typical of this old photographic process. To avoid the camera from appearing recognizably in the portrait, the following precautions were taken: a long lens was used so that the camera position could be far back away from the lighting; black cloth was draped around the shiny parts of the camera; and a wide aperture was used so that the depth of field would be shallow and the camera well out of focus.

Alignment

The two most convenient positions for taking copyshots are horizontally on the floor or a table, and vertically against a wall. With small originals, the horizontal position is usually easier, but with large paintings it may be necessary to photograph them while they are hanging in place. A custom copying stand is useful if you do this type of work frequently, or you can adapt an enlarger. Otherwise, you can use a regular tripod for vertical copying against a wall or a tripod with an extended horizontal arm for copying horizontal originals.

▲ Vertical copying
One straightforward way of keeping the illustration flat and level is to place it on the floor and photograph it from above. An extended horizontal arm will keep the camera clear of the tripod. A plumb line or sprit level can be used to center the camera vertically above the picture.

▲ Copy stand
If copying is likely to be a regular exercise, a standardized setup of camera and lights may be convenient. A copy stand can be adapted from an old enlarger (one way of recycling predigital equipment!).

Alignment is a critical procedure, and even a slight error can cause the effect known as "key-stoning," which will turn the rectangular borders of a painting into a trapezoid and can even throw part of the image out of focus. There are four basic methods of aligning the original to the film plane:

1. Use a level to check that both the camera back and the original are precisely horizontal or vertical.

2. Where the original has to remain at an angle (a hanging painting, for example), measure this angle with a clinometer or a plumb line and protractor, and then adjust the camera back to the same angle.

3. Use a grid focusing screen (some digital cameras have this as a menu option) and compare the edges of the artwork with the etched lines. Occasionally, however, the original itself may not be exactly rectangular.

4. Place a small mirror flat against the surface in the center of the original, focus the reflection of the camera manually sharply in the viewfinder or the LCD screen, and move either the original or the camera until the reflection of the lens is dead center. Remember to reset the focus before shooting. This is a very accurate method.

Fidelity

As in duplicating, completely accurate reproduction is not possible and some color may be distorted by certain types of film. As an independent check, place a Color Target or Separation Guide alongside the original. This is an accepted standard, and if the shot is intended for reproduction, the printer can then correct colors and tones without viewing the original illustration. Also, you can measure the known values on the target in an image-editing program, and use them to correct the image. Contrast is often a problem; if your camera allows it, experiment with tone compensation. For the best results, eliminate flare by placing the original against a dark background, such as black velvet, and use naked lamps unless the painting or its frame may show reflected highlights, in which case you will need to diffuse the lights.

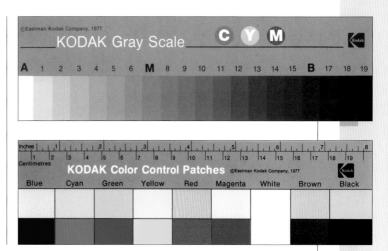

Color patches and grayscale
Several manufacturers, including Kodak, make standard color patches and grayscales. Use them when copying painting or illustrations where accurate reproduction of colors and tones is important. Place these within the frame of the photograph and shoot them beside the original illustration as an extra measure of color and brightness accuracy. They can be measured digitally during image editing.

Mirror alignment
Place a regular hand mirror flat against the artwork (if you can), and focus on the reflected image of the camera. Adjust the positioning until the image of the lens is exactly in the center of the viewfinder or LCD.

Lighting flat artwork

In total contrast to the lighting of objects, the ideal illumination for a copyshot has no character, but is simply efficient, covering the subject evenly, without shadows or reflections.

The first principle in lighting for a copyshot is to get the entire area completely even, with no fall-off in any direction. The most even lighting is equally from all sides, and the ideal lighting arrangement uses four identical lamps positioned at the corners and equidistant. To avoid a hot spot in the center, aim each light toward the opposite corner. A simpler arrangement, which is usually effective enough, uses just two lights. Again, aim each at the opposite edge of the original, but position them at a greater distance than with four lamps. Even a single lamp, or daylight from a window, can be used provided it is diffused and a reflector is placed at the opposite side.

To measure the evenness of the lighting from more than one lamp, place a piece of plain card stock against the original and hold a pencil perpendicular to it. The shadows cast by each lamp should be equal in length and density. Alternatively, use a light meter with the white plastic receptor for incident readings. Hold it facing the camera right next to the artwork and take several readings from different positions, including the corners. Each measurement should be identical. Also hold it in the center, aiming it in turn at each light while shading it from the other(s). Again, the readings should all be equal. Always flag off the lights from the camera with pieces of card stock attached to stands, or use a professional lens shade.

Reflective surface
Pictures covered with glass or with a varnished surface can be a particular problem. To cut down unwanted reflection, place black card stock or velvet in front of the camera, with a hole for the lens.

Two lamps
A good result can also be achieved with two light sources placed at either side. They should be aimed at opposite sides of the illustration.

All-round lighting
The best lighting arrangement for a completely even spread uses four identical lights, one at each corner. Direct each lamp at the opposite corner to avoid a strongly lit center.

Reflections can be unexpectedly troublesome. They are at their most obvious with varnished oil paintings, but can also appear almost imperceptibly with other textured surfaces, such as paper used for prints and for photographs. Even apparently matte surfaces can suffer, causing colors to appear less saturated. To avoid reflections, position whatever lights you are using at about 45 degrees to the original. A position closer to the camera will cause reflections and a shallower angle will show texture. There is even less risk of reflections if the camera is positioned further back, with a moderately long-focus lens. For absolute control of reflections, cover the lights with polarizing sheets and the lens with a polarizing filter. Rotate the filter until the reflections are reduced, but beware of small violet highlights from very bright reflections. Because the light has to pass through two polarizing screens, an extra three stops exposure is needed. When the original is behind glass that cannot be removed, use the same techniques, but in addition hang a sheet of black velvet or black paper in front of the camera, with a small hole cut for the lens.

Gold
Avoiding too much reflection in the gold leaf is achieved using the black card method shown opposite. Even then, however, it is important to ensure that reflected light is not too strong.

Checking the lighting
If more than one light source is being used, hold a pencil vertically at the center of the illustration. The shadows cast by each lamp should be of equal length.

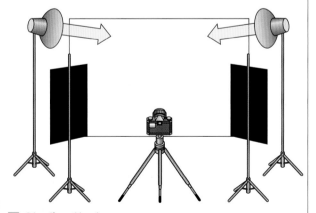

Shading the lens
Because it is particularly important to avoid flare to reproduce the full contrast in the subject, the lights should be flagged from the camera with pieces of dark card stock.

Coins and stamps

Specialized collections call for accurate documentation, and if the image database will be added to later, lighting and viewpoint need to be consistent.

The usual reason for photographing coins from a collection is to document them, meaning straight-on, clearly, and cleanly lit (and both obverse and reverse, in most cases). If the coin is in mint condition, as it's likely to be, it may be highly reflective, depending on the kind of metal, and this brings special lighting needs. The normal approach is as with any shiny surface—use a diffused light from an angle that covers the full face of the coin. However, there is an extra problem with coins in that most are circular, and a circle is a strong memory shape. If you shoot at a slight angle for the light, the coin will appear slightly misshapen, but if you shoot straight down, the light cannot be fully reflected in the surface. Without a shift lens, the solution is to use a long lens to reduce the angle, and then correct in image editing with the Perspective tool. An alternative lighting method that gets around this is sidelighting—from at least two sides—so that the relief is highlighted but the base is dark.

Half-silvered mirror, or thin, plain glass

Diffused

45°

Coin

Brightfield axial lighting

In one sense, a straightforward coin photograph is a copyshot. The camera should be parallel with the coin so that it appears truly circular. In addition, however, many coins have all the problems of reflective objects. To combine bright reflected lighting with perfect alignment, use axial illumination. This is light that appears to come from the position of the camera, along the lens axis. With a special box, using a half-silvered mirror, or even very thin plain glass, any lamp can be made to produce axial lighting. The lens axis and light axis are set at right angles to each other, and the glass at 45°. Part of the light is lost, passing straight through the glass, but part is also redirected down to the coin, where it is reflected straight back up to the camera. The inside of the box should be matte (flat) black to reduce unwanted reflection from the top of the glass, and the lamp should be diffused.

Low-angled darkfield lighting

An alternative lighting method, which works best with proof coins that have a mirrorlike finish, picks out only the relief details, leaving the main surface area black. The principle is a glancing light from the side that reflects only from the raised areas. Black paper taped to the front of the camera bellows allows only the lens to show, so that nothing bright can reflect in the flat surface of the coin. A reflector, in this case gold foil, opposite the light balances the lighting.

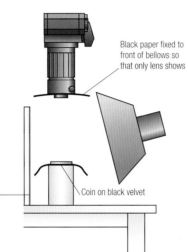

Black paper fixed to front of bellows so that only lens shows

Card covered with gold foil

Coin on black velvet

Postage stamps

Stamp collections also call for a documentary approach, with the additional requirement of color accuracy (as with copyshots). Also consider including, as in this example, the edge of a ruler for exact dimensions. If you later want to arrange the images in sets, this will be essential if shots were taken at different times with inevitable small differences in scale. The background against which stamps are displayed in real life is a matter of taste, but a dark background makes it easier to select stamps for cutting out. An alternative to all of this is to scan stamps, but check to make sure that there are no reflections from coatings and metallic inks.

Correcting the angle

This group of coins (an extremely rare set) posed a special problem of angle, because in order to have the diffused area light reflected in all of them, the camera axis had to be at a slight angle. This created some distortion, which was corrected using the Perspective tool at the image-editing stage. A predrawn perfect circle in an overlying layer was used as a reference for the correction.

Case study: **out of the studio**

Sometimes the studio, for all its facilities and possibilities of control, is not the most effective setting for a still life. It certainly scores on efficiency, particularly of lighting, but there may be other, more important qualities needed. Most still life photographers, once they have established a way of working in familiar indoor surroundings, with an assembly of lighting and other equipment, tend to tackle each project as one to be solved in a studio manner, building up everything from scratch. It's worth remembering, however, that there are no rules about this, and sometimes an outdoor location can be perfectly relevant. Just as unplanned still life scenes can be found anywhere, they can also be constructed. This was the case here, with a set of small ceramic pieces that the artist, Yukako Shibata, had conceived as being partly organic in form. After a straight studio shot, we looked for other treatments.

Studio
The first approach had been to concentrate on the pieces' physical qualities: their shape, variations in size, and the subtleties of their glazed off-white surfaces. A sheet of black Perspex/Plexiglass was selected as a background. This would provide a strong, definite contrast, while the delicate reflections that would be visible from a low shooting angle would add interest. A broad area light was suspended low over the grouping in order to light them evenly while giving a suggestion of the glaze through its large reflection.

Grass
There was something mushroom-like about these little domes, so we decided to treat them as organic entities, and took them to a woodland location. Special care was taken so that blades of grass appeared to be growing around the pieces.

◀ Tree roots
▼ Even more successful as a location, once we thought about it, were the roots of a tree, partly because they added the suggestion of an enclosing frame, and partly because in nature this is a likely habitat for mushrooms. Lighting control was sacrificed, but the weather was good, with hazy sunlight in the late afternoon. This brought gentle specular highlights that helped to define the glaze on the ceramic components of the artwork.

▶ Pond
Finally, another small work by the same artist, featuring a subtlely painted sphere sitting in the center of a square mirror, was shot in the same general location. To make the most of the reflective surface, we chose an area with taller clumps of grass, shooting toward the sun for contrast. The suggestion here is of a small pond.

Nature **in Detail**

Nature means detail. In some of the earlier chapters, including *Natural Landscapes* (page 226), one of the themes is the wider context of the natural world, the landscape, where not only is the scale large, but the various components are seen fitting together—mountains rising above plains, rivers connecting them, vegetation covering them from foreground to distance. Here, however, we make a selection from the natural world. By closing in and framing with care, the camera can be made to isolate parts from the surroundings.

The American photographer Eliot Porter (1901–90) did more to refine the esthetics of the close considered view of nature than anyone else. He believed nature photography to be of two types, either "centripetal" or "centrifugal." In centripetal photography, all the elements work to converge on a center of interest, drawing the attention inward, away from the context of the wider surroundings. In centrifugal photography, the composition is more dynamic, drawing the eye toward the edges, encouraging the viewer to think about what lies outside and why the photographer excluded it.

It is perhaps the centrifugal approach that draws more strongly on the art of photography. A photograph of a beetle, for example, demands very little in the way of composition. We simply want to see it, which means large in the frame and clearly. There are subtle, efficient improvements that can be made, such as making sure that the background is not unnecessarily confusing, or placing the creature slightly off center if it is moving so that a larger area of background is ahead of it, but

essentially the design of the image does not really call for surprises. But when it comes to choosing a part of an interlocking view, whether of grasses, trees, or rock, with their interplay of color, shadow, and shapes, the image frame then becomes a creative tool of real importance. Design in photography always relies heavily on how you crop the image, but it matters more in nature photography, where the act of closing in is central.

There are two main purposes in nature photography: documentary and esthetic. In one, the subject takes priority, while in the other its visual qualities are the starting point. In the following pages, I've tried to look at nature from both points of view, in the hope of showing that an informative image can be visually stimulating, and that a photograph that sets out to explore the purely visual can also add to our sense of nature. Porter, though knowledgeable as a naturalist, wrote, "I do not photograph for ulterior purposes. I photograph for the thing itself—for the photograph—without consideration of how it may be used." However, he was happy for his work to be used for environmental awareness.

In this section, we turn from the constructed and controlled still-life image to the detail that occurs outdoors naturally, much of it unexpected. One of the inspiring qualities of nature photography is that, on this small scale, nature always delivers visual surprises. The subject matter is wide-ranging: not just the plant and animal kingdoms, but minerals and rocks, from the texture of a limestone cliff to precious gems. The field is vast, and appears even larger when looked at closely.

Color and pattern

Nature is the source of an amazing range of graphic material from which you can create images that are both abstract and minimalist.

Just as some nature photographs turn inward, while others draw attention to what might be outside the frame, there is also a subtle distinction between those close-up images that document the natural world and those that are mainly an artist's exploration of it. The documentary approach is more concerned with the facts—what a particular species looks like; its identifying characteristics; how it behaves or where it grows. This in no way prevents the photograph from also having an aesthetic appeal, but a clear, legible view is the first priority. The other approach starts from a different point of view—that there is much beauty to be found within the natural world. It may be beauty of color, of line, or of form, and even though it has a role to play in the survival of the plant or animal, this is secondary to the picture.

To a botanist, the color of a flower may mean one thing, as the function of a snake's repetitive pattern might to a herpetologist. They play a part in natural selection. But quite divorced from this they also make very appealing images in themselves. Nature provides the material for abstract imagery, and it reveals itself above all in color and pattern. In a sense, of course, nature is the source of all color, shape, and line that appears in art. Artists' pigments

Azalea in bloom

A large and spectacular azalea tree, more than two centuries old, blooms a rich red in the summer. Shooting from very close—almost inside the tree—with a wide-angle lens captures the maximum number of flowers while excluding the surroundings.

Cracked

This outpouring from a mud volcano had baked under the tropical sun. To fill the frame with as large an area as possible, a 20mm efl lens was fitted and the camera tilted down.

▷ Cone shell
Like flowers, shells are a guaranteed source of close and unusual detail. This painterly pattern is from a cone shell; an image of the full shell appears on page 421.

◁ Orchid
Flowers can be relied upon for endless color combinations. Close cropping excludes the background and determines the color arrangement.

△ Variations on green
A pond in a Japanese garden based on Shinto plantings is deliberately designed with green pebbles to extend the theme of natural green.

△ Snakeskin
At this scale, cropping in close so that they are disassociated from the animal or plant of which they are a part, many patterns appear new and unusual. This snakeskin posed no depth of field difficulties as it could be stretched flat and photographed with the camera pointing vertically down. The light chosen was a naked flash aimed from one side, with a white card reflector opposite to even the illumination. The naked lamp helped reveal the texture of individual scales.

are extracted from such sources as rocks and insects. But the nature photographer has a much wider palette at his or her disposal than does a painter, because the full, complex range is there growing in the natural world.

Looking at nature from the position of photographer rather than naturalist, the act of closing in with the camera becomes an essential tool of photography. This is the way in which you can select from a plant or a small grouping, or from an animal, just the graphic elements that you want to record. The examples shown here have in common a framing that has cut right in on a scene to show just one of these visual features. Defining the element is completely up to the photographer, of course, and might mean a single hue or a small range of hues; a pattern that appears to cover a large area; or just a few components of the pattern. All of this is a matter of closing in to exclude the other elements.

Flowers and fungi

These are the staples of close-up nature photography; they are relatively easy to find, static, and always beautiful at some degree of magnification.

Photographically, flowers, mushrooms, and toadstools are similar subjects, in that their size and location calls for a similar approach. Individual portraits fall within the range of close-up photography, but being relatively static subjects they are, on the whole, easier than insects. Rather than photograph the first specimen you find, look for others that may be in better condition or in more attractive settings. Most plants that flower do so seasonally, and this varies from species to species, not only in the dates of first flowering, but also in duration. Other than just keeping your eyes open on a trip, it helps to know which blooms to expect in particular months, and there are many

Stinkhorn
Fungi, such as this Stinkhorn mushroom, generally appear suddenly (sometimes overnight) and deteriorate rapidly. The window of opportunity for shooting is small, and they need to be photographed as soon as found.

Pitcher plant
A pitcher plant (*Nepenthes villosa*) growing close to the ground on the slopes of Mt. Kinabalu, Sabah, Malaysia. The bizarre shape with its lid-like covering of a leaf has evolved for trapping insects and dissolving them for sustenance in the liquid at the bottom of the pitcher. Some plants, like these, which grow at an altitude of around 9000 feet (2740m), have a very narrow range of habitat. This concentration makes them fairly easy to find.

wildflower guides that give this information.

Woodland is especially rich in plant life. With so much vertical growth and with a seasonal leaf fall, the soil receives ample nutrients from the decomposed litter. In clearings and around the forest edges where sunlight can penetrate, ground plants are common, and open woodland often has a profusion of flowers in the spring and summer. Even more characteristic of the forest floor are fungi, which feed on decaying organic matter, breaking it down into simpler chemicals that plants can use for nutrients. Some of the largest and most spectacular fungi are woodland species specializing in breaking down lignin from rotting wood. The best time to find fungi is in the fall, when there is most dead organic matter on the ground. In tropical forests, most flowers are at higher levels, and are epiphytic—clinging to stems and branches. The most spectacular of these are the orchids. Their flowering times depend on the species rather than the month as there are no distinct seasons in true rainforests. Use a long-focus lens and tripod for high-level epiphytic plants. In the habitat that contrasts the most with these lush forests—desert—flowers are rare, typically appearing after rains and in the spring, but they are highly visible when they do appear.

Generally, flowers and fungi can be photographed at three different scales: as standard portraits, nearly filling the frame; in extreme close-up, concentrating on details, or as components in a small landscape, shot from a distance. The viewpoint chosen depends on the species, but a low camera position is often useful. Intervening blades of grass and debris can be cleared or bent back out of view. Backgrounds are usually best when simplest, and the farther they are behind the subject, the less sharp and distracting they will appear. A long-focus lens enhances this effect. Small alterations to the camera position can change the background radically.

▽ Iris
One way of simplifying the view of a single flower is to find a specimen that is separated from its background, and use a wide aperture for a shallow depth of field, as in the case of this Yellow Iris (*Iris pseudacorus*) in the rain. Use the LCD screen to preview the effect of different apertures on blurring the background.

▷ Marsh orchid
Wetlands are excellent locations for plant photography, with species such as this European Northern Marsh Orchid. Most flowers grow below the level of sedges and grasses, which easily make a solid green background. In the case of this flower, the color contrast was a welcome element.

Life in miniature

By far the majority of the world's creatures are tiny, and while most escape our attention unless they interfere with our enjoyment, the living macro world is endlessly rich in subjects to photograph.

Small-scale wildlife is everywhere, although largely adept at avoiding large creatures like ourselves, principally through concealment and camouflage, and, when that fails, by speed and agility. Finding insects, spiders, and other invertebrates is often no more complicated than squatting down to ground level and looking with macro-attuned eyes—which is to say, carefully hand focused on small objects. Familiarity with nature on a small scale soon brings a sense of likely places to find creatures—on the undersides of leaves, under stones, in crevices in fallen trees, at the margins of ponds. Each niche has its own inhabitants.

Woodland is especially full of niche habitats. In particular, the heavy forest litter on the ground—leaves, branches, fallen fruit, and dead trees—is a major source of food and shelter, and is, on the whole, the most rewarding place to search. Ants, beetles, and wingless insects make up most of this

◢ Slug
This slug crawling over a bed of rain-soaked moss was in one sense easy to photograph—the color contrast between it and the greenery made an attractive composition, and, because it moved slowly, there was sufficient time to compose the shot at close distance. Its reaction to a close approach, however, was to withdraw its eye-stalks and stay still, and it took several minutes before it felt safe enough to set out once more.

population. For bees, butterflies, and other insects that help in pollination, the heads of nectar-bearing flowers like snapdragon and honeysuckle are good sites to investigate. In temperate climates, the greatest abundance of insects is in high summer, and most are active during the heat of the day. Keeping sufficient depth of field for a sharp image of the entire insect is probably the main technical problem, and the usual answer is to use a portable flash unit.

Occasionally, however, there are situations where you can work by daylight alone. These opportunities are not to be missed as they provide a chance for a variety of naturally lit shots that can make a welcome change from the conventional and predictable character of flash lighting. One such opportunity is very early in the morning, when insects are sluggish and can

be photographed with a slow shutter speed. If the air is still, it is even possible to fit the camera to a tripod and make exposures of around one second. Of course, the very inactivity may be a little dull.

Another opportunity is to create silhouettes of the subject against the sun or its reflections. This can be particularly successful with a spider on its web, or with any insect that is clearly outlined on a leaf or stem. In either case—slow shutter speed or backlighting—the larger the insect, the less magnification is needed and the less of a problem depth of field is. With most insects, you can make the most of whatever depth of field you have by shooting side-on to its body.

For most insects, a thorough search among forest litter, in cool damp places under rocks and wood, on bark, and on the undersides of leaves is as successful a technique as any. Butterflies, however, are not very approachable and baiting may be better, using a "sugar" mixture painted on, say, a tree trunk. This is likely to yield better results in clearings and at the edges of woodland than in dense forest.

Webs

In morning light and into the sun, these strands glistened, making this a good angle from which to shoot. Having taken the photograph under natural conditions, I decided to enhance the strands by spraying them with a fine mist of water.

Rock pools

The small pools left behind by the tide are an outdoor and ready-made version of an aquarium. Anemones and a hermit crab in an abandoned shell are the main inhabitants of this temporary rock pool, a marine microcosm that survives the twice-daily retreat of the tide with just a few inches of water. Using the method shown above, with the sun low in the sky and a dark card used to cut down reflections from the surface, it is a straightforward matter to photograph tidal pools like this.

A new background

The mist spray on the web resembled early morning dew, and helped to define the individual strands. To make this even more definite, a sheet of black cloth was held behind the web, but without blocking the sunlight.

Special flash setups

Active subjects, such as insects and small animals, call for flash, but at close distances the built-in camera flash unit has serious drawbacks.

For most photographs of insects and small animals in the field, flash is essential. To achieve sufficient depth of field for most of the image to be sharp, the lens must nearly always be stopped down close to its smallest aperture. With natural light, even on the brightest day, the shutter speed would then have to be quite slow at a normal (around ISO 100 to 200) sensitivity to prevent camera shake without a tripod, and in any case too slow to freeze the movements of an active subject. And, for the many small creatures that are nocturnal, there is no alternative to flash.

The major problem with built-in flash is that it is positioned on top of the camera body to aim at normal shooting distances, and so creates a parallax-related effect. At close range, the center of the beam is likely to be too high. Not only this, but with a normal lens focal length, the lens housing itself can obstruct the lower edge of the beam and cast a shadow over the insect. One solution with SLR cameras is to use a longer focal length of a macro lens, which reduces both problems. Nevertheless, an ideal lighting setup would avoid this flat, on-axis illumination, and also provide some shadow-fill. If your camera allows synchronization with separate flash units (not all of them do),

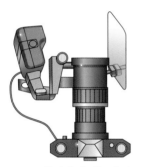

Single flash with reflector

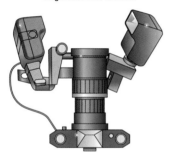

Two flash heads

⬆ SLR flash setup for close-up fieldwork
⬆ Single flash with reflector
This is a basic configuration of a single head aimed at the subject from about 45°, with a small reflecting mirror on the opposite side to fill in the shadows. The lighting is more natural if the head is elevated slightly as well. Keep the flash close to the lens to minimize shadow areas.

Two flash heads
A second, smaller flash unit, aimed from the other side of the lens, is a more effective fill-in than a reflector. Synchronization with a slave cell is safer than a sync junction because it places a smaller load on the camera's sync contact.

▷ Off-camera flash
This cricket was photographed in a Thai forested national park at night. The small flash unit was extended on a bracket, as in the illustrations shown left, and aimed from one side. Although this can enlarge the shadow, it also provides a more normal-looking lighting arrangement.

you'll find that it avoids wasting time and missing opportunities to have a fixed, standard arrangement of flash units.

One of the simplest is shown here, with two variations—single flash with reflector and double flash. The method of attaching the units to the camera is not so important, provided that the units are adjustable and can be locked into position. Provided that your camera can sync with any type of flash unit, small, simple ones have the advantages of being cheap and uncomplicated. Once you have tested the setup, there is no real need for automatic exposure—simply note the aperture setting that works at any given distance, and use that in manual mode. This kind of setup is especially useful at night, when fiddling about with adjustments is inconvenient, to say the least. As maximum depth of field is usually the ideal with this kind of close-up, it is better in most situations to decide first on the aperture and then adjust the flash output or distance.

▶ Macro flash

A macro flash is similar to a ringflash but is simpler in construction, with two lamps on either side of the lens. It casts very slight shadows right and left.

Aperture settings

As a way of calculating the settings, trial and error is fairly painless with a digital camera because of the instant feedback. Nevertheless, if you have a flash meter, use it, making allowance for lens extension. Alternatively, you can use this formula:

$$\frac{\text{Flash to subject distance}}{\text{guide number}} = \text{aperture} \times (\text{magnification} + 1)$$

The result is in feet or meters, depending on which guide number you use. For example, with a guide number of 60 (in feet) and a 50mm lens extended by 75mm (a magnification of 1.5×), then to use an aperture of $f22$ the flash distance will be:

$60 \div (22 \times (1.5 + 1)) = 60 \div (22 \times 2.5) = 1.1$ feet, or 13 inches

◢ Close-ups with ringflash

A ringflash is, as its name suggests, a circular tube, and is designed to fit around the front of the lens to give shadowless, frontal lighting. Although the results can look monotonous if used frequently, it gives extremely consistent results, and is particularly useful in crevices and other cramped spaces. Because the flash is in a fixed position in relation to the lens, the only exposure adjustments possible are aperture setting and power output. At high magnifications, the flash is so close to the subject that a small aperture and great depth of field are possible, but at small magnifications the flash distance is likely to be too great for a satisfactory depth of field.

Indoor sets

The professional nature photographer's way to guarantee images of small creatures is to construct a special captive set that you can then design and light perfectly.

An alternative to photographing insects in the wild is to collect them and photograph them later in controlled conditions, such as in a studio or at home. Use a net to catch flying insects and to sweep vegetation, or hold a cloth tray underneath leaves and branches and beat them with a stick. Take any appropriate vegetation back with you if you intend to reconstruct the creature's habitat realistically.

There are two kinds of enclosed sets for photographing wildlife in the studio: those for terrestrial animals (vivaria) and those for water dwellers (aquaria). They have different requirements of construction and management, and they also demand different photographic techniques. Dry sets can be used for small mammals, such as field mice and voles, a variety of lizards and other reptiles, and some insects. Although the habits of many creatures call for custom-built tanks or containers, a single basic design can be adapted for most.

One method is to build a large vivarium, well stocked with the appropriate vegetation or other suitable material, and wait for the animal to settle into a routine. Then you will just have to wait for the animal to be in the right position for you to photograph it. You will almost inevitably have to shoot from a high position, and this kind of set is really only suited to creatures that will not attempt to climb or jump over the sides.

Vivarium shaped to match the angle of view of the lens.

Shaped vivarium with angled "scoop" and lid.

A flexible collar prevents an animal from escaping.

Adaptable sets
Consider a set design that can be adapted. If you plan the shape to fit the angle of view of the lens you use most frequently, there will be no wasted space and, more importantly, no hidden corners.

Designing a set

Much more control can be achieved by building a set that serves the camera. By angling the side walls toward the camera, a set can be constructed that covers exactly the angle of view of a chosen lens, no less and no more. Barring focusing problems, the animal will always be in the field of view. A simple housing to suit docile subjects can easily be built from plywood, board, or Perspex. Decide on the focal length of lens you will use—for example, a 50mm efl macro—and measure out the field of view on the uncut material that will form the base. This can then be cut to shape, forming the foundation for the remainder of the construction. A slightly more elaborate version has a hinged perspex or glass lid and so can be made escape-proof. In this case,

Soft lighting
One of the simplest and most useful lighting arrangements is a single overhead light source, diffused through a windowlike attachment (a box fronted with translucent plastic or cloth). Shadows are soft and there are no hard, bright highlights. In this photograph of a Leopard gecko, the area of the light is many times the size of the subject, imitating the effect of a hazy sun.

to avoid degrading the image quality by shooting through a glass front panel, a flexible sleeve puts the lens inside the vivarium, yet still provides a good seal. An additional sophistication is a scooped background, so no obviously artificial horizon line will appear in the shot.

Studio photography allows a great deal of control, including the opportunity to arrange the setting for the subjects and even to design the whole picture. One approach is to imitate the natural habitat as closely as possible, but this is by no means the only one. How you choose to present an animal is only partly influenced by its behavior; the rest is up to the photographer. There may be one particular aspect that you want to highlight, such as the way a gecko grips a vertical surface. You may decide to treat this in a detached, scientific way, or treat the photograph as a studio portrait, with no pretensions to naturalism. Natural backgrounds are the most demanding, simply because they need to appear accurate. A good knowledge of the real habitat is essential. If in any doubt, carefully examine photographs of similar environments. Once you have assembled the correct vegetation, rocks, and other elements, start laying out the set, but avoid "over-designing." Being too neat is tempting, but the result will look artificial. Deliberate untidiness will help to give more naturalism to the picture.

Simple settings
When you simply need a clear, straightforward portrait, look for an uncomplicated yet relevant and natural background. This leaf, sloping diagonally down, is both an unobtrusive setting for this tiny arrow-poison frog, and demonstrates the creature's size.

Wet sets

Aquatic creatures occupy a three-dimensional world with great possibilities for interesting pictures, and an aquarium designed for photography makes this manageable.

Aquaria pose a special set of problems for the photographer, but they have one distinct advantage—they offer a great range of camera viewpoints. Remember at the outset, however, that conditions such as temperature, chemical composition of the water, and oxygen content are generally critical, and monitoring is often even more important than with dry sets.

Marking the field of view
Mark the field of view so that you can predict when a fish will be in frame while guiding it, without having to look through the viewfinder. With the camera in position, check the limits of view on the front and back sheets of glass, marking them with tape.

Shrimps in oil
This shot was meant to recreate shrimps in seawater polluted with oil leaked by a tanker. It is taken using a sample of water with organisms from a regular collection by a research college in Maine which studies the effect of oil pollution. The set construction is backlit.

Converting aquaria for photography

Commercial aquarium supplies are usually the most convenient starting point. It is nearly always easier to adapt an existing tank for photography than to build one from scratch. Even in a fairly small tank, the water pressure near the base is high, and it can be surprisingly difficult to make an efficient seal. Water and electricity are dangerous companions, so electrical cables and components must be well insulated. It is also a good idea to raise cables off the floor, where spilled water will collect. Most aquarium photographs are inevitably taken through glass, so check that the sides of the tank are free from defects. For the very best optical conditions, it may be worth replacing the front sheet with plate glass. To do this yourself, you will need fresh rubber sealant for the new glass. Once fixed, fill the tank immediately with water so that the pressure will make the seal watertight.

Not all water-dwelling creatures need aeration; many small freshwater fish, for example, can live happily without it—so it can be turned off temporarily. In some cases, however, a few bubbles can improve the sense of movement in a picture. The most useful aeration system is a simple modular one, with a small pump, plastic tubing,

adjustable valves, and a variety of bubble-generating heads. With a system like this, the rate and size of the bubbles can be adjusted to taste. Some species, particularly marine ones, need running water, for which a water pump will be necessary. Seaweed makes a good background for marine photographs, and this also needs flowing water to survive. If you collect water from a natural supply, which is safer than using domestic water, which is usually chlorinated, run it through a filter first to remove particles.

Controlling movement

The problem of focus and depth of field are even greater when working with wet sets than with dry sets. Fish in particular have three dimensions in which to move about, and controlling their position in some way is usually necessary. Although it is possible with flash illumination to hold the camera by hand so as to follow movements, it can be frustratingly difficult. A more considered approach is first to fix the camera's viewpoint and then to encourage the subject to move into position.

Arrange the camera position so that the background and reflections are under control. Look carefully to see if the back edges of the tank are visible with the aperture stopped down. Focus on a prearranged position for the fish, and then mark off the field of view on the tank front with a grease pencil or adhesive tape. You can then shoot without looking through the viewfinder, freeing you to control events inside the aquarium. To confine the fish to the plane that you have already focused on, hang a sheet of glass inside the tank, close to the front. The fish now has little choice of moving out of focus, and whenever it swims into the area that you have marked off, you can shoot. If you need even greater control, you can block off the whole of the area surrounding the field of view with a Perspex/Plexiglass insert. With this method, which virtually creates a small tank within the aquarium, the fish is compelled to stay inside the picture frame. Be careful, however, that this extreme confinement does not place the fish under noticeable stress, which will in any case make its movements unduly agitated. Small aquatic creatures need much closer control. Depth of field at a macroscopic level is very limited, and a normal aquarium is not very satisfactory. A simple miniature tank can be made with no more than two small sheets of glass, a short length of flexible plastic tubing, and clamps. The two sheets are held together with a U-shaped curve of tubing sandwiched between them. The tubing forms the seal, and its diameter determines the thickness of the tank.

Message in a bottle

A magazine cover called for a well-lit bottle on the sea-bed, which meant introducing fish and enough particles to look realistic. White sand was poured into an aquarium, which was then lit by a diffuse overhead studio flash.

Background

In most situations, the background of the aquarium will be out of focus, even when the lens is stopped down to its minimum aperture. Nevertheless, care should be taken to make it appear right. For some subjects, you may choose a clinical, uncluttered setting so as not to interfere with the detailed appearance of the subject. In this case, a plain white background may be best. This can be created with the backlighting arrangement described above. Otherwise, you can provide a black or colored setting either by hanging a velvet sheet behind the rear glass or, if there is a danger of reflections, by putting a sheet of black or colored plastic inside the tank. For a natural-looking background, the habitat of the creature you are photographing will be the deciding factor. Water vegetation is a good, safe choice, but a blurred painted sheet of appropriate colors, such as green and brown, or blue and black, may be all that is necessary to give the right impression of depth.

Shells

Shells display some of the most elegant forms in nature, and are rewarding subjects to explore in a close-up setting, as pure objects rather than as part of the marine ecology.

When photographing shells, the most important element is lighting. As a general principle, one single main light source, partly diffused, gives good, uncomplicated modeling. Two lights aimed from different directions will, if positioned carelessly, cast conflicting shadows. Not only is this ugly, but it confuses the detail in the shell. With a single light, the shadows can be filled in slightly by using a piece of white card stock or silvered reflector. A hand mirror gives the strongest fill-in. Crumpled aluminum foil glued to a card is a simple device for selective shadow-fill. Shells with shiny surfaces need particular care, as they inevitably reflect the light source. Consider adding an extra sheet of flexible diffusing material and curving it over the shell.

Anything other than a featureless background is usually a distraction with shells. Plain black or plain white backdrops are obvious choices, depending on whether you want to emphasize the outline of the shell or the surface detail. Contrasting backgrounds are good for shape, while similar-toned backgrounds concentrate attention on texture and pattern.

It's usually easiest to photograph shells vertically downward, with the shell resting on a flat surface, light to one side angled downward, and camera directly overhead. The choice of angle will often depend on the key features of the specimen. Gastropods, for example, are usually positioned to display the aperture. With a black background, you can either lay the shell directly on the velvet or raise the specimen a few inches on a vertical rod and adjust the light so that very little illumination spills onto the velvet (support the shell on modeling clay or putty). Take care that the camera is pointing absolutely vertically downward so that the support remains hidden.

If you are shooting against a light background, a plain white surface, such as white card velvet, can be used, but the shadows underneath are likely to be deep. Making a cut-out at the image-editing stage (using Paths) may improve the image, and you could add a digital drop shadow for realism. However, it may be less trouble to backlight the surface on which the shell

Black and white points

This mass of shells contains a wide variety of tone and color. As photographed (top right), the image seemed perfectly acceptable, but, as the color-corrected version (main image) illustrates, a more vibrant result was possible. In a standard technique of image editing, using Levels, the white point was set to the highlight of one cowrie shell, while the black point was set to the shadowed area indicated.

rests. This is also very effective with thin shells to show internal features, and with sliced sections of a shell to display the geometry of spiral partitions. The light should be well diffused for an even white background. An alternative background arrangement is a glass shot, where the fossil is laid on a horizontal glass sheet, which itself is raised above a white or colored piece of card stock. With careful positioning, the background card can then be lit separately, and no shadows are cast. Here, the effect makes it look as if the shell is floating. The main light must not be so close to the camera position that it is reflected in the glass.

There are also techniques for removing reflections, but use these with discretion as they can radically alter the shell's appearance. Dulling spray is a crude method that leaves a sticky film that is clearly visible in a high-resolution photograph. If you use polarizing filters and sheets be aware that light transmission will be reduced by nearly two stops.

The color of some shells can be intensified by wetting. One complex variation is to submerge them completely. The lighting must then be positioned very carefully to avoid reflections from the water's surface.

Cone shell
To reduce reflections in the shiny surface, crossed polarizers were used. A sheet of polarizing material was placed in front of the light, and a polarizing filter over the lens. One occasional danger with polarizers crossed in this way is a slight violet cast in the reflected highlight, but this can be removed during the image editing stage.

Golden cowrie
This golden cowrie was photographed against black Perspex/Plexiglass to enhance its color. However, the setting's reflective surface posed a problem. Using a main light overhead, the base of the shell was too dark (top left), while adding a mirror reflector (above left) also introduced an unacceptable highlight. The solution was to combine the two versions as layers, partly erasing the lower part of the darker image (above right) to allow the lighter version to show through (right).

Minerals

The properties of geological specimens vary greatly, and each needs to be treated on its own merits, with the lighting adjusted to show off its essential and unique qualities.

Just as plants and animals can be collected and brought into the controlled conditions of studio lighting for a different, more analytical kind of photography, so can rocks and minerals. Minerals are basic constituents of the Earth's crust, each with a precise chemical composition, while rocks are accumulations of minerals, with much greater variety of form and appearance. Try to choose good specimens of their type—crystals of feldspar, for example, are often found twinned (that is, interlocked), and it is worth hunting for an example where this property is clearly visible. The same general lighting conditions apply to minerals and rocks as to shells and fossils, and many of the same techniques can be used.

When minerals are allowed to solidify out of solution freely, they form crystals, with characteristic shapes and flat faces. Understandable, perfectly formed crystals are rare, and most minerals grow as aggregates of crystals, where the individual crystal shape is submerged in the form of a larger mass. These forms are also characteristic and enable the mineral to be identified. Mica, for example, frequently occurs in flat, flaky sheets; hematite is often found in gently rounded shapes known as a mammilated form; and native copper is commonly found in a dendritic form, branched like a fern. The way in which individual minerals break is another property. When the break is irregular, it is called a fracture; some minerals fracture very distinctively, such as the curved surface of obsidian. Other minerals more frequently exhibit cleavage; this is a break that is closely related to the structure, usually close to where a crystal face would have been formed.

The optical properties of minerals can include transparency, color, and luster. Of these, luster is usually the most challenging problem for photography, as it is

Simple setup for specimens

This is an uncomplicated setup for small cut specimens that can be moved around easily.

When arranging the lighting, there are four considerations:

1 Intensity. This should be sufficient to allow a small aperture for depth of field.
2 Direction. Conventionally, the main light is normally aimed from the top left or top of the picture. Other lights can be added for fill.
3 Diffusion. Less diffusion reveals fine textural detail; more diffusion is better for overall shape and for tone.
4 Reflection. Use white card stock, silver foil, or mirrors on the opposite side from the main light to fill shadows.

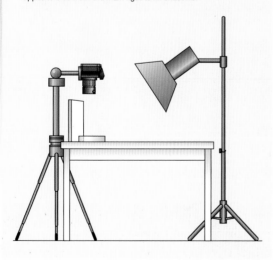

essentially a subtle quality—the way in which a mineral's surface reflects light. Descriptions such as metallic, resinous, greasy, silky, or pearly luster are quite easy to understand and also easy to see when a specimen is turned in the hand to vary the play of light across it. In a still photograph, however, to make such refined differences obvious you will have to experiment with different lighting positions and diffusion. Knowing the essential properties of a particular specimen will help you to decide on the style of lighting. If a mineral has an interesting luster, for example, such as the greasy or waxy look of chalcedony, then a well diffused light will reveal this most clearly. On the other hand, the same lighting would do nothing to display the compact, powdery texture of loess, a clay deposited by wind, which would appear better with a hard, direct light. A low-angled light reveals surface interpretation most clearly, but if the texture is unimportant in a specimen, try more frontal illumination.

Crystals are probably the most difficult of all minerals to photograph, because of the interplay of reflections from the various faces—and refractions if the crystal is transparent. We deal with these under gemstones on the following pages.

Form and structure
This is an amethyst block. Here I was interested in showing its form, and the interpenetration of the individual crystals, and chose monochrome to avoid the distraction from the strong color. The lighting, partly diffuse, is overhead and just behind, to catch reflections in some surfaces and refractions through others.

Thin and colorful
Translucent minerals present another opportunity for photography—by cutting a thin section and back-lighting it, as with this yellow onyx. Back-lighting can often bring out greater color saturation, and this can be adjusted later during color correction.

Scanning cut sections
A common way of presenting rock specimens is in cut sections, such as this small slab of ruin marble (so-called because of its supposed resemblance to a painting of ruined walls and columns). If the texture is important, then the lighting can be directional, but here, where the section has been polished to heighten tonal contrast, even illumination is called for. One alternative is to light diffusely, but if the specimen has been cut along a perfect plane, as here, a desktop flatbed scanner may be simpler. Make a low-resolution test first, and check for unwanted reflections and specular highlights.

Gemstones

By their nature, gemstones are defined by and valued for their appearance, and this makes them among the most challenging and rewarding of all possible close-up subjects.

The majority of gems are hard, transparent stones (such as diamonds, topaz, zircon, emerald, and so on), and so typically combine two important qualities for photography—reflection and refraction. In their natural state, many are rough or rounded, and quite unlike their final presentation in jewelry, but cutting and faceting, an essential part of the business, enhances both of these visual qualities. Reflection, from the different faces of the crystals, helps to define the outer surface. Refraction not only reveals inner details, but gives the essential sparkle. Capturing both in a photograph requires very careful positioning, the gem in relation to the camera, and the light in relation to both. The ideal is to display as many of the faces as possible and to keep the general appearance simple. The best way of achieving this is to vary the illumination on each face. As a starting procedure, look for a viewpoint that shows several faces and adjust the lighting so that each reflects slightly differently. Try to catch the reflections of a large diffused light source in at least two major planes, then use reflectors of different strengths, such as foil and white card stock, carefully placed around the gem to give different intensities of reflection in each plane.

Not all gems are faceted, and this largely reflects fashion and the tastes of different cultures, as well as the decorative possibilities of certain gems.

Surface texture
This pearl (the specimen is actually the largest known gem-quality pearl) needed soft lighting for its highly reflective surface, but not so even that the curved form and characteristic sheen were lost. A square softbox was chosen as the solution, fitted to a flash head and suspended overhead, with two pieces of white card stock on either side as reflectors. Flash was essential to freeze the movement of the model's hand.

Emerald
This is the 17th Century Indian emperor Shah Jahan's "Taj Mahal" Emerald from the collection of the Sackler Gallery in Washington DC. Engraving was a popular technique of the period, and the lighting had to show both this (through angling the light to reflect in the surface of the stone) and the stone's color (by placing a piece of aluminum foil cut exactly to shape under the emerald).

In Southeast Asia, for example, where rubies and sapphires are important gemstones, the taste is for rounded cabochons. The term "gems" also embraces objects other than hard stones, most notably pearls, which are a natural accretion found inside an oyster, deposited in layers around foreign matter such as grit as a protection by the animal. Pearls have their own special visual qualities, in particular a nacreous luster and play of color, created by the outer translucent layers and slight interference patterns.

Odd-shaped diamonds

For this group shot of unusually shaped diamonds, a single, well-diffused light was used. A black background was chosen to enhance the refraction by contrast. The area light provided one bright tone for reflection, while a medium tone for other crystal faces came from a white card reflector. The light also displayed refraction. The key to success in a shot like this is the precise angle at which the stones sit. Modeling clay cannot be used to prop up transparent stones, as it would show, and the answer in this case was to use small diamond chips, which are unnoticeable amid the play of light and color. The arrangement is inevitably painstaking.

Jade

High-quality Imperial jade rivals emerald in its gemlike qualities. For this shot, I was interested in contrasting the polished cabochon with the raw boulder from which it is cut. These river-washed stones acquire a brown skin, and for trading purposes a grindstone is used to cut a "window" to give some clue as to the quality of jade inside.

Jade backlit

Another way of showing gem-quality jade was to backlight it for maximum color intensity. To add interest to the composition, the slot from which this stone carved piece was cut was included.

Sapphire

A 202-karat star sapphire from the famous mines at Mogok. The star effect is only obvious under a pinpoint light.

The Language of **Color**

Particularly in this chapter—and I hope it won't be tedious—I'll be drawing on the experience of painters rather than just photographers. There are two good reasons for this. One is that the history of thinking about color has largely been in painting, and seldom in photography until recently. By contrast, the body of work and discussion in monochrome imagery—black and white—has been very strongly placed in photography, and this is the focus of a later chapter in this book, *The Language of Mono* (see page 508). The other reason is that digital photography has opened many doors in the imaging process and, with a new wealth of digital tools with which to choose and control colors in photographs, it is now legitimate and valuable to look at how the construction of color has been thought and argued about over the centuries. Digital photographers can now enter this world and, while this might sound grandiose, it's an opportunity that does exist and yet is only just beginning to be exploited.

In other words, what might once have been of mainly academic interest, as a foundation preparation for art appreciation, is now highly practical. Two developments in digital photography will serve to illustrate the new ways of thinking about color that have already easily entered photography: the color circle and Red, Green, and Blue (RGB). The color circle as a way of displaying pure hues has a long history, going back in a meaningful sense to Isaac Newton, yet how many photographers ever considered it? Now, along with color-space models, it is familiar to anyone who has used Photoshop. It even

makes an appearance in most digital cameras—when you adjust the hue, as in fine-tuning the white balance, the units are in degrees, which is to say the 360 degrees of the color circle. RGB is even more well-known, a well-integrated acronym that implies a general understanding of how color photographs are—for want of a better word—engineered from three primaries. In the days of film, knowing that color film worked on the same principle, with a tripack construction, was of little practical use. You couldn't take it apart and alter the three layers. Now, of course, you can.

Once all this knowledge has been established, it still pays to revisit the color spectrum through the eyes of the photographer. Later in this chapter we'll see not only the theories, both past and present, that tie all colors together, but look at the individual colors themselves. The visual power of red, the brilliance of yellow, or the coolness of blue all present different factors for consideration. Part of the equation here is the learned, psychological responses to colors, both overt and hidden. Green, for example, tends to have positive connotations—spring-like lush vegetation, growth, and even "go" signs—while red can be a warning color. The better you understand the symbolism, the better you'll be able to take advantage of it in your work. In turn, your photographs will be more pleasing to the eye and you'll be better able to decide how to approach the next step of the modern workflow, digital manipulation, which we'll explore in greater depth throughout the book.

Color theory, color practice

Our response to colors is complex, involving reactions at an emotional, subjective level to the physical facts of light at different wavelengths.

Used well, color can be by far the most powerful element in a photograph. If it strikes a sympathetic chord in the viewer, it can be the very essence of the image. In this, it differs from other graphic elements. The arrangement of lines, for instance, may create a sensation of movement or stability, but color invokes responses at different levels, including some that are not always possible to describe accurately. Nevertheless, the difficulty of finding an exact terminology does not lessen the importance of what Gauguin called the "inner force" of color. It is often more appropriate to say that we experience, rather than simply see, a color.

The physicist James Clark Maxwell, in 1872, determined that the human eye distinguishes color by responding to three different stimuli, the so-called tristimulus response that is very closely related to the way in which digital cameras and computer monitors work. He wrote: "We are capable of feeling three different color sensations. Light of different kinds excites these sensations in different proportions, and it is by the different combinations of these three primary sensations that all the varieties of visible color are produced." In fact, the three stimuli are three different pigments in the cones of the retina—erythrolabe, chlorolabe, and rhodopsin—which are sensitive to red, green, and blue.

This discovery had major implications, not only for the recording and display of color—digital sensors, film, and computer monitors work using much the same principle as the eye—but on the fundamental idea that all colors can be created by mixing three. Painters had already come to that conclusion, though with different hues, and all this lent a special force to the concept of basic colors, the ones that can be used as building blocks to make others. Here is a case where physical fact transforms into color esthetics, and for much of this chapter we'll look at color through its basic perceptual hues. The starting point is the palette of pure colors.

Most of the theory of color esthetics has been developed with painters in mind, and for the most part has only vaguely been applied to photography. I shall attempt to redress this balance a little in the following pages. The usefulness of studying color theory for a photographer is that it will refine

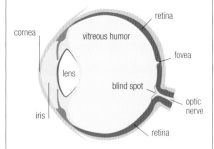

The eye and perception
The lens focuses an image, with the iris helping to control the amount of light entering, as in a camera lens. The retina contains a mixture of rods and cones, one sensitive to low light but monochrome, the other needing more light but sensitive to color. The fovea has the highest concentration for high resolution.

Combined sensitivity

Adding the three kinds of cone together gives spectral vision that is clearly weighted toward green, but the addition of the rod sensitivity gives an even spread.

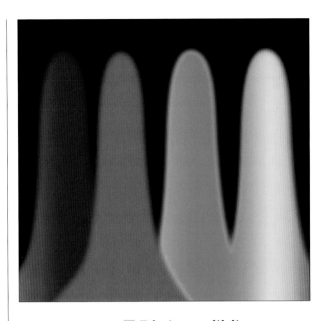

Tricolor sensitivity

Like a sensor, there are three types of cone, each sensitive to a different wavelength. Note that the red-sensitive cones actually peak in yellow. Scotopic, monochrome vision, peaks in between blue and green. These charts show the wavelength response of the green-sensitive cones, blue-sensitive cones, red-sensitive cones, and scotopic vision (rods).

your discrimination and judgment. It is too easy to evaluate colors and color relationships on the simple, subjective grounds of "like" or "don't like." Certainly, most people do judge color in this way, but this is analogous to enjoying music without having any musical training; while the lack does not inhibit the pleasure of listening, a study of music will definitely enhance it. Moreover, if as a photographer you want to become skilled in creating powerful color effects, the theory will give you the means. Although color provokes a subjective response in a viewer, it does obey definite laws; as we will see in a few pages, when we consider relationships between colors, the principle of harmony is not only a matter of whether an effect seems pleasing, but also depends on the actual, physical relationships and can be measured.

The multi-level sensation of color

Our ultimate response to color depends on a mixture of the physical, physiological, and psychological components. Color is wavelength and measurable scientifically. It is then processed by the eye-brain combination, beginning with the retina. Finally, the brain relates this stimulus to its own experience, which can involve associations as varied as emotion, preference, and symbolism.

Color models

An essential first step in describing and dealing with color is to measure it in a standard way, and there are several of these methods, each with its particular uses and each using three parameters.

This is part of a terminology that has sprung up with digital imaging, but in fact color models evolved centuries ago. The first color diagram known is from the 15th century, but it was a scale of the different colors of urine for medical use. The scientific analysis of color and the creation of graphic models to represent it began in earnest after the publication of Isaac Newton's *Opticks* in 1702. His key discovery was that light contains a sequence of wavelengths that each have a specific color, but this has overshadowed two other important contributions. One was to arrange colors

Newton's circle
The spectral colors identified by Newton are those of the rainbow and are commonly described by seven names: red, orange, yellow, green, blue, indigo, and violet. All of these can be laid out in a continuous progressive sequence, but if this sequence is arranged as a circle, as Newton did, the relationships between all the hues become clearer. The circle is also a great help in understanding the reasons for color harmony and balance. It is the basic tool of color theory. Newton described the colors in his book, rather than showing them, and they have been interpreted here. With seven identified hues, it is, of course, asymmetrical.

The spectral circle
The color spectrum is in fact continuous, one hue blending into the next. Here it is arranged as a circle and rotated so that red (0° in the usual notation of hues) is at the top.

The color triangle of Delacroix
The French painter Delacroix constructed a triangle with arcs of primary colors at each apex, connected by the secondaries.

in a circle to show their relationships with each other, and that which followed from it: the notion of complementary colors, opposite each other on the circle, which mix to create a neutral.

The earliest color models were circles, though other shapes were used, such as the triangle and linear scales. For considering hues these two-dimensional diagrams are adequate, but as the full range of color needs three parameters, the more complete color models are now usually represented as 3D solids. As we will see in the next several pages, the most widely used and accepted set of parameters for defining color are hue, saturation, and brightness.

Considering just the color circle and hue—the essence of color—there is a conflict between those models based on reflected light and those based on transmitted light. We will keep returning to this issue, because it causes

Blanc's color star
A color star by Charles Blanc, in 1867, uses conventional primary and secondary colors, but the tertiaries have more than usually exotic names.

The Munsell circle
The American painter Albert Munsell published in 1905 his color model that was to become the standard for colorimetry, and is used to this day (GretagMacbeth charts use his system). It is based on five principal colors—red, yellow, green, blue, and purple—and five intermediates, all finally sub-divided into 100. This circle was the basis of the more valuable solid.

Ostwald's circle
The German chemist Wilhelm Ostwald in 1916 produced a 24-part circle based on the four perceptual primaries: red, yellow, blue and green. Edward Hering had argued, like Mondrian, that green was perceptually basic.

Field's linear scale
In 1835, George Field, color-theorist and friend of the painter John Constable, produced this linear diagram of primaries, secondaries, and tertiaries, beginning with red, yellow, and blue. The triangles are divided into light and dark modulation.

problems with identifying primary colors and complementary relationships. When Newton began the debate with his splitting of the prism and his color circle, he was showing spectral colors, while most other color theorists worked, quite reasonably enough, with pigments that are seen by reflected light. In digital photography we use both systems—transmitted light for viewing on the monitor and reflected light for prints—so we cannot escape the conflict. This is examined in more detail on the following pages but, basically, not only are the hues somewhat different between the two systems, but they are viewed in completely different circumstances so that there is no common ground for comparing them. The spectral color circle of Newton

The Munsell tree

In Munsell's 3D solid, chroma runs around the circumference, with a scale of desaturation inward toward the center, and a polar axis from black to white. But because maximum saturation (chroma) is reached at different levels of brightness by different hues, the final shape is asymmetrical and so often represented, as here, as a tree. Here, Munsell's steps have been replaced by continuous tone.

Itten's color star

Seeking to represent the light-and-dark modulation of his color circle, Itten devised this star-like projection of a sphere onto a flat surface. Pure hues are in the middle zone.

Itten's circle and triangle

The color circle of Johannes Itten at the Bauhaus also begins with red, yellow, and blue. With the secondaries and tertiaries this divides into 12 parts. The color triangle is derived from this, although the tertiaries are necessarily different.

printed here is only an approximation, as it is impossible to reproduce accurately on paper with printing inks.

As color models developed, they took into account the ways in which colors are modulated to be brighter or darker, and to be more or less saturated. Painters could achieve all of this modulation with black and white pigments (or with complementaries), which is why it took some time to arrive at a full understanding of the three axes of color—hue, saturation, and brightness. Reproducing these made a three-dimensional solid necessary, and the first was that created by Albert Munsell.

Primary colors
Red, green, and blue are the primary colors of the digital age, while red, yellow, and blue mix to form most other shades for the painter.

L*a*b*

CIE Lab (strictly speaking, L*a*b*), was developed in 1976 by the Commission Internationale d'Eclairage, designed to match human perception as closely as possible. It uses hue, saturation, and brightness along three axes, and digitally these are three separate channels, which can be accessed in Photoshop. Significantly, it is a very large color space, and so is a useful theoretical model that can contain most other models. One axis/channel is L* representing luminance (that is, brightness), a second is a* for a red-green scale, and the third b* for a blue-yellow scale. The principle is that red cannot contain green (nor vice versa) and blue cannot contain yellow (nor vice versa). Shown here are a circular cross-section and a cross-section through the 3D solid. This latter cross-section represents the spectral color gamut with a characteristically asymmetrical shape due to the human eye's extended sensitivity toward green. We will see this shape later when we look at color spaces and gamuts.

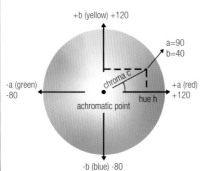

Saturation

Pure hues are fully saturated, meaning that they are at full intensity, while most of the colors that we meet in life are a lower percentage than this, all the way down to a completely desaturated gray.

Hue, as we just saw, is the first parameter of color according to the way we perceive it. The others are saturation and brightness, and both are modulations of hue. Saturation, also known as chroma, is a variation in the purity of a color, its intensity or richness. At one end of the scale are the pure, intense colors of the color circle. As they become less saturated, they become more gray, "muddier," "dirtier," and less "colorful." In the physical world, rather than the digital photographic one, pigments, dyes, and paints become

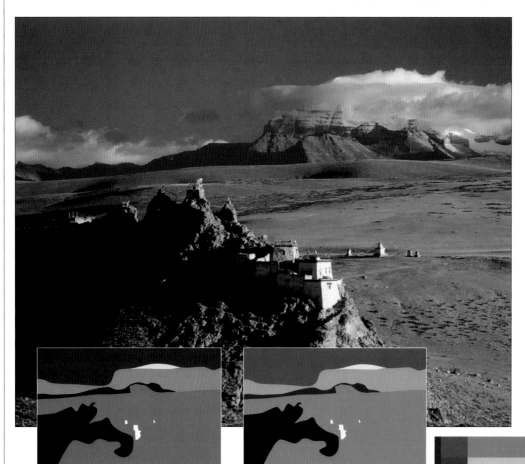

Nature's less-than-saturated colors

Fully saturated colors are rare in nature, and tend to be very localized, as in flowers and the pigmentation of some animals. Even what we might react to as a strong blue sky is, in reality, quite adulterated. The scene here, from an altitude of 16,500 feet (5,000 meters) in the Tibetan Himalayas, illustrates the point. The clarity of the atmosphere and the altitude intensify the colors, and they look strong without comparison. But seen in a schematic way as blocks of colors, and compared with fully saturated hues, the reality is more moderate.

unsaturated when they are mixed with white, black, gray or their opposite colors on the color circle, which are known as complementaries. The primary hues that we saw on the previous pages, and most colors that we describe without qualification (such as "blue" rather than "cobalt blue") are fully saturated, and any variations are in one direction only—toward gray. In nature, particularly on the grander scale of landscapes or panoramas, most colors are unsaturated.

Most photographic subjects are things that the photographer has discovered, rather than built themselves, so adulterated or broken colors are the staple palette. In nature, grays, browns, and dull greens predominate, and it is for this reason that the occasional pure color is often prized and made the feature of a color photograph when found. Rich colors are therefore more often seen as desirable by the majority of photographers than are pastel shades. There is no judgment intended here—rich combinations and pale combinations can make equally powerful images—but it goes some way to explaining the attraction of intense colors. If they were a more dominant component of the landscape, more photographers would perhaps be drawn toward the subtler shades.

Brightness
As these two cross-sections of an HBS (HVC) solid show, different hues show maximum saturation at different levels of brightness. Thus, yellow is most saturated when brighter than, say, purple.

Hue
Hue, brightness (value), and saturation (chroma) each occupy an axis perpendicular to the others, to give a 3D model. It is easy to see from this why Hue is measured as an angle from 0° to 360°.

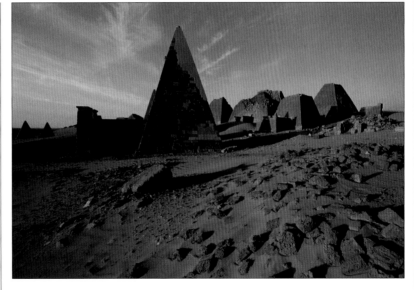

Saturation
On this image, of ancient pyramids in Sudan, a range of saturation has been applied from left (completely desaturated) to right (double the normal saturation). Choosing the appropriate level is not as easy as it might at first seem.

The color of light

The first part of the color equation is the wavelength of the light source—be it the sun, camera flash unit, or tungsten lamp—and it varies the whole breadth of the spectrum.

Low sunlight

Evening sun, filtering through a window in the Shaker village of Hancock, lights these boxes of herbs with a warm glow rich in reddish shadows. Indeed, color and shadows make the main contribution to the image.

Optimized

As an experiment, optimizing this so that the paper is neutral and mid-toned shows how different, and less interesting, it would look were it not for the color of the light.

The phenomenon of color is an interaction between light and surfaces. This is true of anything visible. Light of a certain color falls on an object that itself has a particular color. What is reflected (or, in the case of something transparent, transmitted) to our eyes is a combination of the two. For digital photography in particular, this is not just an academic distinction.

Color exists and functions at different levels, as already described, but it is at its most measurable and objective as a wavelength of light. And light fits in to very small part of the electromagnetic spectrum, which includes X-rays, infrared, radio waves, and other wavelengths, some of which are in one way or another important for us. This spectrum is continuous, between short and long, and the only thing that sets light apart from the rest is that we can see it. In other words, we make up our own definition for it. As Sir Isaac Newton determined in 1666 when he analyzed the visible spectrum with a prism, our eyes identify each wavelength in the narrow band between about 400 and 700 nanometers (nm) or millimicrons (10^{-9} meter or 1/1,000,000mm) with a particular color for which we have a name. Traditionally (but it is only tradition), there are seven distinguishable colors in this spectrum, which in nature occurs most recognizably in a rainbow—violet, indigo, blue, green, yellow, orange, red. Nowadays it is more usual to divide the spectrum into six named segments, omitting indigo. Seen all together they appear as white, which is exactly the light we live by most of the time from the sun when it is well above the horizon. There's no mystery in this. Our eyes evolved under sunlight and our brains treat it as normal—basic, colorless lighting. And, as you already know from using the white balance menu in a digital camera, this is a practical, not a theoretical, matter.

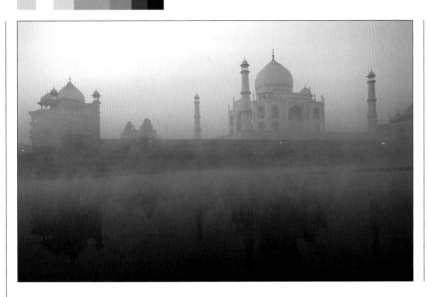



The shortest wavelength that most people can see is violet, and the longest is red, and the fact that deep violet and far red appear to our eyes as very similar makes it possible to arrange all these colors conveniently in a circle, but it's worth remembering this is just a construct. Violet at 380-450nm and red at 630-780nm don't actually meet; they continue in opposite directions into ultra-violet and infra-red. Interestingly, unlike our other sense organs, our eyes cannot discriminate between the wavelengths—colors—in a mixture. We simply see a mix of wavelengths as one color. When all the wavelengths are present we see them as white, while a sunset mix from, say, 570nm to 620nm we see as "orange-red."

Taj Mahal
Before sunrise, mist over the Yamuna River catches mainly blue from the cloudless sky and magenta from just below the horizon in the direction of the sun. In the soft illumination at this time of day, the scene is suffused with a distinct color combination.

Colors in the electromagnetic spectrum

The electromagnetic spectrum is infinite, but even the "useful" range for us, from X-rays and gamma rays to long-wave radio, is many times larger than the visible spectrum, from about 400nm to about 700nm.

Violet	**380–450nm**
Blue	**450–490nm**
Green	**490–560nm**
Yellow	**560–590nm**
Orange	**590–630nm**
Red	**630–780nm**

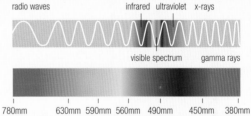

radio waves　　　　　　　　　　infrared　ultraviolet　x-rays

visible spectrum　　　　gamma rays

780mm　　　630mm 590mm 560mm 490mm　　450mm　　380mm

red sensitivity p cones

relative sensitivity — 100 / 50 / 0

wavelength (in nanometers) — 400 500 600 700

scotopic vision rods

relative sensitivity — 100 / 50 / 0

wavelength (in nanometers) — 400 500 600 700

The eye and color
The human eye is more or less sensitive to different wavelengths, and as you might expect is most sensitive to those in the middle, around yellow-green. For this reason, yellow is for us always a bright color, while violet is always dark—explored in detail on the following pages. There is also a difference in the eye's spectral sensitivity between dark and light. We see color through the cones in the retina—the eye's photopic system—but at low light levels the color-insensitive rods take over—the scotopic system. As the diagrams here show, the two systems peak at different wavelengths.

The color of objects

The second element in the equation of color is the surface struck by the light. According to its composition, it can reflect, transmit, and absorb the light selectively, and this makes an object "colored."

Leaves are green, Caucasian flesh is pinkish, a marigold is orange, and we know these are intrinsic properties of the things themselves. This is common sense, but has implications that are easily overlooked in digital photography when color is being adjusted. The final color that we see, and that the camera records, depends not only on the light source but also on the surface it strikes. Because the menu settings on digital cameras place so much emphasis on measuring the color of light and adjusting the sensor's response to it through the white balance, it's easy to overlook the contribution of the objects in the scene.

The composition of a surface determines among other things how much light it reflects, transmits, and absorbs. A coat of glossy white paint reflects a high proportion of the light, transmits none (it is opaque), and absorbs very little. Most of the light, therefore, is reflected right back. A piece of black cotton velvet, by contrast, reflects hardly any light, transmits none, and absorbs most of it. This seems blindingly obvious because of the way we describe objects and surfaces. However, with the exception of white, black, and gray objects, every other surface reacts to light selectively, meaning that

▲ **Red glass**
Colored glass has a long history in decoration, from stained-glass windows in European churches to this finial on the roof of the Lake Palace, in Udaipur, India.

Refraction and color

Refractive Index (RI) is the ratio between the speed of light in a vacuum (such as the sun's light reaching Earth), and the slower speed in a transparent substance (air, glass, or water, for example). The higher the RI, the more the light is slowed down, and if the light strikes the surface at an angle, it changes direction—the basis of lens optics. From the point of view of color, RI is important because it is different for different wavelengths. It is lower for long wavelengths like red, and higher for short ones. Prisms and raindrops, for example, break up the spectrum because of this.

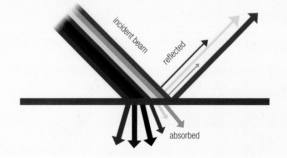

it favors some wavelengths—colors—more than others. Reflection and absorption work together inversely. Most fresh leaves are green because they absorb so much red. A daffodil appears yellow because its petals absorb blue.

Transparent materials transmit more light than they reflect or absorb, and when they do this selectively (like the acetate in 3D glasses) they appear colored. Moreover, the effect builds up with depth—normal glass absorbs a little red, so thick slabs take on a greenish tinge, while water absorbs first red, then yellow, and continues until, far below the surface, the color is simply blue—an effect well-known to underwater photographers, who need flash to restore the lost colors. Seawater cupped in your hand seems colorless but 30 clear feet (10 meters) of it over white sand, seen from above, appears a strong blue.

Metamerism

Certain colors that appear to match under one type of lighting look different under another type. This happens quite strongly between daylight and tungsten, and between daylight and some fluorescent light.

Colored objects, colored light

The equation is more complicated when the light source is colored. In orange early-morning light, leaves that are normally green appear quite dark because their red absorption is working on a higher proportion of the total light. And when the light is very strongly colored, as in sodium-vapor street lighting, any surface that absorbs that particular wavelength will look almost completely black.

Color with depth

An aerial view of shallow waters off an island in the Philippines illustrates clearly how increasing depth (here from the bottom to the top of the image) renders the appearance of seawater first green, then blue.

Red

Visually, red is one of the most insistent, powerful colors, and immediately attracts attention, in addition to having many strong associations.

When set against cooler colors, greens and blues in particular, red advances toward the viewer, meaning that it seems to be in front of the other colors and, under the right conditions of subject and color intensity, can bring a genuinely perceptible three-dimensional effect. It has considerable kinetic energy, and produces some of the strongest vibration effects against other colors.

Tilak
The red dot painted in the center of the forehead in India is so widely used that mounds of the red powder are a common sight in markets all over the country.

Red lighting
Objects bathed in red-filtered artificial lighting take on a peculiar tonal quality. Deep shadows are virtually black, but highlights remain red, and do not lighten as would be normal in a full spectrum. The result is a limited tonal range. You can reproduce this effect by using a Wratten 25 red filter over the lens in normal light.

Red wine

To better analyze the subtle distinctions of hue in wine, a French sommelier uses the warmth of candlelight in the traditional manner. Viewed through the glass, this flickering light has the advantage of a known color temperature, and being redder than daylight renders the appearance of the wine brighter.

Primal color

An image that is usually better received by viewers before they know what it is of—blocks of congealed pig's blood on sale in a northern Lao market. Nevertheless, blood is one of the key associations of red.

Vermilion

The preferred choice of pigment for painters throughout history, vermilion has always been the most expensive and most intense. This antique block is being used in a scriptorium for the creation of a hand-written Bible on parchment.

A tradition of red paint

Along the northeastern coast of America, red has long been a favored color for timbered barns and other buildings. This striking example is in New Brunswick, Canada.

Yellow

Yellow is the brightest and lightest of all colors, and this brilliance is its most noticeable characteristic, which accounts for the way it is used practically and thought of symbolically.

Indeed, yellow does not exist in a dark form—if it is degraded with black, it simply becomes an earth color between brownish and greenish, but a dark yellow is still brilliant in comparison with all other colors. As it is most often found set against darker tones, yellow often seems to radiate light in a picture. Matching its brilliance with other colors is difficult: a similar blue, for example, would have to be quite pale. There is very little latitude in yellow; to be pure it must be an exact hue, while even a slight tendency toward yellow-green is obvious. All colors have a tendency to change character when seen against other colors, but yellow is particularly susceptible, as the pair of photographs here illustrate. It is most intense against black, and most insipid against white. Out of orange and red it extends the spectrum in the direction of brightness. Against violet and blue it has a strong contrast.

Expressively, yellow is vigorous and sharp, the opposite of placid and restful. Probably helped by association with lemons (a commonly perceived

◢ A very limited hue

With pure yellow in the center, this space moves left toward green and right toward orange. Only personal taste can set these limits, but for most people yellow quickly turns into green on the one side and orange on the other. Most people have little tolerance for a contaminated yellow.

yellow green	"lemon"	yellow	"golden"	yellow orange

▶ Yellow's variable energy

As the color squares demonstrate, a bright color like yellow receives energy from a dark setting, but is drained by a pale one. The central yellow square is identical in each. Far from being an exercise in optics, this has a real impact on photographing yellow. The yellow of the oil in the flask is actually more saturated than the aspen leaves, but the shadowed slope behind the trees on a Colorado hillside makes them seem distinctly more colorful and intense. Both oil and leaves are backlit and so show the full color without being diluted by surface reflections.

form of yellow), it can even be thought of as astringent, and would rarely be considered as a suitable setting for a food photograph, for example. Other associations are mainly either aggressive or cheerful.

There is no clear line separating the expressive and symbolic associations of yellow (this is true of most colors). Much of its vigor derives from the source of its most widespread symbolism: the Sun (which actually appears white until it's low enough in the sky for us to look at it without discomfort). By extension, yellow also symbolizes light. A second symbolic association with a very concrete base is gold, although yellow-orange is usually more appropriate.

In large-scale scenes like landscapes, pure yellow is not common, and tends to be found in specific objects. It tends to exist in smaller objects, like plants: buttercups, marigolds, daffodils, and leaves in fall; fruits like lemon, melon, and star fruit. Egg yolks also put in an appearance. In the mineral world, sulfur is the strongest yellow, but is rarely seen, since it is most likely to be found in nature encrusted around volcanic vents. As a paint and tint for manmade objects, yellow has a special popularity when the idea is to catch attention, as in road warning signs, school buses in North America, mail boxes in Germany, and fishermen's waterproofs. It is also used just to be bright and cheerful.

Yellows

PALE GOLDENROD

LIGHT GOLDENROD YELLOW

LIGHT YELLOW

YELLOW

GOLD

LIGHT GOLDENROD

GOLDENROD

DARK GOLDENROD

Egg
A Japanese dish, dashimaki tamago, is a rolled version of an omelet, and has the characteristic yellow formed by egg yolk mixed with egg white. Japanese food presentation is traditionally highly visual (one Japanese saying is that we "eat first with our eyes"), and the yellow is accentuated by the choice of a dark red dish.

Bright paint
Yellow's simple brightness attracts people to use it as a paint whenever they want an object to stand out. The reasons for doing this may be functional (for safety and attracting attention) or for pleasure in a cheerful, vigorous color, as with this small Mediterranean fishing boat.

Blue

This is a quiet, relatively dark, and above all cool color, very common in photography and with a wide range of distinguishable varieties.

Blue recedes visually, being much quieter and less active than red. Of the three primaries, it is the darkest color, and it has its greatest strength when deep. It has a transparency that contrasts with red's opacity. Although pure blue tends toward neither green nor violet, it has a considerable latitude, and is a hue that many people have difficulty in discriminating. Identifying a pure, exact blue is less easy than identifying red or yellow, particularly if there are no other varieties of blue adjacent for comparison. A valuable experiment is to shoot and then assemble a number of images, all of which were of things you considered to be "blue." The variations in hue are often a surprise; without color training, the eye tends to imagine that hues are closer to the standard of purity than they really are.

▼ A beach in the tropics

A classic scene of palm trees overlooking shallow reefs in the Caribbean. Compare the color with that of the aerial view—seen from ground-level, the water reflects the brighter, paler sky closer to the horizon. Pale green water in the distance is evidence of very shallow coral reefs.

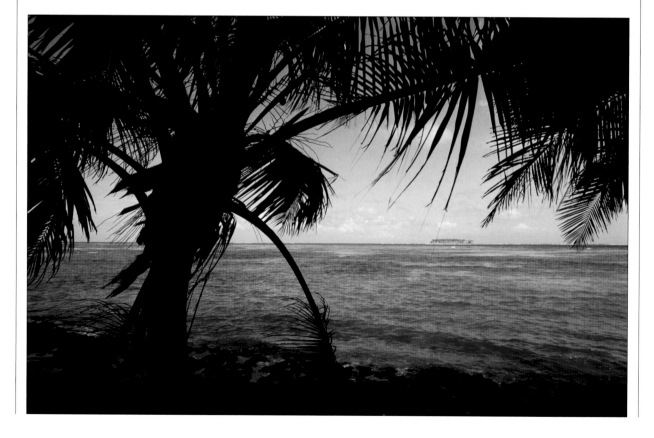

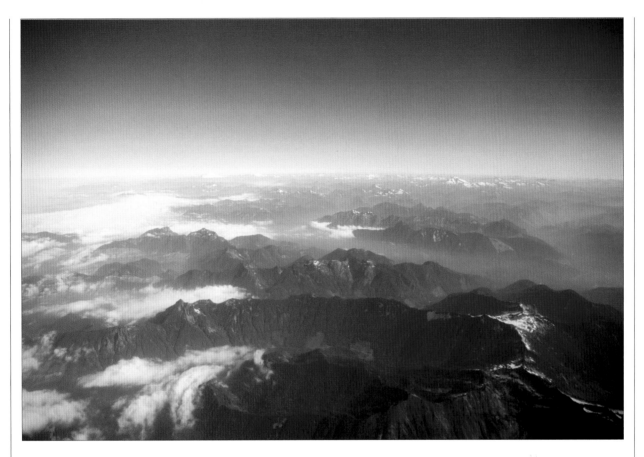

Expressively, blue is, above all, cool. Used in decoration, it even produces the sensation that the actual temperature is lower than it is. The contrast with red also occurs in other ways: blue has associations of intangibility and passivity. It suggests a withdrawn, reflective mood. The primary symbolism of blue derives from its two most widespread occurrences in nature: the sky and water. There are other, subjective, symbolisms; for example, the painter August Macke of Der Blaue Reiter (The Blue Rider, an expressionist group of the early 20th century) wrote: "Blue is the male principle, sharp and spiritual..."

Photographically, pure blue is one of the easiest colors to find, because of the scattering of short wavelengths by the atmosphere. The result of this is that a clear daytime sky is blue, as are its reflections (in the form of shadows, and on the surface of the sea and lakes). Water absorbs colors selectively, beginning at the red end of the spectrum, so that underwater photographs in clear, deep conditions have a rich blue cast.

Aerial
A clear sky is the most accessible source of blue for photography, and is at its most intense at altitude—here a view of the Cascades in Washington State from an altitude of 30,000 feet (9,000 meters).

Green

The key color of nature, green is also the hue to which our eyes are most sensitive, and we can discriminate within it a large number of individual greens.

Between yellow and blue, green has the widest distinguishable range of effects of all the primary hues. It can take on many different forms—depending on how yellowish or bluish it is—and each with distinct characteristics. Although it has a medium brightness, green is the most visible of colors to the human eye: at low levels of illumination, we can see better by green light than by any other wavelength.

Green is the main color of nature, and its associations and symbolism, for the most part positive, derive principally from this. Plants are green, and so it is the color of growth; by extension it carries suggestions of hope and progress. For the same reasons, yellow-green has spring-like associations of youth. Symbolically, green is used for the same purposes as its expressive associations—youth and nature, with plant-life in particular. For a more specific example, green signifies "go" at traffic lights, as opposed to the prohibition of the red "stop" light.

Greens

DARK GREEN

DARK OLIVE GREEN

DARK SEA GREEN

SEA GREEN

MEDIUM SEA GREEN

LIGHT SEA GREEN

PALE GREEN

SPRING GREEN

LAWN GREEN

GREEN

CHARTREUSE

MEDIUM SPRING GREEN

GREEN YELLOW

LIME GREEN

YELLOW GREEN

FOREST GREEN

Green pebble pond
A small pond created in a Tokyo garden to evoke the colors of the wooded Shinto heartland to the south of Japan, in which the designer has artfully included a special variety of green pebbles to the low undergrowth of ferns.

Comoros market

In the morning market in Moroni, capital of the Comoros Islands, unripe bananas blend with the seller's green attire— a color popular for religious reasons in this Islamic republic.

Malachite

The most intensely green of all rocks is malachite, which has an intense, even garish hue similar to viridian. Here it has been used for the surface of an inlaid table in a converted Indian palace.

Forest green

Bright sunlight on dense foliage in a coastal forest on the Bay of Fundy, New Brunswick, reflects in the waters of a stream flowing around moss-covered rocks. A long exposure blurred the ripples and so enriched the green.

Violet

The mixture of blue and red stands out among colors as being the most elusive of all, both in our ability to identify it and to capture and reproduce it photographically.

Many people have great difficulty distinguishing pure violet, often selecting a purple instead. It is worth making your own attempts and then comparing these with the color patches printed here. The difficulty in recognizing violet is compounded in photography by the problems in recording and displaying it. The gamut in color monitors and printing inks is particularly unsuccessful with this color. You can be reasonably certain of testing this for yourself if you photograph a number of different violet colored flowers. Pure violet is the darkest color. When light, it becomes lavender, and when very dark it can be confused with dark blue and blue-black. If reddish, it tends toward purple and magenta; if less red, it simply merges into blue. The difficulty of discrimination, therefore, is in the zone between violet and red.

Burmese nuns
The garments of Burmese nuns at a convent in Sagaing, near Mandalay are pink and red, but in the blue-tinged shadows on a clear day they take on violet notes.

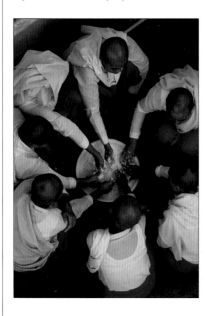

Lavender fields
Lavender growing in rows in Provence, in the south of France, is also a color definition in its own right, yet still falls within the broad range of violet as a secondary hue.

Tet fireworks
Vietnamese fireworks in a market stall for sale in the days leading up to the annual Tet festival.

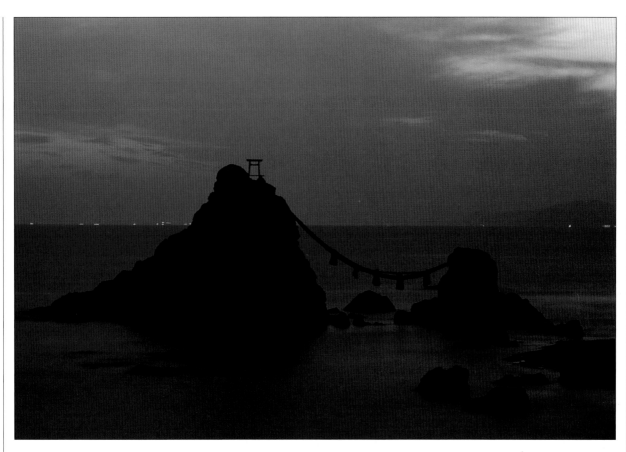

Violet has rich and sumptuous associations, but can also create an impression of mystery and immensity. A violet landscape can contain suggestions of foreboding and otherworldliness. By extension, purple has religious, regal, and superstitious connotations. Violet symbolizes piety in Christianity, and quasi-religious beliefs, including magic and astrology. It is sometimes used to represent apocalyptic events.

Violet is a relatively difficult color to find for a photograph. In nature, some flowers are violet, but are often difficult to record accurately on film. The wavelength of ultraviolet used as "black light" is recorded by a sensor as a pure violet. Under certain conditions, the light before dawn and after sunset can appear as a reddish version of violet.

Violets

MAGENTA

VIOLET

PLUM

ORCHID

MEDIUM ORCHID

DARK ORCHID

DARK VIOLET

BLUE VIOLET

PURPLE

MEDIUM PURPLE

THISTLE

Dawn
Dawn and dusk produce a huge range of colors depending on the state of the atmosphere and weather, often with unpredictable results. Off the southeastern coast of Japan, the two famous rocks known as Meoto-Iwa (the wedded rocks), tied together by rope, are backlit by a rich, purplish sky that has not been enhanced digitally.

Orange

Combining the strong characteristics of its two neighbors, red and yellow, orange is a rich, radiant color inextricably associated with the glow of incandescent light.

Orange is the mixture of yellow and red, and absorbs some of the qualities of both. It is brilliant and powerful when pure and—since yellow radiates light and red radiates energy—it is by association very much a color of radiation. When lighter, as pale beige, and darker, as brown, it has a neutral warmth. Orange is the color of fire and of warm late afternoon sunlight. It has associations of festivity and celebration, but also of heat and dryness. Symbolically, it is interchangeable with yellow for the sun, and with red for heat.

In the world outside, pure orange can be found in flowers, and in a slightly adulterated form in the light cast by tungsten bulbs, candle flames, and other sources of low (less than 2,000K) color temperature. In film photography an 85B standard filter (a dull orange) was used with type B film (film adapted for tungsten light) in daylight to compensate for the blue cast of the film, and this has a digital equivalent in colorizing tools such as Photoshop's Photo Filter (under *Image > Adjustments*).

Oranges

ORANGE

COPPER

COOL COPPER

CORAL

GOLD

MANDARIN

OLD GOLD

Orange from heat

Metal samples being heated in a laboratory furnace. A pure example of orange as color temperature.

Religious color

In Japanese Shinto, this particular shade of orange, moving toward red, is a sacred color, here painted on the torii gates lining a temple approach.

Gold

Reflecting not just sunlight but neighboring gold, a gilded chedi in northern Thailand glows a range of orange-to-yellow.

Sikh guardians

Ceremonially attired guardians at the Golden Temple, Amritsar, in India, the focus of the Sikh faith.

Tiles

Rooftops in the center of the old city of Bruges, in Belgium. The striking color of roof tiles can be seen across the Benelux region of continental Europe and north into Denmark.

Reflected sunset

Almost red as it nears the horizon, the sun reflects as a shimmering band in the muddy waters of the Mekong River at Vientiane, the Laotian capital.

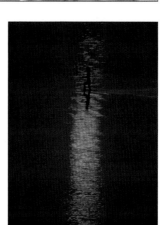

An orange

The fruit itself, of course, is the classic example of the color.

Black

Black is the absence of light and tone, and in photography is produced simply by no exposure. While in its pure form it contains no detail, it is essential for establishing the density and richness of an image.

Black, being the extreme of density and solidity, and the base density of an image, needs the contrast of another shade or color in order to make any kind of picture. As a result, it is used in images mainly as a background, as a shape (such as in a silhouette), or as a punctuation. Black can never be too dense; indeed, the limitations of a printed image on paper are often such that it appears weak, a very dark gray, and this subtly influences our appreciation of a photograph in a negative way. This slight weakness is particularly unsatisfying in a black, which ought to represent a solid anchor for all the other colors and shades, wherever it occurs in a picture; hence the importance in making sure that a small area of pure black appears somewhere in the majority of images. Although, obviously, there are many photographs which cover a softer scale of tones and benefit from a gentle appearance—a delicate modulation in a foggy landscape, for example—most images tend to look satisfying to most people when they cover a range that has a pure, strong black somewhere in the scene. This is a natural perceptual response, and as such is the basis for the part of optimizing an image that involves setting the black point. Overexposure, low contrast, and careless optimizing of a digital image will create this weakness in the base black.

Background
One of black's essential uses is to function as an empty background that, by contrast, throws an object forwards toward the viewer, here the lightly colored shell of a Precious Wentletrap. It is easy to remove all traces of tone from the cotton velvet background through less exposure.

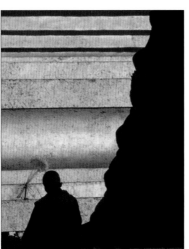

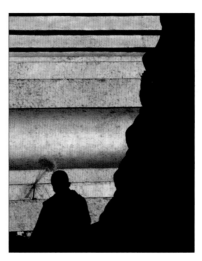

Silhouette
Lit background and shadowed foreground is the recipe for silhouette, as in this image of a monk meditating in front of Rangoon's Shwedagon Pagoda. A true black reinforces its "silhouetteness," and from the original shot with its fuller range (left), the black point dropper in Photoshop was used to intensify the effect in the righthand image.

Having said that, it is also very important for the success of a well-modulated photograph to distinguish between details in the shadow areas, and this essentially means being able to discriminate between very small differences in the lower levels, particularly between 0 and about 20 in an 8-bit image (on a scale from 0 to 255). Extreme subtleties of tone in images that have blacks against blacks are interesting and challenging to explore (in painting Édourd Manet

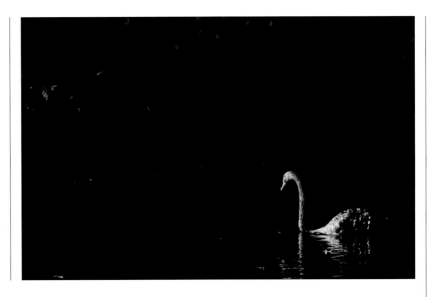

Black swan
A variation on the "black cat in a coal shed," this image of a Black Swan against deep shadows relies totally on its white and pale gray highlights to give form and recognition.

was able to achieve what Matisse called "frank and luminous black" in works such as *The Balcony* and *Breakfast in the Studio*). The master Japanese printmaker Hokusai discriminated between types of black: "There is a black which is old and a black which is fresh. Lustrous black and matt black, black in sunlight and black in shadow." He advocated a touch of blue to make black "old." The distinctions between lustrous and matt are, of course, familiar to any photographer choosing paper for prints. As a pure background, however, it can be either dense, like a solid wall, or empty, as in featureless space. If you want to guarantee that a studio background reproduces as pure black, you may need to use such a material, and then further deepen it when editing.

Where black shades to gray, the gray is very sensitive to its neutrality or otherwise. Any slight hint of a color cast is immediately recognized, and then inferred to be a part of the blackest areas. If you do not set a neutral black point in an image, it is common to have dark shadow areas which actually contain a color cast, though this may be difficult to see on a monitor screen. Boosting the monitor brightness temporarily will usually reveal this, as also of course will running the cursor over these areas and checking the RGB values.

The neutrality of black outweighs most of its associations and symbolism, but where it appears extensively in an image it can be heavy and oppressive. Nevertheless, it can also carry hints of richness and elegance. In the 16th and 17th centuries, most notably in 17th-century Holland, it was the color of high fashion among the aristocracy.

White

Although theoretically white is the absence of color and of tone, in practice it is the most delicate of colors and plays a very important role in almost every image.

White is the absence of any tone whatsoever. Nevertheless, just as a black object must contain tonal highlights and modeling in order to be recognizable, so a white image needs at least the modulation of pale grays or off-whites in order to be a part of an image. These slight modulations are very susceptible to color cast, however—even more than with black—and achieving complete neutrality is not easy. (This is a problem chiefly associated with gray, and we examine it below.) One famous still-life painting, *The White Duck* (1753) by Jean-Baptiste Oudry, is a spectacular exercise in the subtlety of chromatic whites; the artist wrote: "You will know by comparison that the colors of one of these white objects will never be those of the others."

Whites

WHITE

SNOW

GHOST WHITE

WHITE SMOKE

GAINSBORO

FLORAL WHITE

OLD LACE

LINEN

ANTIQUE WHITE

Doves
As with blacks, exposure is critical with white subjects, and if there is sufficient time, bracketing is recommended. Typically, without adjustment an image like this would need one *f*-stop or more of extra exposure beyond that set automatically.

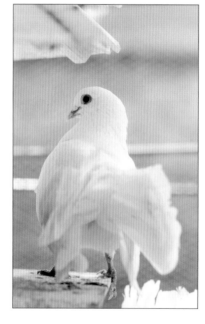

White on white
A smock hanging on the wall in Pleasant Hill Shaker village, Kentucky makes a study in white, but it is the shadows that define it and set the reference tone for the exposure.

Photographically, white needs care in exposure, and more so now with digital cameras than with film. Slight underexposure makes it appear muddy; slight overexposure destroys the hint of detail and usually gives an unsatisfactory sensation of being washed out. Film has a non-linear response to exposure, which means practically that, even when you overexpose it significantly, it tends to retain some traces of detail. The sensor in a digital camera, however, has a more linear response—the photosites that make up a CCD or CMOS sensor chip continue to fill up at the same rate, in proportion to the exposure, right to the top. Once full, they cannot absorb any more information, so cannot register any further subtlety in shade. The effect is that it is easier to lose all detail completely with a digital camera, and the highlights are blown out, or "clipped" as the condition is usually known. Although its neutrality robs white of strong expressive association, it generally symbolizes purity. It also has associations with distance and even infinity (as it was used by the Russian painter Kasimir Malevich in his *White On White* series between 1917 and 1918).

Neutral colors

Although they lack hue and fit nowhere on the color circle, the three neutral shades of black, white, and gray are essential components of color photography. Not only do they exist as counterpoints and setting for the colors just described, but they are mixed with these pure hues in varying degrees to make adulterated browns, slates, and other subdued colors. We should treat them as a special, but essential, part of photography's color palette.

Stalks in snow

Snow, of course, is white, but that also means that it is highly reflective, and to appear pure has to be seen under neutral cloudy light. Even on an overcast day, a slight bluish tinge appears.

Cranes in winter

Japanese cranes on the northern island of Hokkaido, calling in the late afternoon. The small amounts of black plumage help give definition in another essentially white-on-white image.

Case study: **chromatic grays**

Because of its neutrality, its lack of "color," we are very sensitive to the accuracy of gray—or so we think. Yet ask any two people to point to a perfectly neutral gray and you're unlikely to find agreement. The measurable differences may not be far apart, but the opinions probably will be. Fortunately, the means for measuring exact neutrality are instantly at hand digitally, and RGB is for once the most easily read color mode. In a truly neutral gray the three values are the same. We can easily distinguish slight differences in hue, though only when we see them side by side. This spread is more like a project with two objectives: to find and assign a full range of these so-called chromatic grays, covering at least the six primary and secondary hues, and to find the limits of gray; at what point with the addition of hue and saturation does the result become a distinct color rather than a colored version of gray? Naturally, there are no fixed answers.

Roots and stone
Warmer grays are found in a strange combination of the roots of a ficus that have grown around and lifted the head of a Buddha sculpture in the city of Ayutthaya, Thailand.

HMS Belfast
A light cruiser, launched in 1938, now moored near Tower Bridge, London, serving, in military gray, as a tourist attraction.

Morning mist

Another case for maintaining subtlety of hue and not simply making the scene neutral. The pale blues and greens of English fields below power lines help evoke the sensation of a damp winter's morning.

Subtle desaturation

This is the full spectrum of hues with a vertical dark-to-light gradient, and 96 percent desaturation applied. This almost-complete removal of saturation results in a range of colors that are more gray than anything else, yet still retain differences in character.

Blue mud

It's important when shooting near-neutrals to see and remember the subtleties of hue. The mud in which these Namibian elephants were bathing in Etosha was actually a pale blue. If I had failed to notice, I may later have "corrected" them to true gray.

Working **Digitally**

With digital photography there is both the necessity and opportunity to control and adjust color in ways that are completely new to photography. The necessity is because, unlike with film, there is never a single point in the process at which the colors of an image are fixed. Traditionally, and with slide film, the moment of exposure established how the colors would appear. You could change the way it was printed, either in the darkroom or in repro, but the original slide would always remain the reference. Digitally, the image is captured with much more flexibility, and the color of each individual pixel is open to change at any point afterward. If the photograph is captured in Raw format, the settings (including white balance) are kept separate from the data and can be revisited at any time. Indeed you are asked to look at these settings as you open a Raw file in Photoshop, assuming your camera model is one of those recognised by the Adobe Camera Raw compnent.

The opportunity lies in choosing exactly how any and every color should look, regardless of what it was in the scene or as captured. This opens up possibilities for creative expression that until now have been foreign to photography, and it is for this reason that throughout this book I refer to the ways in which painters have considered and dealt with color. This is definitely not a recommendation to work in a "painterly" manner, but rather to approach photography as a colorist.

The techniques for handling color digitally all require a familiarity with software, in which I include the firmware installed in the camera (you could think of this as embedded software). If you simply want to shoot without having to consider image qualities such as color, you need no more than the basic version of the camera manufacturer's downloading and browsing software. If you want full color control, however, the list of software to consider expands greatly. Photoshop has such an established position in image editing that most photographers use it at some stage of the process, but there are alternatives. Camera manufacturers' software continues to develop in sophistication and scope, and there are also independent programs designed to manage all the essential workflow from downloading the images, organizing them, making changes, and beyond.

Then there is specialist software aimed at very specific aspects of digital color. One important area is camera profiling, used in conjunction with standard color targets. Monitor calibration and printer profiling, also part of the digital color workflow, call for specific hardware and software. At first this might seem very daunting, but the principles are relatively straightforward and the software does the hard work. Beyond this, new software is being developed all the time to deal with newly identified issues, such as memory colors, or to take advantage of improving camera or computer power, such as high density range facilities. Keeping up-to-date with these and evaluating them is now, for better or worse, another part of digital photography. It might seem an inconvenient distraction from the photography itself, but it is unavoidable, becomes easier with practice, and in the end pays dividends.

Color management

In digital photography, the number of different devices used in the workflow, from camera to monitor to printer, makes it essential to control the color so that it stays consistent.

Color management is the process by which you ensure that the colors you see in the scene in front of the camera are kept as they should be throughout the several stages of capture, editing, and delivery. It is, and is likely to remain, a hot issue in digital photography, because before you can use color creatively with any degree of subtlety, you need to be confident that the combination of equipment and software that you are using will deliver exact colors when you need them.

And yet, while digital imaging now provides all the means for controlling color, color management was never such an issue in the days of film, which often suffered more from color shifts and inaccuracies. The key to this seeming inconsistency is that with film there was a physical object to which everyone could refer. Even if the colors in that piece of film were wrong in

Basic workflow

Color management requires the conversion of all color descriptions to be converted into an independent color space. This takes place within the computer.

While cameras and scanners apply their own idiosyncrasies, monitors and printers can also display colors wrongly. The CMS allows for all this, to make the display as close as possible to the original.

some way, and allowing for some differences in the quality of the light box on which it was viewed, it remained tangible. Now, with digital photographs, there is no single reference image, only versions of it that depend on the viewing platform—and computer monitors and the systems on which they operate are hugely variable.

The software used for managing color is called a Color Management System (CMS), and for any serious photography is absolutely necessary. Fortunately, color management is now standard with most good cameras, computers, and imaging software. If you have at least an accurate generic camera profile (normally automatically readable), a calibrated monitor, the right entries in Photoshop's Color Settings, and a calibrated printer profile, your color management is likely to be in good shape.

Render intent

Some colors will be out of gamut when you change from one color space to another, and so the color management system needs your guidance in how to effect the compromise. This is known as render intent, and Photoshop offers four choices.

- With a **perceptual** intent, the color space is simply shrunk.
- With a **saturation** intent the vividness of colors is preserved (more useful for graphics than for photographs).
- **Absolute colorimetric** makes no adjustment to the brightness.
- **Relative colorimetric** changes only those colors that are out of gamut between the two spaces, and is the normal intent for photography.

Color gamut is the range of colors that a device (camera, monitor, printer, for example) can display. A CMS maps the colors from a device with one particular gamut to another. Typically, the CMS uses a Reference Color Space that is independent of any device, and a color engine that converts image values in an out of this space, using information from the "profile" supplied by each device. So, for example, a CMS converts monitor RGB colors to the smaller gamut of printer CMYK colors by using an intermediate color space that is larger and device-independent, such as L*a*b*. Thus, it converts from RGB to L*a*b* and then to CMYK, changing some of the colors according to the render intent. This determines the priorities in the process, in which inevitably some need to be altered (see the Render Intent box).

Color mode
Some cameras allow the user to set the color mode.

Color space

A color space is a model, often represented as a three-dimensional solid, for describing color values, and it has a "gamut," or range of colors that it is capable of recording or displaying.

The standard color space for digital photography is RGB, defined naturally enough by the three components red, green, and blue. Camera sensors use an RGB filter to distinguish colors and computer monitors' display colors by mixing RGB. In practice, there are a number of RGB spaces, including sRGB, Adobe RGB (1998), and Apple RGB, some larger than others and covering slightly different areas of hue. You might wonder what could be better than the largest color space possible, and what could be the advantage of a small color space. The answer lies in the final form in which the photograph will be displayed—as an inkjet print, for example, or as a CMYK repro print in a magazine, or on-screen. The wide gamut of a large color space can indeed record very many subtleties of color, but this is no use at all if you can't display them. Color spaces are matched to different purposes, and the two most widely used are sRGB—small but ideal if you go straight to print from a camera image without image editing— and Adobe RGB (1998), which is wider and better suited to image editing in Photoshop.

Working space

The two most common color spaces available in photography are Adobe RGB (1998), the larger of the two shown here, and sRGB. The latter is convenient for printing, but fails to capture as many greens and reds.

Device spaces

The color gamuts of a typical 8-bit monitor (white) and typical digital color print paper (pink) compared (in so far as is possible when printing using CMYK). For comparison, the gamut of an average color transparency film (blue) is superimposed.

Working with HSB and Lab

Although RGB is standard in photography, it is arguably not the most convenient way of editing images on the computer. HSB controls and Lab mode have much to recommend them.

Image editing programs, such as Photoshop, offer a choice of controls for adjusting color, and they go by different names. Some are "modes" (Lab in Photoshop), while others are adjustment dialogs (Hue/Saturation and Replace Color). Despite this unnecessary confusion in Photoshop, we know that HSB and Lab are both models and can be used to alter color in ways that are often more useful than regular RGB, which functions as the default mode.

The advantage of HSB is that it is the closest thing we have to an intuitive method. Not surprisingly, it is the model that is accessed by all good color-correction software. In Photoshop, the two most important

controls are Hue/Saturation and Replace Color. iCorrect EditLab Pro 4.6 is a specialist color software application. Sliders are the usual control mechanism and, valuably, HSB allows color ranges small to large to be targeted. This makes selective color control possible from within the dialog box .

Lab also has some important advantages, although they are not quite so obvious. Remember that Lab was developed as a very large color space rather than as a user tool. In fact, Photoshop uses Lab as an internal color space when making some changes. By separating Lightness as an individual channel, Lab is at its most valuable when you want to make brightness changes with no effect whatsoever on the balance of colors. There are fewer occasions for using the other two, color channels a* (green-red) and b* (blue-yellow), although if you know that you want to make a shift on either of these two axes, they are very direct.

Large color spaces do play an important role, but as intermediate spaces for conversion. L*a*b*, developed in 1976 by the Commission Internationale d'Eclairage (CIE, and so this space is also referred to as CIELab), was designed to match human vision as closely as possible in the way we perceive and appreciate color. It has three parameters, or axes: one for brightness and the other two for opposing color scales. L* stands for luminance (that is, brightness), a* for a red-green scale and b* for a blue-yellow scale. The logic behind this is that each of the three axes oppose complementaries—dark against light, red against green, and blue against yellow. In human visual perception, red cannot contain green, nor blue contain yellow. Being a large color space, it is also useful for converting colors from one model to another, as nothing is lost. Indeed, Photoshop uses L*a*b* internally for converting between color modes, and it is available for image editing. Nevertheless, it is what is called a device-independent color space.

The other color space that figures largely in professional photography is CMYK, representing the inks used in printing books, magazines, and the like. The initials stand for the three complementaries of RGB—cyan, magenta, and yellow—and K, meaning key, for black, which is a necessary ink in printing to achieve full density on paper. The CMYK color space is significantly smaller than others used digitally so, while it is an essential last step for repro, it needs skill and experience to use because colors can be lost in the process of conversion. Most photographers leave CMYK conversion for the printers or client to do.

Sampling in a range

Sampled colors within a color range: to target a range of hues, use the drop-down menu within Photoshop's Hue/Saturation dialog. To exclude one of these ranges, make an increase overall (that is, on Master) and then make an equally strong decrease to the color you want to stay as is. For more precise targeting, having selected a hue range as above, then click on the exact color in the image. The hue selection sliders at the bottom of the dialog box will change slightly, and you can close them up for even more precision.

Calibrating monitors

The monitor screen is where all the important decisions about digital color are made, and the procedure for making sure that it accurately represents colors is calibration, an essential first step.

As supplied with the computer and without adjustment, the monitor display will give you a reasonable accuracy of color—usually. For professional or creative color adjustment, however, an unknown level of reasonable is not good enough. Moreover, calibration to an adequate degree is easy, and often provided at system level by your computer (if not, consider another computer). At the very least, you want to be sure that you are displaying neutral grays as truly neutral, not only for the midtones, but also for the blacks and whites.

Before all else, make sure that the viewing conditions are good. Simply put, this means that the ambient light level in the room should be at least half of the brightness of the screen (black is better, but tiring on the eyes) and that the surroundings of wall, desk, and so on are neutral, not colored. Needless to say, the screen desktop should be a simple neutral gray, not a photograph of the family or the dog.

Monitor calibration is the starting point for color management, and there are two basic methods: by eye and with a measuring device. The eyeball method is not bad at all, and is available at system level on modern Windows and Mac operating systems, via a set-up assistant. The sequence prompts you to adjust by eye the brightness and neutrality of the black, white, and mid-points, also the gamma (see box for definition) and the color temperature. You then save the results as a monitor profile.

Lighting
An ideal lighting environment, with soft daylight from behind the monitor (to cut down on reflections).

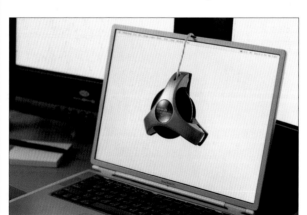

Spyder
A colorimeter is used to measure your monitor's performance and create a profile for it. Simply place it on your screen and the software supplied will cycle through some colors and create a profile.

More accurate is hardware calibration, using either a colorimeter or a spectrophotometer placed on the screen to measure the actual display. These devices come with software that runs a program of color variations, at the end of which a monitor profile is automatically created. The sequence shown here is that followed by OptiCal software, using a Spyder colorimeter. The resulting profile is then saved as standard.

Gamma

The angle of slope of the response of a monitor to a signal is known as gamma—technically a plot of the intensity of the output signal relative to the input. The standard gamma for Windows is 2.2, which is higher (so darker and more contrasty) than the standard for Macs, which is 1.8. This means that photographs that look good on a Mac will look darker and more contrasty when seen on a Windows computer screen.

Gamma
These images show the result of viewing images on alternate systems. The above was saved in Windows gamma as viewed on a Mac, the right-hand one created on a Mac and viewed on a PC.

Camera profiles

In the same way that a monitor can be profiled by calibration, the unique characteristics of your camera's sensor can also be measured and used to color-correct images.

The ultimate check for the color of light is a standard target that you can carry with you and use to shoot test frames. These vary from a simple neutral gray to customized, and expensive, color mosaics. The most widely used is the GretagMacbeth ColorChecker, which uses special, and accurately-printed, Munsell colors. Another useful reference target is a standard Gray Card. Both of these are widely used and are known quantities, so that shooting a first reference frame of one of these targets makes it possible to balance the colors later.

While the very simplest way of using them is as a basic eyeball check when you open up the digital files in a browser or image-editing program, the most accurate way of using them is to create an ICC profile. These profiles (ICC stands for International Color Consortium) are the basis of color management systems, and are small files that can be accessed at system level by the computer. A program such as inCamera by PictoColor, used as a Photoshop plug-in, can read the photograph of the chart that you shot, compare it with the known values, and construct a small file known as a camera profile that will instruct Photoshop to make the necessary adjustment for any image that you choose. Simple and highly effective, but a camera profile will be accurate only for that exact lighting, which makes it more useful for controlled studio or indoor conditions than general shooting.

Shooting the target

1 Place it square-on to the camera.

2 Make sure the lighting across the chart is even.

3 Use low sensitivity and meter as average.

4 Set the exposure so that there is no clipping of highlights or shadows.

5 For making a camera profile, follow the software instructions.

6 Evaluate in image editing.

GretagMacbeth™ ColorChecker Color Rendition Chart

◀ **Cards**
A GretagMacbeth
ColorChecker and a gray
card kept safely in a
wallet to prevent fading.

GretagMacbeth ColorChecker

A 24-patch mosaic of very accurately printed colors, including neutrals and "real-life" colors such as flesh tones, sky blues, and vegetation. This is the standard color target for photography, though relatively costly because of the special printing. Even more expensive is the GretagMacbeth ColorChecker DC, which has many more color patches. Because the colors are printed matt, the range from "white" to "black" is quite short, and the "black" is really a dark gray. One precaution when making a profile is to make sure that the white and black are close to the recommended values below.

Gray Card

Not for making a camera profile, but still very useful for guaranteeing the basic neutrality in an image, is an 18 percent reflectance gray card. In a digital image it should measure 50 percent brightness and R128, G128, B128. 18 percent is a mid-tone because of the eye's non-linear response to brightness.

Assigning profiles

When you open images shot under these same lighting conditions, assign the profile that you saved. In Photoshop click *Image > Mode > Assign Profile*, then straight away go to *Image > Mode > Convert to Profile* and choose your normal working profile (which will probably be Adobe RGB 1998). Finally, you may need to tweak the result, particularly for contrast. Profiled images tend to be a little flat, and a gentle contrast-increasing S-curve in Curves often improves the image.

Creating the profile

❶ Open the image in Photoshop. If the warning dialog reads "Embedded Profile Mismatch," choose "Discard the embedded profile (don't color manage)." If the warning dialog reads "Missing Profile," choose "Leave as is (don't color manage)."

❷ Check that the grayscale values are as recommended above. Adjust Levels and/or Curves to bring them into line.

❸ Launch the profiling filter.

❹ Choose the appropriate target, and its reference file.

❺ Align the grid by dragging the corners.

❻ Let the software construct the profile, then save it where other profiles are stored on your computer.

A question of accuracy

Ultimately, colors in photography are judged by eye, not by machine, which means that accuracy involves both measurement and perception.

The tools for color control that we've been looking at operate on the premise that there is such a thing as perfect color correction—that for every photograph there exists one accurate version. Inevitably, this leaves aside individual interpretation, but how reasonable an assumption is that to make? In some cases it is fair, but these are remarkably few and tend to be limited to specialist reproduction of pack shots and artifacts such as textiles, paintings, natural history, and other scientific specimens, and the like. For most photography the criteria are different.

We assume we know when the colors in an image are correct, which is to say as they should be. In reality, most people hardly think about it at all, and the question arises only when a color appears to be seriously wrong. If, for instance, sunlight falling on a surface appeared to have a tinge of green, we would "know" immediately that that shouldn't be so. And how do we know that? By experience, which, if you think about it, is not a very good basis for judging how any of the several million colors that we can recognize should be, and certainly not easily comparable with the scientific approach.

As shot
The scene, a new hotel in India, as shot with a Sunlight white balance. At the same time a ColorChecker was shot.

Accurate
In this example, the ColorChecker is used as a guarantee of accuracy, after the shot has been taken. The profile makes no allowance for the "warmth" of the afternoon sun.

By eye
In a case like this, if you want to add warmth, you will have to lower the color temperature by eye after assigning the profile.

Nevertheless, as eye judgment by someone is the final arbiter, it has to be factored in to the equation. Unless you go to the trouble of making a camera profile, which is not normally practical, then all the other tools for color control require some opinion or prior knowledge of what a color should be. This applies equally to choosing a neutral in a photograph, a memory color such as skin tones or sky, or even the quality of light, from cloudy, through shaded, to incandescent. As we saw, there is a wide latitude built into all of these, and this latitude allows for choice. Camera profiling is as close as you can get to verifiable accuracy, yet even it has limitations. Even though a camera profile for one specific lighting situation will guarantee that the colors measure correctly, this is still not a solution that accounts for all factors, since it ignores perceptual accuracy. The obvious case, though by no means the only one, is when the sun is low and the color temperature is lower than midday "white." If you diligently use a color target or even if you simply photograph a gray card and use that to set the neutral gray balance of the images, the results will be measurably correct but will look wrong. Quite apart from any subjective feelings that you may have about early morning and late afternoon light—the attractiveness or otherwise of a scene bathed in golden light, for example—we expect this kind of situation to look warm.

As shot
The Oryx, as photographed with a Daylight White Balance.

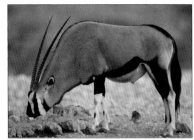

By eye
A more complex exercise in judgment. This Oryx was photographed from a blind at sunset in Namibia, with no opportunity to shoot a gray card. To get the color of the near-neutral accurate is a problem a tracker, guide, or professional hunter is best placed to solve, and their opinions were canvassed the next day. The practical issue boils down to finding the neutral point on the animal and, as three interpretations show, where you sample makes a difference. In fact, as the professional opinion had it, and shown by a midday shot taken on the following day, the most reliable neutral is on the rump (middle).

Memory colors

One of the most valuable methods of evaluating overall color accuracy, though it needs to be used with caution, is to focus on the colors of things with which we are so familiar that we know innately how they should appear.

Certain kinds of color are more fixed in our minds than others, meaning that we have finer discrimination and stronger opinions about whether they are accurate or not. To an extent this varies from person to person, and depends on particular interests, but there are a few standard sets that most of us recognize. They are known as memory colors because they seem to be embedded in our visual memory. Naturally, they play an important role in image editing because they are an immediate key to assessing the color accuracy of a photograph. For memory colors we can most easily say whether they are "right" or "wrong," and to what degree, and we can do this intuitively. Measurement is important in optimization, as we saw, but as color is ultimately a matter of perception, never underestimate the importance of subjective judgment. If it looks right, it is right.

The two most important memory colors are those with which we have most familiarity: neutrals and skin tones. Following this, there are green vegetation

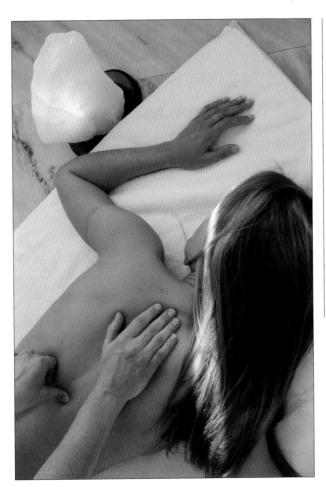

Skin
In the same way that we are highly sensitive to all aspects of the human body (for instance, face recognition), we have an innate judgment of the color of skin, which has to fall within an expected range. Note, though, the differences here even between two pale Caucasian skin tones.

Neutrals

Objects and surfaces in a photograph that should be neutral include concrete, steel, aluminum, automobile tires, asphalt, white paint, black paint, mid-day clouds.

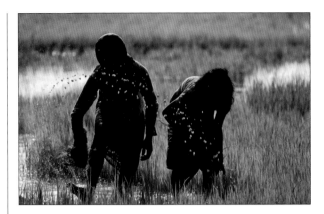

Grass
Plant life is another memory color, although the range of acceptable greens is wider than for most other colors.

Concrete
Urban concrete in its many forms is taken by the eye as a neutral, and makes a good reference for adjusting digital images at the post-production stage.

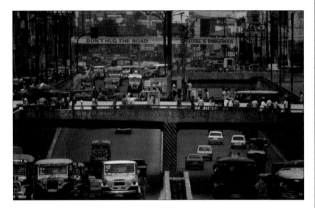

Dedicated software
iCorrect Professional stores a range of memory colors that includes neutrals, skin, foliage, and sky, and also allows users to create their own. The range of color for each of these is defined by three parameters:
Hue as an angle between 0° and 359° on the international CIE color circle (not Photoshop's HSB system).
Chroma A percentage that defines the saturation, also using CIE standards, not Photoshop's HSB.
Δ Hue A value between 10 and -10 that controls the way that the hue changes between dark and light tones. If zero, there is no change from light to dark. If negative, the hue angle decreases as lightness increases. If positive, the hue angle increases as lightness increases.

and sky tones. It also depends on the environment in which you grow up—if you live in New Mexico or North Africa, you will be more attuned to the colors of sand and rock than if you live in northwest Europe. Adjusting the memory colors in a photograph involves matching them to known samples. At its simplest, this means relying on your memory at the time of correction, but you can refine the process by referring to samples that you already accept as accurate. One way is to open a second image that is already well-adjusted and use it for reference. Another is to build a set of color patches that represent memory colors that are correct for you. There is also software that deals specifically with memory colors. The adjustment approach is basically that of source and target.

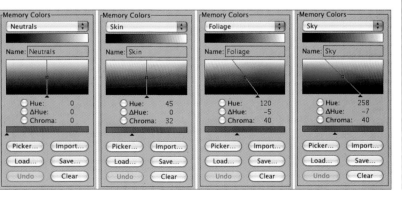

Black point, white point

The most basic, simple and effective technique for bringing the colors and tones of a digital image to their optimum is to find the darkest and lightest points and make them firmly black and white respectively.

The process known as optimization is designed to make an image appear at its best by making the fullest use of the gamut of the monitor and printer. The first step is to spread the range of tones and colors captured as widely as possible over the 8-bit scale from black (0) to white (255). This is known as setting the black point and white point, and there is a choice of techniques. In Photoshop, the starting point is Levels. There are three sliders below the histogram, one each for black point (left), white point (right) and mid-point (center). Drag the black-point slider in from the left until it reaches the first group of pixels in the histogram. These are the darkest pixels in the image, and doing this will make them black. Then do the equivalent with the white-point slider. Click OK. To check the result, reopen the Levels dialog and you will now see that the

Auto Levels or Curves

An alternative to these hand-tuning procedures is to take advantage of automated optimization. In Photoshop, there are the following, available under Options… in the Curves dialog box:

- **Enhance Monochromatic Contrast** The same as the Auto Contrast command. Brightens highlights and darkens shadows while maintaining color relationships.
- **Enhance Per Channel Contrast** The same as the Auto Levels command. Maximizes the tonal range in each channel, and so quite dramatically, with color shifts likely.
- **Find Dark & Light Colors** The same as the Auto Color command. Maximizes contrast while minimizing clipping by searching for the average lightest and darkest pixels.
- **Select Snap Neutral Midtones** Finds the color closest to neutral in an image, and then adjusts the gamma to make it exactly neutral.

Original
When you open the Levels dialog to edit the original image, the histogram has distinct gaps at the top and bottom, suggesting an image without very dark or very light areas.

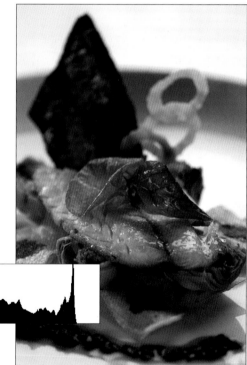

histogram has been stretched to fill the full scale. A useful check when doing this is to hold down the Alt/Option key as you drag the sliders. With the black-point slider the image on screen will be pure white until you reach the first pixels—it will indicate at what point you begin to clip the shadows. With the white-point slider the same key has a similar effect, except that the base color on screen is black.

An alternative method is to use the black-point and white-point droppers to the bottom right of the dialog. First, click on the black-point dropper, then find the darkest shadow in the image and click on it. Follow this by clicking on the white-point dropper, then find the brightest highlight in the image and click on that. To find the darkest shadow and brightest highlight, either use the technique just described, or else run the cursor over the image while looking at the results in the Info panel.

Once black and white have been set in an image, the next step is to establish those tones that you think should be gray as perfectly neutral. The most direct method is to find a point in the image which you know should be neutral, or which you would like to be neutral, and then click on it with the gray-point dropper. Having first found an area that should be neutral, run the cursor over it and watch the Info panel to see if the RGB values are equal.

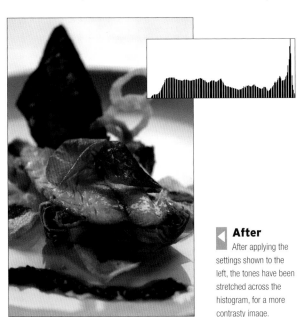

◀ **After**
After applying the settings shown to the left, the tones have been stretched across the histogram, for a more contrasty image.

Setting target blacks

Printers fall short in their ability to reproduce true blacks and whites. Set the black and white points to somewhat less than the extremes by double clicking the black-point and white-point droppers and entering new figures. Reasonable settings are 10,10,10 in RGB for black and 243,243,243 in RGB for white.

PictoColor iCorrect EditLab Pro

This specialist color software uses a four-step approach in a logical sequence. It also has an automatic feature called SmartColor:
❶ Color balance, to remove global color casts. This is done by clicking on neutral objects in the image or by moving sliders. Result: color balance fixed.
❷ Black point and white point selection, to alter the range of the tones—usually stretching it to fit the scale. Result: range fixed.
❸ Global brightness, contrast, and saturation controls, to redistribute the tone values between black and white, and between neutral and fully saturated colors. Result: tone distribution fixed.
❹ Hue-selective editing, to alter brightness, saturation, and hue—yet constrained to user-defined hue regions. Corrects non-neutral colors. Result: individual colors fixed.

The subjective component

So much effort is spent in ensuring color fidelity that it's easy to ignore personal taste and preference. But your work should express a visual idea as much as get things "right."

Color management has reached the point of being an obsession for many digital photographers because the technology is relatively new and calls for attention. The different hardware (including the camera) and software need coordination, and this is what makes color management essential, but the reality is that to handle color well, as a colorist, you must have an opinion about it. Getting color under measurable control is a first and important step. Making your own color statement is the next.

One of the clearest examples of the validity of subjective opinion in color is in the choice of saturation. As we've seen, HSB is the most comfortable, rational way to adjust color, yet psychologically we attach different weight to these three parameters—hue, saturation, and brightness. Hue is generally considered the essence of color. Brightness tends to be thought of,

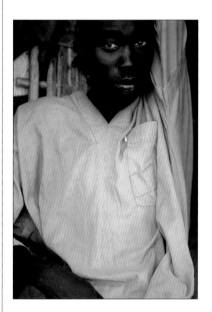

particularly by photographers, as being tied more to exposure and tone than to hue, leaving saturation as the principal modulator—at least in most people's judgment.

The point that I'm making here is that there is a more readily accepted creative latitude in saturation than in other color parameters, and we certainly see evidence for this in color repro for books, magazines, postcards, and the like, where it is frequently altered in the production process. As an experiment, here are two images offered at different saturations. To get full value from the case study, first decide, after studying the choices, which you prefer. Then cover up all the other versions and let your eye accommodate for a few minutes to this one. Even come back to it after a break. Then uncover the other images. Has your perception and judgment changed? Finally, what is the range of saturation that you personally find acceptable? The exercise is even more valuable with one of your own images. The lesson, of course, is that there is indeed a range, not a single point of acceptability.

◁ **Tobacconist**
A Dinka tobacco seller in a market town in Sudan. This is an image about color, in particular, the relationship between a particular yellow set and very dark skin. (Anticlockwise from center: saturation +11, as shot, +11, +22, +33.)

△ **Leaf**
A more obviously colorful image than the portrait, with some obvious tendency towards richness and full saturation. Increasing saturation strongly is a temptation. (Clockwise: saturation +33, +22, +11, as shot, -11.)

Printer profiling

The third and final piece of equipment in most photographers' workflow is a printer, and this too needs an accurate profile, which can be properly done only with professional calibration.

Profiling, whether applied to cameras, monitors, scanners, or printers, is the way to guarantee color accuracy, and is the basis of a sound color management system. With printers there is a little more work to do, some of it professional—but the results are always worth it—you can then have total confidence that what you see on the screen will be very close to what you get as a print. The professional component to this is the measurement of a color target, which really needs a spectrophotometer to be accurate. You can expect to pay for this service.

With cameras, as we saw, profiling is useful only when the lighting conditions are precisely the same for target and shooting, as in a studio. With printers it is not only essential, but also predictable. As long as you stick

◢ **Spectrolino**
GretagMacbeth
Spectrolino (or
Spectroscan) is a precise
color measurement
device for analyzing
output from your printer.

▶ **Profile Maker**
Profile-building software
is used to measure the
results from the
Spectrolino scanner
and create a new color
profile for the device.

to a known set of papers and inks, the profiles you use will always produce the same results. Printers make colors in a completely different way from digital cameras and monitors. They use process colors (cyan, magenta, and yellow, plus other inks such as black, gray, and light magenta) and the image is reflective rather than transmissive. The implication of this is that a spectrophotometer is needed to measure the pigments, and this is expensive and calls for skill in operating it. As a result, printer profiling is normally offered as a service. You could, of course, stick with the generic profile supplied with the printer, but this may be quite far from the way it performs with the papers you choose.

There is now a wide variety of paper and inksets for inkjet printers, and it is worth experimenting to take full advantage of these. Having decided on which to use, the normal procedure is to print out a digital test target supplied by the profiling service. You then return this to be measured accurately and have an ICC profile created—as with camera profiles, this corrects for the difference between the way your printed image looks and the way it should look. You then load this profile into your computer and use it whenever you print. In practice, there would be one profile per paper/ink combination.

Testchart page 1 of 1, Size: 22.8 x 18.5 cm, complete patch amount: 918

GretagMacbeth © 2004

Test target
The TC9.18 target was designed by color guru Bill Atkinson. Its 918 patches provide a great deal of information for the software and works equally well on pigment or dye-based printers using four (or more) inks.

Printing
The first step in creating a color profile is to print a test target, such as the TC9.18 above. You should print a different test target (and create a different profile) for each different kind of paper you plan to use.

Real Life, **Real Colors**

Having looked at the basics of color and at the digital techniques for adjusting it in the last chapters, we can now turn to how color appears in the world before the camera. With all the possibilities for tuning, enhancing, and even creating color that digital photography and image editing offer, we must always start with the colors of real objects in real scenes.

The values and associations of individual colors are complicated immensely as soon as they are seen in the context of other colors. Yellow seen against blue is not the same as yellow seen against green, and it is in the subtle intricacies of color interaction and color relationships that photographs can acquire the power to attract, intrigue, and challenge. As in so much else related to color, the dynamics of these relationships operate at different levels of perception and psychology. There are optical effects generated by the retina, others created deeper in the visual cortex, while overlaid on these are all kinds of acquired likes and dislikes. One of the most vexed areas of color discussion is that of harmony and discord—colors that are considered to fit well together, and to complement each other, versus those that breach an assumed code of approval. This is about taste, fashion, and acceptability, and is ammunition for colorists, whether painters or photographers, to make images that please or displease.

The majority of art, with photography more complicit than most other forms, has been in the service of attractiveness, and this is no surprise. Nevertheless, photography has purposes other than showing things at their most pleasant, and managing color relationships can be a part of this. Another feature of colors as they are found in life, especially in the natural world, is that they inhabit a more subtle, less pure space than the primaries and secondaries that we saw earlier. Differences of hue are much less extreme in the color circles and swatches available in Photoshop. Earth colors, the complex range of plant-life greens, pastels, and metallic colors all have their own special beauty, less insistent and more finely shaded.

Optical color effects

There are several important ways in which colors interact that, because of the psychology of perception, are not as most people would expect.

There is a set of phenomena that has to do with the way we process color in the visual cortex, and they have an important bearing on theories of harmony and discord—and so on the ways in which you can present colors in a photograph. The two most important of these are successive and simultaneous contrast, first identified by the French chemist Michel Eugène Chevreul in the 1820s. Successive contrast, also known as after-image, causes the eye to "see" the opposite hue immediately after looking at a strong color; try the example to the lower right to see this effect. Then quickly shift your gaze to the cross in the center of the blank white square. You should be able to "see" a circle of a different color—blue-green (the same effect occurs if, after looking at the red, you close your eyes tightly). This after-image is a reaction generated by the eye and brain, and the effect is strongest with a bright color and when you have stared at it for a long time. The significance of successive contrast is that the after-image colors are always complementary, meaning directly opposite on the spectral color circle.

▶ **Rainbow zebra**

Applying the vibration effect (see page 484) to a natural pattern, the dark stripes of a zebra have been given a gradient of primary colors. If the white spaces were to be lowered in brightness, to a gray, the optical flicker would be even greater.

The companion effect to successive contrast is simultaneous contrast, in which one color, juxtaposed with another, appears slightly tinged with the complementary of the second. This is at its most obvious when a neutral appears alongside a strong, pure hue, as seen in the illustrations and

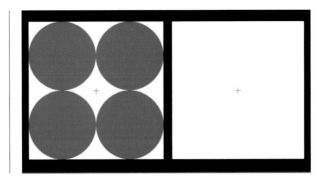

Circles effect

A variation of this effect includes the white ground. Stare as before at the cross in the left box. After at least half a minute shift to the right cross.

the photographs between here and page 485. In other words, a patch of gray on a background of a single hue appears tinged with the opposite color. Although much slighter, this same contrast occurs between two noncomplementary colors; each seems tinged just a little with the opposite.

Simultaneous contrast

One of the most well-known and important optical effects, in which the eye tends to compensate for a strong color by "seeing" its complementary opposite in adjoining areas. The classic demonstration is a neutral gray area enclosed by a strong color. The gray appears to take on a cast that is opposite in hue to that of the surround. Gray surrounded by green takes on a slight magenta cast; grey surrounded by red tends towards cyan. The phenomenon also affects nonneutral areas of color, as the violet and purple pair illustrates. The central squares are identical.

Successive contrast

This effect is similar to simultaneous contrast in principle, but over a (short) period of time. That is to say, the eye reacts to the stimulus of a strong color by creating its complementary, but does so after exposure. Stare at the cross in the center of the red circle for at least half a minute, then immediately shift your gaze to the cross in the center of the white space to the side. You will see an after image that gradually fades—and the color is cyan. If the circle were green (you can try this for yourself by making one in Photoshop) the after-image would be magenta.

Bezold effect

A color illusion related to simultaneous contrast, but with an opposite effect, was identified by a German meteorologist Wilhelm von Bezold, and is a kind of color assimilation. In this, demonstrated by the color theoretician Josef Albers with a red-brick pair of images similar to the photograph here, the presence of a light color (white mortar) appears to lighten the red of the bricks when compared with the darkening effect of black mortar. It is as if there is an optical blending taking place.

Purkinje shift

Named after the Bohemian physiologist who described this phenomenon in 1825, this effect occurs at dusk, when the eye's scotopic system (light-insensitive rods) begins to operate yet there is still enough light for the color-sensitive cones in the photopic system to work. The photopic system is more sensitive to longer wavelengths (reds and yellows) while the scotopic system is more sensitive to shorter (blues and greens). At dusk, therefore, reds and yellows appear darker than they are, and blues and greens lighter.

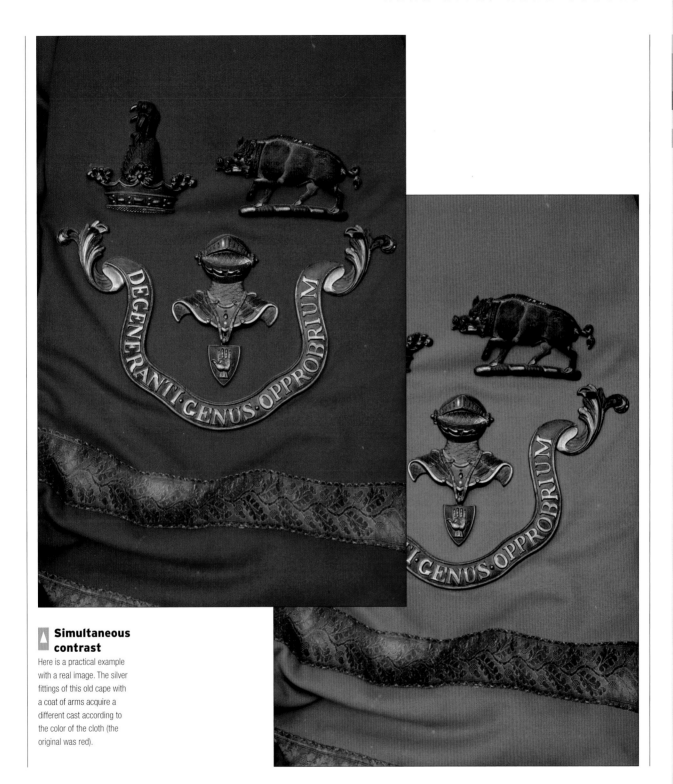

Simultaneous contrast

Here is a practical example with a real image. The silver fittings of this old cape with a coat of arms acquire a different cast according to the color of the cloth (the original was red).

Vanishing boundaries

This is the opposite effect from vibration, in which equal brightness between different colors can make the edge between them seem to disappear, or at least be hard to distinguish. This is sometimes visible with cumulus clouds that vary from white to dark gray against a blue sky—there is a mid-point at which sky and cloud seem to merge.

Vibration

Vibration is one of a family of flicker effects that had their moment of glory in the 1960s with the popularity of Op Art, notably by artists such as Bridget Riley and Vasarely. Arrangements of lines, dots, and patterns can be made to produce various kinds of motion and, at the same time, odd color shifts, most of which are uncomfortable to look at for long. As the art historian Ernst Gombrich wrote: "I admire the ingenuity and enjoy the fun of these demonstrations, and I realize that the artists cannot be blamed if we find them somewhat marginal in importance."

Vibration occurs along the edge between two intense colors that contrast in hue but are similar in brightness. Red is the easiest color to work with because of its richness and its medium brightness and, as the illustration here shows, the effect is powerful. The edge seems to be optically unstable; if you stare at it for long enough you can see a light and dark fringe. This optical vibration makes such pure combinations unsettling to look at for long, even irritating. The key is that the two neighboring hues have the same luminosity and a sharply defined edge, and if you want to enhance vibration, the Hue/Saturation sliders provide the tools.

Interrupted color

This effect has some similarities with simultaneous contrast, but derives its power from the presence of intense colors that interrupt the smooth perception of a single bar of color. Although the eye remains convinced that the two pale bluish squares in the top image are different, removing the strong blue and yellow bands, as in the bottom image, proves that they are exactly the same.

Lobster

A practical application of optical effects is the choice of background, where the tendency of the eye to compensate for a distinct color alters the perception of the object, in this case a cooked lobster. In four extreme examples (extremes of brightness and of color contrast with the lobster), the color appears to differ, particularly between the green background (a redder lobster) and the lobster-colored background (less red).

Harmony

There is a strong argument for arrangements of color that are likable, and it can be justified in terms of the color circle and the placement of colors around it.

The idea that certain combinations of color are harmonious—that is, inherently satisfying to look at—is a persistent one. Painters, designers, and colorists in general have usually approached this from a gut instinct, but there is some theory behind it. Art historian John Gage identifies four classes of harmony theory: the analogy with music (harmonic scale), complementary harmony (opposites on the color circle), similarity of brightness/value, and experimental psychology (based on the reactions of test subjects). In addition, there is similarity of hue (a group of colors in one image from the same sector of the color circle). Ultimately, harmony is a conservative view of color that conforms to expectation. It is safe and comfortable, which is fine if you want images to be beautiful, but its opposite, discord, also has a role to play in art and photography. Generally these theories work, but the implication that images ought to be harmonious is a little dangerous. Nevertheless, we'll look at the combinations that most people find pleasing.

One clue to the way in which harmony can work lies in successive contrast: the after-image. By supplying an opposite color, the eye is, in effect, restoring a balance. This is one of the main principles of virtually all color theories: that the eye and brain find color satisfaction and balance only in neutrality. I should qualify this by saying that an actual gray does not have to be present, only colors that would give gray if combined. One argument is that the eye and brain appear to mix the colors received. This is where the color circle really comes into its own. Any two colors directly opposite each other on the circle give a neutral result when mixed. Such pairs of colors are called complementary, and their combination is balanced in a way that can be tested, as we saw just now with successive contrast. It was Goethe who observed that the eye compensates for one strong color by creating its complementary as an after-image. We can take this further. Any combination that is symmetrical around the middle of the circle has a potential blend that is neutral and, therefore, balanced. So, three evenly spaced colors like the primaries yellow, red, and blue make a harmonious group, as do yellow-orange, red-violet, and blue-green. Sets of four colors can also be harmonious, as can intermediate and unsaturated hues.

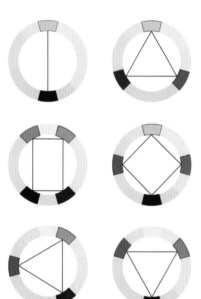

Complementaries across the circle

Using a color circle, harmonious color relationships can be worked out very easily. The only requirement is that the colors used are arranged symmetrically around the circle's center. Given this, pairs and groups of three, four, and more produce a sense of balance.

Complementary proportions adjusted for brightness

Using the relative brightness of pure colors explained in the text, the balanced combination of complementaries, and of the basic three-color sets, looks like these individual blocks.

Brightness and proportion

Even without considering complementaries, a combination of dark and light, tends to look more harmonious when the framing takes this into account. As always, however, harmony is not a rule, and is only one possible component in an image.

Color circle

A color circle, as used in the complementary color examples, with all the colors visible.

Chevreul, who discovered simultaneous and successive contrast, took his results further than just proclaiming a law of perception. He made an esthetic judgment: "In the Harmony of Contrast the complementary assortment is superior to every other." This assumption has been repeated many times since, and the optical effects that he found give it some justification.

Brightness comes into the equation. It is not quite enough to say that certain pairs and combinations of colors are harmonious. Each color has an intrinsic brightness, so complete balance requires that the combinations be seen in certain proportions. In photography, this is complicated by the details of texture, shape, and so on. The color in photographs is enmeshed in the structure of the subject. As a start, however, we can look at the basic combinations of primaries and secondaries. The complementary for each primary color is a secondary: red/green, orange/blue, yellow/violet. However, we have already seen something of the differences in brightness among these six colors, and the strength of each in combination follows this. In descending order, the generally accepted light values, originally determined by the German poet and playwright J.W. von Goethe, are yellow 9, orange 8, red and green 6, blue 4, and violet 3. When they are combined, these relative

Harmony by similarity
Choosing a range of colors that are all adjacent on an arc of the color circle ensures a comfortable relationship between them. The color bar shows this diagramatically and the two photographs show a practical application. An alternative is to modulate one color by saturation.

values must be reversed, so that violet, for example, occupies a large enough area to make up for its lack of strength. The areas needed for these colors are, therefore: violet 9, blue 8, red and green 6, orange 4, and yellow 3.

The color blocks above illustrate the ideal balance proportions of the three complementary pairs and the two sets of three. Other combinations can be worked out in the same way. For simplicity and continuity, the proportions shown here are for pure standard hues, but the principle applies to any color, whether intermediate on the color circle, a mixture, or poorly saturated. The brightness or darkness of the hue also affects the proportion.

There is a very important caveat to this principle of color harmony. You can apply it with complete success, but its foundation is the psychology and physiology of perception and no more. Used precisely it has something of a mechanical, predictable effect, and what you gain in producing a satisfying sense of equilibrium you are likely to lose in character, interest, and innovation. Color harmony can show you how to make an image look calm and correct, but it is hardly conceivable that anyone would want all or most pictures to generate this impression. You should know the base-line of color harmony, but only as a foundation. Good use of color involves using dissonance and conflict where appropriate.

A different approach to harmony is unity through similarity, which essentially means choosing a set of neighboring colors. These could be neighbours in hue—all from one side of the color circle—or else modulations in saturation or brightness of a tighter set of hues. There is a long history in art of achieving a gentle, pleasing range of colors in this way. Art historian Kenneth Clark made the analogy that colors "close together have a spectacular beauty—they are often like the faintly shadowed vowel sounds so often a source of magic in verse."

Mixing with blur

One highly characteristic feature of photography is optical blur—a gradual softening and mixing of the image away from the distance at which the lens is focused. Gradated focus is even considered to make an image "photographic," and received attention from Photo-Realist painters beginning in the 1960s. In terms of color, defocusing blends hues, as these images show. This apparently natural optical effect has itself a harmonizing property, whatever the colors.

Red and green

This combination of the strongest hue (red) and the most common in nature (green) is frequent and powerful, although the most balanced mixture uses a bluish green.

Pure red and pure green have the same luminosity, and so combine harmoniously in equal proportions. This, however, presupposes that both colors are pure and exact, though of course this rarely happens, and in practice there is little point in measuring the areas precisely. Indeed, although both red and green have wide ranges, the actual perceptual complementary to red is closer to cyan than to green. In nature, red/green combinations are mainly limited to plant-life; although green is abundant in many landscapes, red is much less so. An early *National Geographic* cliché was a red-jacketed figure in a landscape, as a simple means of drawing attention, and many photographers will seek to include an area of red in an otherwise largely green image, simply to draw the eye.

Red and green, when they do have the same luminosity and are saturated, exhibit the color effect known as vibration. Irritating though it can be when you look at it for a period of time (and problematic for some

▷ **Jacaranda**
On the margins of red, in the direction of mauve and purple, this lone flowering jacaranda tree in the Amazon rainforest nevertheless creates an image that draws on the red-green principle of harmony.

▷ **Restaurant sign**
The glass wall entrance to a Thai restaurant designed by a Japanese in Tokyo features a subtle pairing of the two colors for a delicate, intricate effect.

Berries
A sprig of glossy red berries in dappled woodland in New Brunswick appears all the more intense for being surrounded by green.

Mandala
A mandala made by pouring lines of rice onto a painted surface, at a Jain temple in Gujarat, India. The detail was cropped in-camera to give equal weight to the red and green.

types of TV screen and computer display for that matter), the effect is eye-catching and dynamic, and greatly enhances the energy of an image. To some extent it occurs between any two brilliant colors, but nowhere is the effect as strong as it is when red is involved, and it happens most distinctly between red and green.

As you might expect, changing the proportions weakens the harmony. However, when the balance is extreme, the smaller

color acquires extra energy. Compare the two pictures on the opposite page; instead of a color combination, we could see them as examples of a color accent. The lettering is proportionally a smaller area of the image than the lavender tree, but it probably stands out more strongly. The effect is also stronger when red is on a green background than vice versa, because of the tendency of warm colors to advance while cool colors recede. This effect is reitterated in the berries picture shown at the top of this page.

Orange and blue

Of the three classic color harmonies, orange/blue is probably the easiest to find photographically, because both colors are close to the color temperature scale of light.

Orange is twice as luminous as blue, so that the best balance is when the blue is twice the area in a picture. Compared with red/green combinations, this makes for less optical confusion about which color is the background. It also drastically reduces the vibration, so that orange and blue are generally more comfortable to look at. The German expressionist painter August Macke described blue and orange as making "a thoroughly festive chord."

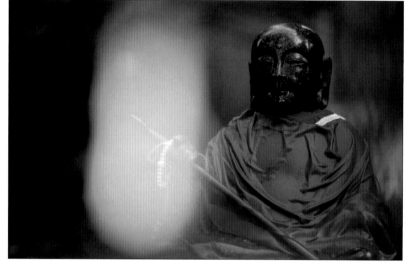

▲ **Metal shutter**

A modern house in Ahmedabad, India, uses a range of primary colors in its decoration, including these hand-made metal shutters.

◄ **Haveli**

An old courtyard house, or *haveli*, in the Rajasthani city of Bikaner, freshly painted in a pastel variation on orange and blue. The individual hues on the three images here are all different, but the combinations work visually in the same way.

▲ **Buddha and flame**

Using selective focus to combine this classic pair of colors, a blue-clad Buddha image in Koya-san, Japan, was photographed through the flame from a candle burning in front.

Orange and blue lie very close to the opposite ends of the color temperature scale, so that they can be found in many common lighting conditions. A low sun, candle-light, and low-wattage tungsten light bulbs are some of the sources of orange—not pure, but close enough. On the other hand, a clear sky, and the light from it, is a ubiquitous blue. At sunrise and sunset, therefore, there is a natural complementary effect from the orange sunlight on the one side and the blue shadows on the other (and it was Leonardo da Vinci who appears to have been the first to notice this). As well as contrasting in brightness, orange and blue have the strongest apparent cool/warm contrast of any primary or secondary pair of complementary colors. This produces an advancing/receding impression and, with the appropriate setting, a relatively small orange subject stands out powerfully against a blue background, with a strong three-dimensional effect.

Reverse proportions

An interesting exercise, and one that's easy to perform digitally, is to reverse the proportions between the two colors. As shown here, make a duplicate layer and on this shift all the hues 180º using the Hue/Saturation control on Master. Then erase those areas from the upper layer that you do not want to alter—in this case, the faces of the girls.

If you change the image so that the orange now dominates a small blue area, the classic effects are by no means completely lost. As the result shows, the combination of the two hues alone is enough to produce a general sense of harmony. The eye is drawn to the smaller area of color. In focusing just on this part of the image, the eye receives a local impression that is more balanced, with the blue seeming more powerful than its area merits.

Marigolds

At a restaurant in Mumbai, marigolds (the most widely used of Indian flowers) float in a blue pond. Again, camera position and cropping insure that the orange area is proportionately smaller than the blue.

Ship painting

A Greek fishing boat being painted on a quay. The expanse of blue hull, greater than seen here, and a clear space made it easy to choose a telephoto zoom setting to refine the proportions of the two colors.

Yellow and violet

The third combination contrasts the brightest and darkest colors in the spectrum, with intense results, but the rarity of violet makes it an uncommon relationship.

This third complementary pair combines the brightest and darkest of all the pure hues. As a result, the contrast is extreme and the balanced proportions need to be in the order of 1:3, with the yellow occupying only about a quarter of the image. At these proportions, the yellow is almost a spot of color, and the sense of a relationship between the two is correspondingly weak.

The relative scarcity of violet in subjects, and settings available for photography, makes yellow/violet an uncommon combination, particularly as in the ideal proportions the violet must occupy a large area. One of the few reliable natural combinations is in flowers; the close-up of the center of a violet is a classic example.

▲ Racquets
A presentation set of Real Tennis (an indoor game from which both tennis and squash derive) racquets to a member of the British royal family. Closing in to a detail made more of the color relationship.

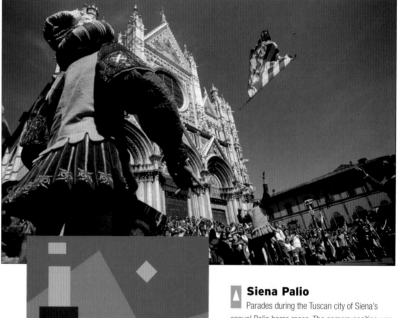

▲ Siena Palio
Parades during the Tuscan city of Siena's annual Palio horse races. The camera position was chosen to include all the components, and it also gives the opportunity to play with the yellow and purple color combination over the gray buildings.

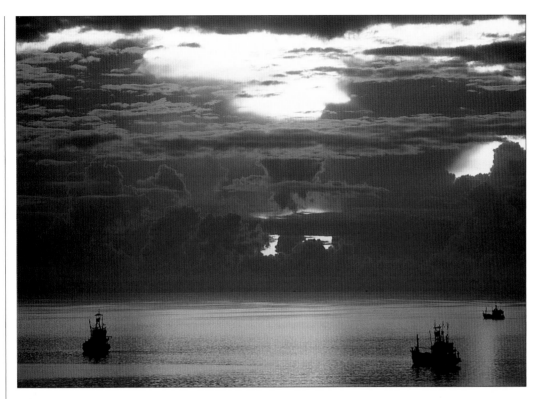

Stormy sunrise

Yellow-violet color harmony is the principal reason for the attractiveness of this dawn view of fishing boats in the Gulf of Siam. Even though the two hues are pale, the harmony is persistent, and contributes to the calm, placid feeling. The contrast has been digitally enhanced.

Flower

The very center of a violet contains this color harmony. By closing in with a macro lens, the proportions can be adjusted when shooting.

Multicolor combinations

Relationships between three and more colors in one frame become complex, and depend on strength of hue to remain significant.

The more colors that appear in a scene, the less likely they are to remain distinct as color masses. At a certain point they merge perceptually into a colorful mosaic and lose their individual identity. Several small areas of the same color do not necessarily add up perceptually to one single mass, and in real life there are limited occasions for finding even a three-color scene that is distinctive. Naturally, selective digital enhancement can help improve the relationship.

While red-yellow-blue is the most powerful mixture of pure hues, other less well-balanced combinations of color can have similarly impressive effects. As you can see from the pictures in this rest of this chapter,

Cuzco
Three color-coordinated Peruvian children crossing the square in Cuzco.

Painted Prahu

Although they are set among other, mainly neutral, hues, and scattered over the image, the intensity of the three pure primaries punches through to dominate this image of painted Balinese fishing boats. No other color combination has quite the same power and intensity, even in small quantities.

Pastel harmony

Even though the colors in this house-painting scene in northern Sudan are not precisely equilateral, they are close enough for a harmonic relationship because they are essentially pastels— paler versions of the basic hues.

Moroni market

A market in the Comoros, with a brief coming together of four primary colors.

there is a major difference between groupings of strong, bold colors and those of delicate, pastel shades. Pure hues fight intensely for attention, and the strongest combinations are those of three colors. Even a fourth introduces excess competition, so that instead of building each other up, the colors dissipate the contrast effects.

Wherever you can find groups of pure colors, they make easy, attention-grabbing shots. Being unbalanced in their positions around the color circle, they do not mix to gray in the visual cortex, and so contain the element of tension. Considered as part of an overall program of shooting, strong color combinations are the short-term, straight-between-the-eyes images. They fit well into a selection of less intense pictures as strong punctuations, but several together quickly become a surfeit.

We can extend the balancing principle of complementary pairs to three and more colors. Going back to the color circle, three equally spaced colors mix to give a neutral color (white, gray or black depending on whether light or pigments are missed). The most intense triad of colors is, as you might expect, primary red, yellow, and blue. The color effect in a photograph depends very much on how saturated they are and on their proportions: equal areas give the most balanced result.

Enhancing triple harmony

Increasing the saturation appropriately will make color relationships more distinct—though at the expense of subtlety and other image qualities. As an exercise, this image of a Shaker schoolhouse, already quite rich and sharply lit, has been given even greater saturation in Photoshop. The building itself, already neutral, is hardly affected, but the surroundings resolve themselves into a grouping of primaries.

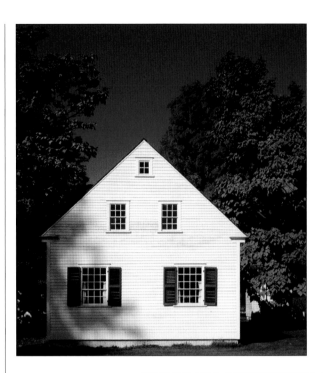

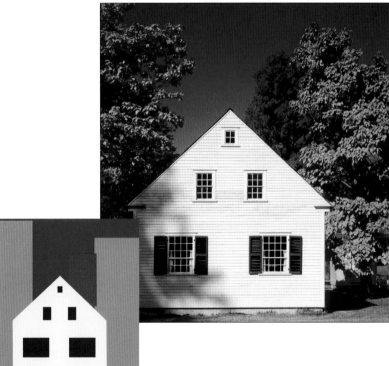

Three-way balance

Evenly spaced around the color circle, the three primary hues form an equilateral triangle. Together they cancel each other out, mixing to produce neutral gray. Also evenly spaced around the circle, the secondary hues balance each other in exactly the same way as the primaries.

Color accent

A small area of bright color set somewhere in the frame and contrasting with the background is a special case in color relationships with a particular relevance for photography.

If we accept the idea of harmony as having some basis in the physiology of perception, with a tendency for the eye to seek some sort of balance, then it's easy to see how composition in photography naturally drifts toward certain proportions between masses of color in a scene. The harmonious proportions that we looked at on the previous pages represent a higher comfort level than most. It does not, of course, make them in any sense better. This idea of a natural set of proportions has a particular relevance in photography because so much of what we shoot is "found." Faced with a scene that appears to have the potential for a successful image, the usual tactics for composition involve closing in or pulling back, altering the zoom and moving the frame, and the proportions of color brightness influence this to a greater or lesser degree.

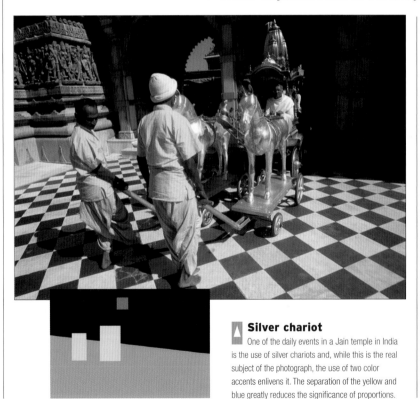

Yet when there is an extreme difference in proportion between colors—meaning when one at least is very small relative to the frame—the dynamics become those of a point within a field, the equivalent of a black dot on a white background. The proportions become, in effect, irrelevant. One color becomes an accent, or a spot color, and the eye is very much pulled and directed by its placement. When the accent color "advances" from a "retreating" background, the effect is at its strongest—as in yellow/red out of blue/green. Paradoxically, perhaps, under certain conditions the very localization of a small color accent gives it more perceptual strength.

Silver chariot
One of the daily events in a Jain temple in India is the use of silver chariots and, while this is the real subject of the photograph, the use of two color accents enlivens it. The separation of the yellow and blue greatly reduces the significance of proportions.

Drying robes

The immediate attraction of this scene as a potential photograph was the backlighting of the saffron robes enhancing the silhouette of the monk. The decision to take a wide shot was a desire to give context and to accent the bright orange color.

Because of the small areas involved, it is possible to have spot color combinations in which there are two or more different accents. This complicates matters because the two spot colors have a relationship between themselves as well as with the background. The most distinct effect is when the setting or background is relatively colorless and the two purer hues occupy localized areas. This effect was used by painters such as Delacroix and Ingres to promote harmony through variety in some of their paintings. They used scatterings of complementary colors such as blue and orange, and red and green.

This special form of color contrast inevitably gives greater prominence to what painters call "local color," the supposedly true color of an object seen in neutral lighting, without the influence of color cast. Color accents, above all, stress object color.

Splash of red

Here, in a deliberately abstracted framing of downtown San Francisco, the splash of red reflection in the truck's panel helps to tie the otherwise neutral and metallic elements together into a coherent design.

Hip joints

Here the red accent, on one of a number of artificial hip joints, stands out from an entirely neutral background.

Discord

The negative of harmony is discord, equally subjective, dependent on opinion, and liable to change. It has its own terminology, with terms such as clashing, strident, and vulgar.

▶ Carnival
Carnival in Kingston, Jamaica is an occasion for an excess of energy, not only through music and dance, but visually. The whole idea is to be bright, not restrained.

▶ Japanese kitsch
A dispenser selling cuddly toys in a Japanese city street. Pink is one of the favored colors of a deliberate kitsch, its garishness enhanced by the green glow of fluorescent lights.

Just as the concept of harmony is loaded with personal and cultural values, so its counterpart, discord, assumes a raft of opinions and prejudices. Moreover, the major underlying assumption is that there are combinations of colors that must somehow offend. This is not at all safe and yet, as with harmony, there is some truth in this, partly perceptual, partly cultural, partly to do with fashion. By definition, colors that clash cannot be from the same region of a color model. They must be distinctly different, yet without the optical connection of being complementary. This means that at least one of the colors needs to be strongly saturated. Also, any optical effect that is uncomfortable to look at can enhance discord.

Beyond these fairly basic optical and perceptual principles, discord depends on cultural values, and also fashion. Culturally, the element of disapproval is strong, as you might expect, because colors that are thought to clash are in some way at odds with whatever is safe, undemanding, and conservative. Whether in choice of clothes or in interior decor, it raises the issue of good taste versus bad, where there are no absolutes. Possibly the most common use of clashing colors is in advertising, as attracting attention overrides any questions of taste.

In art, discord is typically used to challenge assumptions, awaken the audience's attention and make statements. Kandinsky made this point forcefully in his *On The Spiritual In Art* in 1911-12 when he wrote that: "harmonization on the basis of simple colors is precisely the least suitable for our time..." going

on to proclaim that: "Clashing discord ... 'principles' overthrown ... stress and longing ... opposites and contradictions ... this is our harmony." Earlier, in *The Night Café* (1888) Van Gogh used discord to communicate what he wrote of as a place where one could go mad: "I have tried to express the terrible passions of humanity by means of red and green ... Everywhere there is a clash and contrast of the most disparate reds and greens." This may sound at odds with red-green harmony, but he chose greens that tend towards a livid yellow.

Deliberately offending is also a staple of conceptual art, and it has the same possibilities in photography. To date, however, there have been few photographers who have made any notable use of clashing colors, and the reasons are not hard to find. Before digital, choosing colors in photography meant finding them in real life and composing to fit. As discordant colors tend to be avoided when most people are making color choice, they are not common. British photographer Martin Parr is one of the few who have made a signature of this kind of color combination because it is an integral part of his preferred subject matter—the vulgarity of the British on holiday.

Digital imaging allows such choice of color to be made by the photographer independently of the subject matter, if wanted. Individual colors can be enhanced, shifted, or, if necessary, completely replaced. This is still an under-explored area. Like everything else in color choice and manipulation, there needs to be a sound reason, and more conspicuously so if the aim is to increase visual discomfort.

Notionally the opposite of harmony, discord is, if anything, more problematic because of its negative connotations. To say that two or more colors in combination are discordant—that they "clash"—is to suggest that there is something wrong about the choice. Just as there is an underlying assumption that harmony is generally a good thing, the idea of discord carries with it the sense that it is better avoided. These are clearly dangerous assumptions, if only because they rest on the idea of an established order.

Teej festival

In this annual celebration near Kathmandu, a line of Nepalese women exhibit a vibrant clash of brightly colored saris. Discordant, certainly, but also full of energy.

Van Gogh's palette

It's always useful to learn from a master. In the first of these proportionate color bars, taken from Van Gogh's *Night Café*, the painter strived deliberately for discord. Compare this with the colors used in *Bedroom At Arles*, in which he aimed for harmony.

Muted colors

The majority of colors facing the camera in the real world are very far from pure, and while they have less impact, the subtle variations can be very enjoyable.

In traditional color theory, the pure colors have prominence, and painters are trained to construct hues from the primaries and secondaries. In contrast, photography deals almost exclusively with the range of colors found in the real world, and its color priorities are consequently different. As we have seen through cataloging the principal hues, they are not particularly common in nature. Most found colors can be seen as "broken"; that is, they are seen as a mixture of hues that gives a deadened, unsaturated effect.

Such muted colors are, however, very rewarding to work with, because of the great variety of subtle effects. Color theory gives an artificial stress to the pure primary and secondary colors, as these are the foundations of all others; it would be a mistake to infer that pure hues are inherently more desirable in a picture. The differences between soft colors are on a much narrower range than the pure colors, and working constantly with them trains the eye to be more delicate in its discrimination, and to prize rare colors. Russet, sienna, olive green, slate blue—these and an almost limitless variety of others, including the chromatic grays, make up the broad but muted palette of colors available for most photography.

Muted colors

PAPAYA WHIP

BLANCHED ALMOND

BISQUE

PEACH PUFF

NAVAJO WHITE

MOCCASIN

CORNSILK

IVORY

LEMON CHIFFON

SEASHELL

HONEY DEW

MINT CREAM

AZURE

ALICE BLUE

LAVENDER

LAVENDER BLUSH

MISTY ROSE

▶ **Caen Hill**
A remarkable flight of locks in the English canal system. The extremely diffuse light of a dull day is ideal for this image, allowing the geometric succession to dominate.

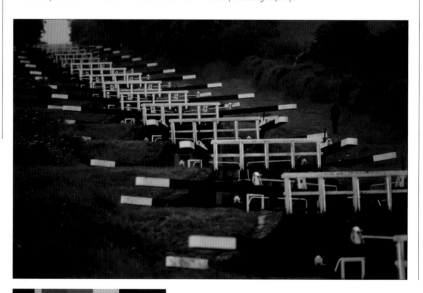

◁ Soft furnishings

In a modern Indian apartment, beige and pale silvery grays are the designer's theme for this corner, with an organza screen, couch, and pillows.

△ Pastels

Faded jeans and a pale yellow Samba dress have a pastel effect during "Brazilian day" on the streets of Paris.

▷ Jaipur balcony

A gentle combination, though colorful, of shutters and a balcony in the Rajasthan city of Jaipur. This is an example of pastel color.

Darkness, as in shadow detail, is necessarily devoid of strong color, as the Dutch tenebrist painters such as Rembrandt and Frans Hals discovered. These "painters of shadows" excelled at their handling of the lower tonal range by using palettes that were almost monochromatic.

At the other end of the brightness scale are pastel colors. These, from a painter's point of view, are created by adding white rather than gray or black, so that they are never muddy in appearance, but rather soft, delicate, pale, and light, retaining a hint of the purity of the original hue from which they derive, without the strength.

△ Roast suckling pig

Brown, here in a rich, reddish form on the glazed skin of spit-roasted pork in a popular restaurant district in Manila, is the most well-defined of all muted colors. Others, such as drab greens, are variations of more saturated hues, but brown is always under-saturated.

Case study: **unreal color**

Until now, photography has not had the technical opportunity to render colors in any way the artist pleases. Digital imaging, however, allows total manipulation of color, as we have partly seen already. Add the techniques of selection discussed earlier to the methods of altering color, and you have a powerful set of tools that you can use to express the color of an image as you like—and as radically as you like.

◄ Broad bean salad
The original dish, with a bed of beans the color that anyone would expect them to be (British broad beans are similar to Fava beans).

◄ Duplicate layer
Because there will inevitably be some retouching, and maybe even changes of decision, it makes sense to perform the operation on a duplicate layer.

◄ Replace color
The easy choice for altering a selected color is the Replace Color command. The color sampled is the green of the beans, and the Fuzziness increased to include all of them. This also takes in some of the egg yolk, but we can deal with that later. The Hue is shifted towards blue, Saturation increased to make this more definite, and Lightness increased slightly to taste.

**Stage one
alteration**
This is the effect of
the Replace Color
procedure—on the whole
as wanted, but the egg
yolks have taken on a
greenish tinge. I want to
eliminate this, otherwise
the image will seem
simply to have been
colored blue. The yolks,
when yellow, will make
a contrasting reference
color. Because the
operation has been
performed on the upper
duplicate layer, it is a
simple matter to use
the Eraser brush
to take these
discolorations out.

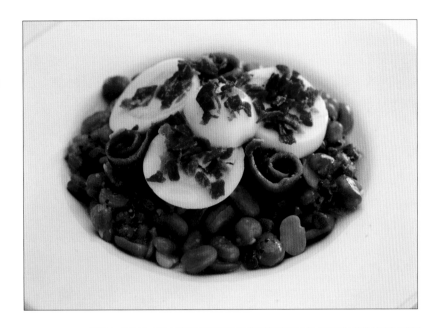

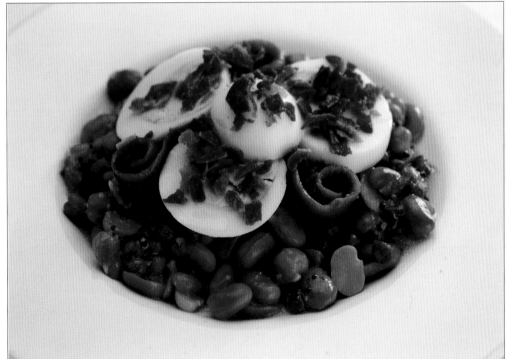

◀ **Final image**
With the duplicate
layer retouched to reveal
some areas of original
color from the background
image, the image is
flattened. The result is
a truly unappetizing
dish that no-one in their
right mind would want
to sample.

The language of **Mono**

Creatively, it was a fortunate limitation that photography began in black and white. Technically, this was all that was possible when, in 1826, Nicéphore Niépce became the first person to fix an image permanently. He used a light-sensitive coating that hardened on exposure, allowing the areas that received little light to be washed away. So, as we can see, photography started as an invention that relied on quantity of light, not wavelength (which determines color).

This was certainly a restriction in terms of photography's ability to reproduce scenes, so why was it fortunate? The palette was restricted, but this had the effect of confirming photography as a creative medium in its own right. Quite apart from the huge conceptual difference between capturing a photographic image from life and constructing an image through painting or draftsmanship, the single scale from black to white made the jump from reality to interpretation a definite one. Color photography became possible as early as 1903 with the invention of the autochrome process, and by the 1960s had become commonplace, yet black and white didn't disappear and wasn't seen as inferior. Rather it acquired an even more particular identity. Essential to shooting in black and white is the ethos of "less is more," in which the loss of color positively helps to focus attention on other relationships in the image. Removing the component of hue focuses attention more closely on the intricacies of modulation of tonal shades, and there is an element of rigor—that of a formal discipline that often gets lost in the emotional and cultural associations of color. Indeed, until very recently black and white has been central to the development of photography as an art, and as a means of communication. It allows photographers the freedom to select from the full-on richness of the colorful world, to make personal choices and express their individuality.

What we could call the language of black-and-white photography, therefore, is strongly oriented to the graphic qualities of proportion, line, shape, form, and texture, and in a way this recapitulates the Renaissance view of art. Writers on painting, such as Cristoforo Landino, were accustomed to separating the elements of painting into, for example, *rilievo* (modeling in the round), *compositione* (composition), *disegno* (linear design), and *colore* (color). The skills of draftsmanship, in working with line, shape, and volume, were considered to be different in principle from the handling of color, even though all were combined in an oil painting. Fast forward to photography, and we find that the very real separation that occurred because of the early process has persisted, at least for photographers who find it creatively liberating to put all their energy into imaging without color. In particular, a large part of the pleasure of black and white is dealing in subtle distinctions, and we can see this, for example, in high-quality printing. For most monochrome photographers this is the ultimate objective, and as we will see, being able to discern detail in shadows and highlights is one of the hallmarks of excellence.

Different concerns

Switching between color and black and white photography calls for a shift in our way of seeing, with important changes in the graphic priorities for the image in question.

▼ **Portraiture**
The dynamics of expression, and the always compelling focus of the eyes (to which the viewer's own are drawn) make portraits less dependent on color. Nevertheless, choosing the appropriate tone for the skin is an issue.

As photography in general has moved from completely black and white to mainly color, there has been a major shift over many years in the perception of what a photograph is. When black and white was universal, everyone understood that the image was an interpretation of a scene into a very specific medium, dominated by tones. What color photography has done is to convince us that taking a picture is capturing reality in two dimensions—an illusion, of course, but an effective one. This is not a criticism of color photography, but we could say that black and white sharpens the faculty of constructing an image from a full, moving, three-dimensional occasion.

Practically, and from the point of view of composing and organizing the image, the priorities are necessarily different between color and black and white. This of course is assuming that the photographer is trying to get the most out of the medium—color sensibility from the color image or tonal quality from the black and white. In both cases we can take it as read that the basic issues of accuracy and optimization have already been taken care of, including exposure, focus and shutter speed.

With color, the concerns are dominated by the elusiveness and subtlety of defining the several million colors that the eye can appreciate. Adjusting the exposure affects not only the brightness and "correctness" of the image, but also alters individual colors. For example, with increasing exposure, red becomes pink, while with decreasing exposure, yellow becomes ocher— different colors entirely to our eyes.

In a high-contrast scene, this often means choosing between colors. Then there is the less easy-to-define overall color character for the image, made up of the relationships between hues and color cast, which gives an indication of style at first glance. The relationships between individual colors are responsible for perceptual and subjective impressions of contrast, harmony, and discord. Overall saturation, now in the digital age, is so much easier to choose than it ever was with film. This calls for more decisions on a scale from a colorful and rich rendering of the image, to a restrained, understated palette.

Against this list for color photography, the creative priorities for and black and white have greater scope and yet are more restricted. The absence of color focuses attention on specific dynamics, partly because black and white prints tend to be judged more critically in terms of tone and subtle renderings of highlights and shadows, and partly because the formal graphic qualities of shape, line, form, mass, and textural rendering are made more apparent. Finally, an issue that is now more important than ever in digital photography is that of which tones of gray best represent the original colors of a scene. As we'll see in the next chapter, digital post-production gives an infinite choice, and this new freedom takes over from the rather limited filtering that was possible with black and white film. The new technology, its possibilities, and to a certain extent its ubiquity among users, make it important to think about the visual "weight" of colors in every scene.

Bas-relief
Texture is a great strength of black and white. By finding the best light, the photographer can give the image a tactile dimension. In this case, the angle of the sun brings the stone alive.

Silhouette
Shooting into the light creates the chance to play with the dynamic range, and high contrast is another image quality at which black and white excels. Texture from reflections plays a role.

Contrasting creative concerns

Black and white	Color
Contrast	Color effect of exposure
Key	Color style
Geometry	Color relationships
Volume	Color intensity
Texture	Color into tone

Case study: **visualizing in mono**

The reality of what works as an image in monochrome, rather than in color, is complex. It depends on an interplay of content—the subject matter in front of the camera—the photographer's intention, and the all-important ability of being able to think in black and white: what one of the great technical black-and-white photographers of the 20th century, Ansel Adams, called "visualization." With content, there is a push-pull effect between subjects that have the makings of a black-and-white image through offering strong geometry, form, and texture, and those that clearly have a color component that attracts the eye through its richness or subtlety, or relationships between hues. Here and on the following pages is a set of color originals and their translation into black and white. Some work better than others, some lose through translation, and some simply work in a different but equally valid way.

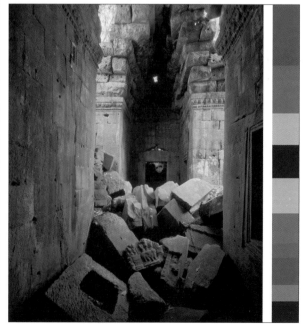

◀ **Ancient stones**

The theme of this interior of a ruined Khmer temple is variations on color, but in black and white it becomes an exploration of shadows.

▲ **Duomo**

This shot of the facade of this famous church in Milan is in color, bright but with a touch of the postcard. In black and white the sky no longer detracts attention from the form.

▲ **Tibetan streets**

The color is clearly what caught the eye in this scene of prostration at the monastery of Tashilunpho, and without the distinction of the red, the figure of the man all but disappears.

The essential graphic qualities

Restricting the palette to eliminate the complex perceptual effect of color has the effect of concentrating attention on the graphic elements of line, shape, form, and texture.

Without color, photographs automatically acquire formality of composition and tone. Irrespective of the content, the image depends for its form on the closely linked compositional elements of line and shape, and on the modulation of tone between dark and light. Not only are these graphic qualities of more importance for a monochrome image than for one in color, but also they define the character of the photograph. If the photographer chooses to emphasize one of these qualities skillfully, it can become as much the subject of the image as the physical object or scene. Each of the three examples here is essentially an exploration of one graphic element—texture, volume, or light.

Line and shape are a function of the kind of large-scale contrast that defines edges, and in black and white these are automatically more prominent than in color. How these edges divide the frame, interact with each other, and guide the eye depends on composition, and they are at their most definite in a silhouetted image. Edges enclose shapes, and these become distinct when they sit comfortably within the frame, without breaking its edges or corners.

The form of an object is a more complex quality than its shape, because it is essentially a quality of three dimensions, not two. While shape is very much a graphic and two-dimensional quality, as in a two-tone silhouetted image, form is plastic and three-dimensional, needing a lighting technique that reveals roundness and depth. Conveying volume is in many ways easier in black and white than in color, but it calls for close attention to the

Play of light
The imperfections in old glass window panes create a fluid, shifting effect as the sunlight shines through them onto a chest of drawers. The image is almost, but not quite, abstract.

way light falls on a subject. The most reliable technique is to use a carefully graded modulation of light and shade. This means, essentially, directional lighting that throws distinct shadows, and from an angle that gives a reasonable balance between light and shade. Lighting from the front casts

few shadows and so is much less effective at this than from the side. There are many variables, including the precise angle of the light, the diffusion or concentration of the light source(s), and the relationship, if any, between object and background.

Texture is the rendering of a surface, with infinite variety from smooth and shiny to rough and gritty. In a black-and-white photograph it is the interaction between the physical qualities of an object's "skin" and the way in which light falls on it. Not only is choosing the angle of lighting the key to conveying volume, but also it changes the appearance of the detailed structure of surface, and so has an effect on the tactile impression. Roughened surfaces, such as the stone in the bas-relief close-up here, typically come alive under cross-lighting that skims across them. Because texture is a quality of the detail in a subject, the closer the view, the more important it becomes.

Given the right circumstances, light itself can be the subject of a photograph. While it can never be entirely divorced from the objects and surfaces on which it falls, provided these give just enough clues to help the viewer locate the image in the real world, the play of light—its modulation—can be beautifully captured in monochrome. Provided that the effect does not depend on color contrast to work, black and white is perfect because it keeps attention on tone.

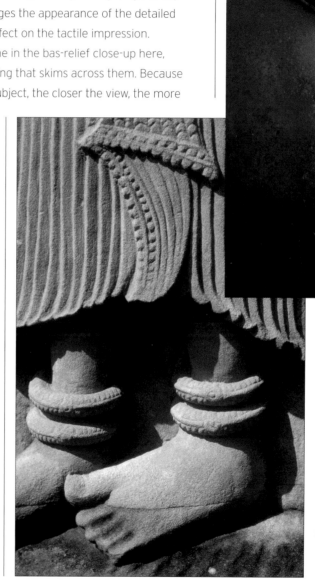

Form
In this studio-lit shot of a basalt Buddha statue, shape (outline) is sacrificed for form (volume), achieved by a single diffuse area light at an angle that reveals the rounded form of the face to shade into darkness.

Texture
A deity carved in sandstone and photographed close enough to show the fine detail of the stonemason's work and the granular texture of the stone itself. The acute angle of the sunlight to the carving, almost at right angles to the camera axis, makes this possible.

Case study: **the problem of skies**

In landscape photography, which includes architecture as well as nature, the sky and ground often form two distinct zones in the image, and do not always coexist happily. The problem is that of tonal range, because the average brightness of a sky can be several f-stops higher than that of the terrain below. It's not an issue unique to black and white, but because so much attention is focused on the tonal scale in a monochrome print, deficiencies are that much more apparent. With color an irrelevance the value of a blue sky is moot, while clouds can be a rich subject for exploration. The key is to work within the tonal range of the sky, and this often means digitally selecting the sky. This is really no more than a more precise version of "burning in" under a traditional enlarger, using your hands or a shaped card. In this shot of Angkor Wat, the sky, with its diverging lines of late afternoon cloud, is pleasant enough, but relies very much on color.

The first step is to take a quick look at the individual RGB channels for an indication of which carries the richest sky tones. As the sky in the original is blue, the blue channel lightens it almost out of existence, and unsurprisingly the red channel is the most useful. Even so, this is only the starting point, and in order to work independently on the sky, with no adjustment of the temple, it needs to be selected. Being so much paler than the stone, it is easily selected with the Magic Wand tool, and then it is simply a matter of experimenting with the Curves dialog to make it darker and more interesting.

Channels
Clicking on the Channels palette and then on any individual channel immediately displays just that selected one in black and white. The red channel predictably holds most of the tonal information of the sky.

Split Channels

The Split Channels command from the palette's drop-down menu irreversibly breaks down the image into three, from which we select the red.

Refined adjustment

Clicking on the upper corners of the sky indicates where on the curve they lie, and dragging this upper part of the curve back to the right gives a more realistic rendering.

Select sky

Using the Magic Wand tool at a tolerance setting of 20, the sky is selected by Shift-clicking repeatedly. This adds newly clicked areas to the selection.

Save selection

When complete, the selected sky area is saved as an Alpha channel.

First adjustment

In the Curves dialog, dragging the center strongly to the left darkens the sky distinctly and well, although the upper part, which in the original was the most strongly blue, is too dark.

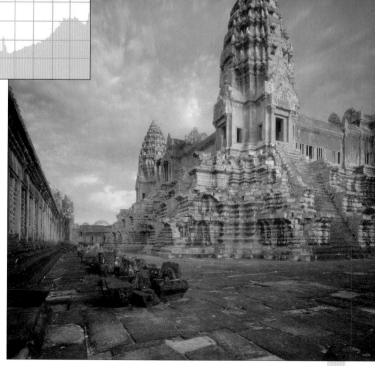

Basic color conversion

The simplest digital tools for converting color images into black and white in a single step aim for a result that accords with our innate sense of the brightness of colors.

By default, there are two simple methods of turning a color image into monochrome, and both of them are available as standard in Photoshop. One is the removal of color from each of the three RGB channels, called desaturation. The other is a one-step conversion of the three-channel image into a single grayscale-channel image—a mode change, in other words. They are almost, but not quite, the same in effect, and it is both instructive and useful to try both out for yourself on different images, and compare the results.

Saturation is the amount of chroma in an image, the intensity or richness of hues, and is one of the three elements in the HSB (Hue, Saturation,

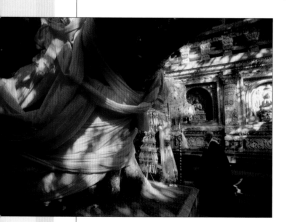

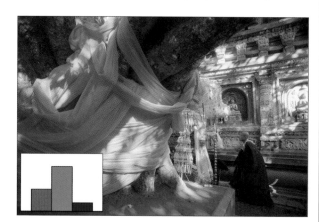

Grayscale
The Photoshop command that collapses the three color channels into one grayscale channel emphasizes green and diminishes blue. In the event, the low blue outweighs the high green to make the orange distinctly light.

Original
Saffron cloth around the tree at Bodh Gaya, India, where the Buddha achieved enlightenment. The orange will react to the channel proportions used for conversion.

Desaturate
The Photoshop Desaturate command gives equal weight to all three channels, here rendering the orange cloth noticeably darker than above. Desaturation is also available as an adjustable control in the Hue/Saturation dialog.

Brightness) color model (valuable in image editing because it closely follows the way we perceive color). The usual editing tool for adjusting it is a slider in the *Image > Adjustments > Hue/Saturation* dialog. Dragging the slider to the left reduces the intensity of all hues until, at far left, minus 100%, there is no hue—no color whatsoever—visible. This is how the Desaturate command (under *Image > Adjustment > Desaturate*) works, by fully desaturating each channel. The image remains RGB but appears in monochrome.

Grayscale conversion uses a different principle. It combines the three RGB channels into one single channel without hue, but in doing so does not necessarily combine them equally. Photoshop's default conversion algorithm (under *Image > Mode > Grayscale*) combines them in the following proportions: Red 30%, Green 59%, and Blue 11%. This conversion intent is designed to give a black-and-white result that looks natural to the eye—an effect that most people would consider to be normal, were they to give it any consideration at all. (Incidentally, this conversion reduces the number of channels from three to one, and so achieves a commensurate reduction in file size).

We can go further into this. An equally balanced conversion would be 33% for each channel (to maintain a normal level of brightness, the total should be 100%), but the Photoshop version favors green and diminishes hue. The combination keeps flesh tones looking natural, and these on balance are probably the most important for most people (though it works less well on some non-white skin tones). This procedure is a first hint of what is possible in the rich, complex, and largely new world of digital conversion from color to monochrome. The fact that the three channels can be combined in different ways has enormous implications, as will become apparent. Indeed, because you can combine them to taste, you are obliged to think about the proportions.

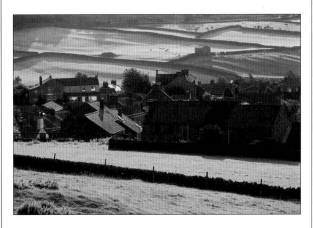

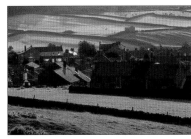

Original
In this scene of the Yorkshire Dales in England, yellow-green is the dominant color, but there is also a slight blue cast to the shadows. The equal-channel conversion produces an image with moderate contrast.

Grayscale
The default 59% green lightens the fields, while the 11% blue deepens the shadows, to give distinctly more contrast to the monochrome rendering.

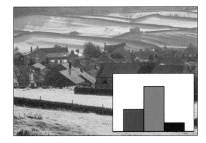

Work on a copy or Save As a Copy

There are many procedures for making radical alterations to a digital image, but one essential is to make sure that you do not overwrite the original. The most sensible working method is to make immediate backups, in which case this is not an issue. But if you decide to make black-and-white conversions before backing up the original, then first make a duplicate file, or in Photoshop Save As a Copy before you begin work. Over-caution prevents overwriting!

The traditional filter set

Long experience of translating the world of color into monochrome provided film photographers with the means to alter the brightness of individual hues.

Wratten filters

Kodak's gelatin Wratten filters are manufactured by dissolving organic dyes in gelatin, then coating this solution onto prepared glass to solidify. Following this, the gelatin is stripped off the glass support and coated with lacquer. Although fragile and easily marked, the very thinness of a traditional filter makes it optically very clear.

For film photography that allowed time to set up the shot—as in landscape, architectural, and portrait photography, rather than reportage—a set of colored filters evolved to give photographers some control over how bright different colors would appear to be in black and white. For the normal run of photography this takes too long to decide upon and implement, but when fine image quality and the precise delineation of different areas of the print is important, the tonal filtering of color becomes a special and valuable skill.

The principle is straightforward—that of using a strongly colored filter over the lens to block the light from certain colors in the scene. A green filter, for example, obviously passes green light without hindrance (which is why the filter itself looks green). More importantly, however, it acts as a barrier to opposite colors. One of the keys to color theory, for which Isaac Newton was largely responsible (at the same time as demonstrating the color spectrum), is the arrangement of these hues into a color circle. There is an important relationship between colors that face each other across the circle. They are complementary and opposite. A filter of one color will block the light from its complementary, rendering it dark, even black. The opposite of green is a variety of red, and viewing the circle through a green filter makes the reds appear darker than they would in ordinary white light.

In nature, at least on the larger scale of landscape, colors are rarely pure and intense, so there is little practical use in having a full set of filters in many varieties of hue and strength, quite apart from the complications of handling them. The traditional filter set, even for photographers who made full use of this technique, rarely contained more than a few, and the standard ones were drawn from Kodak's Wratten series, as shown here. Choosing and using them was (and is) by no means simple. They demanded experience in knowing what the results would look like; an adjustment for the density of the filter; and judgment in how light the filtered color should appear, and how dark the opposite colors. As the table shows, there was a small number of basic predictable effects, from darkening skies to minimizing freckles, and these are explored in more detail later.

For the few digital cameras that offer black-and-white image capture as an alternative to full color, these traditional filters work in the same way as they do with black-and-white film. They also work, of course, with regular RGB digital image capture, but this is pointless and time-consuming given that the same results, with all the benefits of other software tools, and of course the ability to undo, can be achieved by manipulating channels in post-production—the subject of the following pages.

Filters

Yellow Kodak Wratten filters

8 Yellow. Darkens blue sky toward the expected response of the eye.

9 Deep Yellow. Similar to 8, but the effect is a little more dramatic.

11 Yellow Greenish. Darkens blue sky and slightly lightens definite green foliage.

12 Deep Yellow. Also known as Minus-blue. A definite darkening of blue skies and haze penetration.

15 Deep Yellow. More dramatic darkening of skies in landscape photography.

Orange and Red Kodak Wratten filters

16 Yellow-Orange. Greater over-correction of blue than the yellow filters. Darkens green vegetation slightly.

21 Orange. Absorbs blue and blue-greens for higher contrast in many landscape situations.

25 Red Tricolor. Extreme darkening of blue sky and shadows under a blue sky, with contrast-heightening effect.

29 Deep Red Tricolor. The strongest darkening of skies possible with a lens filter.

Magenta Kodak Wratten filters

32 Minus-green, for the strongest darkening of greens.

Blue Kodak Wratten filters

44A Minus-red, for darkening reds.

47 Blue Tricolor. Lightens blue skies, enhances distance effects and often lowers contrast in landscape photography.

47B Deep Blue Tricolor. Stronger effect than 47.

Green Kodak Wratten filters

58 Green Tricolor. Darkens flesh tones for a more natural effect with Caucasian skin, and makes lips appear more definite.

61 Deep Green Tricolor. A stronger effect than 58.

The most popular traditional filters for black-and-white photography on film

Wratten 12 Yellow	Wratten 58 Green
Wratten 25 Red	Wratten 61 Deep green
Wratten 29 Deep red	Wratten 32 Magenta
Wratten 47B Blue	Wratten 44A Cyan
Wratten 47 Deep blue	

Using channels

The three RGB channels in a digital photographic image each display a unique tonal version in black and white—the starting point for complete control over the final conversion.

Channels get right to the heart of black-and-white, because each one is monochrome. Open any RGB image in Photoshop and click, one by one, on the Red, Green, and Blue channels in the Channels palette. Depending on how colorful the original image was, they will differ from each other quite noticeably. This is the digital equivalent of using black-and-white film with strongly colored filters over the lens. Looking at the red channel is like shooting through a deep red filter, adjusting of course for the exposure. Like a filter, the red channel passes so much of the light from a red object, like the balconies of the Japanese pagoda shown here, that it appears very bright. Colors that contain very little red, such as a deep blue sky, hardly register at all in the red channel, and so appear dark.

Extracting a single channel

In shots with strong color elements, the three RGB channels will look quite different, and may even impart an unexpected atmosphere. From this color image of Daisho-in temple on the sacred Japanese island of Myajima, the red channel predictably brings a harsh contrast, but the blue channel delivers a soft, misty view.

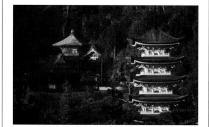

Red channel

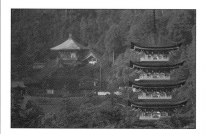

Green channel

Blue channel

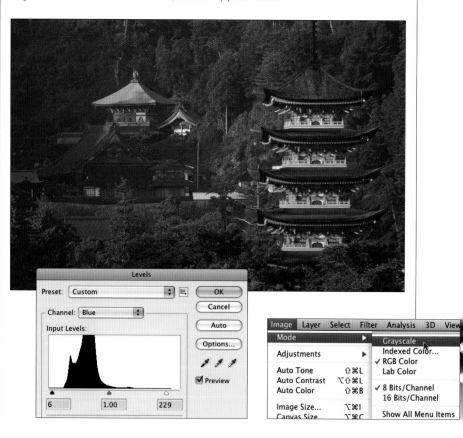

This has obvious creative uses. The three channels offer different, but perfectly valid, conversions from color to black and white. Extracting one is a simple two-step affair, as shown. There are further possibilities, too. Convert to CMYK and click on these new channels individually. Or delete one channel. The tonal relationships within the image shift with each move.

But selecting individual channels is just the start, because they can be blended—in monochrome—in any combination at all. The ideal tool for this is within Photoshop, the Channel Mixer accessed under *Image > Adjustments*. For black-and-white imagery, check the Monochrome box in the dialog window, then experiment with the channel sliders. 100% Red, with 0% Blue and Green, is the equivalent of looking at the Red channel on its own. An equal 33% for each channel is the same as a straightforward desaturation without bias. Other combinations favor different colors, and merit experiment on an image-by-image basis. In order to keep a sensible overall tonal balance, neither too dark nor too bright, the percentages should add up to +100%. Nevertheless, some startling effects are possible by straying deliberately from this while using the Constant slider to compensate for the brightness. This fourth slider adjusts the values of the output, from solid black at far left to pure white at far right. As the three channel sliders each cover a 200% range, this leaves a lot of room for dramatic effects.

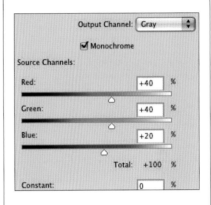

Channel mixing

Using the Channel Mixer in Photoshop, with the Monochrome option checked, gives total control over the proportions of the three primary colors—up to 200% in either direction, positive to the right and negative to the left. The Constant slider usefully allows you to compensate for difference in brightness when using such extreme settings, as in the two of these examples.

Default black and white

The two most basic ways of extracting a monochrome image from a full-color original are to convert to grayscale (*Image > Mode > Grayscale*) and to desaturate (*Image > Adjustments > Desaturate*). The effect is the same, but with desaturate you retain the three color channels. Each of the three channels is affected equally.

Individual channels

A simple and effective way of achieving distinctly different tonal renderings of color in monochrome is to separate the individual color channels.

A standard RGB digital image is made up of three channels, each carrying the information from a distinct wavelength. The tricolor method of reproducing the full spectrum of color is at the heart not only of photography but of human vision, and goes back to the discovery in 1872 by James Clark Maxwell that the eye perceives color by means of just three pigments in the retina—red, green, and blue. Color film uses the same principle, as do the sensors in digital cameras—and color monitors for that matter. The most

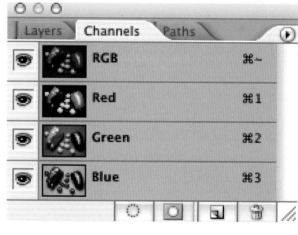

RGB channels
In a standard color image from the camera, the full color (top) is made up of red, green, and blue channels, seen split into their monochrome versions below.

Split channels
The Split Channels command neatly divides the image into three (if RGB) or four (CMYK) black-and-white images.

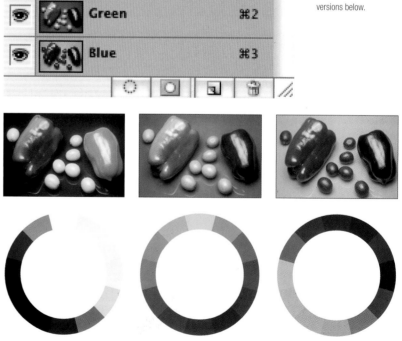

Red Green Blue

common image mode is RGB. The Split Channels technique is the simplest way of making the conversion, and if compared with a standard Grayscale conversion, you can see the difference that individual channels make.

The scale of this difference, of course, depends on how pure and how distinct the colors of the original are. For the example below, we've taken an extreme of four—a red and a green pepper, and lemons, on a blue plastic background. These are complicated slightly by difference in brightness as well as hue; the peppers and background are close to each other, but yellow is inherently much brighter than any other color. There is no such thing as a dark yellow; it simply becomes another color, such as ocher.

Using channels is the equivalent of using strongly colored traditional lens filters. The red channel passes the red component of the image, so that this is light in tone. At the same time, it blocks other hues in proportion to how different they are from red. The most distinctly opposite color from red is cyan, with blue close by. Hence, the red channel in this example brightens one of the peppers, darkens the other somewhat, and strongly darkens the background. Equivalent changes happen with the green and blue channels. To make this clearer, I've included a standard 12-zone color circle with the hues arranged so that they oppose each other across the circle.

One other color mode offers three different tonal interpretations, although not in the way you might expect. CMYK is used for offset printing, and while it is normally avoided by photographers because of its smaller color gamut than RGB (and because digital photographs are RGB to begin with), it has three color channels with extreme effects, and black (K). However, while intuitively you might imagine that these channels, once split, would lighten cyan, magenta, and yellow respectively, because of the different construction of a CMYK image file, they darken these colors. In practice, as the color circles show, the cyan channel behaves like an exaggerated version of the red channel, magenta a slightly strengthened version of green, and yellow as a strong blue.

CMYK channels

Converting the image to CMYK mode makes it possible to split it into the complementary color channels cyan, magenta, and yellow. The black (K) channel is normally of no use for this exercise.

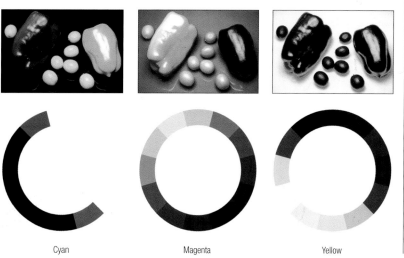

Cyan Magenta Yellow

Practical channel mixing

The most powerful and flexible way to control channels is to mix them as percentages with monochrome as the output, using Photoshop's Channel Mixer.

The principle of channel mixing is simple enough, but the implications are considerable. A set of sliders allows you to choose the percentages of each channel used in the final output, no more, no less. Simply click the Monochrome check box before starting. The range of adjustment extends not just from 0% to 100%, but down to minus 100% as well. This makes some extreme, even bizarre, effects possible. Average brightness normally depends on keeping the sum of the three percentages in RGB at 100%, but a fourth slider—Constant—controls brightness so that even extreme adjustments can be kept at a reasonable tonality. It can be adjusted to compensate, since otherwise combined RGB percentages higher than 100% will give a lighter image, lower percentages darker. use with caution though: at the extremes the contrast may be unusually high or low.

In practice, the four sliders give a huge choice and experimentation tends to be most people's approach. The examples here give an idea of what is

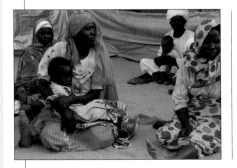

Color original

This picture of Sudanese women and children is a useful example thanks to its strong and varied colors; there are neutral areas (the background), and dark, medium, and light shades.

A variety of mixes

Five different mixes of the three channels illustrate at a glance how powerful this control is. Mix (1) has the default equal values for all three (equivalent to Desaturate). Mix (2) is the opening setting for the mixer (100% red). Mix (3) is the default Grayscale Mode conversion. Mixes (4) and (5) aim for the darkest and lightest renderings possible of the orange garment.

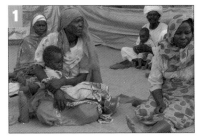

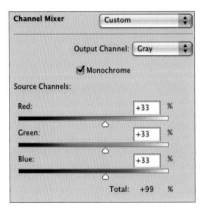

Channel Mixer	Custom ⬍
	Output Channel: Gray ⬍
	☑ Monochrome

Source Channels:

Red:	+33 %
Green:	+33 %
Blue:	+33 %
	Total: +99 %

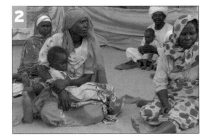

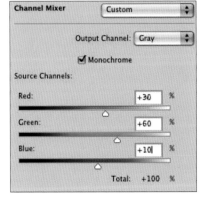

Channel Mixer	Custom ⬍
	Output Channel: Gray ⬍
	☑ Monochrome

Source Channels:

Red:	+30 %
Green:	+60 %
Blue:	+10 %
	Total: +100 %

possible, though it can help to go through the procedure outlined on the previous pages, and see how the image looks channel by channel to get a sense of what direction to aim for. The essential point is that channel mixing gives total control over the spectral response of a black-and-white image. As the Extremes box illustrates, even unlikely and unnatural translations are possible, such as a black yellow and a white red.

The example here, of Sudanese women in their traditionally colorful robes, was chosen with care, because it contains two distinct sets of colors—neutrals and strong hues. The near-neutrals are the gray tarpaulin background, the white clothing, and the skin tones, which are actually a dark brown (a median value of Red 80, Green 50, Blue 35). These change very little whatever permutations of the channels are selected, but they do provide a valuable guide to optimal brightness of the image. One of the issues with channel mixing is that it can alter overall contrast and brightness to extremes. Clearly, there are few reasons for clipping either highlights or shadows, and it is usual to keep an eye on both the lightest and darkest areas to make sure that they remain readable. Yet there is still often plenty of room for placing the mid-tones high or low, and this is not always easy to judge. The Histogram palette helps.

Interactive histogram

As an aid to alerting you to clipped highlights and shadows, and to indicate the position of the mid-tones, keep the Histogram palette open, preferably the expanded view with all channels showing, and uncached refresh. The original histogram will be in gray, and any changes you make with the channel sliders will display instantly in black (easier to read than the "Show Channels in Color" option).

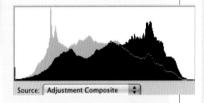

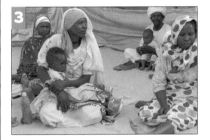

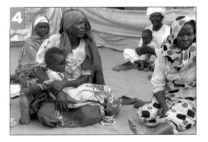

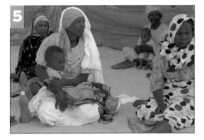

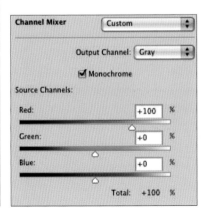

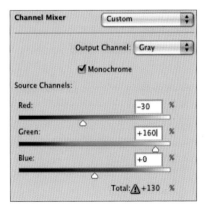

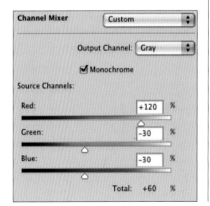

Using an adjustment layer

Many of the image alterations commonly performed in converting to black and white and manipulating tones can be made in the form of adjustment layers.

Photoshop's adjustment layers are usually promoted for their ability to work non-permanent changes on an image—they sit over the original and can always be revisited and adjusted over and over again. Arguably more important is that they allow constant feedback to complex changes that are not easy to predict, as is very much the case with channel mixing. As should be evident by now, and certainly after the several examples throughout this chapter, channel mixing is absolutely the method of choice for converting color to black and white, but it adds a layer of complexity to the entire procedure, which also includes setting black and white points and adjusting Curves. One of the difficulties with channel mixing is that it is yet another permutation, and because it is performed as part of a sequence, you may need to retrace your steps to see its effects on a different Curves or Levels adjustment.

Adjustment layers go part of the way to alleviating this. Opening a Black & White layer (*Layers > New Adjustment Layer > Black & White*) allows for exactly the same adjustments as if you performed them directly on the image, but they reside in their own (disposable) layer. If, having adjusted the tints in a particular order, you then activate the underlying image (Background), any changes you make here will immediately be translated into a black and white mix.

So, for instance, you can raise or lower the saturation on the Background image and watch the effect filtered through the Black & White adjustment. These other adjustments can, of course, themselves be made via adjustment

◢ Original
This view of a volcanic crater lake in Indonesia has one distinct color only—green—with just a hint of blue in the sky. We'll use three adjustment layers to convert it. The first step, from the choice of a dozen adjustment layers, is Levels, for a basic optimization.

◧ Black/white points
The first step is to set the black and white points, as usual in optimizing. Here there is no real need to check the effect visually, and using the Auto command in Levels works perfectly.

◨ Resulting histogram
The resulting histogram shows the values spread fully across the range.

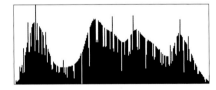

THE LANGUAGE OF MONO

layers. Because the channel mixing is the stage at which the color image is converted to grayscale, the Black & White or Channel Mixer adjustment layer (you only need one of the two) always needs to sit on top of the layer stack, which could reasonably contain, for instance, a Levels layer, Curves layer, and Hue/Adjustment layer. And more. Double-clicking on the layer thumbnail brings up the dialog window for any adjustment layer and allows you to continue making changes.

And the disadvantages of using adjustment layers? None really, but I rarely use them in practice, and the reason is simply that I prefer to make the decisions and move on, rather than leave an image with a stack of changeable options. In a professional image workflow, there is often not enough time to keep going back and tweaking unfinished business (though clearly you must keep a copy of the original unconverted file). Obviously, this does not need to apply to a more personal, leisurely way of working. The interactive nature of adjustment layers, on the other hand, is definitely an advantage while assessing the effects of different procedures on the final conversion to black and white.

The ready-attached layer mask

Open a Channel Mixer adjustment layer and you will see from the Layers palette that it already has a layer mask. Having made the mix of channels, the image as it appears will be in black and white, but by choosing a paintbrush with the foreground color set to default black, you can paint onto the mask in order to remove the black-and-white conversion. Do this selectively and you can make a partly colored/partly monochrome image, as if hand-painted.

Mono
The result of the three operations is this monochrome rendering. However, studying it, I think I would like to light up the lake even more.

Curves layer
The second step is to adjust the mid-tones within the range. To place more visual emphasis on the crater, the brightness of the clouds is reduced by dragging the upper quadrant right, while holding the dark areas in their original tones with a second point at lower left.

Black & White layer
A layer is added which mixes the channels in order to brighten or darken the selected part of the spectrum, much like a task-specific channel mixer. The aim is to lighten the green so that the lake glows, reduce the blue in the sky, and make up the tonal difference in red.

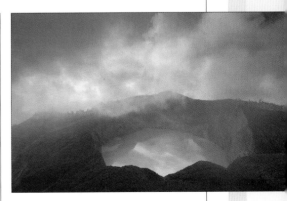

A fourth layer
Rather than interfere with the channel mix already created, we can adjust the green of the lake easily by adding a Hue/Saturation layer and increasing the green saturation. Effectively this increases the effect of the channel mixing.

Case study: **appropriate proportions**

In this reasonably straightforward example, a Shaker village in New England with fall colors, it's clear that channel mixing has enough difference in hue to work on. The focus of attention is the complex of buildings, which are close to neutral, with white wooden walls and close-to-black roofing. In other words, there is no reason for them to be much affected by what we do with the channels—we need only ensure that the overall tonality from the walls to the roof remains unchanged. Using a desaturated version as a guide, I can work toward a more pleasing black-and-white conversion. The aim is to be true to the overall impression of fiery leaves. Also, I'm happy to have a more "thundery" impression from the sky, even if it is not exactly realistic and lacks a sense of "lift" behind the buildings. The final result, as always, is one person's interpretation and not in any sense "correct."

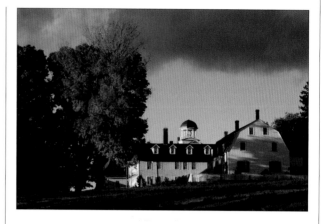

Color original

This fall view of Shaker buildings in New England is so successful in color that ordinarily I would not try a black-and-white conversion. Nevertheless, for the purposes of the exercise it offers a challenge because it works by virtue of a combination of lighting and color.

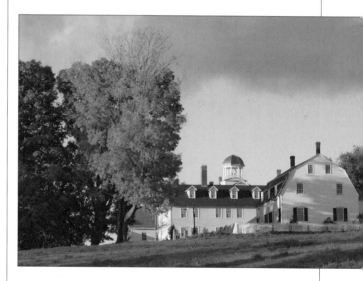

Default desaturation

For reference, this is the default conversion from the Desaturate command, which gives equal values for all three channels. My immediate impression is that the sky is too light, the grass slightly dull, but worst of all, the rich glow from the tree has been lost.

Channel Mixer Custom

Output Channel: Gray

☑ Monochrome

Source Channels:

Red: +76 %

Green: +12 %

Blue: +12 %

Total: +100 %

Constant: 0 %

Raised red

Raising red to 76% while lowering green and blue equally to 12% gives a perceptually more true result, but I still think it could be improved.

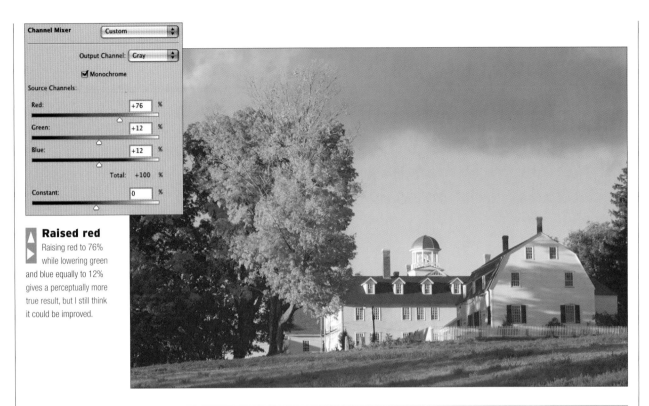

Final

So, a very high red value with a low blue value achieves the bright leaves, and the effect on the grass is to deepen the shadows, by contrast making the lit areas of green appear brighter. Given this, there's no need to adjust the green channel.

Channel Mixer Custom

Output Channel: Gray

☑ Monochrome

Source Channels:

Red: +112 %

Green: 0 %

Blue: -22 %

Total: +90 %

Constant: 0 %

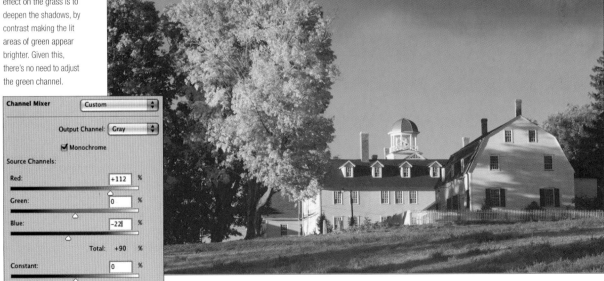

Case study: **mixing to extremes**

With all three channel sliders capable of being adjusted upward and downward by 200%—an overall range of 400%—tones of individual colors can be altered far beyond any realistic interpretation. The occasions for needing to do this are few, but in these two examples I wanted to see how close to white (and later black) it would be possible to shift one specific hue in a photograph. In theory, any hue can be rendered at any level on the tonal range, from 0 to 255, but the difficulty is keeping the rest of the scene within range. Strong movements of one slider need to be balanced by opposite movements of either or both of the others. Analyzing the RGB values of the target hue makes it easier to decide what the proportions of the mix should be.

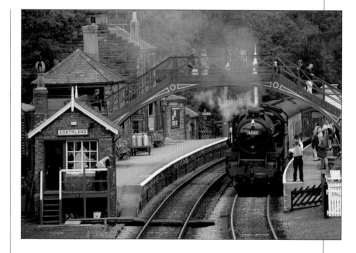

Goathland
In the case of this preserved railway station in the north of England, the target hue is the orange of the safety vests. Even at a glance, it is clear that the colors of most of the scene are weakly saturated; grays, dull greens, and browns predominate. Even strong channel mixing is unlikely to have much effect on these, so it should be easy to concentrate on altering the orange.

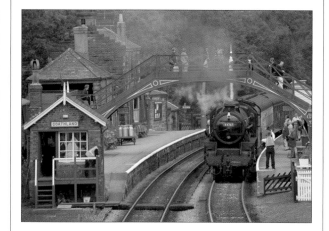

Default conversion
As a reference, we first make a standard Photoshop Grayscale conversion and save this as a copy. This renders the orange as a medium-light gray (25%), the same as the surface of the platform.

▶ RGB analysis

The vests, in this overcast light, are a consistent strong color, well saturated. Running the cursor over them with the Info palette visible shows the RGB values, which predictably favor red. In fact, the green is a little more than half the value of the red, and the blue a little more than half the value of the green.

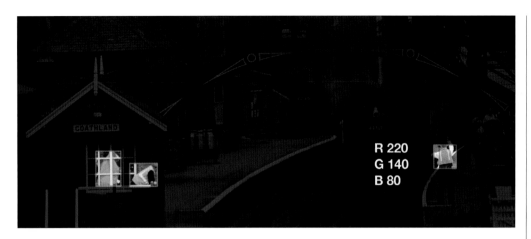

R 220
G 140
B 80

◀ Bright orange

To render the orange to its maximum grayscale value, the technique used is to follow the original RGB proportions. The color with the highest value is set to maximum—that is, red to 200%—and the other two are arranged approximately in proportion to balance. With one value at 200%, it is inevitable that the others will be at minus values, and these are judged by eye so that the neutrals in the scene match the rendering in the standard Grayscale conversion. Two by-products are that the dark red of the bridge becomes light, and that the steam from the locomotive, bluish in the original, disappears.

Channel Mixer — Custom

Output Channel: Gray
☑ Monochrome
Source Channels:
Red: +200 %
Green: −18 %
Blue: −84 %
Total: +98 %
Constant: 0 %

Channel Mixer — Custom

Output Channel: Gray
☑ Monochrome
Source Channels:
Red: −80 %
Green: −40 %
Blue: +200 %
Total: +80 %
Constant: 0 %

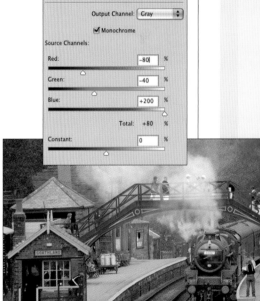

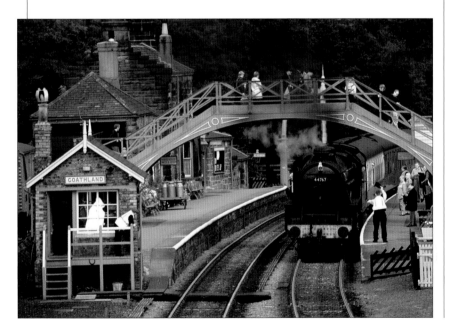

▲ Dark orange

Now we attempt the reverse values, applying the same principle. The lowest of the RGB values is blue, so that slider is set to its maximum, and the other two are arranged in approximate proportions to balance. Again, the effect is judged by eye, and the overall neutrality of the scene helps a great deal. The steam, which is complementary in color to the safety vests, is now as light as it can reasonably be.

Hue adjustment

Now that the tonal translation of colors into black and white is infinitely adjustable, shifting hues across the spectrum can have a profound effect.

As if all the color-to-monochrome adjustments already described were not enough, here is yet another that gives strong, global changes that are difficult to predict. The Hue/Saturation dialog under *Image > Adjustments* uses the HSB color model that corresponds very closely to the way we intuitively think about color. Hue relates to wavelength and to the names we give to colors (as in red, yellow, cyan, and so on), Saturation is the intensity of the color effect (or chroma), and Lightness is self-explanatory. Whatever method of conversion to black and white is used, whether basic Photoshop Grayscale, or Desaturate, or the Channel Mixer, the effect depends on the proportions of red, green, and blue. Any changes that you make via Hue/Saturation will obviously affect the outcome, and none more so than the Hue slider, which in its basic function shifts all the colors around the spectrum.

The scaling of the Hue slider is by degree, with red at 0°/360°, and all the hues arranged notionally in a circle so that their complementaries are 180° opposite. The opposite of red is blue-green (that is, cyan), and its hue angle, therefore, is 180°. By moving the slider strongly, red can become green, or indeed any other hue, and all the other colors move by the same amount. In a color image, the most by which this slider is used under normal circumstances is a very few degrees, usually to counter a color cast. Any

Color original
The original has some noteworthy characteristics, which will strongly affect the outcome. The sky is an intense blue but the landscape is almost completely neutral. As before, here we have our standard color circle to see the effects of three positions of the hue slider, each differing by 90 degrees (0 and 360 are identical). For comparison, this is the default Grayscale conversion.

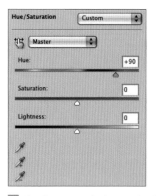

A strong red channel mix
We begin with a Channel Mixer Adjustment Layer, which opens with a default mix of +100 percent red, which we keep because it gives a dramatic sky.

Add hue adjustment layer
Next we open a Hue/Saturation Adjustment Layer below.

more and the image simply looks oddly colored without any good reason. In black and white, however, tonal shifts do not elicit the same reaction, particularly if the viewer has no color reference for comparison. The main effect is a redistribution of contrast within the image.

Just as in the normal "color" use of the Hue slider, there are refinements to this global and rather crude shifting of hues. Instead of working with the Master selection (all hues), choose one from the drop-down menu to restrict the range of the spectrum over which you are going to make changes. This done, a set of four sliders appears below on the main spectrum bar to indicate the range of hues that will be affected. These can be dragged around to alter the range. The two inner vertical bars define the range between them of 100% alteration, while the two outer triangular sliders set the limits of the fall-off of alteration, which is feathered for a natural effect.

The effect of these hue adjustments is powerful and potentially useful on a black-and-white image. The real problem, of course, is fitting such a strong adjustment method into all the others that you might want to use. The permutations are too many to visualise easily. This is where adjustment layers become particularly useful. Create a Channel Mixer Adjustment Layer on top, and choose any reasonable mix. Then open a Hue/Saturation Adjustment Layer below it, and work the Hue slider as described. The tonal shifts in the monochrome image are instantly viewable.

Hue angle +270°
Plus 270 degrees of hue angle. The most evenly distributed scale of tones in monochrome. Only the purple stands out darkly.

Hue angle +180°
Plus 180 degrees of hue angle. Yellow's evident brightness disappears from the monochrome circle.

Hue angle +90°
Plus 90 degrees of hue angle. Turns the yellow-to-red arc into close variations of green, and a monochrome conversion that divides the circle almost in half.

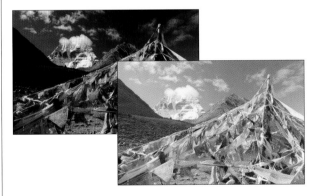

Hue angle +100°
Shifting the angle positively 100 degrees turns the blue sky to magenta, so lightening it dramatically in monochrome with the same channel mix of +100 percent red. Note that the landscape is unaffected, but the flags are. The colored version is how the hue shift would look without the channel mixing conversion.

Hue angle -120°
Moving the hue slider in the opposite, negative direction by 120 degrees turns the blue sky green, with a correspondingly less strong effect in monochrome.

Layer masks

When using channels-into-layers, adding a mask to each layer adds an even greater degree of control by, allowing selective removal.

Yet another argument for controlling the tonality in a black-and-white conversion by turning the channels into layers is selective retouching. Channel mixing, powerful though it is, works across the entire image. If you want to selectively apply one mix to a particular area of the image and another mix to the rest, the solution is slightly cumbersome—preparing two mixes, layering one over the other and erasing. Layer masks used with layers that have been copied from channels, as described on the previous pages, offer a more elegant solution, but still with a hands-on painting-and-erasing capability. Masks determine what is revealed or hidden from an image, and a Layer Mask is simply a grayscale image attached to a particular layer. White reveals the entire layer—that is, it is opaque—while black hides everything. So, painting with a black brush on a white layer mask has the same effect as erasing parts of the layer to allow the lower layer to show through. Shades of gray allow varying proportions of the lower layer to show through.

You can create a layer mask by selecting the target layer, then, from the menu clicking *Layer > Add Layer Mask* and then choose either Reveal All or Hide All. The mask appears in the Layers palette alongside the thumbnail of the layer. Alternatively, there is a New Layer Mask button at the bottom of the Layers palette.

Its uses are extensive. You might have assembled a layer combination

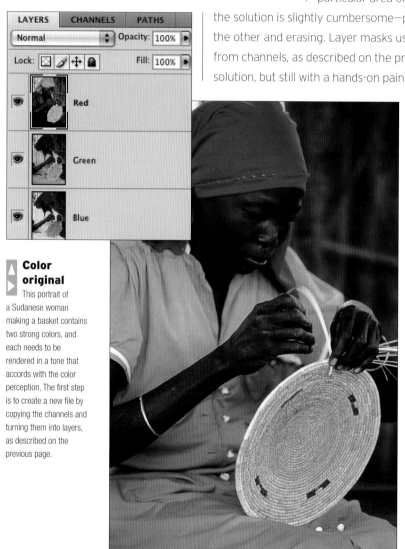

Color original
This portrait of a Sudanese woman making a basket contains two strong colors, and each needs to be rendered in a tone that accords with the color perception. The first step is to create a new file by copying the channels and turning them into layers, as described on the previous page.

with blue on top, red below, and green at the bottom, and adjusted the opacities to work for most of a landscape image. Yet suppose that you wanted to darken the blue areas of the sky further. With this technique, the solution would be to paint in black over the sky area of the upper layer, effectively removing it from what was once the blue channel. This reveals the darker rendering of the sky from the red layer. And painting with a brush is not the only way of retouching—another option is to use the gradient tool for a smooth transition across the layer mask.

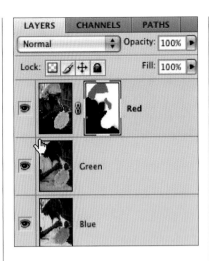

Add a layer mask
A layer mask is added to the top, red, layer with the Reveal All option selected.

◣ Brush over dress
Once you've added the layer mask, using the Brush tool at 100% opacity, work over the dress and scarf. The almost-neutral dark skin is virtually unaffected, allowing broad brush strokes.

▶ Partly restore headscarf
The headscarf is now over-darkened. To bring it back a little, set the eraser to 50% and brush over just this part.

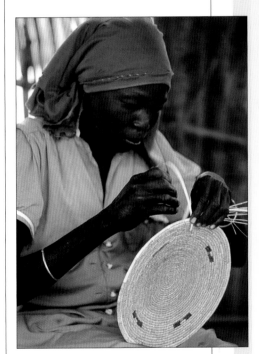

Retouched version
The final version has colors that are more as the eye perceives, or at least expects, with a pale dress and a darker headscarf that still contrasts with the skin.

Using and displaying layer masks

To activate the mask so that you can paint on it, click its thumbnail in the Layers palette. A paintbrush appears on the left to show that it is ready for painting.

To view the layer mask in the main image window, Option/Alt-click the layer mask thumbnail. The mask now appears over the image. Return to the normal view of the image by clicking in the same way.

To disable a layer mask, Shift-click its thumbnail, or go to *Layer > Disable Layer Mask*.

To enable it again, Shift-click the thumbnail once more, or go to *Layer > Enable Layer Mask*.

To alter the appearance of a Layer Mask in the same way as you would Photoshop's Quick Mask Mode (for instance, display it in red and at a percentage opacity), first display the layer mask as above, and then double-click its thumbnail. The Layer Mask Display Options dialog appears. Alternatively, double-click the masks' thumbnails in the Channels palette.

Case study: **drama in the red channel**

In traditional black-and-white film photography, a red filter over the lens is the simple way to achieve an intense, high-contrast tonality in outdoor scenes with strong sunlight and a blue sky. It is also easy to go to extremes, and the degree of drama is a matter of taste. Ansel Adams was critical of what he called the "lunar" quality in images that overdid this red-filtering effect. In this example, however, I wanted exactly that lunar quality of stark otherworldliness, as if there were no atmosphere at all. The view lends itself to this treatment: the summit of a bleak, still-active volcano in the Andes, close to sunset with long shadows. This is by way of an experiment, to see how far we can go in creating a dramatic version. Of course, as the original is in color and we are working in post-production, this is only one of many possible versions.

◢ Color original

The full-color image fulfills the criteria needed for a strong red channel mix on a landscape—the sunlight is strong, visibility good and without haze, and although there is no clear sky visible, it is deep blue behind the camera and so reflected distinctly in the low clouds in the middle distance, and all-importantly in the shadows. Moreover, the altitude is high and there is a high UV content to the light. There is also a distinct and attractive color-temperature contrast between the sunlit and shadowed areas, as we would expect.

◢ Default conversion

As usual, we first make and save a default Grayscale conversion. The channel mix is, as we already know, red 30%, green 59%, and blue 11%, and so the balance is average on red, but with much more emphasis on green than we are going to make with our new channel mix.

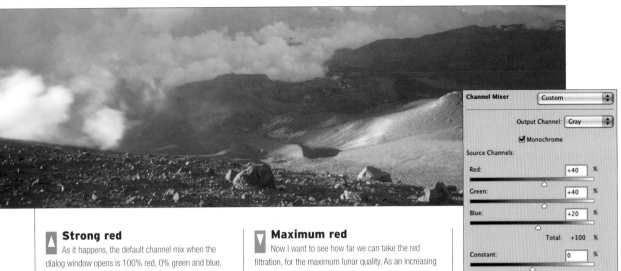

Channel Mixer — Custom
Output Channel: Gray
☑ Monochrome
Source Channels:

Red: +40 %
Green: +40 %
Blue: +20 %
Total: +100 %
Constant: 0 %

▲ Strong red

As it happens, the default channel mix when the dialog window opens is 100% red, 0% green and blue, and this is in exactly the direction that I want. The contrast is higher, but as the histogram indicates, there is no clipping at either end of the scale. The center foreground rocks and the ridged mound just beyond are key indicators—I'm trying to increase the local contrast in this area, as measured by the brightness of the sunlit sides and the darkness of the shadows. The upper part of the image, occupied by bluish clouds, is also darkened.

▼ Maximum red

Now I want to see how far we can take the red filtration, for the maximum lunar quality. As an increasing red channel bias has the effect of increasing contrast in this scene, the limit will be the point at which highlights and shadows are clipped. The danger highlight that needs to be preserved is the left part of the toxic steam from one of the volcano's fumaroles. That must be held, but we can exercise some choice over the shadows. By experiment, this combination, with red at 160%, is the maximum. Apart from the starkness of this new version of the image, notice also how the overall composition is strengthened by having a broad, diagonal, dark band separating the brighter areas at upper left and lower right.

Channel Mixer — Custom
Output Channel: Gray
☑ Monochrome
Source Channels:

Red: +160 %
Green: −44 %
Blue: −16 %
Total: +100 %
Constant: 0 %

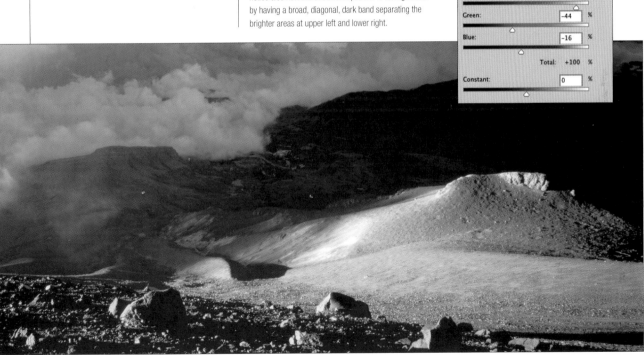

Case study: **yellow's compromise**

Again drawing on the experience of black-and-white film photography, the single most widely used lens filter for outdoor shooting is yellow. As with red, it needs direct sunlight and a clear sky to have its typical effect, as it acts on blue. Its popularity with film lies in the characteristic of a silver-halide emulsion to be over-sensitive to blue and UV light.

A yellow filter typically restores the perceptual darkness of a blue sky and its reflections. The huge tonal control possible with digital imaging makes much of this rationale moot, but there remains the popular photographic issue of sky contrast between clear blue and clouds; a distinction preferred by most. Yellow offers a reasonable, rather than an extreme, treatment of skies.

Neither red nor yellow are exact complementaries of blue, by the way, but they are close enough to have a distinct stopping effect. The blue of sky light in any case varies from a hue angle of about 190° to 220°.

Acoma
This image was shot under near-ideal conditions in New Mexico, in clear winter weather—an ancient native-American pueblo built on top of a sandstone mesa. The local rock has a warm, yellowish tone, which contrasts with the clear deep, blue of the sky.

Red Channel

Green Channel

Blue Channel

Split-channel preview
A quick channel split (performed on a copy as it is an irreversible action) has the value of showing the extremes that we want to avoid. Remember that here we are looking for a reasonable, balanced contrast, and certainly don't want to lose detail in the extensive shadows. Red is extreme in one direction, blue in another, and the differences are obvious. The green channel is quite interesting.

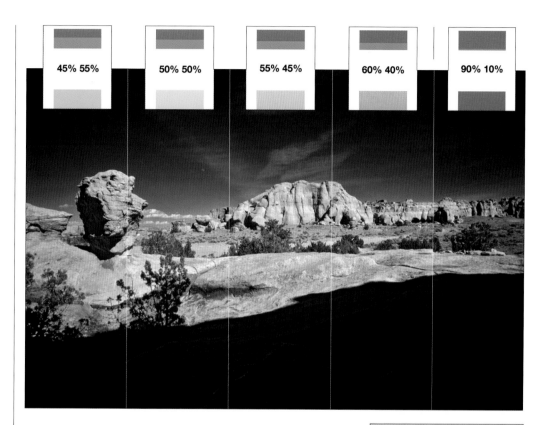

45% 55% 50% 50% 55% 45% 60% 40% 90% 10%

Degrees of yellow

In the traditional Wratten filter set, there is more than one yellow. Here, digitally, we've constructed a set of filters that vary from greenish to reddish. With additive color mixing, yellow is the product of red and green. This was done with channel mixing, and as the percentages demonstrate, around the standard yellow mix of equal red and green, small percentage differences make noticeable changes to the perceived hue. Notice, however, that the monochrome effect is not so strong perceptually— more a subtle distinction in contrast.

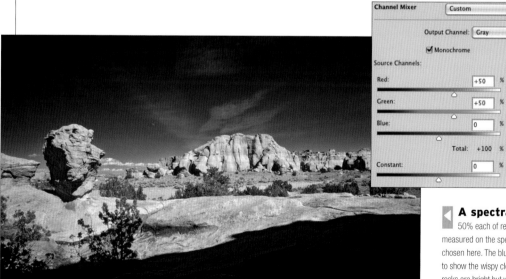

A spectral yellow mix

50% each of red and green gives a pure yellow measured on the spectrum, and this is the final mix chosen here. The blue sky is quite dark, and sufficient to show the wispy clouds—an important factor. The rocks are bright but without clipping, and the foreground shaded area is rich and dark with good contrast.

Channel Mixer Custom

Output Channel: Gray

☑ Monochrome

Source Channels:

Red: +50 %

Green: +50 %

Blue: 0 %

Total: +100 %

Constant: 0 %

Case study: **blue's atmospheric depth**

Still with landscape photography, because of the overriding effect of blue skylight and atmosphere, let's now look at a treatment that's the complete opposite of red and yellow filtration.

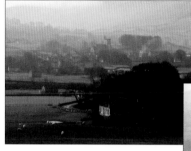

Desaturated

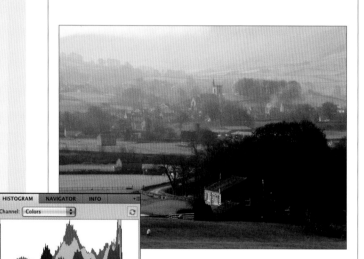

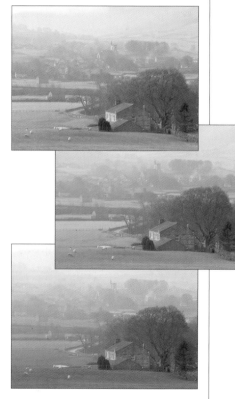

Grayscale

Landscape with atmosphere

A slight mist hangs over this Yorkshire valley of Wensleydale, in England, as the dew evaporates in the early morning sunshine. The strong, punchy treatment would be to counteract the paleness in the blue-tinged distance with an orange or red "filtration," but a more sensitive approach might be to emphasize the aerial perspective for a better sense of depth and atmosphere. As the UV content in the air helps to make the distance blue, this is likely to be a case for the blue channel.

Examine the channel histograms

Opening the full channel-by-channel histogram display in color helps the analysis. The more prominent, broader spike toward the right of the blue channel's histogram (the lowest) is clear evidence of the pale haze. Let's now proceed to the next step.

Five basic versions

As the image overall is not strongly saturated, we can't expect great differences between the two standard conversions and between the channels. These standard conversions in Photoshop are Grayscale, Desaturate, and the three channels from the Split Channels command. Certainly the differences are mild if we examine the distance, but notice that the blue-channel version is darker in the foreground—too dark if the farm buildings are intended to be the principal subject.

Red, Green, and Blue Channels

HISTOGRAM　NAVIGATOR　INFO

Channel: Colors

Source: Entire Image
Mean: 137.38　　Level:
Std Dev: 59.42　　Count:
Median: 139　　　Percentile:
Pixels: 4915200　Cache Level: 1

Red

Green

Blue

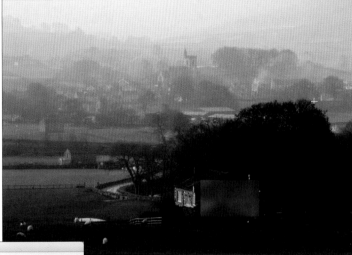

▲ Decide on an average area

As we can see, a single channel will not always automatically be optimized. We need to do some work, and the first step is to exercise judgment as to which parts of the scene ought to be an average 50% gray. The stone wall of the building nearest to the camera seems a likely candidate, and using the Average Filter method, we analyze it. At 75% it is a mid-shadow value, and too low for taste.

▲ Decide on the lightening

With a section of the wall still averaged, it is easy to decide on the amount of lightening necessary. In Levels, simply drag the mid-point slider over to the spike that represents the marquee value. In doing this, however, I change my mind about making this area mid-gray. It seems a little too bright. Maybe 60% would be better. Take a note of the new Input value for the mid-point: 1.49.

▲ Lighten the image

The Input value measured in the previous step, 1.49, is then applied to the entire image. This brings the building, trees, and grass of the middle distance to values that look normal. The distant haze is now distinctly brightened, so that the scene acquires a luminous quality absent in the earlier black-and-white versions.

Case study: **luminous green foliage**

As with all tonal conversion filtration, the color used brightens objects of its own color and darkens the complementary, which in the case of green is magenta. This makes green a useful tool when dealing with skin tones and make-up such as lipstick; we will come to this shortly. For now, however, we consider the green channel in terms of what it does to its own color, which is prominent in nature as foliage. One caveat here is that normally green vegetation is much less saturated than most people would expect. We subconsciously tend to use our imagination a little too much when we see trees and grass. In this example, however, I've chosen a scene that does happen to have an unusually high saturation of green—new grass in the Yorkshire Dales, England, under a cloudy sky (good for saturated color because there are no specular reflections from the blades of grass).

▶ Hikers and green fields

The original image (which actually works very well in color, so this is more of an exercise) contains a variety of greens, differing in brightness and saturation. Using the Average Filter technique, I've prepared samples from the four zones. The old stone barn is gray, which gives us an easy standard for any brightness adjustments, although there is, in fact, a tinge of blue to it, as we'll see when we make some extreme changes.

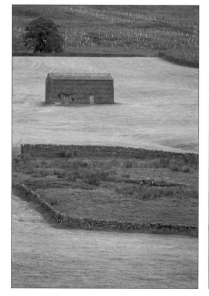

▶ Grayscale for reference

As a yardstick, the standard Grayscale conversion gives a black-and-white image that is already biased toward green (RGB 30% 59% 11%), although viewed alongside the color original, it disappointingly lacks the expected brightness. The human eye is especially sensitive to green wavelengths, and this is what we want to convey here in black and white.

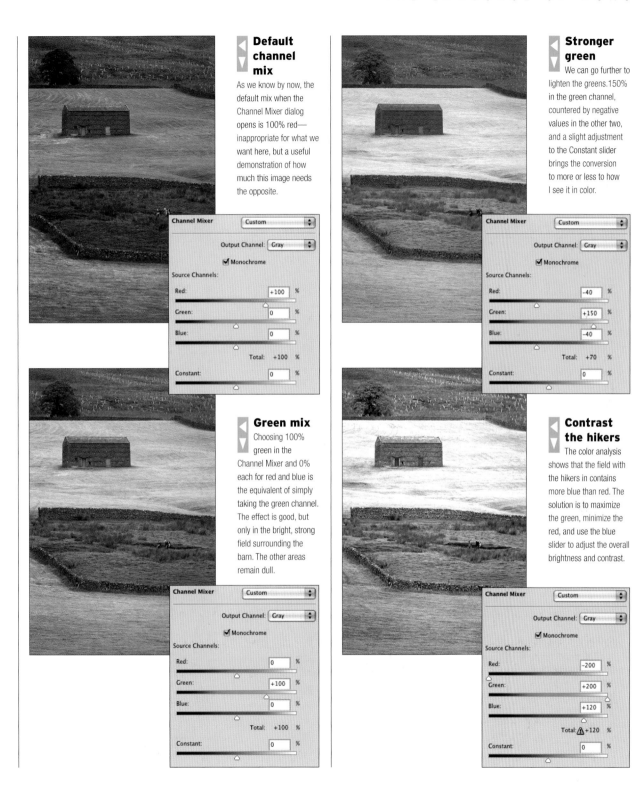

Default channel mix

As we know by now, the default mix when the Channel Mixer dialog opens is 100% red—inappropriate for what we want here, but a useful demonstration of how much this image needs the opposite.

Channel Mixer — Custom

Output Channel: Gray

☑ Monochrome

Source Channels:

Red: +100 %
Green: 0 %
Blue: 0 %

Total: +100 %

Constant: 0 %

Stronger green

We can go further to lighten the greens.150% in the green channel, countered by negative values in the other two, and a slight adjustment to the Constant slider brings the conversion to more or less to how I see it in color.

Channel Mixer — Custom

Output Channel: Gray

☑ Monochrome

Source Channels:

Red: -40 %
Green: +150 %
Blue: -40 %

Total: +70 %

Constant: 0 %

Green mix

Choosing 100% green in the Channel Mixer and 0% each for red and blue is the equivalent of simply taking the green channel. The effect is good, but only in the bright, strong field surrounding the barn. The other areas remain dull.

Channel Mixer — Custom

Output Channel: Gray

☑ Monochrome

Source Channels:

Red: 0 %
Green: +100 %
Blue: 0 %

Total: +100 %

Constant: 0 %

Contrast the hikers

The color analysis shows that the field with the hikers in contains more blue than red. The solution is to maximize the green, minimize the red, and use the blue slider to adjust the overall brightness and contrast.

Channel Mixer — Custom

Output Channel: Gray

☑ Monochrome

Source Channels:

Red: -200 %
Green: +200 %
Blue: +120 %

Total: ⚠ +120 %

Constant: 0 %

Flesh tones: dark and light

Although we are not accustomed to thinking of skin as having definite color, it does have a bias that affects its appearance in black and white.

As in other aspects of photography, anything to do with the human face evokes viewer reactions based on familiarity and expectation. What this means in practice is that when looking at a portrait photograph, we have a distinct sense of what is the right or wrong color. This translates into black and white as a skin tone that is lighter or darker, and with less or more contrast. There is certainly a wider range of acceptable tones in black and white than there are hues in a color photograph (where even a slight hint of green, for example, triggers a response of wrongness), but this is still narrower than the range for subjects such as the sky, plants, and buildings. In other words, skin tones are a case for special consideration, the more so in black-and-white photography because they can be manipulated at will.

The main reason for this is that human perception is trained to "read" faces: to recognize them, evaluate them, and take information from them. If there is something out of the ordinary in the color or tone, the first reaction is to wonder why and

Dinka classroom
There are actually many color casts of black skin; in this case, Dinka children in Sudan, the lightening effect of 100% red in a channel mix (compared with default Grayscale) is moderate, but helps to reduce the contrast between skin and clothes.

Japanese girl
From the original above, a red favoring mix with +76 red, +14 green, and +10 blue.

then imagine the cause. If a face that we expect to be pale appears dark, we might imagine excessive sunbathing is the cause. Darker still would simply be disturbing, because there would be no obvious explanation. Faces are special in this way. No other "object" normally receives so much instant attention. Interestingly, the photography in black and white is rarely seen as the culprit. If a color image has an overall color cast it is assumed to be a photographic fault, but in black and white, as long as the overall brightness and contrast are within a normal range, individual tones are treated as part of the subject.

As in facial recognition, we are most familiar with, and have the strongest opinions about, the skin tones of our own ethnic group. Even within one ethnic group there are large differences from individual to individual, and it is important to avoid preconceptions. Nevertheless, in most skin there is a higher proportion of red than green or blue. In very pale and very dark skin, as in the white English children (right), the red bias is least, and tends to show more in the mid-to-dark tones. The Japanese girl has the lowest proportion of blue, and the distinctly brown face of the Pathan man has the most red. When using the Channel Mixer, you need to take each image on its merits—there is no blanket solution. The differences between equal-channel desaturation and default grayscale conversion are usually very slight.

▷ **Pathan Man**
This portrait of a Pathan tribesman has the highest proportion of red. Using the averaged samples technique it is possible to see this, and the conversion has been made accordingly, with a red mix.

△ **Mad Hatter's Tea Party**
Light Caucasian skin responds moderately to variations in the red channel, but the choice is a matter of taste—the lightening effect may cause the skin to look too pale.

Fine-tuning dark skin

Very dark skin, such as that of many sub-Saharan African people, generally needs a black-and-white conversion that emphasizes local contrast.

As we saw briefly on the previous pages, skin color varies hugely. The terms "white" and "black" are completely inappropriate as a way of dealing technically with skin tones. Nevertheless, very dark skin needs a different tonal approach from very pale skin. In principle, we usually want to maintain a rich, dark treatment, while not losing detail in the shadows (which is easy to do). In practice, this often means raising the contrast in the darker part of the tonal range, as this example demonstrates. The portrait is of a girl from the west of Sudan, and while it is not possible to say that the skin color is typical of sub-Saharan Africa, nor is it unusual.

If we make an RGB analysis, using the Average Filter on squares of skin, we can see that throughout, red is strongest on this face and blue weakest. However, note that the relative proportions alter with shadow, so that the

Color original

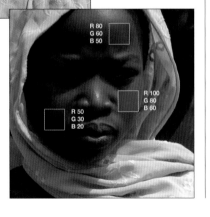

In the original color image, the face is half in shadow from a bright but fairly low sun. The overall color is brown, so red is predictably quite high. The brightness levels measured with the HSB option in the Info palette are 40% for the brightest patch, 30% for the darker and 20% for the darkest.

R 80
G 60
B 50

R 100
G 80
B 60

R 50
G 30
B 20

Default channel mix

Opening the Channel Mixer displays the default, which is 100% red, the dominant color in this instance. The overall brightness of the face is satisfactory, but it lacks contrast.

Proportionate mix

Referring back to the color patches and their RGB values, the channel mix is adjusted roughly in proportion to the values, with red strongest and green weakest. There is a slight improvement in contrast, and no clipping of the highlights, but the face still lacks local contrast.

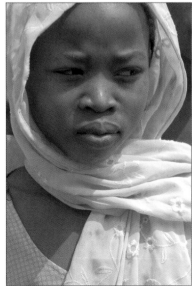

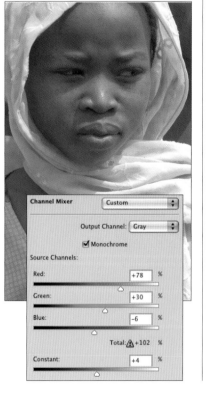

Channel Mixer	Custom	
Output Channel:	Gray	
	☑ Monochrome	
Source Channels:		
Red:	+78	%
Green:	+30	%
Blue:	-6	%
	Total: ⚠ +102	%
Constant:	+4	%

shaded areas have a slightly higher red component than those in sunlight. This will affect the contrast when we convert to black and white. Be aware, though, that black skin from some ethnic groups can have much less red. If neutral and very dark, it will also pick up environmental reflections—much more so than pale Caucasian skin—and under a strong skylight this can even give a bluish appearance.

Moving to the Channel Mixer, the choice of the favored channel is determined less by a need to lighten or darken overall, than by contrast. With the exception of a few specular highlights (in this example on the forehead, the tip of the nose and the lips), all the values are in the lower half of the tonal range. One of the effects of this is to give a rather flat appearance, and the key issue is usually reaching sufficient contrast. In the steps shown here, it was possible to produce a satisfactory result by adjusting the channel sliders so that they followed the initial RGB values, but a better result was a more extreme mix to boost contrast in the face. Unfortunately, the bright shawl could not survive this treatment, so we resorted to a composite—not elegant, and by no means always necessary, but it created the effect that was wanted.

Compositing
The only solution is to composite the face from the high-contrast mix with the clothes from the proportionate mix. The former is pasted as a layer over the latter, and brushed out where needed with the eraser.

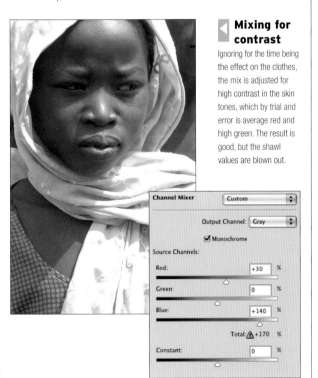

Mixing for contrast
Ignoring for the time being the effect on the clothes, the mix is adjusted for high contrast in the skin tones, which by trial and error is average red and high green. The result is good, but the shawl values are blown out.

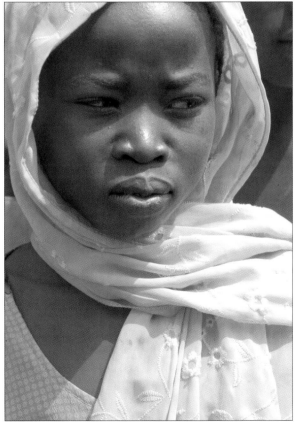

Fine-tuning light skin

Pale skin usually benefits from the opposite approach to that just demonstrated for dark skin—namely less local contrast and texture.

The distribution of tones over a light-skinned face is quite different from that on dark skin, and the convention is for a reasonably high-key effect, with the exception of the mouth, eyes, and eyebrows. In practice, these features tend to be more prominent, so, as here, need special attention. The very term "light skin," of course, covers a wide range, and there are ethnic variations, differences caused by complexion (florid, pallid, freckles) and, importantly, by make-up.

If the intention is an attractive result, then it's essential to pay close attention to small details, like variations in pigmentation. It's not fair to call these blemishes, but from the point of view of "beauty photography," reducing or removing them is almost always considered an improvement. I'm being careful here to connect this to intention, because in reportage faces are usually better left as they are, while the treatments discussed here are designed to give a result that is pleasing to the sitter in a portrait situation. I've deliberately chosen a freckled face. The freckles obviously have a higher red component than the surrounding skin, so that they are in danger of becoming too prominent but equally can be suppressed through channel mixing.

▲ Color original
The combination of complexion, eye make-up, and dress makes this a colorful image that will, because of this, respond quite strongly to any changes in the channel mix. Note that the pink cheeks will probably respond even more to variations in the red channel than will the freckles.

▲ Default grayscale
The default Photoshop Grayscale conversion, because it favors green, gives more prominence than we want to the freckles, and cheeks that are rather too dark.

◀ Make duplicate layers
Because it is likely that we will have to adjust different parts of the portrait separately, the first step in making adjustments is to create a couple of duplicate layers. These can be composited later.

▲ Red extreme
The default channel mix of 100% red is a starting point. As expected, it lightens the overall skin tone and reduces the freckles. On the downside, the mouth now lacks definition because the red lipstick has also been lightened, the eyes have become unnaturally dark, and the hair highlights too bright. This mix is applied to the bottom, background layer. Note that, in this case, we do not want to remove the freckles completely, simply keep them more subdued.

Channel Mixer — Custom
Output Channel: Gray
☑ Monochrome
Source Channels:
Red: +100 %
Green: 0 %
Blue: 0 %
Total: +100 %
Constant: 0 %

Blue extreme

The blue channel is the least commonly used for portraits, but for information let's see what it does here. Apart from a bizarre treatment of the complexion, it does, as we might guess, brighten the eyes—and this is something we need. It is applied to the top duplicate layer, but then turned off so that we can work on the middle layer.

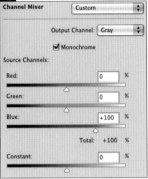

First composite

Now working on the lower two layers of the three, the skin areas of the upper layer (balanced mix between red and green) are erased with a soft brush.

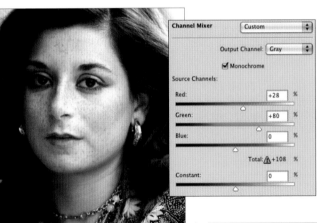

A balance of red and green

Bearing in mind that we can make partial use of the extreme red and extreme blue mixes, we take the middle layer of the three and give it a channel mix that is adapted from the default grayscale, but with all blue removed.

Second composite

Finally, we turn on the top layer (blue mix), and erase all of this apart from the eyes, which are at their brightest in this channel.

Digital **Black** and **White**

Having established the relative tonal values between the colors in the original scene, the major editing stage is to optimize the black-and-white photograph. This is the basic and essential sequence of the image workflow, and while it is clearly a part of post-production, taking place on the computer rather than in the camera, it is more akin to processing. Depending on how you choose to shoot—JPEG, TIFF, or Raw—the actual sequence and the amount of work involved will vary, but essentially, the aim of all of this is to make the best of the image as shot. This is where digital photography has created a new way of thinking about image quality. There is now a range of well-established software techniques to deal with every aspect of this, from setting the limits of the tonal range to precise enlargement that intelligently manages artificial detail. Most of these can be worked from within any good image-editing application, of which the most widely used remains Adobe Photoshop, but there are also specialized programs dedicated to particular issues, such as combining the information from different exposures into a single tonal range. So, for some photographers, the optimizing workflow consists of two or three steps in one application, while for others, it involves moving from one application to another and can involve several stages.

Beyond optimizing, there is also the possibility of interpreting the image in any number of different ways. In silver-halide black-and-white photography, for instance, the negative is capable of being printed using a variety of alternative methods. It holds a number of potential positive images, and an experienced photographer or printer can assess it to appreciate its limits and possibilities. You might want a stark treatment with dense blacks, or perhaps a fully-toned image that lacks punch but reveals all, from shadows to highlights. These are subjective judgments that call on technical expertise in printing. Predictive skill is needed, because the accuracy of the printing plan is proved only by examining the dried silver print.

Digital black and white makes much more of this idea of the potential image, in three areas. The first is that there is usually more information available, particularly if you shoot in Raw format. When some photographers talk of a "digital negative," this is what they are referring to, a computer file format that stores the image captured by the camera's sensor as closely as possible—a bank of data that can be processed in many different ways. Importantly, as digital rather than analog, this data is separated—for example, the color is stored in three channels that allow infinite tonal interpretations. Second, the processing tools are increasingly powerful, using ever more sophisticated algorithms to distribute the tones, from black to white, across the image, all with virtually instantaneous feedback onscreen. Third, all of the procedures between shooting and the finished print can be handled as a single suite on the computer, and with the three key machines linked—camera (directly or via the memory card), computer, and printer—the image workflow is straightforward and efficient.

The zone system

This classic method of assigning tonal values ensures that the final print captures the essential details.

The Zone System was invented by Ansel Adams and Fred Archer in the late 1930s, and its aim was to be a commonsense application of sensitometry—a straightforward way of translating the range of brightness in a scene to the tonal range of a print, via the camera. Although developed for black-and-white film, it has a new lease of life with digital photography, precisely because you now have the best means of all to adjust tones. At the heart of the Zone System is the idea of dividing the grayscale of brightness, from darkest shadows to brightest highlights, into a set of zones. In the original, shown here, there are ten, identified by Roman numerals. 0 is solid black, IX is pure white, and V is mid-gray. Adams and Archer intended it to be a tool to "liberate" photographers from technique and allow "the realization of personal creative statements," and for anyone committed to the craft of photography and who enjoys a slow picture-taking process, this is still the best way to use it.

The idea is to first identify in the scene the important tones—important for you, that is. As it turns out, the three key zones are V, which is mid-gray, the same as a standard Gray Card, III, which is dark but significant shadow texture, and VII, which is significant highlight texture. The tonal values in a scene are assigned to this simple scale of ten, each one f-stop apart. You first place the key tone in the Zone you want, such as a textured shadow in Zone III. As the Zones are one f-stop apart, the other tones will naturally fall into their appropriate Zones. Zone V is the one constant—it is always mid-gray. Essentially, the Zone System is a way of assigning priorities to different parts of an image.

Different photographers have different ideas about how an image should look tonally, and the Zone System allows for this individuality. Used successfully, it will ensure that the print matches the way you see the scene, which may well be different from the way someone else would want it to appear. Another benefit of the Zone System is that it allows for the fact that the paper on which you print has a narrower range than the camera's dynamic range (and this in turn cannot capture the full range of brightness in a contrasty real-life scene).

▶ **Relating zones to print values**
Moving a scale around a print shows immediately which tones in the image match particular zones. In a medium-contrast scene like this, all the Zones are included. Mentally doing this helps to visualize the final print, which could in this case legitimately vary by at least one Zone—that is, one f-stop.

Case study: **placing a tone**

The Zone System works best when you have the time to consider and measure the light values in different parts of the scene. From the outset this image of a Shaker village in New England, looking out over a rocking chair, was bound to present contrast issues. Without considering later adjustment, here were two possible interpretations. In the lighter version, the just-visible shadow area between the window and the door was placed in Zone II so that some detail would register. This, however, would have to be at the expense of losing highlight detail in the white picket fence outside, which would fall into Zone VIII. If, on the other hand, this fence detail were considered important, and so placed in Zone VII, the shadow detail left of the door would have to be sacrificed—or rather, dealt with later in image editing. In the event, this darker exposure was chosen in order to avoid the clipped highlights.

The zones

Zone 0
Solid, maximum black. 0,0,0 in RGB. No detail.

Zone I
Almost black, as in deep shadows. There is no discernible texture here.

Zone II
First hint of texture in a shadow. Mysterious, and only just visible.

Zone III
TEXTURED SHADOW. A key zone in many scenes and images. Texture and detail are clearly seen, such as the folds and weave of a dark fabric.

Zone IV
Typical shadow value, as in dark foliage, buildings, landscapes, and faces.

Zone V
MID-TONE. The pivotal value. Average, mid-gray, an 18% gray card. Dark skin, and light foliage.

Zone VI
Average Caucasian skin, and concrete in overcast light.

Zone VII
TEXTURED BRIGHTS. Pale skin, light-toned and brightly lit concrete. Yellows, pinks and other obviously light colors.

Zone VIII
The last hint of texture, bright white.

Zone IX
Solid white, 255,255,255 in RGB. Acceptable for specular highlights only.

Adjusting tonal distribution

After the black points and white points have been set, step two is to optimize the brightness of the mid-tones.

Once the end-points of the tonal range have been set, you are free to experiment with the tonal distribution. It's important to remember the distinction between an overall lightening or darkening of the image and the altering of tones within a set range (see box). The only sensible procedure is to set the black and white points first, then adjust the tonal distribution.

The standard method is with the tone curve, using the Curves dialog. In other words, first Levels, then Curves. The RGB tone curve begins as a straight diagonal from black (0) at lower left to white (255) at upper right. The horizontal axis represents the starting, or Input, values, and the vertical axis the new, Output, values as you adjust the curve.

As long as you leave the end-points of the curve where they are, in the corners, the limits of the tonal range of the image will remain as you set them in Levels. They can be dragged away from the corners—the equivalent

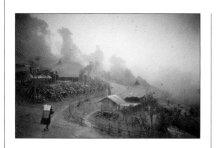

Village in mist
Leveled, and awaiting mid-tones adjustment.

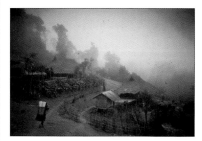

Mid-point darkening
Highlight advantage, but losses in the shadows.

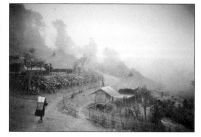

Mid-point lighting
Better shadows, but the center sky washes out.

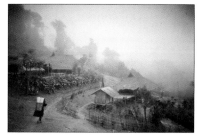

Lighten shadows
The best so far, but no improvement on the original.

of altering the black and white points in Levels–but this tends to give extreme results. The grid, divided into four horizontally and vertically, is a useful guide. It makes three intersections along the curve: mid-point, mid-shadows, and mid-highlights. The basic method of lightening or darkening the image without altering the black and white limits is to drag the mid-point right or left. This is the same as dragging the middle Input slider in Levels. The effect is to redistribute the middle tones of the image toward brighter or darker while pulling the other tones with them, to a greater or lesser degree in proportion to how close they are to mid-gray (or the point moved).

However, the tonal distribution can be altered in many more interesting ways. If you first click on the mid-highlights (the upper right intersection on the grid) instead of the mid-point, dragging will have a greater effect on the lighter tones than the darker. To take it to the next level, click on two points on the curve and move each independently. Dragging the mid-highlights left and the mid-shadows right gives an S-curve, increasing contrast. These two points dragged in the opposite directions results in a reversed S, and so lower contrast. More refinement is possible, and the permutations are endless, making Curves a powerful tool for adjusting tonal relationships.

Brightness v. Curves

There are three systems of changing the apparent brightness of an image. The Brightness slider under *Image > Adjustments > Brightness/Contrast* shifts the entire tonal range, with its end-points, with inevitable clipping of highlights or shadows. The Lightness slider under *Image > Adjustments > Hue/Saturation* squashes the range from either the shadow end or the highlight end, with a reduction in contrast and no clipping. Moving the middle parts of the tone curve shifts only the central body of the tonal range, with no clipping.

▼ Final curve

From the previous tests, it was decided that the key improvement would be an increase in contrast limited to the mid-tones that make up the central part of the frame. The curve reflects this, by keying the mid-shadows and mid-highlights to hold the upper and lower parts of the range in place, and then subtly applying an S-shape to the middle.

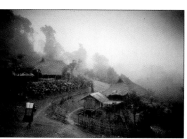

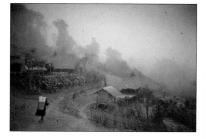

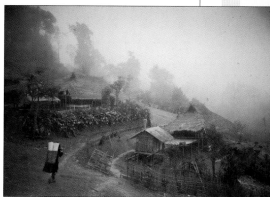

▲ Increase contrast

The huts look better, but too much lost at both ends.

▲ Decrease contrast
Smoother tonal distribution, but the central area flat.

A different approach to tones

Photoshop's Shadow/Highlight command redistributes tones in a pragmatic way designed to deal with the purely photographic issues of backlighting and contrast.

A relatively new and distinct procedure that is photographically oriented separates the range of an image into three zones, and for each one allows a sophisticated lightening, darkening, and change of contrast. Rather than operating on the principle of tonal curves, it uses procedures more akin to sharpening and other filters, by searching for neighboring pixels across a radius that you can choose. Essentially, it was designed to deal with blocked shadow areas and washed-out highlights, as commonly happens with backlit subjects taken against bright backgrounds (in the former case) and subjects too close to the on-camera flash (in the latter).

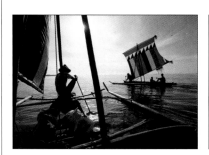

Original
Scanned from a color transparency, this shot of shell fishermen in the Philippines is high in contrast and atmosphere, but shadow detail has been sacrificed in the exposure in order to hold the highlights.

Adjusted shadows
Since the digital original was made with a drum scanner, there is very good detail to work with. With these settings, the shadows open up beautifully.

These are common problems for amateurs, but even so, the advanced algorithms used in this procedure make it useful for more delicate adjustments on a wide range of images.

Because of the corrections for which it was designed, the Shadow/Highlight command assumes more-or-less normal exposure in the mid-tones, and there are three sets of sliders, for the shadows, the highlights, and "adjustments." For both the shadows and highlights, you can select the range covered, extending from either end toward the mid-tones (Tonal Width), and this limits the alterations. The Amount specifies the strength of the lightening (in the case of the shadows) or darkening (in the case of the highlights). Finally, and least intuitively, you can set the Radius, which determines how far is searched around each pixel to decide whether it falls into the shadow zone or highlight zone. As this is measured in pixels it depends on the size of the image

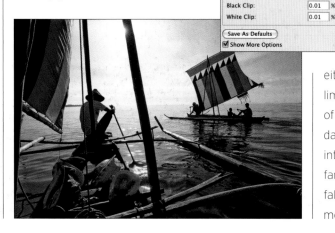

and the size of the subject within it that you are trying to adjust. The remaining two sliders, under Adjustments, allow you to control the contrast over the mid-tones (the gap left between the shadow and highlight areas that you defined) and raise or lower the brightness in the shadows and highlights.

No clipping is involved, as the black and white points are left unaltered, but like any adjustment, using it to extremes can have odd results. As it tends to be used most for opening up shadow areas, a typical effect is an unrealistic lightness and lack of contrast confined to the shadows. There is often a strong temptation to reveal hidden details, but it needs to be tempered with realism.

Adjusting too far

The unique procedures used in this command can create effects that are strange, but difficult to define. The usual adjustments of Levels and Curves are so familiar to everyone that the limits of acceptability are generally agreed. This command, however, is more open to interpretation, and Extreme Radius settings, can produce halo-like effects.

Radius 10

Radius 50

Radius 100

◢ Adjusted highlights
A surprising amount of bright sky becomes visible when the highlight settings are adjusted.

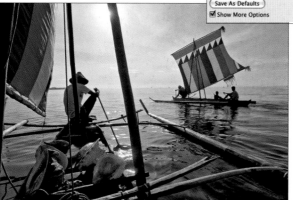

▷ Mid-tones
Finally, the mid-tones are lowered in contrast very slightly to give a more even distribution to the water.

Gradient mapping

An alternative technique for setting both the tonal range and its distribution is to map the image to a preset gradient.

Mapping is a digital imaging technique in which all the pixel values in an image are plotted according to a specific intent. The procedure looks at every pixel and says, in effect, "If this pixel is such-and-such, we will change it to this new value by referring to this particular map." This is simpler and more relevant for a black-and-white image than for color because there is only a single channel—mapping a monochrome image is essentially tone mapping, and it can be a useful way of setting black points, white points, and the way in which the grays in between are adjusted. This is very much a procedural adjustment that works by calculation rather than on-screen interaction. It is precise, measurable, and repeatable, but not intuitive, since it's harder to experiment with.

Photoshop conveniently offers this global tonal control under *Image* > *Adjustments* > *Gradient Map...* using the Gradient Tool as the reference. Simple in theory, but to make finely controlled adjustments you'll need to familiarize yourself with the effects of different gradients.

Slot canyon
A wide range of tones is contained within this shot of a shaft of sunlight illuminating a narrow canyon, but the exercise will be in how the tones are distributed.

A basic gradient
Open the Gradient Editor and choose the first, basic gradient, a smooth transition from black to white. This performs an automatic monochrome conversion.

Drag left
Dragging the mid-point slider left shifts the bulk of tones toward white, as shown by the histogram.

Gradient Type: Solid
Smoothness: 100 %
Stops
Opacity: % Location: % Delete
Color: Location: 66 % Delete

▲ ▼	**Drag right**	▶	**Adding a tone**
	Dragging the mid-point slider right shifts the bulk of the ones toward black.		Clicking below the bar adds a new stop, and this can be assigned a color, here a mid-gray. This inserts a gray band into the gradient, with an effect similar to a soft posterization.

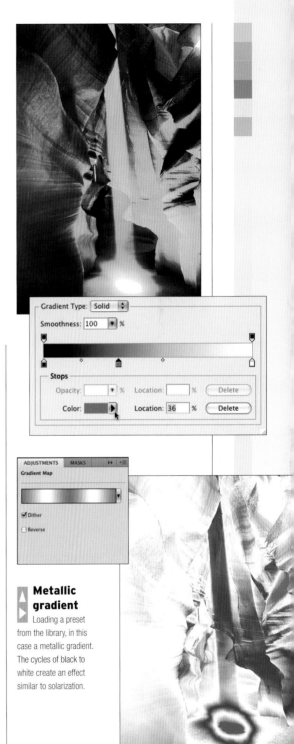

Gradient Type: Solid
Smoothness: 100 %
Stops
Opacity: % Location: % Delete
Color: Location: 36 % Delete

ADJUSTMENTS MASKS
Gradient Map

☑ Dither
☐ Reverse

▲ ▼	**Metallic gradient**
	Loading a preset from the library, in this case a metallic gradient. The cycles of black to white create an effect similar to solarization.

The simplest gradient of all is a linear one from black (0) to white (255). By default, this is the gradient you will be offered when you go to *Image > Adjustments > Gradient Map*. Keep the Histogram palette open to watch your changes, and aim to fit the ends of the tonal range neatly into its box.

Any other gradient can be applied, although to be useful in black and white you will need to create it first. The place to do this is the Gradient Editor, accessed by clicking once on the gradient sample in the Gradient tool's options bar. In most cases, you will want one that begins with black and ends with white, but there are infinite adjustments that you can make to the gradient in between. With the standard black-to-white linear gradient as a starting point, in the Gradient Editor click once on either of the color stops at the ends of the bar to create a diamond-shaped mid-point slider in the middle. Take this diamond and drag it to the left or right. This will display a new gradient skewed toward the highlights (if you drag left), or towards the shadows (if you drag right). The disadvantage of the Gradient Editor is that you can only guess what the effect will be, but in principle, applying a gradient which has its mid-point dragged toward the shadows will shift the mid-tones lighter, and vice versa. Things become interesting, however, if you add another "color" to the gradient—for a black-and-white image another tone. Click anywhere below the gradient bar in the Editor and a new stop is created; by this means it is possible to produce some very intricate gradients.

Dodging and burning

Digital tools can mimic the traditional darkroom techniques of increasing and holding back exposure in local areas of a print.

Emulating photographic techniques is one of the ways in which software developers try to improve their products. The aim is to make photographers feel at ease by offering things that they are familiar with from the days of film. Digital dodging and burning falls into this category—comfortable for those nostalgic for the darkroom. Of course it will never replicate traditional techniques entirely, but the principle of adjusting the brightness of local detail is sound, and there are several ways to achieve it within Photoshop.

First, the Dodge and Burn tools in the Toolbox. Traditionally, dodging was performed in a wet darkroom by holding back the exposure from the enlarger lamp, normally using a small, shaped piece of black card or metal. This was at the end of a thin rod, and by moving it constantly during the exposure, the edges of the area being held back were softened and the shadow of the rod was unnoticeable. Dodging larger areas at the edges of the frame could be done by shaping the hands and moving them. Burning was the opposite—adding extra time to selected areas after the initial overall exposure. This usually needed a shaped hole, either cut into a large piece of black card or by cupping the hands.

Digital dodging and burning tools are only partly similar, as they alter the brightness of an existing image rather than alter the exposure, but they do have an added advantage, not possible traditionally, of being restricted to a tonal range: shadow areas, mid-tones or highlights. This gives some control

The plan
Shown here in diagrammatic form, the plan for selectively lightening and darkening involves three areas—darker areas of trees and fields left and right, and the immediate vicinity of the sun.

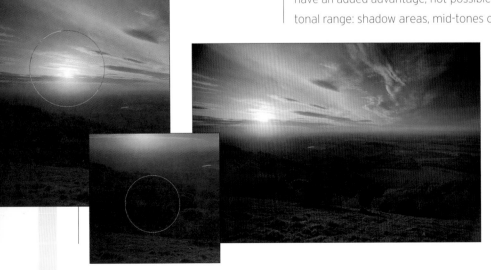

Burn then dodge
The tool is set soft and large, over 600 pixels, and with a very low Exposure (strength) setting of 6% so that several strokes can be applied. The range is then set to Midtones for a realistic effect, a slightly smaller brush size to suit the shape of the areas, and a Exposure setting of 10%.

Painting a selection
A different approach to the adjustment is to paint a selection in Quick Mask mode, first for the darker areas.

over local contrast, as the examples here show. And of course, you can take as much time as you want, and go back over any excesses.

Given all the other methods of controlling the tonal range in a black-and-white image, dodging and burning is best as a final touch-up technique on small areas (larger areas are more conveniently dealt with by the Shadow/Highlight command). The danger, exactly as with the traditional technique on a silver print, is a falseness through being overused, so that the patch that has been treated stands out against the surrounding tonal range. All too typically, the darkest tones in a dodge appear weak and the lightest in a burn acquire a veil of light gray.

As digital dodging and burning has more to do with result than procedure, there are alternatives. One is simply to make a selection by brushing over the area in Quick Mask Mode, allowing you to make the area as soft and shaped as you like, and then use Curves to alter the tones up or down. Thinking this through further, as dodging and burning is supposed to alter the exposure, a truer alternative if you shot the image in Raw format would be as follows: prepare two files from the original RAW at different exposures, and place them on top of each other as layers in Photoshop. Gently erase areas of the higher layer for the other to show through (place the lighter one on top if burning is required, or the darker on top to dodge).

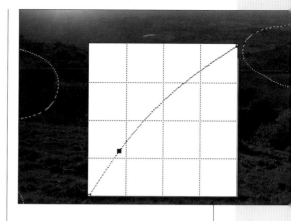

Curves
Use Curves to lighten the areas, with a point that makes this biased towards the shadows.

Result
Compare the result with the original. Burning is slightly more successful than the dodging, which lacks contrast.

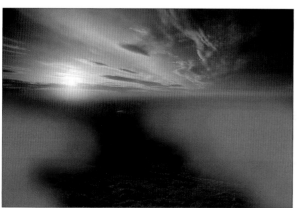

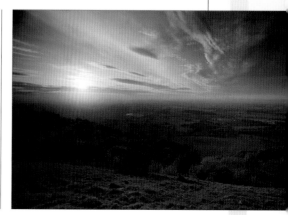

Selective composite
Another approach is to stack a copy of the image over a version that's been subject to overall lightening, then erase parts of the top layer.

High dynamic range images

A sophisticated technique for covering a wide tonal range is to create an extremely high bit-depth image and map this to the final 8-bit version.

When the range of brightness is extreme—more than 2,000:1 or in excess of 11 f-stops—even the compositing techniques just described hit problems. The real answer is to use a special file format that can cover a high dynamic range, put all the exposures into that, and then use tone mapping to compress the otherwise unviewable result back into a normal format. This is a highly technical and specialized procedure, and the principle is HDRI, or High Dynamic Range Image. The software used here to perform the operation is PhotoMatix, which works in RGB, and so the procedure is conducted before conversion to grayscale, even though the image can be, as here, fully desaturated.

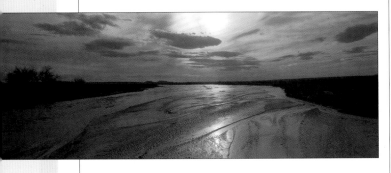

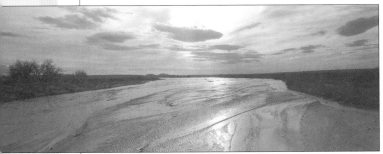

▲ **Two versions**
Although the dynamic range of this page's paper is too small to convey the effect properly, when viewed on a lightbox, the negative can be seen to contain a wide range of detail. The problem is compressing it so that it can be printed. A dark scan and a light scan now contain all the information that we need.

▲ **Generating HDR image**
PhotoMatix software allows a choice of response curves when creating the High Dynamic Range image. Here the default is chosen. (There is also a HDR tool in Photoshop under *File > Automate > Merge to HDR.*)

▲ **On-screen**
The on-screen appearance is very dark and contrasty, but a small window reveals an optimized version of what is under the cursor.

▼ **Tone mapping**
The next step is to map the full range down to a standard 8 bits or 16 bits per channel.

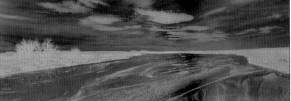

The software is designed to work with digital capture, but it can also, as in this example, handle scanned negatives perfectly well. This was a virtually unprintable medium-format panoramic image that I had shot years ago, in New Mexico. Had I been shooting digitally, the capture would have needed a number of exposures (see box) and the range would have been higher, yet still the HDRI technique would have coped. Nevertheless, the range of the original negative was too high, so even though this was well within the capabilities of the technique, it was still a challenge for the image. The final version has to encompass bright cloud values close to the sun and shadowed foliage on the river banks.

Just two scans were made and used, one for the highlights and one for the shadows. The software first combines these (it can handle more) into a single HRD image, in the Radiance format. The apparent peculiarity of this is that the HDRI contains all that information, but neither the monitor display nor a print can come anywhere close to displaying it. This calls for the next step, which is to map this high range of tones to a normal bit-depth. In other words, compress it and arrange for a pleasant distribution of the intermediate tones.

A multiple exposure sequence

Begin shooting at one end of the exposure value range and continue in steps of between one and two stops. If you start at the shadow end, display the histogram in the camera's LCD and choose the exposure setting that gives just a slight separation between the left edge of the scale and the left (black point) end of the histogram. Vary the shutter speed, not the aperture, to avoid any visible differences in depth of field. Switch the display from histogram to clipped highlight warning, and continue the sequence until there is no clipping at all. You will then have covered the full brightness range of the scene.

▼ **Rio Puerco**
HDRI tone mapping combines a massive range from a difficult shot remarkably well.

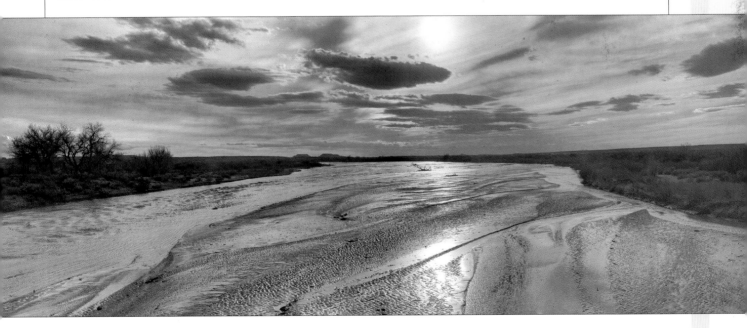

Noise control

Tackle unwanted noise with a combination of the appropriate camera settings and post-production filters.

Noise is probably the most common artifact in digital capture (artifact being any part of the image that was introduced by the process and not from the original scene). At first glance, (digital) noise looks somewhat similar to film graininess, and indeed it increases with the ISO sensitivity in the same way. Nevertheless, noise has quite different origins, and in close-up can be seen to have a different structure. There are ways of suppressing it during shooting, and of reducing it, later, in post-production. However, because it exists at the finest level of image detail, it is not easy to separate from genuine image detail. If you enlarge a section of noisy image to 100% or 200%, the individual specks are obvious, but so too are the pixels that constitute "real" detail. In fact, the only distinction between the two is your own knowledge of the scene and judgment. This makes automated noise reduction difficult—it needs to be directed by an experienced eye, otherwise the procedure will remove or soften the detail that you want to keep.

At the stage of shooting, there are ways to avoid excessive noise, which, incidentally, varies between makes of camera according to the design of the sensor and the in-camera processor. The first and most obvious precaution is to use the lowest ISO setting possible. The second is to make use of the

Blind area artifacting

A side-effect of noise reduction is the destruction of apparent detail in busy areas of the image. The filter settings that are appropriate for a low-detail area, such as sky or smooth skin, will remove too much from high-detail areas such as vegetation and hair. This argues for first making a selection of the smoother areas of the image (where noise is in any case more noticeable) and confining the noise reduction to these. Dedicated noise-reduction software may have algorithms that take care of this.

Camera software

The Nikon Capture Editor, supplied with Nikon's cameras, has the advantage of being tuned by the manufacturer for its own range.

Photoshop Raw

Other image-editing applications, like Photoshop, also have noise reduction facilities, but by their very nature have to be more general.

Dfine

This plug-in allows separate operations for luminance and chrominance noise, and has the ability to select zones, and to load a specific camera profile.

camera's noise-reduction option for long exposures. This exists because there are different kinds of digital image noise, and the most prominent, but correctable, is long-exposure or fixed-pattern noise. Because of individual differences that occur during sensor manufacture, each one has a unique pattern of misfired pixels that is most evident in low light. As its name suggests, it is a fixed pattern, and so can be subtracted by the camera's processor, hence the option on better cameras.

In post-production, noise can be reduced by a variety of processing algorithms, most of which rely on being able to identify pixel-level differences in contrast and smoothing these out with averaging, median, or blurring filters. There is a distinction between luminance noise (dark and light specks) and chrominance noise (colored specks), and some software uses separate procedures for each. If the end-product of an RGB image is to be black and white, the chrominance noise does not matter. Because noise reduction is a specialized process, it makes little sense to try and tackle it with the ordinary Photoshop tools. Photoshop Raw, as shown, has a noise control, but consider using the camera manufacturer's editing software, on the grounds that the manufacturer is likely to have the best information of the noise problems specific to that sensor. Or there is dedicated software, like PictureCode's Noise Ninja, for which specific camera noise profiles are supplied.

Photoshop Camera Raw

For Raw images, luminance and chrominance noise are filtered separately. If the image is to be converted to grayscale, chrominance noise is less important.

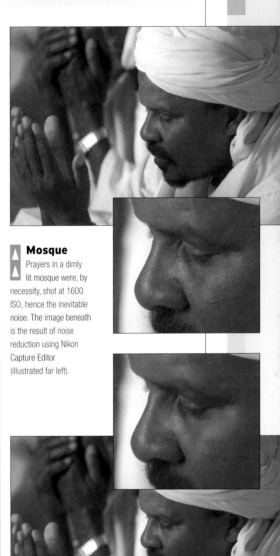

Mosque
Prayers in a dimly lit mosque were, by necessity, shot at 1600 ISO, hence the inevitable noise. The image beneath is the result of noise reduction using Nikon Capture Editor (illustrated far left).

Copying in black and white

Making an accurate record of flat artwork calls for a precise adjustment of the tonal range so as to preserve the often minute details.

Paradoxically, copying for reproduction in black and white usually demands more care than when a color image is the final output, and this is particularly true for flat artwork in which the base is white, as in a document or a wood-block print. The reason for this is that the variety of hues in a color image can easily mask errors in lighting and exposure. Black and white's much more restricted palette draws attention to things like vignetting, uneven lighting, and the background tone of the "white." Nevertheless, there are ways of dealing with any problem in image editing.

With a full-color original, such as a painting, it helps to have a measure of the actual colors, and professional copyists use a color target close to the original or held in front of it for a reference shot. Color accuracy is not, of course, as important for a black-and-white reproduction, so this step is not essential. What replaces this as a matter of judgment is deciding what tonal values to assign to the different colors, just as with regular photography. There is often a tendency to exaggerate tonal contrast for a more dramatic effect, and in reproducing original artwork this is not really appropriate. Copying may not be a particularly creative activity, but it does demand proficiency and remaining faithful, perceptually, to the original. The example here of a full-length portrait shows the kind of decisions that need to be made.

Original
This oil portrait was photographed under reasonably accurate lighting—3200K quartz-halogen, with a 3200K white balance setting. Color accuracy is important even in black and white, in order to decide the channel mix.

White point
The white point, as set using the Levels tool (as shown to the right).

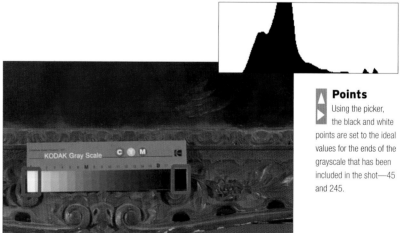

Points
Using the picker, the black and white points are set to the ideal values for the ends of the grayscale that has been included in the shot—45 and 245.

More technically demanding is simple black on white flat artwork. Here, the essential is to reproduce the white as brightly as possible without blowing it out through over-exposure. At the same time, the black parts of the artwork need to be rich and dense, but without "bleeding," which is to say keeping finely drawn or etched lines separate. At image capture, the extremes of black and white can make the camera's histogram difficult to read, as they will each tend to be at an end of the scale. More useful is the highlight warning display on the LCD, letting you adjust the exposure so that the image is as bright as possible without clipping.

There are two lighting issues. One is to make it even across the original, for which it's normal to use at least two lights, aimed evenly from opposite sides. Four are even better, although more cumbersome to set up. A workable alternative is direct sunlight, uncontrolled though it may sound. One advantage of the sun is that because of its distance there is no illumination fall-off. But with this, the second lighting issue comes into play—reflection. Very few surfaces are completely matte, and even a textured white paper will show hot-spots if the angle of lighting is too frontal. A low angle, whether from the sun or artificial lights, is usually best.

Final
Using a channel mix of 80% red, 20% green, and 0% blue, as tested on the color swatches, the painting now has an equivalent perceptual contrast to the optimized color original.

Curves
A standard contrast-enhancing curve is now applied, and the image is ready for grayscale conversion. The result of a standard conversion is shown above.

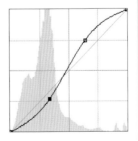

Scanning negatives

The advantage of scanning a black-and-white negative for digital printing over normal silver halide printing is the wide range of digital tools available for editing and optimizing the image.

Basic scanning sequence

1. Load the preview in as large a window as possible, and rotate 90° if necessary.
2. Crop accurately. If you choose to leave a margin of the rebate (the unexposed area around the edge), be aware that this will affect the histogram display.
3. Set the file size and output resolution. In fact, the resolution, measured in dpi, is less important, as it can be changed later without affecting the image. The file size, however, in megabytes, determines the size at which you can print the image. At 300 dpi, a 8Mb monochrome scan will print to letter (A4) size (17Mb for 16 bits per pixel).
4. Set as high as possible a bit-depth to capture the maximum tonal information. That is, more than the regular 8 bits per channel.
5. Set the white and black points, without clipping highlights or shadows.
6. Adjust the brightness, using either the curve or a slider, based on the appearance of the image on-screen.
7. Set the amount of sharpening to either low or none (sharpening ought to depend on the final size of use, and is usually best left until immediately before printing).
8. Scan and save.

In the changeover from film to digital, there comes the stage when it makes sense to archive the negative files, not only for filing and digital storage but also so that they can be entered into the digital workflow of post-production and desktop printing. Slide scanners have the option for handling black-and-white negatives, and this involves displaying and capturing inverted tones to produce a positive scan, and using a single grayscale channel rather than the three RGB channels. This, of course, makes scanning faster—a real convenience with high-resolution scans.

Scanning software offers many of the same optimization tools that Photoshop has, including Levels and Curves. Thus there are two stages at which you can make these adjustments, but, as with digital capture using a camera, it is important to acquire as much of

 Chapter House

The original 6 x 6cm negative of a stone ceiling in London's Westminster Abbey. Most of the detail is evidently in the shadow areas.

▷ **The scan**

Using a Nikon slide scanner, the settings are selected as Neg (Mono), 6 x 6, and Grayscale. The illumination (Analog brightness) is set so that the highlights just fall within the range, leaving a very small gap at the left (shadow) end.

the information as possible at the scanning stage. In particular, this means setting the black and white points correctly, and the objective is to capture as wide a tonal range as possible without clipping either end. Much depends on the scanner software. If there is any uncertainty about clipping, err on the side of caution and set the black and white points at a little distance from the ends of the histogram. Of course, if you make no adjustments at all, then you will not have made use of the full dynamic range of the scanner, and any later optimization will, in effect, stretch out the more limited tonal range of the image. Clearly, it pays to scan at the highest bit-depth possible, for the same reasons as shooting Raw format with the camera. A slight difficulty with scanning negatives is that the D-Max and D-Min of the original film are very far from black and white. Examine a properly exposed black-and-white negative on a lightbox and you will see that the densest areas (maximum exposure) are gray, while the film rebate (no exposure) is a pale gray because of the tone of the acetate film base. When you load a negative into the scanner, the histogram as it first appears will show significant gaps left and right, and they do need to be closed up. The more adjustment you leave to Levels in Photoshop, the less of the subtle tonal gradation you will be able to hold.

Photoshop changes

The positive scan before optimizing (above) then after Levels adjustment (left). As the scan settings were chosen carefully, there is very little closing up to do in Photoshop.

16-bit

This is a 16-bit scan, retaining significantly more information than the 8-bit versions shown at the top of the page. Radical changes can be made to it at little cost to the overall quality.

Moody final

From the 16-bit original, this adjusted image still has subtle tonal grades. It has also been sharpened for press.

Scanning positives

Continue the archiving process by scanning color transparencies in a slide scanner and prints in a flatbed model.

A scanner provides the same opportunities as digital capture for finessing the conversion of a color scene into black and white, including the choice of gray tones for individual colors. The basic scanning procedure is exactly the same as for film negatives, as just described, except that the mode is positive and RGB.

Having made all the adjustments recommended in the box "Basic scanning sequence" on the previous pages, also adjust the color balance and saturation. This makes it important to assess the color of the slide first, on a color-corrected lightbox, before placing it in the scanner. Look for neutrals and memory colors in the slide, and make a mental note of them. Neutral areas, such as concrete and shadows on white, are particularly valuable, as they can be measured with the scanner software's sampling tool. If you make regular use of a slide scanner, you should in any case calibrate it.

When only a black-and-white print survives of an image, flatbed scanning is both a means of safeguarding the image and a first step in retouching

Dust and scratches

Always clean the film to be scanned, to remove dust and particles. If there are embedded particles in the film, consider washing the film. Many scanners have an option for finding and removing dust and scratch artifacts, although some that use a separate infrared channel during the process will work only with color slides, not black-and-white silver negatives.

Settings
The image is cropped to within the mount, the size and resolution set to the desired amounts (the maximum at 300 dpi), and the Curves used to lighten the mid-tones.

Mode
With a slide scanner, the procedure is essentially the same as for a negative. The input here is Kodachrome, and the output Grayscale.

blemishes. However, while a good print carries the advantage of being a considered expression of the raw negative, and has been optimized to the satisfaction of the printer/ photographer, the much greater disadvantage is that its dynamic range is much less than that of the original negative. The dynamic range of a print varies between about five f-stops for matte paper and seven to eight f-stops for glossy, but the range for black-and-white negative film is in the order of 11 f-stops, around 2,000:1. If you have the negative and a fine print, scan the negative and use the print as a guide for optimization.

Print
The original is a 4 x 5 inch Polaroid black and white—small, but high quality. A flatbed scanner is used with its plug-in software, and the mode set to Grayscale.

Size
Scale and resolution are set—800% at 400 dpi Sharpening (USM) and dust and scratch removal are activated at their default settings.

Setting
Finally, the tonal range is optimized by closing up left and right and applying a little lightening of mid-tones with the curve.

Mood and atmosphere

Fine-tuning brightness and contrast can alter the character and lighting of a scene for a personal interpretation.

In black and white, more than in color, there is no such thing as a perfectly "correct" print. Instead there is the individual photographer's idea of how the image should look; what Ansel Adams called "visualization." Here is how he described his ideas for one of his most famous images (*Clearing Winter Storm*, Yosemite National Park, 1940): "Although the scene was of low general contrast, my visualization of the final print was quite vigorous. The subject had a very dramatic potential." Or consider the work of English photographer Bill Brandt, who favored glossy grade 4 paper for intense blacks and brilliant whites, and once said, "I try to convey the atmosphere of my subject by intensifying the elements that compose it." Other photographers have aimed for lower contrast in order to reveal everything from shadow to highlight with the subtlest of distinctions.

Just because the mood of an image is a less tangible quality than, say, its composition, makes it no less important to think about. The technical issues of digital imaging understandably occupy a lot of attention because they are new, complex, and detailed, but there is a tendency for them to push to one side those creative qualities that are less easy to pin down. Setting black and white points, and other ways of optimizing, are technical procedures that

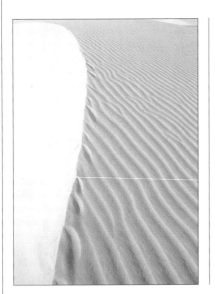

◢ **White Sands**

White Sands, New Mexico is a favorite location for black-and-white landscape photography because of the constantly changing graphics of shadows on the brilliant gypsum sand. In this high-key treatment, the mood is open and bright, with no shadow tones.

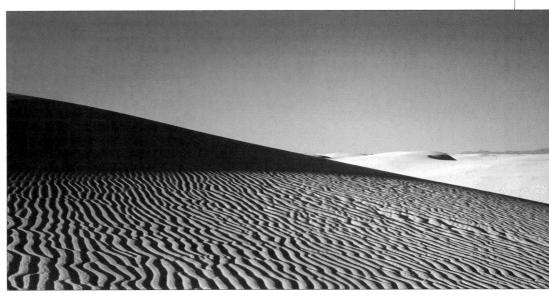

ought to follow on from your ideas of how an image should look, and not determine it.

Consider the following descriptions as applied to black-and-white photographs: bright and open, mysterious, threatening, subdued, airy, cheerful, soft, brittle. All are valid, even though open to personal interpretation, and the language is far from technical. It describes the overall effect and not the process. Nevertheless, the means for creating these types of atmosphere suggest themselves readily enough in monochrome, as the table illustrates. Here is yet another instance in which discarding the dimension of color from images tends to focus attention on the nuances of the tonal range. Arguably, mood and atmosphere are better served in black and white than in color.

▼ **White Sands**

A quite different atmosphere ignores the whiteness of the sands and concentrates on graphic relationships, using the full range with strong blacks.

▶ **Chapel of St John**

This vaulted Norman chapel in the heart of the Tower of London was photographed without artificial lighting to capture its natural atmosphere, a mixture of mysterious and deep shadow details among the stone pillars and arches, and the flooding light from the far end.

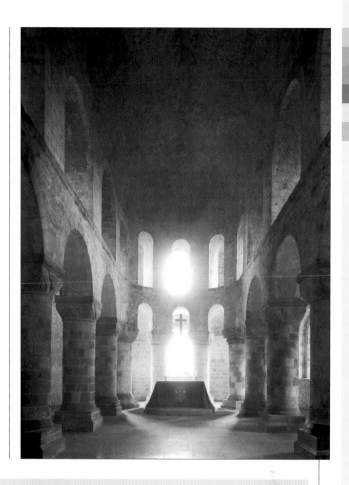

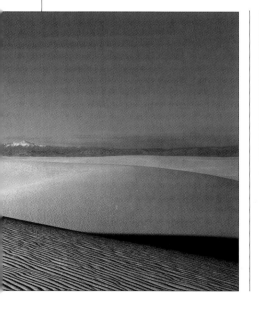

Qualities and effects

Technical qualities	Mood effects
Most of image falls into mid-to-light tones, large areas of highlight, no blacks, limited shadows.	High key, bright, cheerful, but also possibly slightly mysterious through the sense of not being able to see everything. Luminous.
Most of image dark, with few highlights. The concentration of graphic activity is in the shadow areas.	Low key, rich, and dense, can be threatening, possibly mysterious.
Image largely in the second quarter of the tonal range (dark-to-mid), with no true blacks and very few light tones.	Murky, crepuscular, with possibly industrial and even pollution overtones.
Shadows and highlights clipped or almost clipped, and much of the image close to these ends of the scale, with limited areas of mid-tone gray.	High contrast, stark, lunar, chiaroscuro, sharp, and brittle.
Most of image concentrated in the mid-tones, with few if any dark shadows and bright highlights.	Low contrast, dull, subdued.
Image largely in the third quarter of the tonal range (mid-to-light), with few dark areas but no really bright highlights.	Soft, delicate, misty.

Case study: **defining the mood**

On the previous pages we saw how the mood and atmosphere of a picture can be defined. This example shows the conversion from an original 16-bit file to a more artistic print.

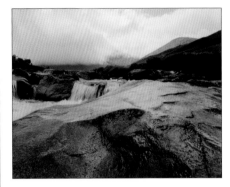

1 The original image in 16-bit, looking at first glance rather dark and flat–an excellent starting point! Next to this is a second, darker exposure for the sky.

2 Sketch showing the intended plan. The sky will receive two treatments to make it thundery.

3 The first action is to make the tonal range fit neatly within the full scale, by setting the white and black points. Holding down the Alt key (or Option key) at the same time as moving either slider reveals the point at which the highlights/shadows will be clipped. The actual setting is a little back from these.

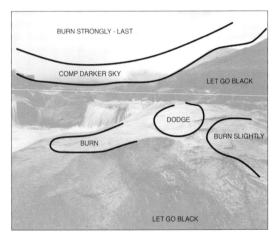

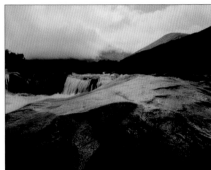

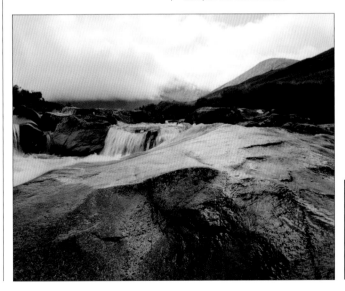

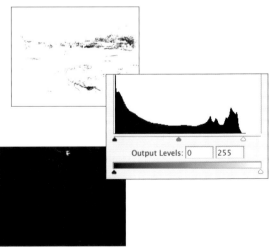

Output Levels: 0 255

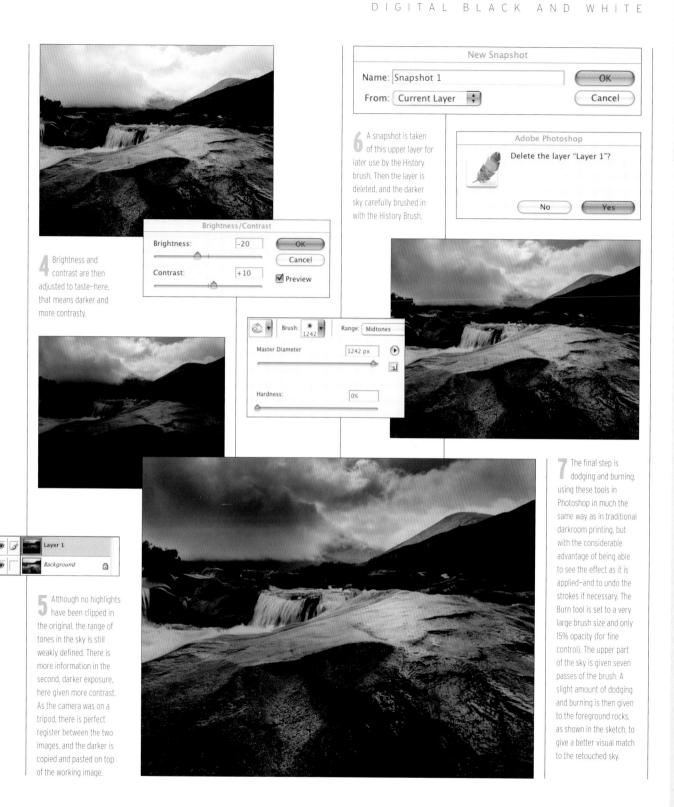

New Snapshot

Name: Snapshot 1

From: Current Layer

OK

Cancel

6 A snapshot is taken of this upper layer for later use by the History brush. Then the layer is deleted, and the darker sky carefully brushed in with the History Brush.

Adobe Photoshop

Delete the layer "Layer 1"?

No Yes

4 Brightness and contrast are then adjusted to taste–here, that means darker and more contrasty.

Brightness/Contrast

Brightness: −20

Contrast: +10

OK

Cancel

☑ Preview

Brush: 1242 Range: Midtones

Master Diameter 1242 px

Hardness: 0%

● Layer 1

● Background

5 Although no highlights have been clipped in the original, the range of tones in the sky is still weakly defined. There is more information in the second, darker exposure, here given more contrast. As the camera was on a tripod, there is perfect register between the two images, and the darker is copied and pasted on top of the working image.

7 The final step is dodging and burning, using these tools in Photoshop in much the same way as in traditional darkroom printing, but with the considerable advantage of being able to see the effect as it is applied–and to undo the strokes if necessary. The Burn tool is set to a very large brush size and only 15% opacity (for fine control). The upper part of the sky is given seven passes of the brush. A slight amount of dodging and burning is then given to the foreground rocks, as shown in the sketch, to give a better visual match to the retouched sky.

Toner effects

Traditional toning baths for silver halide prints, which add a gentle coloration, can be replicated in image editing using several different methods.

In silver halide printing, toner solutions became popular in the 19th century as a means of increasing the range of expression in a print through changing the color from black. The subtlety of the effects varied with the kind of toner and the process (longer development times typically produced stronger coloring when the print was later put in the toning bath). There was, in addition, an archival effect. Esthetically, toning had its proponents and its critics, but in general, it seemed to be most successful when used subtly. Toners work on emulsion, which means that in appearance their effect is

St James's Park

A telephoto view of Whitehall and Horse Guards Parade, in London.

Selenium effect

A slight increase in blue, an even smaller reduction in red, and a gentle increase in contrast replicates selenium toning.

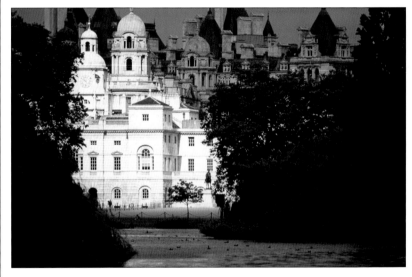

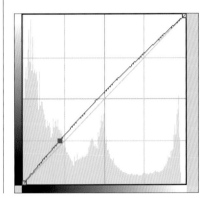
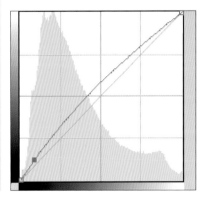
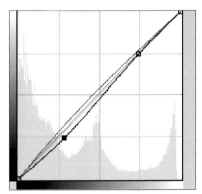

usually strongest in the mid- or mid-to-dark tones. It is least obvious in the highlights (where there is little to work on) while very dark shadows approach black in any case and reveal little color.

All of this can be imitated digitally during image editing, and if you like toning effects it helps to have some familiarity with the traditional range of toners. The most common was sulfur toning, which delivered a pronounced sepia effect. The method used is bleach-and-redevelop, in which a first bleach bath converts the metallic silver into a silver salt, which is then altered into brown silver sulfide by means of a second bath of sodium sulfide. The problem is the extreme overall effect, which is by no means to everyone's taste. Selenium toning has a less obvious and, for most people, a more pleasing result, with a subtle cooling of the print. Ansel Adams, for example, used it extensively in combination with papers that had a cool emulsion color, working for a cool purple-black image by using a cold-toned developer and a slight toning in selenium.

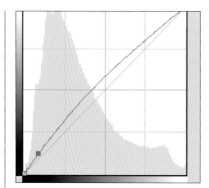

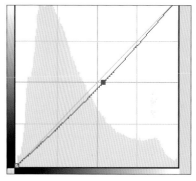

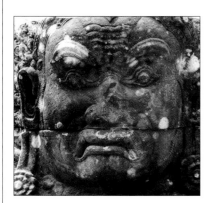

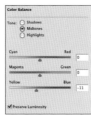

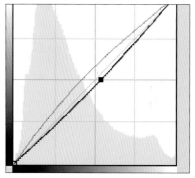

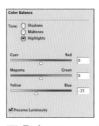

Balance
This control usefully separates hue changes across the tonal range, making it easy to concentrate the sepia in the darker tones and add a yellowing in the lighter.

Curves
Curves are used to do essentially the same thing—increase reds with a bias towards the shadows and reduce blue (that is, increase yellow) toward the highlights.

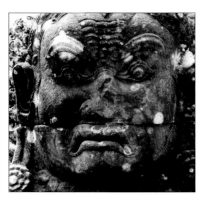

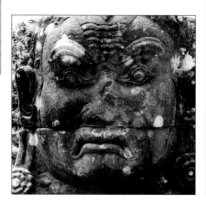

Analyzing traditional tones

An alternative and more factually based approach to toning is to work from traditionally prepared and toned prints to extract the color response.

We can cast the net wider than pure toning baths to include traditional and specialized printing processes, on the grounds that the appeal of these effects lies in the subtle addition of color, whatever the chemistry. This suggests a more pragmatic way of reproducing the effects digitally—first prepare the prints of an identical target, then scan these and analyze the response. The difficulty is that some printing techniques, such as palladium and cyanotype, are highly specialized, and there are few skilled practitioners. The problem was solved by Jan Esmann of PowerRetouche, by recruiting help from experts in each printing and toning process. The prints were analysed for tonal range and for the variations of color within that range.

His Toned Photos plug-in has nine presets, including Platinum, Palladium, Cyanotype, and Kallitype. The results vary in color, the way it is distributed across the tonal range, and also saturation and the breadth of the range.

Roots
A gallery at one of the Angkor temples encased in the roots of a giant silk-cotton tree. The ancient atmosphere might benefit from an old-fashioned look, as if it had been photographed when first discovered.

▶ Power Retouche

The Toned Photos plug-in contains a number of presets that automatically convert from a color original into a traditional type of print. Part of the conversion allows for the difference in paper.

Ta pro

Van Dyck

Silver

Silver gelatin

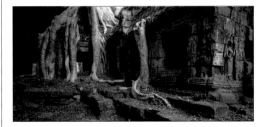

Platinum

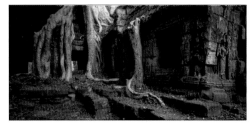

Sepia

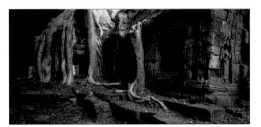

Kallitype

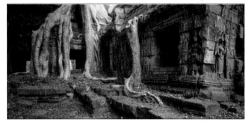

Light Cyan

Palladium

Cyanotype

Mimicking film response

For photographers unhappy to be weaned off a favorite black-and-white emulsion, there are convincing digital imitations.

Many black and white film photographers have a favorite emulsion, although how real the claimed differences are between brands is moot. There certainly was a major distinction between old orthochromatic (relatively insensitive to red) films and modern panchromatic, but from one modern brand to another the differences are slight. They are mostly in the dynamic range and the shape of the characteristic curve. One way to simulate a particular emulsion's response curve is simply to download the response curve from the manufacturer's website (for those that are still in business). Then tweak the Curves graph of an image in Photoshop to approximate this, and save it as a preset for later use. This is very much a matter of judgment, but given the very fine shades of difference, this is probably as good a way as any. Another approach is to photograph a grayscale, scan this, and analyze the tonal response. But the scanning probably introduces much greater differences than exist in the first place. One third-party software company has actually gone to the trouble of analyzing the tonal performance and spectral sensitivity of different black-and-white emulsion brands and produced one-click "Filmtype presets"—this is the Black and White Studio plug-in from PowerRetouche and, alongside DxO FilmPack, a definite recommendation if you want your digital imagery to look like Tri-X, for example. It certainly saves considerable

◢ Ava
The starting point for adding a grain effect is this misty view of an old watch-tower in Burma. The smooth gray tones will show any grain distinctly.

▼ nik Color Efex Pro
This plug-in, part of the nik Multimedia Color Efex Pro! suite, has Grain as one of five sliders.

◁ Make your own
One option, if you have a great deal of time, is to make your own noise and exaggerate it or soften it with Curves.

Old Photo
nik Color Efex Pro!

Brightness	45 %
Grain	19 %
Paper Color	138 c
Contrast	132 %
Contrast	R

Save Load Help ((((⊖) Cancel OK

Image is 5679 × 3810 pixel at 300.00 dpi. Printing at 18.93 × 12.70 inches.
Virtual memory: Image is segmented into 580 blocks.
Acceleration: On.
Image mode = RGB.

effort, and is just one of many effects that use traditional black-and-white photography as a starting point.

Another aspect of black-and-white film imagery that retains a certain esthetic appeal is grain. The loose equivalent in digital capture is noise, but the similarity is superficial, because the reasons for each are quite different. Noise in a digital image has almost no saving graces, and is much more closely related to the noise in an audio signal—an artifact that interferes with the content. Grain in film, despite looking similar (except in close-up) and being also associated with increased ISO sensitivity, does have some justification. It derives from the clumping of processed crystals in the emulsion, and so is intimately a part of the process, as much as brushstrokes are to a painting. This, at least, is the argument for those photographers who like its presence, and in the days of film there were identifiable differences between brands of emulsion in the grain structure they displayed. This is not the place to argue the merits of graininess, but as it has its adherents, simulating it digitally is valid. The visible grain in a silver image is not, incidentally, a view of the individual crystals, but of much larger clumps.

Original APX 100

100TMX HP5

T400CN Delta 100

400TX PanF

▲ Woodland

This converted black-and-white shot of bluebells in woodland has considerable detail, and will need a strong grain effect to make a difference. With this technique, we create our own grain with a noise filter.

▶ Hippo

An ox-pecker perched on the brow of a hippopotamus provides a test-bed for seeing the subtle differences between the tonal responses of different black-and-white negative films.

Controls [Film]

Lens Color-filters
[None]

☐ Add Filter

Strength — 100

Film Spectral Sensitivity
Filmtype presets

Wavelength

Magenta - 400
Blue - 440
Cyan - 42
Green - 510
Yellow - 58
Orange - 618
Red - 645

Panchromatic
Orthochromatic
• Perceptual Luminance
100TMX TMAX (Kodak)
T400CN (Kodak)
400TX Tri-X (Kodak)
APX 100 (Agfa)
HP5+ (Ilford)
Delta 100 (Ilford)
PAN F+ (Ilford)

Duotones

This established graphic arts tool can be re-purposed to both improve the monochrome printing performance of a desktop inkjet printer, and add subtle colors.

Duotones were developed for the printing industry, both as a way of adding a spot color to an image and as a solution to the problem of the narrow range of grays that most printing presses are capable of. An 8-bit monochrome image has 256 levels from black to white, but a typical press can manage only about 50. A duotone using a black and a gray significantly increases the dynamic range for the press. All of this is of limited interest to most digital photographers, but the tools for creating duotones (and tritones and quadtones), conveniently available in Photoshop, can be put to the unintended use of increasing the range of expression in desktop inkjet printing.

These printers can't actually use duotones in the way they were intended, but the image can be adjusted in several interesting ways. The reason is easy to understand. Whereas a color RGB image has 16.8 million levels (256 x 256 x 256), a grayscale image has just 256, and if the printer is using just its black ink, it finds it hard to create 256 separate shades of gray by means of its

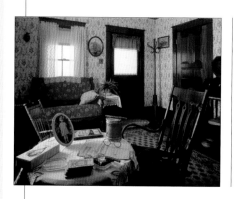

▲ A 1930s living room
An Italian-American living room installation in a museum is the starting point. The shot has an historical atmosphere, and may well suit a duotone treatment.

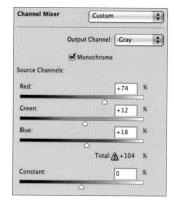

▲ Convert to monochrome
First create the monochrome effect that you prefer, by using desaturation, the Channel Mixer, or any of the other conversion methods.

◄ Grayscale
Next convert the image to 8-bit grayscale. In Photoshop, images can only be changed to duotone if they are single channel and 8-bit. *Image > Mode > Grayscale.*

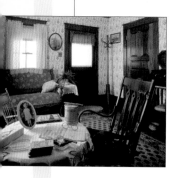

dithering procedure. Printing in full color mode allows the printer to use all of its inks, and the dynamic range is improved, but at the potential cost of unpredictable color casts. Duotones, like gray component repalcement, are another way around this impasse.

In a sense, duotones replace channels, with the added advantage that each ink that you specify has a readily available Curves dialog that allows precise adjustments of its tonal range. We'll deal with this aspect of duotones on the following pages. For now, the first step, having made the conversion to Duotone in Photoshop, is to assign the inks, and normally the first one will be black. Graphic arts professionals need to specify an exact ink, hence the drop-down list of presets available in the Color Options dialog, offering a range of process and Pantone colors. This precision is not necessary for desktop inkjet printing, because your printer uses its own set of inks, so when selecting these colors you can make the choice solely on appearance. There is also another way of choosing a color: using the standard Photoshop Color Picker, also available from the Color Options dialog.

If there is a problem with duotones, it is the infinite choice of colors and settings, so to begin with ignore the curve boxes that appear at the left of each ink in the Duotone Options dialog, and concentrate on the ink colors. Preferences are largely a matter of personal taste.

First ink
For ink 1, create a pure black in the Picker and use this as a starting point. You can go back and change the color at any time.

Second ink
For ink 2, use the Picker again and choose any other color, in this example, blue-green. Click the Preview box off and on to see the scale of the change.

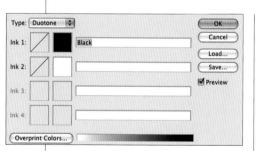

Two inks
Two inks are available. Click the second square of Ink 1 to access the Color Options dialog. This offers two ways of choosing an ink color. One is from the presets available under Book. The other is via the normal Color Picker. Click Picker.

Duotone dialog
Open the Duotone Options dialog window by going to *Image > Mode > Duotone*. Choose Duotone under Type and make sure the Preview box is ticked so that you can see the results of any changes you make in real time.

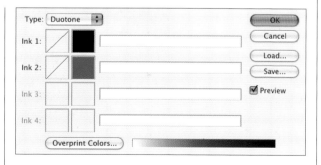

Manipulating duotone curves

Arguably the most powerful use of duotones is in assigning the different colors to discrete parts of the image's tonal range, by means of curve adjustment.

Simply adding one color to black, as on the previous pages, is interesting, but largely misses the opportunities offered by duotones. Each ink/color has a curve attached to it, on the left in the Duotone Options dialog. Clicking on this opens up the Duotone Curve window, with the graph on the left and percentages on the right. By now, you should be familiar with the adjustment of a curve: it is the same here as the regular Curves dialog, without the black and white point tools, but with a finer grid mesh to allow more precise positioning of points along the curve. Whatever the tonal range of the image, it appears by default as a straight 45° line. As you click to add and move points along this line, the percentage boxes at right show how much ink will be applied to that point on the curve.

◄ Original
This shot of an opulent 19th-century Swiss interior is ideal for our purposes.

▲ Select a preset
Load the Photoshop Presets (in the folder structure *Duotones > Gray/Black Duotones*), and choose any of the presets. In this example, we use "424 CVC."

▼ Ink 1
Click on the curve box for ink 1, then drag the curve to lighten the application of black to the highlights.

▲ Grayscale
Convert the original to grayscale using the technique on the previous page. We can now experiment with the Photoshop library of preset tones.

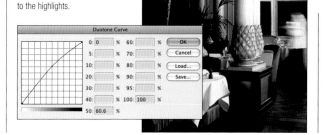

▲ Ink 2
Next click the curve box for ink 2. Drag the top right corner down, then add another point on the curve and drag it upward. This shape reduces blue-green in the shadows.

Curve adjustment is at the heart of duotones, but getting a feel for the effect of altering them takes time. The basic approach is to assign each ink/color to a different part of the overall tonal range, and the most usual is to use black for the shadows (to ensure a rich, dense lower end to the scale) and the other color for the mid-tones and highlights. Even so, where to begin is a common problem. Fortunately, Photoshop offers preselected colors which can be accessed by clicking Load in the Duotone Options dialog. These are particularly useful if you are beginning to experiment with duotones, because each has a different combination not only of ink colors but also of curve settings. A glance at a number of presets will show you how infinitely adjustable, and complex, the combinations can be, even with only two inks. Probably the best advice to start with is to take an image with which you are familiar, and load different presets from the Gray/Black Duotones library, one at a time, to familiarize yourself with the effects of different curve shapes. Don't hesitate to remanipulate the loaded curves to see what happens. Once you have a reasonable grasp of how the curves work, do the same with the PANTONE Duotones and Process Duotones libraries. This adds the dimension of color, and a delicate application of this to certain tonal areas can give a surprising improvement to the appearance of the tonal range.

A final step, but only for when you are comfortable with making the choices for a duotone, is to move on to tritones and quadtones. These dramatically increase the range of options. As we'll see, using four inks, each with adjusted curves to assign them to different but overlapping parts of the tonal scale, can produce the complexity of effect that was once the prerogative of advanced toning in selenium and other chemicals.

Black & PANTONE Warm Gray 8 CVC

Black & PANTONE Warm Gray 8 CVC

Black & PANTONE 506 CVC

Black & Yellow

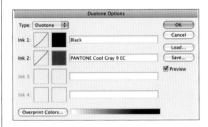

Cool gray 9
A "Cool Gray 9." As with each choice, go to the Duotone Curve dialog for each ink, one at a time, and look carefully at how it has been constructed.

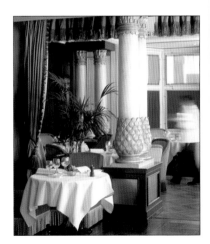

Other presets
Go back to the Duotone Curve dialog for each ink, and adjust the curves to achieve your desired results.

Stylized black and white

Among the stable of imaging effects suites are a number designed specifically for monochrome, to create unusual or atmospheric graphic treatments.

This is a huge area of image conversion, although away from the basic standards of a balanced, optimized photographic image. To make this kind of alteration there are many filters both within Photoshop and as third-party plug-ins. Purists committed to "straight" photography will abhor these treatments, but for others they have their uses. There is a distinction, which may or may not be useful, between stylizations that are traditionally connected to the photographic process (such as solarization, posterization, and lith film) and those that convert images to other art media (such as crayon, pen and ink, and charcoal). The Photoshop Filter menu is a place to begin at no extra cost, in particular the Sketch, Artistic and Brush Strokes sub-menus. Third-party software, as plug-ins or standalone applications, offer more sophisticated and adjustable conversions, as the examples here show.

Alpine flowers
This is the color original, chosen due to its clear shapes and distinct lines.

Poster edges
From Photoshop's Artistic filter set, this filter performs a posterization (see the following pages) and adds an edge effect that converts edges into lines, like a drawing.

Bas Relief
One of the Sketch filters, this treatment offsets highlighted edges on one side of the image with darkened edges on the other side.

Spatter
In the Brush Strokes set of Photoshop filters is this effect that mimics spattering, with characteristically ragged edges.

Stairs

A filter within nik Multimedia Abstract Efex Pro!, this creates a stair-stepping effect across the luminosity of an image, at the same time making adjustments based on hue.

Solarize

Also part of nik Multimedia Abstract Efex Pro!, this filter simulates the traditional solarization darkroom effect achieved by a brief exposure to light.

Duplex

This filter from nik Multimedia Color Efex Pro! simulates the duplex print process by creating a single-hue image with the color values across the image changed for a stylized look.

Posterization

Used on an appropriate image, this traditional technique for simplifying the continuous tonal range of a photograph into a small number of distinct, flat tones can produce an interesting graphic stylization.

Posterization is both an imaging fault and a way of deliberately stylizing photographs. It works by clumping a range of tonal values into one single value (hence the name), for an early and widely used graphic technique for making posters—with flat blocks of color or tone. As a fault, you can see it in action by making strong changes to an 8-bit image and viewing the results in Levels, where a characteristic "toothcomb" effect is evidence of clumped values with gaps in between. For intentional creative effect, Photoshop offers a dedicated filter, under *Layer > New Adjustment Layer > Posterize*. The skill in using it successfully lies in choosing not only the number of levels to which the image will be reduced, but also in choosing the "breaks"—the divisions between the tonal ranges that determine the edges of the new posterized tones. A successful break helps to identify the content of the image rather than confuse it.

The first step is to find an image suitable for posterization. Because the process drastically simplifies the tonal range, graphically simple images nearly always work the best, and it may even help to retouch some areas

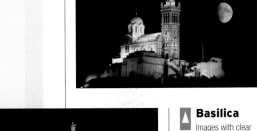

▲ Basilica
Images with clear shapes and simple tonal areas posterize the most successfully. This late evening view of a church overlooking Marseilles harbor still has enough tone in the sky to separate it.

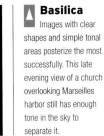

▲ Convert to black and white
A channel mix favoring red strongly lightens the building and darkens the sky for good separation. This is done as an Adjustment Layer.

▲ Posterize Adjustment Layer
A posterizing layer is added, and four levels selected.

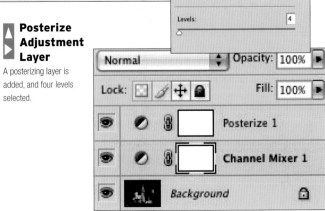

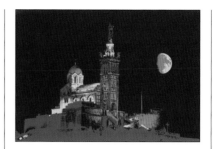

of the image, such as the background, to improve the simplicity. The next step is to convert the image to grayscale while retaining all three channels, and the Channel Mixer is ideal for this. As with most special effects, the final outcome may be difficult to predict, so it's advisable to maintain some flexibility—hence a Channel Mixer Adjustment layer is recommended. You can easily go back to this layer to alter the mix. Note that while the Posterization filter can be applied to a color image, this restricts the number of posterized levels to at least six—the minimum number of levels for the posterization command is two, but this is then applied to each color. Converting to grayscale first removes this restriction.

Above the Channel Mixer layer, create a posterizing layer (*Layer > New Adjustment Layer > Posterize*). This offers a choice of the number of levels, with a minimum, obviously, of two. As an adjustment layer, this is easy to return to and alter the number, but tends to be more successful graphically with a small number of levels. Four is often a good number to begin with.

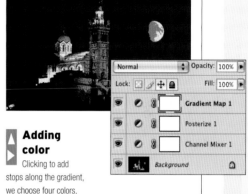

Adding color
Clicking to add stops along the gradient, we choose four colors, one for each posterized level. The application is startlingly effective.

Muted color
To modify the bright colors, the fill opacity of the Gradient layer is reduced, here to 33%.

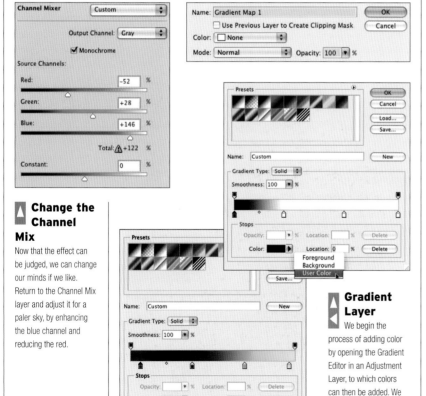

Change the Channel Mix
Now that the effect can be judged, we can change our minds if we like. Return to the Channel Mix layer and adjust it for a paler sky, by enhancing the blue channel and reducing the red.

Gradient Layer
We begin the process of adding color by opening the Gradient Editor in an Adjustment Layer, to which colors can then be added. We start with a default grayscale map.

Adding age

One specific class of image distress is an antique effect designed to imitate an early silver halide print or other, old-fashioned print processes.

A very specific way of stylizing images in black and white is to give the impression of age. This is a kind of pastiche, and calls for some justification. Like all stylization, it runs counter to the ethos of the well-tuned fine print, and is generally the reverse of optimization, with a final result in which highlights are lost and the overall contrast reduced, in addition to color shifts.

St Pancras Hotel
The image used for antiquing is an interior view of a Victorian railway hotel, abandoned for many years.

There is third-party imaging software designed specifically for this, and the examples here are three plug-in filters from nik Multimedia and one from AutoFX Software. With rather more effort, and several distinct steps, similar effects can be created using Photoshop filters and commands. The typical symptoms of aging are fading, loss of highlights, and paper discoloration. Alternative ways to suggest an antique flavour to a print are to reproduce old-fashioned styles of presentation, such as vignetting and decorative borders.

Antique Photo
Part of Mystical Tint, Tone, and Color from AutoFX Software, this filter includes color cast, soft-focus effect, fading and sepia tinting.

Monday Morning

In addition to color and brightness adjustment, this filter, part of the Color Efex Pro! suite, has a Smear control to give a softening effect similar to soft-focus, and a grain control.

Old Photo

This filter in the Color Efex Pro! suite allows any of the RGB channels, or all, to be used for the conversion, and also includes a paper tinting control.

Ink

In the Color Efex Pro! suite from nik Multimedia, this filter changes the color set in the image to make it appear as if it were printed on old photographic paper. Further desaturation is then applied for a monochrome effect.

Hand-coloring

Digital post-production brings a new convenience and a wider range of treatment to an old-fashioned process—that of adding color washes to a monochrome print.

Hand-coloring was an early technique for introducing color into a monochrome image, unsophisticated in principle although demanding in painting skill. It now has a new lease of life in digital post-production, with several alternative techniques to choose from. Traditional hand-coloring uses light washes of watercolor or dye, and so has most effect on highlight areas and least in the shadows. In other words, it works on the opposite end of the tonal scale to traditional toning solutions, and for this reason one approach was first to apply a light toning and then to brush in color. The digital equivalent naturally has no such constraints, but if the aim is to replicate the hand-colored effect, it helps to be familiar with its nuances.

▲ **Musicians**
A group of musicians playing at a Colombian party provides the basic image.

▶ **Hand-colored**
The final result of hand-coloring, which is muted and concentrates mainly on the instrument and face, leaving most of the image black and white.

▲ **First desaturate**
This initial step prepares for one of three alternative techniques. For purposes of comparison, reference and reverting, this is done on a duplicate layer.

▲ **Painting**
This is the basic approach, with a low (20%) opacity to give the desired muted effect, and a brush size and hardness that is constantly altered to suit the area of the image being painted.

▲ **Color Replacement**
This tool has advantages over simple brushing in that the tolerances can be set so that the color is automatically confined to one area of tone. Here, the brush is set to once-only Sampling, Contiguous, and a Tolerance of 20%.

Hand-coloring was never a realistic alternative to full-color photography, but instead added a subtle and less saturated overlay. An interesting and effective variation on this is partial coloring, as in the example here, in which the monochrome background helps to enhance the colored area by contrasting with it.

There are endless ways of adding color—or rather of controlling the coloring to give this style—but three of the most practical are painting on a new layer, undercolor exposure, and the Color Replacement tool. The first method is uncomplicated, but relies entirely on your skill with a brush. Open a new layer (New Layer in the Layers palette). Then choose the foreground color and brush size and hardness, and paint, changing colors and blending modes as necessary.

Undercolor exposure makes use of the original full-color RGB image to create partial coloring. The principle is to prepare a less saturated and stylized color base using procedural rather than hand-brushing techniques, then to create a grayscale overlayer (say a Channel Mixer Adjustment layer), and to erase—or, better still, mask out—specific parts of this by hand.

The third alternative is interactive brushwork using the Color Replacement tool. The value of this tool, designed for work on color images, is that it allows you to choose the parameters under which the color is applied. In addition to percentage tolerance, this goes beyond the usual brush options to include contiguous and discontiguous—the former confines coloring to areas that adjoin the first application.

Undercolor
In this technique, an overall muted color is used as the base. First, the image is slightly desaturated.

Monochrome layer
A Channel Mix Adjustment Layer is created above the Background layer.

Layer Mask
Painting on a layer mask has the effect of revealing the color Background image.

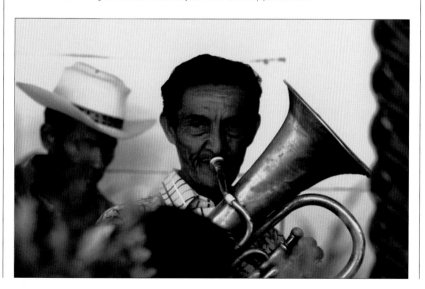

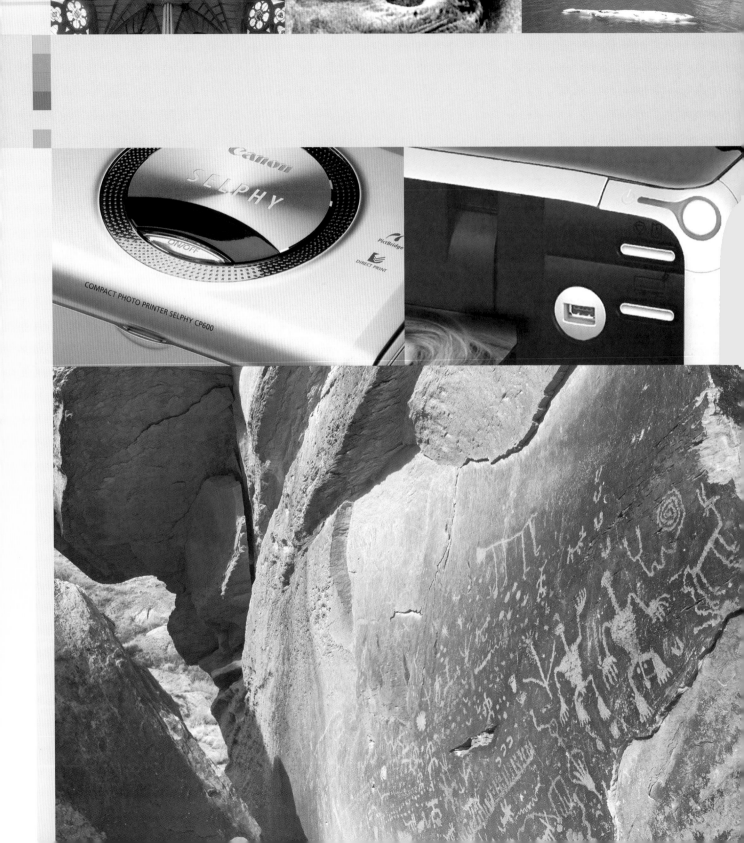

The **Print**

A fine print has always been the ultimate goal in black-and-white photography—more so than with color photography, in which the processes involved in printing have always been more limited and less easy to manage by oneself. For that reason we'll use this point in the text to consider printing, and especially monochrome prints. Not, of course, that prints are the only possibilities for display: digital projection, websites, and printing services have actually made the fine print easier and more interesting to achieve. The only thing missing is the ritual of the wet darkroom, which undeniably has a kind of alchemical appeal, but which is also messy, time-consuming, and unpredictable. It can certainly add to the experience of creating images, and is very insistent as "process," but these are features that most people nowadays would consider to be drawbacks.

Digital desktop printing, by contrast, is clean, visible, and immediate. The only chemicals are inks and pigments, which are preloaded as cartridges or tube-fed from sets of bottles (known as continuous ink systems). Conveniently and comfortably, everything takes place under normal lighting, which bypasses the need to set aside and seal off one room dedicated to printing. Nor is there any need for plumbing, or for the disposal of chemicals. The only delay is in the time it takes for the paper to move past the printing heads, and even this is a matter of time rather than uncertainty, because provided that the monitor, editing software, and printer have been set up correctly, what you see on the screen is what you will get as a print.

As in so much else digital, a rapid spurt of technological development has not only breached the barriers of acceptable quality and cost, but has taken printing performance to new levels that would have been hard to imagine in a purely silver halide world. Now the quality of both inkjet and dye-sub printers makes printing to professional and museum standards an affordable reality, and this makes a huge difference in the access photographers have to this ultimate form of the image. Because the physical space of a darkroom is no longer required, printing becomes as easy as any other stage in the digital process. And convenience is not the only benefit, because perhaps the most exciting thing about digital printing is that you can keep it as part of a closed loop. Whether in the studio or at home, you can manage every stage of post-production yourself, and the rapid feedback you receive from the printer makes it easy to fine-tune the print. Moreover, with inkjet printing, which has become the de facto standard, it is now possible to print on almost any type of paper. No longer are you restricted to the glossy, semi-glossy, and matt varieties that were the staple of silver halide printing. Manufacturers of inkjet-dedicated paper now offer far more choice, and beyond that, more adventurous photographers are experimenting with the countless different varieties of non-dedicated paper. Handmade paper from the most obscure sources imaginable can be fed into most inkjet printers for ever more individualistic prints.

Desktop printers

Two digital printing technologies, inkjet and dye sublimation, offer a huge range of desktop printing possibilities in black and white as well as in color.

The advances in printing technology, principally in inkjet, but also in dye-sublimation, have radically altered the options for producing high-quality display prints. Inkjet technology involves spraying minute droplets of ink through a set of nozzles, and is now the standard for desktop printing. Dye-sublimation printers use wide ribbons for successive contact printing of inks via a thermal transfer method, and have the advantage of producing prints that are close in look and feel as traditional glossy silver-halide prints, although only proprietary paper can be used. For black and white printing there are special monochrome cartridges, and the result is a true continuous-tone image, without the dithering used by inkjet printers. Nevertheless, inkjet printing will probably remain the standard for its flexibility of size, choice of inks, and choice of papers. Indeed, any paper can be run through an inkjet printer, and for special effects there is plenty of room for experiment.

Dye sublimation

This is a thermal transfer process in which cartridges supply sheets of ribbon containing dye to the size of the print. Heating elements in the print head are activated as the ribbon passes over it, causing the dyes to vaporize and soak into the paper. The paper has to pass to and fro in register for successive dye transfer, which in the case of black and white printing means using blacks and grays. As the ribbon is for one-time use, and special paper is needed, dye-sub printing tends to be expensive.

Canon Selphy

The most common form of dye sublimation printer on the market these days is the compact photo printer. The technology was once widely used in computer color proofing too, but the cost has proved prohibitive when compared to inkjet technology.

Inkjet inks

A standard set of inkjet inks for a Canon printer. Different printers take different cartridges—some, like these, are sold separately. Others come in a combined unit that you must replace when one ink runs out.

Inkjet technology

Many desktop machines are now designed specifically
for photography, with a larger number of heads and
high-resolution output. A stepper motor moves the print
head assembly, with its nozzles, one for each ink color or
tone, one line at a time over the paper. Dithering results
in a mix of inks, and output resolutions of 1440 dpi and
2880 dpi are common. When comparing resolutions,
remember that at the smallest level an ink dot can either
be on or off (black or white, cyan or white, etc), so this
sort of resolution isn't directly comparable to the 300dpi
most printing houses prefer, or the resolution your
computer screen works at.

Canon Pixma printer

This modern inkjet shows how far the technology has
come in a few years, while still remaining versatile. This
printer has two paper trays and even the ability to print
onto CD or DVDs (in some regions), as well as producing
excellent photographic prints using its two black inks.

100%

500%

Dithering

Inkjets make the
appearance of
continuous tones using
dithering—arranging
patterns of dots on the
page with varying
degrees of density. A
close look at any section
of output reveals these
patterns, sometimes
known as halftones.

1000%

Contact sheets

Almost all browser and image-editing programs now offer options for creating that mainstay of black-and-white image selection, the printed contact sheet.

Contact sheets have always had a special role in the editing process of traditional black-and-white photography—more than their simple physical convenience might suggest. Editing in this case means the selection of images for final printing from the shooting sequence, with a printed contact sheet providing a kind of summary of the photographic session. Naturally, with black-and-white negative film, a set of positive "thumbnails" was the only way to read details such as the expression on a face, but even though this is no longer an issue in digital imaging, a printed sheet remains a valuable and highly recommended intermediate step. Viewing digital images on a monitor is convenient in some ways, but has the drawbacks that it ties you to the computer and is only really satisfactory in a darkened room.

Photoshop
The Contact Sheet II dialog, with its interactive display of the layout according to the rows and columns chosen, and the quantity of information that will be displayed.

Most browsing and image-editing software has the facility to produce contact sheets for printing. They are not, of course, actual contacts of anything, and can be sized and ordered as you wish, with whatever embedded information you care to display. It's worth taking time to review the options for customizing these prints so that they suit your working method. Naturally, as a preparation for black-and-white printing, it helps to print out the images in grayscale, even though they will have been shot in color. The two most likely choices for creating contact sheets are your camera's browsing application and Photoshop, though there is a wide choice of other software available. The two examples shown here, from Nikon and Photoshop, illustrate the options, which include image size, layout, and the amount of embedded information. In deciding on which application to use as a regular method, note that the images may be created from thumbnails (fast operation but low quality) or downsized from the originals (excellent quality but slow).

A preview of conversion methods

As the layout and ordering of contact sheets is completely flexible —and usually a batch processing operation—consider printing them with variations of one image across each row. For example, the three "default" grayscale conversion mixes in Photoshop are Grayscale (bias toward the green channel), Desaturate (an even mix of channels), and Channel Mixer (100% red channel as it opens). In this example, the images from a take have been batch processed to create these copies, arranged 4 across with the color original first.

Nikon View
Camera manufacturer's software used for printing contact sheets directly from the Browser. Here, there is a fixed choice of rows and columns, from which 4 x 4 Up has been selected.

Photoshop contact sheet
A specimen contact sheet, with images displayed right way up (this takes more space with a mixture of horizontals and verticals).

Printer calibration

In order to achieve precision in black-and-white neutrality, and predictable delicacy in toned prints, professional calibration is highly recommended.

Calibration, as we've already seen, refines the accuracy of capture (the camera) and display (the monitor) to a precise degree, and if excellence of image quality is important, it should be a part of the workflow. While it's true that color reproduction, through its complexity, needs this more than black and white, the subtleties of the tonal range in grayscale tend to attract close attention. To complete this necessary control over image quality, the printer also should be calibrated.

To an extent, desktop printers have some degree of built-in calibration, in that each machine has a generic profile that can be accessed by the computer to which it is connected. Nevertheless, printers work in quite a different way from the other devices involved, and the process of translating an RGB image that has been optimized for a monitor leaves plenty of room for unwanted changes to creep in. They use process colors that are complementary to RGB, which is to say cyan, magenta, and yellow, plus other inks including black, gray, and pale process colors. In addition, the printed image is reflective, which lowers its contrast range and introduces the paper's color into the highlights.

There are also issues peculiar to black and white printing, involving print density and neutrality. A black-and-white image displayed on an 8-bit monitor (almost all monitors are) has 256 distinct levels of tone, and even though this is much less than the 16.7 million of a full-colour RGB image, it is perfectly sufficient for the human eye. Unfortunately, most inkjet printers as supplied with their cartridge inksets have only one black ink, and the dithering process used by the printer cannot produce the 256 tones from just this. Printing in full color mode solves this problem, but in attempting to create a monochrome image from five or seven differently colored inks, some unexpected color bias is likely, and this is also likely to suffer from metamerism (the hue appears to be

Test target

The first stage of calibration is printing a test target. Here the TC9.18 target is being printed from a Epson printer. The Lyson ink tanks to the right are what's known as a continuous flow system, whereby much larger external tanks can be used in place of the manufacturer's (often expensive) own-brand inks.

different under different types of lighting). Of course, if you are actively looking for a hint of color in the print, such as with duotones and color gradient mapping, it is easier to direct the bias than to achieve perfect neutrality.

A custom profile necessarily involves professional help, because the measurement of a test print calls for a spectrophotometer, which is expensive and needs a skilled operator. The principle is that you print out a test target using known Photoshop and printer settings. The profile-maker then measures this and the software analyzes how it differs from the known values, and produces an ICC profile to correct. The examples here were prepared by Udo Machiels of Atmos Designs in the United Kingdom. If your printer is profiled for a full-color inkset, it will usually work well enough in printing black and white, but may still not be achieving perfect neutrality. One solution, already mentioned, is to deliberately tone the image, so that at least you know in which direction the color will shift. Otherwise, consider a monochrome inkset or a small gamut inkset, but note that monochrome inksets do not lend themselves to calibration. An additional professional solution is to use RIP software, which is expensive but can produce outstanding results. One such software is Colorbyte's ImagePrint, which enables absolutely neutral tones. Another is isphoto's Shiraz RIP, a more complex and professional application that allows you to build your own linearization and CMYK profiles.

Profiling sequence

The typical procedure is as follows:
1. Print a standard test target, using standard printer settings.
2. Allow the inks to stabilize.
3. The print is measured with a spectrophotometer in conjunction with profiling software.
4. The profiling software compares this measurement with the known values of the target and constructs an ICC profile that compensates for the difference.
5. Load the profile onto your computer and select it for all printing.

Ink and paper

Pigment and specialist monochrome inksets greatly increase the potential of high-quality inkjet printing, as does the huge range of papers.

For inkjet printers there is now tremendous scope for choosing inks and papers to suit your particular needs. While printer manufacturers supply their own ink cartridges, there are third-party alternatives that are not only less expensive but can offer advantages in quality. If you plan to print regularly and often, one of the best small investments is in a CIS (Continuous Ink System). This is a set of bottles of ink that are arranged alongside the printer on a tray. A tube from each feeds ink to cartridges that replace the originals at the print head. The great advantage of Continuous Ink Systems is that they are much cheaper to operate than the printer manufacturer's own cartridges—sometimes by as much as ten times. Ink levels in the bottles can be checked visually and topped up when necessary individually. Whether you opt for CIS or regular cartridges, there is a choice between pigment and dye inks, from different manufacturers. Dye is standard, and tends to work better on glossy and satin finished paper, but lacks archival qualities. Pigment inks are thicker and the better ones are definitely archival, and better suited to matte paper. There is also available a selection of monochrome inksets that use a mixture of blacks and grays.

One of the greatest advantages of inkjet printing is that it works independently of the paper, which unlike silver-halide printing and dye-sub digital printing does not need to be pre-treated. Coating or sizing does help, but in practice you can run any paper at all through a desktop inkjet printer. Specialist art suppliers carry hand-laid paper from different sources, and if you are looking for a more textural, even painterly effect in your prints, it is worth experimenting with these. Within the range of conventional inkjet papers, there are now many manufacturers, offering different finishes and different paper weights.

Monochrome inks
Using special monochrome inks brings out better detail in midtones. The upper image was printed using ordinary process color, and the lower using Lyson Quad Black inks. Notice that the contrast is stronger and the definition sharper.

Consumables

Using good quality materials, both inks and paper, is vital to making a good print. All inkjet inks are prone to a degree of fading, especially magentas, but these effects can be minimized by using archival quality products.

Lyson Daylight Darkroom

These subtly different graduated bars are printed using Lyson's Daylight Darkroom inks. These replace the normal tanks in the printer with variants of black from which Mac or PC software can create prints in rich monochrome.

Monochrome inksets

Using four intensities of black ink in place of the normal CMYK colors is one way of achieving a tonal gradation that matches traditional silver-halide printing. In the examples on this page, from Lyson, the Quad Black inks are available in three versions: cool, neutral and warm tones. Flush the printer heads if changing from a CMYK inkset. For perfect accuracy, consider installing a true monochrome print driver.

Mounting and display

The presentation of the finished print is the final step in serious black-and-white photography, and needs the same level of attention as all of the post-production stages.

Mounting board
Mounting board is available in a variety of different colors, textures, and thicknesses.

Prints are intended for display, and while there are many and varied ways of doing this, from sandwiching between sheets of acrylic to printing directly onto aluminum, there still remains one commonly used traditional procedure. In this, the print is attached to a mounting board, covered with an overmat into which a window has been cut, protected by a sheet of glass, and framed. There are good protective reasons for doing this, and there is a sufficient variety of finishes available in the two most visible components—the frame and the overmat—to allow idiosyncrasy. The three overriding concerns are that the print is held flat, is protected and can be hung in an easily viewable position.

There are fewer comparisons with the mounting of paintings than might be imagined. In principle, a photograph is much less a physical object than is a painting, which is both unique and has tangible surface qualities. A photograph is always, by definition, a reproduction—put another way, it is a window to a scene. This argues for a plain, simple presentation, the more so for a monochrome image. Anything but the mildest, most natural-looking color becomes a distraction. The mounting and display of a black-and-white print should concentrate attention on the print area, not complement it. Any exceptions to this take the print away from pure photography and more into mixed media—which is, of course, completely valid, but not the subject here.

The mounting board has the job of supporting the print, and can be natural (traditional museum board is 100% cotton fibre) or synthetic (foamboard with a polystyrene core), and can be self-adhesive or plain. If plain, there are several alternatives for fixing the print to the board. If the paper is thick, it can be held in place by corners or hingeless strips that have adhesive-free edges (and digital prints usually have an advantage in flatness over silver prints in that they do not suffer warping through having being soaked). If you choose to mount the print fully and permanently to the board, the choices include dry-mounted adhesive film, mounting tissue and cold-mounted adhesive rolls. Depending on which you use, you may also need a dry-mounting press or tacking iron. However, with fairly thick paper that is already flat, the overmat will help to keep it secure on the mounting board.

The overmat serves a number of functions, protecting the surface of the print by keeping it separated from the glass, holding the edges of the print flat against the mounting board, and providing an esthetic "window." The usual material is museum board similar to that used for mounting. By far the most difficult and skilled job in the entire mounting process is cutting the window in the overmat, as the inner edges receive a lot of attention when the print is viewed. They must be straight and neat, and by convention they should be at a 45° angle, which calls for a special mat cutter. Pre-cut overmats can be bought, but then you will have the restriction of having to crop the image to fit. An alternative to an overmat is a separator, typically of hollow rectangular-section acrylic, that fits around the edges of the mounting board and keeps the print from touching the glass.

For simplicity, frames are typically very simple in both section (usually square) and material, with aluminum and wood being the most popular. A cleanly mitered joint at each corner needs skill, and it is normal to buy these ready-cut as kits. As most prints are made to conventional sizes this is normally no inconvenience. Both glass and acrylic are alternatives for the front of the frame. A non-glare finish helps cut reflections, and conservation glass specifically cuts UV penetration—which will cause fading. Acrylic cuts out almost all UV. The finished frame can be hung with picture wire attached to either ring hangers or corner clips on the frame.

Lighting is the final consideration. With a glass-framed print, the most important precaution is to avoid reflections at eye level. Low-reflectivity glass helps, naturally, but the position of light sources needs to be considered. A slight downward angle to the framed print (which is normal anyway) prevents picking up the reflections of ceiling lights. Also, try to ensure that prints do not face windows. Ideally, illuminate each print with its own spotlight, placed high so that there is a good angle between the beam and the normal line of sight, and with the beam masked down as precisely as possible to the edges of the image. The two methods of masking are miniature adjustable barn doors, and a shaped four-sided mask placed close to the focal point of the light beam (if the spotlight is at an angle to the print, the shape will be trapezoidal). Increasing the illumination on just the print both raises its prominence on the wall and reduces environmental reflections in the glass.

Pre-cut frames
There are a variety of pre-cut shapes on the market.

Bevel cutter
This is FrameCo's 101 Bevel Cutter, which holds the blade at a 45° angle for you, while you drag it along the rule.

Appendix:
Digital Camera **Basics**

For the most part, digital cameras operate much as their film predecessors did. The basic functions of camerawork—framing the view, focus, setting the exposure by means of aperture and shutter speed, and shutter release—are the same. Digital SLRs, the upper end of the market, have indeed hardly changed at all, on the outside. The major difference is that a digital sensor chip has replaced the film, and for many aspects of photography this works as a near-seamless handover. For quite a number of the picture situations that we've been through in this book, it would not have mattered substantially what kind of camera you picked up. I think it's important to keep this perspective in mind, and not get too carried away with the technological marvels of digital capture and processing.

Nevertheless, the implications of switching from film emulsion to digital sensor are significant. A camera, like any craftsman's tool, repays study and familiarity. While you can expect to be able to get images that are perfectly satisfactory technically with no more than a

quick glance at the manual—and that is as it should be with any well-designed piece of equipment—a good knowledge of the digital workings will help you raise the quality level by a few notches. In this appendix, we'll look at the basics of the equipment, at the mechanical, the optical, and the electronic.

Digital cameras offer some choices that were never possible with film, for example, image size and resolution, sensitivity to light, and color balance. It's good to have choice, but it calls for you to make informed decisions when you are shooting, too. There are also aspects that are completely new, such as file format—the type of digital file in which your images will be saved and which most people will later open on their desktop computer or laptop. And the need for power, cables, and the electronic paraphernalia that inhabits the digital world. You can make all of this as complicated as you like, but I prefer to stick to the essentials, so as to spend more time on the photography itself. Here, in 22 pages, are those essentials.

Your digital camera

The first step towards taking better photographs is learning how to access all of your cameras features. The faster you can do this, the better you can respond to a shooting opportunity.

While professsional models are SLRs, the bulk of the digital camera market—leaving aside mobile phones—is made up of compacts of varying degrees of sophistication. The main feature that distinguished SLRs is the interchangeable lenses. Sensor resolution is not necessarily different and, being light and unobtrusive, compacts are often easier to take with you.

Viewfinder

Digital SLR cameras like this one still feature a traditional prism-based viewfinder which gives the view through the lens optically, but many compact models send this information direct to the LCD display by digital means.

Mode wheel

To switch between the various manual and automatic shooting modes this dial is turned. Most camera models offer a number of shooting modes with varying degrees of automation, from full auto to complete manual control of focusing system, shutter speed, aperture width, and ISO sensitivity.

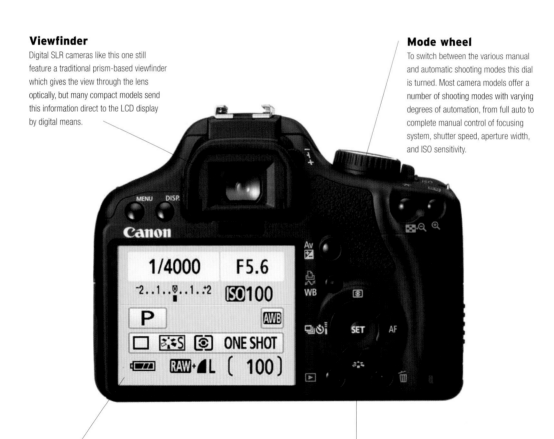

LCD Display

The LCD is perhaps the most visible difference between a digital camera and a traditional film one; a screen in which instant previews can be seen. On this model the screen is also used to display camera settings when shooting.

Menu control buttons

On many cameras the control buttons serve dual functions, just as they do with this model. When navigating the menus, these five buttons serve as directional buttons. When shooting, the four directional buttons provide shortcuts to camera functions which speed up navigation to the most vital menu functions.

Shutter release

The shutter release button is pressed halfway to activate the auto-focus, and fully to take the shot.

Function dial

Just above the shutter release is a wheel switch which is used to alter selected settings without having to remove the eye from the viewfinder.

Interchangeable lens

What sets SLR cameras apart from their compact brethren is the ability to replace the attached lens. This is a general model suitable for everyday photography, though longer telephotos and close-range wide angle lenses are available.

Lens release

The large mechanical button on the front of the camera body releases the interchangable lens.

Zoom grip

To zoom in and out, turn the grip on the lens barrel. Compacts might require you to press a button instead.

Hotshoe

Attachments, like a seperate flash, can be connected via the plate on top.

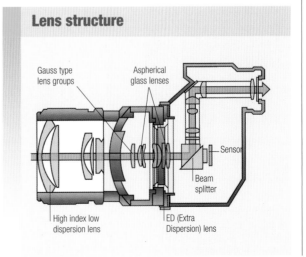

Lens structure

Gauss type lens groups

Aspherical glass lenses

Sensor

Beam splitter

High index low dispersion lens

ED (Extra Dispersion) lens

The Sensor

The sensor is more than just a replacement for film. It feeds or is served by almost all of the camera functions and is an integral part of the camera.

As the technology is still evolving—there is a lot of room for improvement even now—new higher-performance sensors appear quite frequently. This inevitably means new cameras, as there is no question at this point of simply upgrading a sensor. It also means that if the sensor is sometimes exposed to the environment, as in an SLR, it needs particular care and attention to avoid particles on the surface and damage.

A sensor is an array of photoreceptors embedded on a microchip, along with the circuitry and components necessary to record the light values. The circuits are etched into the wafer by repeating the photolithographic process of light exposure and chemical treatment, with extreme precision. The width of circuit lines is typically less than 4 µm (4 microns). As an indication of the complexity, Canon's 11.1-megapixel sensor has approximately 700 feet (200 meters) of circuitry. The individual unit of a sensor is the photosite, a minuscule well that is occupied principally, though not exclusively, by a photodiode. The photodiode converts the photons of light striking it into a charge; the more photons, the higher the charge. The charge is then read out, converted to a digital record, and processed. Each signal from each photosite becomes the light and color value for one pixel, which is the basic unit of a digital image.

Photodiodes record light rather than color, so this has to be added by interpolation in the vast majority of sensor designs. The usual method is to overlay the sensor array with a transparent color mosaic of red, blue, and green. As in color film and color monitors, these three colors allow almost all others to be constructed. The difference here, however, is that the color resolution is one-third that of the luminance resolution. Oddly, perhaps, this doesn't matter as much as this figure suggests. Interpolation is used to predict the color for all the pixels, and perceptually it works well. As the the chapters on both color and black-and-white photography demonstrate, color is a complex issue, psychologically as well as physically. The ultimate aim in photography is for the color to look right, and this is heavily subjective. Nevertheless, there is at least one radical sensor design made to improve objective color accuracy.

Small and large pixels

In the search for higher resolution, there are two possible directions for manufacturers. Smaller photosites or larger sensors. There are special technical challenges for each, and resolution is not the only thing affected. A larger receptor is slower to fill up, and this is claimed to give a better dynamic range, as is the case for deeper receptors.

Bayer array
For a long time this was the only color filter array pattern used for image sensors, though Kodak and others are researching alternatives.

The color filter array

The photosites on the sensor respond to the quantity of light, not wavelength. Color is added to the image by filtering the light. The entire sensor is covered with a Color Filter Array (CFA), a mosaic of individual red, green, and blue filters, one for each photosite. The camera's processor must then interpolate the missing two-thirds of color information from the surrounding pixels, at least the neighboring block of eight.

The CFA pattern, as illustrated here, is not an even distribution of the three wavelengths. In order to better correspond with human vision, which is most sensitive to green-yellow, there are usually twice as many green filters as red and blue.

Photosite collects light photons Readout from the photosite Light photons travel from lens

The photosite

The individual photosite in a sensor array is commonly compared to a "bucket" into which light, rather than water, is poured. An absence of light means an empty bucket, therefore no electrical charge, resulting in black. If light continues to be added, the bucket overflows, at which point the result is pure, featureless white. This accounts for the linear response of digital sensors to light rather than the subtle fall-off that allows film to capture a relatively wide dynamic range.

The low pass filter

Ordering the light rays as they enter the sensor is the job of the optical low-pass filter, which covers the entire sensor. This is necessary in order to suppress moiré and such inaccuracies as ghosting and color overlapping, and succeeds by facilitating the light reception by photosites. This results in more accurate data separation. The filter illustrated here is Canon's three-layer filter, in which a phase plate, which converts linearly polarized light into circularly polarized light, is sandwiched between two layers that separate image data into horizontal and vertical directions. Another substrate cuts infrared wavelengths by a combination of reflection and absorption to further improve color accuracy.

While the low-pass filter protects the sensor from direct exposure to the environment, it is also very fragile and should never be touched.

△ Photosites
The photosite can be thought of as a bucket, collecting light. The more light that falls into the "bucket," the brighter the readout (here indicated by the shaded squares beneath).

▽ Sensor
Image sensors are protected by a number of filter layers.

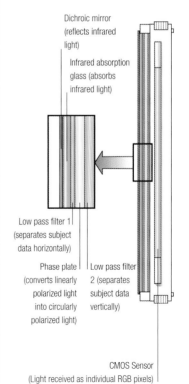

Dichroic mirror (reflects infrared light)

Infrared absorption glass (absorbs infrared light)

Low pass filter 1 (separates subject data horizontally)

Phase plate (converts linearly polarized light into circularly polarized light)

Low pass filter 2 (separates subject data vertically)

CMOS Sensor (Light received as individual RGB pixels)

Cutting
CMOS chips are produced as part of a silicon wafer, like other computer chips, and are cut into individual chips using a special diamond-edged saw.

Chips
Once cut into separate pieces, the chips can be placed onto circuits like any other computer chip.

CMOS Vs. CCD

The major competitor to CCD sensors is CMOS (Complementary Metal Oxide Semiconductor), and while the main issue is manufacturing cost, it has implications for performance. Chips of all kinds are made in wafer foundries, and CCDs are a specialized variety, so more costly than other kinds. CMOS foundries, however, can be used to manufacture computer processors and memory, and so CMOS sensors can take advantage of economies of scale. This makes them much cheaper than CCDs to produce, although some of this saving is offset by the need to overcome some performance problems, notably noise, which means additional onboard processing. In other words, CCDs are inherently better for high-quality imaging, but once data processing has been factored in there is little to choose in performance at the top end of digital SLRs. In summary, the CMOS compares to CCD as follows:

1 Individual amplifier, giving a speed advantage in transferring data.
2 Lower power consumption (volts).
3 Simpler and less expensive manufacture (in the order of 1:3).
4 Requires suppression of pixel dispersion.

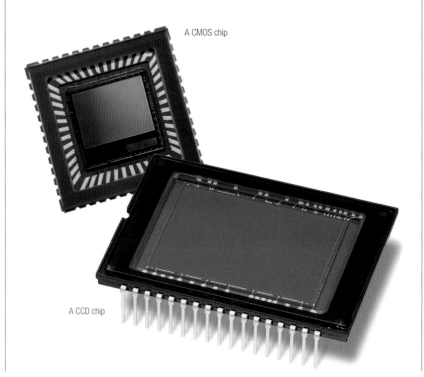

A CMOS chip

A CCD chip

Moiré

Moiré, which usually appears as parallel multicolored stripes in wavy patterns, is an interference effect caused by the overlapping of tight, fine patterns. In digital photography, this special kind of artifacting is particularly common because of the grid pattern of photosites on the sensor. If a second pattern with a similar spacing is shot, such as a textile weave, it can interact to create this third, moiré pattern, as shown here. The camera's low-pass filter helps to reduce the effect, although only to a certain degree as strong correction softens the image overall. The lenses, sensor, and software in a digital SLR system are all designed for high sharpness and accuracy, and this makes moiré more likely. To avoid or reduce moiré:

1 Change the camera angle or position.
2 Change the point of focus and/or aperture. Moiré is a function of sharp focus and high detail.
3 Vary the lens focal length.
4 Remove with image-editing software.

Plant

As in all silicon production, silicon wafers are checked very thoroughly for flaws. Here a microscope is used to do that by a staff member at major chip manufacturer Micron.

Moiré

Taking the two grids seperately, their pattern is clear. When they are combined the result is a strong moiré.

Warning

Always inspect for moiré at 100% magnification. At smaller magnifications you can often see a false moiré, which is the interaction of the image with the pixels in a camera's LCD screen or a computer monitor.

Resolution

Image quality is usually measured in terms of resolution. A higher resolution means a better quality, but after a certain point it simply becomes unnecessarily resource-hungry.

Resolution is back as an issue after being largely out of the news for two or three decades. The best way to approach it is from the way the photograph will be used. If you know that, or can at least estimate it, everything else falls into place. Until approximately the 1980s, prepress technology, or rather its limitations, restricted the size at which small film negatives or transparencies could be printed successfully. Color 35mm film was often a problem, and the preferred answer for publishers was to have a larger original, hence the professional popularity of 120 rollfilm, and 4 x 5in and 8 x 10in sheet film. Improvement in prepress technology, in

△ Digital v Film

This view of an old windmill on the beautiful Greek island of Mykonos was shot using a digital camera with a six-megapixel resolution.

Basic specs

Prepress and display prints	Width x height (in)	Width x height (mm)	MB @ 300 ppi
A5	5.83 x 8.27	148 x 210	12.7
Magazine full page			
(Time magazine size)	7.5 x 10.1	190 x 260	19.5
US Letter	8.5 x 11	216 x 279	21.2
A4	8.27 x 11.69	210 x 297	25.5
8 x 10in print	8 x 10	203 x 254	21.1
A3	11.69 x 16.54	297 x 420	51.0
A3+	13 x 19	329 x 483	63.4
Magazine double spread			
(Time magazine size)	15 x 20.2	380 x 260	78

Monitor display (pixels)	Width x height (in)	Width x height (mm)	MB @ dpi
15-in full screen (800 x 600)	12 x 9	305 x 229	1.4 / 66 ppi
17-in full screen (1024 x 768)	13.6 x 10.2	345 x 259	2.3 / 75 ppi
20-in full screen (1280 x 960)	16 x 12	406 x 305	3.5 / 80 ppi
20-in cinema display (1680 x 1050)	17 x 10.6	432 x 269	5.1 / 100 ppi
23-in cinema display (1920 x 1200)	19.5 x 12.2	495 x 310	6.6 / 100 ppi

Note: software commonly assumes monitors to be either 72 ppi (Mac OS traditional) or 96 ppi (Windows default assumption), though in reality it varies.

particular scanning, gradually took care of this, but now things have changed once again. Camera sensor technology is still evolving, with the result that for most hand-held cameras, resolution is still not as high as many people would like, while the few high-resolution models are costly. All this will change, but for now we need to be aware of what the limits are—and which techniques are available to help push the envelope.

Screen or print?

The way to deal with resolution is to work backward from the end use. What looks good on a monitor will not necessarily look good as a normal print, but if the screen view is all you need, that doesn't matter. Professionally, the main uses are prepress, display prints, and the Web. For both prepress and display prints, digital files should be at twice the resolution at which they will be printed. A high-quality web offset press, for example, has a line-screen resolution of 133 and 150, so the digital file should be 300 dpi. This is the standard, default resolution for printing.

What ultimately counts, of course, is the number of pixels that goes into making the image. Simply expressed, you need a 22MB file for an 8 x 10in print, and about the same for a full page in most magazines. Each camera megapixel gives 3MB of image (that is +3 for the three RGB channels), which means that seven megapixels will do the job perfectly and a six-megapixel camera will be adequate. In terms of use, a full page is one of the most basic professional units, while a double-page spread—twice the size—takes care of any possible use that an editorial client might want to make. Stock libraries are in the best position to know the demands of the market, and Corbis, for instance, set the following specifications for their own images: 40MB for editorial sales, 50MB for commercial. Resolution, together with sharpness and noise, are also matters of judgment. If you have a unique or important photograph by virtue of its content, image quality takes second place. This regularly happens in news journalism and in art, too, and always has.

Setting the resolution

All digital cameras offer the option of saving images at a size other than the sensor's optical resolution. Unless you're especially strapped for memory space, always select the highest resolution available, which (at least on a standard grid pattern sensor chip), will save one pixel per photosite on the chip, giving the best possible read-out from your camera.

Digital resolution vs film resolution

It is not a simple matter to compare the two, because the measurement systems are different, and because digital images are in principle "cleaner" than film images. Digital images can be measured by the density of pixels, but other factors creep in, particularly the quality of the lens. The usual measurement is pixels per inch or per centimeter along a straight line. A full-frame 36 x 24mm sensor with 12 megapixels would have a resolution of 4048 x 3040 pixels.

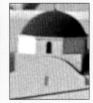
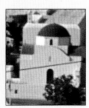

Digital 100% Digital 200% Film 100% Film 50%

File format

There are many different ways of encoding images for digital storage, but JPEG, TIFF, and Raw have emerged as the three main solutions in use today.

From a photographer's perspective there are only really three issues when it comes to selecting image formats: quality, size, and compatability. Quality needs no further explaination, but size can be more of a problem than first imagined. Larger files, by which I mean those which use more space on a memory card, or in a computer's retrieval system—as opposed to having more pixels—require more of those resources. This has cost implications, since you need more storage, and affects file transfer speeds on the internet.

The solution to ever increasing file size is digital compression, a process which reduces the file size at the cost of some processing time. Further compression is achived using what has become known as "lossy compression," a process by which some of the detail of the image is discarded at that processing stage. JPEG is

JPEG compression

JPEG compression can leave noticeable artifacts. The more compression applied, the more obvious the effect.

Basic Fine Normal

Nikon Raw
This picture is being viewed in the Nikon Raw processing program supplied with the camera. Raw processing requires the computer stage; unlike JPEGs, the memory card cannot simply be placed into a printing kiosk or desktop inkjet for instant results.

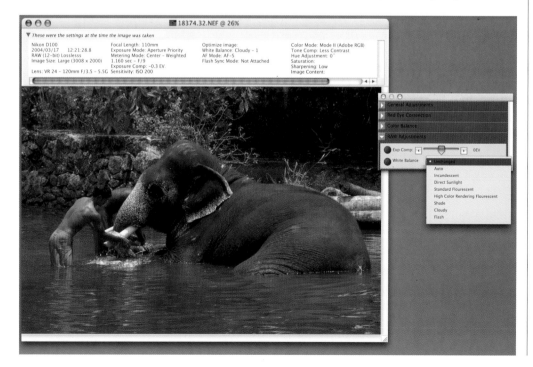

Images per 100MB

Use this table to calculate the image capacity of memory cards. Exact figures may vary according to the camera make.

File format	5 megapixels	6 megapixels	8 megapixels	10 megapixels	12 megapixels
Raw*	12	10	8	6	5
Raw compressed**	27	22	18	13	12
TIFF	6	5	4	3	2
JPEG 1:4	24	23	16	12	11
JPEG 1:8	48	46	28	24	22
JPEG 1:16	96	92	56	48	44

*As this is a proprietary format, it varies between camera makes. This figure is extrapolated from Nikon .NEF
**Depends on the manufacturer's compression algorithm. This figure is extrapolated from Nikon .NEF

TIFF

This detail of a floor was taken with a Nikon D100 and saved as a TIFF file. Unlike the JPEG format, a standard TIFF file describes each pixel in terms of each channel, either red, green, and blue (as in this case) or cyan, magenta, yellow, and black (key). The file sizes can be large.

Format recognition

Easch file format has a suffix that designates it. This is an unnecessary addition to the filename for Apple Macintosh users, but Windows computers still find them significant, and even some Mac applications struggle to recognize a file without its extension. Mac users who share files with Windows users should take care not to put periods (full stops) in their filenames except where they divide the name and the file extension, as this can confuse Windows machines.

TIFF	.tif
JPEG	.jpg
PICT	.pct
Nikon Raw	.nef
Canon Raw	.crw
	.cr2
Fujifilm Raw	.raf
Olympus Raw	.orf
Pentax Raw	.pef
Minolta Raw	.mrw
Kodak Raw	.dcr

the most established of these lossy formats, and is almost universally the one used by digital cameras. It allows you to opt for different quality settings; the lower the qualty you select, the smaller the image size, and the more images you will be able to fit onto the same memory card.

The TIFF is long-established in the publishing industry as a common lossless standard that preserves all image data, at the cost of significantly bigger files. A newer alternative is Raw, which is not strictly one file format but rather a collective name for the camera-specific files that many models can now save. They record all the information that the camer's meters can monitor, and the highest level of detail from the image sensor. When read back on the computer these files can be "developed." When shooting JPEG the camera must do all this processing as you shoot, but Raw processing gives you time to explore the extra leeway in exposure and color correction.

Lenses

Lenses are such a significant component of cameras that they have evolved their own fiercely competitive marketplace, their own intelligent features, and even their own jargon.

When 35mm SLRs were introduced back in 1936, the single feature that assured their success was their ability to accept a large range of different, interchangeable lenses, from fish-eye to super-telephoto. An SLR system is a tool-kit for photography that leans heavily on its lenses, with the facility to see exactly how the image will be captured, and this same advantage carries over to digital. Existing lenses for film SLRs can be used with digital SLR cameras with few complications, even though some new camera features will be unavailable with older models of lens. This is all straightforward, except for issues related to the smaller size of sensors and, at a deeper level of performance, the pixel size.

As it stands, camera manufacturers have followed two different routes. A few, notably Canon and now Nikon, have introduced sensors the same size as 35mm film. This makes them totally compatible with the lenses you already have. Others have adopted sensors with a smaller area—typically around 23 x 15mm—for ease of manufacture. This affects a whole raft of image properties, including some of the standards that photographers are used to, such as using focal length as a way of describing the angle of view; a bad habit, perhaps, in retrospect, but absolutely the norm; 24mm for example, was a kind of shorthand for the dynamics of one type of wide-angle image. The smaller sensor covers less of the image projected onto it than

Wide-angle issues

For all cameras except those that follow the full-frame standard, the fact that the sensor is smaller than film makes life more difficult in wide-angle photography. Typically, SLRs built to 35mm camera specifications have sensors around ⅔ the size of 35mm film, meaning that your old lenses lose ⅓ of their covering power. On the positive side, this means that telephoto lenses have that much greater magnifying power when fitted to a digital SLR, but you lose out at the wide-angle end of the scale. This limitation has forced manufacturers to introduce new, wider lenses. If dedicated to digital cameras, these can be very wide indeed. A 12mm lens, for example, is the equivalent of something like an 18mm lens for 35mm. And, if you move from film to digital, this is an additional investment. Strong barrel distortion is another potential implication to consider.

Dedicated digital designs

These are lenses that cannot be used with film SLR bodies. Features can include the following: no mechanical aperture ring, apochromatic (high color correction) glass, and in the case of smaller sensor cameras, very short focal lengths for wide-angle models and a small image circle that covers no more than the sensor. This last feature enables digital photography lenses to be smaller, lighter, and have larger zoom ratios.

Smaller circle of confusion

Focused on a point, a lens renders it sharply—as a point. Slightly out of focus, the point appears as a tiny circle. The circle of confusion (CoC) is the smallest that this circle can be and still appear sharp to the eye *at a normal viewing distance*. This is obviously open to interpretation, but traditionally lens manufacturers have accepted between 0.025mm and 0.033mm for 35mm film. When the image is smaller than this frame size, the image has to be magnified more, and so the circle of confusion is smaller. This calls for uncompromising lens quality.

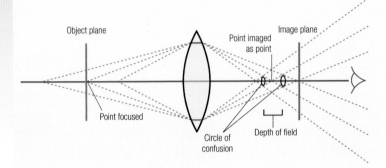

Equivalent focal length

Focal length descriptions such as 20mm, 50mm, and 180mm for 35mm cameras are so embedded in the working language of photography that they will continue to be used for a long time. Indeed, for full-frame 35mm-format digital SLRs, they remain perfectly valid. The variety of sensor sizes, however, leaves us without a convenient way of describing a lens's main characteristcs—its angle of view and magnification.

Once solution is equivalent focal length (EFL), which is what the lens would be if the image it delivered were on a 35mm frame. Divide the diagonal of a 35mm film frame (43.3mm) by the diagonal of the sensor then multiply the focal length by this.

A series of focal lengths, from 20mm EFL at the widest end to 300mm EFL at the longest. The intervals are 28mm, 35mm, 50mm, 100mm, and 200mm.

would a full 24 x 36mm frame, and so the picture angle is less. Practically, this means that a standard 50mm lens mounted on a digital camera with a sensor area of 23 x 15mm behaves like a lens of around 78mm focal length on a non-digital camera. Similarly, wide-angle lenses have less of a wide-angle effect, while telephotos appear to be more powerful. This leaves a significant gap at the wide-angle end of the range.

Depth of field is also affected (it is increased), and this has various consequences all the way back to sharpness and circles of confusion. Sharpness is not a precise definition, but depends partly on resolution and partly on perception. High contrast, for example, increases apparent sharpness. As the circle of confusion is smaller for a small sensor (see Smaller circle of confusion box, above) and the image is magnified more, depth of field increases. This is generally good to have, but a problem when you need the extremes of selective focus, as in some styles of food photography, for instance.

There is a lower "quantum" limit on sharpness set by the size of the individual pixels on a sensor. A 24 x 16mm sensor that images 3,000 x 2,000 pixels, for example, has photosites measuring 0.008mm (8μ). As semiconductor technology reduces this size further, it increases the demands on lenses. Most high-quality lenses optimized for film can resolve detail to

Bokeh

The overall appearance of the out-of-focus parts of an image, judged aesthetically, varies according to the aperture diaphragm and the amount of spherical aberration correction, among other design features. It comes into play chiefly with telephoto lenses used at wide apertures, and it particularly concerns portrait photographers. This has become fashionably and unnecessarily known in the West by the Japanese word ボケ (pronounced bok-e, with a short, flat "e"), which in this context means simply "out-of-focus." A major influence is the shape of the aperture, which tends to be replicated in specular highlights, polygonal in most cases, while a mirror lens produces rings. The more blades to the aperture, the more spherical these soft highlights become. The optics also have a subtle effect.

about 10 sensors can be as low as 5 microns. One important effect is that color fringes caused by chromatic aberration must be smaller than the size of a pixel. Old lenses often fail in this. A further issue is cornershading, although this can be corrected digitally.

The new zooms

The time has long passed since prime lenses (single focal length) gave a measurably sharper image than zooms. In top-quality zooms, resolution is now just as high, and the new generation has impressively wide ranges, e.g. the Nikon 18-200mm and the Leica D Vario-Elmar 14-150mm from Panasonic, often in compact, lightweight housings. One drawback is that the effective full aperture is smaller at the long end of the zoom range, meaning the lens is "slower." Another is that it is impossible to fully correct lens distortion over

Lens filters

With white balance and hue correction now taken care of digitally, there is no longer any need for light-balancing and color correction filters. Three front-of-lens filters do, however, remain valuable: ultraviolet, polarizing, and neutral grad.

The Ultraviolet filter reduces haze effects by cutting some of the short wavelengths. Also valuable for physically protecting the front lens element from scratching. Neutral grads can be raised or lowered in their holder and rotated to align the transition zone of the filter with the horizon. Polarizing filter (circular) cuts polarized light, so particularly useful for darkening blue skies (most strongly at right angles to the sun) and reducing reflections from glass, water, and other non-metallic surfaces. Polarization cannot be replicated by software.

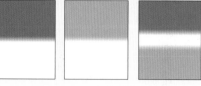

Nikon lens Nikon 18-200mm lens with VR (vibration reduction system).

Leica lens Leica D Vario-Elmar lens 15-150mm from Panasonic.

the range. A prime lens can be corrected, but a zoom that covers a wide-angle to telephoto range, for example 24–120mm, will have barrel distortion at one end and pincushion distortion at the other. This increases the importance of software that will correct distortion in post-production.

Anti-shake technology

This enormously useful feature goes by different names according to the manufacturer, VR (vibration reduction) for Nikon, IS (image stabilization) for Canon. Essentially, this is a reactive, mechanical system for reducing camera shake. Motion sensors detect small, jerky movements of the kind associated with holding a camera unsteadily, and pass the information to a set of micro-motors surrounding floating lens elements. These apply small opposite movements virtually instantaneously to cancel out the shake. This kind of lens is claimed to improve the shutter speed at which it can be handheld by up to four stops. Longer, deliberate movements, such as panning, are excluded from correction. Switch this feature off when the camera is locked down on a tripod. An alternative approach, used by Sony, moves the sensor rather than the lens elements, so is fitted in the camera body rather than lens, and works with all lenses.

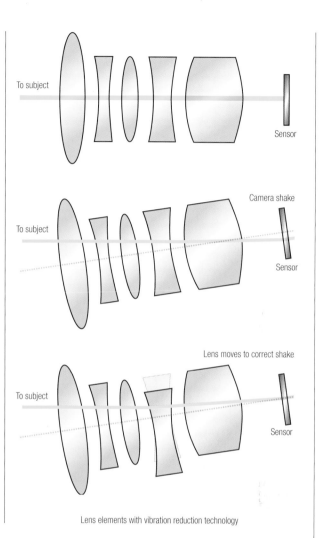

Lens elements with vibration reduction technology

Standard versus wide-angle

Wide-angle and telephoto lenses sit on either side of a notional standard focal length. Notional because it in turn depends on perception. The idea of a standard lens is one that gives the same view as the eye, neither wide nor compressed, but in reality, it is imprecise. The usual rule of thumb is that the standard focal length is equal to the diagonal of the film frame or sensor. For a 35mm frame that would be 43mm, but by convention 50mm efl has become "normal." This is, in any case, a perceptual issue, and a realistic guide is the focal length at which the view through the viewfinder and the view with your other, unaided eye are the same.

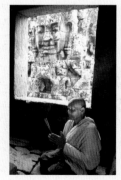
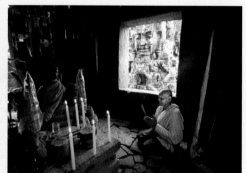

Exposure

Controlling exposure is the art of controlling the total amount of light that falls onto the digital sensor.

A major problem with digital sensors is achieving a high dynamic range, at least as good as the tonality of film. Specifically, the difficulty is retaining highlight detail in normal-to-high contrast scenes. The larger the photodiode, the greater the sensitivity and the wider the dynamic range, but this is in conflict with the need for smaller photosites on the sensor to increase the resolution, as discussed in the box on page 614. The photodiode must fit within the total photosite area, and still leave sufficient room for other components. Moreover, typical photodiodes still reach saturation (that is, a full tonal range) faster than is ideal.

Loss
This image is slightly overexposed, which has led to clipped highlights. The histogram reveals these in the form of a tall spike spilling out of the range at the far right-hand end—too much of the image, in other words, is white.

No loss
In this alternative shot, the histogram shows both highlights and shadows within the range of the histogram, so there are no areas in the image in which detail has been clipped.

Double-diode

One approach to the highlight problem, adopted first by Fujifilm for high-end compacts, is to use a secondary smaller-aperture photodiode. With several times less sensitivity than the primary diode, it will record highlight detail in conditions when these have been lost by its larger companion. The data from both is combined by the camera's processor. The effective gain in tonal range is in the order of two f-stops. A disadvantage is that the asymmetric design of the photosite limits the size of the sensor because of the risk of shading toward the edges.

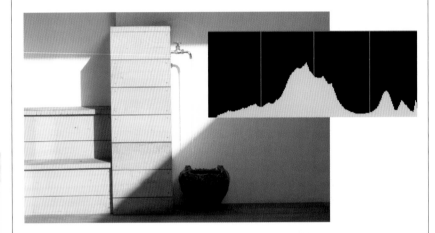

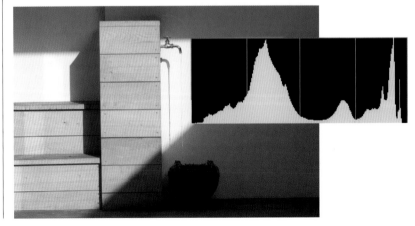

Blocked highlights

In these highlight areas, digital sensors tend to compare unfavorably with film because of their linear response. Typical film response to exposure shades off at both ends of the scale, hence the familiar S-shape of the characteristic curve (see box, right). Practically, this means that film has some latitude in the highlights and the shadows. Its response is not linear. Digital sensors, however, do have a linear, straight-line response, and this results in easily blocked highlights. Anyone familiar with film is used to there being some hint of detail in most highlights, but this is not so when using digital. Once the charge in the photodiode "well" is filled up, the highlights are blocked, and it is as if you have a hole in the image, or triple 255 when measured in RGB. This is referred to as blowing the highlights and should be avoided because, even using a Raw file, it is impossible to recover information from these areas of the image.

Film vs sensor response

The fundamental difference between the way in which film responds to increasing exposure to light and the way in which a digital sensor responds is best shown in the shape of the characteristic curve. This plots the brightness of the image (on a vertical scale) against the brightness of the light striking it (on a horizontal scale). With both film and sensors, most of the middle tones in a scene fall on a straight line, not surprisingly called the "straight-line section," meaning that the image brightness marches in step with the subject brightness. At either end, however, film reacts in a special way. It falls off in a gentle curve in the shadows (lower left) and highlights (upper right). For example, in the highlights, twice the exposure results in less than twice the brightness, which is very useful, because it tends to hold highlight detail. The same applies to shadow detail. Sensors, however, inherently lack this smoothing out of the curve.

In a normal photograph of a normal scene, the shadows are at the lower left and the highlights at the upper right, with most of the tones in the middle, the straight-line portion of the curve. Significantly, this means that with film, highlights do not easily blow out, increasing exposure has less and less effect on the density. In other words, with increasing exposure to light, film response starts slowly (shadows) and finishes slowly (highlights). Photodiodes on a sensor, however, lack this cushioning effect.

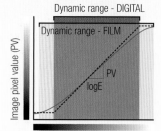

Dynamic range - DIGITAL

Dynamic range - FILM

Image pixel value (PV)

PV

logE

Subject luminance (logE)

Traditional negative

These images show a negative film image of the ceiling of the Palace of Westminster Cathedral. Black-and-white film has a huge dynamic range, able to discern detail in very dark, or very light areas. This dynamic range is extended significantly by film's response to low and bright light (see Film versus sensor response box, left). As yet, digital is not quite as forgiving, so achieving rich tonal information at both ends of the brightness spectrum is more difficult. The technology is improving all the time, however.

A film negative of the Palace of Westminster

Negative
(detail)

Print (detail)

The resulting print

Kitbag

There is a virtually limitless range of equipment available for photographers, and more coming onto the market all the time.

Though it always depends on how lightly you need to travel, everything on these pages will come in useful. In addition to the obvious—filters, lenses, and the like—it's always a good idea to carry some basic tools and tape. When you're on the road, you may find you need to conduct running repairs, or simply use the tape to protect the memory card slot in a dusty or sandy environment. Be as prepared as possible.

Tripods

There are a few items that no photograhper can afford to be without, and one of those is the tripod. You need a tripod in any situation where the light doesn't permit you to use a fast shutter speed, as well as specialist circumstances like shooting accurate panoramas. Tripod efficiency depends on two things: design and materials. The first essential quality for any tripod is that it stays firm under average conditions. In a studio, a heavy, solidly built tripod is an obvious choice. Location shooting or travelling over a period, however, puts a premium on light-weight construction.

Just as there is no point even considering a lightweight tripod that is too flimsy to hold the camera firmly (or too short for normal use), neither is there any reason to have a tripod that is over-specified for a small camera. Cost enters the equation because strong, light materials like carbon fiber are more expensive.

Memory cards & case

Compressed air

Duct tape

Cable ties

Army knife mini tools

USB card reader

Grad filter

Rubber pad for removing stuck filters

Solar viewing glass

Polarizing filter

LED flashlight

Video cable

Color target

Bracket and card

Hotshoe spirit level

Bulb blower

Spare battery

Spirit level

Cleaning tools

Battery charger

Lock and strap

Cable release

Remote flash

Power

Digital photography is dependent on power in a way film never was; power-hungry LCD displays mean you need to take measures to ensure you always have enough energy to keep shooting.

The power capacity of a battery is measured in Milliamp-hours (mAh). This indicates the battery's overall charge storage capacity, and the higher the mAh, the longer the performance. Higher capacity batteries are more expensive, but valuable for digital cameras, which have a high drain. A rating of around 1800mAh is considered high. For the most part, however, you will only be able to fit a standard component from your manufacturer into your camera, so you will simply need to learn how many of these batteries you need between charges.

There are some additional possibilities available for certain camera models, in the form of battery grips. These attach beneath an SLR camera body in much the same way as an external motor drive did to older film cameras, and allow you to fit either additional branded batteries or—conviniently if you are travelling—standard shop-bought AA cells.

Memory effect

NiCd batteries (but not NiMH or Lithium Ion batteries) are prone to memory problems. This memory effect is a loss of capacity caused by recharging the battery before it has fully discharged. Small gas bubbles reduce the area of the battery cell's plates, and over time, the charge becomes smaller and the battery fails faster. To correct this, the battery needs to be reconditioned.

Chargers and adaptors
Depending on your camera model, you might be supplied with a battery charger that allows you to fit different plugs to a standard "figure of eight" adaptor.

Rechargable

If your camera takes ordinary AA or AAA cells then consider using rechargeables. Bear in mind that these batteries do not hold as much power as alkaline or lithium disposables.

Recharging strategies

Follow the camera manual, but also bear in mind the following:

☐ With NiCd and even NiMH, try not to recharge before the battery is fully discharged. With Li-Ion batteries, however, shallow discharge actually increases the cycle life (a cycle is a full charge followed by a full discharge).

☐ Do not overcharge.

☐ Smart chargers may be able to discharge the battery prior to recharging, to enable top-up charging, and to switch themselves off once a full charge has been achieved.

☐ Follow a charging regime that suits the way you work. At minimum, this probably means one spare, with the discharged battery put on charge as soon as possible.

World socket types

Across the world there are four basic mains electricity socket types, and variants within all of these. When traveling it's essential to have the correct adapters. The voltage also varies from around 110v in the Americas and Japan, to the 220-240v systems common in Europe. Many camera chargers can tolerate either, but you must check.

American	British	European	Australasian
	 Br(M) Br(G)	 Eu(J) Eu(C)	
Br(D)	Br(D)	Eu(F)	Au
		 Eu(K)	

Canada	Hong Kong – Br(D, G)		Australia
Cuba	India – Br(D, M)		Kiribati
Haiti	Ireland – Br(G)		Papua New Guinea
Honduras	Libya – Br(D)		Tajikistan
Jamaica	Malaysia – Br(G)	Cameroon – Eu(C, E)	Tonga
Japan	Myanmar – Br(D, G)	Denmark – (C, K)	Uruguay
Liberia	Pakistan – Br(D)	Egypt – Eu(C)	Uzbekistan
Micronesia	Qatar – Br(D, G)	France – Eu(E)	Nauru
Nicaragua	South Africa – Br(M)	Germany – Eu(C, F)	New Zealand
Panama	St Lucia – Br(G)	Greece – Eu(C, E, F)	Western Samoa
Puerto Rico	Tanzania – Br(D, G)	Hungary – Eu(C, F)	
Tahiti	U.A.E. – Br(D, G)	Italy – Eu(F)	(Despite differences,
Taiwan	United Kingdom –	Norway – (C, F)	this plug type mates
Trinidad &	Br(G)	Poland – Eu(C, E)	with some used in
Tobago	Zimbabwe – Br(D, G)	Russian Federation –	the People's
United States		Eu(C, F)	Republic of China,
Venezuela		Spain – Eu(C, F)	though China also
Virgin Islands		Switzerland – Eu(J)	uses Br(G) and
			Am types)

Inverter for cars

DC/AC inverters make use of one universal power supply—the lighter socket in an automobile (and also some aircraft power outlets). The inverter simulates your normal home power.

▲ Fail-safe mains adaptor

With an adapter like this, leave the ends of the wires bare and attach local plugs as necessary. Most chargers and transformers are sealed units and so should not have their plugs cut and changed.

▲ Multi-adaptor

An adapter that accepts two or three of your own country's plugs saves the cost of having more than one foreign-socket adapter.

Glossary

aperture The adjustable opening in a camera lens through which the light travels on the way to the image sensor. The size of the opening is measured in f-stops, with f1 a wide or large opening, and f32 a small one.

artifact A flaw in a digital image, for example compression artifacts are common in lossy compression.

algorithm A mathematical procedure that allows a step-by-step solution. In image editing this math is performed on the pixel values to alter the look of the image.

alpha channel An additional channel (aside from Red, Green, and Blue or CMYK) that represents transparency. For example, if a pixel was 50% of each of the Red, Green, and Blue channels it would be Gray, but if it also had a 50% value in the alpha channel then it would be partially transparent too.

aspect ratio The ratio of the height to the width of an image, screen, or page. For example 35mm film and many subsequent digital cameras have a ratio of 3:2, though some cameras adopt standard 4:3 TV of 16:9 HDTV formats.

backup A copy of either a file or program made in case the original is deleted or destroyed by accident. Backup is also sometimes used as a verb to describe the process of making a backup.

backlighting The result of shooting with a light source—natural or artificial— behind the subject.

bit The basic data unit of binary computing, which can either be on or off (zero or one).

bit-depth The number of computer data bits used to store each channel or each pixel of each channel's color data. For example a RGB image with a bit depth of 8-bits per channel has 24-bits total. This gives the possibility of 16.78 million possible colors, 256x256x256 shades; the number 256 deriving from the base-10 number that can be represented by eight binary digits. 16-bits gives 65,536 possibilities, by comparison, or 281 trillion colors.

bitmap An image composed of a pattern of pixels, as opposed to one mathematically defined (a vector or object-orientated image). Originally a bitmap referred to only images composed of two shades, typically black and white, represented by the two states of a binary bit, but the term is also used to describe images with multiple bits-per-channel.

bits-per-second (bps) A way to measure data communication speed, for example that of the technology used to transfer images from a camera to a computer.

buffer An area of temporary data storage, normally used to absorb differences in speed between devices. For example, a file can usually be sent to a printer faster than the printer can work, so it is stored in a buffer that which allows the main program to continue operating.

bus Electronic pathway for sending data within a computer or between a computer and an external device (see USB). The speed of internal busses plays an important part in the overall speed and responsiveness of a computer.

cache An area of information storage set aside to keep frequently needed data readily available.

calibration The process of adjusting a device, such as a monitor, so that it works consistently with other devices, such as scanners and film recorders.

CCD (Charged-Coupled Device)
A tiny photocell, made more sensitive by carrying an electrical charge before it is exposed. Used in densely packed arrays, CCDs are a common recording technology in digital cameras and scanning devices.

CGI (Computer Generated Image)
Electronic image created in the computer, as opposed to one that has been transferred from a camera or other device. The implication is that the subject is unnatural or a fiction.

channel Part of an image stored in the computer; similar to a layer, but representing the primary colors (and any alpha channels) in the image. For example, an image might have a Red, a Green, and a Blue channel, or a Cyan, a Magenta, a Yellow, and a Key channel.

clipboard Part of the computer's memory used to store an item temporarily while being copied or cut so it can, for example, be pasted in another place or another application.

cloning In image editing, the process of duplicating pixels from one part of the image to another, for example to "paint away" a blemish.

CMOS (Complimentary Metal-Oxide Semiconductor)
Energy-saving design of semiconductor which, after pioneering work by Canon, has become a standard digital camera image sensor design. An advantage is the ability to hold some processing circuitry on the same silicon wafer as the image sensor, which has cost advantages for the camera manufacturer.

CMS (Color Management System)
Software that ensures color consistency between different devices, so that at all stages of image editing the color balance stays the same.

CMYK (Cyan, Magenta, Yellow, Key)
The four primary colors used in standard process printing. Key is black; if the inks, paper, and printing equipment were perfect, the first three inks should mix to create black. In practice using just the

three primaries results in muddy browns, over-inked paper tearing, and unreadable text where the inks haven't registered (lined-up) perfectly.

color gamut The range of color that can be produced by an output device, such as a printer or a monitor.

color model A system for describing the color gamut, such as RGB, CMYK, HSB, and Lab.

color separation The process of separating an image into the process colors in preparation for printing. See also CMYK.

color space A model for plotting the hue, brightness, and saturation of color.

compression Technique for reducing the amount of space that a file occupies on a storage medium. Creating ZIP files is a common way of compressing files. The computer uses an algorithm to encode the information more efficiently, and the process needs to be reversed before the files can be used again. An alternative is to use lossy compression, where some detail is permanently discarded.

contrast The range of tones across an image from highlight to shadow.

CPU (Central Processing Unit) The processing chip at the heart of the computer, and not the box which houses it as well as other components. CPU speed is measured in gigahertz (GHz).

cropping Delimitating an area of an image.

cut-and-paste A computer procedure for deleting part of an image and adding it elsewhere.

database A collection of information stored on a computer in such a way that it can be retrieved to order. While this is often thought of as the electronic version of a card index file, databases are also immensely powerful ways of cataloging image collections, and there are database-driven features in programs like Adobe Photoshop Elements' Browser, for example.

default A standard setting or action, used unless deliberately changed.

densitometer Software tool used for measuring the density (brightness or darkness) of small areas of an image, monitor, or photograph.

dialog box An onscreen window, part of a program, for entering settings to complete a procedure.

digital A way of representing data as a number of distinct units. A digital image needs a very large number of units so that it appears as a continuous-tone image to the eye; when it is displayed these are in the form of pixels.

digital zoom A false zoom effect used in low-end digital cameras; information from the centre of the image sensor is enlarged with interpolation.

digitise To convert an image into digital form that a computer can read and work with.

dithering The technique of appearing to show more colors than are actually being used, by mingling pixels. A complex pattern intermingling adjacent pixels of two colors gives the illusion of a third color, although this gives a much lower resolution.

DMax (Maximum Density) The maximum density–that is, the darkest tone–that can be recorded by a device.

DMin (Minimum Density) The minimum density–that is, the brightest tone–that can be recorded by a device.

download Sending a data file from the computer to another device, such as a printer. More commonly, this has come to mean taking a file from the Internet or remote server and putting it onto the desktop computer. See also upload.

dpi (dots-per-inch) A measure of resolution in halftone printing. See ppi.

driver Software that sends instructions to a device connected to the computer.

dye sublimation printer A color printer that works by transferring dye images to a substrate (paper, card, etc.) by heat, to give near photographic-quality prints.

dynamic range The range of tones that an imaging device can distinguish, measured as the difference between its DMin and DMax. It is affected by the sensitivity of the hardware and by the bit depth it is working in.

EPS (Encapsulated PostScript) Image file format developed by Alsys for PostScript files for object-oriented graphics, as in draw programs and page layout programs. See also object-oriented image and draw(ing) program

feathering Digital fading of the edge of an image or selection. Feather widths are usually measured in pixels.

file format The method of writing and storing a digital image. Formats commonly used for photographs include tiff, pict, bmP, and jpeg (the latter is also a means of compression).

film recorder Output device that transfers a digitized image onto regular photographic film, which is then developed.

filter Imaging software included in an image-editing program that alters some image quality of a selected area. Some filters, such as Diffuse, produce the same effect as the optical filters used in photography after which they are named; others create effects unique to electronic imaging.

FireWire Apple's trade name, and the most common colloquial name, for the IEEE 1394 bus. It is commonly used to attach peripherals, including cameras and scanners, to computers. The original standard is now usually known as FireWire 400 to acknowledge the newer FireWire 800; the number represents their speed in megabits per second.

firmware The common name for software stored on EPROM. (Electronically Programmable ROM). These chips are often used by camera manufacturers so that the internal software can be updated. The ROM's contents can be updated, but still remain static when the camera is off. See also ROM.

frame grab The electronic capture of a single frame from a video sequence.

fringe A usually unwanted border effect to a selection, where the pixels combine some of the colors inside the selection and some from the background.

gamma A measure of the contrast of an image, expressed as the steepness of the characteristic curve of an image.

GB (GigaByte) Approximately one billion bytes (actually 1,073,741,824).

GIF (Graphics Interchange Format) Image file format developed by Compuserve for PCs and bitmapped images up to 256 colors (8-bit), commonly used for Web graphics.

global correction Color correction applied to the entire image.

graphics tablet A flat rectangular board with electronic circuitry that is sensitive to the pressure of a stylus. Connected to a computer, it can be configured to represent the screen area and can then be used for drawing.

grayscale A sequential series of tones, between black and white.

halftone image An image created for printing by converting a continuous-tone image into discrete dots of varying size. The number of lpi (lines-per-inch) of the dot pattern affects the detail of the printed image.

hardware The physical components of a computer and its peripherals, as opposed to the programs or software.

histogram A map of the distribution of tones in an image, arranged as a graph. The horizontal axis is in 256 steps from solid to empty, and the vertical axis is the number of pixels.

HSB (Hue, Saturation and Brightness) The three dimensions of color. One kind of color model.

hue A color defined by its spectral position; what is generally meant by "color" in lay terms.

image-editing program Software that makes it possible to enhance and alter a scanned image.

image file format The form in which an image is handled and stored electronically. There are many such formats, each developed by different manufacturers and with different advantages according to the type of image and how it is intended to be used. Some are more suitable than others for high-resolution images, or for object-oriented images, and so on. See also TIFF, JPEG, PICT, EPS.

imagesetter A high-resolution optical device for outputting images on film or paper suitable for reproduction from a digital file.

indexed color A digital color mode in which the colors are restricted to 256, but are chosen for the closest reproduction of the image or display.

interface Circuit that enables two hardware devices to communicate.

interpolation Bitmapping procedure used in resizing an image to maintain resolution. When the number of pixels is increased, interpolation fills in the gaps by comparing the values of adjacent pixels.

inkjet Printing by spraying fine droplets of ink onto the page. This is, by some distance, the most common home printing technology.

ISO (International Standards Organisation) The body that defines design, photography, and publishing elements. In cameras, ISO is used as shorthand for the ISO light sensitivity standard measurements (ISO 100 etc.)

JPEG (Joint Photographic Experts Group) Pronounced "jay-peg," a system for compressing images, developed as an industry standard by the International Standards Organisation. Compression ratios are typically between 10:1 and 20:1, although lossy (but not necessarily noticeable to the eye).

KB (KiloByte) Approximately one thousand bytes (actually 1,024).

Lab, L*a*b* A three-dimensional color model based on human perception, with a wide color gamut.

lasso A selection tool used to draw an outline around an area of the image.

layer One level of an image file, separate from the rest, allowing different elements to be edited separately.

LCD (Liquid Crystal Display) Flat screen display technology used in digital cameras and some monitors. A liquid-crystal solution held between two clear polarising sheets is subject to an electrical current, which alters the alignment of the crystals so that they either pass or block the light.

lossless Type of image compression in which no information is lost, and so most effective in images that have consistent areas of color and tone. For this reason, not so efficient with a typical photo.

lossy Type of image compression that involves loss of data, and therefore of image quality. The more compressed the image, the greater the loss.

luminosity Brightness of color. This does not affect the hue or color saturation.

LZW (Lempel-Ziv-Welch) A lossless compression process used for bitmapped images.

macro A single command, usually a combination of keystrokes, that sets in motion a string of operations. Used for convenience when the operations are run frequently.

mask A grayscale template that hides part of an image. One of the most important tools in editing an image, it is used to make changes to a limited area. A mask is created by using one of the several selection tools in an image-editing program; these isolate a picture element from its surroundings, and this selection can then be moved or altered independently. See also alpha channel and selection.

MB (MegaByte) Approximately one million bytes (actually 1,048,576).

menu An onscreen list of choices available to the user.

midtone The parts of an image that are approximately average in tone, midway between the highlights and shadows.

mode One of a number of alternative operating conditions for a program. For

instance, in an image-editing program, RGB color, CMKY color, and grayscale are three possible modes.

noise Random pattern of small spots on a digital image that are generally unwanted, caused by non-image-forming electrical signals.

noise filter Imaging software that adds noise for an effect, usually either a speckling or to conceal artifacts such as banding. See also artifact and noise

Pantone Pantone Inc.'s color system. Each color is named by the percentages of its formulation and so can be matched by any printer. See also CMYK and CMS (color management system)

paste Placing a copied image or digital element into an open file. In image-editing programs, this normally takes place in a new layer.

PDF (Portable Document Format) An industry standard file type for page layouts including images. Can be compressed for internet viewing or retain full press quality; in either case the software to view, print, and mark up the files–Adobe Reader–is free.

PICT A file format developed by Apple that supports RGB with a single alpha channel, and indexed color, grayscale, and bitmap modes. Very effective at compressing areas of solid color.

pixel (PICture ELement) The smallest unit of a digitized image—the square screen dots that make up a bitmapped picture. Each pixel carries a specific tone and color.

plug-in Software produced by a third party and intended to supplement a program's performance.

PNG (Portable Network Graphic) A file format designed for the web, offering compression or indexed color. Compression is not as effective as JPEG.

PostScript The programming language that is used for outputting images to high-resolution printers, originally developed by Adobe.

ppi (pixels-per-inch) A measure of resolution for a bitmapped image.

processor A silicon chip containing millions of micro-switches, designed for performing specific functions in a computer or digital camera.

program A list of coded instructions that makes the computer perform a specific task. See also software.

RAID (Redundant Array of Independent Disks) A stack of hard disks that function as one, but with greater capacity and, optionally, added data security.

RAM (Random Access Memory) The working memory of a computer, to which the CPU has direct, immediate access.

resampling Changing the resolution of an image either by removing pixels (lowering resolution) or adding them by interpolation (increasing resolution).

resolution The level of detail in an image, measured in pixels (e.g. 1024 by 768 pixels), lines-per-inch (on a monitor), or dots-per-inch (in the halftone pattern produced by a printer, e.g. 1200 dpi).

RGB (Red, Green, Blue) The primary colors of the additive model, used in monitors and image-editing programs.

ROM (Read-Only Memory) Memory, such as on a CD-ROM, that can only be read, not written to. It retains its contents without power, unlike RAM, although some ROM chips can be updated See Firmware.

saturation The purity of a color; absence of gray, muddied tones.

scanner Device that digitizes an image or real object into a bitmapped image. Flatbed scanners accept flat artwork as originals; slide scanners accept transparencies and negatives.

selection A part of the onscreen image that is chosen and defined by a border, in preparation for making changes to it or moving it.

SLR (Single Lens Reflex) A camera which transmits the same image via a mirror to the film and viewfinder.

software Programs that enable a computer to perform tasks, from its

operating system to job-specific applications such as image-editing programs and third-party filters.

stylus Pen-like device used for drawing and selecting, instead of a mouse. Used with a graphics tablet.

subtractive primary colors The three colors cyan, magenta, and yellow, used in printing, which can be combined to create any other color.

thumbnail Miniature onscreen representation of an image file.

TIFF (Tagged Image File Format) A file format for bitmapped images. It supports CMYK, RGB, and grayscale files with alpha channels, and Lab, indexed-color, and it can use LZW lossless compression. It is now the most widely used standard for good-resolution digital photographic images.

TTL (Through-The-Lens meter) A device that is built into a camera to calculate the correct exposure based on the amount of light coming through the lens.

TWAIN A cross-platform interface developed as a standard for acquiring images from scanners and digital cameras and the computer software, solving compatibility issues.

upload To send computer files, images, etc. to another computer or server. See also download

USB (Universal Serial Bus) In recent years this has become the standard interface for attaching devices to the computer, from mice and keyboards to printers and cameras. It allows "hot-swapping," in that devices can be plugged and unplugged while the computer is still switched on.

USM (Unsharp Mask) A sharpening technique achieved by combining a slightly blurred negative version of an image with its original positive.

video card A board installed in a computer to control or enhance a monitor display.

Index

Abbé condensers 361
abstraction 227, 262, 265, 268, 271, 276, 335, 346, 408
access 318
accessories 167, 252, 340, 358, 362, 373, 375
accuracy 468–70
achromats 360–61
across-the-street composition 184
activity 136–37, 180, 206, 212, 221, 284, 287, 292, 298, 302, 310–12, 316
Adams, Ansel 183, 227, 235, 248, 252, 263, 267, 512, 538, 554, 576, 581
Adams, Robert 267
adjustment layers 528–29, 535, 593, 597
Adobe 553
Adobe RGB 462, 467
advertising 170, 320–21, 367, 372, 502
aerials 276–77
after-images 480, 486
afternoon 36–37, 40, 254–55, 277–78, 284, 297–98, 302, 319, 450, 469, 516
aging 594–95
aiming off 182–83
aircraft 276–79
Albers, Josef 482
algorithms 519, 553, 560, 568–69
Alien Skin Eye Candy 383
alignment 167, 402–3
angle of camera 29, 301, 368–69, 396, 403, 617
angle of light 378, 514–15, 540, 571, 609
angle of sun 32–33, 36–37, 47, 53, 297, 571
angle of view 110, 140, 148, 153, 184, 221, 238, 295, 416, 622–23
angles in flight 279
animals 281–86, 288, 290–91, 297–99, 301, 306, 310, 407–9, 414, 416–17, 422
anniversaries 210–11
anti-shake technology 625
anticipation 194–95, 219–21, 237, 278, 293, 319
antique effect 594
aperture 9, 12, 48, 54, 92
 camera basics 617, 621, 624, 626
 close-ups 339, 342–44, 346, 348, 354–55, 359–61, 364
 daily life 178–79, 184–85, 187, 189
 natural landscapes 273, 277
 nature in detail 414–15, 419, 422
 photographic lighting 114, 116
 portraits 133, 144, 146

still life 387
 wildlife 297
aplanatic condensers 361
Apple 621
Apple RGB 462
aquaria 416, 418–19
Archer, Fred 554
architecture 152, 316–17, 322–23, 326–30, 516, 520
archiving 572, 574, 606
area lights 112
art 227–29, 322, 367, 370, 403–5
 camera basics 619
 digital black and white 570–71, 590
 monochrome basics 509
 nature in detail 408
 prints 606
Art Nouveau 320, 391
artifacts 382–83, 468, 568, 574, 585, 617
artificial lighting 10–11, 77, 571
Artistic 590
astigmatism 342
Atmos Designs 605
attachments 104–5
Auto FX DreamSuite 383
autochrome 509
AutoFX software 594
automated settings 181, 191, 275, 277, 293, 306, 336, 354, 359
available light 76–91
axial lighting 162

backdrops 130, 160, 202, 324, 420
background 22, 39, 45–48, 62
 backlighting 16, 33, 40, 44–45
 close-ups 355
 digital black and white 560
 natural landscapes 258, 272
 natural light 48, 52, 70
 nature in detail 413, 419–20
 people 160
 photographic lighting 118, 120–21
 still life 374–75, 389, 394
 wildlife 300–301
backscattering 294
backup 519
banding 382
banking 279
barn doors 102, 106, 112, 117, 378, 609
barrel distortion 622, 625
baseball pitchers 220
batch processing 603
batteries 305–7, 630–31
beaches 301
beauty shots 116, 157, 162–64, 550
behind-scenes shots 216–17
bellows extensions 341, 345, 349
Bezold effect 482
Bezold, Wilhelm von 482

bicolor 380
billboards 320
birds 277, 284, 286, 288, 292–93, 301–3
bit depth 453, 472, 567, 572–73, 578, 586, 592, 604
black 378–80, 391, 435, 438–39
 cards 116–17, 121, 300, 378
 digital black and white 553, 557–59, 563, 571, 576, 581, 586–89
 monochrome basics 525, 527, 530, 532, 536–37
 point 253, 275, 379, 452–53, 472–73, 558–59, 561–62, 567, 572–73, 576, 588
 prints 604, 607
black and white 252, 427, 433, 508–45, 552–97, 599–600, 602–4, 608
Black and White Studio 584
Der Blaue Reiter 445
bleeding 571
blind areas 568
blinds 288–90, 303
blinking 144, 150
blocked highlights 627
blower-brushes 308
blown highlights 153, 155, 455, 627
blue 427–28, 435–37, 439–40, 442
blur 54, 144, 154, 187, 222–23, 269, 297, 335, 346, 361, 382, 489
boats 302
body language 142–43
boke 624
borders 594
borescopes 364
botanists 408
bottles 121
bounce flash 94–95, 154
bracketing 13, 16, 46–47, 54, 77, 89, 261, 306
Brandenburg, Jim 267
Brandt, Bill 576
breaks 592
briefing 278
bright cloudy skies 60–61
brightening 66–67
brightfield lighting 361–62, 398
brightness 10–11, 14, 26, 45–46
 available light 80
 camera basics 627
 color basics 431, 433–34, 442, 446, 453
 color management 484, 486, 488–89, 493–94, 500, 505
 daily life 179
 digital black and white 554, 558–59, 561, 564, 566–67, 572, 576
 digital workflow 463–64, 467, 473–75
 manmade landscapes 326

monochrome basics 510, 516, 518, 520, 523, 525–27, 547
 natural landscapes 252, 271
 natural light 52, 60, 66–67
 still life 382, 389
brochures 376
brown 435, 442, 450, 455, 527, 547
Brown, Capability 331
browsers 602–3
brush size 166–67, 169, 597
brush Strokes 590
brushwork 164–67
bubbles 394, 418–19
buildings 315–20, 322–28, 530, 546, 557
burning 564–65

cable release 359
cables 134
calibration 459, 461, 464–66, 574, 604–5
Camera Raw 569
camera shake 54, 144, 185, 291, 344, 414, 625
camera tape 307–8
camera-to-subject distance 160–61
camouflage 286, 412
candid shots 128, 177, 180, 192, 194, 200, 208–10, 218, 286, 316
Canon 614–15, 621–22, 625
capacitors 93, 98
captions 224
car inverters 631
Cartier-Bresson, Henri 146, 192
case studies 18–19, 24–27
 close-ups 350–51
 color basics 456–57
 color management 506–7
 digital black and white 556–57, 578–79
 manmade landscapes 332–33
 monochrome basics 512–13, 516–17, 530–33, 538–45
 natural landscapes 256–57
 still life 376–77, 400–401
catch-lights 145
caves 246, 312–13
CCD 455, 616
celebrity shots 168
center-weighted metering 14, 22–23, 39, 191
centrifugal photography 407
centripetal photography 407
CFA (color filter array) 615
channel mixing 523, 526–30, 532, 534–36, 547, 549–50, 593, 597, 603
Channels palette 522, 537
Chardin, Jean 367
chargers 631
checklists 131
cheekbones 157, 162, 168

Chevreul, Michel 480, 488
children 174–75, 208
chlorolabe 428
chroma 434, 518, 534
chromatic aberration 342, 624
chromatic grays 456
chrominance 569
CIE (Commission Internationale d'Eclairage) 463
CIELab 463
cinema monitors 241
cinematography 100
circle of confusion 338, 623
circling subjects 279
cities 202–3, 315–20
city lights 88–89
clarity 56
Clark, Kenneth 489
Classicism 232, 315
Clearing Winter Storm, Yosemite 235
clichés 246, 258
clinometers 403
clipping 455, 466, 473, 527, 556, 559, 561, 573, 577
clipping highlights 567, 571–72
clipping paths 376–77
cloning tools 164, 167, 326, 387
close imaging 336
close-focusing 335
close-up lenses/modes 339
close-ups 93, 97, 181, 334–65
clothing 141, 149, 286, 300, 305, 307, 502
cloud 29, 34, 40, 45, 53
CMOS (complementary metal oxide semiconductor) 455, 616
CMS (color management system) 460
CMYK 461–63, 523, 525, 605, 607
co-axial flash sync terminals 97
coastlines 231, 249, 268–69, 300–302
coins 398–99
cold fronts 58
color 167–68, 171–72, 177, 179
 accents 491, 500–501
 balance 9, 77, 191, 254, 281, 361, 473
 casts 9, 21, 80–83, 89–90, 112, 294, 304, 445, 450, 453–54, 473, 481, 501, 511, 534, 547, 587
 channels 463
 circles 427, 430–33, 435, 437, 455, 479–80, 486, 489, 498–99, 520, 525, 534
 conversion 518–19
 correction 466, 468
 management 460–61, 464, 466–67, 474, 476, 614
 models 430–33
 prints 599–600, 603–5

space 460–63
temperature 20, 34–35, 42, 52, 57, 78, 80–81, 100, 102, 272, 274, 450, 464, 469, 492–93
theory 428–29
washes 596
weight 511
Color Picker 587
Color Replacement 597
Color Settings 461
Color Target 403
color-space models 427
Colorbyte 605
ColorEfex 66, 253
colorimeters 465
colorimetrics 461
colorists 479, 486
coma 342
combining exposures 60–61, 90
compacts 612
complementary colors 431–33, 435
color management 480–81, 486, 488–89, 493–94, 498, 501–2
digital workflow 463
monochrome basics 520, 534, 540, 544
composite focus 348–49
compositing 396
composition 130, 138–40, 142–43
compressed perspective 186–87
compression 327, 566–67, 620
computers 9, 64, 153, 167, 169
concentration 116–17
condensation 295, 307, 313
condensers 360–61
cones 117
conjugates 338–39, 342, 346
conservation 267, 285, 303
conservation glass 609
Constable, John 228, 256, 315
contact sheets 602–3
context 132–33, 136, 232, 248, 270, 282, 372, 380, 407
contingency plans 129
continuous ink systems 599, 606
contrast 23–27, 38–39, 42, 45–48
convection 311
converging verticals 312, 324–26, 329
conversation 127, 133–34, 204
cookbooks 392
cool colors 444–45, 491, 493
copying 570–71
copyists 570
copyshots 356, 402–4
cornershading 624
cosmetics 162
Cotán, Juan Sánchez 367
coupling rings 358
craftsmanship 188
critical photography 317
critical views 266–67
cropping 144–45, 196, 221, 236–39, 241, 325, 327, 407, 572, 609
crowds 214
Cubism 243

Curves 64, 165, 467, 472, 516, 528–29, 558–59, 561, 565, 572, 584, 587–88
cut-outs 376, 420
cyanotype 582
cylindrical format 242–43

Da Vinci, Leonardo 493
daguerreotypes 177, 402
daily life 176–225
darkfield lighting 362, 399
dawn/dusk 36, 51, 75, 89, 153, 259, 265, 285–86, 310, 319, 449, 482
daylight 10–11, 62, 66, 77–79
DC/AC inverters 631
decisive moments 192–93
Delacroix, Eugène 501
depth 118, 246, 304, 349, 419, 439
depth of field 9, 98, 144, 146, 149
camera basics 623
close-ups 335, 338, 342, 344–46, 348, 356–57, 363–64
depth maps 64
desaturation 518–19, 523, 530, 534, 547, 566
deserts 281, 308–9, 411
device-independent color space 463
dichroic filters 102
Diderot, Denis 367
diffraction 342–43, 348, 362
diffusers 52, 56, 94, 97, 104
digital negatives 553
dimensionality 510, 514
diopters 339
discontiguous option 597
discord 479–80, 486, 502–3, 511
displacement maps 169, 327
display 608–9
distressing 594
dithering 587, 604
documents 570
dodging 564–65
dpi (dots per inch) 572, 618–19
drinks 394
drop shadow 382, 420
drop-out black 378–79
dry-mounting presses 608
dulling spray 421
Duotone Curve 588
duotones 586–89, 605
dust 29, 70–71, 131, 271, 308, 574, 628
dust storms 308
dye-sublimation printers 599–600, 606
dykes 302
dynamic range 554, 566–67, 573, 575, 584, 586–87, 614–15, 626–27

earth colors 479
edge lighting 48–49
edges 514
effects 64–65, 585, 592–94, 600
effects light 156, 172–73
efl (equivalent focal length)

183–87, 277, 416, 623, 625
electricity socket types 631
electron microscopes 363
embedded information 603
Embedded Profile Mismatch 467
Emerson, Peter Henry 315
endoscopes 364–65
enlargement 553
enlargers 402
environmentalists 315
Epson 586
equalization 243
erythrolabe 428
Esmann, Jan 582
ethnicity 547, 549–50
etiquette 218
exercises 138–39, 167
experts 329, 392
exposés 266
exposure 9–10, 12–13, 16, 22–23
available light 79, 89–91
calculation 121
camera basics 621, 626–27
lock 39
photographic lighting 92–94
still life 405
expression 126–27, 130, 133, 137, 140, 142, 168–69, 178, 201, 207, 602
expressionism 445, 492
extended portraits 206
extension rings 294
eye-contact 127, 142, 148, 287
eye-line 137, 141, 150, 196
eyepieces 360–62, 364
eyes 74, 126, 133, 141, 144–46
close-ups 336, 338, 346, 363
color basics 428–29, 436–37, 446
daily life 186–87, 190–91
digital workflow 464, 467–69
monochrome basics 510, 512, 514, 519, 521, 524, 550
people 157, 162–64, 167–68
prints 604
wildlife 286

f-stops 10, 12–13, 47, 54
faces 74, 126, 130, 133
daily life 185, 191, 196–97, 212, 214
digital black and white 557
monochrome 546–47
poses 137–40, 142, 144–46, 156–58, 161–64, 167, 169
prints 602
wildlife 286
fading 167, 594
fall-off 102, 110, 112, 404, 571
fashion shots 160, 164
feathering 167, 171
feeding 284–85, 288
fiber optics 364–65
fidelity 403
field curvature 342
file formats 566, 620–21
file size 519, 572, 620–21
fill-in flash 154–56, 208

filters 45, 60, 69, 102–3
camera basics 615, 617, 624
close-ups 361, 363
color basics 450
digital black and white 560, 568–69, 590, 592–94
manmade landscapes 323, 326
monochrome basics 520–22, 525, 538, 540, 542, 544, 548
natural landscapes 252–53, 265, 270–71, 277
nature in detail 421
still life 382–83, 405
wildlife 295, 300–301, 304, 308
fireworks 90–91
firmware 459
first light 52
fish-eye 622
fixed focus 293
fixed-lens cameras 355, 358–59
fixed-pattern noise 569
flags 106, 112, 116–17, 121
flare 47–49, 66–67, 106–7, 156, 243, 253, 278, 403
flash 9–11, 21, 42, 92–99
meters 97
people 134, 149, 153–55, 172
photographic lighting 101, 104, 113, 116
still life 394
synchronization 9, 11, 94
wildlife 294, 300, 313
flash-to-subject distance 354
flesh tones see skin tones
flexible color 381
flexscopes 364
flicker effects 484
flowers 410–12, 494
fluorescent 9–11, 21, 82–83, 86, 90, 100, 102, 374, 439
fly-on-the-wall shots 208
flying 276–79
foamboard 608
focal length 23, 50, 52, 70
close-ups 338–39, 341, 354
daily life 179, 181–86, 191, 194
manmade landscapes 325–9
natural landscapes 231, 235, 242–43, 249, 271, 277, 279
nature in detail 414, 416
people 133, 138–39, 161
photographic lighting 93
still life 369
wildlife 293–94
fog 29, 64, 70–71, 269, 272–73, 297
follow focus 293
food 373, 392–93, 443, 623
foreground 11, 45, 68–69, 93
forests 227, 296–97, 302, 331, 355, 411–13
form 509, 511–12, 514
frame shapes 236–41
frame-filling shots 282
frames 608–9
freckles 520, 550
freezing motion 137, 154, 222, 292, 414

Friedrich, Caspar David 228
front lighting 514–15, 571
front-curtain sync 223
frontal lighting 38, 40, 42–43, 69, 93, 118, 162–63, 258
Fujifilm 621, 626
full-length shots 79, 142–43, 160, 181, 197, 570
fungi 410–11
furbo filters 383

Gage, John 486
gamma 464–65
gamut 448, 461–62, 472, 525, 605
gardens 62, 317, 330–33
Gauguin, Paul 428
gels 102, 172
gemstones 424–25
geometry 512
gestures 137
geysers 310–11
ghosting 615
glass 380, 388–89, 394, 405, 416–19, 421, 439
glass plates 177
Goethe, Johann Wolfgang von 486, 488
golden light 254–55
Gombrich, Ernst 484
gradation 64
gradient mapping 562–63, 605
gradient tool 382
graduated filters 45, 60, 252, 301, 624
graduated focus 489
graffiti 317, 320–21
grain 77, 177, 383, 568, 585
graphic qualities 514–15
graphics tablets 167
grassland 298–99, 302, 544
gray 434–35, 438, 453–57, 464
cards 20, 112, 466–67, 469, 554, 557
point 473
prints 604
grayscale 327, 467, 518–19, 536, 554, 566, 572, 584, 586, 597, 603–4
grayscale conversion 525, 529, 534, 547, 569, 593
green 427–28, 435–40, 442
GretagMacbeth Color Checker 466–67
grid focusing screens 403
ground level 231, 329
group shots 148–51, 160, 210–11
guests of honor 209
guide numbers 92–93, 354–55, 415
guides 203, 234, 264, 284–85, 320

Haas, Ernst 254
habitats 280–313, 411–12, 416–17, 419
hair 141, 156–57, 164, 170–71, 295
halo 48, 561
Hals, Frans 505
hand-coloring 596–97

handheld metering 121
handheld shots 144, 185, 261, 419, 625
hands 137, 142–43, 286, 295
hard light 156, 172
hardware 459, 465, 474
harmony 479–80, 486–89, 491–93, 500–502, 511
haze 29, 48, 54, 64, 67–69
HBS controls 463
HDRI (high dynamic range imaging) 566–67
head-and-shoulders 133–34, 140, 156, 160–61, 181, 197
heads 141–42, 181, 187, 196–97
heat shimmer 308
heat-proofing 102–3
hides 303
high contrast 26–27, 38, 45–48
 black and white 577
 natural landscapes 252, 265, 272, 275
 people 158
 photographic lighting 116
 wildlife 301, 306
high key 550, 577
high-performance fluorescent 100–101
high-pressure systems 286
highlights 17, 20, 22, 39
hills 241
histograms 9, 16–19, 153, 190–91, 472–73, 527, 563, 567, 571–73
Hokusai 453
homes 134–35
horizon 11, 30, 36, 40, 43–45
 color basics 436
 manmade landscapes 324
 natural landscapes 235, 238, 240, 244, 250, 258, 260, 263, 266, 268, 270–71, 274, 279
 natural light 52–53, 60, 68, 74
horizontals 196–97, 236–38, 240, 305, 325, 402–3
hot spots 404, 571
hot springs 310–11
hotshoe connections 92, 154, 613
housings 102, 294–95, 308, 311, 414, 416
HSB controls 165, 253, 306, 326, 431, 474, 518–19, 534
Hudson River School 254
hue 431–34, 442, 444, 446
 color basics 455–56
 color management 480–81, 484, 486, 489–90, 496, 498–99, 501, 504–5
 digital black and white 570
 digital workflow 462–63, 473–74
 monochrome basics 509, 512, 518–20, 525, 527, 530, 532, 534–35, 546
 prints 604
Hue/Saturation 463, 484, 493, 519, 529, 534–35, 559
humidity 68

ICC (International Color Consortium) 466, 477, 605
ice 306–7, 394
iCorrect EditLab Pro 473
identity photos 141
ideograms 321
image size 325
ImagePrint 605
impressionistic landscapes 227
in-between moments 192
in-flight precautions 277
inCamera 466
incandescent light 9–10, 80–81, 86, 100–103, 274, 359, 450, 469
indigo 436
indoor daylight 78–79
indoor sets 416–17
indoor shots 466
information sources 285
Ingres, Jean Auguste 501
inkjet printers 462, 477, 586, 599–600, 604, 606
inks 448, 477, 587–89, 599, 604–7
interactive landscapes 242, 244
interactivity 130, 335
interference-contrast 362
interiors 78–80, 83, 86, 94, 102, 160, 208, 247, 307, 373, 380, 502
internet 620
interpolation 292, 614–15
interpretation 323, 346, 423, 553, 561, 576–77
interrupted color 485
interview shots 136–37
intimate shots 200–201, 210
into-sun shots 44–46, 50, 255, 265, 301, 304
inverse square law 9, 11
inverters 631
IS (image stabilization) 625
ISO settings 10, 54, 91–92, 150
 close-ups 354, 361
 daily life 179, 189, 208, 212
 digital black and white 568, 585
 natural landscapes 261, 273
 wildlife 297
isphoto 605

Jackson, William Henry 229
jars 121
jewelry 390–92, 424
joules 98
journalism 619
JPEG files 553, 620–21

kallitype 582
Kandinsky, Vasili 502–3
key frames 192
key-stoning 403
kinetic energy 440
kitbags 628–29
knapsacks 305
Kodachrome 254
Kodak 20, 520, 621

L*a*b* mode 461, 463
lakes 227, 278, 302, 445
lamp positions 102
landforms 264, 281
Landino, Cristoforo 509
landmarks 317
landscapes 11, 40, 61–62, 64
 black and white 557
 manmade 314–33
 monochrome 516, 520–21, 534, 537, 542
 natural 226–79
 people 152
 wildlife 282–83, 300, 302, 304–5, 308, 310–11, 313
lasso tools 171
lavender 448
layer masks 529, 536–37
layers 528–29, 535, 593, 597
layout 603
LCD screen 13, 15–16, 21, 39
 available light 77, 82, 86
 camera basics 612, 617, 630
Leica 624
lens focal length 138
lens shades 48–49, 253, 404
lens types 622–25
lenses see lens focal length; lens types; macro; telephoto; wide-angle; zoom
letterbox format 241
level flight 279
Levels 165, 467, 472, 528–29, 558–59, 561, 573
Li-ion batteries 630
light boxes 108, 121, 375, 461, 573
light levels 67, 77–78, 179, 300, 302
light loss 342
light meters 404
light tents 386–87
lighting 9–11, 20, 23–24, 29
 natural light 36, 42, 59, 62, 69, 72, 74
 photographic lighting 92, 104, 118, 120
Lightness 463
lightning 62, 273
likeness 125
limbs 142–43
liquids 394–95
lists 128, 131
lith film 590
local color 501
local contrast 548, 550, 565
local detail 564
locations 130–34, 149, 153, 170
long lenses 186–87, 214, 218–19
long object conjugates 338
long-exposure noise 569
Lorant, Stefan 224
loss of light 342
lossless compression 621
lossy compression 620–21
low contrast 24–25
low key 577
low light 62, 212, 286, 302, 569
low sun 40–43, 45, 308, 319, 469, 493
low-pass filters 615, 617

luminaires 116
luminance 463, 569, 614
lunar quality 538
luster 422–23, 425
Lyson 607

Machiels, Udo 605
Macke, August 445, 492
macro 46, 146, 312, 335–36, 339–40, 342–43, 345, 348, 355, 359, 412, 416
macro lenses 340–42, 414
Macs 464–65, 621
magazines 125, 129, 132, 136
magic hour 254
Magic Wand 171, 516
magnets 363
magnification 336–38, 340–43
 camera basics 617, 623
 close-ups 345, 349, 354, 359, 361, 363
 nature in detail 410, 413, 415
Maisel, Jay 254
make-up 162–64, 544, 550
Malevich, Kasimir 455
mammals 284–86, 298, 416
Manet, Edouard 453
manipulation 168–69, 370, 427, 458–77, 506
manmade landscapes 314–33
manual settings 12
maps 203, 234, 278
marshes 302–3
mask painting 171
masking layers 171
Master Selection 535
Matisse, Henri 453
matrix metering 13–15, 22, 39, 181, 191, 359
Maxwell, James Clark 428, 524
mechanical stages 360–61
medium telephoto 184–86
memory cards 214, 236, 553, 620–21, 628
memory color 190, 459, 469–71, 574
memory effect 630
memory shapes 398
meniscus lenses 339
metallics 479
metamerism 439, 604
metering 12–15, 22–23, 39, 59, 90, 92, 121, 181, 191, 301, 342, 359
Meyerowitz, Joel 269
micro 358–59
microscopes 336, 342, 358–63
midday 9, 36, 74, 152, 274, 276, 299, 308, 319, 355, 469–70
migration 284–85
minerals 422–23, 443
miniatures 412–13
minimal views 268–69
minimalism 370–71, 408
Minolta 621
mireds 102
Missing Profile 467
mist 29, 64, 70–71, 153, 256, 269, 273, 297
mixed lighting 82, 86–87, 100, 102

mode changes 518
modeling 156, 383, 396–97, 420, 454, 509
modeling form 118–19
models 15, 138, 140, 143–44, 162–63, 396–97
moiré 615, 617
moment-capture 192, 194, 220–21
monitor 599
monitors 428, 432, 448, 453, 459
monochrome 229, 427, 505, 508–45, 552–97, 604, 606–7
mood 576–79
moonlight 54–55
morning 36–37, 40, 255–56, 260
mosaics 242–43
motion blur 144, 222–23
mountains 72–73, 227, 231–32, 241, 263, 407
mounting 608–9
Muench, David 267
multi-pattern metering 13–14, 22, 181, 191
multicolor combinations 496–99
multiple exposure 567
Munsell, Albert 433
Munsell colors 466
murals 321
mushrooms 410
muted colors 504–5
Mylar 380

natural lighting 29–75, 128, 152–53, 294
naturalists 285, 409
nature in detail 406–25
near-far composition 183
negatives 572–73
neighboring colors 489
neon lights 319
nervous subjects 133, 136, 142, 285
neutral density filters 361
neutral graduated filters 45, 60, 252, 624
newspapers 125, 136
Newton, Isaac 427, 430, 432–33, 436, 520
NiCd batteries 630
Niéphore, Niépce 509
night shots 88, 273, 285, 319, 415
nikMultimedia 253, 594
Nikon 14, 358, 393, 603, 621–22, 624–25
NiMH batteries 630
noise 54, 150, 177, 189, 261, 354, 383, 568–69, 585, 616, 619
Nomarski system 362
nominal subjects 268

O-rings 295
objectives 360–61
off-axis shots 43–44, 48, 137, 153, 158, 294
off-center shots 183, 283, 407
offset printing 525
Olympus 621
on-camera flash 92–96, 98, 154–55, 313, 354, 356, 414, 560

Op Art 484
opacity 382
open shade 15
OptiCal 465
optimizing 472, 553, 558, 572–73, 575, 590, 594, 604, 614
optimum aperture 343
orange 436–38, 442–43, 450–51, 486, 488–89, 492–93, 501, 521
orientations 197
orthochromatic film 584
O'Sullivan, Timothy 229
Oudry, Jean-Baptiste 454
overcast 56, 66, 258–61, 272, 276, 298, 302, 557
overexposure 12, 17, 47, 61–62
overhead lighting 163
overhead shots 277
overlooks 234–35, 352
overviews 318
overwriting 519

palladium 582
Panasonic 624
Panavision 244
panchromatic film 584
panning 91, 214, 223, 243, 625
panoramas 237, 240–44, 435, 567, 628
Pantone 587, 589
paper 477, 571, 575–76, 581, 594, 599–600, 604, 606–8
parades 214–16
parallax 414
parks 317–18
Parr, Martin 503
partial coloring 597
parties 208–9
pastels 479, 498, 505
pastiche 594
paths 170
patterns 238, 265, 272, 276, 297, 301, 381, 408–9, 420
peak moments 220–21
Pentax 621
people 124–75, 211, 218, 222–23, 232, 258, 286, 316–17, 324
perspective 42, 56, 68, 75
 correction 325, 327
Perspex 374–75, 380, 387, 416, 419
phase-contrast 362
Photo Filter 450
Photo-Realism 489
photodiodes 614, 626–27
photojournalism 128, 133, 224
photomacrography 336
PhotoMatix 566
photomicrography 336, 358–61, 363
photomontage 402
photons 614
photopic system 482
Photoshop 16, 61, 67, 90
 color basics 427, 450
 color management 479, 481
 digital black and white 553, 560, 564, 569, 572–73, 584, 586–87, 589–90, 592, 594

digital workflow 459, 461–67, 472
monochrome basics 518–19, 522–23, 526, 528, 534, 537
natural landscapes 253
people 164–65, 169–71
prints 603, 605
photosites 614–15, 617, 623, 626
PictoColor 466
picture essays 206, 224–25
PictureCode Noise Ninja 569
pincushion distortion 625
planar output 242–43
planning 128–29, 151, 153, 162
 daily life 180, 188–89, 211, 214, 219, 221, 224
 natural landscapes 278–79
 still life 368–69
plants 330, 407–8, 410–11, 422, 446, 490, 546
plate cameras 356
platinum 582
Plexiglass 374–75, 380, 387, 419
plug-ins 253, 327, 466, 582, 584, 590, 594
plumb lines 403
polarization 64, 363
polarizing filters 69, 270–71, 277, 300–301, 308, 326, 363, 405, 421, 624
Porter, Eli 407
portraits 74, 79, 112, 116
 daily life 177–78, 180, 185, 188, 197–98, 200–202, 206–7, 211, 218, 222, 224
 digital black and white 570
 monochrome basics 520, 546, 548, 550
 nature in detail 410–11, 417
 poses 125–28, 130, 132–33, 138–41, 143–45, 148, 152, 156–57, 159–61, 164, 166, 168, 174
 still life 367
 wildlife 281, 284
poses 133, 137, 140, 142, 177–78, 198, 200, 202, 206, 208, 210
post-production 102, 164–65, 168, 511, 521, 538, 553, 568–69, 572, 596, 599, 608, 625
posterization 590, 592–93
posters 367
power 630–31
power points 131
PowerRetouche 582, 584
ppi (pixels per inch) 618–19
pre-wedding events 211
presentation 608
previews 336
prime lenses 624–25
printers 236, 403, 460–61, 463, 472–73, 476–77, 553, 575, 586–87, 599–601, 604–6
printing 448, 509, 525, 553, 572, 582, 586–87, 599, 602–3
prints 224, 236, 598–609
 color basics 432, 453
 digital black and white 554, 564–65, 567, 570, 574–76, 578,

580, 582, 594, 596
 digital workflow 462, 466
 monochrome basics 516, 520
prisms 358, 362, 432, 436, 438
Process Duotones 589
processors 568–69, 626
product shots 48
profiles 461, 464–67, 469, 476–77, 604–5
 camera basics 627
 digital black and white 557, 566, 569, 574, 586, 597
 digital workflow 461, 467, 473
 monochrome basics 516, 521, 532, 548–49
 prints 604
rhodopsin 428
RI (refractive index) 438
Riley, Bridget 484
rim lighting 40, 116
ringflash 162
ringlights 356
RIP 605
rites of passage 212–13
rivers 407
rock pools 300
Romantic painting 232, 254–55, 262
rotating 572
Rowell, Galen 254, 263

S-curve 467, 559, 627
safari vehicles 290
salt 295, 300
sampling 463
sand 308
saturation 66, 90, 191, 528, 534, 544, 597, 626
 camera basics 626
 color basics 431, 433–35, 456
 color management 489–90, 498, 502
 digital black and white 597
 digital workflow 461, 473–75
 monochrome basics 511, 518, 528, 534, 544
 natural landscapes 254–55, 271, 273
 still life 405
 wildlife 294, 304, 306
saving 519
scale 146, 186, 206, 232–33
 close-ups 336, 346, 350, 363
 manmade landscapes 323, 326–27, 330
 natural landscapes 244
 nature in detail 407, 411–12
 still life 388, 396
 wildlife 305
scanners 356–57, 460, 476, 573–74
scanning 572–75, 582, 584, 619
scene-setting 130–31
scent 286–87
Scheimpflug principle 345
scotopic system 482
scrapbooks 143
scratches 612, 624
screen images 236, 241, 462, 464–65, 476, 599, 619
scuba-diving 294
seascapes 268, 445
second light 156, 571

reverse proportions 493
reversed grad filters 271
RGB channels 518–19, 522–27, 572, 619
RGB values 20, 427, 453, 456

selective focus 184–85, 223, 623
selenium toning 581, 589
self-consciousness 136–37
sensitometry 554
sensors 9, 12–14, 20, 26, 54, 73, 121
 available light 84
 camera basics 612, 614–17, 619, 622–24, 626–27
 close-ups 335–39, 342–43, 354, 363–64
 color basics 428, 438, 449, 455
 daily life 177, 183, 185, 187
 digital black and white 553, 568–69
 digital workflow 462, 466
 monochrome basics 524
 natural landscapes 237
 wildlife 281, 293, 304
Separation Guide 403
separators 609
sepia 581
sequential shots 348–49
sets 372–73, 416–17
settings 130–32, 380–81, 410, 416
shadow fill 94, 119, 163, 414, 420
Shadow/Highlight 560, 565
shadows 22, 31, 36, 38–39
 available light 79, 89
 digital workflow 466, 473
 natural light 42–43, 56, 66, 69, 72, 74
 photographic lighting 92–93, 107–8, 110, 114, 118
shakkei 330
shallow focus 184, 335, 344, 346–47
shape 118, 509, 511, 514
sharpness 116, 144, 146, 168
 camera basics 619, 623
 close-ups 335, 338–39, 342–44, 348–49
 natural landscapes 278
 nature in detail 412
 wildlife 292
shells 420–22
Shibata, Yukako 400
shift lenses 325, 398
shot lists 128
shoulder angle 141
shoulders 142–43, 156
shutter lag 220
shutter speed 9, 12, 51, 54
 camera basics 621, 625, 628
sidelighting 37–40, 69, 118, 258, 272, 302, 398, 515
Sierra Club 315
signage 320
silhouettes 16, 37, 44, 46–47, 52, 70
 natural landscapes 247, 255, 258, 261, 265, 273
 nature in detail 413
 people 154
 photographic lighting 114, 118
 wildlife 302, 306
simultaneous contrast 480–82, 485, 488
Sketch 590

skies 20, 29–31, 34–35, 39, 90
 color basics 443, 445
 color management 484, 493
 digital black and white 568
 monochrome basics 516–17,
 520–22, 530, 534, 537–38,
 540, 544
 natural landscapes 227, 235–
 36, 238, 241, 243, 250, 252–55,
 258, 260–61, 269–72, 274, 279
 natural light 46, 52–54, 56–
 61, 64, 67
skin 391, 568
skin tones 153, 190–91, 469–70,
 519, 521, 527, 544, 546–51, 557
skylight 21, 31, 34–35, 52, 57, 72,
 542, 549
skylines 317
skyscapes 270–71
slave triggers 97
sleet 263
slide shows 224
SLRs 14, 187, 223, 237, 251
 camera basics 612, 614,
 616–17, 622–23, 630
small-town life 204–5
smart selection tools 171
SmartColor 473
snoots 117, 158
snorkeling 294
snow 29, 48, 305–7, 389
socket types 631
soft boxes 112, 158
soft light 156–59, 172, 256, 261
software 229, 241–43, 253, 327
 camera basics 617, 624–25
 close-ups 356
 digital black and white 553,
 566–69, 572–73, 584, 590–94
 digital workflow 459–61, 463,
 465–67, 471, 473–74
 monochrome basics 521
 prints 599, 603, 605
solarization 590
Sommer, Friedrich 268
Sony 625
space 160–61
special effects 593, 600
spectrophotometers 465, 476–77,
 605
spectrum 427, 436–38, 442, 445,
 494, 520, 524, 534–35
specular highlights 549, 557, 624
spherical aberration 342–43, 624
spigots 104
Split Channels 525
split-diopter lenses 339
sports 218–21
spot colors 500–501, 586
spot metering 14, 22–23, 39, 191
spots 97, 116, 156, 158, 162, 319, 609
spray 300
Spyder 465
square format 238
sRGB 462
staining 362
stalking 286–87, 297, 302
stamps 398–99

Stieglitz, Alfred 229, 271
still life 10, 48, 78, 107, 112, 114, 230,
 353, 356, 366–405, 407, 454
Stitcher software 241–43
stock libraries 619
stock shots 320
stopping down 342–44, 348, 414,
 419
storage 572
storms 62–64, 235, 250, 262–63,
 281, 300, 308, 315
storytelling 132, 150, 206–7, 224,
 244
straight-line section 627
streams 269, 297, 299
street art 317, 320–21
street furniture 320–21
street lighting 10, 319, 439
street photography 180–81, 186,
 203
striplights 375
strobes 154
studios 158–61, 172–74, 177, 345
 camera basics 628
 digital workflow 466, 476
 flash 96–99
 nature in detail 416–17, 422
 still life 367, 370, 392, 400
style 511, 590–92, 594, 597
styling 372–73
stylists 372, 392
stylization 590–92, 594, 597
subjectivity 182, 474–75
Sublime 262–63
substitute ice 394
subtractors 173
suburbs 315, 317
successive contrast 480–81, 488
Sugimoto, Hiroshi 269
sulfur toning 581
sun 46–47, 56, 58, 67–68
sunlight 29–31, 36, 57, 59, 78, 86
 color basics 450, 453
 daily life 190
 digital black and white 571
 digital workflow 468
 monochrome basics 549
 natural landscapes 254, 263,
 273, 276, 278
 nature in detail 411
 people 152, 154
 role 62, 64, 66–69, 72
 still life 355, 395
 wildlife 281, 286–87, 295–98,
 300, 302, 304, 319
sunrise/sunset 20, 30–31, 40
 available light 83
 color basics 449
 color management 493
 manmade landscapes 319
 monochrome basics 538
 natural landscapes 235, 254,
 256, 258–61, 271, 274–75
 people 153
 role 50–53, 74–75
Sunshine filter 66
supports 104–5, 143
swimmers 220

sync cords 355
Szarkowski, John 267–68

tacking irons 608
tactility 515
talking heads 137
tanks 418–19
telephoto 13, 23, 40, 46
 available light 90–91
 camera basics 622–25
 daily life 182–87, 201, 209, 214,
 219, 221, 223
 manmade landscapes 318,
 325, 329
 natural landscapes 231–32,
 234, 238, 248, 258, 261,
 265–66, 277
 natural light 48, 52, 54, 69
 people 133, 138–40, 146
 wildlife 281, 283, 292, 304–5,
 312
television monitors 211
tenebrism 505
Terrazzo 383
test shots 86, 112, 129, 151, 191, 281,
 466
test targets 605
texture 33, 38, 42, 44, 56
 close-ups 352
 digital black and white 554,
 557, 571
 natural light 60, 75
 nature in detail 407, 420,
 422–23
 people 164, 166–68
 photographic lighting 112
 prints 606
 still life 370, 380–83, 392, 405
 wildlife 302, 306, 308
Thoreau, Henry David 315
thumbnails 602–3
tides 300
TIFF files 553, 620–21
tilt of head 141–42
tilting cameras 324–25
tilting lenses 345
time exposure 223, 269
timetables 128
toadstools 410
Toned Photos 582
toner effects 580–81
tools 384–85
toothcomb effect 592
torso shots 140–41, 160
tourism 318
towns 315–16
tracking 292
traditional tones 582–83
trans-illumination 120
transformers 98
transparency 120–21
Tri-X 584
trinocular microscopes 358–59
tripods 43, 48, 54, 60–61
 available light 77, 90–91
 camera basics 625, 628
 close-ups 355, 358
 daily life 214, 222

natural landscapes 253, 261
nature in detail 411, 413–14
people 127, 151
photographic lighting 97
still life 375, 402
wildlife 297, 312–13
tristimulus response 428
tritones 586, 589
tropical beaches 301
tropical light 74–75
true macro 342–43
TTL (through-the-lens) metering
 23, 121
tungsten 10–11, 21, 80, 88
 close-ups 359, 361
 color basics 436, 439, 450
 color management 493
 daily life 212
 photographic lighting 96,
 100–102, 104, 108, 113, 116–17
tungsten-halogen 100, 113
Turner, J.M.W. 228, 262–63
twilight 52–53, 259–61, 270, 274
two-pass technique 167

ultraviolet filters 69, 277, 300, 304,
 308, 624
umbrellas 15, 112, 133, 156, 158–59
undercolor exposure 597
underexposure 12, 17, 191, 265, 301,
 306, 455
underground landscapes 313
underwater housings 294–95,
 308, 311
underwater shots 294–95, 439
unreal color 506–7
unusual landscapes 198–99,
 264–65, 276
urban landscapes 316–17

valleys 227
Van Gogh, Vincent 503
vanishing boundaries 484
vapor lamps 10–11, 84–86, 88, 439
Vasarely, Victor 484
vehicles 290–91, 299
ventilation 102, 113, 308
verticals 33, 185, 196–97
 converging 312, 324–26, 329
vibration 484, 490, 492
video 211–12, 224
viewing conditions 464
viewpoints 227, 231, 234, 237
 close-ups 345, 364
 manmade landscapes 316,
 318, 322–23, 325, 328, 330–31
 natural landscapes 243, 251
 nature in detail 408, 411,
 418–19, 424
 still life 389
 wildlife 282, 290, 296–97, 301,
 303, 310, 313
Vigeland, Gustav 321
vignetting 359, 570, 594
violet 436–37, 442, 444, 448–49,
 481, 486, 488–89, 494–95
visual cortex 479–80, 498
visual pollution 266

visualization 512–13, 576
vivaria 416–17
volcanoes 310–11
voltages 631
VR (vibration reduction) 625

Warahara, Ikko 269
warm colors 491, 493
water holes 284–85, 299
waterfalls 278, 394
Watkins, Carleton 229
weather 227, 231, 235, 252, 260,
 262–63, 272–74, 278, 285–86,
 297, 304–5, 330
websites 224, 358, 376, 584, 599,
 619
weddings 155, 210–12
Weston, Edward 229–30, 267,
 315
wetlands 302–3
white 374–75, 380, 435–36
 cards 20, 389, 394, 420–24
 color management 480, 482,
 484, 498, 500, 505
 point 275, 472–73, 558–59,
 561–62, 572–73, 576, 588
white balance 20–21, 51, 75
 available light 80–81, 83–84,
 86, 90
 camera basics 624
 color basics 427, 436, 438
 digital workflow 459
 photographic lighting 100,
 102, 112
wide-angle 45, 52, 69–70, 130
 camera basics 622–23, 625
 daily life 182–84
 manmade landscapes
 324–25, 329, 331
 people 133, 138–39, 150
wilderness 228–29, 266, 315,
 318
wildlife 280–313, 412, 416
wind 153, 249, 263, 269, 300, 305,
 308
window lights 112
windows 78–79, 131, 133–34, 246,
 278, 290–91, 316, 354, 389,
 464–65, 609, 621
without-view shots 183
wood-block prints 570
woodland 62, 296–97, 411–13
work as subject 188–89
workflow 427, 459–60, 476, 529,
 553, 572, 604
world socket types 631
Wratten filters 520–21

Xaos Tools Paint Alchemy
 383

yellow 427, 436–37, 439

zone system 554–57
zoom 23, 182, 219–20, 249
 camera basics 613, 624–25
 ratios 187, 622
 setting 138